African Vodun

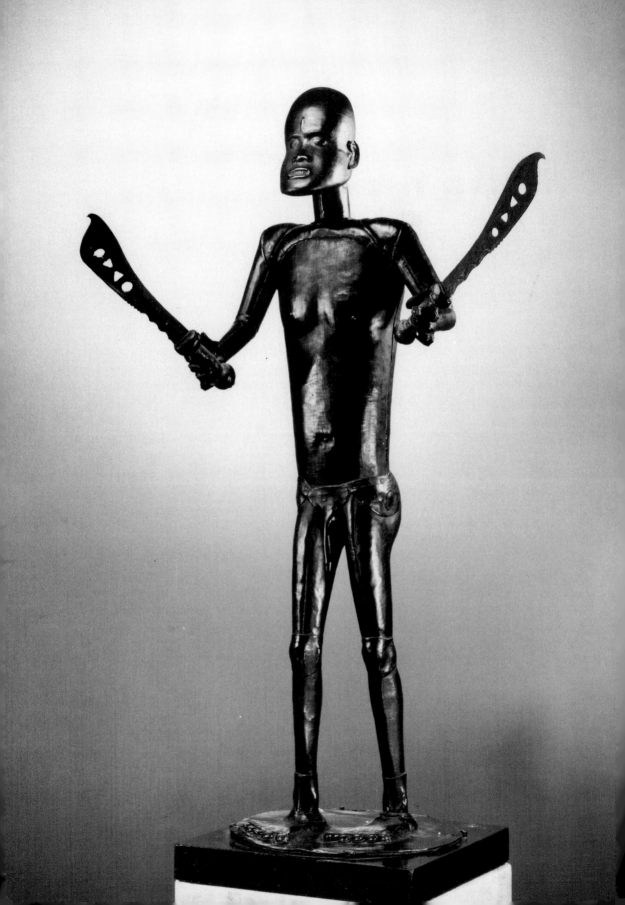

African Vodun

Art, Psychology, and Power

Suzanne Preston Blier

The University of Chicago Press
Chicago and London

Suzanne Preston Blier is professor of art history
in the Department of Fine Arts at Harvard University.

Publication of this book has been aided by grants from the Getty Grant Program
and the Millard Meiss Publication Fund of the College Art Association.

The University of Chicago Press, Chicago 60637
The University of Chicago Press, Ltd., London
© 1995 by The University of Chicago
All rights reserved. Published 1995
Printed in the United States of America

03 02 01 00 99 98 97 96 95 1 2 3 4 5

ISBN: 0–226–05858–1 (cloth)

Library of Congress Cataloging-in-Publication Data

Blier, Suzanne Preston.
 African vodun : art, psychology, and power / Suzanne Preston
Blier.
 p. cm.
 Includes bibliographical references and index.
 ISBN 0-226-05858-1 (cloth)
 1. Sculpture, Black—Benin. 2. Sculpture, Primitive—Benin.
3. Sculpture—Benin. 4. Sculpture—Religious aspects—Benin.
5. Sculpture, Black—Togo. 6. Sculpture, Primitive—Togo.
7. Sculpture—Togo. 8. Sculpture—Religious aspects—Togo.
I. Title.
NB1910.B57 1995 94-2180
730′.09668—dc20 CIP

"The work of art is . . . both a symptom and a cure"
—Paul Ricoeur, *Freud and Psychology*

To:

My late grandmothers, Marjorie Perry Clark and Mildred White Preston, for their example and guidance

My parents, William S. Preston, Jr., and Janet Clark Preston, for their love, rigor, and strength

Contents

Acknowledgments

Few experiences in life are as personally illuminating as pregnancy, a state which characterized much of the seminal writing period of this book. Except perhaps for a serious illness, no other human condition makes one as much aware of the simultaneity of one's interior and exterior and the inherent conflation of individual space, time, and identity. Pregnancy also conveys to one unique attributes of otherness. In the late months of pregnancy one is alternately stigmatized (with people glancing furtively and cutting a wide path) and made the subject of intense public concern (complete strangers often approaching to offer admonishment or advice). This book addresses another dimension of interior and exterior identity, that grounded in the importance of the psyche in artistic expression. Taking my cue from maieutic discourse (from the Greek for midwife, the ancient Socratic dialectic method), the following analysis constitutes a form of intellectual midwifery in which art, to paraphrase the Oxford English Dictionary's definition of maieutics (1971), assumes a critical role in bringing into consciousness conceptions which otherwise would remain hidden. Research on art has numerous parallels with obstetrics, as one seeks to deliver into view aspects of created works which previously were obscure.

In completing the research and writing of this book, my scholarly labor was supported by a number of grants and fellowships which I gratefully acknowledge. Fieldwork in Africa was financed by a Fulbright Senior Research Fellowship and a grant from the Social Science Research Council. During the course of writing, I also benefited from a John Simon Guggenheim Memorial Fellowship and residency periods at two stimulating scholarship centers, the first, the School of Historical Studies at the Institute for Advance Study, in Princeton, New Jersey, and the second, the Getty Center for the History for Art and the Humanities in Santa Monica, California.

In Princeton, my thanks especially to Irving Lavin, Clifford Geertz, Hildred Geertz, Isabelle Schulte-Tenckhoff, and Steven Warner. At the Getty Center, I am particularly grateful for discussions with Kurt Forster and Thomas Reese as well as fellow scholars Johannes Fabian, Sanford Kwinter, Mogens Trolle Larsen, Tom Levine, Sabine McCormick, and Hayden White. My analysis also has benefited from conversations with various colleagues at Columbia University, where I previously taught, among these, George Bond, Richard Brilliant, David Freedberg, Marcia Wright, Joan Vincent, and coparticipants in Jean Howard's Reading Group (Betsy Blackmar, Caroline Bynum, Elaine Combs-Schilling, Ann

Douglas, Jean Howard, Martha Howell, and Natalie Kampen). Other scholars from various disciplines who have worked on Africa and the diaspora also have been helpful during different stages of the writing, particularly Edna Bay, David H. Brown, Karen McCarthy Brown, Denis Hynes, Ivan Karp, Corinne Kratz, and Patrick Manning. Several sections of the book were presented in lectures at Columbia University, Princeton University, Swarthmore College, the University of Pennsylvania, the College Art Association, and the Triennial Symposium on African Art. I am grateful to associated commentators and questioners for their insights.

The difficult task of examining related arts in American and European collections and tracking down the necessary photographs was aided by the help of a number of individuals whom I wish to acknowledge. Most important, I am indebted to Joseph Adande, Jakline Eid, Ted Celinko, Kate Ezra, Bryna Freyer, Jean Fritts, Christraud Geary, Ben Heller, Sue Horsey, Hélène Leloup, Michel Leveau, John Mack, Francine N'diaye, Don Nelson, Mary Nooter, Diane Pelrine, Robin Poyner, Josette Rivallain, Claude Savary, Arthur Sherin, Roy Sieber, and Susan Vogel. For their research support and aid in preparing the manuscript, my deep appreciation also goes to Suzanne Agiayo, Elizabeth Cameron, Senta Germain, Andrew Kent, Alisa Lagamma, Eunei Lee, Michelle Nordon, Elizabeth Preston, Carol Saller, and Karen Wilson.

Field research was made possible through the support of numerous individuals in Africa. American Embassy personnel were critical throughout, among others, George and Judy Moos, Constance Padavano, and especially, Amelia Broderick. I also owe a debt of gratitude to individuals in the Benin Ministry of Youth, Culture, and Sports who helped me to acquire permission to work and photograph in the Musée Historique in Abomey. A large number of Beninois also went out of their way to make my research productive, particularly the Legonou family (Aristide, Margarite, Blandine, Giselle, and Constant), Joseph Fanou, Joseph Langanfin, Alexis Adandé, Joseph Adandé, Pierre Métinhoué, Ayari Rachida De Souza, Bacharou Nondichaeo, and the many men and women who shared with me their knowledge, lives, and traditions. Michel Bagbonon helped in the difficult task of preparing the Fon and Evhe language texts for publication. My special thanks to them all.

Finally, a very special thanks both to Rudy, for his ongoing support, love, and intellectuality, and to Jocelyn, whose exuberance and smiles lightened the burden of writing.

Linguistic Note

The Fon, Evhe, and related languages are characterized by three tonal levels as well as vowel and consonant variations not known in English. The writing of its sounds thus presents a number of difficultues for European or American readers. In transcribing words or phrases, I have followed for the most part the orthography used by R. P. B. Segurola for his *Dictionnaire Fon-Français* (Cotonou 1963), with several exceptions. I have used an "n" to indicate nasalized vowels. Also differences between high, low, middle, and modulating tones have not been indicated here, except where related information is essential to the discussion of meaning. The pronunciation of letters within the text is as follows:

a is pronounced as in *saw*
e is pronounced as in *say*
ε is pronounced as in *met*
i is pronounced as in *seat*
o is pronounced as in *blow*
ɔ is pronounced as in *cough*
u is pronounced as in *use*
c is pronounced as in *church*
ɖ or *Ð* represents a "d" which is pronounced retroflexively

The fricative "h" is written as "x"; to facilitate reading by nonspecialists, however, often I have included the fricative versions of associated words in parentheses, as in Dahomε (Daxomε). Except where noted, nouns in the text are represented in the singular. When not otherwise indicated, native words are given in Fon. French and German language citations are given here in English.

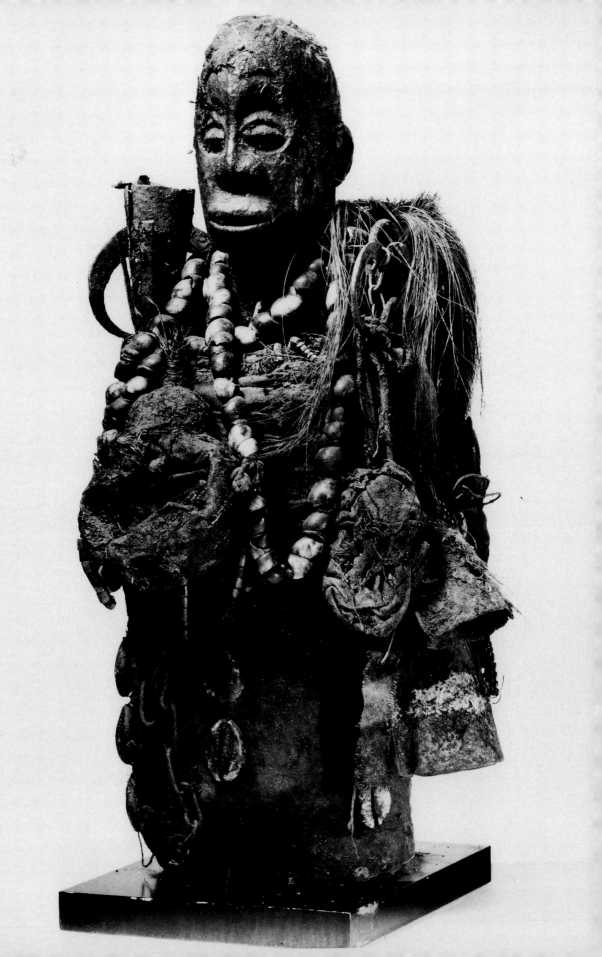

Introduction
Ties That Bind: The Psychology and Power of Art

"[T]here are no forms of art which are not forms of experience outside of art."
—Kenneth Burke, *Counter-statement*

"The truth of art lies in this: that the world really is as it appears in the work of art."
—Herbert Marcuse, *The Aesthetic Dimension*

Try to imagine a sculpture of greater visual provocation, one which more powerfully jars sensibilities or confronts silent spaces, than the one illustrated here (fig. 1). This is clearly not an object of sublime beauty; its surface is covered with what Michael Taussig would call (1987:6) a "garbage heap" of matter—iron beads, straw, bones, leather, rags, pottery, fur, feathers, blood. In their varied massing on the surface they emanate qualities of tension, anxiety, and danger. In this work a range of emotions seem to explode from within, the sculpture almost outgrowing itself and transgressing its own limits.[1] Through the ambiguous and anomalous simultaneity of body interior and exterior, the figure projects a quality of intrigue and foreboding, making visible a psychological landscape of striking complexity. Reinforcing this, the packed exterior leaves few if any open spaces, its *horror vacui* barely mitigated by the occasional deep patches of darkness which penetrate from within. The sculpture's surface bristles with textures, tastes, smells, colors, and references to sounds—materials of the senses. In the complex tonality of these diverse additive materials, feelings predominate.

Adding to this sensate quality, packets of potent substances hang heavily from the figure's surface, producing competing visual tensions of bursting and constriction. A range of suturing forms—cords, beads, iron chains, and cloth and leather wrappers—secure these and other elements to the figure, drawing one's eye and emotions into the work and its provocative power. Although little of the body remains in view (the stomach and chest being particularly heavily covered with additive matter), the hands and feet suggest poses of stasis and immovability. Above the body mass, the head stands out almost defiantly its enlarged crown, bold eyes, and forward-thrusting jaw both engaging and challenging the viewer with the mysterious power which lies within. Slicked over the head and torso, a thick patina of blood, oil, and feathers, serves as a visceral signifier of

1. Fon *bociɔ* figure. Republic of Benin. Wood with multimedia surface materials, including beads, cloth, fur, feathers, cowries, iron gongs, iron chains, and Hevioso axe. Height: 35 cm. Probably collected in the 1960s. Former collection of Ben Heller. Photo courtesy of Ben Heller. Published in Kerchache et al (1988:pl. 416).

the work's ritual history. Religious potency is further marked by attributes of various deities, here the iron gongs of Gu (the god of metallurgy) and the ritual axe of Hεvioso (Xεbioso, the god of thunder and lightning).

What draws our attention to this figure in equally provocative ways is its underlying emphasis on the grotesque, in that which is at once strange and destabilizing. M. M. Bakhtin's writings on related themes (1968:256) are of interest in this regard. Examining European folk traditions of the grotesque, Bakhtin argues (1968:305) that the primacy and potency of the grotesque lie in its association with ideas of displeasure, disequilibrium, and change. To Bakhtin (1968:317–18):"The grotesque body . . . is a body in the act of becoming. It is never finished, never completed. . . . Thus the artistic logic of the grotesque image ignores the closed, smooth, impenetrable surface of the body and retains only its excrescences (sprouts, buds) and orifices, only that which leads beyond the body's limited space or into the body's depths."[2] In key respects, the sculpture illustrated here suggests a similar image—open, rough, penetrated, inside out, a world turned upside down in reversal. Through its emphasis on themes of exterior and interior, surface and depth, containment and exclusion, covering and exposure, separation and fusion, tension and release, control and ambiguity, the work conveys the image of an inverted body, one in which internal elements are exaggerated and internal and external spaces have been interpenetrated.[3]

This sculpture, like others treated here (fig. 2) and in subsequent chapters, calls out for discovery, challenging one to locate the conditions which lie behind it. Yet, I will argue, like oblique signs discussed by Barthes, these forms remain in many respects unknowable, resistant to interpretation. Exploring a range of concerns informed at once by psychology, phenomenology, critical theory, and semiotics as well as field data rich in local language and native voice, my intent is not to read these works in order to explicate their forms and reveal their hidden meanings, but rather to bring to light the multiple codes, conventions, and conditions that help to make possible their understandability.[4] As a study of the epistemology of representation, this book explores artistic knowledge from the perspective of complexities and contradictions within the works themselves.

The sculptures examined in this book are produced primarily in the lower areas of the West African countries of Benin (formerly Dahomey) and Togo, a region occupied by the linguistically related Fon, Gun, Ayizo, Mahi, Hueda, Ouatchi, Aja, Ouemenu, Evhe, Gen, and affiliated peoples (Merlo 1977:100)(figs. 3, 4).[5] Certain African-derived cultures living in the Americas create similar works. So important is this sculptural tradition to the identity of the area where it originates that the Fon are mockingly depicted by their neighbors the Yoruba of southwestern Nigeria through Egungun performances in which maskers wear costumes displaying objects of this sort (fig. 5). The most widely employed term for these figures in the Fon and Ayizo area of southern Benin where the tradition is especially strong is *bociɔ* (*bochio, botchio, bocie*), that is "empowered (*bo*) cadaver (*ciɔ*)." Complementary nonfigural objects are known by the Fon, Gen,

2. Ouatchi? figure. Togo. Wood with multimedia surface materials, including cloth, beads, cord, small figures. Height: 52 cm. Twentieth century. The artist of this work also carved figure 117. Indianapolis Museum of Art. Gift of Dr. and Mrs. Wally Zollman. Cat. no. 1986.183.

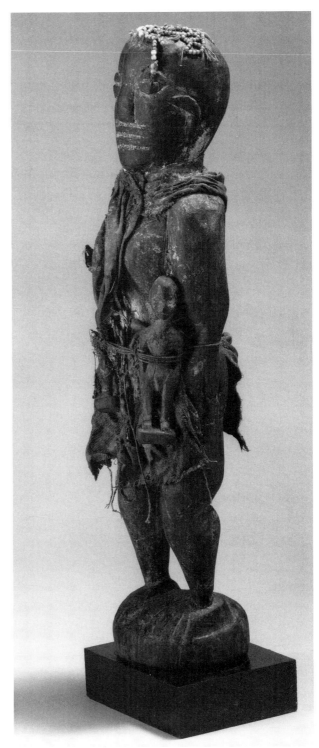

Aja, and Evhe as *bo* (*gbo, ebo*) "empowerment objects" (figs. 6, 7).[6] The etymologies and larger significance of these terms are discussed in greater depth in chapter 3.

The part of Africa where *bociɔ* (pronounced bow-chee-aw) are found was called by early travelers the Guinea Coast, the Slave Coast, or the western reaches of the Bight of Benin.[7] Peoples who live in this region share not only common sculptural interests but also belief in *vodun*, mysterious forces or powers that govern the world and the lives of those who reside within it. Sculptures of the

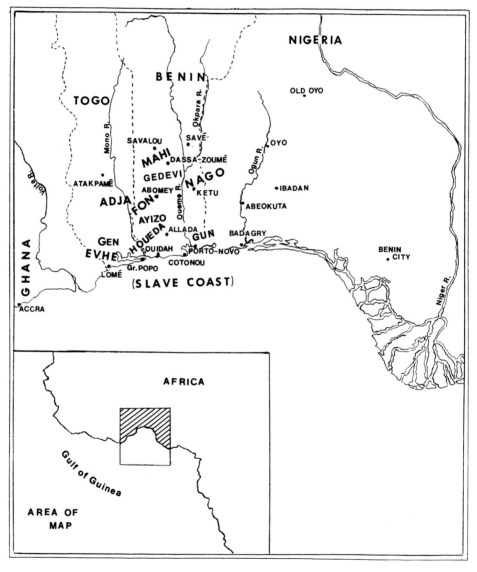

3. Map of the former Slave coast of West Africa.

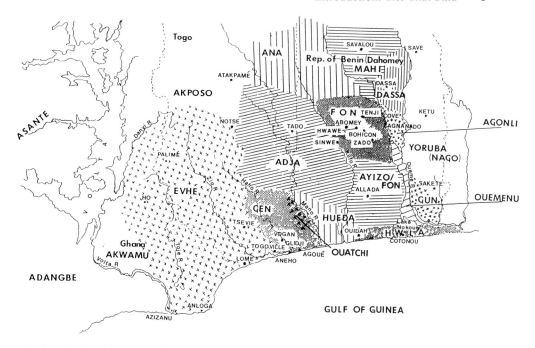

4. Map showing the location of cultures in the area.

bocio type function in conjunction with these *vodun* energies both in protecting humans and in offering avenues of individual empowerment and change. Although *bocio* sculptures are not the only arts identified with *vodun* in this area,[8] and do not in any real sense represent, symbolize, or signify the *vodun*, they are as we will see, closely identified with *vodun* power, religious tenets, and philosophy. As Herskovits explains (1964:31–32) in reference to Fon *bo* and *bocio* forms, they are "not an isolated phenomenon, but [have been] ... closely integrated with the other aspects of religion. In Dahomey ... the derivation of the powers which actuate [the *bo* and *bocio* arts] are ... ascribed to [*vodun*, such as] Legba, the Earth gods, and, most importantly, the 'little folk' [*aziza*] of the forest."

In addition to a common belief in *vodun*, much of the local populace also came under the influence (directly or indirectly) of the powerful Danhomɛ (Dahomey, Danxomè, Daome)[9] state from the seventeenth to the late nineteenth centuries. (figs. 8, 9). *Bociɔ*, as we will see, played a key role in local power relations, constituting at once strategies of vigilance and designs for change. One of my primary concerns in this book is how the *bocio* arts affected associated concerns—particularly as regards the lives of commoners.[10] Works of this sort, I argue, constitute instruments of empowerment which both directly and indirectly influence community and societal relationships.[11] Following Marcuse, I maintain that if "art cannot change the world ... it can contribute to changing the con-

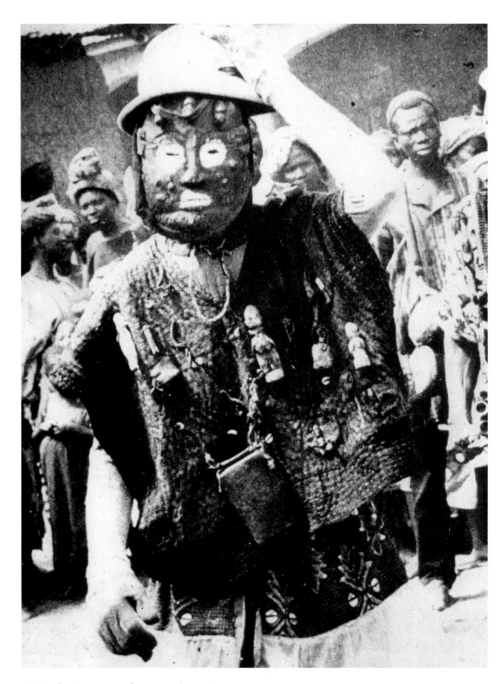

5. Yoruba *Egungun* (*Agbegijo*) masker (Oshogbo, Nigeria) portraying a Dahomey warrior wearing a costume featuring *bo* and *bociɔ*. The Yoruba artist who created this mask also has sought to incorporate Fon stylistic attributes in the carving of the face (note especially the eyes). The masked persona also is shown to be suffering from smallpox (a reference to the powerful Fon god Sagbata). The colonial helmet worn by this figure may be intended to refer to the role of the Fon kings in the slave trade. Photograph: Ulli Beier. Published in *Nigeria* (1964) no. 82: 194.

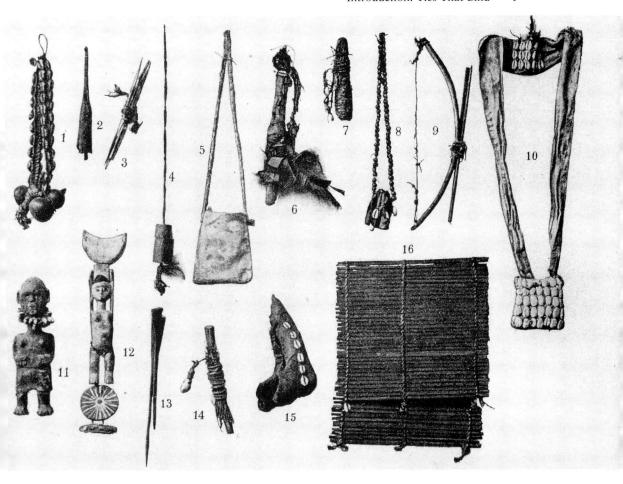

6. Figural and nonfigural power objects. Togo. Published in Speiss (1902:315).

sciousness and drives of the men and women who could change the world" (Marcuse 1978:32–33).

Bociɔ appear to have had a long history of manufacture in the area of southern Benin and Togo, and descriptions of related objects are common in the accounts of early travelers.[12] Labeled variously as "fetishes"[13] (fig. 10), "idols," "*gris-gris*," "devils," "ill-formed monsters," "villainous *magot* (ape)," and "*marmouset* (grotesque form)," early writers often emphasized the works' unattractive features, eclectic materials, ubiquity, and divinatory associations.[14] Hardwicke and Argyll, summarizing (1746:27) the findings of several period sources, observed that

the Whidah Negros have an innumerable Multitude of Images, each private Person assuming as many as he pleases. These . . . are to be seen in great Numbers in their Houses [fig. 11], Chambers, Fields, the Roads, and the Foot-Paths all over the Country, under proper Huts and Niches. . . . The inferior Fetishes, used for smaller Concerns, are made

7. Pendant-form *bo* on sale in the Be market in Lome, Togo. Called *nibusi*, it is worn to keep mosquitos and other minor troubles at bay. Photograph: Suzanne Preston Blier. July 7, 1984.

of Stone, Bone, Wood, or Earth; but herein they differ . . . from other Negros: That this small Fetish is the first Thing they see after they are determined upon any Affair, or Business, and sometimes determines them to that affair. On this Account it is taken-up and invoked.

One of the most complete descriptions of a sculpture of the *bociɔ* type, this one from the coastal area around Ouidah (fig. 12) was published by Marchais (1725, in Hardwicke and Argyll 1746:26–27; fig. 3):[15]

Agoye . . . [a] public Fetish, is an ugly Monkey-like Image of black Earth, or Clay, resembling a Frog, rather than a human Form. It is placed, or rather squatted, on a Kind of

8. Map showing the
limits of the Danhome
Kingdom.

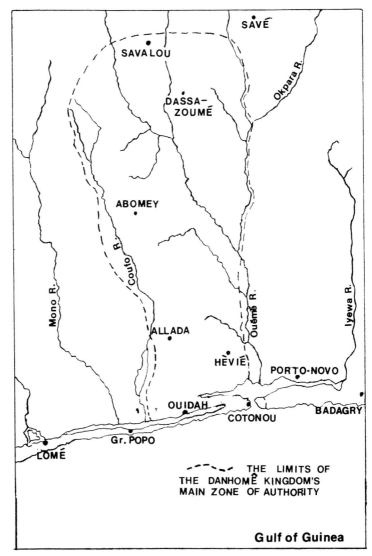

Pedestal of red Clay, on which is a Slip of red Cloth . . . about the Neck is a Band of scarlet
Cloth, a Finger broad, at which . . . hang four *Bujis* [cowries]. The Head is crowned with
Lizards and Serpents, intermixed with red Feathers; and from the Top issues the Iron of
an Affagaye [cresset; *asɛn*], that goes through a larger Lizard, beneath which is a Silver
Crescent. This Idol is on a Table in the House of the grand Sacrifice.

The Agoye sculpture described above is a multimedia work combining a range
of natural and manufactured materials whose unique properties together serve
to empower it. Like more recent *bociɔ*, this sculpture had a striking visual pres-
ence.[16] What Agoye and other later *bociɔ* share in common is not only markedly

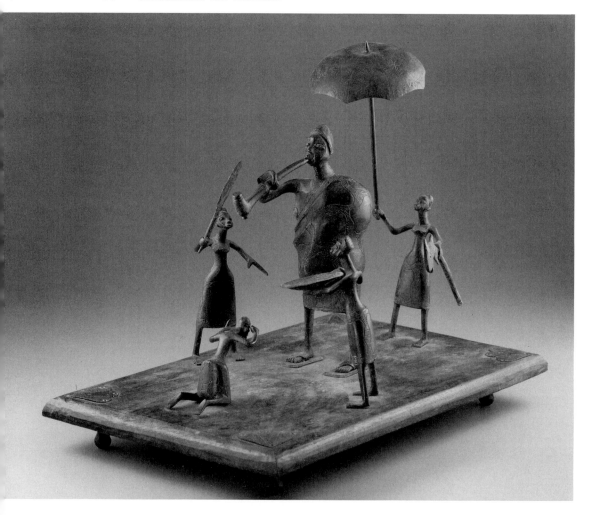

9. Fon processional showing a Danhomɛ king (probably Gbehanzin) smoking a pipe. Abomey, Republic of Benin. In the rear, the ruler's wife holds his umbrella and fish-form *makpo* scepter. In front, one woman kneels in a gesture of servitude and allegiance. Another woman holds a fan. Still another holds a platter of food. Brass. Twentieth century. Huntondji artists' guild. Indianapolis Museum of Art. Cat. no. 1989.685.

expressive features which are defined by the massing of diverse materials on the surface but also a concern with averting danger from the community and those who live within it.

Another distinguishing feature of the early *bociɔ* works from this region is their above-noted importance as a "popular" art, as sculptures which are closely identified with rural residents and commoners. Such objects, as we will see, stand in marked contrast to the elite, urban, and state *bociɔ* arts associated with roy-alty. As Ahouansou points out for both traditions (n.d.: 55–6), "The modes of

expression of [Danhomɛ] royal arts were numerous and strongly marked by Yoruba influence. . . . but the popular art, the statuary art and especially the *botchio* spirit guardians of the house are an art incontestably autochthonous." [17] While I disagree with Ahouansou on the degree of Yoruba influence on the royal art corpus, his point on the commoner *bociɔ* as a distinct sculptural grouping is correct. Their nonelite status as well as their scale, gestures, postures, subject matter, and overall form and function are strikingly different from royal art works (fig. 13). In light of these status distinctions in *bociɔ* representation, my analysis in important ways draws on Bourdieu's concept (1977) of the "positioned subject," with each person (and art form) being understood to have a distinctive place in society as defined by factors such as class, gender, age, and urban or rural identity which taken together convey a particular view of the world. [18]

Of special interest in *bociɔ* contexts is the visual contretemps which is played out between the different statuses of objects, those of commoners versus royalty, popular versus elite, slaves versus slave owners. [19] Through juxtaposed themes of

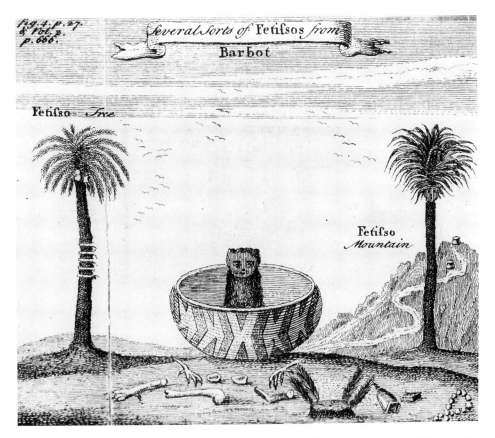

10. Guinea Coast "fetishes." Illustration after Barbot. Published in Hardwicke and Argyll (1746, 3: pl. 8).

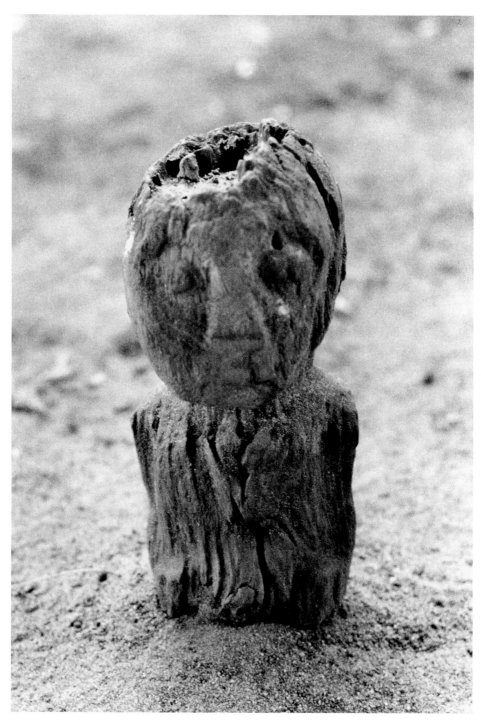

11. Fon *bociɔ*. Wood. Height: approx. 15 cm. Abomey, Republic of Benin. Photograph: Suzanne Preston Blier. May 8, 1986.

12. "Agoye, God of Councils."
From Whydah. Republic of
Benin. Published in Hardwicke
and Argyll (1746, 3: pl. 5).

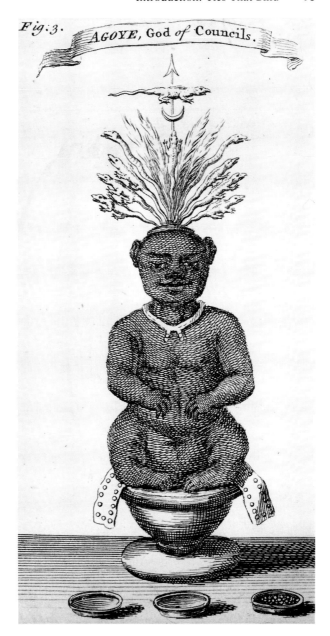

peasantry and princedom, official and contraband, concealment and display, a range of contrasting and competing social values come into play. Themes of inversion and carnivalesque reversal also are central to *boci̇ɔ* conceptualization.[20] In referencing the chaos, incongruity, and disorder of everyday life, these works challenge the status quo.[21]

Equally critical to my study are a range of psychodynamic concerns. Two

perspectives on the psyche predominate in academic and nonacademic circles, the first maintaining that the psyche is defined by distinctively universal attributes which are comparable cross-historically and cross-culturally, the second arguing that scholarly discourse on the psyche (and psychology generally) has tended to be delimited by Western and specifically modern concerns as articulated by Freud in the unique circumstances of late nineteenth-century Viennese society. It is my view that anxiety, distress, and various forms of mental illness are found in all human settings and that while the mind and mental processes may share essential features cross-culturally, each society has its unique definitions of mental process and its own distinctive approaches to the attendant problems.[22] Accordingly, while Western concepts and constructions of the psyche are of considerable theoretical and metaphoric interest, of equal importance are the diverse psychological models employed in other periods and places.[23] My interest in *bociɔ* lies in this way in the means through which power and psyche find expression at the local level, in the mentalities and cultural formations of the groups which create and use them.[24]

In southern Benin and Togo, as we will see, art assumes a critical role in psychotherapeutic practice. In this feature and in other ways, psychotherapies display a multifocality rarely evidenced in the West, often involving not only words (talk), medicines (various plants, salves, and solutions), and in some cases hypnosis (here trance) but also a full range of sensate experiences. Integrated into the therapeutic process as well are important religious components, family interventions, traditions of role playing, and individual metaphoric journeys. In general, aggressive response in contexts of personal difficulty is widely promoted, worked out at the level of ritual and the psyche rather than through interpersonal means. And, while transference is seen to be critical, in this part of Africa it is often an object (in this case a *bociɔ* or *bo*) rather than (or in addition to) the intervening therapist that is the primary medium of this transference process. In part for this reason, greater emphasis is given in this text to issues of transference than to interpretation, the subject of most psychologically grounded art historical studies.[25]

My analysis in its shared emphasis on form and content combines essential elements of social historical and formalist methodologies, addressing these issues through the multivalent frame of psychology and the variant phenomena which constitute mental life in its narrow and broader ramifications.[26] Reflecting the above, the core chapters of this book examine the commoner *bociɔ* art traditions from the perspective of a range of psychodynamic concerns.

Chapter 1 looks at *bociɔ* social history, aesthetics, and the legacy of the slave trade. Sculptural activation and audience response are addressed in chapter 2. Chapter 3 explores general themes of transference and catharsis in regard to *bociɔ* functioning. Chapter 4 turns to the significance of the body in sculptural expression. Chapter 5 examines the construction of the psyche and its corollaries in art. Alchemy and associated artistic complements are the subject of chapter

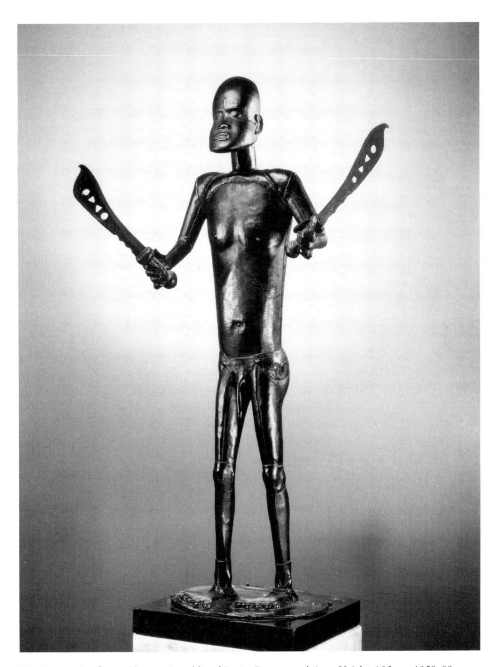

13. Fon warrior figure. Abomey, Republic of Benin. Brass, wood, iron. Height: 105 cm. 1858–89.
Artist: Ganhu Huntondji? Commissioned by King Glele (1858–89) and dedicated to his father, King
Guezo (1818–58). The facial markings (a vertical mark down the forehead, three vertical lines on the
cheeks and three "bird's feet" marks beside the mouth) are similar to those once identified with the Gen
(Popo, "Mina") in the lower Mono River area (see Courdioux 1878:595). Why the figure would have
these marks is not clear, although Guezo appears to have waged war in that area. Former collection of
Charles Ratton. Photo: Gérald Berjonneau. Arts 135. Archives Musée Dapper, Paris.

6. The application of additive materials and the use of suturing are analyzed in chapter 7. Chapter 8 takes up different types of commoner *bociɔ* genres and the distinctive emotional grounding which each expresses. The final chapter scrutinizes contrasting royal art forms and delimits aesthetic and expressive differences which are defined in commoner and elite art typologies. Because of the problems in researching temporal dimensions of popular art traditions generally, and *bociɔ* commoner arts specifically, the historical grounding of this analysis is somewhat fluid. While I have included the descriptions of early European travelers to the area, the bulk of information is derived from twentieth-century sources.

With its two-part emphasis on psychodynamic concerns and power associations within dynastic contexts, this analysis departs from most previous African art studies.[27] Certain art traditions elsewhere in Africa, however, can be seen to share important formal or functional features with the sculptures treated here. Like *bociɔ*, many such works incorporate a range of potent materials, which individually and in combination serve to empower the object. Among the more important complementary forms are Bamana traditions of *boli* figures and *komo* masks, both object types being constructed out of a wide range of organic materials applied to a wooden substructure (see McNaughton 1979). As in *bociɔ*, a range of power concerns also are addressed within these works. *Bociɔ*'s closest visual heteronyms (to use Jakobson's term 1987:104), however, are Kongolese power sculptures (Thompson 1978; MacGaffey 1988, 1991)[28] and similar power figures from Zairian groups such as the Yaka (Bourgeois 1979; Devisch 1990b). Parallels between *bociɔ* and these latter traditions include a diverse range of body-piercing forms, binding elements, and materials applied to (or in) the stomach as a means of empowerment.

In addition to these traditions a range of other African arts complement *bociɔ* in the primacy accorded underlying psychodynamic functioning. The various African divination forms are particularly important in this regard, for like *bociɔ*, they are intended to provide relief in contexts of personal difficulty and dilemma. African masks and figures which are used to counter danger or provide individual and community security in circumstances of social and psychological need also have striking parallels. Among these are Baule "spirit lover" figures (Vogel 1976; Ravenhill 1980), Bamana Jo figures (Ezra 1986), Senufo "firespitter" masks and Sandogo figures (Glaze 1981), Kwele Gun masks (Siroto 1972), and Ibibio Ekpo masks (Messenger 1973), to name but a few. What makes the *bociɔ* relatively unique among these diverse forms is the explicitness and potency with which these concerns are expressed visually.

The first commoner *bociɔ* figures which I saw in the Republic of Benin were housed in a special consultation room of a Fa diviner in Abomey (Agbomɛ) (fig. 14). At the back of this room, several figures on pointed bases were inserted into the packed earthen floor. Other flat-based *bociɔ* sculptures were placed on a small table in the corner. Outside, not far from this structure on a secluded path

leading to the city market, a large *bociɔ* was placed in the earth next to some trees (fig. 15). While one can see other shrines and domestic structures in Abomey which contain similar works, figures in public view are becoming increasingly rare here. Only in the smaller communities outside Abomey are *bociɔ* still seen with any frequency in the open air, not only along paths and access roads, but also in agricultural fields and near house compounds. As in Abomey, *bociɔ* also are placed within house and shrine interiors—here positioned not only on the floor or on a table (as in the Abomey diviner's house) but also in the rafters, affixed to walls, or secreted underneath a bed or in a special trunk or box.

14. Fon *bociɔ* empowered by Hɛvioso, the god of lightning. Height: approx. 46 cm. Artist: Mikpanhye. Abomey, Republic of Benin. Photograph: Suzanne Preston Blier. June 23, 1984.

The differing urban and rural settings where *bociɔ* are found are distinguished from each other in other ways as well. Abomey, like other larger towns and cities, today is characterized by its vibrant mix of shops, markets, schools, hospitals, residences, religious structures, and automobile, radio, and other repair places. Status is defined not only by the presence or absence of standard wealth signifiers such as cars, motorcycles, bikes, televisions, telephones, radios, refrigerators, and piped water access, but also by the size of one's house compound and the materials out of which it is made. Rectilinear, zinc-roofed, cement block structures typify the houses and shrines of the middle and wealthier residents, these often painted in bright hues of pink, blue, green, or yellow. The houses of persons of lesser status generally are smaller and often have a rammed earthern core with a thin veneer of brightly painted cement. In most such structures, and in the rammed earth, plasterless houses of rural residents, one or two small windows penetrate into the interior, providing a tunnel of light into the otherwise dark spaces within.

House compounds in rural communities generally are scattered among various agricultural fields and palm groves. In Abomey, a city of roughly 35,000, in contrast, a certain spatial cramping is evident, reflecting not only population pressures, but also the important presence of the royal palace, an enormous structure of over forty-four hectares, which houses the residences of the past rulers. Historically status in the city was defined largely by one's proximity to the king, with most Abomey residents being in some way affiliated with the court. While Agoli Agbo, Danhomè's last king, was removed from the throne by the French in 1900 (having been placed here by them in 1894), still today many of the city's inhabitants are descendants of persons who had once played a role in the court—as relatives of the king or as ministers, priests, military personnel, and artists whose goods and services were valued by the state. Issues of social hierarchy were (and are) complex. The king had enormous power through his control of trade, religion, jurisprudence, and the state militia. Other members of royalty had markedly less influence. Brothers of the king, because they were potential threats, often were sent to outlying regions to make their homes on distant agricultural plantations. The local tradition of naming foreigners (often former war prisoners) to high-ranking ministerial and military positions meant that power within the state often varied considerably over time.[29]

Rural residents and commoners (the latter defined generally as everyone who was neither a member of the ruling king's family nor one of his high-ranking ministers) had quite different power bases than those of the capital and court. The general Fon term for commoners is *anatɔ* (a reference to the indigenous Ana residents of the area). Rural residents are known as *agbogunu* "thing outside the walls" (outside Abomey [Agbomɛ]) or *glesi* ("wife of the field"). While village economy was largely agricultural—corn, manioc, palm oil production, legumes, and small animal husbandry were most important—rural residents also had a range of other employment. Some, particularly women, were traders who trav-

15. Fon *bociɔ*. Abomey, Republic of Benin. Approx. 1 m. Photograph: Suzanne Preston Blier. June 23, 1984.

eled to near and distant markets selling their agricultural and other wares. Many men and women also were religious specialists in various local temples. Others participated in indigenous medical and therapeutic care. The roles of individuals varied significantly according to whether one was a man or woman, the oldest or youngest member of a family, a senior or junior wife, a parent of many or few children, and a holder of sizable wealth or little means. In these role differences, life today has changed little from the past. In other respects, however, the changes have been dramatic, owing not only to centuries of Western influence, but also to the long-term effects of the demise of the Danhomɛ state and its once sizable control over rural life. Not only did rural residents pay dearly both in agricultural goods and in labor for state institutions such as the military and the court, but also, as noted below, threats to individual and community freedom were continually felt.[30]

In researching this book, I spent two periods of residence in Africa, the summer of 1984 and an eleven-month period in 1985–86. During my summer stay, I traveled extensively in southern Benin and Togo, spending much of my time both in the commercial capitals of Cotonou, Porto-Novo, and Lome and further inland, principally in Abomey. In the course of the more extended residence period, following a month of intensive Fon language training in Cotonou, I moved to Abomey, where I resided (along with my husband) in the compound of a family who had once been priests to the Fon royalty. During the research period, I worked both in Abomey and in the nearby towns of Bohicon, Hwawe, Zado, Tenji, Sinwe, Savalou, Dassa Zoume, and areas in between. My research concerns involved both nonroyal and royal traditions. *Bociɔ,* it should be noted, represented only a small part of my research interest at the time—architecture, city planning, state history, religion, divination, gender discourse, and the complex range of other arts also were important. Of these subjects, *bociɔ* and *bo* in many respects were the most difficult to research.

Not only were my questions on this subject frequently met with silence, and photos of related objects responded to by averted eyes, but when someone did agree to speak with me about this topic, often there followed a prefatory statement that he or she never had made, used, or seen such sculptures. As a result, many features of this art tradition remain obscure to me. In the course of time, however, I have come to believe that to some degree this is because the works themselves are not meant ever to be "understood" in a standard sense, but instead remain enigmatic and obscure to local residents and foreign observers alike. This, I maintain, does not reflect an arbitrary desire to hide or cover the work's hidden ("secret")[31] meanings from foreign (or local) audiences, but rather has grounding in the highly personal psychodynamic roles these objects play in local communities and a certain understandable hesitancy in discussing works so closely tied with an individual's innermost thoughts and fears. Also important to the above is the belief that if anyone other than the maker knows of a work's

precise materials and methods of construction, he or she will have power over its commissioner.

Arts of this sort thus present clearcut methodological challenges, particularly when compared with far more openly discussed art traditions in this part of Africa and elsewhere—for example the emotional poems examined by Lila Abu-Lughod in her provocative book, *Veiled Sentiments*. The above problems with respect to *bociɔ* are further exacerbated by the fact that increasingly these arts are no longer being made. Given these difficulties, one could rightly ask how such a subject could be explored at all, much less in a book-length analysis. While certain types of information about these works eluded me, the range of data which I acquired offer a unique perspective of the complex nature and ongoing significance of this tradition.

Several methodological decisions made during and after field research are important to note here. First, I determined that to learn anything about these arts I would have to approach them obliquely. Thus while in the field I focused on the experiences of those who either knew about or had heard about related objects, concentrating on the rationales which lay behind their commissioning and employment. The general materials that went into their manufacture and the religious and therapeutic ceremonies in which such objects played a part were also a major concern. As in my previous study of Batammaliba architecture (1987), diviners and divination sessions proved to be of critical importance, for not only were the former extraordinarily knowledgeable, but the latter functioned as a primary psychotherapeutic frame in which not only personal anxieties and difficulties but also *bociɔ* commissions were brought up.

Once I had returned from Africa and began to prepare my *bociɔ* material for publication, I decided that this data could be meaningfully enriched by broadening the scope of the analysis to include not only earlier Fon scholarship on *bociɔ* but also complementary traditions of related cultures in the area. This I did not only to provide greater breadth and depth to my own findings, but also to bring to the analysis a more cross-cultural and cross-disciplinary perspective, for previous studies had been undertaken primarily by anthropologists and religious scholars.[32] My decision to extend the geographical base of analysis has broad-based support in traditions of local manufacture and use. During a 1984 visit to the famous Be market in Lome, Togo (an Evhe area), I found that many of the *bo* and *bociɔ* on sale there, along with many of their sellers, came from the Fon capital of Abomey. Historic traditions in the region indicate similarly that warfare brought many foreign artists into the Fon area, where they continued their own traditions along with the new ones of their conquerors. Fon and other *bociɔ* incorporate a range of stylistic features which reflect these diverse foreign sources.

In the formative stages of my writing about these arts, other (less pragmatic and less field-oriented) methodological concerns also came into play. Although

in my previous book I took up the issue of psychotherapeutic concerns in African architecture, I was becoming increasingly interested in psychology and the means whereby one's mind is both raveled and unraveled through the psychotherapeutic process. My husband's professional interests also have taken him increasingly in this direction. Aware that not all of my readers will be as interested as I have been in the psychological dimensions of these arts, I have endeavored to make the sculptures (and the associated text) stand on their own, quite apart from this subject. Related discussions on aesthetics, functional concerns, activation processes, viewer response, body representation, alchemy, and the like are broadly focused with this in mind. Similarly, while I have sought to explore the *bociɔ* arts through differing lenses and theoretical frames within each chapter, bringing to light the multifaceted identities of each work through this means, I also have attempted to keep the prose relatively jargon-free. In so doing, I hope in effect to have allowed the works to speak for themselves—to the degree that this is possible.

On a less personal level, themes of conflict and response, a central part of what I perceive to be the importance of these works, also are a vital part of one's experience as a historian of African art. To some extent, in the course of examining non-Western traditions against the grain of dominant Western canons of both art and scholarship, Africanist art historians, like *bociɔ*, frequently become agents of cultural confrontation and exchange. In associated exegesis, different forms of objectification come into play, but as with *bociɔ*, passions remain close to the surface. A certain discomfort with the status quo and a desire to promote traditions which generally have been overlooked (and by this means disempowered) also have a fit with *bociɔ* issues explored here.

Vodun Art, Social History, and the Slave Trade

1

"A man without force is without the essential dignity of humanity."
—Frederick Douglass, *Life and Times*

"To have seen a country is not the same as to have lived it"
(*Edumɛ kpokpo a, me edumɛ yiyi o*).
—Gen proverb

Between 1710 and 1810 over a million slaves (principally of Fon, Aja, Nago, Mahi, Ayizo, and Gedevi[1] descent) were exported on English, French, and Portuguese vessels out of the Bight of Benin and what was then called the Slave Coast of Africa (Curtin 1969:228; Manning 1982:335) (fig. 16). This trade, which continued from the region in varying degrees through the end of the nineteenth century, contributed to one of the greatest intercontinental migrations in world history (Curtin 1967; Polanyi 1966; Law 1991). Many of those who were sent from this area were brought to Brazil and various Caribbean islands. The slave trade had dire consequences not only for the men and women who crossed the Atlantic but also for many of those who remained in Africa. In the kingdom of Danhomɛ the acquisition and trading of slaves had assumed dimensions of a national industry (fig. 17).[2] To a large extent, the Danhomɛ state economy was based upon annual raids and military expeditions against neighboring groups and villages, the primary purpose of which was to capture men, and to a lesser extent women and children, who could be sold for profit.

In the course of these campaigns, which often took place soon after harvest, many people lost their lives immediately in confrontations with the Danhomɛ troops; others lost their freedom, homelands, and dignity when they were taken prisoner and were brought to the Danhomɛ capital, where they were either sold into slavery or were kept as prisoners, later to be killed in state ceremonies or forced into involuntary life-long servitude in the state militia, court harems, plantation labor groups, or households of the governing elite.[3]

Those fortunate enough to flee the advancing Danhomɛ armies also suffered greatly. Most returned to their homes to find their farms burned, their granaries emptied, their animals stolen or slaughtered, and their houses and temples destroyed. For them the answer often was further flight and hiding. With the famines that often followed, medical problems, infertility, and high infant mortality were rampant (see Manning 1982). The prime targets of the slave raids, primarily young men, were precisely the ones who would have been essential in providing the labor needed to rebuild and sustain the community. Without them, survival was tenuous. Although the situation often was dire, it would have been intoler-

able without a viable means of both comprehending and coping with the difficult conditions. This included the prominent use of *bociɔ* and *bo*. No matter what the misfortune, works of this type provided a means of personal and social response to the attendant problems or concerns.

The physical and psychological suffering experienced by persons living in (or near) the Danhomɛ state during the period of international slavery was not to

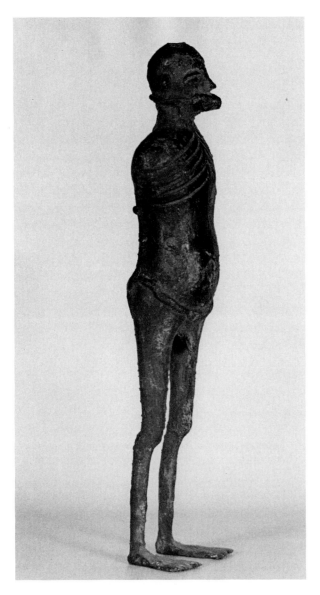

16. Fon slave, gagged and bound. Abomey, Republic of Benin. Brass. Height: 25 cm. Twentieth century. Huntondji workshop. Mr. and Mrs. William S. Preston, Jr.

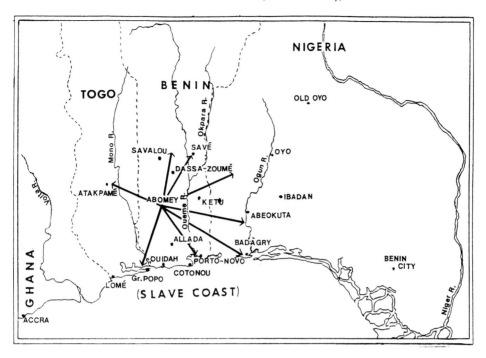

17. Map showing principal region of Danhomε military aggression.

any degree dissipated when the slave trade was outlawed by European states in the nineteenth century. Coinciding with this ban was a new European demand for palm oil to be used in the industrial production of soap. This need was accompanied by the setting up of large oil palm plantations in Africa. In Danhomε these plantations were worked by slaves overseen by the kings and other powerful persons. The slaves were obtained, as before, through warfare and raids. Thus at the same time that European states sought to end the horrors of international slavery, they simultaneously encouraged the acquisition and extensive use of slave labor within Africa for palm oil production. The social impact of this economic change was great,[4] for by 1900 fully one-fourth to one-third of the population in the Danhomε area were first- or second-generation slaves, many of whom were working on plantations (Manning 1982:192).

With the French conquest of Danhomε in 1894, the difficult conditions of rural peoples appear to have been little improved. Although the French were able to enforce a cessation of the slave raids that had been used to acquire plantation labor, colonial officials to a large degree reinforced and gave legitimacy to essential conditions of the past by allowing princes and newly appointed *cercle* chiefs to retain control over many of their former slaves and the lands they worked.[5] As late as the 1930s, when Herskovits, along with several members of the Danhomε aristocracy, visited a village of slave descendants, the latter showed clear indica-

18. Illustration of a slave. From Jacques Etienne Victor Arago, *Souvenirs d'un Aveugle: Voyage autour de Monde* (Paris, 1839), vol. 1, pp. 118–19. Published in Paul Lovejoy (1986).

tions of fear and discomfort (Herskovits 1967, 1:103–4; Blier 1988b:140). As Patrick Manning points out in reference to the above incident (1982:192), "The heritage of slavery in this region where slavery and slave trade were so much a part of life for centuries is deeply and subtly ingrained."[6]

The fundamental links between individual disempowerment and emotional expressions thereof find ample evidence in *bociɔ*. Often bound tightly in cords, these works evoke the image of a prisoner. They suggest what the Fon call *kannumon*, "thing belonging [in] cords," i.e., the enslaved person. Such individuals (fig. 18), themselves signifiers of personal demise, were potent reminders of the disturbing effects of war, poverty, insecurity and loss of freedom. As Ahanhanzo Glele, a descendant of the powerful nineteenth-century ruler King Glele, notes (1974:158): "The *kannumon* came from several sources: regular wars (war prisoners), commerce (individuals bought from Hausa, Bariba, and Nago merchants), the ravaging of populations not under Agbomɛ domination, and generally poor people in the state of dependence."

The prominence of cords and binding in commoner *bociɔ* (fig. 19) traditions is a poignant reference to the trauma which resulted from state-induced or sup-

ported violence. If slaves, ex-slaves and the many others who were fearful of enslavement suggest that W. B. Friedman (1956:175) calls potent "bundles of power," *bociɔ* can be said to represent these bundles in manifestly visual ways. *Bociɔ* arts, I maintain, were not merely intended to be reflections of violence and danger, but rather were thought to offer important strategies for responding to the difficult social conditions in which people found themselves at this time. These sculptures were not indifferent or adiaphoric to the sufferer's plight, but served as a means of readdressing wrongs and dissipating attendant anxiety.

Yet resolution of individual and social tension represents but one aspect of each sculpture's textual meaning, for these works also are provocative signifiers of the danger of leaving difficulties unresolved. Such works offered a way of both accepting and refusing the negative by helping their users to objectify conflict and to "think-through-terror," as Taussig would say (1987:5).[7] As Marcuse suggests (1978:9), art provides one with a way of uttering what is otherwise unutterable, allowing one to escape from one's bondage however defined. *Bociɔ* through this means enabled area residents to gain a certain sense of control over the sometimes grave social, political, and physical conditions around them.[8]

In several impassioned books on the difficulties of colonialism in Algeria, psychiatrist Frantz Fanon has argued (1968) that the psychological ills suffered by Algerians during their war for independence often were attributable to the horrors of the political situation in which they found themselves. In both precolonial and postcolonial Danhomɛ, many inhabitants also suffered from various forms of psychological trauma. *Bociɔ* functioned in a certain sense as counterfoils and complements to such problems, responses to what Clifford Geertz discussed (1983:55–70) in terms of psychopathology encouraged by social disorder.[9] The visual power of *bociɔ* objects reveal in key respects the social and personal impact of such insecurity and disempowerment. This is an art in which a full range of anxieties is manifestly felt. And insofar as anxiety derives from the feeling of helplessness that fear evokes, *bociɔ* help to relieve related concerns in the face of life's lesser and greater traumas. Works of this sort no doubt were made and used prior to the slave trade. Indeed the specific problems which these works are commissioned to address include a range of personal and familial concerns which sometimes had little relation to war or slavery. Nonetheless, these sculptures appear to have assumed special poignancy and meaning in the area owing to the often difficult circumstances promoted by the slave trade. Related images express what Marcuse calls (1978:19–20) a "consciousness of crisis" (*Krisenbewusstein*).

The Power of Bociɔ Counteraesthetics

Questions of the social and psychological grounding of *bociɔ* arts are addressed in provocative ways in the potent aesthetic concerns which they define. *Bociɔ* aesthetic criteria accordingly offer a unique ground against which to explore

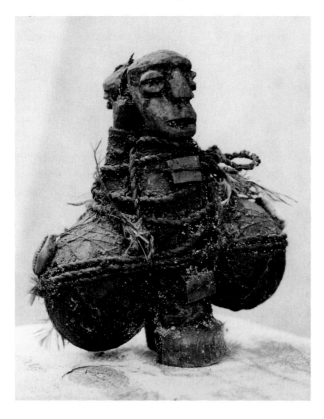

19. Fon *bociɔ*. On sale in Be market in Lome, Togo. Photograph: Suzanne Preston Blier. July 7, 1984.

20. Ouatchi? sculptures. Togo. Wood with multimedia surface additions, including cowries, cloth, and cord. Height: 86.6 cm. Both male and female figures are carved with an amputated left leg. Female figure has three heads. Collected in the 1970s. Art Sherin and Sue Horsey. Photograph: Jack Sherin.

questions of art, power, and expression generally. Perhaps not surprising in light of the above discussion of political difference and distance, *bociɔ* aesthetic signification is closely bound up with societal (and countersocietal) values such as dissonance, force, destruction, decay, and danger.[10] *Bociɔ* arts, as we will see, express not only an aesthetic of negativity, but also what Kristeva calls *frappe* or shock (fig. 20).

With these works, as in any art corpus identified so closely with social and psychological expression, the aesthetic criteria used in sculptural evaluation are complex. The "strong" object, explains Sagbadju (7.1.86),* "is not something of beauty." Ayido observes similarly (5.2.86) that "one does not need to carve a sculpture so that it is attractive in order to have it work."[11] In art as in life, two terms are employed by the Fon to indicate general attractiveness: *acɔ* and *dɛkpɛ*.[12] The former refers to things which are ornamental, delicate, refined, decorative, dressed, and tidy, and the latter designates ideas of beauty, elegance, and attractiveness generally. The vast majority of commoner *bociɔ* clearly stand out in marked contrast to these two aesthetic ideals. These sculptures are not ornamental, refined, elegant, or attractive in any standard sense of the words. Nor do

*These and similar parenthetical numbers within the text refer to interview or ceremony dates.

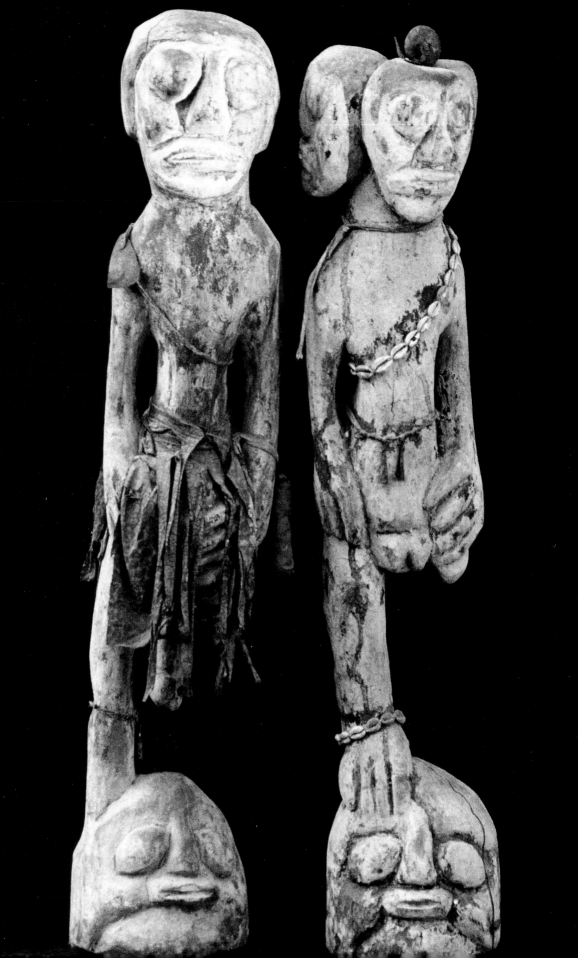

these figures conform to the variant secondary aesthetic criteria that are said by Fon artists to be important to them in evaluating beauty in sculptural form. The latter include qualities such as youthfulness (*ḍekpe*—beauty in Fon is synonymous with youth), smoothness (*ḍiḍi*), completeness (*bisese*), and correctness (*pɛpɛ*).[13] As we have seen within commoner *bociɔ*, there also is little to suggest youthful grace, surface polish, a sense of finish, or exacting anatomical detail.

These lacks are all the more striking in view of the strong emphasis in the kingly *bociɔ* arts (fig. 13) which is given to refined features and attributes which are elegant, ornamental, polished, and exacting in form. Thus whereas Fon royal *bociɔ* arts conform in essential ways to local beauty criteria, commoner works emphasize counteraesthetic, even antiaesthetic values and features of ugliness. The counteraesthetics of commoner *bociɔ* arts[14] are of considerable interest in this light because they constitute in essence the aesthetic of choice of the subaltern groups[15] living in this area—the rural residents, nonroyals, and those generally suffering from the effects of disempowerment.

What is suggested here is that artists of commoner *bociɔ*, aware of the diminished political statuses of their patrons, to some extent reified the latter's positions by emphasizing certain counteraesthetic features in their arts. The two Fon terms used to indicate a negation or lack of beauty, *magnon* (which also signifies "ignorant" and "unschooled") and *gnlan kan* (designating "bad" or "beastly"—literally "bad cord"), suggest a complementary emphasis on attributes perceived to be rural or outside the encultured mainstream, as defined by the elite. The artists, activators, and users of commoner *bociɔ*, by intentionally avoiding qualities associated with beauty and refinement in royal art contexts, promoted status difference through privileging antithetical forms of aesthetic expression. While associated concerns were never discussed by local artists or *bociɔ* users, the visual differences between commoner and royal *bociɔ* aesthetic expression are striking.

Secondary aesthetic criteria employed to designate the lack or negation of beauty (*magnon* and *gnlan kan*) underscore these status differences in interesting ways. One feature said to characterize works showing a lack or negation of beauty is messiness (*gudu gudu*: disorderly, piggish, mixed up, troubled; from *gu*, designating things which are spoiled, corrupted, inutile, wasted, or negated). Commoner *bociɔ*, in conforming to this counteraesthetic of messiness and disorder, may in some way be seen to complement the confusion and disorder that defined many of their users' lives. In local divination sessions in which commoner *bociɔ* are discussed, these concerns come up with considerable frequency.

Three other values said to characterize commoner *bociɔ* counteraesthetics also have important sociopolitical and psychological complements. These include fury (*adan*), strength (*sien*, "resistant," "solid"), and force (*hlon hlon*). Associated qualities are revealed most importantly in audience responses to *bociɔ*, as discussed in chapter 2. Like *gudu*, "disorderly," the above also offer insight into *bociɔ* signification. Accordingly, *adanwatɔ*, "father of fury," is the term frequently used to describe powerful people in the community who are able to bring

their influence to bear on others living around them (Asogbahu 5.8.86). Each *bociɔ* serves similarly as an "object of fury," something which accords its users considerable power.[16] Ancillary meanings of the term *adan,* the most important of which are audaciousness, anger, intrepidness, hardness, courage, coerciveness, and scolding (Segurola 1963:4), also are of interest. In their roles as aggressive and protective forces, *bociɔ* display similar values. Supplemental associations of the Fon term *hlon hlon* ("force") carry provocative secondary meanings as well, in this case, of violence, vengeance, and vindictiveness (Segurola 1963:227). These attributes complement at once the sometimes embattled social and political contexts in which such objects are made and the force that is thought to be necessary to counter danger and difficulties that lie in life's path.

The selection of *bociɔ* materials for their physical and metaphoric strength and the emphasis in these works on knotting and tieing suggest in turn the strength *(sien)* which these objects are intended to express through their forms and functioning.[17] The prominent use of raffia cord, with its characteristic solidity and resistance, is significant too, for comparable strength is essential to *bociɔ* roles in turning away danger and discord from their various owners. Appropriately ancillary meanings of the counteraesthetic term *sien* designate things which are courageous, insistent, secure, resistant, persevering, tenacious, forceful, severe, opinionated, hardheaded, and hardened (Segurola 1963:471). Similar qualities are vital to *bociɔ* in their roles in helping one to survive or better one's condition in life. Seeing these and related visual properties within sculptural form no doubt gave local viewers a sense of assurance and security in the face of various difficulties. Through emphasizing aesthetics of shock which in various ways privilege conflict, contradiction, chaos, obscurity, mystery, and brute force, these works convey an emotional energy of considerable potency.

Angst Turned Inward: Artistic Contexts of Sorcery

The enormous anxiety associated with both *bociɔ* aesthetics and the circumstances of difficulty and danger so critical to *bociɔ* use and meaning also has important parallels in local perceptions and practices of witchcraft.[18] In the area of *bociɔ* manufacture, as in many other parts of the continent where there was no acknowledgment of accident, greater and lesser personal traumas often have been attributed to the malevolence of other humans, especially those labeled as witches.[19] Stated simply by Max Gluckman (1969:86,108), humans "suffer misfortunes and then believe that they have been attacked by a witch. . . . Beliefs in . . . witchcraft help to distract attention from the real causes of natural misfortune."[20] S. F. Nadel amplifies this idea (1970:278): "[W]itchcraft beliefs enable a society to go on functioning in a given manner, fraught with conflicts and contradictions which the society is helpless to resolve; the witchcraft beliefs . . . absolve the society from a task apparently too difficult for it, namely, some radical readjustment."[21]

Protection from acts attributed to witches was one of the primary roles of *bociɔ* and *bo*. Because misfortune or death in the community often is said to be brought about by some act of sorcery, in periods of elevated difficulty and mortality due to factors such as war, malnutrition, disease, and other causes, witchcraft fears were especially strong. Through the extensive use of objects such as *bociɔ*, prevailing community anxieties about sorcery were at once assuaged and made more trenchant. While state control and the slave trade were not the primary sources of witchcraft ideation in the area (and indeed related traditions are found in a range of other world and historical contexts), problems of individual and community survival resulting from the centuries of warfare no doubt exacerbated already difficult social relations, contributing further to sorcery ideation at the local level.

Here as frequently elsewhere, rather than blame the king or other authorities for their suffering and difficulties, the Fon and their neighbors turned within, accusing members of their own families or communities of bringing on associated misfortune. As Evans-Pritchard writes for the Azande (1976:46–47): "People do not accuse nobles and seldom accuse influential commoners of witchcraft. . . . A man quarrels with and is jealous of his social equals. . . . [This is because] a noble is socially so separated from commoners that were a commoner to quarrel with him it would be treason. Commoners bear ill-will against commoners and princes hate princes. . . . [Thus it] has been noted that witches only injure people in the vicinity, and that the closer they are to their victims the more serious their attacks."[22]

Often, as suggested above, it was someone with whom one had had some form of personal dispute who became the focus of witchcraft accusations. In the course of daily life there were ample occasions for such friction. There were the usual disagreements not only between husbands and wives but also between in-laws, co-wives, and siblings, these disputes arising out of everything from sexual jealousies, to disagreements over work obligations, to financial problems within the house. There also were certain to be conflicts among one's many neighbors and acquaintances which would have led to discord and jealousy.[23] According to Herskovits (167, 2:287), when the Fon are asked to indicate local sorcerers, they "stealthily point out two or three such persons in the marketplace who usually may be remarked to be doing somewhat better business than those who sit near them." If anxiety can be said to result from a sense of helplessness in situations of continuing difficulty, the belief that it was members of one's own community and family who were responsible for actions of sorcery would have made such feelings all the more potent.

Not surprising, many of the physical complaints attributed to sorcery malevolence by the Fon and their neighbors are those which accompany stress and anxiety. Most of these complaints in turn find prominent visual or functional expression in *bociɔ*. Among the most prevalent sorcery-identified symptoms are stomach cramps, vomiting, diarrhea (or constipation), weight loss, sleeplessness,

and nighttime pain.[24] Menstruation difficulties are frequently attributed to this source as well. Prominent themes of bound stomachs, purging, body interiors, nighttime protection, and sterility also are addressed frequently within the *bociɔ* corpus.[25]

Themes of inversion similarly are expressed prominently in both sorcery contexts and *bociɔ*. I have already discussed the formal features of inversion addressed within these works, most important, the conflation of body interior and exterior in figural portrayal. In contexts of sorcery this is expressed equally strikingly but in different ways. Thus daylight generally is perceived as the period of human activity; night in contrast is the time of sorcery action. As Pazzi explains for the area generally (1976:48), "During the night . . . when humans take their rest and all is invaded by silence, nature becomes dangerous, because it is under the control of the malevolent forces of sorcery." The common sorcery-related complaints of sleeplessness and nighttime pain coincide with the above. *Bo* and *bociɔ* serve at once as counterfoils and complements to sorcery aggression, for these works are said to be most powerful during the night. Within the context of sorcery accusations, vital political concerns with inversion also are raised.[26] According to Fisiy and Rowlands (1989:83), witchcraft plays a vital role in resisting state elites. Witchcraft beliefs in southern Benin and Togo served (like *bociɔ*) to empower local people and to provide them with a degree of force (albeit invisible and supernaturally defined) which paralleled and to many people even surpassed the physical might of those in positions of authority.

There also are important gender dimensions with respect to both witchcraft accusations and *bociɔ* use. Sorcerers in this area are said to be of both sexes, but far more frequently it is women who are believed to have this hidden power (fig. 21).[27] In paired *bociɔ* figures, accordingly, the females often are slightly taller than the males, a poignant reference to the former's increased supernatural power potential (fig. 22, 23). Indeed, the deity most closely identified with motherhood and childbearing, Minona or Na,[28] is also widely known to be the patron deity of witches. As Herskovits states for the Fon (1967, 2:287), "Minona is their goddess, and gives them their power." The paradoxical nature of Minona's identity as god of both mothering and witchcraft (nurturance and destruction, birth and demise), is further brought out in the commonly held belief that sorcerers are responsible for preventing inception and bringing death to newborns (an idea reinforced by the high infant mortality rates here as elsewhere in sub-Saharan Africa).

When it comes to power, women are associated with considerable ambivalence.[29] Within the largely male-dominated family structure, they have relatively little power,[30] yet through their frequent identity with treacherous nocturnal acts of sorcery they are perceived to have hidden, supernaturally based power. The Fon diviner Ayido notes (4.26.86) the striking temporal dimension and inversion principle at play here: "In the day it is the men who have the power, at night it is the women who are strong."[31] Through their association with invisible ("secret")

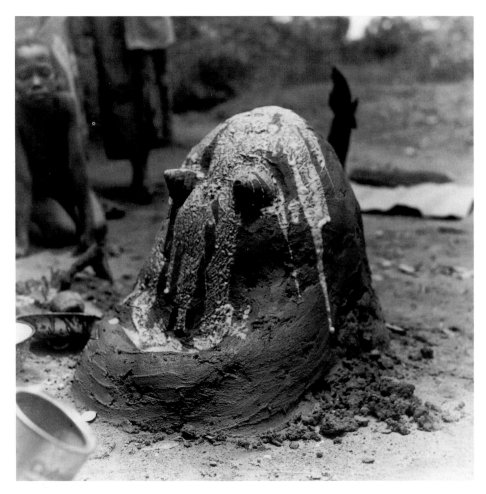

21. Fon altar dedicated to Minona, goddess of motherhood and sorcery. Town of Sodohome, Republic of Benin. Photograph: Suzanne Preston Blier. March 19, 1986.

22. Evhe? figural pair. Togo. Wood. Height: female, 70 cm; male, 67 cm. Collected in the 1970s in Lome, Togo. Collection of Art Sherin and Sue Horsey. Photograph: Jack Sherin.

strength, women (and to some extent commoners) may have been able to acquire a degree of influence, for it was felt that if one continually countered or angered someone, they could (and would) resort to witchcraft.[32] One of the Fon names for sorcerers, *kennesi*, coincides with this belief, for *kennesi* translates as "wife [*si*] who knows [*ne*] grudge [*ken*]."[33] Sorcery in this sense served as a means of expressing anger toward the members of the society who had wronged one.

In the context of both gender and class difference, rather than directly confront broad-based social or political institutions perceived to be essentially unchangeable, *bociɔ* address the personal feelings of resentment, anger, and anxiety which result from situations of difficulty. These works confront problems pri-

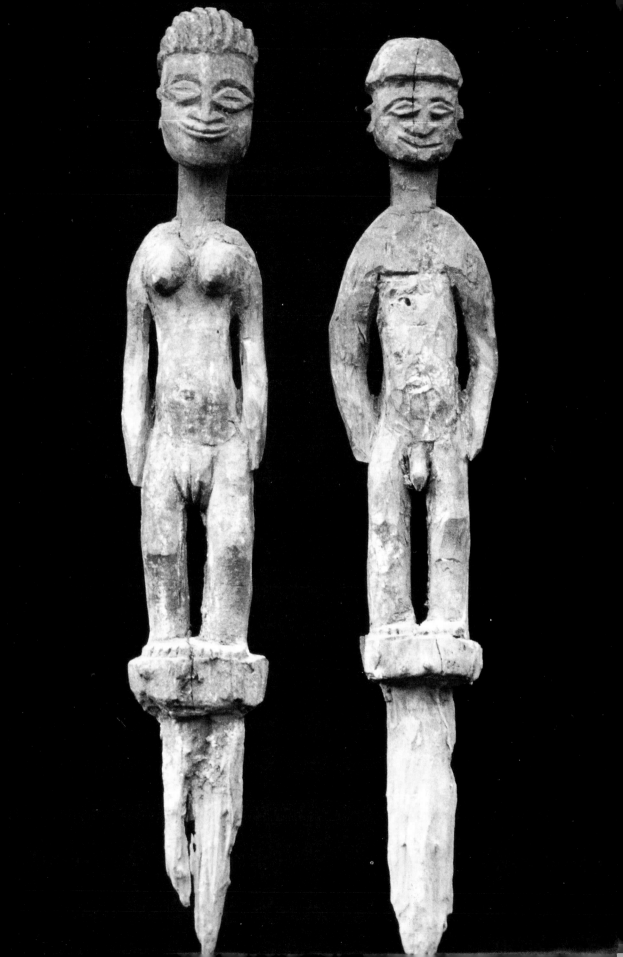

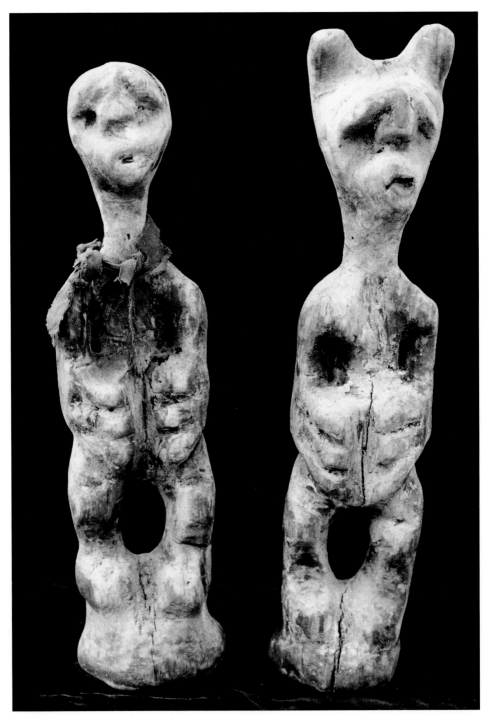

23. Ouatchi? figures. Togo. Wood, cloth. Height: female, 53 cm; male, 50 cm. Collection of Art Sherin and Sue Horsey. Photograph: Jack Sherin.

marily at the micro level. Yet when macro-level conditions changed, a concomitant response was also felt within the *bociɔ* arts. In exploring this response, it is important to examine the changing dynamics in *bociɔ* manufacture in the recent era.

While it is difficult to assess the impact of twentieth-century political developments on this art corpus, as noted above there are far fewer figures being made and used today than in the past—particularly in the cities and larger towns. The reasons for this, which are as diverse as they are interesting, include the conversion of many area residents to Christianity (and the admonition of church authorities about the use or toleration of objects of this type). Also important are governmental (and societal) disapproval of practices considered—like *bociɔ*—to be linked to antisocial acts such as sorcery whether for positive or negative ends. The sale (or theft) of major and minor works of art to fill the demands of Western art collectors clearly has been a factor as well.

Several other considerations, I suggest, also may have contributed to the diminishing use of *bociɔ* in this region in recent years. Among these is a general decrease in some of the problems which historically fostered the commissioning and use of these works.[34] Recent improvements in the quality of life as a result of better medical care, increased food supplies, universal education, and improved economic possibilities particularly in cities but also in the countryside also have been important.[35] The colonially imposed juridical structure in turn has meant that disagreements and personal wrongs, which in the past *bociɔ* helped to protect one against, now had another outlet.[36] The decrease in *bociɔ* manufacture and use in recent years thus appears to have been paralleled by both a certain amelioration of community life and a sense of increased options in facing social difficulties.[37] While nonfigural *bo* of various sorts continue to be employed in sizable numbers, the primacy accorded both figural and nonfigural power objects seems to have abated.

Vodun: The Philosophical Roots of Art

To understand the role that *bociɔ* historically played in this area it is also important to understand something of the religious and philosophical tradition of *vodun* (*vodu, vodou, voudou, voodoo, voju*).[38] Few subjects carry as much mystique and misunderstanding in the West as this one. The term first appears in print in 1658 in the *Doctrina Christiana,* a work by the ambassador of the King of Allada to the court of Philip IV of Spain (fig. 24). The text, which is written in both Spanish and Ayizo (the latter designated as "lengua Arda"), translates *vodu* as "god," *sacra,* "sacred" or "priestly," and mentions the term in various forms about sixty times (Labouret and Rivière 1929). This early reference is of both historic and linguistic importance because it situates *vodun*'s origins in the language family to which Ayizo, as well as Fon, Aja, Evhe, Mahi, and related languages, belongs.[39]

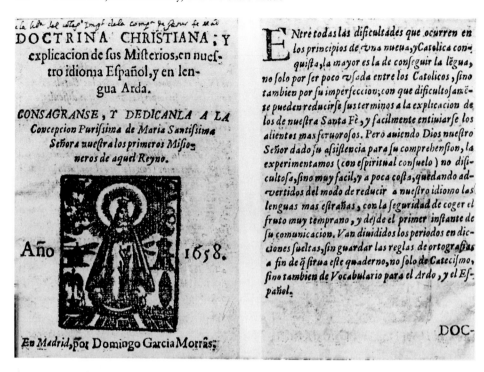

24. *Doctrina Christiana,* 1658. Published in Labouret and Rivet, *Royaume d' Arda,* 1929.

The meanings and linguistic roots of the term *vodun* offer, as we will see, critical insight into *bociɔ* and *bo* signification. Although Segurola, who has compiled the principal Fon language dictionary, argues (1963:552) that the origins of the word are now lost, other scholars since then have offered a range of etymologies.[40] To Gilli (1976:9–10), whose research has focused on the Ouatchi area in Togo, the etymological roots of *vodun* rest in the Evhe word *vo,* which means "hole" or "opening." Gilli suggests that the word also is employed in this region in reference to the practice of Fa divination and, presumably based on the above, means "to reassure oneself." In Gilli's words, "*Vo* here is a symbol of the hidden, the secret, of what we cannot explain but which troubles us and makes us uneasy. The presence of this *vo* can also deceive us without our perceiving it and the *vo* becomes the cause of our error. One says in this case, *me da vo,* 'I have been deceived.'" Complementing the above, *vodun* shrines often take the form of a hole in the ground into which special empowering materials are placed.[41] The sanctified hole is then refilled with earth and, in some cases, a conical mound of earth is raised on top. Gilli's etymology of *vodun,* identified as it is with the religious and symbolic importance of holes, finds broad support in area shrine construction. *Vodun*'s second radical, *dun* (*du*), Gilli suggests, has grounding in the term for Fa (Afa) divination signs (*du*). Somewhat analogous to Western astrological signs, each Fa divination sign, or *du* (*odu*), has a distinc-

tive name (e.g., Abla-lete, Tula-Meji) and a specific corpus of information relevant to individual lifecourse, identity, and religious affiliation. In Gilli's view (1982a:12), each *du* carries the significance of "messenger" or "sign." Taken together, these radicals suggest *vodun*'s meaning as "messenger of the hole" or "messenger of the hidden, the invisible." The latter radical's meaning, however is in my view problematic, for it suggests that the Evhe term *du* ultimately derives from the Yoruba word for divination signs, *odu.*

To Bernard Maupoil (1981:53), a scholar of Fon religion and divination, *vodun*'s linguistic roots are grounded instead in ideas of incomprehensibility. According to him (1981:54), in the Fon area the term *vodun* suggests the idea that "we have thought a long time, at the most profound level of ourselves; we have meditated on the causes, on our origin, on the mystery of creation and on life; but unable to understand, we have cried: *hun!* this goes beyond us." According to Maupoil's translation from the Fon, *vo* refers to something "unseizable," "invisible," or "resting above"; *dun* is identified by him as a synonym for *hun*, the latter being an exclamation sometimes emitted at the end of an argument, often in exasperation.[42] While Maupoil's translation of *vo* is of interest, the meaning he gives for *dun,* like Gilli's, is less secure, for *hun* is more an utterance (like Ah! or Whew! in English) than a distinctive articulated word.

My sources in the Fon area suggested etymologies which not only are quite different from the above, but also provide a better explanation of the term's second radical, *dun.* Two people, both diviners—one from Abomey, the other from Sodohome—offered particularly insightful translations. Like the other etymologies examined above, theirs are grounded on *vodun*'s constitutive radicals, *vo* and *dun.* Both people gave the salient meaning of *vo* as "to rest" or "to relax," and *dun* as "to draw water."[43] Their translations of *vodun,* "rest to draw the water," have important philosophical and psychological grounding. According to Sagbadju, the first of these diviners: "One says *vodun,* 'put yourself at ease to draw water,' [because] if you work until you are debilitated and you rest quietly for a bit, your body will be at ease. When your body is at ease, the exhaustion will leave your body, and you will be well" (8.14.86). The second diviner, Ayido, bases his etymology on similar ideas:

When one says *vodun* it is because in this life, there is a pool that is below, and one draws from it. One sees pools in the forests . . . if you go to these places, you should relax and sit first before drawing the water and returning home with it. If you are in a hurry you will fall into the pool. That is why one says, "If one comes into this world it is at a pool that one arrives." One should rest first before drawing. If you are in too much of a hurry, you will fall into the pool. That is what one means when one says *vodun.* (4.25.86)

The essence of *vodun,* the above suggests, lies in the need for one to be calm and composed. One must take the time to sit quietly rather than rush through life. When women go to the spring or river to draw the daily water, they rest for a moment on the bank before filling their containers. So too in religious ceremon-

ies, before bringing back the pure spring water one waits at the edge in silence for a short time. In part this waiting serves to underscore the vital connection between each person and the spring, the latter being particularly important because it is where human conception is said to originate.

In another interview, Ayido elaborated (4.25.86) other features of *vodun* philosophy:

> If you come into this world and are always in a hurry, you will die. You will not be able to buy something you want, you will search out the wife of another, and someone will make a *bo* against you. Thus you did not rest [you were not patient enough] to draw your water in this life. If you die, you caused your own death, and your death will have no importance. . . . That is why one says *vodun*. It is comparable to all that is done in life. . . . When one goes to school . . . it means the respect and the obedience one must have for one's teacher. One must repose to draw the water of life (*gbɛ sin*) because if you are in too much of a hurry to acquire something, you will try to steal it. You hurried life. You hurried to draw the water. You did not have the necessary patience.

And in yet another interview, Ayido observed (5.2.86): "Life is a pool that humans come into this world and find. We must be patient. When you are born in a family you must learn patience. If an adult is speaking, you must open your ears and listen. If you are patient and hear what one says, the pool that is the source of life, you will take from it. It is for this reason that one says *vodun vodun*, 'rest to draw the water; rest to draw the water.'"

As the above suggests, within the concept of *vodun* there rests a deep-seated commitment to certain forms of human conduct in life. In this translation of the term *vodun* we are made to understand in an ideal sense what it means to be human and how one's life should be lived. As expressed above, *vodun* constitutes a philosophy which places a primacy on patience, calmness, respect, and order both in the context of acquiring life's basic necessities and in the pursuit of those extra benefits which make life at once full and pleasurable. Perhaps reflecting the importance of this idea, a critical part of the annual ceremonies in honor of the family *vodun* is a procession to a local spring in search of water for offerings and ritual cleansing. That the phoneme *vo* also suggests ideas of invisibility and unseizability in this area reinforces *vodun's* importance as both philosophy and religion. If what is most powerful and significant in life (the gods) is invisible, unseizable, and unknowable, then one has little choice but to relax at the spring from which life (like water) comes.

Yet another translation of the term *vodun* recently suggested to me by Michel Bagbonon, a man originally from the area of Bohicon, complements the above in terms of philosophical essence if not actual language. Like Gilli he maintains (4.2.93) that *dun* derives from the *du* signs employed in Fa divination. *Vo*, for Bagbonon, has its roots in the ritual offerings, or *vɔ*, which are undertaken in response to a particular *du* sign. As he explains, when one has gone to the diviner to learn the *du* for a particular problem, and when one has made the appropriate

offerings (*vɔ*), it is then that one can rest tranquilly. The process of seeking the divination *du*, Bagbonon notes, recalls the action of going to a well or spring to draw the water. The relief one gains from making the requisite offering in turn complements the act of resting beside the spring.

The following song recorded during an ancestor *ɖɛ* (offering) suggests some of the ways in which this philosophy of calmness, composure, patience, and acceptance of what life may hold is expressed within the verbal arts.

> Sɛ [Sɛgbo-Lisa, the high god] created you and said to stay
> > And no matter how, one stays.
> To gamble with Sɛ
> > One always loses.
> The feet of the bat are above, the head below.
> > Others cannot do that.
> > The bat is superior to the other winged creatures.
> People who are very heavy say that
> > Others will not be heavy.
> > They want to see other's hardship
> When I congratulate you.
> > I refuse to complain.
>
> —Agbanon 3.8.86

The importance of accepting life and whatever it may offer is also made clear in the following prayer recited during a family offering.

> What Sɛ gives you is enough.
> If you stay without money and clothes,
> It is enough.
> If you do not have any liquor, or any food,
> That small portion suffices.
> If Sɛ gives you this small portion,
> It suffices for you.
> Even if you do not have a bike, or any clothes
> This small portion will suffice.
> Even if you do not have any calabashes or bottles,[44]
> This small part will suffice.
>
> —Village of Sodohome, 2.14.86

A similar idea is suggested in the popular Fon proverb: "The duck does not beat its wings to say cock-a-doodle-do" (7.1.86).

The need to accept life and what it brings is conveyed through body gestures as well. To this end Ayido explains (4.25.86) the significance of the Fon gesture of placing one's hand on the hip—a gesture assumed frequently by persons in positions of power.

The one who puts his hands on his hips says that my good hand, that which Sɛ gave me, I will not remove it. . . . He says, if I am in life [*gbɛ*] and Sɛ gives me something, I will eat. . . . As we are in life, you found some money, and I did not. The sickness that you

should not suffer from, you begin to suffer from. . . . At this time, you who had money will die. The poor man is there and the rich man died. That is why if Sɛ did not give you wealth and you do not become rich, one puts the hand on the hip and says, "If Sɛ gives me something, I will eat it." I don't envy the life of anyone else. . . . If the thing is not in your Sɛ and you ran to do something, if you go there, you will hit against a stone. Wealth, for example, some people have it. At the same time, others live in poverty. . . . It is the way that Mawu wanted it that it is. (4.25.86)

Related to this philosophical concern with the acceptance of life no matter what unfolds, is an insistence that at all times one should display composure in the face of life's difficulties. Even at funerals, relatives are chastised if they cry or show outward signs of grief. For cultures in this area, any outward sign of emotion is taken to be evidence of frailty and loss of control.[45] As Ayido notes for the Fon (5.2.86), "Those who get angry ruin things." Only in certain prescribed contexts—war and religious possession are the most important—is it considered appropriate to display emotion.

For this reason, self-control, composure, and the appearance of calm were once a frequent subject of body cicatrization patterns. One such pattern shows a serpent grasping a frog. Explaining the significance of this image, Sagbadju noted (8.2.86), "When the serpent traps the frog, it cannot keep it because the frog puts venom in its mouth. . . . if something wants to happen to you, the person who will save you will arrive." In other words, stay calm in the face of danger, help will arrive. Two other cicatrization patterns, one taking the form of birds' feet (hɛfɔ, xɛfɔ), the other wild animal feet (kanlinfɔ), also underscore this idea of the ability of humans to surmount difficulties in life by remaining in control. In the case of the former pattern, Sagbadju asserts (8.2.86): "When one designs the bird foot on the arm, one is saying, 'The bird does not fall on the tree so that one hears the noise of its feet.'" Explaining, Sagbadju observed, "You cannot do something to me that will arrive to harm me." In other words, any attack will be as imperceptable (nonthreatening) as the sound of a bird landing on a tree branch. The cicatrization pattern of an animal paw also is identified with the need for calm, quiet, and composure. As Sagbadju notes (8.2.86), "One designs the feet of the leopard [because] . . . the animal that makes noise does not trap the leopard of the forest to eat it." As models of behavior in both the animal and human worlds, these cicatrization forms reinforce a program for human conduct and response which is grounded in the philosophy of *vodun*.

Despite this emphasis on outward calm and control, however, Fon philosophy is decidedly not a fatalistic one in which life is deemed to hold a predetermined course. Far from it, for yet another critical feature found in Fon philosophy is an insistence on the changeability of life and the imperative that each person actively participate in (and indeed promote the alteration of) difficult situations in the world. Accordingly, a fortune often was spent by people of every status, age, wealth, and profession for *bociɔ* and *bo* intended to promote changes in one's life situation (figs. 25, 26, 27). For every problem there was a solution; for every

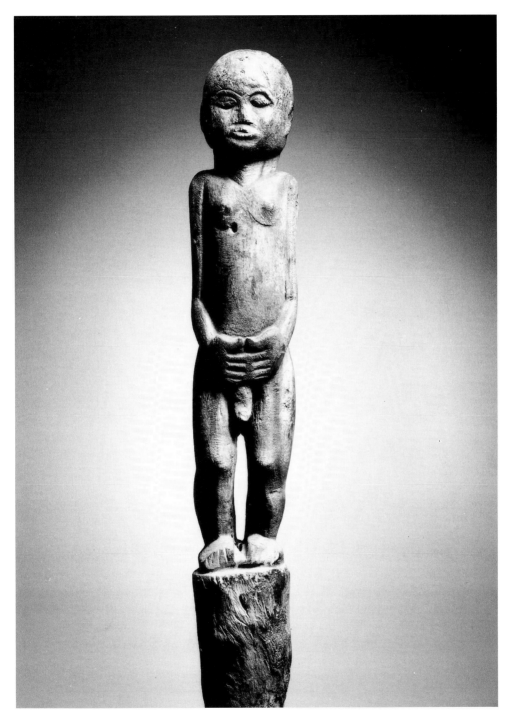

25. Mahi? sculpture of the *kuɖiɔ-bociɔ* type. Republic of Benin. Male figure. Height: 69 cm. Carlo Monzino Collection. Formerly Jacob Epstein Collection. Published in Vogel (1986).

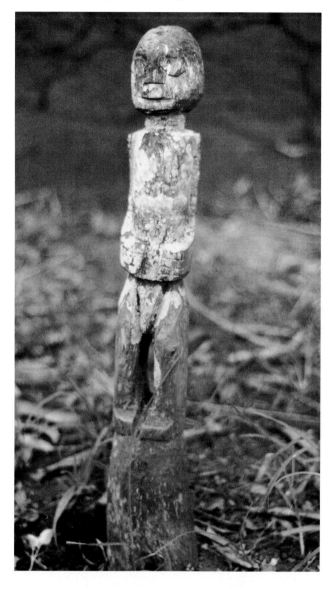

26. Fon *bociɔ*. Bohicon area. Republic of Benin. Height: approx. 76 cm. Photograph: Suzanne Preston Blier. June 17, 1984.

27. Fon *bociɔ*. Republic of Benin. Female figure. Wood. Collected in 1928. The centerpiece of Merlo's book, *Un chef d'oeuvre d'art nègre: Le buste de la prêtresse* (1966), this sculpture is said to represent a Yewe priestess. 25 cm. Albright-Knox Art Gallery, Buffalo, NY. Albert H. Tracy Fund, 1937. ACC: 37.8.

roadblock there was a detour; for every missed meeting there would be a future rendezvous. These and similar concerns are a central part of the commissioning and use of *bociɔ* and *bo*.

These works constitute at once the most varied, numerous, and emotionally charged art form in this area. In certain respects they represent a visual comple-ment and counterfoil to the *vodun* ideals of quietude and acceptance, for they are grounded in a philosophy of action. Fon, Evhe, and related groups made heavy financial and emotional investments in objects such as *bo* and *bociɔ* in

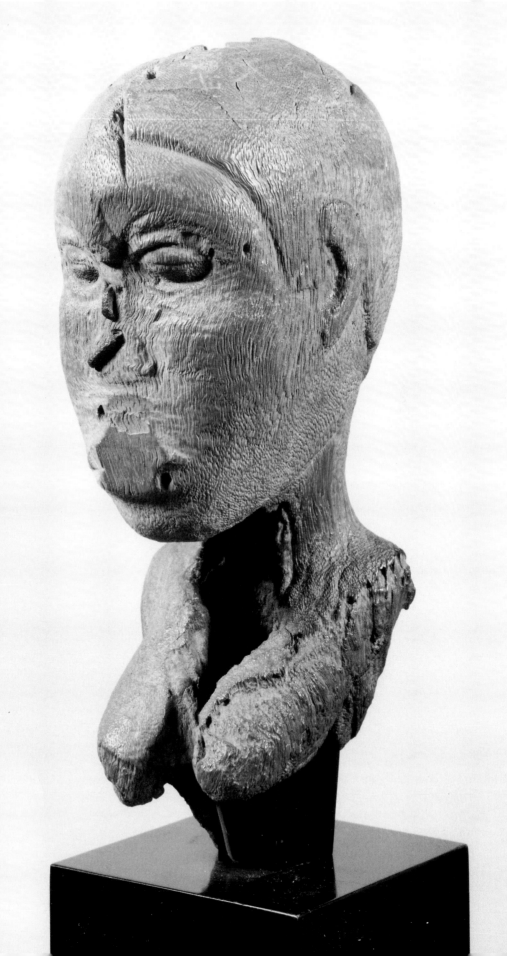

order to counter danger and to prove that one could indeed remain cool and calm in the face of life's lesser and greater traumas. This was the case not only for the general populace but also for the king, court ministers, and the army. War, politics, economics, and religious ceremony were but a few of the areas in which a favorable outcome was seen to be heavily determined—both positively and negatively—by the efficacious use of *bo* and *bociɔ*.

Belief in the changeability of life in many respects also was critical to *bociɔ* functioning. Particularly for those for whom life seemed to offer little, belief in the possibility of change held out a continual source of hope. "Life is like a palm tree leaf," suggests one Fon proverb—the wind will blow it in one direction but then it will blow it in the other (Akalogun 7.1.86). The palm leaf (*deman*) accordingly also was once a widely used Fon body cicatrization pattern. Sagbaju describes this pattern (which was generally incised on the stomach), and suggests something of its underlying psychological and philosophical importance (8.2.86): "If [the palm leaf] moves to the left, it will return to the right. If I am poor today, tomorrow I will be [rich]. . . . This is because if the wind blows the palm leaf to the right, it will also bring it to the left. One should not, on seeing that I am poor today, begin to laugh, for tomorrow I will be wealthy." *Bo* and *bociɔ* are intended to promote similar changes.[46]

The Fon word for human, *gbɛtɔ*, literally "the father of life," also offers insight into this aspect of worldview and *bociɔ* functioning. This term conveys not only the critical importance of life's acceptance, but also, and equally important, the active roles which humans are expected to take in shaping critical life events. According to the principle of *gbɛ*, humans are held not only to control life (*gbɛ*) through pursuits such as the hunt (*gbɛtɔ* is also the word for hunter), but also through interaction with other living things and supernatural powers through speech, *bo* (or *bociɔ*), and other means.

Still further insight into the meaning, philosophical roots, and aesthetic manifestations of *bociɔ* can be seen in an examination of the term *hun*,[47] which is used as the synonym of *vodun* in many contexts. In Fon religious terminology, *hun* is employed in reference to a number of *vodun*-related concerns. Thus *fon hun* ("to awaken the *sacra* or god") is the Fon name for the ceremony to resuscitate a novice after this person's ritual death. *Hun gbe* ("language of *hun*") is the ritual language spoken by particular groups of devotees. *Hun kpamɛ* ("fence of *hun*") is the convent. *Hun gan* ("chief of the *hun*") is the principal priest. *Hunsi* ("wife of *hun*") is the male or female novice. Ancillary linguistic meanings of the term *hun* also are important. As Segurola notes (1963:233), the term *hun* signifies not only "God," but also "heart" and "blood." The term *hun* additionally is used to signify "drum" (an instrument whose beat recalls that of the heart), "bellows" (which similarly are associated with a pumping action), "cotton tree" (bombax—an enormous tree from which drums are carved), and "vehicle" (the earliest examples of which—the pirogue—were made from the

hollowed-out trunks of cotton trees). Like *bociɔ*, these *hun* signifiers are promi-nently associated with action. While *vodun* is linked to the values of calmness, composure, and quiet acceptance, *hun*, like the blood that pulses through the veins (and the rhythmic beating of drums and bellows), carries with it a message of agitation and response.

Probably stemming from the above, *hun* also is employed in certain historical contexts to refer to the capital of the Danhomɛ kingdom, Abomey (Agbomɛ), and as an extension of this to the kingdom of Danhomɛ in general. In divination accounts one speaks of the four great city-states in the area: Ke (Ketu), Hun (Agbomɛ: Abomey), Ja (Adja: Tado), and Ca (Chabe: Savɛ). This use of the term offers evidence of the considerable ancestry of *hun* as a linguistic signifier in the Abomey area, for Tado (Ja) appears to have lost its position of dominance before Abomey's founding in the late seventeenth to early eighteenth century (Cornevin 1962:49).[48] The early importance of *hun* as an area toponym is reinforced by the fact that *hun*, not Danhomɛ (or a derivative thereof), is the name which divina-tion texts employ in designating this state.[49] In these texts, the term *hun* appears to signify both a place and the gods that were worshiped there. Like both *vodun* and *bociɔ*, the term *hun* in this way has importance not only with respect to philosophy and religious identity but also with regard to larger historical and sociopolitical concerns.

Of further significance is the use of the term *hun* to mean blood. Like blood, both *hun* and *bociɔ* are considered essential to human life and well-being. As Agbidinukun explains (4.3.86), "All the things that have created people are called *hun*." To Agbanon similarly (2.25.86), "All the *vodun* are called *hun*. . . . *vodun hun*, it is they that gave birth to one, providing the blood that flows in one's body."[50] The use of blood as a focal point for many religious sacrifices—includ-ing, frequently, those of *bociɔ*, also reinforces the above. *Bociɔ* and *bo* works, in their identity with action, heat, and sacrifice, complement key attributes of *hun*. Serving both to protect humans and to offer avenues of individual empowerment and change, these works, like the beating drum rhythms which bring on *vodun* possession, promote ideas of individual empowerment and response.

The two principal colors of *vodun* ceremonies are interesting in this perspec-tive. The color white complements the underlying *vodun* values of coolness and composure; the color red recalls not only blood but also *hun*'s more aggressive associations with danger and heat (fire).[51] White, it can be said, suggests the more serene nature of the godhead (particularly as identified with prayer); red refers to the more active dimension of religious belief through sacrifice and pos-session. *Bo* and *bociɔ* in their identity with action, heat, and sacrifice serve as visual signifiers of *hun* by addressing those qualities that are associated with danger and the flow of blood. Yet in the composure, coolness, and calm which works of this sort are said to bring to their clients, they also evoke the more quiet, restful tenets of *vodun* philosophy.

Vodun and Bociɔ Complements in the Americas

The arts of *bociɔ* and *bo* also have important complements in religion and cultural expression in the Americas. The African American folklore tradition of sticky, tar-covered entrapment-figures made famous in the Uncle Remus story may in part derive from this source. "Voodoo dolls" (whose image in the West today frankly is more a product of a vivid imagination than historical substance) also may originate in this area. Works of this sort, which were often intended to help a person win another's affection, acquire particular benefits, or promote personal interests through supernatural means, appear to have functioned in ways which in many respects are similar to *bo* and *bociɔ*.

Perhaps the most auspicious appearance of objects of this sort in the Americas was in the village of Salem, Massachusetts, during the era of the famed witch hunts.[52] A key figure in the events of 1692 was a Barbados slave named Tituba who worked in the kitchen of the local minister, Samuel Parris, and who in the words of Kai Erikson (1966:141) "enjoyed a reputation in the neighborhood for her skills in the magic arts," among others, divination.[53] According to Erikson (1966:141), "it was not long before a mysterious sorority of girls, aged between nine and twenty, became regular visitors to the parsonage." Erikson explains the effect they had on the small community of Salem village (1966:144): "Already the girls had become more than unfortunate victims: in the eyes of the community they were diviners, prophets, oracles, mediums, for only they could see the terrible spectres swarming over the countryside and tell what persons had sent them on their evil errands." The belief that some of these young women displayed symptoms of "hysteria" coincides with the possibility that Tituba herself was an experienced medium (Hansen 1969:38). Related traditions of possession are an important feature of *vodun* religious practice—both in the Americas and in Africa. Also critical is Tituba's ready confession to having seen mysterious beings from the spirit world. Although there is some dispute as to whether Tituba was Indian or African in origin, according to Erikson (1966:143) she "had grown up among the rich colors and imaginative legends of Barbados and . . . was probably acquainted with some form of voodoo."

Not far away in Essex County, another Barbados native, a black slave named Candy, similarly was found culpable of practicing witchcraft. Among the objects in her possession which were said to signal her guilt was "a handkerchief wherein several knots were tied [along with] rags of cloth, a piece of cheese and a piece of grass" (Hansen 1969:70). Knots (and tieing generally), rags, grass, and foods also are found prominently in *bo* and *bociɔ*. Another Essex resident, a white woman named Bridget Bishop, in turn was said to have in her cellar "several puppets made up of rags and hogs' bristles with headless pins in them with the points outward" (Hansen 1969:65). Although as Hansen points out (1969:65), figural works such as these were found in European contexts of magic and witchcraft (and related European texts were widely known in the Americas; Herskovits

1967, 2:237),[54] the presence of such objects in Salem does not preclude the possibility that certain of these figural forms also may have had an African source—particularly when found in circumstances in which Africans were known to have played a part.

"Dolls" of this sort remained prominent in African American art and ritual practice (Wahlman 1993:109–10); in Haitian religion particularly striking complements were and are still found.[55] Moreau de Saint Méry writes in 1797 (in Herskovits 1964:221) that "The Negroes believe in magic and that the power of their fetiches has followed them across the sea. . . . Little rude figures of wood or stone, representing men or animals, are for them things of supernatural power and they call them *garde-corps* [body guards.] There are a great number of Negroes who acquire absolute power over the others by this means."[56] Their name, *garde-corps,* complements the French term for these objects in the Porto-Novo region of Benin (i.e., *garde-cercles/* area guardians). Another early figure in wood which has been documented in the diaspora was published in 1875. This work, which was identified with runaway slaves in Cuba, incorporates a range of empowering materials in the area of the stomach (see Thompson 1983:124). Both in this feature and in its subsidiary horn attachment it displays striking *bociɔ* parallels. Wooden figural traditions of the *bociɔ* type, however, are relatively rare in African American art in the diaspora today, no doubt in part because historical decrees prohibited the sale of charms and magic objects of various sorts (Metraux 1972:35), and such works would have caused particular concern among authorities because of long-standing European associations of objects of this type with witchcraft.

While figures in wood and stone appear no longer to be made in Haiti and other *vodun* contexts in the Americas, there is a tradition of small, cloth-covered figures which are said to have similar functions. (figs. 28, 29). Karen McCarthy Brown, discussing (1991:348) the religious practices of a Haitian *vodou* priestess named Alourdes, observes that

in her cures, Alourdes puts problematic human relationships into a tangible, external form, where they can be worked on and ultimately transformed. When a love relationship is desired, she binds two dolls face-to-face. When the dissolution of a relationship is sought, she binds them back-to-back. For restive, "hungry" spirits, she prescribes a meal of their favorite foods. To treat a violent marriage, Alourdes makes a charm for the wife by filling a jar with ice ("to cool him down") and molasses ("to make him sweet"). Then she wraps the charm in some article of the husband's clothing and turns the whole thing upside down, a clear signal within the Vodou science of the concrete that a revolutionary change is desired.

The cloth figures discussed here with their relatively nonthreatening "doll" looks, nomenclature, and textile coverings probably were more acceptable to local authorities than the more provocative and emotionally charged wooden *bociɔ* forms used in African and early African American contexts.

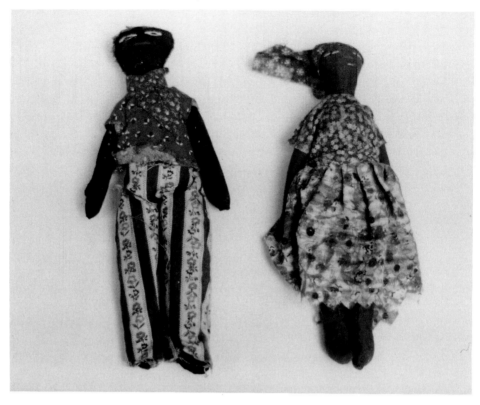

28. Haitian cloth figures left on a tomb. Collection of Karen McCarthy Brown. Photograph: Suzanne Preston Blier. December 1992.

Like *bociɔ*, these cloth figures utilize various plants and body signifiers in the course of their manufacture and as a means of empowerment to help locate the subject of concern. Both traditions also share an important identity with the dead. In Haiti, figures of this sort frequently are brought to the cemetery in order to activate their power. In Africa, death imagery is found both in their name (*bociɔ* means "cadaver of *bo*") and in their roles in deflecting death from the owner.

In Haiti, in addition to textile figures, other *bo*-related forms include bundles made up of powerful substances (called in French, *paquet*, "packages," or *paquet-kongo*, "Kongo packages") which are characterized by their emphasis on binding. While these are thought by many scholars to have a Kongolese source, their emphasis on binding also has important complements in West African *bo* and *bociɔ*. Haitian traditions of *pwen* (*pwe, pwoin*, "points"—the name deriving from the French pronunciation of this word)[57] also have *bo* corollaries. These forms, which are used by persons to negotiate their way in the world, are said by Brown (1991:348) to be "condensations of complex social, psychological,

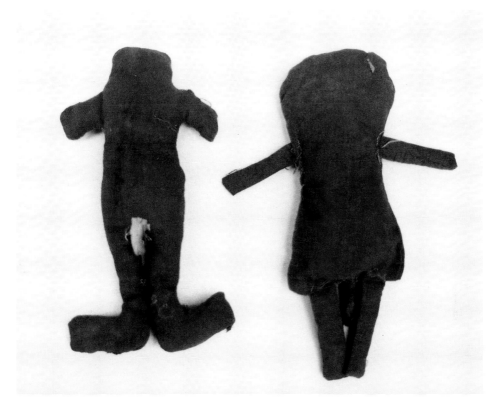

29. Haitian cloth figures left on a tomb. Collection of Karen McCarthy Brown. Photograph: Suzanne Preston Blier. December 1992.

and spiritual conditions." The variant forms of *pwen,* among these "words, gestures, ritual objects, or herbs rubbed into a small cut in the person's skin" (Brown 1991:94, n. 1), have numerous parallels with *bo*.[58] The Fon tradition of attaching bottles filled with empowered *bo* substances to trees or bushes in order to protect one's property also has its complement both in Haiti and rural areas in the American south.[59]

Linguistic traditions in Haiti suggest still other connections with West African *bo* and *bociɔ*. Although the cloth figures described above are called *poupée* ("doll" in French) rather than a linguistic derivation of *bo* or *bociɔ,* it is often the Man*bo* priestess or the *bokor* practitioner who is responsible for their manufacture. Like her African complements, the *manbo* (*mambo, mabo*) priestess, whose name and identity appear to derive from the Fon name *nanbo,* "mother of *bo*" (the Fon term *nana* meaning "mother"), plays a vital role in local rituals.[60] As noted above, the Haitian term *bokor* or *boko,* from the Evhe and Fon terms for diviner (*bokɔ,* "knowledgeable in *bo*"; or *bokɔnon,* "master of *bo* knowledge"), refers in its Haitian context in turn to a practitioner of "black magic"

(Metraux 1972:267). With the Haitian *bokor,* as with African *bociɔ,* there also is a certain quality of inversion at play. As Herskovits notes (1964:223), the *bokor* sometimes is called the one "who wears his back to the front."

So too in Haiti, it is the *hungan,* or "chief of *hun,*" who along with the *manbo* assumes a leading role in temple affairs and ritual. Both the *hungan* and *manbo* serve as primary intercessors with the gods, here called *loa* from the Fon words *lɔ,* "mystery," and/or *lɔn,* "the heavens").[61] Most *hungans* and *manbos* in turn are perceived to be not only high priests but also persons knowledgeable in the use of empowerment objects. The same is true of Haitian *gangan* (ritual aid, from the Fon, "superior" or "chief"). Herskovits notes accordingly (1964:222) that "the *hungan,* the *gangan* [and] the *bocor* . . . employ essentially the same techniques and operate with the same forces, the differences between them being one of degree rather than of kind. . . . In the main, it can be said that though the *hungan* and the *gangan* practice magic, their main preoccupation is with the *loa*—the maladies they send to affect a man and his possessions—while the *bocor* is concerned almost exclusively with setting in motion the agents that actuate black magic." The *manbo, hungan, gangan,* and *bocor* in this sense all are meant to protect people from the malevolent effects of *azeto* ("sorcerers"—the same term used by the Fon),[62] or *loup-garou* (as they are better known in Haiti, from the French for "werewolf"), the latter word suggesting the sorcerer's ability to transform into various animals and birds.[63]

In Haiti two types of *vodun* (*vodou*) power find expression in philosophy and art. The first, Robert Farris Thompson notes, (1983:164) represents "the 'cool' side of *vodun* being, associated with the achievement of peace and reconciliation." The latter, or hot side, he points out, is "associated with the spiritual fire of charms for healing, and for attacking evil forces." In Haiti, the former "cool" attributes are generally identified with Arada or Rada Vodun (hence acknowledged in the name to derive from the Allada area or nearby cultures in southern Benin and Togo). The "hot" *vodun* traditions in contrast are generally known as Petro *vodun* (apparently after Don Petro, who organized a new *vodun* sect in 1768) (Bastide 1971:141). While the latter traditions integrate certain Kongolese elements (see Thompson 1983:179–191),[64] both forms of Haitian *vodun* also show clear complements with Fon, Ayizo, Evhe, and related *vodun* concerns with composure, calmness, and acceptance on the one hand, and action, heat, and response on the other (the latter as identified especially with qualities of *hun*).

Deren suggests that Petro *vodun*'s political associations also have clear parallels with the West African traditions discussed above. She writes (1953:62): "Petro was born out of this rage. It is not evil; it is the rage against the evil fate which the African suffered, the brutality of his displacement and his enslavement. It is the violence that rose out of that rage, to protest against it." This description strikingly complements *bo* and *bociɔ* as objects of empowerment, heat, and emotional expression which are intended to counter aggression and danger from varying sources.[65]

Haitian *vodun* religion and philosophy (in both Rada and Petro manifestations) also recall West African *vodun* forms in the important psychological roles associated traditions fulfill. According to Ari Kiev (1961:264): "The Voodoo folk religion provides not only religious and spiritual guidance for the people, but also a reasonable theory and treatment method for the psychiatrically ill." Haitian *vodun*, like traditions in Benin and Togo, has prominent political associations as well.[66] *Vodun* accordingly played an important historic role in Haiti in unifying and empowering men and women of African descent in their fight for freedom from political oppression. A number of historians thus identify *vodun* with the onset of the Haitian slave revolt that led to that country's independence in 1791 (Metraux 1972:41). The revolution is believed to have begun after a *vodun* ceremony held on August 14, 1791, by a *houngan* (*vodun* priest) named Boukman. This person also is sometimes described as having been a *bokor* or practitioner of *bo* (Deren 1953:62–63).

Although *vodun* (*vodou*) and objects functioning in ways similar to *bo* and *bociɔ* appear to have been important in North American black culture prior to this time (as witness the accusations at Salem), *vodun* saw an increasingly significant role in the United States following Haiti's revolution, when the island's French plantation owners fled to the north with many of their house slaves (principally of Fon, Mina, and Yoruba origins—as opposed to the field slaves, who were predominantly Kongolese in origin; Bastide 1971:106, 146). The migration grew even larger after the Franco-Spanish War of 1809, when many whites left Cuba (here again often with their house slaves) to settle in New Orleans and nearby areas (Bastide 1971:106, 146).[67]

Here *vodun* reached a pinnacle in the middle of the nineteenth century with the famed New Orleans "Voodoo queen," Marie Laveau.[68] New Orleans *vodun* (or *hoodoo*, as it was sometimes called),[69] like that practiced elsewhere, came to be identified as a source and symbol of personal and group empowerment. Here too, both *vodun* and *bo*-related practices were associated with people standing apart from and against elite or official cultural forms. As in Salem and Haiti, cloth figures were occasionally used in related practices.[70] *Bo*-type objects and traditions of "conjuring" here too shared critical social and psychological functions with those in West Africa.[71]

In part for this reason, African American *vodun* arts which complement *bo* and *bociɔ* have been associated with considerable fear and suspicion. The perception of *vodun* as a religion of terror and irrationality has continued over the years in much of the general writing about this subject. Exemplifying this idea, a recent newspaper article describes opposition to a new lager beer from New Orleans called *Dixie Blackened Voodoo,* which the state of Texas sought to ban because "its name and label, which shows a swamp, conjure images of witchcraft and the occult" (*New York Times,* July 4, 1991). Although this ban was eventually overturned, an employee of the Texas commission which was involved in the action noted that "we still feel like the voodoo connection is not in good taste

and not in the public interest." Were the person speaking about commoner *bociɔ* used in contexts of West African *vodun*, his comments would have a certain ironic validity, for these works were indeed intended to display not only counter-vailing aesthetics but also powers which to some degree opposed those of the ruling elite. Yet in African *bociɔ*, as we have seen, counteraesthetic and empow-erment associations also were linked in important ways to personal and commu-nity well-being.

Audiences, Artists, and Sculptural Activators

"When you are attacked by a snake use whatever stick is available
to you"
(*kpo e ɖo mɛsi ɔ sin dan wɛ e nɔ hu*)

—Fon proverb

"[A] major motivation for art is tensions which exist in the spectator
of art prior to his exposure to the work of art. The work of art
mediates the relief of the preexisting tensions by generating new
tensions."

—Hans Kreitler and Shulamith Kreitler, *Psychology of the Arts*

Force, writes D'Arcy W. Thompson (1966:10) with respect to the Newtonian
language of elementary physics, "is recognised by its action in producing or in
changing motion, or in preventing change of motion or in maintaining rest." As
Thompson explains (1966:11), "[T]he form of an object is a 'diagram of
forces.'" Action is a central component of object meaning as well. Walter Benja-
min observes accordingly (1978:305–6) that "between the active [person] and
the external world all is interactive, their spheres of action interpenetrate."[1] In
the context of *bociɔ*, force and action can be said to play similar roles. They are
a vital part not only of object creation but also of object reception and significa-
tion. Throughout the area where *bociɔ* are made, things are believed not just to
happen, or to stop happening, but to be activated (and deactivated), set on a
course of action (and counteraction) by powerful individuals, by religious pow-
ers, or just as often, by metaphysical means through the interaction of particular
materials or properties. This chapter explores the diverse ways that *bociɔ* arts are
made, empowered, and perceived. Following Kenneth Burke (1966), emphasis is
given to the symbolic as act. Discussion thus is concerned less with the sign as
material, than with the process of signification itself. The pages that follow ex-
amine the multiple ways that agencies and energies, in the words of Thompson
(1966:10), "act on matter," transpose its features, and transfer its properties.

The discussion in this chapter focuses on four key actors within the creative
endeavor—the artist, the producer, the user (viewer), and the cultural advocate
or spokesperson.[2] In the center of this four-part frame is the artwork itself, which
both derives shape and meaning from and gives shape and meaning to the ideas,
actions, and expressions of the persons who in one way or another have to do
with it. Each participant within this process offers unique perspective into the
role and significance of each work. In the context of *bociɔ*, the artist[3] characteris-
tically is the person who carves or models the underlying figure. The producer

empowers the sculpture with various surface additions preparatory to (or during) its use.[4] The user includes any of the work's diverse clients or audiences. Cultural spokespersons comprise the myriad of individuals—diviners, priests, elders, family heads, and the like—who are charged with the guardianship of information on objects of this sort. Each text (object), I suggest, is so thick in signification as a result of the roles of these diverse individuals that no single explanation or interpretation of object meaning can be adequate.[5] If in the discussion below, the artist is less central to the discussion than are other participants, it is because, like Barthes, I see the artist as but one of many key figures in the creative endeavor.[6] The artistic process, I argue, is both much larger and richer than standard artist-centered models generally have acknowledged.[7]

This chapter begins with an analysis of *bociɔ* users and audiences and their roles as interactive contributors to the creative act. I then turn to artists and sculptural producers. Throughout we hear the voices of local cultural spokespersons who articulate salient characteristics of this art in the context of its production and reception. Finally, discussion focuses on the divergent means of sculptural activation. Four modes of empowerment will be explored in this context: heat, speech, tieing, and supernatural interaction. Each will be discussed with an eye toward what it offers with respect to *bociɔ* signification and what it reveals in terms of viewer response.

Audiences: The Psychodynamics of Viewing and Using

Audiences (or as is generally the case here, users and clients) play a critical role in the creative process, for each such individual brings unique insight to the understanding of the work. In the words of Dilthey (1985:152), "Only through the cooperation of the imagination of the reader or listener do figures take shape from it." Iser suggests similarly (1980:106) that "[c]entral to the reading of every literary work is the interaction between its structure and its recipient." Questions of viewer input into artworks are complex. Todorov points out for literature (1980:67) that "nothing is more commonplace than the reading experience, and yet nothing is more unknown." The problem lies both in defining and delimiting the unique characteristics of a given viewer (reader), and in determining how the experience of viewing can be contextualized within the larger continuum of "universalized" and "individuated" (particularized) response.

On one side are found art historians such as Ernst Gombrich (1973) and David Freedberg (1989) who argue that perception (and reception) are grounded on certain shared "truths." In the words of Freedberg (1989:23), "we proceed in the belief that however much we intellectualize, even if that notion is spontaneous, there still remains a basic level of reaction that cuts across historical, social, and other contextual boundaries. It is at precisely this level—which pertains to our psychological, biological, and neurological status as members of the same species—that our cognition of images is allied with that of all men and women."

On the other side are situated writers as diverse as Friedrich Nietzsche and Roland Barthes who maintain that "truth" remains fundamentally grounded in the individual. As Nietzsche explains (in Lapsley and Westlake 1989:18), it is "each individual, constituted by the multiplicity of forces, [who] interprets reality from the standpoint of his or her own needs or interests." To Barthes, in turn, each viewer in a certain sense "creates" (writes, constructs) his or her own artwork. In this way every text, in Roger Fowler's words (1987:203), is "rewritten" for each successive reader according to what she or he carries to it, or as Adorno explains (1984:379), the "continuum of aesthetic experience is coloured by the sum total of experience and knowledge available to the experiencing subject."[8]

Added to these viewership perspectives is a position held by several recent literary and film critics who present what might be called here a "viewing middle ground." Susan Suleiman, one such individual, maintains that (1980:20) "an interpretive strategy . . . can only be understood as a collective phenomenon, a set of shared conventions within a community of readers." Essential to her argument is what she calls "community," the group of individuals who through some form of shared (or comparable) experience (identity) come to understand works in a similar way. Kaja Silverman's writings also are situated (1983:222) within the frame of a shared "community" of respondents, particularly in her discussion (after Mulvey) of the distinctions between the male and female viewer in terms of the meaning and manner of the gaze.

How does one bridge these differences in audience or viewer definition and delimitation? Following on our earlier discussion of the textual plurality, I would argue that each model of viewing holds certain qualities of "truth." Turning our attention specifically to the *bociɔ*, it is clear that some images or modes of expression (indeed many of those which distinguish this tradition)—such as death, bondage, swelling, and deformity—have clear cross-cultural and cross-historical signification as markers or signals of danger, much like the skull and crossbone images placed today on poisons in the West. These signals of danger accordingly are encoded with universalized signification which may affect viewer response everywhere.

It is also true that each local viewer (or user) of such a work brings to it his or her unique (and in the case of *bociɔ*, often emotionally highly charged) way of understanding this art. Each user's identity with a sculpture in a sense serves to "look through" the object, seeing it as if through a looking glass, with essential qualities being reflected back in accordance with the particular desires, hopes, or fears of this individual. In this process of looking through the object, each art viewer or user thus conveys his or her particular perspective on the work being viewed and used. Viewers in this sense to a large extent do create their own texts. Within distinctive "communities" of *bociɔ* viewers[9] objects of this type also have certain shared (or at least comparable) features of signification.

Although each of these "ways of viewing" is in its own way important, individual viewer response—especially that of local viewers in the region of *bociɔ*

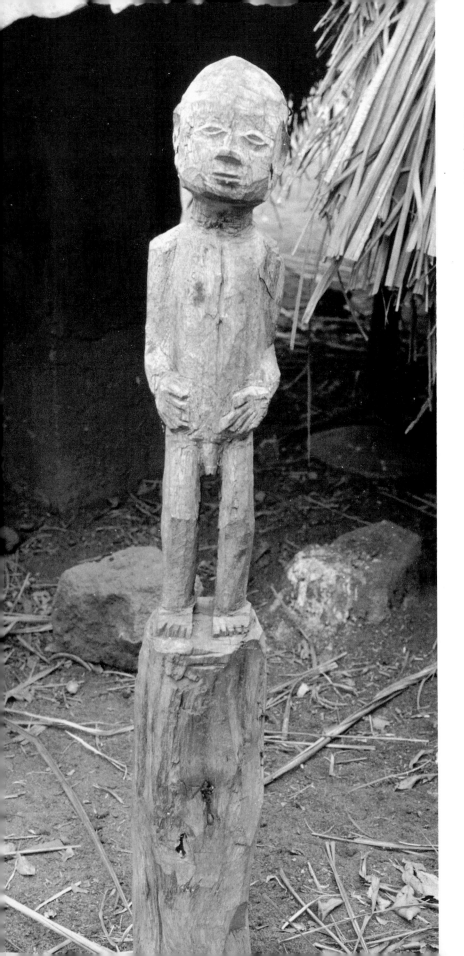

30. Gedevi-Fon *boci̇* of the *kuɖi̇* type. Bohicon area, Republic of Benin. Artist: Toboko? Photograph: Suzanne Preston Blier. December 18, 1992.

manufacture—necessarily must be privileged over others because of the powerful (and highly individuated) psychodynamic roles such objects play. Local viewer response to *bociɔ* in the region of their manufacture (fig. 30) is of special interest in this regard. In my queries about these figures, the most frequent statements I heard suggested mystification, fear, and distrust. These concerns, as we will see, constitute critical elements of *bociɔ* sculptural aesthetics and ideation. Asked why one had attached small objects to a bottle-form *bociɔ*, Sagbadju observed (8.2.86), "One attaches them so that when someone sees this, he will say that it is a strong power and he will buy it." The emotional power of *bociɔ* also is discussed by Agbanon (3.7.86): "[One] makes things that will cause fear. It is not only important how a *bo* works, but also how it looks. If one sees it, one should be able to say that one saw *something*." Fear and related concerns are important elements within this sculptural aesthetic. Dewui's response to a bottle-form *bociɔ* is insightful (7.3.86): "It is the water, alcohol, or powder that goes into the bottle that does the work. Anything else is there to frighten people. One puts things in the bottle and sews other things around it so that when one sees it one will believe in it. With a simple bottle one will not believe." Describing another figure, Dewui noted similarly (7.3.86): "All those things are created for people who do not believe in anything. One does this so that one can frighten them. Real *bo* are not as big; they are made of things that are gathered together, but people will not believe they really work, so one makes them complex by adding various things."

Sagbadju, for whom fear also is important, has observed (7.1.86) that "when you come from afar and you see it, you will be frightened. That is why one makes it this way." These sculptures, in other words, are intended to convey a sense of emotional power which is often both disorienting and disturbing (fig. 31). As Dewui explains (7.3.86), *bociɔ* "are there for the mystification of the people." He adds: "One sees these things in the temples of the sorcerers . . . so that when you come you will know it is a . . . [mysterious force]. . . . When one comes to see that, one is afraid and one will think he really has something there. One makes these statues so that when someone sees them, this person will be afraid. The [sculpture] is like a glass, if one does not do something to make the people afraid, and if one presents this glass and says it has a great power, you will not believe it." The above term "mystification" (*e non do blɛ men nan*) carries a strong suggestion of deception, especially since this word also translates as one who is in the process of tricking another person. *Bociɔ* as we will see are associated closely with actions of trickery and deception.

Features of force, fear, shock, fury, disorder, and deception, in sum, play a critical role in *bociɔ* reception (fig. 32). These criteria in turn have a role in effectuating particular types of viewer response—be it of mystification, danger, or awe. *Bociɔ* features in this sense may help to "intensify the impression of the fearful," in the words of Dilthey (1985:14). Through related aesthetic values,

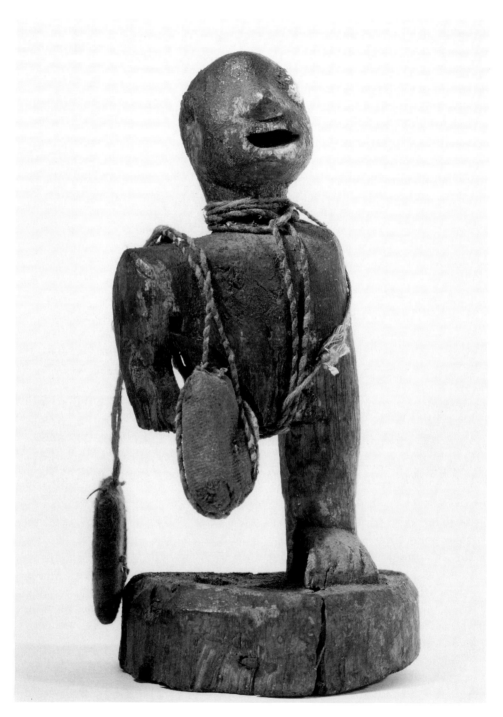

31. Evhe power figure. Lome, Togo. One-legged and one-eyed. Wood, cord, leather, and miscellaneous materials. Height: 35 cm. The work was used to guard against spies. Musée de l'Homme, Paris. Cat. no. M.H.32.78.17.

32. Fon *boci*. Republic of
Benin. Wood, monkey jaw, and
miscellaneous materials.
Wooden peg inserted in the
forehead. Height: 27 cm.
Probably collected in the
1960s. Former collection of
Ben Heller. Current collection
of Don H. Nelson.
Photograph: Jerry Thompson.
Photo courtesy of the Museum
for African Art.

boci address important issues of anomie identified both with individual disori-
entation, anxiety, and isolation, and problems in society itself.

In part these responses find basis in contemporary political and social realities
in the area. If not wholly illegal today, the making of such objects and the use
of other means of supernatural ("magical") power is decidedly frowned upon.
Moreover, the 1970s Marxist government hunt for sorcerers or other manipula-
tors of extramundane *bo* power and the resultant cutting down of trees which
they were believed to inhabit is still a vivid part of this culture's collective mem-
ory. The stumps of these felled trees remain in many communities today as vivid
evidence of this governmental action.[10] At the same time, while many of the
newly educated elite no longer make (or use) *boci*, most local residents at some
point in their lives have employed *bo*—if only as a protection or aid in combating
illness. What this suggests is that the "community" of local viewers identifies
with key *bo* and *boci* concerns ranging from fear (vis-à-vis their perceived

power) to mistrust (promoted by contemporary political voices) to awe and even respect (based on *bo* empowerment associations and the potent, protective benefits they are thought to bring).[11] The active participation of *bo* and *bociɔ* users in the process of sculptural creation and empowerment no doubt also influences their viewing experience.[12]

Merlo provides a good example of the interactive roles which users play with regard to sculptures of this type (1977:99): "Once the [*kudio-*] *botchio*[13] is installed, each member of the family can sacrifice to it every time they feel a need for protection. The women give it a libation of palm oil and address prayers to it when they go to the market." Through the process of this and other types of devotional action, meaning is continually reinvested and renewed in the work (fig. 33). Each work thus mobilizes emotional identification within the viewer, who in turn invests in and superimposes onto the sculpture particular forms of invested response.[14] Works of art in this sense can be seen as externalizations or projections of psychic states, not primarily as concerns the identity of the artist[15] (as traditionally has been suggested within psychoanalytically oriented art studies), but rather equally with respect to the individuals who view and use them. For as in language, so too in art, a vital role is played by features of stress, pitch, and tension in both the communication and reception of ideas.

This factor of interactive audience reception is further enhanced by the strong feelings of indebtedness which develop on the part of *bociɔ* users toward the individual artistic activators (object producers) who create objects of this type. Quénum asserts accordingly (1938:81) that "the people have a devotion for the *boto[non]*, a devotion too obsequious for the latter not to exploit."[16] Whether or not this relationship is indeed one of exploitation and obsequiousness as Quénum suggests, it is certain that recompense and a sense of indebtedness continue long after the commission has been completed. As Agbanon explains (3.7.86): "If you make a work for a person and he survives, when this person for whom you did something good sees you, he will greet you. If he can buy you some drink, he will buy it for you. . . . The one who does good things so that people will survive, will not go hungry."

The close bond between *bociɔ* maker and client also is exemplified in Ayido's explication of the circumstances under which he acquired one of his works. As he explains (5.2.86):

A Mahi man made my *bo*. I was cultivating at the time and we became friends. He was already old and dragged himself along the ground because he could no longer walk. When I went to the fields, I brought him wood. When I went to his house, I emptied the jar in which he urinated. I brought him yams and manioc. After I returned from my village I brought him more gifts. It was because of this that he said he would give me a very good thing. And he cited the things for me to purchase and I brought them. He said, "If you hold this and use this, nothing bad will visit you. Even if you are the head of a family and you do no matter what, nothing bad will come and look for you."

33. Fon *kuɗiɔ-bociɔ*. Abomey, Republic of Benin. Photograph: Suzanne Preston Blier. July 2, 1986.

In this example, we can see not only the strong bond between maker (artistic activator) and client (user-audience) which develops in the course of *bociɔ* manufacture, but also the ardent personal ties which may precipitate the initiation of the creative process itself.

Often both the maker-client relationship and the psychological impact of the completed work are influenced by the heavy expenses which the client is obliged to incur in acquiring objects of this type.[17] Gilli has observed (1976:19) that such works often cost as much as 35,000 cfa (about $50), a staggering price considering that the average yearly income is around $250. The high price, he suggests, helps to "create a confidence and assurance in what [powers] it possesses." Knowing the basis of this fee also is critical, for it reflects not only high labor costs (that someone of importance is doing something of significance to alleviate one's problems) but also expensive material outlays (that substances of great potency and rarity are employed to achieve powerful ends). A *bociɔ* which I saw being sold by a diviner in 1986 to a client in Abomey carried the price of 50,000 cfa (about $71). Of this price, the maker noted (7.3.86) that the carved figure cost 5,000 cfa, the materials which were applied to it cost 25,000 cfa, and the diviner (activator/producer) retained 20,000 cfa, because, as he explained "it is I who learned of the thing and how to make it." The carver, as the above illustrates, received but 10 percent of the total *bociɔ* cost, while the activator (producer) received 40 percent.[18] Together their fees constitute half of the purchase price (the materials comprising the other half). Since they share monetary and aesthetic importance in the making of *bociɔ,* these artists and activators will be taken up next and their vital creative roles explored in turn.

Artists and Activators: Creating Figures with Force

Some African artists struggle to create works in which the processes of their labor remain invisible; there are others who strive toward modes of expression wherein the means of production is clearly apparent. *Bociɔ* artists unquestionably conform to the latter group (fig. 34). It is as if they intentionally insert into their works evidence of each step undertaken in the course of artistic production. Not only are the sculptural planes heavily faceted, thereby enabling viewers to locate each cut of the adze, but many of the variant empowering materials also are displayed in full view on the surface of the figure itself. Every work accordingly carries essential qualities of the force and actions with which it was created. Indeed only those works which have been left out-of-doors for long periods of time develop the sort of surface smoothness which characterizes many other African sculptures. Within the *bociɔ* tradition, it is this "production" primacy, this concern with the *process* of creation, this aesthetic of raw energy which is such a critical part of both artistic intent and audience response.

In order to understand the roles that local artists play in the context of sculptural production, it is necessary to call attention to both the diversity of individu-

34. The carver Toboko with two of his objects, a *bociɔ* and a twin figure. Bohicon area, Republic of Benin. Photograph: Suzanne Preston Blier. December 18, 1986.

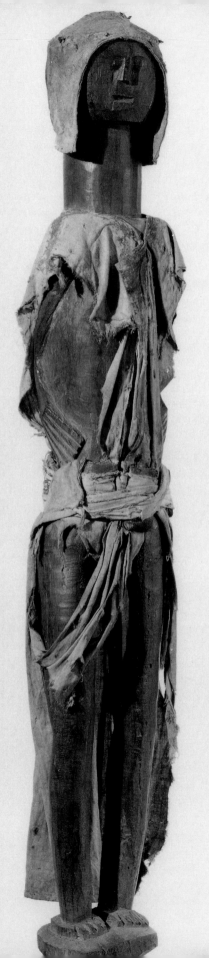

35. Dassa power figure. Called *ope*. Dassa Zoume, Republic of Benin. Wood, cloth. Height: 125 cm. Planted in front of the house and said to represent a chief. Collected by Merlo in 1928. Musée de l'Homme, Paris. Cat. no. M.H.31.74.2189. Published in Merlo (1977: fig. 20); and *Minataure* (1933).

als who take part in this process, and the range of backgrounds from which they come. While women sometimes make non-figurative *bo*, only men carve *bociɔ* sculptures. In the latter works because the additive materials are more important than the figure itself, the sculpting is frequently done by nonspecialists. As a result, there exists a remarkable stylistic and qualitative range in works of this type, for specialist sculptors (who are known in Fongbe as *atinkpatɔ*—from *atin*: wood; *kpa*: carve; *tɔ*: father or agent) generally are called upon to carve *bociɔ* only if a work is being sought from outside one's immediate family. Most of these specialists work within compounds with several related members all practicing the carving arts. While the main centers of *bociɔ* carving today are found in small communities outside Abomey such as Mougnon, Lisa-Zoume, Hwawe, Zado, Tendji, and Cové, within the city of Abomey itself a number of carvers also practice.[19] Other important areas of *bociɔ* carving include Savalou and Dassa Zoume to the north (fig. 35) and various coastal communities to the south (figs. 36, 37) (see also Appendix).

Specialist carvers working within these varying settings have different social identities. Although most live in rural, agricultural villages, some—such as an Abomey prince discussed by Herskovits (1967, 2:364)[20]—are members of the royal family. Additionally in Abomey, while a few *bociɔ* carvers are associated with large, well-established court-linked artist compounds (such as that of Hontondji, the royal brass and silver smiths), others are descendants of slaves and prisoners of war, many from families of Yoruba descent brought into the region as a result of the nineteenth-century wars. *Bociɔ* art styles thus reflect the ethnic diversity of the local artists, and certain Fon *bociɔ* figures show distinctive Yoruba features.[21]

Most of the various specialist carvers discussed above work by commission, beginning an object only after being approached by a client and learning of any special requirements regarding the type of wood, height, gesture, or distinctive characteristics which are desired.[22] Once the carving process has begun, most artists take about eight to ten days to complete a work (Dle 12.10.85).

When the figure leaves the hands of the carver, however, it is only partially complete. At this stage, the "producers" (or "art activators") select the essential additional matter and incorporate it onto the surface or body of the object. Indicative of the preeminence of their roles, some of these individuals gain considerable fame. As Spiess noted (1902:320), among the Evhe: "several priests have reputations far and wide because of their potent fetishes. Still today in Togo one hears the names of the deceased priest Amegasi who resided in Keta. . . . Also in Tegbui and Anlo there are to this day well known fetish priests." Wood carvers are aware of their clearly ancillary roles in *bociɔ* manufacture and take this into account in the objects' conceptualization. The carver Marcellin Hueglo noted (1.3.86) in this regard that "it is [others] who ask one to carve the objects and we carve them and leave a place so that one can put calabashes and bottles on

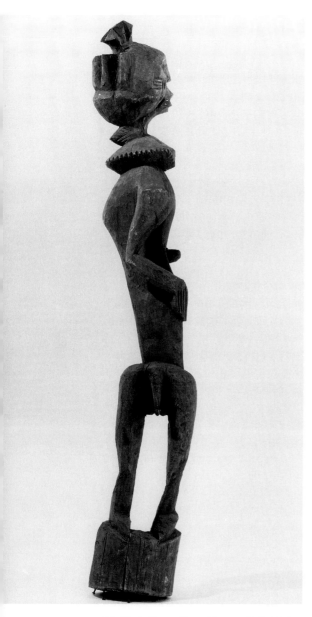

36. Hwla figure. From Gbessou (Lake Nokoue west of Porto-Novo). Republic of Benin. Wood. Blue and red pigments. Height: 85 cm. Ethnic markings, a series of vertical marks on the cheeks and horizontal marks on the lower cheeks or temples was once characteristic of peoples of the lower the Oueme River area around Porto-Novo. Collected by Merlo in 1928. Musée de l'Homme, Paris. Cat. no. M.H.30.21.76. Published in Merlo (1977: fig. 18) as Godomey-Gbessou style.

37. Hwla *bociɔ*. Area of Cotonou-Godome, Republic of Benin. Wood. Height: 47 cm. Collected by Merlo in 1928. Musée de l'Homme, Paris. Cat. no. M.H.30.21.88. Published by Merlo (1977: fig. 16). Merlo identifies this work as Godome-Ouidah style.

the body. As Mawu created man knowing he would wear pants, thus in making the *bociɔ* one leaves a place knowing that it will wear a number of things."

Like the sculptors, the *bociɔ* producers or activators who secure the necessary "calabashes and bottles on the body" are from strikingly different backgrounds. According to Le Herissé (1911:149), "All Dahomeans are more or less makers [activators] of charms [*bo/bociɔ*], however some acquire more skill than others in the art of preparing them." As we will see below, a critical factor in their success is their perceived ability to draw on special knowledge or power sources to aid them in the process of sculptural empowerment. In this regard the *bociɔ* activators fall into a number of distinct categories or groups.

One such grouping consists of priests identified with various deities or *vodun*. Because of their important roles in the creation of *bo*-related arts, priests sometimes are referred to in Fon by the name *hunbonon*, "familiar/mother (*non*) of the sacred (*hun*) bo" (Maupoil 1981:64). According to Maupoil, "All *vodun* possess special [*bo*] whose secrets are part of the education of the priests." In the making of these objects, the priests utilize not only specialized religious knowledge but also the power of their affiliated gods. Associated objects, in turn, generally are intended for the well-being and welfare of their devotees. As Ayido explains in regard to these works (4.25.86), "It is the priests who do things and people survive." Many of the works which they create form part of the *vodun-bociɔ* genre.

Like these priests, diviners or geomancers (*bokɔnon*) (fig. 38) are identified as a vital grouping of *bociɔ* art activators who draw not only on the specialized knowledge which they derive from their profession, but also from the empowering force of their sponsoring agent, in this case Fa, the source of all divinatory insight. As with *vodun-bociɔ* sculptures, objects deriving from the *bokɔnon* diviners are intended to promote the health and welfare of those who come to consult with Fa. *Kuɖiɔ-bociɔ* and Fa-*bociɔ* sculptural genres are particularly important in this respect.

Another category of individuals identified with the creation and activation of *bociɔ* sculptures are those known in Fon as *botɔnon* (*bo*: activating object; *tɔ*: agent; *non*: familiar/mother) or in Evhe, *ebotɔ*, individuals who not only sell the necessary additive materials in the market, but knowing their properties, also can be called on to empower works of this type. Like the priests and diviners (who sometimes also are conferred this name), these individuals are believed to specialize in objects having particular orientations and results. According to many, those individuals who seek out the *botɔnon* frequently have malevolent ends in mind. Ayido, a diviner, describes the *botɔnon* this way (4.25.86): "Whatever idea is in their hearts they do. They know that if one takes a particular leaf and puts it on something, it can destroy things. It is this bad idea that leads people to find the things with which to make *bo*. [They do this saying] 'If I find money, you will not find any. If I have wives, you will not have any.' It is these people who make the bad *bo*." Most *bociɔ* of course fit this model, for as

discussed in the next chapter, what is good for one individual often is bad for another.

People called in Fon *kennesinon*, "familiar/mother of malice," or *azɔnḍotɔ*, "Master (*to*) of making (*do*) harm (*azɔn*, or sickness)," and in Evhe *dzotɔ*, "master of fire," constitute still another grouping of *bociɔ* activators. These individuals who are knowledgeable in the ways of sorcerers (and according to some, sometimes commit sorcerous acts themselves) create works of considerable power and importance linked generally to the sorcery-*bociɔ* genre. As with the *botɔnon*, popular opinion maintains that their works frequently have malevolent orientations. As Savary notes (1971:3–4): "The [works] . . . created by the *azondɔto* are special *bɔ*, generally of an offensive nature (*bɔ nyanya*). . . . The *azondɔto* acts in secret, most often for his own interest, or that of another. . . . In the eyes of society, his situation remains precarious, because it is he that is held responsible for all known calamities."[23] Here, as with the other art activators discussed above, these individuals are perceived to be able to draw on various forces for the purpose of *bociɔ* empowerment. The ties of the *azɔnḍotɔ* with the nefarious world of sorcery give them special abilities to reinforce or counterbalance the evil which affects individual lives.

Numerically by far the most important group of *bo* and *bociɔ* art activators, however, are ordinary nonspecialist family members who create works of varying types for relatives, friends, and neighbors.[24] As Migan explained about the history of one such work (12.31.85), "I make them for myself and others. It was my father who taught me." A similar response to the making of a particular *bo* form was provided by Nondichao (11.15.85): "I have a lot of them, but as I get older I will begin to give them to my children so that they will have the ones that I have. When my son is older, he also can go to the *botɔnon* and purchase some with money. Thus he will be more developed than his father and will leave recipes here and there."[25] With such objects, the sources of empowerment are believed to lie both in the assurances provided by knowledge which has been passed down from generations and in the powers of the ancestors who had made such works in the past.

Despite the numerical importance of family-based *bociɔ* and *bo* activators such as those described above, it is generally believed that the strongest, most efficacious works are made by specialists outside one's own family—priests, diviners, *botɔnon*, and *azɔnḍotɔ*. As Le Herissé explains (1911:149): "The sorcerers whom one consults with on one's destiny and their *bokonon* (diviners) are the most expert. Their renown is fast established and it is for them an important source of revenue." A similar sentiment was expressed by Agbanon (2.25.86): "If you use only the *bo* made in your family, others will reach you to kill you. One should go elsewhere for one's *bo* because the one who knows you should not make them for you. . . . If you see a great person, one who is someone in his house, in his family, you will go to him to acquire the *bo* that he made to live a long time; he will tell you and he will cite the things to do." The interest in

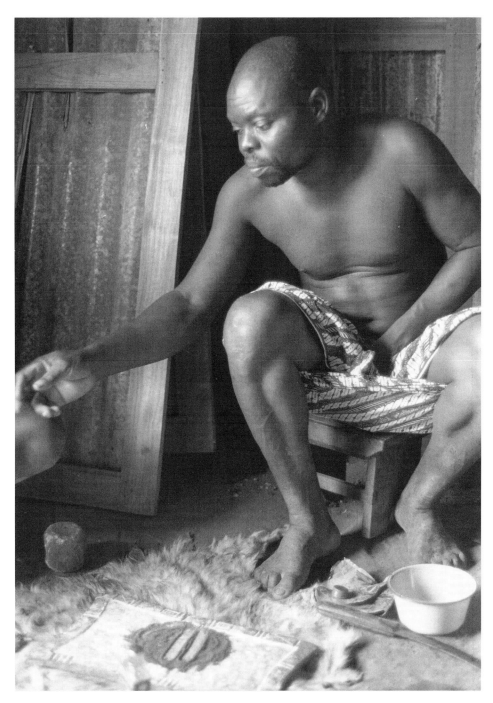

38. The Fa diviner, Atinwulise Sagbadju prepares a *bo*. Abomey, Republic of Benin. Photograph: Suzanne Preston Blier. July 2, 1986.

seeking persons outside one's immediate family, and in particular individuals with a reputation for making objects which "work" and are "efficacious," is significant with regard to questions of both making and viewing art, for clearly the response and emotional effect of any object is strengthened the more one believes in its potential validity. That one must pay more dearly in monetary terms for works acquired from outside specialists may contribute to their perceived potential as well.

Risks Incurred by Artistic Activators

In addition to the time and emotional investment of the artistic activator, personal difficulties associated with *bociɔ* empowerment in the postcarving phase of their manufacture also add significantly to their importance in the eyes of those who commission works. Obstacles or difficulties at this stage of manufacture take a wide variety of forms, including special restrictions on the time or days of the week when work on *bo* or *bociɔ* can take place. According to Nondichao (11.15.85): "If you want to make [one of these objects] you should never do it on ordinary days; if you do, the *bo* will not have any effect. However if you fabricate them Saturday or Tuesday they will be very good. Likewise, when I use my motorbike on Tuesdays I take extra precautions because if someone has already sent me a *bo* with malevolent intent it can push me toward an accident if I am going fast."

In addition to these considerations, there are also certain risk factors that come into play. For in assembling the diverse materials (particularly those which are not intended ordinarily to be brought together) there is always the threat that they will work against one. While this threat is potentially considerable in terms of physical response, its greatest liability is emotional. As Mewu explains (6.19.86), "At the moment you unleash the *bo*, all the bad things in your mind may go against you." Savary also discusses the emotional grounding of risk in *bociɔ* manufacture (1971:4). "One should not forget that offensive magic is like a sword with two cutting edges, returning easily against the one who employs it, more so because in this domain it is not difficult to find its master." [26] What is important to remember is that this factor of danger which is central to the larger process of artistic creation increases the impact on audiences by heightening the power of the objects as well as the responses they illicit. This danger calls for a deepening personal response and investment in the associated work.

This quality of danger within the process of *bociɔ* fabrication is equally grounded in the idea that both activators and users must be prepared for the unknown. For in initiating an action through the making of such objects, one is entering into the realm of the unfamiliar (i.e., if every *bociɔ* is unique, there is no real way of knowing how it will work). On a given day, for example, the wind may be blowing the wrong way and one may bring to oneself harm that had been intended for another. As Sagbadju explains (7.9.86), "There are different

powders and they can trap you. One can blow them away from one and even so, one will get stomach aches and diarrhea."

In turn there is no way of knowing precisely what will result from the cataclysm which follows the bringing together of powerful *bo* materials.[27] Accordingly many perceive there to be a very real danger in the process of uniting things which are by nature opposed. The production of this sort of mixed metaphor in which matter is detached from its original context and pressed into a new combination of elements is clearly risky.[28] Rivière discusses (1981:176) the principles which lie behind similar oppositional processes in local Evhe medical treatments:

All treatments for sicknesses operate generally [from a ground of opposition]. First there are plants called *amafafa* (cool, peaceful plants). Before they are administered, these plants are generally put in water—which has the same virtues as the plants. The *ama dzodzo* (hot plants) are considered as exciting; their contact irritates. Sometimes they have pricks or thorns. Their use derives from the homeopathetic principle according to which to vanquish sickness, one must first excite, provoking symbolically the fever, [then cool it].

In other cases it is a question of bringing together two things, each of which has a particular incendiary effect, doing so often in the name of another person. One example of this was cited by Dewui (7.3.86): "It is the things one puts inside *bociɔ*; it is the different things that one gathers together [that matter]. For example, the cigarette and the lighter should not be united. When one unites them, one will say that it is you who brought them together. One will put it in a calabash in the sun and call your name. When the oil liquefies, you will fall. If one does not bring it into the shade so that it will harden, you will fall and die."

Yet another risk factor is based on the idea that no one can foresee what will result from the act of intentionally polluting a significant power by placing on it material known to be proscribed. This element of intentional violation also has an important impact on artistic response. As Sagbadju observed for one such work (8.2.86), "One is afraid of it because what the ancestors must not see is added; what the poisonous serpents should not see is there; what the sorcerer should not see is included, and when they see this they flee."

The above feature of personalization, of initiating an act in the name of someone or something else is of considerable interest both to issues of object efficacy and to questions of user investment and response. Savary adds further insight (1971:4) both into the process of activation by pollution and into the question of viewer/user input: "One 'charges' or puts the statue into action by a rite consisting of having it 'absorb' the interdictions of the divinities that it represents. Their rage, temporarily fixed on the statues, can then be directed to such and such an individual. The actions of this object are generally exercised at a distance, either in provoking death or in going against the particular norms of the *vodun* it materializes." Here too the personalization of intent and action (in this case

the "fixing of the rage") is of central importance in understanding the psychody-namics of both object activation and viewer/user response.

Dynamics of Bociɔ Activation

As we have seen, with the making of empowering arts such as *bociɔ,* there is considerable emphasis placed on interactive properties. A variety of activation means are employed to *cathect* (Caughie 1981:299) or "energize" the work with this in mind. The first can be defined as the dynamic of material assembly itself. In answer to my question, "When does the power enter into the *bociɔ?*" Sag-badju responded (7.1.86), "The moment one puts all the things together, the power comes in." This process of activation by assemblage is, however, not the sole means of empowerment. Sagbadju notes in this regard (7.1.86) that "one must first group all the things, pronounce the incantatory words, eat the pepper, spit on it, and kill the chicken." Responding to the same question on another occasion, he observed (7.9.86) that "before it works, one must give it food, kill the chickens, eat the pepper grains, call the name of the person who wants to send it to, and say where one wants it to go."

As the above examples make clear, in addition to the actual unification of necessary matter (which because of their associated properties set off or bring about a particular reaction) other important activation forms also come into play. The most important of these are speech (and associated saliva), heat (in the form of pepper and alcohol, among other things), knotting (attaching or twist-ing), and offering (sacrifice, killing) to a higher force (*vodun,* the ancestors, etc.). De Surgy alludes to heat, speech, attachment, and supernatural power in his description of Evhe *bo* activation (1981a:171): "There is no preparation or acti-vation of an *ebo* without the spitting of pepper grains preceded or followed by spitting of alcohol effectuated [in turn] by the pronouncing . . . in a high voice the magical words called *gbesa:* 'attach the voice' in the direction of the ingredi-ents used."

In a more detailed example of object empowerment recorded by Rivière, also among the Evhe, we can see both the interaction of these activating forces and the critical input of the client/user into the empowerment process. The diversity of both materials and empowerment means in this example is typical of many *bociɔ* objects. According to Rivière (1981:185–86):

The seller (*dzosatɔ* [*satɔ:* seller of; *dzo:* fire, or *bo*]) asks the buyer (*dzolala*) to bring him a chicken (white, red, or black, according to the type of magic wished), thirty kolas, cowries, raffia fiber, black pepper (*ataku*), squirrel fur, feathers of the green touraco which sings out the hours, and palm wine (*sodabi*). The seller twists the fibers to make a cord, to which he attaches the feathers, fur, and perfumed herbs. He then covers the cord with red clay. Meanwhile the seller and buyer together pronounce the magical name of *dzoka* [cord of *dzo*].

The seller then knots the cord, eats seven grains of pepper, and spits three times on the cord in repeating the name of the magical power. The two people kneel. The seller chews again seven pepper grains and spits them into the mouth of the buyer. The buyer chews twenty-one grains of pepper and spits them. . . . The seller calls the buyer by a new name, which must remain secret because to know the name of someone permits the magic to act on him. After the transmitter says the formula ("I gave you a power which will protect you in bad days as well as at night"), the receiver responds ("I believe, I received it"). Following reciprocal periods of silence, a communal sacrifice is made in honor of the newly acquired magical power.

As we can see from the above, the process of activation is a highly charged and complex one involving a range of means through which the user is intentionally "sutured" to the work. Here again heat, knotting/twisting, saliva (speech), and offertory acts are clearly evident.

In his summarization of the above activation process, Rivière describes (1981:186) the importance of these empowerment modes, delineating them as follows: (1) heat (fire, pepper, red clay, alcohol); (2) knotting/twisting, the cord which joins the signs representing agility (squirrel fur), prophesy (features of green touraco), and medicine (*ahame*); (3) saliva to transmit power into the work (the spitting on the object by the buyer); and (4) symbols of plenty and wealth (the number 21 [3 × 7] and cowries). Rather than designate the fourth category as "plenty and wealth," I would identify it as "incorporating signs of spiritual empowerment" (since the numbers 3 and 7, and the offering of the chicken are closely associated with the *vodun*). In many respects the above four modes complement the general stress on process in alchemical practices discussed in chapter 6.

Herskovits provides another example of the diverse (yet complementary) means employed in the activation of objects of this type in his description of the making of a Fon work identified with field protection (1967, 2:286):

To make one of these *gbo*, a cactus of the type called *selu* which is sacred to Sagbatá is cut with a newly made knife, and allowed to remain in the temple of the Earth gods for three days. On the third day it is placed on the grave of a man or woman who has died of smallpox, where it rests for three days more before it is removed. In the meantime, its owner must have caught sixteen bees. These bees are rolled in black and white cotton with the piece of cactus and suspended from a tree for a day. The charm is next entrusted to an impotent man, who keeps it on his sleeping mat over night. On the eighth day, it is given to a blind man to take to the owner's field, where it is finally put in place. If this *gbo* is to be sold to another, the following rite must be carried out when the transfer is made. *Ataku* pepper, millet flour, and palm-oil are first given to the *gbo*. Then three grains of *ataku* are taken in the hand of the buyer, who places them on the *gbo*, after which the ownership and control of it passes into his hands. It is believed that if someone steals the crops of a field protected by this *gbo*, he will contract smallpox in seven days, and if he does not confess what he has done, will die after seven more days.

In the above we can see both similarities and differences between key elements of Herskovits's and Rivière's examples with respect to overall strategies of empowerment. Summarized briefly, the empowerment means delimited in Herskovits's text include: (1) heat/attack (pepper, cactus, knife, bees, tomb, palm oil, blindness, impotency, night, smallpox, death); (2) attaching/knotting/twisting (rolling the bees in the black and white cotton); (3) speech/transference (confession, use of hands in transferring power); and (4) spiritual forces (Sagbata [Earth God], smallpox, the *vodun* numbers 3 and 7, millet flour, Fa [the numbers 8 and 16]). In this example, "hand transfer" replaces the "speech/saliva" activation of the Rivière empowerment text. While speech or saliva is far more common, both hand and mouth transference address similar concerns with the transition of potent powers.[29]

Reinforcing the empowerment stress and the cathartic roles which *bociɔ* play, strong emotions such as anger can be seen to be grounded in complementary qualities of heat, knotting, speech/saliva, and supernatural intervention. As Lakoff points out (1987:381), "The physiological effects of anger are increased body heat, increased internal pressure (blood pressure, muscular pressure), agitation, and interference with accurate perception." Anger in cultures where *bociɔ* are made similarly is identified at once with heat (fire, rage), pressure ("the binding of one's stomach"), agitation (sweat, saliva) and often interference with perception (blindness or deafness to all reason—sometimes perceived as resulting from interference by the gods). These four strategies similarly appear in contexts of fear, in which one's movements are frozen (inert, the antithesis of heat) with fright, one's stomach is knotted in nervous anticipation, one is made speechless (the reverse of speech) with shock, and one is unable to react as one usually would, often hearing or seeing danger even where it is not present.

Significant too in terms of the above examples is that *bociɔ* are intended to address the full range of human senses—visual, acoustic, olfactory, tactile, and gustatory.[30] Each of the four empowerment means in turn is identified with one or more sensory mode. Speech and saliva are linked, respectively, to taste and hearing. Fire (heat) is associated especially with touch and taste but also with smell.[31] Tieing is connected especially to sight but incorporates as well features of touch. What one finds here in this way is a sculptural emphasis on synasthesia—the joining together of two or more sensory values.[32]

In this valuation of synasthesic experience, *bociɔ* sculptures encourage active viewer participation by compelling one to respond to them through a diversity of senses. *Bociɔ* "look" raw in other words because they are intended to address the viewer(s) at the rawest sensorial levels. *Bociɔ* in this way comprise an art whose full aesthetic can be understood not only by seeing, but also by touching, smelling, and if one recalls their original offertory dedication, hearing and tasting. This is not to say that *bociɔ* do not also address the intellect (the noesis, in Husserl's terms) but rather that these works (in contrast to royal *bociɔ* sculptures) privilege that which is sensate. As Silverman explains vis-à-vis literary texts

(1983:55), because "these traces assume a sensory form (visual, acoustic, olfactory, tactile, gustatory), and they possess a strong affective value (i.e., they are emotionally charged). They supply the unconscious with its raw signifying material." In order to understand how this sensorial feature of *bociɔ* is achieved, let us turn our attention to the primary modes or actions of their empowerment.

Speech, Saliva, and Ritual Transfer

As has been amply shown in recent years, language is critical to the larger process of art signification. "Language," according to Stewart (1984:13), "gives form to our experience, providing through narrative a sense of closure and providing through abstraction an illusion of transcendence." What is true of language in the above is generally also true of speech. And speech is crucial to *bociɔ* functioning in that the utterance of particular words or phrases (*bo gbe*), in the course of making a *bo* or *bociɔ*, plays a vital role in sculptural activation. Quénum defines (1938:78) *bo* accordingly as "a piece of metal, wood, cord, chain . . . garnished with different objects (bird feathers, reptile or animal teeth) on which one pronounces obscure formulas to make them act." Pazzi tells us similarly (176:305) that a *bo* is "a power founded in the magic formulas that one pronounces, according to a defined ritual, on a material object."

Critical to the activation potential of speech is both its transferential nature and its potent social and psychodynamic grounding.[33] Throughout the area of *bociɔ* manufacture, speech plays a privileged role. Pazzi observes (1976:241) that "speech . . . at the level of ordinary life is that which permits communication between people. . . . But speech also assumes a magical power, mysterious, efficacious, and frightening when it is pronounced in rites." This notion of speech as wielding an unknown potential is observed also by Barthes (1989b:76): "Speech is irreversible; that is its fatality. What has been said cannot be unsaid, *except by adding to it.*" This feature too is important to our understanding of the mystical properties accorded speech in *bociɔ* activation. Speech serves a critical function in delimiting or defining *bociɔ* power.[34]

The exact words that are used to empower a *bo* or *bociɔ* vary considerably with the type and aims of the object being created or activated. Often the desire (hope, need, fear) and means of achieving that objective are addressed. Le Herissé notes (1911:149–50) that the pronouncing of the formula "which is aimed at rendering the *bo* efficacious, is but the putting into action of a play of words . . . meant to empower the charm by rendering grace . . . to god."[35] The name of the work often is important. According to Allado (1986:47): "Each [*bo*] has a name. In order for it to function it is necessary that this name [*gni kɔ*] is pronounced."[36] Sometimes, however, the content of the wording addresses more emotional concerns. When activating one such sculpture Ayido remarked (5.2.86): "[Present here is] . . . the death that will come to look for me, the sickness that will come to look for me, the battle that will come to look for me, or

will look for my wife and children. This [statue] is the person that I send [against them so that] I will not die, my child will not die, my wife and grandchildren will not die." [37] As Agossou explains (1972:5), "Speech is force; its value is as an act." [38] Diction, that is, the choice of words, clearly is essential to both empowerment and meaning, for only through this means is long-term catharsis achieved.

In the phrases or short utterances used to activate these works, an important ancillary empowerment feature is the incorporation of saliva onto the surface of the work[39] (see fig. 98). Pazzi observes in this regard (1976:157) that "in the saliva (*atan*) that one spits, accumulate the mysterious magical forces that emanate from humans." [40] In a way, saliva is identified as the glue which holds the words together on the object's surface. As Dewui explains, in the process of making a *bo* (7.3.86), "One speaks to it, puts drink in the mouth, blows on it, and kills animals for it." In other words the saliva (the drink-laden spittle that is "blown" onto the sculpture) is a means of projecting and attaching the requisite words. Maupoil notes similarly (1981:353) that: "To put saliva on someone or an object constitutes . . . the accompaniment of a wish. It is in this way that a father, wanting the wishes that he just made for his son to come to pass, will press a bit of saliva on his head or in his hand." [41] Even at the most basic level of saliva, the utterance thus carries a potent message of empowerment. Bakhtin's comments (1968:352) on the role of oaths and curses in the conceptualization of the "grotesque" have striking resonance here: "Oaths, curses, and various abusive expressions are a source of considerable importance for the grotesque concept of the body. . . . Each abusive expression always contains in some topographical and bodily aspect the image of pregnant death."

Fire and the Heat of Matter

Like speech and saliva, fire also serves an important role in *bo* and *bociɔ* activation. Critical to its empowerment features is the identification of fire with both harm and healing. According to Rivière (1981:175–76), in ritual practice among the Evhe: "two symbols are accorded first place—that of fire and that of the knot. . . . Like fire, [a *bo*] can be a good thing when it heals and enlightens, but it becomes bad when it . . . destroys." [42] Agbanon in turn emphasizes (2.25.86) fire's close association with heat and illumination.[43] In part for this reason, red palm oil (which was used as fuel in traditional lamps in the area) is incorporated into many *bo* and *bociɔ* works (Agbanon 3.4.86). So important is fire to *bo* and *bociɔ* identity that, as noted above, Evhe objects of this type frequently are referred to as *dzo*, a term meaning fire. The Evhe word for the person who activates these objects in turn is *dzotɔ*—master (*tɔ*) of fire.

While the beneficial, life-giving properties of fire are generally acknowledged in the context of *bo* and *bociɔ*, most individuals identify the associated fire with malevolent or dangerous qualities. Pazzi observes that (1976:73) "The word fire

is synonymous with sorcery. . . . Fire also is associated with vengeance. The power from which the fire bursts forth is the lightning. That is why one conveys to lightning the vengeance that can be discharged by one directly." Rivière suggests similarly (1981:176) that "*Dzo* [fire] represents the first disorder, the initial power of chaos, the first impulse, and the fever of beginnings which oppose order and reflect thought. One associates it with harm and vengeance. . . . *Dzo* is situated on the side of the occult and nature as opposed to culture. . . . Fire is opposed to the calm and coolness of water. Fire burns, devours, engenders misery; water appeases, regenerates, creates interior peace (in the stomach)."[44] The above description carries considerable visual and psychological significance for *bociɔ*, whose aims and material qualities often are seen to stand in marked contrast to values of peace, coolness, and social harmony. Like fire, many such sculptures address the world of heat, anger, battle, danger, and war.[45]

Another feature associated with fire which has important visual and psychodynamic ramifications for *bo* and *bociɔ* is its identity with complexity and disequilibrium. According to Rivière (1981:177), "*Dzo* [fire] represents the multiplicity and dispersion, ubiquity and multipresence, as opposed to the unity and concentration." Like *dzo, bociɔ* share many of the above features of complexity and disorder. In terms of both signifying and visual components, *bo* (*bociɔ*) appear to run counter to concerns such as unity (singular voice in medium or meaning) or concentration (in the sense of a unique source or grounding of energies).

As suggested above, fire is transferred to *bo* and *bociɔ* through diverse means. One is through the addition of red parrot feathers because, as Agbodjenafa suggests (12.16.85), these feathers constitute "a power; they are red like fire." In Fa divination verses, in turn, the parrot's red tail feathers are seen to have the ability to start fires. Red parrot feathers, it should be noted, also are closely associated both with the *vodun* (as are the similarly fire-associated pepper grains discussed below) and with kings, and thus carry additional potentialities with respect to the transfer of powers from religious and political agents. Because of its heat and association with fire, hot water also is seen to play an important role in the activation of these sculptures. According to Dewui (7.3.86), "One puts hot water on them . . . because if one does this the person will not have peace . . . he will fall sick, something will happen to him, his child or wife will become ill. Difficulties will happen to him."

Pepper too has a vital activation role. Pazzi notes (1976:107) that diviners use the pepper seed (*atakun*)[46] as a sign or mark of *bo*. Le Herissé's description of the fabrication of *bo* (1911:149) makes clear pepper's important place: "The making of them is the occasion of a small *mise en scène*. The maker offers a pinch of local pepper to his client. This latter swallows a part and hits his chest with the right hand, then he brings to his mouth that which remains of the pepper and spits it immediately on the charm, in exchange for which he gives the agreed-to price." In addition to its association with heat, pepper's identities with

pain and mystical power are also of considerable importance. According to Agbanon (2.19.86): "If . . . someone throws one of the grains of pepper at you, he thus has gunned you down. If this pepper enters your body it becomes a big thing that will make you suffer and in time you will begin to swell. All your body will begin to be destroyed and you will die."

Agbanon suggests in turn that efficaciousness and the frequent associations of pepper with "bite" and strength are often closely linked. According to him (2.21.86), "Pepper is the food of *bo* and *vodun*. When you eat it, it is sharp in the mouth and if you send any part of it, it will arrive at its target. . . . Since it is bitter in the mouth, the *bo* will do anything you ask." Pazzi notes similarly that (1976:107) "the diviners use [pepper] as a symbol of *bo*. And they spit it on all medical potions as an expression of magical efficacy." Also essential to the function of pepper in the activation of these sculptures is its connection with tears. The tears sometimes caused by consuming pepper are similar to those which express the feelings of sorrow or pain that accompany death or misfortune. As Agbidinukun explains (7.31.86), "When one eats kola, the eyes are tranquil, but when one eats pepper, the eyes become moistened with tears." This production of tears reinforces the important cathartic roles of sculptures of this type.

Actions of Tieing, Twisting, Knotting, and Binding

Another important source of sculptural empowerment is the action of tieing, knotting, twisting, or binding (fig. 39). In principle, every *bociɔ* is empowered by some form of complementary tieing action. Whether it is the twisting of raffia fibers with the feathers and fur of offertory animals to make a cord and then knotting it, or rolling bees in black and white cotton, some form of physical binding is a part of each such work. The meanings of these actions within *bociɔ* are striking and complex. Most important, in the act of tieing, an aspect of "taming" is expressed (*dompter*—in Lacan's sense of the term—1981:105) wherein key emotional concerns are subdued through the binding motion. Or, as explained by Silverman (1983:69), through this means one is in the process of "'binding' the excitations which press for discharge." Binding and tension not only share a common psychological ground but also are in some contexts linguistically tied as well. In the West, the word "tension" has its origins in the Latin *tensus*—stretched thin, like a lash or thong. In the area of *bociɔ* manufacture, as we will see, binding also has important psychological and linguistic complements. It is in part for this reason that the vast majority of *bociɔ* figures incorporate some form of attachment—of cord, cloth, chain, or other material. Additive matter, rope, and twine have potent psychological significance with respect to concerns as emotionally charged and varied as death and life, destruction and family inheritance, and poverty and wealth.

The Fon word meaning to attach, *bla*, designates not only "to tie" or "to bind" but also "to lock" and "to fix." Tieing or binding in this sense affirms that

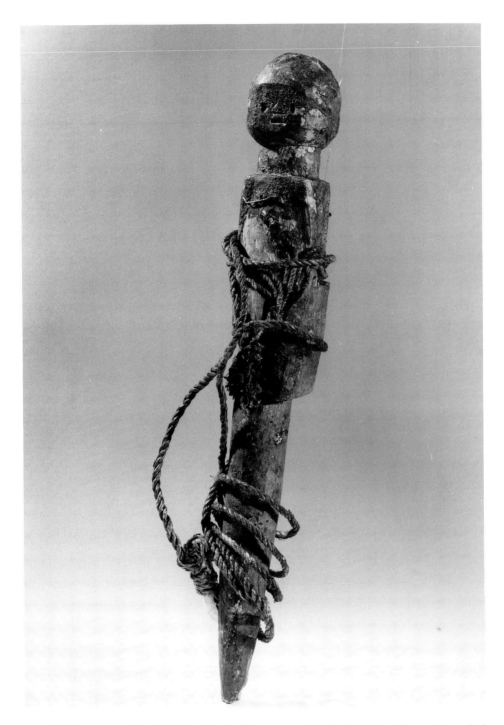

39. Evhe figure. Lome, Togo. Wood, cord, miscellaneous materials. Height: 16 cm. The powder applied to the figure is said to make thieves invisible if they are attacked. Collected by Merlo in 1928. Musée de l'Homme, Paris. M.H.32.78.32.

a particular action has taken place and that a desired result is now "fixed in position." Significantly among the Fon, the term *bla* also is employed in emotion-ally charged contexts such as the bandaging of a wound or the binding of a cadaver before burial. The term in addition has important associations with ideas of dispute and discord. Thus *bla kpa* ("bound onto the side") means "to carry an arm." *Bla agbaja* ("bind on the cartridge belt") means "to prepare for battle." "Complot" similarly is designated by two terms, each identified with attach-ment: *bla se* ("binding destiny") and *bla gbe* ("binding speech"); *ɖo go*, "to make a knot," in turn means to get ready for war (to seek success, and not to give up in an important enterprise). Among the Evhe, binding also is important. Ellis points out (1970:91–92) that the Evhe refer to *bo* as *vo-sesao*, a word whose root means "to bind" or "to fasten." He adds (1970:92): "This verb is used solely with reference to amulets, the priests who supply them binding or fastening them on the persons or the property of those who buy them."

Feelings such as pain and pity also are identified through language use with the word *bla* and complementary binding actions. In Fon, *bla u* ("bound body") refers to one who is emaciated, sickly, or poor. *Bla u nu me* ("thing bound in") is employed to suggest that one has pity on someone. Each of these uses of the term has significance for the understanding of psychodynamic properties of *bociɔ* and their associations with personal battles, complots, or actions intended to achieve such ends as impoverishing or destroying one's enemy, or protecting oneself and one's family from related attempts by others.

Similarly diverse and powerful emotional concerns are linked to the action of knotting. De Surgy notes accordingly (1981a:241) that among the Evhe "the act of magically attaching or knotting (*sa*) all that is judged as bad lies at the heart of ritual actions aimed at bringing about a particular result." [47] So too, among both the Evhe and Fon, the act of making an oath is referred to as *gbesa*, the knotting (*sa*) of speech (*gbe*). As de Surgy suggests (1981b:97), "One constrains him by speech, one pronounces the *gbesa*." Through the action of knotting, signifi-cation thus is knit, or better still, "raveled," into every work, with each accom-panying twist or knot becoming in a sense what Deleuze calls (1990:52) "turning points" and "points of inflection." From the point of view of psychological meta-phor, knots or twists of this type suggest to Deleuze "points of fusion, condensa-tion, and boiling; points of tears and joy, sickness and health, hope and anxiety, 'sensitive' points." Barthes (1974:160) uses the metaphor of the braid in a similar way to convey how meaning is attached to texts. To "attach" or "tie" a sculpture with its various materials serves both as a means of securing or suturing different elements and emotions to the work, and as a visual and linguistic action intended to call up associated qualities of negative and positive empowerment. [48] As Sag-badju explains (7.1.86) "When one ties it, one says what one would like to con-vey. One names the person as one is attaching it." The emphasis on tieing within the processes of sculptural activation underscores in this way the psychothera-peutic potential which objects of this type hold.

Powers Bestowed by Supernatural Energies

The fourth, and in many respects most important, empowerment means is that of bringing into the work the strength of certain supernatural energies or powers which convey to each object its unique vitality and force. I chose here the term "supernatural energies" because they are comprised of diverse elements, among these various *vodun,* including Dan (or Da, the serpentine wind god), Sagbata (the Earth god), Fa (the divination god), Legba (the trickster and messenger god), Minona (the god of motherhood and sorcerers),[49] Gu (god of war, technology, metal) and Hɛvioso (Xɛbioso, god of thunder and lightning), as well as the tiny spritelike forest beings called *aziza,* known for their distinctive incorporeal powers. All *bociɔ* are activated by some form of supernatural force or energy of this type (whether singular or in combination), agents whose vitality is incorporated into the sculptures through the course of their activation (often through the use of offertory blood). Herskovits notes in regard to these variant activators that (1967, 2:287–88) it is: "from the *aziza* and other spirits of the forest, from Legba, from the Fa group, Da and the Great Gods [that one] obtains knowledge of how to endow [the work] with effective power."

The first such forms we will take up are the *aziza.* These miniature forest dwellers are believed to control the hunt and all that pertains to the forest.[50] In addition to these responsibilities, as Sagbadju asserts (7.9.86), "The *aziza* own all the *bo.*" Herskovits notes that (1967, 2:261) "by far the most important spirit in the giving of *gbo* is . . . *aziza.*" Ayido explains similarly that (6.15.86): "*Aziza* is the chief of the *bo,* . . . [it is] the owner [*to:* father] of *bo.* When *aziza* says that such and such will happen today, it happens." And, as Nondichao points out (11.15.85), since it is "the *aziza* [that] empower *bo,* the effects can be grave."

Descriptions of the *aziza* vary. While few individuals claim to have ever seen them (indeed many assert that ordinarily they are invisible), others characterize them as small, humanlike forms with a single leg and long white hair (fig. 40). Herskovits suggests accordingly (1967, 2:262) that "asked for a [description of] . . . *aziza* the Dahomean most often pronounces the word "monkey,"—though . . . merely [saying] . . . [that] they are small and hairy."[51] Pazzi's description is a bit more detailed (1976:94):

[The *aziza* is] . . . a fairy having one leg, one arm, a single long hair that covers them entirely and makes them invisible. They inhabit the forest and their houses are in large termite mounds. One does not whistle in the woods for fear of attracting their attention. One does not collect a bundle of wood that one finds beside the road because the *aziza* could have placed it there, to come back to get it later. . . . *Aziza* know the virtues of leaves and it is they that reveal them to humans. That is why one fears and venerates its mysterious power.

Pazzi goes on to explain (1976:94) that the chief of the *aziza* is Age (god of the forest), who is celebrated as the power that teaches humans the secrets of

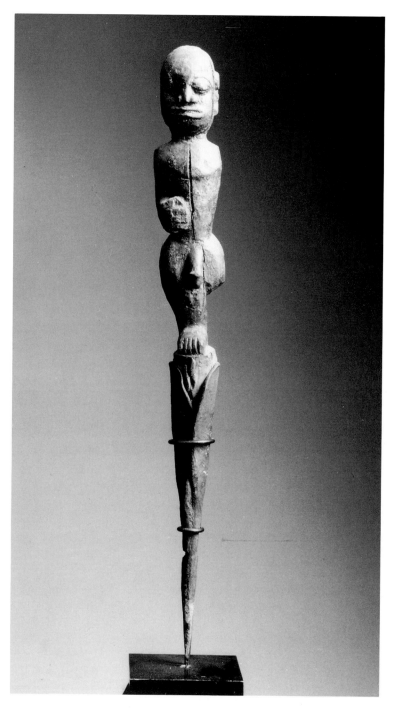

40. Fon *bociɔ* figure with one leg and one arm. Republic of Benin. Wood, iron.
Height: 44 cm. Probably collected in the 1960s. Former collection of Ben Heller.
Current collection of Don Nelson. Photo courtesy of the Museum for African Art.

art, farming, and hunting.[52] It is thus not surprising that it is the *aziza* who are credited with the conveyance of essential life-giving knowledge to humans. Through the *aziza,* mortals are said to have learned not only the methods for cooking yams and extracting oil from palm nuts, but also the medicinal and alchemical properties of various natural substances (Maupoil 1981:7). These hairy (if invisible), deformed (monopedal), forest inhabitants in sum are the source of critical features of human technology and civilization.

The close link between *aziza* and both *bo* and *bociɔ* activation also is based on the assumed knowledge of these beings regarding the medicinal and empowerment properties of leaves. Herskovits explains that (1967, 2:262) "to the extent that the Dahomean refers to that branch of magic which is medicine concocted of leaves and herbs, he is prone to associate the name of the *aziza* with such *gbo."* Pazzi notes similarly (1976:94): "The *aziza* know the virtues of leaves, and it is [they] who reveal them to humans. That is why one fears and venerates [their] mysterious power."[53]

The reasons why particular types of trees, wood, or plants are selected for the making of *bociɔ* sculptures reflect the important powers which *aziza* have conveyed to them. "The *aziza* already gave these trees power," explains Sagbadju (7.1.86). Lanwusi notes similarly (6.16.86), it is the "*aziza* who confer knowledge and power to the leaves so that they will do things." *Aziza* also have an important role in conjunction with the choice of cords which are bound around sculptures of this type. With respect to one such cord Sagbadju notes (7.1.86), "The *aziza* already empowered the cord, thus [the object] will do its work." That forest beings play such a critical part in the selection of these cords is further reinforced by the belief, as Pazzi points out (1976:95), that "like the inextricable knot of the large vines, *aziza* is the father of the vine and no vine will ever attach itself to him."

According to tradition it was an *aziza* who first taught humans the art of making and activating *bo* and *bociɔ.* One such account provided by Agbanon (3.18.86) suggests that

it was a hunter who first brought the *bo* to humans. While he was hunting, this hunter saw an *aziza* in the forest and raised his gun to shoot. The *aziza* said, "Don't kill me," and the hunter obliged. In thanks, the *aziza* gave the hunter a *bo*. This *bo* told him which animals he would kill, and when the *aziza* left, the hunter indeed shot the animals that had been indicated to him.

Another hunter, a man who was mute, also met an *aziza* and following this meeting went to the sky, staying there a year before returning to earth with various *bo*. This hunter, a man named Gbakwesegon, reached the sky after climbing first a baobab and then a pair of black and white threads which were attached to the sky. When the hunter came down from the sky he gave the *bo* he had acquired to his children. Although he was a man who could not speak, it was he who went to the sky and brought back the *bo*.

Several images stand out in the above text—the hunter, the act of saving something from death, the sacrifice (the disappearance for a year), the prediction come

41. Fon *bociɔ*. Bohicon area, Republic of Benin. Offering to *bociɔ* in order to promote the return of an object stolen from a community member. Photograph: Suzanne Preston Blier. February 30, 1986.

true, the privileging of certain senses (the speechless man as transmitter of knowledge and power), the journey, the crossing of realms, and the presence of cords (thread). Each of these signifiers enters prominently into the *bociɔ* tradition, and more important, into that part of the tradition which helps the user to "look through" the work, to find in turn some form of cathartic relief.

Another account which attributes to the forest-dwelling *aziza* the origins of the arts of *bo* is published by Herskovits (1967, 2:259):

Mawu gave *gbo* to Legba . . . and . . . the *aziza*. . . . The *aziza* lives in the bush. Now and then, in former days, a hunter while in the bush looking for game would come upon the *aziza* who would ask him, "What are you looking for?" The hunter would say, "I am hungry, I have nothing to eat." Then the *aziza* would reply, "When you come again to kill animals, bring two chickens; in the meantime I will find the necessary leaves. Meet me here in two days." When the hunter returned, he was given a *gbo* and that very day he killed several animals. Sometimes an *aziza* found a hunter in the bush and asked him if he had children. If the hunter said he had none, the *aziza* told him how to find the materials for a *gbo* for his women.

Here the signifiers are equally rich—a hunter, a quest, a life-threatening need (hunger), a crossing of space, a sacrifice (the death of the chickens), a projection come true (the two-day wait), and a restoration to life (food: game, as well as children). In this example too, essential qualities of *bociɔ* activation and belief are expressed.

Exactly how the *aziza* function in the context of sculptural empowerment is not clear, but they are believed to draw on their in-depth knowledge of the forest and the properties of its various earths, plants, and animals for this purpose. As Sagbadju explains (7.1.86), the *aziza* are in charge of the animals that one hunts in the forest; it is they that enable one to be successful in the hunt. It is these agents in sum who are able to aid one in one's quest. Savary, discussing the relation between the *aziza* and the forest (1976:238), notes that "one finds there the ancient concepts tied with the hunt in which hunters surround themselves with numerous charms not only as protection from wild animals but also to capture them."

In addition to their special forest knowledge, however, these strange beings also are able to draw on their own unique powers with regard to the spirit forces which govern the world. Dewui points out in this regard (7.3.86) that there is a close link between the offerings presented to a work and its activation by *aziza* (fig. 41). The above equation is grounded on the assumption that each offertory animal's blood is identified with a spiritual energy which these spritelike agents are able in some way to manipulate. As Dewui explains it:

If one attaches [*bla*] the object and one does not kill anything for it, it will be nothing. This is because there are certain spirits called *aziza* who are passing in the air. When one makes the offering and uses the blood, these spirits will enter inside. If you speak, they will hear. If it is a bad thing that you command, if it is on the road of a bad thing, they will do a bad thing. When one asks something of them, they will do it. . . . They are the *aziza*. They are the things that are in the air and are moving around. One does not see them, but when one speaks, they hear.

Of interest in the above is the belief that these tiny forest dwellers are able in some way to enter and attach themselves to the blood of sacrificial animals, and

that because of their proficiency in communicating with humans (at least insofar as hearing and understanding human languages are concerned), they are able to direct the life-sustaining blood toward a particular course of action. In a related and clearly significant dimension of the *aziza*'s transferential attributes, these beings are identified closely with both the process of human conception and the establishment of an individual's unique spiritual persona.[54]

Another important source of spiritual empowerment for *bo* and *bociɔ* are various local deities. These divinities, which bear the generic name *vodun,* play a critical role not only in activating objects of this type but also in directing associated response. Here we will focus our attention on Legba, the deity who most frequently (and directly) is identified with *bo* sculptural empowerment (fig. 42). As Ayido notes (5.2.86), the "*bo* are on the path of Legba." [55] Moreover, as Herskovits's sources maintained (1967, 2:257), Legba "was the first to make *gbo.*" Herskovits provides the following Fon account (1967, 2:257–58):

In those days the gods were hungry, for they were given no offerings. Legba made a serpent and placed it on the road to the market, and he told the serpent to bite those that passed. This the serpent did. Now when the serpent bit someone, Legba came to him and said, "Give me something, and I will cure you." But the moment he was given something, he ran to the market, where he bought *akasa* and palm oil and drinking water, and consumed them himself. One day a man came by and pointing to the serpent asked Legba, "What is this thing that bites people?" Legba said, "It is a *gbo,*" and he said, "Bring me two chickens, eighty cauries and some straw, and I will make a *gbo* for you." Legba led this man away from the road, and explained to him all that must be done to make a *gbo.* Then he ordered him to throw a vine on the ground. This vine at once became alive as a serpent, and began to bite people. But this time Legba gave medicine to cure snake-bites. This man whom Legba told how to make *gbo* was called Awe, and thus the first man to know about *gbo* was Awe.

In the above we see a series of themes which recall in many respects the accounts of *aziza* creation of *bo*: the traveler (hunter), a life-threatening need (hunger), the act of saving someone from death (serpent bite), sacrifice (hungry gods, *akasa,* chickens, cowries), the privileging of certain senses (taste, hunger, biting), the prediction come true, the journey (road to market), and the important place of cords (vine). That these features are present suggests a striking convergence of narrative and visual texts in regard to objects of this type.

Legba's identity as messenger of the other *vodun* (the seeker of offerings for the hungry gods) and trickster (the one who transforms vines into dangerous people-biting snakes and then offers medicine to restore to health those so bitten) carries special significance in the context of these sculptures. Asked what gives power to the *bo,* Sagbadju notes (7.2.86), "Legba told the *vodun* to bother you so that he could eat." In other words, Legba as both trickster and boy-Friday of the gods is sent (or sends others) on errands to garnish food (offerings—including those associated with *bociɔ* empowerment) for himself and these deities, a

42. Gen figure from Agome, Togo. Wood, cloth, iron, cord, miscellaneous materials. Height: 69 cm. Small iron bell hangs from nape of neck. The figure is said to represent Legba, the guardian of the courtyard and door. Collected by A. Leiz, 1908. Linden Museum, Stuttgart. Cat. no. 57 084. Published in Cudjoe (1969: fig. 15).

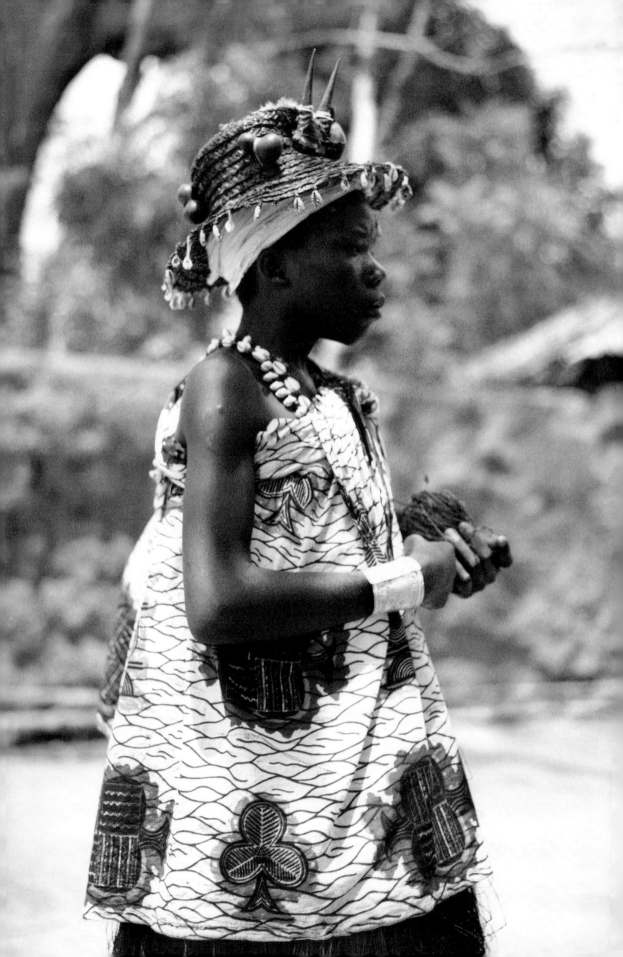

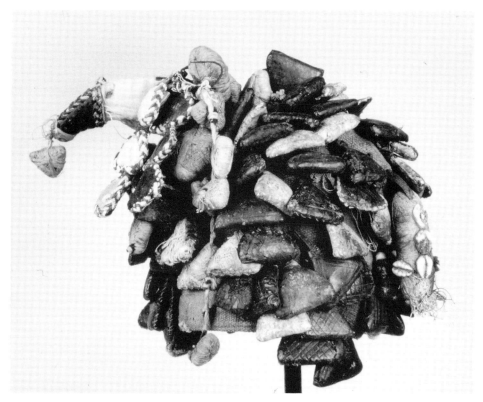

43. (left) Legba devotee appearing during a *vodun* ceremony in Lokozun, Republic of Benin. Note hat with its cowries, calabash powder gourds, and antelope horns. Photograph: Suzanne Preston Blier. March 1, 1986.

44. (above) Fon Legba hat. Republic of Benin. Leather, fabric, string, cowries, tusk. Height: 18 cm. Note careful binding and wrapping of *bo* on the surface. National Museum of African Art. Eliot Elisofon Archives. Smithsonian Institution. Cat. no. 73.1.2. Gift of J. Dale Chastain. Photograph: Ken Heinen. 1984.

small part of which he retains for himself.[56] Legba additionally offers insight into a range of psychological issues identified with the commissioning of *bociɔ* sculptures. This is because Legba often is held responsible for both the onset and the alleviation of many ailments, including a number which are brought on or are aggravated by problems of emotional stress or discord. Herskovits explains (1967, 2:259) that it is "Legba [who] has many *gbo* for headache, for colic, for dysentery, for leprosy, for eye trouble, for rheumatism, and for all other kinds of illness. No one is stronger in *gbo* than Legba."

Appropriately, Legba devotees often wear hats or costumes decorated with leather, cloth, and "power" packets and calabash or horn containers similar to those on *bociɔ* (figs. 43, 44). In discussing this attribute, Ayido points out many of the central features which are of importance in understanding the role that

Legba plays as promoter of both life's benefits and life's stresses. As he explains (7.13.86): "The horns and calabashes of Legba contain good and bad powders. When Legba is dancing he opens a piece of his hat and takes the powder and blows it. Even if he does not say anything, that which he said on the powder previously will begin to happen. If [offerings are made and] Legba eats well in it, he will blow white powder and things will work well for you; or he can blow the red powder and negative powers will return to the one who sent it." [57] Legba's identity with both the "good" and the "bad" strikingly complements the nature and functioning of *bociɔ*. Legba accordingly comes to stand for the potency and power of each of the various activation modes—speech, heat, binding, and supernatural force—and their effect on the various *bociɔ* audiences.

Blood plays a significant role in regard to the supernatural empowerment of *bociɔ* by Legba and other forces, not only as a primary sign that offerings have been conferred (see above), but also because of the essential properties that blood is believed to hold in its own right. Pazzi asserts (1976:167) that "Blood is the seat of respiration which carries the heat of life to all parts of the body as well as to the spirit. . . . The blood itself is spilled in sacrifice to the ancestors or invisible powers; by this, one transfers to them the vital force of the victim." The reasons for this are severalfold. The *yɛ* (spiritual power) of each person or animal is closely linked to blood. Accordingly, blood is employed as a means of transferring vital life force. Such a transfer is often essential to the process of *bociɔ* empowerment.

Maupoil suggests another important feature of blood, that is, its ties to nefarious powers, in his discussion of the divination or *du* sign known as Sa-Meji (1981:507) (a sign identified especially with sorcerers, *kennesi*). Sa, he explains (509) "commands blood, the opening of the eyes, the intestines. This last attribute also renders it frightening." Important here is the linkage made between blood, life, and acts both identified with and opposed to sorcery. Blood's role is essential because it represents the primary signifier of supernatural interaction and empowerment.

Sculptural Termini: Base Power and Difference

As is evident in even a cursory look at *bociɔ* traditions, base shape constitutes one of the more visually pronounced of the objects' variant formal features. In certain works the base is defined by a pointed shaft (*kpo*), while in others, the whole is supported by a carved plinth (*afɔ*, "foot"). These two termini formats comprise yet another signifier of *bociɔ* activation. To the extent that base type carries with it qualities identifiable with larger psychological issues of foundation, displacement, and support, these forms also offer insight into a sculpture's expressive dynamics. While there is little consensus today as to the significance of these differing base forms, most individuals with whom I spoke maintained

that the shape of a given support can be correlated with the source of the sculpture's underlying power.[58] Those works with a pointed base, Ayido suggests (5.2.86), are identified in some way with or empowered by Legba, the trickster and messenger god. In Ayido's words: "People exist with their proscriptions and laws, so too [certain *bociɔ*] have proscriptions that require that they be secured in the earth. . . . The power of Legba comes from the earth and one will put [a sculpture identified with Legba] in the earth in order for it to do the work that one asks of it." Sculptures with pointed bases, in other words, are intended to be inserted into the earth, this being the primary source of their empowerment. Sculptures of the *kuɖiɔ-bociɔ* genre (figures which are believed to exchange a person's impending death or demise with life—see chapter 8) nearly all have pointed bases. Both the placement and empowerment of these *kuɖiɔ* works are linked to Fa geomancy, the consultation process with which Legba plays a critical role as the source of insight (deity mediation) and deity-human interaction. Sculptures with flat bases, on the contrary, are associated with a range of ancillary empowerment sources, the most important being other *vodun* (gods, mysterious powers) and *kennesi* (sorcerers).

While reflecting the source of the sculpture's underlying power, the shape of the base also is important with respect to how such works are perceived to function. According to Sagbadju, each sculpture's base also serves to mark the number of times the work can be employed. Plinth-form sculptures, he asserts, can be reactivated and reused a number of times, whereas those with pointed bases can be activated only once. Of the plinth-supported works Sagbadju notes (7.1.86): "When one speaks the appropriate words to this [sculpture] and one attaches it . . . if another person brings [the requisite materials and payment], you can reattach it and the thing will work for him as well. If a client has money, one can unwrap (redo) it completely for this other person." As to sculptures having pointed bases, Sagbadju maintains (7.1.86): "With the pointed base *bociɔ*, after you have spoken and buried the pointed end in the earth, it is finished. Thus if another person comes to you, you will have to . . . carve a new one." Moreover, according to Sagbadju, although the sculptures with flat bases can be reactivated and reemployed, those with pointed lower termini ultimately have the greatest power. In this feature the underlying concerns or orientations addressed with respect to associated works are made clear. In the words of Sagbadju (7.1.86), "That which is pointed goes into the earth; when you pass your foot over this, what you did there will last until eternity." The psychological signification accorded to base shapes, as the above suggests, can be considerable.

Bociɔ, to conclude, are works of art identified with multiple artists, agents, audiences, and means of activation. The latter, which include speech, heat, binding, and supernatural empowerment (as expressed in, among other things, base shape), influence artistic production and response in critical ways. The above processes help to secure both the gaze and the soul of the viewer, encouraging

these viewers in turn to impart essential qualities of themselves into the work. Through sensory emphasis, which includes sight, touch, hearing, taste, and smell, each *bociɔ* becomes a means through which raw emotions are at once "fixed" and addressed. The *bociɔ*, in sum, constitute an art of dialogue. They are works which encourage response and counterresponse in stressing action and force as a vital part of object signification.

Design in Desire:
Transference and the Arts of Bociɔ

"[A]rt is a part of man's quest for grace; sometimes his ecstasy in partial success, sometimes his rage and agony at failure."
—Gregory Bateson, *Steps to an Ecology of the Mind*

"The same divination sign that proclaims longevity, health, and prosperity also announces a person's death"
(*Du e kan bo mɛ gan le, e jɛn we e kan bo me kʋ*).
—Fon proverb

Figural sculptures known as *bociɔ* are objects through which power is anthropo-morphized and in the process more tangibly visualized (fig. 45). In a literal sense, *bociɔ* comprise any activating object (*bo*) taking the shape of a human body, more accurately a "cadaver" (*ciɔ*). Representations in human form such as these have psychological identities of striking potency, as physical and emotional attributes of both the self and the other are contextualized through them. Each sculpture accordingly serves as a simulacrum—an imitation or effigy of which in De-leuze's words (1987:258–59), "the observer becomes a part."[1] Part of each *bociɔ*'s therapeutic signification comes from emotional displacement,[2] part from the process of transferring onto it various emotions. *Bociɔ* in this way share essential features with literary tragedy which, as Aristotle has pointed out (1968), achieves vital forms of emotional catharsis through pity and fear. Ac-cording to Aristotle, audiences are not provoked or depressed by tragedy in art but rather find therein a certain sense of release and relief.[3] As Wilhelm Dilthey writes (1985:212), the essence of "art lies in the impulse to discharge and com-municate emotional states through expression."[4]

Following Lacan (1968, 1981), and more recently Obeyesekere (1990), this chapter focuses on the role transference plays within the cathartic process.[5] Transference (the passing on, displacing, or transferring of emotion from a per-son onto another person or object) is an often overlooked but vital feature of art's overall psychological functioning, affecting, yet standing apart from inter-pretation, the principal object of most psychologically grounded art studies.[6] To quote Lacan (1981:149), "Transference is the enactment of the reality of the unconscious." In conjunction with this exploration into the artistic meaning of transference and transposition, concomitant issues of emotional transference and transposition also are taken up. Within the context of *bociɔ* art discussion, trans-ference will be seen to be grounded in processes of emotional transposition and the cathartic effect which occurs when a relocation of those feelings takes place.[7]

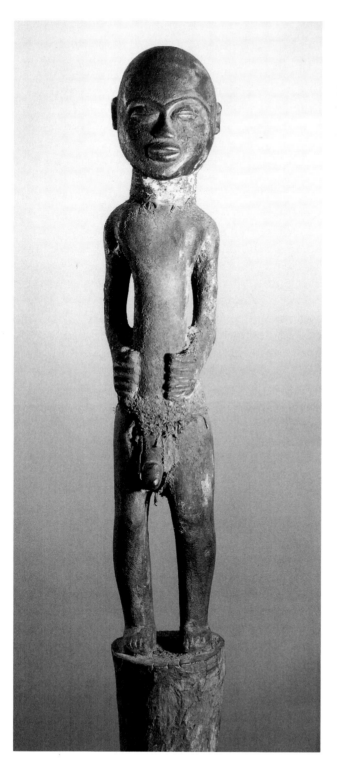

45. Fon *bociɔ* of the *kuɖiɔ-bociɔ* genre. Republic of Benin. Male figure. Wood with multimedia surface additions including cloth and fiber. Height: 101 cm. Saint Louis Art Museum, Missouri. No. 1865:1981. Gift of Mr. and Mrs. Stuart Hollander.

The following pages examine the manner in which various emotions are transferred to and displaced within *bocɔ* sculptural form. I begin this chapter with a discussion of the primacy of the figure and the linguistic identity of *bocɔ* with cadavers and ideas of pollution. Next I look at *bocɔ* in both material and linguistic contexts. The roles of these sculptures in divination and therapeutic counseling are explored in turn. Finally I look at the ways that artistic meaning is manufactured, the contrasting cathartic aims of *bo* and *bocɔ*, and the microcosm and macrocosm of desires and fears which these works address.

Figural Primacy and the Importance of Language

Of central importance in any discussion of emotional transference in artistic expression is the question of who (or what) the human figures shown in *bocɔ*[8] are intended to represent (fig. 46). In his general description of *bocɔ* roles, Roberto Pazzi suggests that they depict the individuals for whom they are commissioned, those desiring to bring about a particular action through the means of such a work. Pazzi describes (1976:305) these sculptures this way: "The [*bocɔ*] statue that one erects outside the house is intended to stop malevolent forces. . . . This statue, which reproduces in a deceptive way the traits of an inhabitant of the house, is in turn exposed to the mercy of the . . . [powers] directed against it (as if it is a question of turning over a cadaver to them) so that [the malevolence] in seeing [the *bocɔ*] will believe that the individual against whom it is directed, is already dead." Most people with whom I spoke concurred with the general thrust of Pazzi's comments. Ayido suggested accordingly (5.5.86) that one's enemies "will treat the statue as if it were you." Of a carved head positioned on a bottle containing *bo* material, Ayido noted similarly (5.5.86) that it represented "the person who is saved, it is he that is represented by the head. The powder there [in the bottle], it was this that was eaten and saved the person's life." Speaking of another *bocɔ*, one which was planted in the center of a courtyard, Ayido explained (8.3.86), "It represents you, yourself," referring to the inhabitant of the house.[9]

While the majority of people identified sculptures in this way as representing the person(s) for whom they were commissioned, makers of *bo* and *bocɔ* said that this was not always the case. Sagbadju suggested (7.1.86) of one *bocɔ* figure that it depicted one's enemy, or "the one who wants to give you a blow." Dewui noted in turn (7.3.86) that the carved head of a *bocɔ* created in the context of Fa divination portrays the *vodun* which empowered the work. The above suggests that while most *bocɔ* are thought to represent the commissioner (or primary user), potentially a range of individuals or forces may be defined in these objects. Such a finding is less contradictory than it at first appears to be, however, for in many figures, representational concerns are multivalent. While portraying a given commissioner, the work at once addresses and incorporates important ideas and features of the forms that empower it or are the object of its actions.

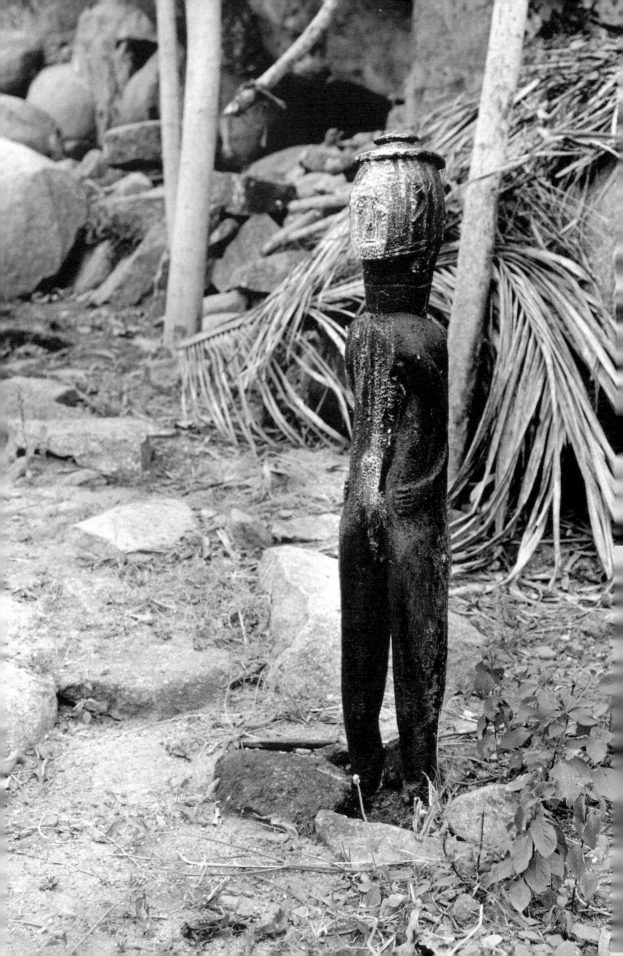

46. Dassa *bociɔ* figure. Dassa-
Zoume, Republic of Benin.
Photo: Suzanne Preston Blier.
December 4, 1985.

47. Gun? figure. Republic of
Benin. Wood with additive
surface material including iron
and cloth. Height: 27 cm.
Collection of Don H. Nelson.
Former collection of Ben
Heller. Probably collected in
the 1960s. Photograph: Jerry
Thompson, courtesy of the
Museum for African Art.

Accounts of *bociɔ* origins offer us further insight into questions of representa-
tion and transference in the *bociɔ* arts. Such accounts emphasize the roles that
these sculptures play in the protection of individuals through the deception and
distancing of one's enemies. One such legend, provided by Zomahoun of Dassa
Zoume asserts that (12.4.85) "in the past, houses did not have enclosing walls
and it was the forests that served as fences. In this early period there was but a
single path that led through the country and trees were cut close to this path.
When night arrived, a *bociɔ* was placed outside the house and was dressed like
a person. This statue was a guardian. If war arrived, the enemy would see this
bociɔ and would shoot at it. When this happened the house owner could flee."
Important here is the emphasis placed on these sculptures not only as human
surrogates or mannequins intended to bear the malevolence directed against as-
sociated individuals, but also as signifiers of danger alluding to the ever present
threat of enemy attack.

Artists maintain that a primary goal in making *bociɔ* is the creation of a work
which conveys the essential features of a living person (fig. 47). Adjakota, one

bɔciɔ artist, says (1.9.86) that "I recognize my work because, when I carve, I do it well and only the breath and the movement of the mouth is missing." Toboko, another artist, asserts (12.18.85) that a beautiful *bɔciɔ* "takes on the form of a human. The eyes should be like human eyes. . . . It will possess all that humans possess—feet, hands, eyes." Because the Fon word for resemblance, *vle* (mimicry, imitation), means also "trap," "insipid," and "disagreeable," in a certain sense, *bɔciɔ* sculptural representations carry with them inherent associations of fakery, falsehood, and danger, ideas central to each object's psychological functioning.

Important though representational concerns may be within this sculptural corpus, *bɔciɔ* more prominently are characterized by attributes which stand in sharp contrast to verisimilitude ideals. There are several reasons for this. Perhaps most significant is the association of essential, distinguishing features of the sculpture with the unique tactile, taste, and olfactory elements of the additive materials they incorporate. More than any specific representational quality within the sculpture, these features serve to identify the work and to delimit its effective power. At the same time, many of the key physical attributes of *bɔciɔ* carvings are grounded in vital psychological and aesthetic concerns which lie outside any purely representational model or ideal.

Language offers crucial insight into the psychological signification of these works. The term *bɔciɔ*, literally "empowered cadaver (or body)," [10] like other Fon nouns derives its essential meaning from its constitutive radicals, *bo* and *ciɔ*. A closer look at these radicals offers evidence of the complex ways in which ideas of transference and catharsis are expressed and contextualized within this sculptural tradition. The second radical, *ciɔ*, "cadaver," will be taken up first.

When asked the underlying meaning of the term *bɔciɔ*, Sagbadju noted (7.3.86) that "this art form is like a man who does not open his mouth[11] because he is dead." In other words, like a cadaver, *bɔciɔ* address at once the world of the living and the dead. Each such work can be said to represent "death living a human life" (Kojève, in Bataille 1990:10). Reflecting the above is a Fon mortuary tradition wherein according to Nondichao's description (1.11.85), "those at the cemetery will carve a piece of wood (*kpatin*) and will dress it to represent the deceased and place it in the tomb. If one closes the tomb without this, the deceased will claim a person's life. However if you have carved and dressed the figure, you have already put someone in the tomb, and no other person will be taken." *Bɔciɔ*, as objects of replacement and displacement which promote life in situations of potential death, are in many respects similar to these entombment figures. As Merlo explains (1977:99), "The *botchio* is not a spirit but a decoy destined to trick death (or harm) by substituting a simulacre for a living person."[12] Each *bɔciɔ* as an imitation, a substitution, a forgery, a fake, a dummy corpse, at once disavows and acknowledges its identity with the "real" world and the world of the imagination. Like Western hunting decoys, *bɔciɔ* effectuate a response through a form of artistic deceit in which issues of life and death play an important role.

The prominent place of the term "cadaver" within the word *bociɔ* is important in other ways as well. Few images carry a more poignant or penetrating psychological imprint than the corpse, conveying as it does to each person the ever present threat of death and demise. Among the Fon, as in many societies, dead bodies give rise not only to deep-seated emotions such as sorrow and loss, but also to profound fears linked to ideas of destruction and both individual and family demise. Bataille's general comments on the corpse (1986:46–47) are of interest in this regard: "Death is a danger to those left behind. If they have to bury the corpse it is less in order to keep it safe than to keep themselves safe from contagion in the presence of a corpse horror is immediate and inevitable and practically impossible to resist." [13]

Bociɔ sculptures are associated with similarly potent concerns. When asked about the linguistic roots of *bociɔ*, it was suggested accordingly that the second radical, *ciɔ* ("corpse") derives from the word *ci*, a term meaning dirt, disgust, or debilitation (Ayido 4.25.86). Repulsion and impairment, in turn, are addressed not only through language and contexts of use but also through the incorporation of specific contaminating ("impure," "opposed") materials. Their function is to set off or contradict other additive elements present in the work in the course of creating powerful and emotionally charged actions and counteractions. As we have seen, fear and danger also are a central force of *bociɔ* aesthetics and viewer response. These works—like corpses—serve both as visual icons linked to the ever present threat of death and as provocative "calls to arms," propelling individuals to counter impending forms of danger and contagion.

Bociɔ: An Art of Actualization

Bociɔ's first radical, *bo* (*gbo*),[14] also affords us unique insight into features of transferential functioning. *Bo* is translated in the Fon-French dictionary compiled by Segurola (1963:94) as "gris-gris," "amulet," "talisman."[15] Such a translation, however, fails to convey any real sense of the deeper cultural values accorded the word. "Activating object" or "empowerment means" is a more incisive translation and is in accord with objects identified as *bo* and *bociɔ*. Adiha asserts that one can easily recognize such a work because "if it orders you to do something, you will do it" (7.5.86). A *bo* thus has the ability to influence persons and things, to make them act.

This activation quality also is emphasized by Nondichao in his explanation of the difference between *bo* and *vodun:* "*Vodun* is a god; *bo* is not a god. One does not worship it. One makes it to defend oneself and also to injure others."[16] In other words, while *bo* are frequently activated by *vodun* and derive essential features from this source, the *bo*'s identity and roles also are rooted in the psychodynamics of self, perception, and individual action. Discussing the distinctions between *bociɔ* (fig. 48) and commemorative *vodun* twin figures (in Fon called *hoho* or *hoxo;* in Evhe and Adja called *venavi*) (fig. 49), Merlo notes other

48. Gen *bociɔ* figure from Aneho, Togo, called *Agbamase*. Wood with additive surface matter including cord, hide, feathers, cowries, and iron. Height 34.8 cm. The torso is encircled with twine which secures hide strips to the surface. The long string attached to the neck originally was wound around the figure's legs. On the head are the remains of bird feathers. Intended to help protect travelers from harm. Collected by A. Leix in 1908. Linden Museum, Stuttgart. Cat. no. 57 089. Published by Cudjoe (1969: fig. 30)

49. Aja twin figures. Togo. Wood. Galerie Simonis, Düsseldorf.

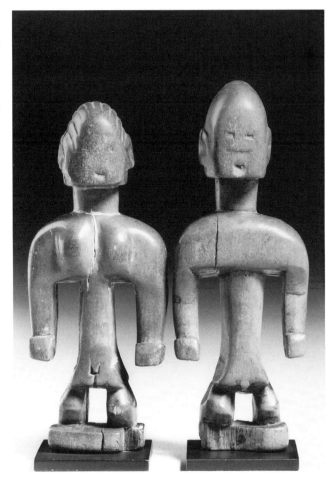

distinctions between these object types (1977:111): "One [the *bociɔ*] is grossly carved, the other [the twin *vodun*] polished one is magic,[17] the other pious. One is mediocre from an aesthetic point of view, the other has a certain [aesthetic] value." These differences also suggest something of the important psychological grounding of *bociɔ*, as works in which emotional expression and response are more important than reverence and aesthetic pleasure as such.

These features also are reinforced in the striking ways in which *bo* and *bociɔ* generally are distinguished from other objects of local manufacture. The following example makes the point especially poignantly. In the late nineteenth century, Skertchly observed King Glele (1858–89) on the occasion of the annual royal ceremonies dressed in a costume comprised of various forms of *bo*. As Skertchly explains (1874:218), the king's "fetish"[18] (*bo*) dress consisted of a "dull brown

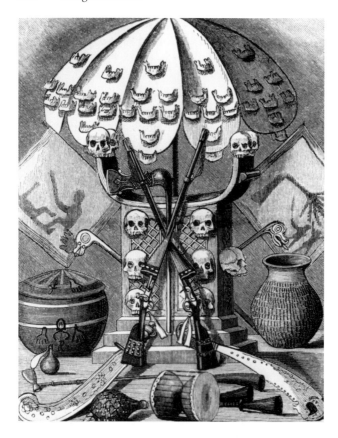

50. King Glele's "jaw umbrella" and stool. Published in Skertchly (1874:216).

mummy-cloth-looking toga [and] an enormous medicine bag . . . of embossed and embroidered leather" decorated with a rampant lion and fish.[19] "The toga" he pointed out, was "decorated with a semé of fetiche charmes [*sic*] secured in little square leather cases and sewn to the dress, intermingled with which were cowries smeared with blood." King Glele in this ceremony also carried a crooked-headed "*bo*-stick" (*makpo, recade*) studded with cowries and surmounted by a segment of a human skull. Skertchly observed in turn that the king was shaded by a "fetiche umbrella [which was] black, with white skulls and cross-bones on the lappets." The *bo* ("fetish") priestesses, Skertchly added (1874:252), "were distinguished by the skulls that dangled from their sashes" (fig. 50).

What the above description makes clear is that *bo* constitute a class of objects which are similar to other objects yet which lie apart. In some cases, such as Glele's "*bo* stick," we see a sculptural form identified with kings (the *makpo* scepter) recast to incorporate within itself powerful objects which are intended to provoke emotional response. Rather than merely *symbolize* power, as for example through the image of a lion (Glele's kingly sign), here both the cowries (the local economic and ritual currency) and the skull (taken from the head of a

defeated enemy) are employed because in and of themselves they *are* powerful. This stress on objects of real power rather than symbols of the same is noted in Skertchly's description of the King's *bo* umbrella. Royal umbrellas usually incorporate *signs* of kingly strength cut from multicolored cloth and sewn in appliqué fashion onto the umbrella's surface. In the case of Glele's umbrella, such symbols are replaced instead by bones.

As we can see from the above, an important distinction is made between *bo* and other cultural artifacts because of the close identity of the former with objects of actual rather than representational power. In *bo,* form and meaning, signifier and signified, have a direct and immediate ontological grounding. *Bo* are believed not just to represent something powerful, but also to be powerful in their own right. It is this feature of active power which is essential to the meaning and cathartic functioning of both *bo* and *bociɔ*. In such works the content[20] or material of manufacture itself carries essential meaning. This valuation of material content as real power is reinforced both in the emphasis given to additive surface matter and in the close relationship which is made between *bociɔ* and the arts of divination or geomancy.

Artistic Power and Prognostication

In the past, and to some extent still today, *bo* and *bociɔ* traditions have been linked to geomancy (divination),[21] the local therapeutic process through which one gains answers to problems in the course of life. Accordingly the Fon word for the geomancer (diviner) or therapist is *bokɔnon,* "owner of *bo* knowledge" (*non*: owner; *bo*: activating object; *kɔ*: knowledge). Alluding to the relationship between *bo, bociɔ,* divination, and therapy, an Evhe creation myth explains that "at the time [God] formed man he also created magic [*bo*], . . . because he himself . . . is too far away for man to go to him and ask for help. However with the aid of magic [*bo*] man can quickly obtain aid" (Cudjoe 1969:52). The interrelationship between *bociɔ* arts and divination in this area appears to be quite ancient, predating even the official introduction of Fa geomancy (the dominant divination method in use today) into the region of Abomey by the Danhomε King Agaja (1708–40).[22] A number of *bociɔ* forms draw on the specific signs (*du*) of the Fa system. The central place of *bo* and *bociɔ* within Fa in turn is what distinguishes this divination tradition from the closely related divination form (called Ifa) employed by the neighbors of the Fon, the Yoruba.

The identity of *bo* and *bociɔ* with ancient (pre-Fa) forms of geomancy in the area is reaffirmed by both diviners and researchers working here. According to the diviner Ayido, "*bo* is the form of consultation that was used here first of all" (5.18.86). Bernard Maupoil, the preeminent Fa scholar, notes similarly that (1981:384) "*bo,* the oracle of the . . . ancestors, was wiped out by Fa." The diviner Sagbadju suggests for this reason (7.1.86) that on the back of the geomancy board is a small circular hole (called in Fon, *bo* [*gbo*]) where one "does

Gede," a reference to the autochthonous (ancient) Gede people of Abomey.[23] Reinforcing this link between *bo, bociɔ,* and divination practice, concerns addressed in contexts of *bociɔ* and *bo* parallel those brought up in the course of geomancy in essential ways.

The relationship between *bociɔ* and divination also finds support in historical traditions of employing associated sculptures in the context of certain non-Fa geomancy consultations. During the late seventeenth century in the coastal area around Ouidah (Whydah), Captain Philipps describes (in Ellis 1970:81) one such early pre-Fa form of *bociɔ* geomancy sculpture. This work, which was observed at the entry of the king's palace in Ouidah, consisted of "a large wooden image which, the natives assured him, gave forth oracular utterances." Another non-Fa divination *bociɔ* from this coastal region is noted by Atkins in the early eighteenth century. An account published by him (in Hardwick and Argyll 1746, 3:27) describes a "small *fetish* [which] is the first thing [the natives] see after they are determined upon any Affair, or Business, and sometimes determines them to that Affair." Another *bociɔ* sculpture illustrated by Hardwick and Argyll is identified as Agoyé, God of Counsels, suggesting here too its vital divinatory role (fig. 12). In the region of Abomey today, according to Ayido (5.18.86), some diviners still use *bociɔ* for geomancy purposes. The situation is similar among the Evhe. De Surgy discusses (1981a:208) one such work identified with the forest god, Age, noting that "diviners who consult through the intermediary of Age use whistles and a series of small cries and . . . often a statue in human form near which he stands."

Bociɔ sculptures which function in these or related divination contexts are said to be distinguished frequently by their inclusion of mirrors. These are intended to aid the work both in "seeing" danger and in "turning it back." Ayido explains (4.26.86) that "the *bociɔ* with mirrors will tell them the reason that you came. . . . If something happens to you and you go to see them, these people will call the sorcerer and refuse him permission to act."[24] Discussing a Janus sculpture with a mirror, Ayido asserted similarly that (4.26.86) "If you bring a problem there, they will look inside and the *bociɔ* will show you everything."[25] Mirrors employed in the context of divination *bociɔ* offer the client/viewer powerful visual encouragement for emotional projection and transference.

Bo Linguistic Variants: Word Play in Transference Contexts

The word *bo* (*gbo*), in addition to being conceptually grounded in ideas of empowerment, materiality, and prognostication, is utilized in a variety of other linguistic contexts which offer important insight into the meaning and significance of these works. In local contexts of art and music (in particular *asɛn* memorial staffs, cloth appliqués, bas-reliefs, proverb gourds, and drum songs) images or sound qualities are employed in ways which suggest a high valuation of semantic fluency. For example in Fon bas-reliefs, a fish (*hue* or *huevi*—the first syllable

pronounced in a lowered tone) often will serve as a visual signifier for time or history (*huenu*, the first syllable pronounced in a middle tone). Mikhail Bakhtin refers to comparable forms as double-voiced words (i.e., words in which new semantic orientations are added to that which already exists). In contexts of *bo* and *bociɔ*, linguistic punning and creative verbal-visual wordplay are defined by similar multivoiced linguistic signifiers.[26] Dialect variations in the area and the shifting use of long and short vowels, guttural elements, and tonalities complement verbal-visual language play in important ways. While I do not want to overemphasize semantic fluency in art signification, local traditions of multivoicing offer certain unique insights into the shared linguistic and visual associations of key artistic forms.

Thus, because the Fongbe word *bo* (pronounced with a fricative or guttural *g* prefix and a dulled *o*, as in *gbɔ* or *gboh*) designates "goat," it is this animal that serves as primary symbol for *bo* and *bociɔ* in Fa divination and related rituals. In part for this reason, the skulls and fur of goats appear frequently on *bo* and *bociɔ* as additive surface materials. Another type of semantic double-voicing can be seen in the identity of the term *bo* not only with empowering objects but also with unexplainable (and generally dangerous) ailments, among these elephantiasis, which are believed to result from the employment of objects of this sort. This idea is further complemented through the use of the term *wli bo* ("take *bo*") as a verb to mean "concern" and "care for."[27] Paralleling the above, *bo* and *bociɔ* are employed predominantly in contexts of concern and care, and related values are an important part of their therapeutic functioning (fig. 51). Moreover several *bociɔ* sculptural genres incorporate features of illness or disease, among these the swelling of key body parts.

The meaning of the dulled-*o* phoneme *bɔ*, "to close," complements other features of these works, most important, their association with closure.[28] Key genre and attachment forms identified with these sculptures in turn are characterized by their inclusion of various closure elements (knots, locks, pins) which serve to secure within the body of the sculpture empowering materials and "words."[29] Through different types of sculptural enclosure, personal desires and concerns are at once recognized and acted upon within each figure. A sense of closure (completion and termination) with respect to related problems or preoccupations is brought about through the use of these sculptures.

The act of lighting a fire is referred to in Fon through the use of the word *bɔ* as well, in this case *bɔ mion*. The term meaning "to light a fire" (*bɔ* here pronounced gutturally [*gbɔ*] and with a dulled *o* and lowered tone) is of central importance to both the empowerment functions and psychological roles of works identified with this sculptural tradition. Not only are many additive materials charred before inclusion, but "heat" is continually applied to these works through the spraying of pepper and other "hot" substances (such as liquor, blood, or palm oil) onto their surfaces in the course of sculptural activation. Heat additionally is identified with the sculptures both through the contexts of

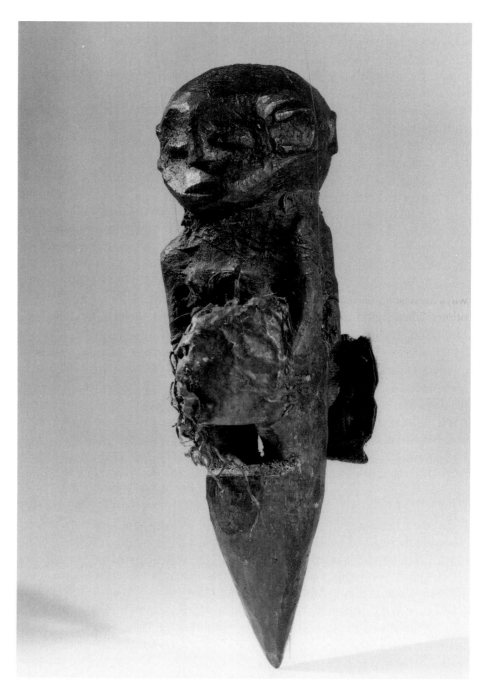

51. Evhe Janus-form power figure called *Toyige*. Lome, Togo. Wood with additive surface matter including cloth, cord, and sacrificial matter. Height: 30 cm. Used as protection against thieves and to put one's enemies to sleep. Musée de l'Homme, Paris. Cat. no. M.H.32.78.16.

their commissioning and use and through the powers they are assumed to have in promoting or propelling situations associated with difficulty or heat.

Further underscoring the primacy of fire in *bo* linguistic conceptualization, the word for fire among the linguistically related Evhe (here called *djo* or *dzo*) is commonly used in reference to the entire grouping of sculptural works of this type (de Surgy 1981a:166–67). Spiess notes (1902:314) that the Evhe draw a connection between fire, strength, and *bo*-related powers. Expanding upon this idea, Rivière explains (1979a:194–5) that an Evhe *dzo* figure, "like fire . . . can be a good thing when it heats and lights, but it becomes bad when it burns and destroys." [30]

In yet another example of *bo* semantic fluency, the word *bɔ*, when pronounced by the Fon with a dulled *o* and modulating elevated tone, designates "mire," "mud," "clay," "soft," and "relaxed." The term *bɔ* in this sense is used to convey not only the idea of being trapped (*e kpɔ ɖo bɔ me:* "he is still mired" by a situation) but also the notion of failure (*e na i bɔ:* "it will go into the mud," i.e., "it will fail"). In both the above examples, the term may offer insight into the ways these sculptures are seen to be able to stop (mire, ineffectuate) the actions of others. Most significant with respect to this identity appears to be the metaphoric associations of mud and mire with the assumed powers of such works to ensnare people and things. As Dewui explains (7.3.86), "When one does not have things like [*bociɔ*] there are lots of traps into which one can fall." In these examples, the role of sculptural empowerment is clear, for figures of this type are believed to help one not only to trap and detain harm that may come in one's direction but also to avert the various traps that stand in the way of accomplishing what one desires in life.

A final etymological association of the term *bo* is discussed by Roberto Pazzi in his analysis of Evhe, Aja, and Fon conceptions of what it means to be human. According to him there is an important link between the word *bɔ* and cultivated forest clearings. Pazzi notes in this light (1976:208–9) that among the Evhe the forest clearing (sometimes pronounced here gutturally, as in *gbɔ*), where "man penetrates to throw his grains and returns to gather the produce," is a place of heightened mystical power. It is a crossroads between the human world and the realm of the supernaturals. He writes: "For the Ewe in effect, and also for the Aja, the conception of *gbɔ*, a clearing in the heart of the forest, is linked to the conception of the heavens, and the place of rest of the ancestors." [31] B. Agudze Vioka reinforces this idea (in de Surgy 1981a:24): "The land where humans come from . . . is a large vast city, around which is a magnificent gold wall. . . . This beautiful city is called *Bome*, i.e., [in] the field." The guardian of this field, Vioka explains, is a female goddess called Bomeno, "mother (*no*) in (*me*) the field (*bo*)," who provides each human with breath (*gbɔ* nasalized, or *gbɔn*). Among the Fon, the actions of cutting, clearing, carving, beating back, and piercing are referred to by the term *gbo* (pronounced here in a lowered tone). The

act of piercing is particularly important in the above, since personal concerns frequently are addressed in *bociɔ* through this means.

Like the cleared field and the great female goddess who resides therein, *bo* and *bociɔ* thus are seen to be not only a vital source of life, but also a sculptural crossroads (*gbon alin; gbon* when nasalized, means additionally to cross, pass, or traverse) linking the realm of humans with those of the ancestors, the spirits, and the gods. Like Bakhtinian *chronotopes* (Bakhtin 1981:84), *bo* thus constitute referents to both time and place, delimiting and crossing temporal planes while at the same time framing and interpenetrating variant spatial realms. There is a vital psychological element in the above, for as de Surgy notes (1981a:28), humans continually are encouraged "to exploit in the best way the invisible field (*bo*) of their resources."

Bo in this sense represent the potentiality of all human action. As we will see, *bociɔ* sculptures play complementary roles in encouraging the utilization of one's inner resources. Here too, the salient identity of *bo* with forest clearings and crossroads is critical, since human potential is believed to be achieved only through effective interaction with the various human and spiritual realms. Furthermore, both in Fon myths and in the manufacture of sculptures of the *bo* and *bociɔ* type, forests assume vital roles. They serve as a home to the tiny *aziza* (forest spirits), who are believed to have provided knowledge of *bo* to humans. Equally important, most of the additive materials that go into the making and empowerment of sculptures of this type are derived from the forests and fields.[32]

Manufacturing Meaning: A Dynamic Art Delimited Visually

The means through which various objects or forms come to be identified as activating powers and thus classified within the *bo* or *bociɔ* grouping is also of considerable interest vis-à-vis the transferential roles and larger psychological significance of these works. Transference potential in this sense is something which is believed to be manufactured. In some cases it is the method of fabrication (the production process itself) which is critical. The making of a textile *bo* called *klibibi* is a case in point. Nondichao describes the role and creation of *klibibi* cloth this way (11.24.85):

One employs this to avoid other *bo*. If you have used *klibibi* to cover yourself, and someone sends a *bo* in your direction at night, the [malevolence] will not arrive. *Klibibi* is a cloth that is very expensive. To have even a small piece costs over 5000 cfa [about $16]. Many people, accordingly, will take a small piece of it and pin it onto their clothes, for if one uses even a small piece, one will be covered by it. This textile is difficult to weave. You need a special place in your home. Those who weave it must get up very early. While they are weaving, they cannot eat, they cannot urinate, they cannot have sex with their wives, they must remain naked while weaving. If they wear any clothing at all, the *klibibi* they are weaving will be ruined. If the weaver wants to eat he first much finish the small piece of cloth on which he has been working.

The function and power of this textile is linked thus in key respects to the diffi-
culties and restrictions associated with its creation.

In other examples, it is the ritual use of materials before they are incorporated
into the sculpture which is essential. One such object was made from the broken
skin of an elaborately carved drum called *satɔ* which is played during royal funer-
als and the annual *huɛtanu* ("customs") ceremonies (fig. 52). Explaining the
functioning of this *bo*, Agbanon noted (2.28.86): "If one wants to do a large
ceremony such as constructing an *atɔ* [the raised funerary or "customs" plat-
form] one will make a solution which includes a piece of skin from the top of a
satɔ drum. If one washes oneself with this solution, no bad thing will happen. If
you are sick or see ghosts, after using this you will no longer have these difficult-
ies. This solution guards life, it exchanges death with life."

In still other cases it is the materials that are applied to the object after it is
completed that transform it into a *bo* and assure its cathartic effect. This is par-
ticularly important with jewelry. Many such works consist of simple undecorated
rings, necklaces, anklets, armlets, or hip cords. As Nondichao explained of one
(11.15.85), "If it is not a ring for beauty, it is a *bo*."[33] Migan, a descendant of
the important court minister of the same name, described the process of trans-
forming a common iron finger ring into a *bo* (12.31.85): "One takes the new
ring and brings it to the house. Then one places various leaves and animals such
as ducks, pigeons, sheep, and chickens on it. Following this one kills these ani-
mals in offering." As the above suggests, only when the empowering materials are
correctly incorporated does a *bo* assume its essential properties and potentials.

Cathartic effect also is grounded in questions of difference. Accordingly, like
the people who make and use them, *bociɔ* and *bo* are characterized by features
of individuality and uniqueness. As with fingerprints, no two are exactly alike.
As Ayido explains (8.3.86): "Two *bociɔ* cannot be the same. Sometimes one tries
to gather together the same things [in making a work] but there are always little
differences. One can gather three leaves and some earth will have fallen on one
and it will not be the same." Even works made out of the same material, a roan
antelope horn, for example, will vary from individual to individual. According
to Ayido (5.2.86), "The *bo* another person makes with the horn is not the same
as mine. Mine is not the same as his. The *bo* of different people are different."
Underscoring this feature of object-uniqueness are *bociɔ* and *bo* naming tradi-
tions. As Rivière notes (1981:182), two *bo* "of the same manufacture will change
names according to regions, and the [*bo*] of the same name in different regions
will include different ingredients." Names, in other words, have little taxo-
nomic value.

As a result, most attempts to obtain exact identification of a *bociɔ* on the basis
solely of a photograph are problematic since, it is maintained, no one except
the maker can know an object's specific identity or properties. As Ayido notes
(4.25.86), "It is the one who made the *bociɔ* who will know its nature; it is not
a *vodun* so that we can give a name to it." Or as the diviner Dewui explained,

52. Royal *Satɔ* drums. Agonli area, Republic of Benin. Photograph: Suzanne Preston Blier. February 26, 1986.

"If I attach things [to a work of this type] I will be the only one who will know what I did. If someone did not do it, he cannot know. . . . One cannot say it is such and such a thing just in seeing it" (6.30.86). A Fa geomancy phrase from the sign Tula Logbe is frequently cited in this regard: "If someone does not make a *bo*, he cannot know its words" (Ayido 7.27.86).

Bociɔ Character: Competing Cathartic Concerns

Despite the acknowledged difficulty of determining the identity or function of a work on the sole basis of its appearance or name, certain larger characterological traits can be delimited with respect to the corpus as a whole. In a general way, all *bo* and *bociɔ* are seen to achieve their cathartic effect either through protective functions or aggressive ends. Stated simply by Maximilien Quénum (1938:79), "There are aggressive *bo* and defensive *bo*." Or to quote Sagbadju (8.14.86), "*Bo* refuse things; *bo* do things." Alapini notes similarly (1952:77), "There are two categories . . . one positive which is offensive, one negative which is defensive." Cornevin makes a related distinction between malevolent and protective works (1981:222): "The *bo* is generally an object that is used to injure one's neighbor or to the contrary to defend oneself against hostile forces." Herskovits's taxonomy of *bo* (1967, 2:256) shares essential features with the above, comprising as it does "specific cures or supernatural aids" and their "antisocial counterparts."[34] In elaborating on this division, Herskovits points out (1967, 2:256) that according to one of his sources, "before a child is born . . . Mawu [God] tells him [/her] 'It is true that I have sent disease into the world, but I have also sent cures.'" Ayido's categories complement the above. As he notes (5.18.86): "*Bo* can kill people . . . [but] when someone is sick they can also cure the person."

Works whose character is seen to be essentially protective or restorative are referred to variously in Fon as *glo* (antidote), *bo dagbe* (good *bo*) or *bo hulɛn gan* (*bo xulɛn gan*, survival *bo*); malevolent and aggressive *bo* are identified instead by terms such as *bo gnagna* (bad *bo*) or *bo dida* (malicious *bo*) (Dewui 7.3.86; Ayido 5.2.86). For the Evhe too, Rivière explains (1981:177), "Our informants distinguish between two types of *dzo* (*bo*), good (*dzo nyui*) and bad (*dzo von*). *Dzo nyui* is that with which one comes to the aid of someone in the case of sickness, danger, protection or success. *Dzo vo*, to the contrary, is the *dzo* of injury, what one looks for to render one sick or infirm."

In actual practice, however, the above division between benevolent and malevolent objects has little real applicability. This is because most malevolent works also have clearcut if ancillary benevolent and protective roles. So too, most benevolent works incorporate features which are essentially aggressive. As Herskovits has observed (1967, 2:285, 287): "Good and bad magic are merely reflections of two aspects of the same principle. . . . The character of the *gbo* is such that while one of these charms helps its owner, giving its aid to protect him from evil intentions or deeds of enemies, it also possesses the power to do harm

to the one who would do such evil to its possessor. . . . [T]he Dahomean is relating what is, to him, an obvious fact when he says that good magic and bad magic are basically the same." De Surgy reaffirms the ambivalent nature of these works among the Evhe (1981a:179–80) "As a rule . . . all [works] . . . which can cure a sickness can bring on the same sickness and inversely."

Le Herissé documents numerous cases of this type of *bo* and *bociɔ* classificatory conflation or confusion (1911:155). For example, to safeguard one's marriage one will commission a work intended to act against (and indeed harm) the real or potential lovers of one's spouse. So too in order to gain financial well-being, a person might request an object that achieves this end by its appropriation of the wealth of another or by its assuring of profits for oneself which another might have had otherwise. Similarly, in trying to stop a bothersome individual, one might acquire a protective work meant to bring about an end to this person's ability to carry out his or her particular actions. In like fashion, to win a war one might seek to demolish an opponent's army; to have rain for one's crops, another's field may remain dry; to trick death into leaving an individual alone, another person may be taken in one's place.

The widely maintained malevolent/benevolent dichotomy with respect to *bo* and *bociɔ* thus in practice is usually untenable because "protective" or "benevolent" sculptures generally function through the negation of another's desires, interests, possessions, or well-being. Every malevolent work, it may be said, serves certain benevolent functions by supporting the interests (and potential well-being) of the one who commissions it. Le Herissé's delimitation of the aims of works having malevolent intent (1911:155) makes this clear. Such objects, he points out, help "to satisfy one's jealousy against the lover of one's wife, to appropriate for oneself the wealth of another, and to suppress a bothersome individual." Even malevolent works such as these bring to one vital benefits. Sagbadju's listing of aggressive *bo* (7.6.86) suggests that even the most outwardly harmful objects have a positive role in providing an outlet for strong feelings and emotions.[35] Rivière reinforces this idea of the cathartic benefit resulting from the externalization of malevolent thoughts (1979b:214) in emphasizing that "the *ebo*, objects or ingredients charged with magic power, do not act except on command and according to the directives of those who possess them."

As one can see from the above, through the action of commissioning, contextualizing, or consulting with such works one acknowledges and in turn rechannels a range of powerful emotions—rage, anger, jealousy, and the like—achieving in the end a degree of cathartic relief. Central to this process is the prominent role of associated works in changing an individual's attitude and actions about a given situation or problem.[36] Through the acquisition and use of sculptures such as these, a vital expiatory effect is achieved wherein secret desires or anxieties are projected onto the sculpture, promoting through this means their eventual dissipation or neutralization. Transferential values of this sort clearly lie at the heart of *bo* and *bociɔ* psychotherapeutic functioning.

It is important to note, however, that as a result of the often difficult and personal emotions communicated in these objects, many individuals perceive there to be something untoward and even unseemly about *bo* and *bociɔ* ownership and use. This too underscores the transferential roles that objects such as these fulfill in conveying potent feelings which otherwise could not be publicly expressed. Le Herissé observed in this light that (1911:155) "In what concerns the malevolent *bo* (*bo gnagna),* we were not able to get any clarification on their composition. And this is easy to understand because each person claims not to know anyone who knows how to make them." Savary notes in turn (1971:3) that "traditional [Fon] society adopts two attitudes: one recognizes the practice of magic for defensive ends, [whether] collective or individual . . . [the other] condemns the use of magic for an offensive end." The considerable secrecy associated with *bo* and *bociɔ* use often has an important social base, for *bociɔ* actions or concerns (while essential to individual well-being) often run counter to what is generally perceived to be the best interests of society.

Because *bociɔ* are assemblages of potent feelings and desires to privilege self over others in society, the surfaces of such objects sometimes are laden (even bursting) with hidden (secret)[37] meaning and import. Deleuze and Guattari's comments on secrecy and form here are apt (1987:286, 288): "The secret relates first of all to certain contents. The content is *too big* for the form . . . or the contents themselves have a form. . . . But the becoming of the secret compels it not to content itself with concealing its form in a simple container, or with swapping it for a container. The secret, as secret, must now acquire its own form." Rarely has this idea been more clearly expressed artistically than in the tradition of *bociɔ.*

The danger and potency of sculptural content are enhanced in essential ways by the diversity of places in which these objects are positioned. Context thus serves as a vital cathartic frame. Nonsculptural works (*bo* as distinct from *bociɔ*) frequently are located on or close to the person (fig. 53). Rivière notes (1981:182) that they "can be suspended from the neck, attached to a belt or ankle, fixed to braids in the hair, put in pockets, secured to guns and put on certain seats." Other nonfigural, body-associated *bo* take the form of special coiffures,[38] cicatrization marks (scarification patterns),[39] textiles, fly whisks, belts, bells, jewelry,[40] drinking horns, and leather (or cloth-covered) protective packets (called generally *tinla* [*tila*]). Still other personal *bo* consist of specially manufactured soaps whose protective powers are conveyed to a person in the course of one's bath. These soaps, like all *bo* and *bociɔ,* derive their efficacy from the unique materials used in their manufacture.[41] Solutions or powders which are consumed or sprinkled over the body comprise yet another grouping of nonfigural works of this sort. House guards also are an important *bo* subcategory. Rivière suggests accordingly (1981:184) that "before construction to protect against difficulties in the house, one disposes talismans on the earth, and suspends others beneath the roof for protection."[42]

53. Fon hunter wearing pendant-form *bo* standing next to an *asen*. Le Herissé (1911: pl. 6).

With figural *bo* (i.e., *bociɔ*), the range of associated locations also is striking. Most such works either are placed at liminal points (entrances to towns, cities, markets, compounds, dwellings, temples, crossroads), or are secreted away at the back of a compound chamber.[43] Height often varies with respect to related placement choice. Merlo notes (1977:99) that "the *botchio* is a statue of which the height does not exceed a meter and which is not inferior to 20 cm. They are large on roads at entrances to villages, shorter in interior courts (except in the residences of Abomey princes), small in front of houses and under the Legba temples which are low enclosures." Size, as the above suggests, has an essential role in defining the empowerment and interaction locus of a particular work. The larger the sculpture, the larger its importance and field of reference.

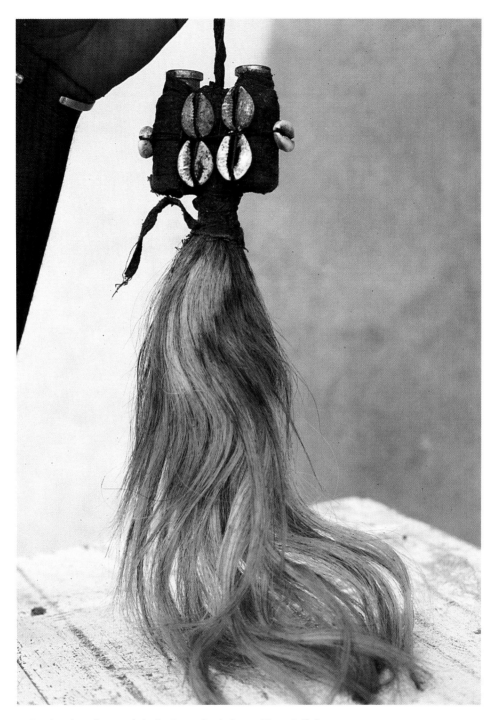

1. Pendent-form *bo* on sale in the Be market in Lome, Togo. Called
nibusi, it is worn to keep mosquitos and other minor troubles at bay.
Photograph: Suzanne Preston Blier. July 7, 1984.

2. Fon *Bociɔ*. On sale in Be market in Lome, Togo.
Photograph: Suzanne Preston Blier. July 7, 1984.

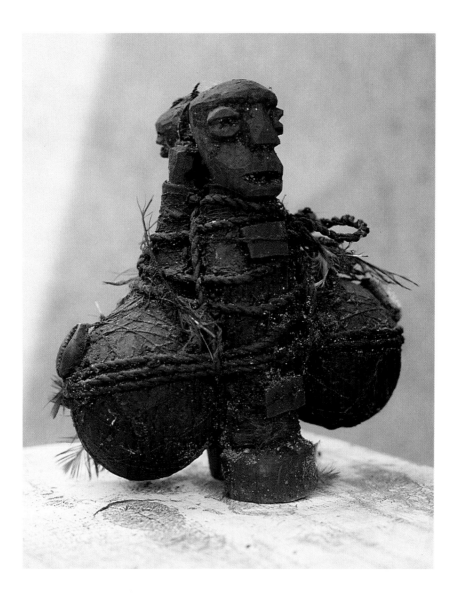

3. *(facing page)*, Fon *Bociɔ*. Republic of Benin. Wood, monkey jaw,
and miscellaneous materials. Wooden peg inserted in the forehead.
Height: 27 cm. Probably collected in the 1960s. Former collection of
Ben Heller. Current collection of Don H. Nelson. Photograph: Jerry
Thompson. Photo courtesy of the Museum for African Art.

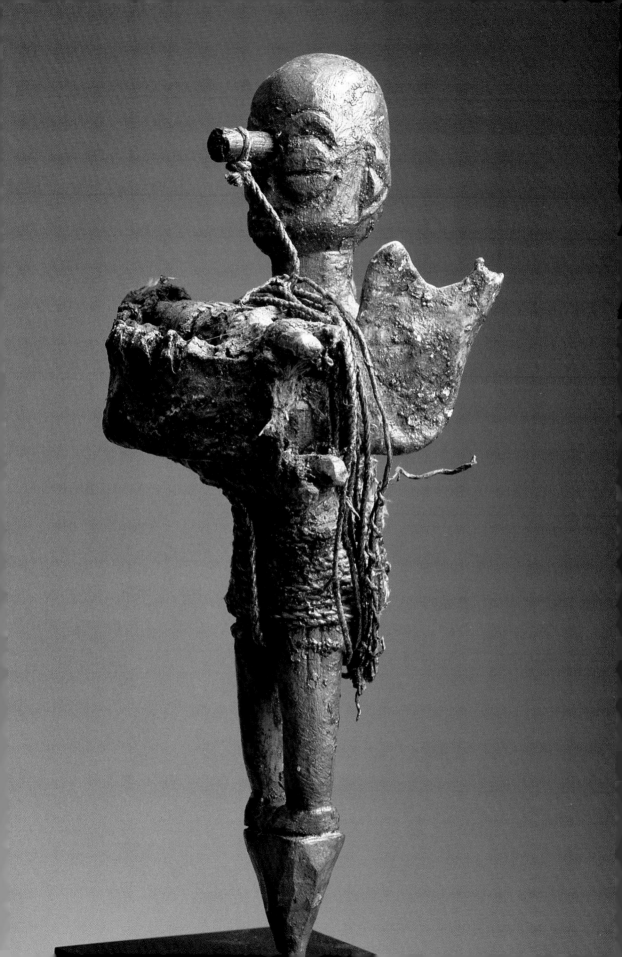

4. Fon Legba hat. Republic of Benin. Leather, fabric, string,
cowries, tusk. Height: 18 cm. Note careful binding and wrapping of
bo on the surface. National Museum of African Art. Eliot Elisofon
Archives. Smithsonian Institution. Cat. no. 73.1.2. Gift of J. Dale
Chastain. Photograph: Ken Heinen. 1984.

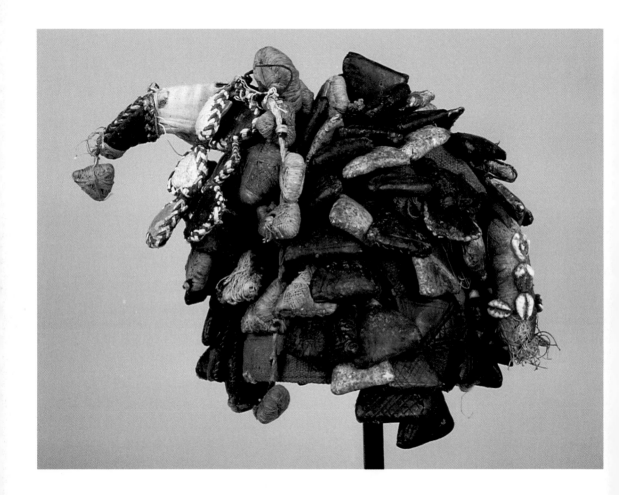

5. *(facing page)*, Evhe-Ouatachi figure. Togo. Wood, cord,
and miscellaneous materials. Height: 41 cm. Wooden pegs are
inserted into ear and chest. Probably collected in the 1960s.
Former collection of Ben Heller. Current collection of
Don H. Nelson. Photograph: Jerry Thompson, courtesy of
the Museum for African Art.

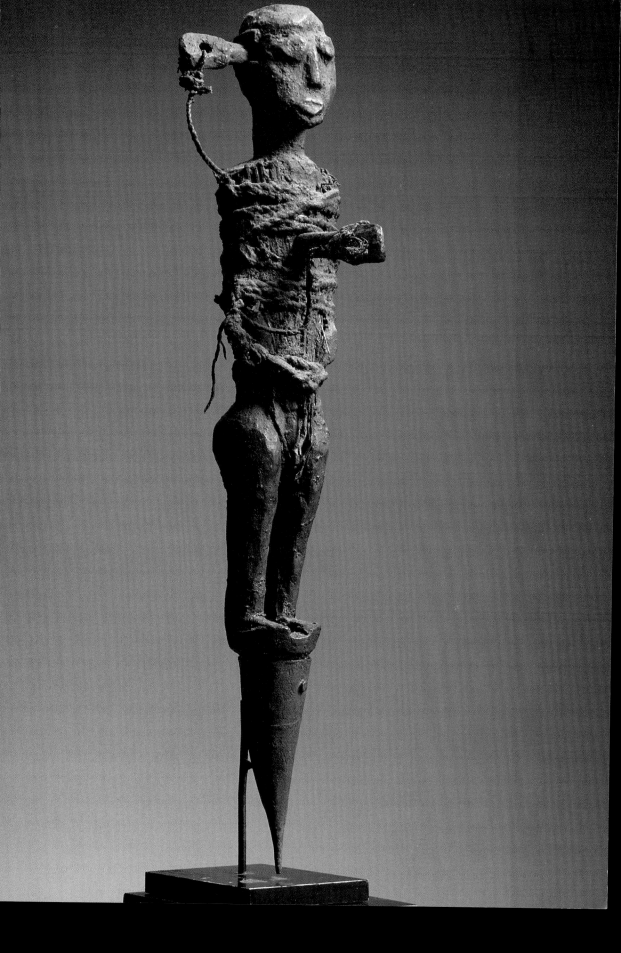

6. *(left)*, Fon *bociɔ* made from the root of an *iroko* tree. Carved by Adibou Glessougbe. Nineteenth century. Abomey, Republic of Benin. Photograph: Suzanne Preston Blier. June 23, 1984.

7. *(facing page)*, Fon *bociɔ*. Female figure. Republic of Benin. Wood, calabash pieces, iron, cord, dog skull, and miscellaneous additive materials. Height: 37 cm. Probably collected in the 1960s. Former collection of Ben Heller. Current collection of Don H. Nelson. Photograph: Jerry Thompson. Photo courtesy of the Museum for African Art.

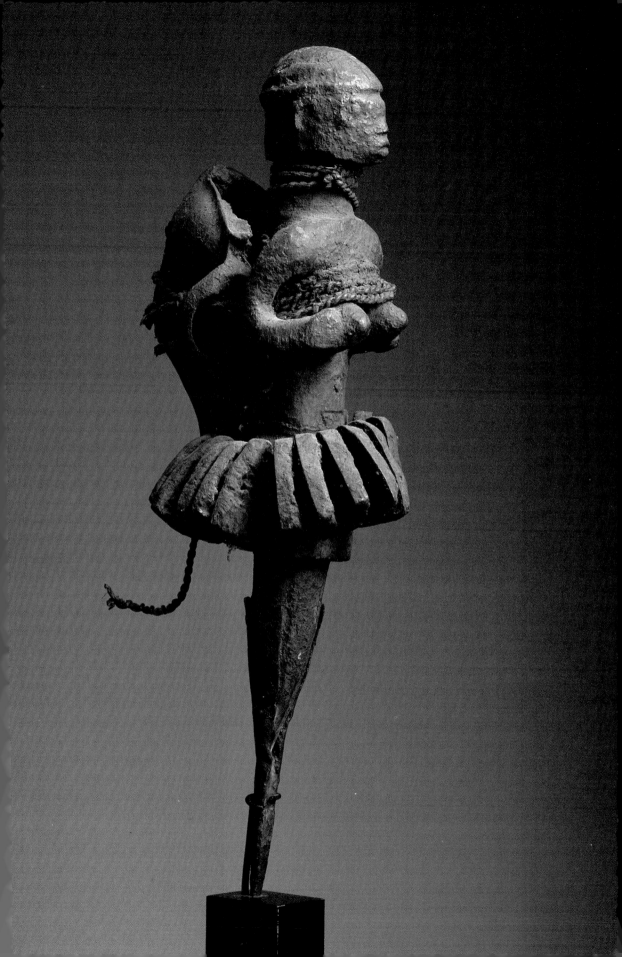

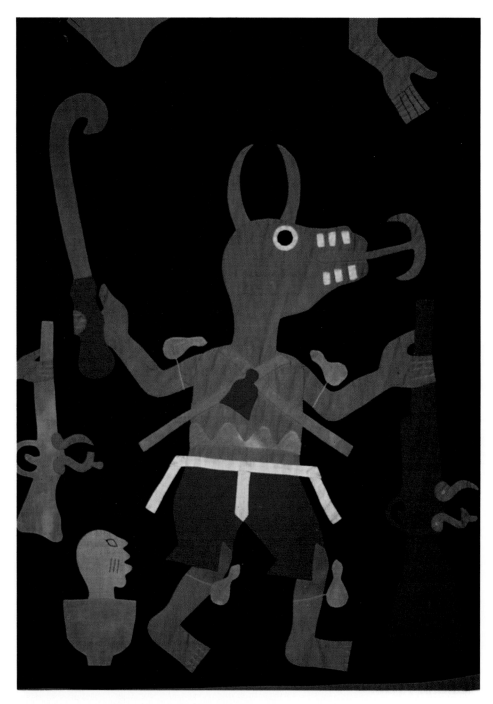

8. Detail from an appliqué associated with King Glele's reign showing the
Daguesu war *bociɔ* with its ram-form head, weapons, *bo* gourds, and lightning
axe blade extending from the mouth. Musée Historique, Abomey, Republic of
Benin. Photograph: Suzanne Preston Blier. May 29, 1986.

Macrocosm and Microcosm in the Delimitation of Desire

Further insight into the social and psychological grounding of *bociɔ* and *bo* is achieved when we look at the range of therapeutic functions which these objects are believed to fulfill.[44] As Le Herissé suggests (1911:148), the purposes of *bo* are as diverse as the imaginations, desires,[45] and fears of their makers and users. In Le Herissé's words (1911:148), "*Bo* . . . are innumerable, because innumerable are the manifestations of desire that they have the virtue of realizing or enshackling, because innumerable also are the objects to which the fantasy of reason of each individual attributes a power." Visual attributes of *bociɔ* reaffirm the importance of fantasy. As Répin notes after visiting a temple of *bo* and *bociɔ* in 1856 (1863:78), "It was filled with idols. There were all sorts, in wood, earth, and ivory, large and small, of human and animal form and even fantasy; serpents, monkeys, and tigers [*sic*], dogs with crocodile heads and men with dog heads." *Bociɔ* and *bo,* in this way, address the full range of human experience and emotion. In an essay on "idols et fétiches" (fig. 54) on the Slave Coast, in *Les Missions Catholique* (1875:592), an anonymous author writes that "the stranger cannot take one step in Dahomé and elsewhere on the Slave Coast without meeting idolatrous signs. Each of these follows his inspiration. . . . the negro accumulated all the objects which, according to him, should obtain protection of genies."

Individual fantasy and fear clearly play a central part with respect to the above. Lists of Fon *bo* (and *bociɔ*) aims and orientations published by Quénum (1938:78–79), Alapini (1952:72), Herskovits (1967, 2:267), and de Surgy (1981a:168–76) give clear evidence of this. Compiled from these scholars, the following enumeration reveals some of the diversity of individual longings, fears, hopes, and concerns associated with these works. Among other things they are commissioned for the following purposes:

To attract a client or lover
To seduce a person
To make a person hated or detested
To immunize against another's poisoning or evil deeds
To protect one from bites of humans, animals, and snakes
To cure leprosy, rheumatism, and other illnesses
To create good will and affection for the owner
To help the owner to realize his desires
To send sickness to another
To make one have a guilty conscience
To render one impotent or foolish
To make one sterile
To separate two or more people
To deal with ideas of obsession, fear, ghosts

To recruit other users of *bo*
To protect against another's magic
To protect one's house and property
To protect one's field
To protect one during funerals
To build confidence and strength
To cause malevolence to return to the sender
To send danger to another
To assure longevity
To cause another to forget something
To poison another at a distance
To aid a person in committing or stopping theft
To bring death

Cudjoe alludes to similar ideas (1969:52–53) in his discussion of *bo*-related sculptures among the Evhe. "Charms" of this type, he explains, are employed in cases of: "ill health, misfortune and financial difficulty . . . or where barren women desire children, and pregnant women a safe delivery. . . . [There are also] hunting charms, charms to make one invulnerable in battle, charms to help improve trade, and charms to protect against evil spirits, as well as innumerable charms to help in cases of illness . . . to protect the owner against witches and harmful magical practices . . . to protect wrong-doers from discovery . . . [and] to protect the traveller." As we can see from the above, the actions and aims associated with such sculptures are extraordinarily diverse. Works of this type reflect in various ways what Silverman calls (following Freud, 1983:57): "the impulse to avoid unpleasure." Dewui notes in this regard (3.7.86) that "the *bo* is not something that one must make; however, we are continually looking to see what one will do so that humans will not be afraid. That is why one gathered all the things together."

Not surprisingly, security is one of the most important problems addressed in works of this type. In some cases security is sought for the sake of the polity. Accordingly, the gates leading into the city often are a setting for numerous *bo* and *bociɔ*. The famous Fon brass warrior *bociɔ* (fig. 13) was positioned at the city entrance for this reason. *Bo* and *bociɔ* also were set up along major roads leading into the kingdom or in special temples along the way. One grouping of protective gateway works was observed in the mid-nineteenth century by Burton in Cana, a town through which most visitors passed before entering Abomey. Burton describes these works as follows (1966:171):

A heap of ashes, the usual sign of entering a great fetish place, points to a white village of *Bo-hwé*, [*bo* houses] tabernacles, or fetish hovels, under huge cotton woods, beginning at about 350 yards from the town gate. . . . The nearest fetish huts are six in number, and are disposed across the road. . . . The hovels contained effigies of chameleons, speckled white and red, horses known only by their halters; squatting men, like Day and Night at

54. Sacred grove with "idols and fetishes" from Anonymous, *Les missions catholique* (1875:589).

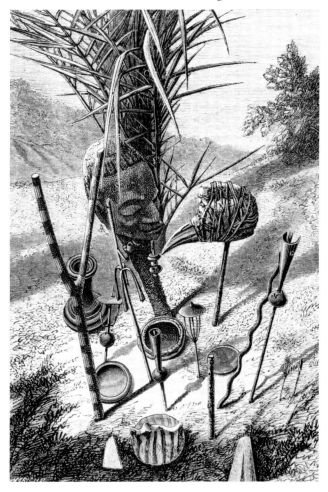

masquerades, half mud-colored, half spotted; others brown all over, and grinning with cowrie-teeth; and the largest a huge chalked gorilla, intended to be human and completely disgusting.

Besides village protection and public safety, one of the most prevalent community issues addressed in *bo* and *bociɔ* is that of weather. Associated works are especially important to farmers and others whose livelihood is dependent on the land. One sculpture of this type, which was described as including parts of a crocodile and python, purportedly was able not only to start fires but also to make it rain. "Placed one way and the whole of life takes fire; placed another way and rain will fall" (Dewui 3.7.86). In this and related objects, in addition to obvious concerns with respect to agriculture, a diversity of deep-seated fears or desires associated with heat (danger, trauma, difficulty) and coolness (peace, well-being) are conveyed at the same time.

Another grouping of *bo* and *bociɔ* identified with personal fears as manifested vis-à-vis the environment are those placed in agricultural fields in an effort to protect the crops. Such objects generally consist of matter attached to the branches of trees or shrubs (if too small, then it is first secured in bottles) (fig. 55). Alternatively, the material is placed on sticks inserted in the ground nearby (Agbanon 3.11.86).[46] These works too provide important relief, something essential in agricultural communities where so many factors vital to crop success (weather, pestilence, theft)—and ultimately to one's life and livelihood—lie outside one's control. Concomitantly, promotion of the town's or city's market in order to encourage sales and profit is a function of other works. According to Agbanon (3.15.86), "*Bo* are used in order to attract people to the market." One such object was described as incorporating a tiny wood-boring insect with a shell-like covering on its back. This insect in life is said to sing "uncharge me," the same words market women will say when they arrive at the market each week bearing heavy goods on their heads.[47]

Efficacy in and safe return from the hunt are aims of still other objects of this type (fig. 56). As Spiess notes for one such work (1902:314), "The *kpekpedzoka* is [used] . . . to protect hunters from wild animals . . . they rub some of the powder on their hands or blow it into the bush." Skertchly suggests (1874:256) that the royal elephant huntresses were always "profusely ornamented with magic relics." Here one can see the important cathartic role of *bo* and *bociɔ* in assuaging fears related to personal safety when one is engaged in highly dangerous activities. Works of this general category were believed to shield hunters and warriors from life-threatening occupational dangers such as gunshot wounds.[48] "With my father's *bo*," Sagbadju explained (7.1.86), "if someone fires at me, the bullets will not enter my body." War *bo* fulfilled a similar role.[49] Rivière noted of such objects (1981:185) that "More dangerous than the hunt, was war. . . . The [*bo*] of war work essentially to protect the individual from bullets, so that the warriors could flee the gun shots of the enemy. One [such *bo*] consists of a cord of braided raffia worn on the arm which one rubs as a means of immunizing oneself against enemy bullets. Another is a cord rubbed in soot and laterite which is worn in the hair. When the enemy is about to shoot, this sees what is happening, and the enemy's gun blows up in his hands." Here too *bo* and *bociɔ* can be seen to have an important role in mollifying fears associated with risky activities.[50]

Spies, thieves, and others involved in dangerous acts for or against the individual or state also employed works of this type. Ellis describes a number of such objects (1970:94): "One kind, when blown against a door or window, causes it to fly open, no matter how securely it may be fastened; another, when thrown upon the footprints of an enemy, makes him mad; a third, used in the same way, neutralizes the evil effects of the second; and a fourth destroys the sight of all who look upon it." Yet another work called *zindo-bo* was said to permit a person to become invisible, thus enabling him or her not only to spy or prepare for a raid but also to steal or commit a crime (Quénum 1938:78). An Evhe object

55. Bottle-form *bo* suspended from tree to protect crops from theft. Village of Hwawe, Republic of Benin. Photograph: Suzanne Preston Blier. May 17, 1986.

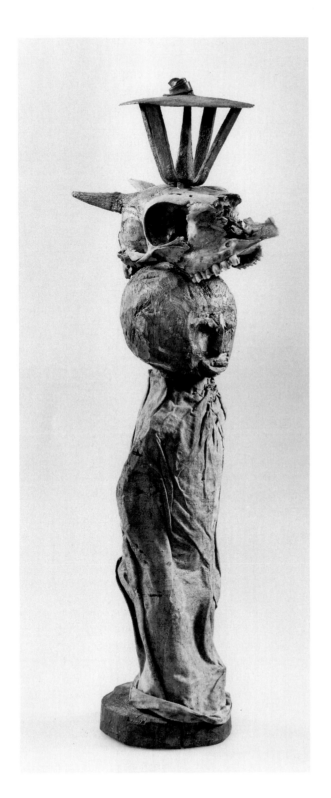

56. Gen male *bociɔ*. Lake Togo, Togo. (Compare with fig. 73.) Wood with additive surface matter including iron *asɛn* memorial staff, male blue duiker (*Cephalophus caeruleus*) skull, and cotton cloth. Height: 40 cm. Used to promote success in hunting. Collected by Schneider, 1913. Linden Museum, Stuttgart. Cat. no. 89 500. Published in Cudjoe (1969: fig. 16).

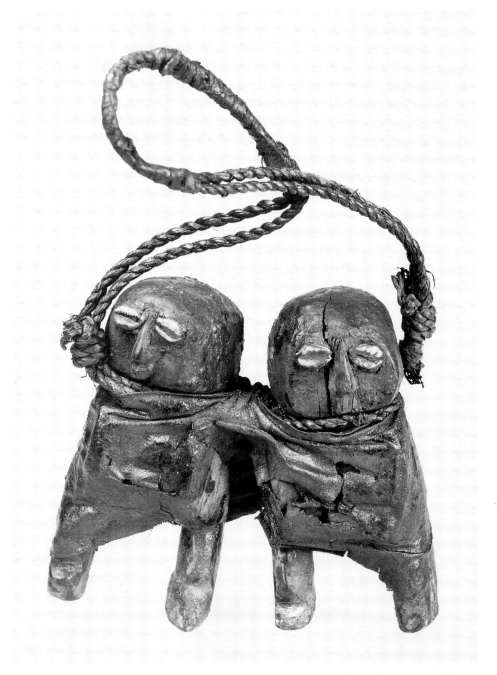

57. Gen figures from Aklaku, Togo. Wood, cowrie shells, cotton cloth, and miscellaneous materials. Height: 15 cm. Its name, *dogli*, which means "to eradicate from memory," alludes to its role in helping a person have his or her deeds forgotten before discovery. Collected by A. Leix, 1908. Linden Museum, Stuttgart. Cat. no. 57 078. Published by Cudjoe (1969: fig. 29).

58. *Bociɔ* carver Antoine Djido, with family *kuɖiɔ-bociɔ* figure. Bohicon area, Republic of Benin. Photograph: Suzanne Preston Blier. June 17, 1986.

called *Dogli* (fig. 57) was used by criminals who wanted their deeds forgotten before they were discovered. These objects were intended to eradicate the memory of such acts. Again, works of this type had cathartic functions in providing assurance to persons involved in dangerous work.

Other *bo* and *bociɔ* are positioned in various parts of the house compound, where they help to protect both the family and its property (fig. 58). As noted above, many objects of this type are situated in the house entryway. Explaining one such grouping, Agbanon noted (2.28.86): "You place in front of the building what is necessary so that the children that are born in the house will not die, so that your wife will not die, and so that good things will enter into the house for you." Or as Sagbadju noted for a carving in front of his compound (8.2.86), "This is used to protect our house so that bad things will not happen there." Le Herissé explains (1911:154) the roles of house-identified sculptures similarly: "*Bocie* in front of the house . . . are destined to receive . . . all the harm that is intended for the inhabitants of the house which they watch over. There is generally one *bocie* for the master of the house, one for the women, and one for the children." The sculptures to which he is referring are generally of the *kuɖiɔ-bociɔ* type, works believed to ward off danger for various family members by tricking death (or harm) into accepting a rudimentary carved figure instead of a living person.

One of the more unusual sculptures of this type was collected in the Togo-Benin border area along the Mono River in 1901 and takes the form of an equestrian. According to Cudjoe (1969:63), "such figures are fixed into the ground in front of the house where they act as guardians" (fig. 59). As with other *bociɔ* forms, the presence of such a sculpture serves a primary therapeutic role by encouraging a sense of sanctity and safety within the home. The threat of house theft also is addressed in *bo* and *bociɔ* of this type, one work being called appropriately *ajotɔ-bo* ("thief *bo*"). Still other *bo* and *bociɔ* are employed to safeguard family gatherings and ceremonies.[51] Accordingly, both at funerals and at the enthronement ceremonies for a new family head, *bociɔ* and *bo* are a frequent sight (fig. 122).

Objects which are intended to assure safe conduct in one's travels away from home constitute another vital grouping of *bo* works. One such travel aid commonly sold in markets is attached to an individual's keys; this work is believed to guard the person from accidents.[52] Others foreshadow dangers along the way. According to Spiess (1902:317), "'the signpost' *dzo* [*bo*] determines whether a journey can proceed without harm." A work of this type now in the Linden Museum called *agbamase* ("the baggage refuses the destiny") was collected in Anecho, Togo, in 1908 (fig. 48). Another personal protection used with considerable frequency is believed to safeguard one from poisons of various sorts. Rings find particularly important use in this regard.

Yet another grouping of works function by keeping sickness at bay.[53] When illness does occur, additional *bo* and *bociɔ* are sought out and employed in an

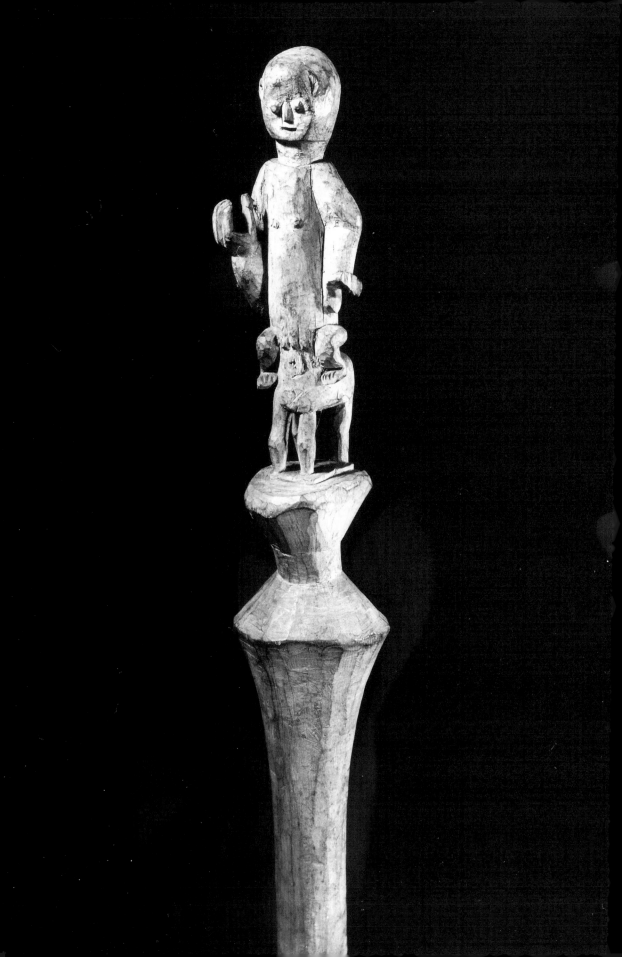

59. Hueda? figure, from the lower Mono River area, Togo. Wood. Height: 75 cm. Inserted in the ground in front of the house to serve as guardian. Collected by von Massow, 1901. Linden Museum, Stuttgart. Gift of Mrs. von Kuylenstjerna. Cat. no. 14 196.

60. Aja male figure from Sagada (near Tado, Mono River area), Togo. Wood, pigment. Height: 71 cm. This work was commissioned when a family member fell ill. According to Cudjoe (1969: fig. 22), "The areas on the figure which correspond to those parts of the body where the sick person is experiencing pain are bound up with cloth which is soaked with chicken blood." The three marks on the left cheek sometimes are found on figures from the lower Mono River area. The diagonal line on the right cheek is a mark of an *abiku*, a person who is in peril of dying soon after birth. Collected by Preil, 1903. Linden Museum, Stuttgart. Cat. no. 28 394. Published in Cudjoe (1969: fig. 22).

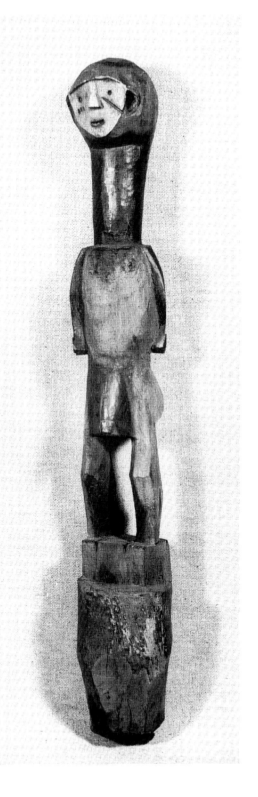

effort to determine the cause and solution. Of one such *bociɔ* it was explained that "if someone is sick, this searches and finds the sickness that the person has" (Alladamabu 6.30.86). Still other types of *bo* and *bociɔ* aid in the treatment of specific medical problems such as stomachaches, head or eye aches, cuts, fever, or venereal disease (Maupoil 1981:143).[54] Répin describes the use of such objects in southern Danhomɛ in 1856 (1863:98): "We saw in a fetish house in Tafoo a large number of ex-voto, fragments of legs, arms, hands, feet, etc., largely sculpted in wood and suspended above the divinity which the believers worship for a cure." Of a sculpture serving this role which was collected in Aklaku, Togo, in 1908 (fig. 60), Cudjoe notes in turn (1969:66), "The figure is known as *Gblogeti,* which is supposed to mean 'one who drives away evil.'" Of another sickness-related work Cudjoe explains (1969:63, 66): "The figure represents illness in general. When a member of the family falls sick a woodcarver is commissioned to produce a figure, which is then sunk in the ground up to the level of its feet. . . . Barren women [also] pray to it for children and pregnant women ask it to protect them at the time of their delivery." Children, as a particularly sickness-prone group, are protected by special kinds of *bo* and *bociɔ* as well. One *bociɔ* of this type called *vi-non,* "mother of children," consists of a number of carved figures placed together in a basket. Another work (fig. 61) was used to help barren women, and once pregnant, to help them during delivery.

Bo protecting individuals and their families from the malevolent effects of sorcery comprise yet another functional grouping (fig. 62). De Surgy writes of such objects (1981a:187): "Protection against sorcerers is one of the most widespread reasons to use [a *bo*]. . . . One hopes not only that it will cure the sickness attributed to sorcerers but especially that it will inflict them with suffering or remorse until they come themselves to avow their faults." Here too one can see the important expiatory role which these cathartic, antisorcery objects perform. Relief from problems of infertility is also a vital concern.[55]

Issues linked to questions of individual aggrandizement, advancement, and aggression are associated with certain forms of *bo* and *bociɔ* as well. As with the works discussed above, these are seen to have significant cathartic functions. If some represent widespread human fears about potential demise, others reflect recurrent fantasies (desires) of success in various endeavors. Among the latter are works believed to attract to oneself both material benefits and people. Rivière explains (1981:196, 201) accordingly that rich and powerful people (ministers, rich trading women) base their powers on charms. They acquire their efficaciousness from a spiritual power. Frequently named *ylo-bo* or "call-*bo,*" works of this type "call" others—wealth, merchandise, lovers, and supporters—one's way. In keeping with this idea, certain of these forms have cowrie shell (the traditional currency in the area) eyes or decorated elements. Rivière describes one such object as follows (1981:182): "[This was] . . . used by young men for girls who resist the former's advances . . . [such works] provoke desire at a distance. The young man calls the young girl he desires by name so that she will join him.

61. Gen figure from Aklaku, Togo. Wood with multimedia surface materials. Height: 122 cm. The teeth are made of cowrie shells; the moustache includes human hair. Several twigs are placed at the back of the neck. A snail shell is suspended from a cowrie necklace placed around the neck. This work, called variously *gblogeti,* "one who drives away evil," and *kokopim* (meaning unknown), was employed both by barren women in prayers for children and by pregnant women seeking protection during delivery. Collected by A. Leix, 1908. Linden Museum, Stuttgart. Cat. no. 57 065. Published in Cudjoe (1969: fig. 23).

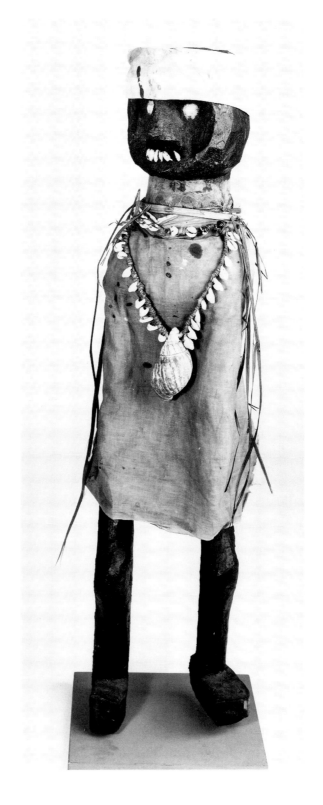

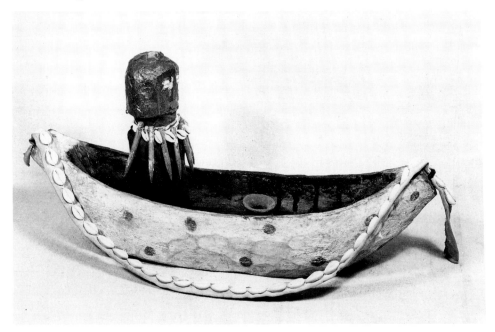

62. Gen? figure from Togo in the form of a figure and canoe. Wood, cowries, cloth, pigment. Length: 59 cm. A small clay pot is positioned next to the figure. This sculpture was used to protect individuals from witches and other malevolent forces. Linden Museum, Stuttgart. Cat. no. 57 074. Published in Cudjoe (1969: fig. 28).

Another called *hudvi* is a piece of cloth containing perfume which obliges the person who touches it to feel like giving a gift."

Effective use of call-*bo* frequently encourages one's competition to commission counteracting forms. Agbanon explained accordingly that (2.24.86): "If you have a number of wives and children, or a lot of money, or if you found the money to buy a motorbike, and you passed a neighbor while driving it, he might be angry with you, saying 'Look at me, am I still an equal? No. Therefore you are an enemy.' He will then make a *bo* so that you will become poor and will have to sell your motorbike." Dewui's description of works of this type is of interest as well (7.3.86): "With these objects one refuses things. . . . Someone says for example that another person should no longer be able to drive his car. If one makes [this *bo*] and if he continues to drive, he will die. . . . Likewise, when one puts this on the doorstep and one says, this person will no longer come to the house, if he continues to come, he will have problems." In the same way that call-*bo* are able to attract particular benefits, these *bo* or *bociɔ* call harm or problems to one's competitors.[56] As in the above example or others similar to it, we can see the critical role of *bo* and *bociɔ* in neutralizing and redirecting individual jealousy or anger.

Works such as these also are thought to nullify one's opponents in judiciary and related contexts. One object of this type described by Rivière (1981:178)

was used at tribunals "to win one's case." Related *bociɔ* and *bo* are employed to render one's accusers ineffective by destroying their ability to reason and respond and/or by provoking in these people a silence or memory loss. One such Fon work which I was shown was called *su-kpika* ("close the mind") and was believed to remove from a denouncer his or her free will and proficiency in reproving one for wrongful acts. A similar object collected in Aklaku, Togo, in 1908 was described this way: "[It] . . . is called *Dogli* which is the equivalent of 'to eradicate from memory.' The priest prays to *Dogli* on behalf of the person seeking his help that the wicked deeds of the latter might be forgotten before they are discovered" (Cudjoe 1969: 70, fig. 29). During family or court proceedings, works like these provided one with the belief that victory was possible, conferring in this way a confidence which may have both eased one's mind and provided the necessary conviction to argue one's position successfully. Just as other works within the larger *bo* and *bociɔ* category, this object had a vital therapeutic role.

Conclusions

In this chapter we have seen the range of functions, orientations, and forms that *bo* and *bociɔ* assume, each of which adds in critical ways to our understanding of their therapeutic functioning. In this context, the figure itself plays a vital role in concretizing and expressing key cathartic concerns. The belief that objects of this type represent at times both the commissioner and the source of harm is essential to their expiatory roles. Also important is the belief that *bo* and *bociɔ* as activating objects have the ability to encourage, or, it is maintained, even assure particular results. At once aggressive and protective, each such work also assumes a vital role in the expression of deep-seated feelings and concerns. Whether comprised of a roughly articulated pole or an elaborately carved sculpture with a thick encrustation of additive elements, sculptures of this type are objects in which the materials and means of manufacture each have a vital signifying function. Whether placed at the gates of the city or in one's private sleeping chamber, such objects incorporate both the desires and fears of the individual and the hopes and anxieties of the community.

The importance of language in the context of *bociɔ* functioning and meaning also is clear. As suggested here, a close etymological link exists between *bociɔ* and cadavers (*ciɔ*), the latter serving to reinforce in these works a powerful image of potential destruction, pollution, and demise. Not simple materializations of dead bodies, however, these works assume vital psychotherapeutic roles both in propelling the individual on and in harnessing (countering, enclosing) associated fears, whether they are of disease, disempowerment, death, or some other equally debilitating concern.

The multifocal linguistic associations of *bo* also are of interest. Not only does this word suggest important ideas of empowerment and action, but it also, through its link to divination, conveys ideas of efficaciousness and supernaturally

sanctioned results. The identity of *bo* with life-threatening and disfiguring diseases such as elephantiasis and associated feelings and actions of concern and caring are critical to *bo* and *bociɔ* meaning as well. Comparable to fire, *bociɔ* also are associated with both the inception and heat of action and its long-term effects. Offering cathartic relief, such objects enclose and dissipate both related desires and undesires. Like the hidden forest clearing, sculptures of this type are seen not only to comprise a rich and diverse array of materials and agents identified with the wilderness, but also to function as a sort of meeting place (crossroads) between the spiritual and human realms. As objects of emotional displacement into which emotions are at once transferred and transfigured, *bo* and *bociɔ* take on a psychological signification of great potency. As materializations of personal tragedies—both real and imagined—these works reveal the power of emotional expression and the striking therapeutic potential of associated arts.

Bodies and Being: Anatomy, Anamnesis, and Representation

"The body is similar but the stomach is different" (Humans share the same anatomy, but each person's interior is unique; *wutu ɖo kpɔ xo mɛ ɖo vo*).
—Fon saying

"The body is a subsidiary thing which bears on the mind that is its meaning."
—Michael Polanyi, "The Body Mind Relation"

Anatomical discourse is grounded in concerns not only of bodies but also of being. Among other things addressed are questions of how, what, and why bodies reveal. Associated inquiries confront issues of exterior and interior and surface and depth, self and other, for bodies represent the interface between individuals and the outside world. Ideas pertaining to bearing and being also are important, for they too are centered on concomitant concerns with the externalization of what lies within and the internalization of what remains outside.[1] Following Kant and more recently Derrida (1987:63),[2] the body can be understood as manifesting essential qualities of a *parergon*, a hybrid of inside and outside. This chapter, through its joining of issues of anatomy and expression, takes up a range of questions concerned with body signification.[3] As Montilus explains for the Fon (1972:5), "The body occupies a central place. . . . It is the base of all one's reflection about the person."[4]

Fusing standard dislocations of body and mind, the following anatomical and analogical investigation explores the ways in which figural representations convey ideas of the psyche through signifying body features. Presented below is a primal mapping of the body, to use Kristeva's term (1982:72), a semiotic, so to speak, of surface and interior.[5] By emphasizing what Kristeva calls (1980, 1982) the body as *chora*, or "receptacle" (a term borrowed from Plato in reference to the often mysterious, invisible, or formless element around which signification is made), I bring to the foreground issues of invisible strength with respect to ideas of individual empowerment in the *bociɔ* arts. As Anita Jacobson-Widding notes (1983:371), "The human body is a powerful medium of expression of both inner, personal states and social relationships." Clearly bodies (and associated representations in art) are a vital means of conceptualizing and conveying social and psychological experience.[6]

Questions of the cultural definition of the body in sculptural representation are particularly interesting in *bociɔ* arts because of the primacy given to figural

anamnesis (from the Greek *ana*, "again," and *mimneskein*, "to call to mind").[7] Associated artistic representations in other words are more concerned with what the mind sees than with what the eye may see. Reflecting the above, body and being often are conveyed within related works through various types of abstraction or distortion, with certain physiological parts being diminished, aggrandized, or in some other way modified in conjunction with different qualities or features of emotional investment. Anatomical anamnesis in this way suggests a representational complement to what Melanie Klein calls "part-objects," in reference to body features or organs which are set apart in the mind and psychologically valorized. Because of the importance to this discussion of the social conceptualization of the body, key body complements—nakedness/dress, coiffure, posture, and gesture—also are examined.

Physical Countenance and Psychological Expression

The body (*wu, wutu, u, utu*),[8] Pazzi explains (1976:146), for the Fon, Evhe, and Aja, "is conceived as a visible dimension of the human being: the word [body] expresses in this way the exterior of the human, the surface which permits one contact with the reality of the world." Word etymology offers additional insight into body perception. "The body seals and conceals a hidden language, and language forms a glorious body," explains Deleuze (1990:280). In the Fon language, the root word *wu* (*u*) is employed not only to mean body but also as a suffix signifying "against."[9] In a certain sense the body is perceived as a ground *against* which all experience is understood, clarified, and classified (fig. 63). Guédou suggests accordingly that (1985:233) "it is the body that receives and evaluates for us all the signs of the universe."[10] In this quality of body "againstness," we also find a basis for two of the most important elements of *bociɔ* sculptural aesthetics, a concern with strength (*sien*) and force (*hlon hlon*).

These ideas are underscored by a secondary meaning of the term *wu* (body), "to measure." J. M. Agossou notes accordingly (in Guédou 1985:234) that "what we really want to emphasize here is the taking of the body as the measure and the reconciler of all. . . . The body is the first dimension of humans in dialogue with *gbe* [life] understood in the sense of vital space, place or milieu." Stemming in part from the above, the term *wu* also is identified with what Guédou calls (1985:233) "the material justification of existence."[11] Linguistic use of the term *wu* (*wutu, u, utu*) reaffirms this identification of the body with measurement and complementary concerns such as cause, query, quantity, or conundrum. Related Fon words include *do utu*, "because" (literally, "on the body"); *ani utu (dani wu)*, "why" ("which body"); *ze jle u*, "surpass" ("break the body of the measure"); *vɛ u*, "to be difficult" ("do harm to the body"). (See Montilus 1972:14; Agossou 1972:58.) What is of central importance here is the emphasis given to the body as a signifying form through which each person is able to examine and evaluate the outside world. As Derrida has explained more

63. Mahi? male figure.
Republic of Benin. Wood,
miscellaneous additive
materials. Height: 46.9 cm.
Indianapolis Museum of Art.
Cat. no. 1986.86. Gift of Dr.
and Mrs. Wally Zollman.

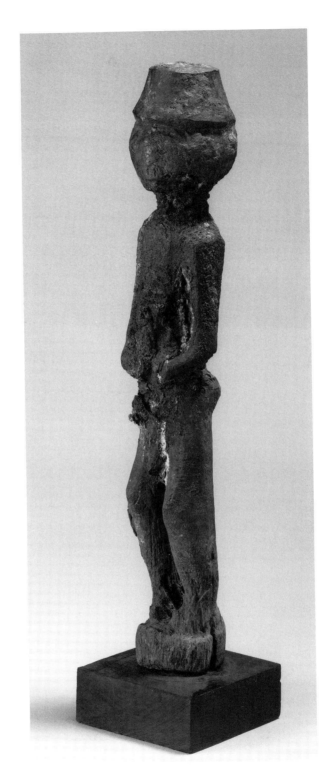

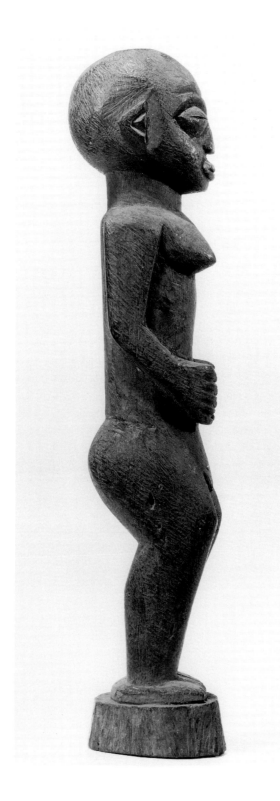

64. Fon *kuɗiɔ-bociɔ*. Female.
Abomey, Republic of Benin.
Wood. Height: 37 cm. Placed
in front of the house to
safeguard it from danger.
Collected by Merlo in 1928.
Musée de l'Homme, Paris.
Cat. no. M.H.30.21.15.

generally (1987:140), "This primary . . . measure proceeds from the body. And it takes the body as its primary object. . . . *It is the body which erects itself as a measure*." As we will see, this feature of the body also is of vital concern in the *bociɔ* arts.

The view that the body serves in part as a measure against which reality is evaluated carries with it important aesthetic signification. In its form and features, the body is frequently compared by the Fon to a gourd,[12] the object which serves both as a primary symbol of life and as the principal measuring means of traditional markets and religious activities. Grain, oil, nails, beer, eggs, and cloth are among the many things that are often measured, served, displayed, or presented in gourd-form vessels. In ritual contexts, in turn, one frequently says "bottle" gourds (*go*) and "bowl" gourds (*ka*, calabash) in reference respectively to male and female children. The importance of gourd imagery vis-à-vis the body also is expressed in terms of particular body features. Pazzi notes accordingly that (1976:180) "the word [for haunch] is the same as for gourd. This protrusion is identified as the gourd of the body." So too, the Fon term for fontanel is *ahonkɛ*, "gourd of the brain"; ankle is *afogo*, "gourd of the foot"; elbow is *awagoli*, "small gourd of the arm"; throat is *gbego*, "gourd of speech"; Adam's apple is *vego*, "bitter gourd"; buttocks are called *gogo*, "real gourd." A wealthy woman (one with large buttocks) is identified as *gogonon*, "possessor of the real gourds." A pregnant woman is called *adogonon*, "mother of the stomach gourd."

Not surprisingly, gourd shapes also are an important feature of *bociɔ* body aesthetics (fig. 64). Such shapes characterize not only the haunches, heads, ankles, elbows, and buttocks of many figures, but also the calfs, biceps, and breasts. As Brand explains with respect to the latter (1981:8): "The calabash shape distinguishes breasts which belong to the category of new breasts called *anonkouin*, signifying 'breast seed.' . . . This form of breasts corresponds to the state of the young girl at the onset of menstruation." Body aesthetics in this sense are closely identified with the view that the body (like the gourd) serves as a paradigm with which and against which all experience is measured and compared. And as we will see below, the body functions as a means through which individual feelings about the world are defined and expressed.

Wu (u), the Fon word for body, also has important ancillary linguistic associations which add to our understanding of body aesthetics, particularly with respect to psychological expression. In the words of Kossou (1983:43): "As the place of physiological reactions, the body is also the foundation and the revelation means of complex phenomena which derive from the psyche." This notion is expressed in the use of the word *wu*, in certain contexts, to mean "impaired because of apprehensions" and "guilty conscience." Important linkages between the body and both the psyche and aesthetic experience can also be seen in common Fon phrases about the body, such as *u ɖo wiwɔ we wɛ*, "your comportment (body) is in the process of betraying you." This is frequently said in reference to people who know themselves to be guilty and who accordingly commit actions

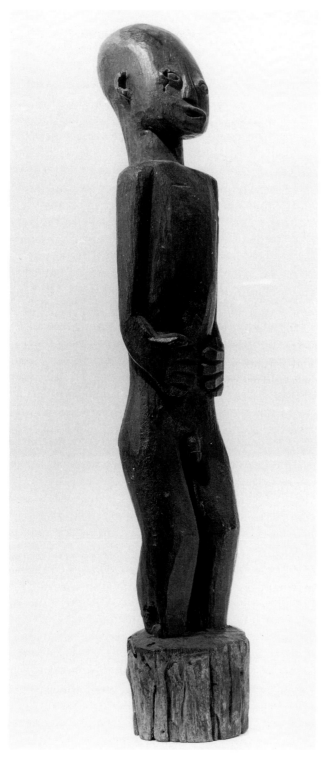

65. Mahi *kuɖiɔ-bociɔ*. Male.
Savalou, Republic of Benin.
Wood. Positioned in front of
the house to distance
malevolent forces. Collected by
Merlo in 1928. Musée de
l'Homme, Paris. Cat. no.
M.H.30.21.3. Published in
Merlo (1977: fig. 13).

which reveal directly or indirectly their faults (Kossou 1983:43–44). The body in this sense plays a primary role in the disclosure and the revelation of inner feelings.

The body also serves as a means for evaluating moral and psychological harm. These ideas too find expression in body terminology. One related phrase observes: "I am not in good form," *u ya mi an* ("the body is not rapid for me"). Another Fon term which suggests the linking of the body with the psyche is "I languish," "I am defeated or sad"*(u ku mi)*, an idiom which translated literally means, "The body *[u]* dies *[ku]* for me *[mi]*." In effect, suggests Kossou (1983:44), "this is the moral state in which one is disgusted with all. . . . The inertia of the body thus reveals for the individual some interior anomaly."

Other meanings of *wu*, Kossou notes (1983:43), reinforce this link with psychological and aesthetic expression. As he explains, the verb *wo* in *wo u*, "to experience apprehensions" (literally "discover the body"), more generally has the sense of "to reveal a secret," "to spring forth," or "to be alarmed." The term *wuji* ("swelling of the body"), Guédou suggests (1985:314), signifies "the shivering . . . the swelling of the pores that convey respect, dread, and fear." That many *bociɔ* incorporate additive materials in such a way as to suggest a severely swollen body is important. What is clear from these examples is that the body is understood not only as a physical presence, but also, and equally important, as an entity of perceptual and psychological significance through which one's emotions and views about the world are projected. Indeed, as Guédou concludes (1985:230), "The term *wutu* or *wu* designates the human body as the visible and tangible part of one's being. It is the body that is the support of all one's spiritual principles." As we will see below, individual body parts also are believed to play an important role in this regard.

The Stomach: Seat of Human Emotions

More than any other body feature, the stomach (*ho, homε, xo, xomε*) is perceived as anatomical and aesthetic bearer of the emotions. Accordingly many *bociɔ* sculptures emphasize the stomach area both through associated gestures (hands positioned on the stomach; figs. 65, 66) and through the location of additive materials. Although the stomach—particularly a large stomach—is also identified with pregnancy (*adogo,* "gourd intestines"), within the tradition of *bociɔ*, pregnancy informs only part of this aesthetic signifier. Of the connection made between stomachs and the psyche, Pazzi notes (1976:144): "The psychological seat of the emotions is the stomach (the intestines). It is there in effect that one feels in full intensity the nutritive sensations (appetite and satisfaction) and those of a sexual nature: the union of these two types of sensations seems to be at the base of feelings of pleasure and pain, goodness and badness, love and hate, for anger is conceived as a 'fire in the stomach.'" Rivière also associates the stomach in important ways with psychological expression (1981:71).

According to him, "it is in the intestines that the secret of the personality resides; this is translated by the words: hidden tendencies." Montilus reaffirms this (1972:12), stating that, "if the head is the granary of thought, the stomach is the reservoir of feelings—joy and anger especially."

This joining of the stomach with the psyche is reinforced in a saying common in the Fon area: "The body is similar but the stomach is different" (*wutu ɖo kpɔ xo mɛ ɖo vo*) (Guédou 1985:230). Another frequently cited Fon phrase, "all

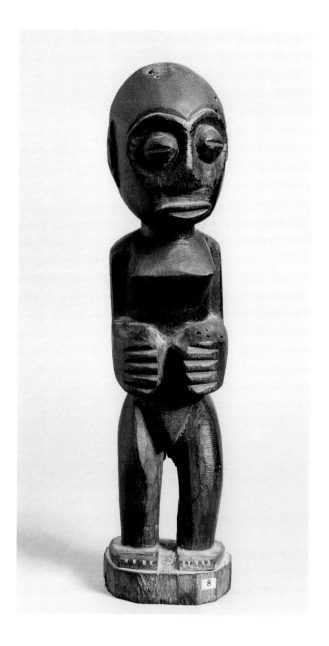

66. Fon *bociɔ*. Female. Republic of Benin. Wood. Height: 41 cm. Wife of a deity, from a shrine. Indiana University Art Museum, Bloomington. Cat. no. IUAM 78.63. Collected by Melville and Francis Herskovits in 1931. Gift of Roy and Sophia Sieber. Photograph: M. Cavanagh and K. Montague. Published in M. and F. Herskovits (1967: pl. 101).

thoughts stay in the stomach" (*nu alin e bi n'i ci xo towe men*), similarly illustrates the association between the stomach and emotional expression (Sagbadju 7.1.86).[13] Or, as explained by Sagbadju (7.3.86) with respect to a *bociɔ* figure, "It is what I will tell him that will rest in his stomach." The frequent depiction of stomachs in sculptures of this type as swollen or distended through the addition of various materials has parallels in an aesthetic vocabulary in which psychological concerns are paramount.[14] Force, disorder, disease, and even fury are suggested by the stomachs of many *bociɔ*, aesthetic values which have clear emotional complements. The image of the stomach as a container for the emotions, however, is not unique to this area, for as Lakoff points out (1987:383–88) more generally, anger often is seen as something which bursts (or is about to burst) from the body. "He was filled with anger; she is brimming with rage; I gave vent to my anger" are but a few of the many complementary linguistic examples in the West.[15]

Among the Fon the emotional primacy of the stomach is expressed most strikingly in the idiom *non hɛn nu xomɛ*, literally "to have the habit of carrying things in the stomach." This saying is employed in reference to the societal ideal of personal discretion. In other words, individuals who are of good character are those who keep feelings and thoughts to themselves. The same term also is used to indicate someone who holds a grudge or does things out of spite or malice. Thus Fon society presents individuals with a paradox or double bind: those people who are respected because they are discrete and are known to keep things to themselves are by definition also the ones who are most likely to harbor grudges and malice. To be correct one must keep things inside, but this causes one to feel enormous bitterness and resentment, feelings which may threaten societal (and individual) well-being. This double bind finds a certain mediation and resolution, through the expression of (and action upon) difficult feelings by way of objects such as *bociɔ* and *bo*. Through sculptures of this type, an individual can at once remain discrete and reveal dangerous emotions out in the open, right on the surface.

The coupling of stomach imagery and the emotions finds additional grounding in everyday actions and ceremonial rituals. For example, people who are in mourning often will tie a cloth around their waists as a sign of the loss they have suffered. During the funeral, in turn, there is a special rite (*n sin nu xomɛ*, "I bound the thing around the stomach") in which gifts of cloth are tied around the waists of persons representing the family of the deceased (Agbanon 2.23.86). In both cases the emphasis given to the stomach is grounded in the desire to express feelings of sorrow about the recent death.

In addition to conveying ideas of sadness and loss, the act of binding the stomach also is identified closely with anger (*xomɛsin*—a Fon term meaning literally "the stomach is attached"). Asked about the relation between the term for anger and the common attaching of cords and other materials around the stomachs of sculptures (fig. 67), Sagbadju noted (7.1.86), "The one who is angry does not do

a good thing; thus the *bociɔ* that is attached is angry. It will not go to do a good thing. It is what you ask in attaching it that it will go to do." [16] Through this visual means we come to understand the important role of *bociɔ* arts in the revelation of ideas of psychological trauma and difficulty.

The link between the stomach and the psyche in both *bociɔ* and life finds linguistic and aesthetic expression with respect to a range of other emotions as well. Accordingly numerous phrases identified with character, personality, and psychological concerns incorporate references either to the stomach (*ho, xo*) or to the intestines (*homɛ, xomɛ*). Among the Fon, terms referring to some of the more positive values are the following (from Segurola 1963:593–94; Pazzi 1976:169):

Generousness, *xomɛ gnignɔn* ("goodness of the stomach")
Contentedness, *e hun xomɛ* ("he has an open stomach")
Peaceful, *fa xomɛ* ("cool stomach")
Friendliness, *xomɛ fifa* ("coolness of the stomach")
Frankness, *e do xomeɛ* ("he spoke from the stomach")
Innocence, *xomɛ vo* ("the stomach is empty")
Togetherness, *xo kple* ("the stomach is assembled")

"Negative" feelings include an equally diverse range of stomach references (from ibid.):

Anger, *e sin xomɛ* ("he has an attached stomach")
Hunger, *xo ve sin* ("the bitter stomach is attached")
Mean spirited, *e ku xomɛ* ("he has a dead stomach")
Apathy, indifference, *xomɛ kuku* ("dead stomach")
Evil, *e gnlan xomɛ* ("he has a bad stomach")
To be in a bad way, *e gble xomɛ* ("the stomach is spoiled")
Viciousness, *xomɛ gbi gble* ("the stomach is corrupt")
Perversity, *xomɛ gnagna* ("the stomach is banished")
Sadness, *xomɛ vive* ("the stomach is bitter")
To doubt, *xo kpon* ("to examine the stomach")

With the Evhe, similarly, a close relationship exists between the stomach and the emotions. As Rivière points out (1980:10): "Language reveals that the stomach, as identified with the intestines (*dɔme*), is the psychological seat of the sentiments. Goodness is called *dɔmenyo*, 'the intestines are good'; anger is *dɔmedzui*, 'fire of the intestines'; likability is *dɔmefafa*, 'coolness of the intestines.'" [17]

Because the stomach is so closely identified with one's feelings, this body part also is referred to frequently in the context of divination (geomancy). As the Fa diviner Ayido noted with regard to one such session (6.6.86), "I consulted this for a woman who had something to say in her stomach." Ayido observed similarly with regard to another consultation (4.25.86) that "the bad things that you

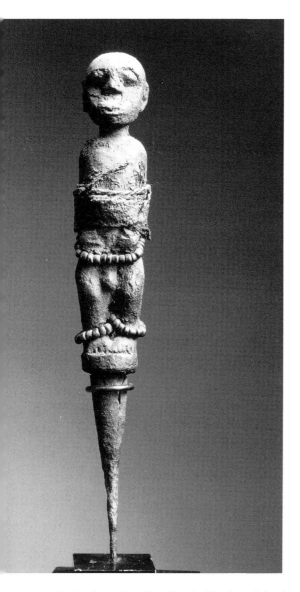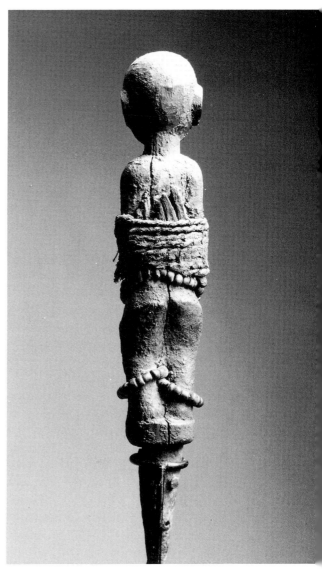

67. Fon *bociɔ*. Republic of Benin. Wood, cord, beads, and miscellaneous materials. Height: 25 cm. Probably collected in the 1960s. Former collection of Ben Heller. Current collection of Don H. Nelson. Photograph: Jerry Thompson, courtesy of the Museum for African Art.

did, none of them can stay in your stomach." During yet another consultation a related exchange was documented (4.28.86):

Diviner: Does nothing remain for you to tell me?

Patient: No.

Diviner: There remains—do you hear?—I say that there is still something in your stomach. It is not only the sexual relations that you should not keep in your stomach . . .

[but also] the person who gave you money [even though] you did not go to his house. You already used his money and you came here and did not say this. . . . This is in your stomach and you did not say this. Fa said that you have something in your stomach. You should have the willingness to . . . tell me a bit now.

Significantly, *atɛ* is the term for both the board used in Fa divination consultation (see fig. 38) and the platters on which market women display food. Explaining the identity of this board, Sagbadju noted (7.18.86), "It is in the stomach of *fatɛ* [Fa *atɛ*] that one consults Fa." Asked about the role of the *atɛ* board, Ayido observed in turn (4.26.86), "If Fa glances over . . . all the words that are in the stomach of the woman, Fa sees them all and begins to say them. As the *atɛ* also looks into the stomach of Fa, *atɛ* will say all that is in the stomach."

As we can see from the above, the stomach is associated not only with one's feelings, but also with their revelation. Rivière suggests accordingly that (1981:86) "to avow one's fault or to confess is 'to render clean the interior of one's stomach' by vomiting verbally that which in one's sentiments has a seat in one's stomach and is aimed at destroying another through murder, adultery, impudence, false witness, calumny, wickedness." Ayido concurs (4.30.86) that "the tongue is there to take the words that are in the stomach and tell them." The Fon phrase *nu do xomɛ dido*, "speaking from the stomach" (literally, "declaration of the words in the stomach"), in turn is used in reference to a type of formal oath-taking (Guédou 1985:266).[18]

Because of the important association of the stomach with the emotions, the taking of oaths sometimes includes the consumption of substances which make one vomit—thus assuring the clarification of what is hidden within one's stomach.[19] In visual terms, *bociɔ* with their mass of additive materials in the area of the stomach suggest a similar image of emotions—rude, messy, and furious—which are brought outside and made visible for the public to see. If, as Deleuze and Guattari argue (1987:151–66), a body without organs—that is, one without fantasy, significances, and subjectifications—is the great human desire, then *bociɔ*—with their surfeit of visible "organs"—convey with striking clarity the depth of feeling associated with human undesire.

Significant too in this regard is the Fon use of the word for stomach, *ho (xo)*, to mean house and room. The relationship between the two is explained by Agbanon (2.28.86): "The room in which man stayed first of all is the stomach. . . . The great house of a person is the stomach." Especially noteworthy here is the complementary emphasis given to the house as a residence of humans and the stomach as a seat of human emotions. In the same way that room interiors are private and personal places which remain necessarily outside the stranger's gaze or physical presence, so too the stomach and its range of emotions normally remain hidden. *Bociɔ* present a quite different image, however, for they often suggest an inverted human in which the deepest thoughts and feelings appear on the surface. These figures comprise both *parergons*, or hybrids, of interior and

exterior and carnival-like conflations of internal and external form. In these works representational concerns with phantasm and simulacrum are similarly linked.[20]

The stomach is also the body feature most frequently identified with acts of sorcery. As Ayido notes (4.26.86), "There are bad ideas [*ayi gnangnan*] that are in the stomachs of certain people that make them savage." Acts of sorcery often are identified with the stomach area. According to Ayido (4.26.86): "The sorcerers insert their hands in your stomach . . . and pull out your intestines. These they eat first of all, and when they do, you will say, 'my intestines, my heart.' . . . When they cut the arteries of your heart, you defecate blood and you will die." Agbanon notes in turn (2.19.86): "If you do not make *bo* against them, the sorcerers will look inside your stomach and will cause diarrhea." With this in mind, as part of the treatment of diarrhea, straw (*sε*—a word which also means "soul," "destiny," and "divine power") is mixed with oil and used as a medication. After this treatment, explained Ayido (5.18.86), "they will no longer be able to see clearly into your stomach."[21] In a tradition identified with similar ends, a grouping of cicatrization marks sometimes is made on a person's chest or stomach. "This is a *bo*," explained Agbanon (3.1.86). "With this cicatrization, the sorcerers will no longer look into your stomach."

Notable in the *bociɔ* arts is the wealth of opaque additive materials placed over the stomach area. These materials can be seen not only as a visual and aesthetic device signifying deep and potentially dangerous feelings, but also as a form of protection intended to prevent sorcerers from seeing into or penetrating the stomach cavity where sorcery-related damage is believed to occur. The Fon term for sorcerer, *kennesi,* also is of significance in that its root, *ken,* expresses emotions (malice, resentment, and rancor) often linked to the stomach. *Bociɔ* aesthetics, which give emphasis to the stomach in this way, reaffirm the importance of this body part in the expression of key feelings of fear, pain, and discord, generally.

On the stomach, the navel (*hon, ahon,* "stem") is identified by many as a passage into the interior of the body.[22] As Ayido explains (3.29.86), "The child is in the stomach and sees the exterior through the umbilical cord. It is for this reason that we do not put a hand on the navel of the woman who is pregnant."[23] As the navel is another locus of emotions and the place for their expression, Pazzi notes (1976:172) that the saying "he looked for the umbilical cord" means "he expressed his thoughts clearly." Le Herissé explains in turn (1911:138) that the messenger and trickster god Legba "stays in the navel where he amuses himself by causing anger. That is why one calls him *hondan,* 'agitator of the navel,' and also *hɔmεsingan,* 'chief of anger,' because anger like joy comes from the stomach, as do pain and pity."[24] That the hands are brought together at the navel in many *bociɔ* figures may be in part a reference to the above.

Emotional and aesthetic values identified with the stomach,[25] whether generally (*ho, xo*) or with the navel in particular (*hon*), find important complements

in the lower abdomen and specifically the kidneys (*ayi, ai*),[26] which are identified as a primary organ of reflection. According to Guédou (1985:259, 261), "The term *ayi* signifies the spirit, conscience, advice, attention, conduct, character, and moral disposition in general. . . . the [*ayi*] is thus the seat of life, reason, and conscience. It is this that permits and motivates our words to flow in conjunction with the impressions one receives of the exterior world." As Segurola explains (1963:28), the *ayi* is the "seat of sentiment, thought . . . conscience, character, and moral disposition."[27] To Montilus, similarly (1972:6) the *ayi* "gives thought to the head. That is why the word *ayi* frequently has the sense of intelligence." Montilus's queries into human body ideation (p. 6) also are of interest: "When one says human, what is human? It is the *ayi* that is human. . . . the psychic force comes from the *ayi.* " Or, as Pazzi points out (1976:168): "The kidneys [*ayi*] are the place of concentration of all sensations which penetrate the body by way of the eyes, the ears, and the senses. In the kidneys are formed one's thoughts that climb by way of the heart to the head, which takes command of all actions."[28]

As with the stomach in general, so too with the *ayi* specifically, language offers additional insight into the signifying roles accorded this body part. Here too there is an important emotional base. The following examples of Fon references to *ayi* are taken from Montilus (1972:7), Agossou (1972:13), and Guédou (1985:258).

> To be nervous, *ayi ce ɖ'aga* ("the *ayi* is above")
> To be vigilant, *ayi ce ɖo te* ("the *ayi* is standing")
> To be calm, *ayi ce ɖo do* ("the *ayi* fell below")
> To be tranquil, *ayi ce j(e) ayi* ("the *ayi* fell on the ground")
> Seek to understand, *ɖ(o) ayi mɛ* ("have the *ayi* in")
> Examine your conscience, *keje ayi towe mɛ kpon* ("search your *ayi* in looking")
> To be careful, *ɖo ayi xomɛ* ("have the *ayi* in the stomach")
> Think of something, *ɖ(o) ayi ji* ("have the *ayi* on")

Because of the close connection made between the *ayi* and the expression of emotion—or thought more generally—the kidneys often appear as ancillary elements in works of art such as calabash engravings, *asɛn* memorial sculptures, and decorated umbrellas. A kidney-form image incised on a calabash sent by a young man to his fiancée is described by Brand (1981:8) as a visualization of the allegorical message "your two kidneys should remain calm." This signifies, according to Brand, "Obey my wishes and you will find me." Commenting on the representation of a kidney on a family umbrella, Sagbadju noted in turn (2.7.86), "Do you go out without your *ayi*? Whenever you go out, you must bring your *ayi* with you." In other words, the *ayi* which is critical to all human action, thought, and memory is with one always. The appearance of kidney-form motifs on the umbrella of a recently enthroned family head prompted Agbidinukun to observe likewise that (5.12.86) "the chief that one enthroned, my thought

(*ayi*) is with him." Of kidney-shaped forms on a family *asɛn*, Agbidinukun asserted similarly (2.14.86), "Our parents who are dead, we always think of them." These same motifs on another family *asɛn* were explained by Adjaho (7.30.86): "This says the child should have his *ayi* and do something for his father." [29] While the kidneys per se appear infrequently in *bociɔ*, their inclusion in other arts identified with the individual and the references made to them through the emphasis on the stomach generally suggest how important they are in expressing ideas of body and being.

Genitals, Buttocks, Back, Chest, and Neck: Midbody Ideation and Expression

The genitals, buttocks, back, chest, and neck also offer critical insight into essential links between physiology, psychology, and aesthetic expression. Together these body parts reinforce striking interconnections between anatomical conceptualization and perspectives of self. As we will see below, the genitals are equated not only with fertility and reproduction, but also with insult, impotence, infertility, trickery, sorcery, and deception. The buttocks similarly are identified with capability and capacity on the one hand, and poverty and distress on the other. With the back, mobility and movement are essential values, but so too are misery and misfortune. The chest in turn is linked to counterposing concerns such as courage, strength, tranquility, and sorrow. The neck, for its part, is identified in important ways with work and fatigue as well as support and stability.

Turning our attention first to the genitals (*sɛli*, "the path of *sɛ*"), Kossou suggests (1983:45) that this body part is associated closely with ideas of individual potential and empowerment (figs. 68, 69). Montilus notes accordingly (1972:12) that the male and female genitals are perceived as "the place where the forming of humans occurs, where one gives life to someone." Both male and female genitals are perceived as powerful and potentially dangerous. The Fon word for penis is *ne* (*ne kuin*, a term which in a modulating instead of high tone serves as a negation); for vagina, the term is *yo* (*ayo*),[30] a word frequently used as an insult (Pazzi 1976:172). As Agbanon notes (2.21.86), the woman's genitals are "more powerful than a *bo*." The ancillary meanings of the word *yo* also are of interest, for the term additionally is used to mean inertia, tomb, glutton—ideas linked in important ways to *bo* and *bociɔ* as well as sorcery. Yet another word employed in reference to the vagina is *minona*, the name of the powerful deity of both witchcraft and motherhood (Agbanon 2.21.86; Ayido 7.13.86). As Sagbadju explains (7.10.86), "It is a woman's sex that is sorcerous. It is by there that man passed to come into the world; it is by there also that man returns into her stomach [when having sex]." [31]

Paralleling the vagina's link to the god of witchcraft and motherhood, the penis is associated with Legba, a deity of trickery, communication with the gods, and sexual potency (Ayido 2.21.86). Erect phalluses distinguish this latter deity's

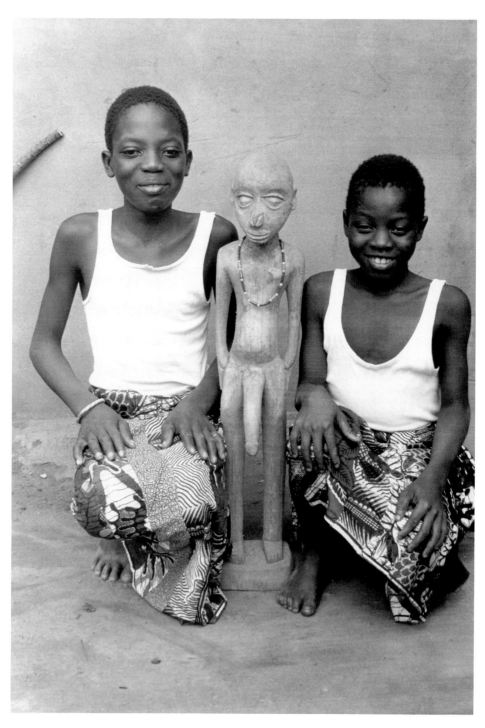

68. Children of Atinwulise, Sagbadju with *bociɔ*. Artist: Benoit Houndo. Abomey, Republic of Benin. Photograph: Suzanne Preston Blier. July 2, 1986.

69. Fon female *kuɖiɔ-bociɔ*.
Republic of Benin. Wood.
Height: 37 cm. Abomey style.
Placed in front of the house to
stop malevolent forces.
Collected by Merlo in 1928.
Musée de l'Homme, Paris.
Cat. no. M.H.30.21.15.
Published in Merlo (1977:
fig. 1).

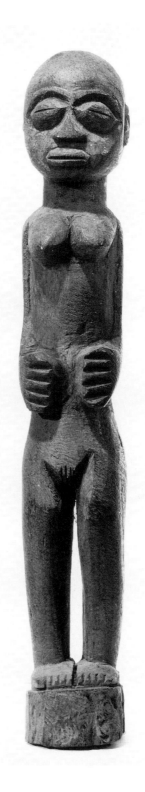

shrines and ritual objects.[32] Like the vagina, the penis has a range of important associations in this case, not only with human creation, communication, and sexuality but also with the road that each person travels through life.

Bociɔ sculptures vary considerably with respect to the amount of attention (and proportional size) given to the genital area. In some, emphasis is minimal. Ayido explains (5.5.86) that "if we want to make a woman, we carve a line between the legs. If it is a man we make a line like the penis." In some, sexual references are excluded altogether even though the figure itself may be identified as male or female (Cudjoe 1969:63–64). With other *bociɔ*, the genitals are shown enlarged, and in the case of the penis, erect.

Are these differences in genital representation significant? On the one hand, enlarged (or negated) genitals may allude to fears concerning infertility, sexual inadequacy, and impotence. Accordingly, Sagbadju suggests that within the *bociɔ* sculptural tradition an erect phallus serves to encourage erections (7.3.86). On the other hand, erect or enlarged genitals may refer to the trickery, deception, and danger that life holds. The latter finds primary grounding in the identity of the genitals as signifiers for the deities Legba and Minona, the supernaturals most closely associated with human trickery and malevolence. Anxiety in this sense also is addressed through the emphasis or deemphasis of the genitals in sculptural representation.

Like the genitals, the buttocks (*gogo*, "real gourd"; *go:* gourd, bottle, anus) also are important body signifiers having clearcut psychological grounding. Owing in part to their prominent gourdlike shapes (and name), this body feature frequently is linked at once to individual beauty and to ideas of capability and capacity. With respect to the former, a ceremonial Ahanbiba song recorded in Abomey notes (2.14.86) that

> You did the dance well
> You have beautiful buttocks.
> Look, look—she has arrived—
> The beautiful woman.

The buttocks, the above suggests, constitute a critical part of an individual's physical attractiveness. At the same time, as an extension of the back, the buttocks also are identified with body movement. Stemming from the above, they have come to represent important values at once linked to life course, well-being, and moral bearing. Large buttocks as noted earlier serve as signifiers of plenty (Pazzi 1976:180). Thus a well-off woman, one who has aquired economic autonomy, often is called *gogonu* "mother of buttocks." In contrast, the dragging of one's buttocks on the ground, Pazzi points out (1976:180) "is a sign of extreme distress." Within sculptural traditions, emphasis given to the buttocks varies. In some *bociɔ* they are hardly designated; in others they are shown to be full and fleshy. However they are conveyed, buttocks suggest the profound desires (for well-being, plenty) and fears (of poverty, distress) of individuals within this cul-

tural area. Here too we can see the importance of an aesthetic grounded in emotional expression.

The back (*nɛgbe, nɛngbe*) reveals a concern with different features of psychological and aesthetic expression. This part of the body is linked to key temporal, spatial, and interpersonal values—both to external forces or individuals that affect one's life and to each person's own past and ancestry (i.e., that which lies behind or in back) (Pazzi 1976:145). As Agbidinukun explained in a ceremony honoring a deceased family member (7.4.86), "The person is no longer here; we are honoring his back" (fig. 70). A royal sculpture associated with King Gbehanzin (1889–94) thus incorporates the image of a palm tree on the back of its base, a reference to this King's ancestral sponsor (*jɔtɔ*), the ruler Agonglo (1789–97). Like the stomach, genitals, and buttocks, the back also is associated with a variety of other concerns, ranging from movement and activity to misery and misfortune. Accordingly, Pazzi suggests (1976:144–45) of the central back vertebra (*tu*) that "this vertebra is the only point of the body which, in dance, remains immobile; as such it is the center of action from which propulsions leave in harmonic movement to all the other members. . . . the central vertebra is thus . . . a bit like the symbol of one's interiority." Because of its association with both mobility and the emotions, in certain *bociɔ* a thin line is incised down the center of the back to indicate this body feature. The lumbar area at the lower back (called *alin*) also is coupled at once with movement and expression. *Alin*, a term which additionally means "road" and "path," by extension, is linked to life course and moral bearing (Pazzi 1976:169). Rivière notes (1980:10 and 1981:71) that "from the lumbar region comes the capacity for action and expression."

In other contexts, the back is identified with personal difficulty. According to Ayido (4.30.86), "*Aovi* [*ahovi*, misfortune] rests at the back of the person." In his words (4.30.86), "Bad things are passed to one from behind." [33] Likewise, the gesture of placing one's hands behind the back of one's head is a common sign of sorrow. [34] As Agbidinukun explains (5.3.86), it is during the funeral that "you will do this [gesture] as you go up to the tomb while crying." For the Fon and Evhe, as in many African cultures, the back additionally is associated with a variety of antisocial actions. To do something behind someone's back is seen to be the equivalent of taking an action against that person. Perhaps in part for this reason, considerable emphasis is given to the back, like the stomach, in the inclusion of additive materials. In Janus figures, which are often associated with sorcery and overt political power, this is particularly striking. In the delineation of the back, the psychological grounding of *bociɔ* aesthetics here too is much in evidence, with related body treatment serving to express a range of emotional values and concerns.

Like the back, the chest (*akɔ, akɔn*) also serves as an important focus of psychological and aesthetic attention in the *bociɔ* arts. Because it is closely identified with the heart, the chest is frequently viewed as a locus of life. [35] As in the West, so too here, a number of emotions are associated with the chest and heart areas. Pazzi notes (1976:163) that the Evhe term for sorrow is "the pain tightened

70. Back of fig. 83, a Fon royal *bociɔ* identified with King Gbehanzin (1889–94). Wood. Height: 54 cm. Abomey, Republic of Benin. Artist: Samissi Houndo? Note the line incised down the back. The palm tree at the base is a reference to his ancestral sponsor, King Agonglo (1789–97). (Same as fig. 83.) Indianapolis Museum of Art. Cat. no. 1989.682. Gift of Mr. and Mrs. Harrison Eiteljorg.

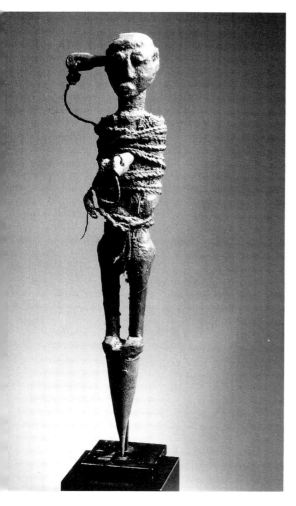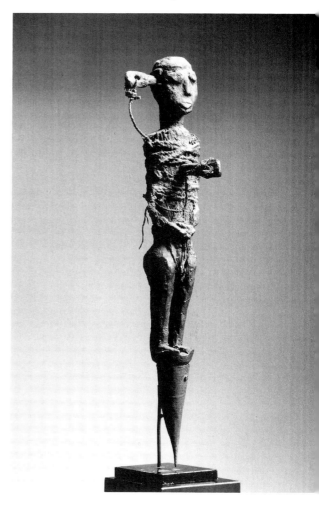

71. Evhe-Ouatchi figure. Togo. Wood, cord, and miscellaneous materials. Height: 41 cm.
Wooden pegs are inserted into ear and chest. Probably collected in the 1960s. Former collection of
Ben Heller. Current collection of Don H. Nelson. Photograph: Jerry Thompson, courtesy of the
Museum for African Art.

around my chest" (*vevesese tu akɔ na*). The Evhe indicate tranquility with the
term *ji je eme nam* ("the heart is seated in me") (Rivière 1980:10). Among the
Fon one says *ku hun*, "dead heart," to express the idea of patience, calmness, or
tranquility (Bokpe 5.29.86). All these terms have striking visual potency when
viewed in relation to the large grouping of sculptures in which the chest area is
pierced with pegs (fig. 71) and/or bound tightly with cord and other materials.[36]
The breasts (*ano, anon,* "mother," "nursing") that are portrayed in the female
bociɔ works[37] suggest the special nutritive function of the breasts.

While gestures which make reference to the chest are rare in *bociɔ* arts, the
importance of such gestures in life offers us further insight into the role of this

body area as aesthetic and psychological signifier. Courage and strength of purpose are particularly identified with such gestures. Ayido notes (5.18.86) that when throwing kola nuts to ascertain the gods' accord for a particular action, one places one hand on the earth and the other on the chest in a gesture signifying "have courage, do not be afraid." Of another gesture which was created by placing the hand on the chest in the context of a ceremony for the *vodun* Gu, Ayido observed (4.28.86) that it signifies "Do not be afraid." The song phrase "I will tap my hand on my chest" in turn indicates the idea of firm promise (Agbidinukun 7.4.86). Gestures associated with the chest reinforce the idea that this body part is identified at once with courage and commitment, concerns which complement emotional responses to fear and loss.

As noted above, a number of sculptures emphasize the chest through the addition of supplementary materials which draw our attention to this body area through visual references to binding, restriction, or tightening. Comparable contexts of chest binding in life offer added insight into the meaning of associated forms of body constriction. In some cases, chest tieing or attachment conveys important ideas of relational bonds, in particular, marriage or devotion to a *vodun*.[38] Characteristically both married women and male or female devotees of a deity will wear some form of cloth wrapped or tied around their chests. As Agbanon notes (1.3.86), "*The vodunsi* [devotee] . . . is already married; his breasts must not be naked." The binding of cloth or cord around the chest of a sculpture in this way underscores deep-seated emotions such as attachment (or fear of loss) as well as related anxieties about courage and tranquility. This type of figural bondage may also serve as a signifier of the strong relationship which has been established between a given sculpture and its owner. At the same time, within this sculptural tradition, the attachment of cords or other materials around the figure's chest also makes reference in a more general sense to the often highly charged emotional difficulties which such objects address. Through related aesthetic expressions, these sculptures implore one to remain calm.[39]

Extending at once from the chest and the back, the neck, called *kɔ* ("load" or "faggot"—a reference to the role of the neck in supporting heavy weights carried on the head), conveys other values essential to a sculpture's role as aesthetic and psychological signifier. This body part is especially linked to ideas of work, physical labor (fatigue) and support. Accordingly as Pazzi explains (1976:159), the Evhe expression *ede kɔce ji,* "it is on my neck," means "it is work for me."[40] So too, the Fon word for tiredness, *nucikɔ,* translates as "the thing remains on the neck." The necks portrayed within *bociɔ* generally are carved in the form of cylinders of varying lengths and thicknesses which serve both as solid supports for the head and as a means of uniting the head with the rest of the body. Sometimes exaggerated in length or width, the neck in these sculptures is identified with the physical difficulties that accompany one through life. In this sense too, the neck adds to our understanding of the important expressive issues that *bociɔ* sculptural aesthetics address.

The Head: Seat of Commandment and Authority

Additional insight into *bociɔ* aesthetic and psychological concerns can be gained from the representation of the head (*ta*). The prominence given to the head within these sculptures both in terms of surface elaboration and with respect to proportional size underscores its centrality in body perception, specifically as identified with notions of success, power, and individuation. Within the head certain features are given special emphasis; most important are the fontanel, forehead, eyes, ears, nose, and mouth. The fontanel (occiput, *ahonka*) is identified closely with the soul and the spiritual nourishment of life. The forehead is linked to individual destiny and fortune. The eyes, it is believed, offer protection and play a part in the revelation of feelings. The ears signify public knowledge. The nose, through its association with breathing, is linked to life and the protective powers of smell. The mouth is identified on the one hand with well-being, and on the other with such variant attributes as speech, discord, interdiction, hypocrisy, and disease.

Of the head as a whole (fig. 72) Pazzi notes (1976:148) that this body part "is the seat of commandment, . . . the symbol of authority in the society." Kossou observes similarly (1983:44): "The head (*ta*) is the seat of thought and reflection; it is the first part that distinguishes the individual. . . . it is by here that the individual receives thought." The head, as the above suggests, is identified closely with ideas of thought, control, and expression.[41] As Rivière explains (1980:9): "The head (*ta*) [is a] social symbol of authority; one covers it as a sign of dignity and wealth. . . . one uncovers it in front of a superior." In language, this connection also is conveyed clearly. Guédou cites (1985:264–65) several related proverbs: "If my destiny is powerful, my head is powerful"; "If my head is living, the thing will come to pass." Good fortune is associated with the head as well. The Fon say accordingly "the good head" (*ku ɖo ta gnignon*) in praise of one's accomplishments (Agbidinukun 4.7.86).[42] So too, "to find the head" means "to achieve the goal that you set out for yourself" (4.28.86). The term "money will have a head" exemplifies the connection between the head and success, for it is employed to mean that one will acquire a considerable amount of money.[43] Gilli notes in this regard (1982a:3) that "The head of an individual also is considered *vodu* because it is thought of as the seat of power and *vodu*. Especially in the case of a *vodusi*, to hit his head or to make him bleed is a violation (*gble*), a dishonor. Afterward he is obliged to submit to a ceremony of purification to regain his identity as initiate which had been lost through this sacrilege."[44] Many *bociɔ* give disproportionate emphasis to the head in relation to the rest of the body. The enlarged head serves to underscore the important valuation of this anatomical part for individual well-being. As with other body areas, pegs or other materials sometimes are inserted into the head, or cords are added to its surface to suggest particular problems. According to Savary (1971:4), such actions signify "the victim's loss of consciousness and memory." At the same time

72. Fon *bociɔ*. Republic of Benin. Abomey style. Wood. Height: 34 cm. Collection of Ruth Franklin.
Facial markings on the temples identify the work with both blacksmiths and royalty. Diamond-shaped
mark on the cheek may signify an *abiku*. Photograph: Marc A. Franklin. Collection of Marc and Ruth
Franklin.

73. Gen figure. Togo. Wood,
cloth, glass beads. Height: 20
cm. Collected by Michael and
Shirley Furst, 1965–68.
National Museum of African
Art. Eliot Elisofon Archives.
Smithsonian Institution. Cat.
no. 68.3.32a. Gift of Michael
J. Furst. Photograph: Franko
Khoury. 1992.

additive materials applied to the head also are identified with fears involving
one's activities, accomplishments, and fortune.[45]

Key anatomical features within the head which are given special ritual and
artistic emphasis also offer insight into *bociɔ* meaning. According to Pazzi, the
most important section of the head is the summit or fontanel (fig. 73) (1976:147–
48):[46] "It is there in effect where the seat of the soul resides. Never does one hit
this privileged place. . . . One says that sorcerers take possession of the soul of
an individual by passing the hand over the summit of his head.[47] That is why the

gesture of posing the hand on the head of someone is very suspect, especially when it is a stranger who touches the head of a child." Rivière notes similarly (1981:70): "The summit (fontanel) is the place of maximum retention of vital dynamism of the heart. It is forbidden to hit it and one suspects sorcerous action of a stranger or a bad-intentioned neighbor who passes the hand over the head of an infant." Underscoring the association of the summit with life and vital force, in the past a round coiffure was made on the fontanel of an infant because, it was believed, through this hole the infant ate while in the womb.[48] In a related sculptural tradition, Herskovits notes (1967, 2:280) that a number of bociɔ have holes in the top of their heads where they are fed. Merlo observed a related tradition (1966:22): "We found at Abomey itself bociɔ of large size in which the summit of the head or occiput was dug with a cavity destined to receive medication. The orifice was obscured with a cover posed on the curve of the head, and maintained by a piece of iron of local fabrication." The fontanel can be seen in this way to play a similar role in sculpture and in life.

The forehead (nukon, "chin of the eye") also is given important emphasis in life and art, since this is the part of the head most closely associated with one's destiny and fortune (Ayido 3.29.86).[49] Accordingly, the yε powder taken from the Fa divination tray is placed on the foreheads of individuals participating in certain Fa-related ceremonies as a means of encouraging the dissipation of misfortune (Ayido 4.30.86).[50] This same powder is placed on the foreheads of many bociɔ sculptures (of the kuɖiɔ-bociɔ and Fa-bociɔ [fo] genres especially) as a means of empowering them and assuring that particular associated problems will be resolved.[51] It is probably the connection between foreheads and destiny which warrants the considerable emphasis on the forehead in many bociɔ sculptures. Occasionally this area also is pierced with pegs (see fig. 32).

The attention given to the face in bociɔ arts offers additional insight into the psychodynamic roles that these sculptures fulfill. According to Kossou (1983:106), "The face is for the Fon a mirror of the soul; one can see there the lies and the embarrassment." What Kossou is suggesting here for the face is said to be particularly evidenced in the eyes (nukun). In the words of Rivière (1981:71), for the Evhe "the eye reveals one's emotions."[52] The eyes serve a critical role in bociɔ signification for this reason. As in life, so too in sculpture, this body feature constitutes a means through which the world is apprised of potential threats to the individual. Sagbadju explains (7.18.86) that "the eyes [of bociɔ] are large because the eyes must look all over."

Important to this feature as well is the identification of the eyes with each individual's protective spiritual counterpart (yε). It is said that one's yε spirit is visible as a reflection on one's pupil. With this in mind, often the eyes of bociɔ sculptures are demarcated with an incised horizontal line—a reference in part to the yε and to its protective powers[53] (fig. 74). Both the prevalence and the importance of this eye treatment suggest how vital the concept of the yε is to each person's identity and security. A cap incorporating an appliquéd eye was ex-

plained by Agbanon this way (2.27.86): "The hat can be destroyed by a hand, but you cannot destroy the *yɛ*." The *yɛ*, that part of each person that guards one's well-being, in other words, will protect one always. In addition to having an identification with the *yɛ*, the horizontal eye line on many Fon *bociɔ* appears to be a reference to sleep or death, for it recalls the line of an eye which has been closed or shut with its upper and lower lids joined. (Sleep, it should be noted, frequently is used here as a euphemism for death.) In this association, the horizontal, closed eye line of *bociɔ* visually reinforces the etymological links between these sculptures and cadavers (*ciɔ*). Related eye forms also may allude to cowries, the traditional currency of the area (fig. 75).

As with many other body parts, the eyes of certain sculptures are bound with cloth or cord. Agbidinukun explained of one work in which a cloth was bound tightly around the eyes (7.10.86), "It is like this that we treat someone who speaks poorly of the king. We put a cloth on his head; we hide him, so that no one will see him again." The binding of the eyes in the above example serves as a poignant reference to the individual's forthcoming death. In other cases, the covering of eyes in this manner is seen as a protective act signifying, according to Ayido (5.2.86), that "no bad thing will look into my eyes."

The depiction of eyes in non-*bociɔ* art contexts also adds to our understanding of eyes and the roles they play in expressing emotions.[54] With respect to a finger ring showing a pair of eyes, Agbanon noted (3.7.86), the eye motif indicates that "my eyes are on your door"—in other words, "I hope to see you." In a calabash engraving the image of eyes signifies "my two eyes will be on you," denoting accordingly "a protection and absolute devotion in life" (Brand 1981:8). An *asɛn* showing an eye was said similarly to convey feelings of longing, signifying in this case, "If I wake up and I am still looking with my eyes, your name will never be lost in the world" (Ahanhanzo 8.12.86). For the presence of eyes on a royal door, Nondichao observed in turn (10.22.85), "If the enemy comes at night the eyes see," that is, the eyes protect the state.[55] In these diverse arts, as with the *bociɔ* sculptural tradition, the eyes offer insight into the variant ways in which this body part is associated with feelings, in particular those of hope, longing, and vigilance.[56]

The ear, *to* (a term which also means "to the side" or "at the end"), for its part is identified with ideas of boundaries and the interface between person and public. This is based on the role of the body (*wu*) as ground against which space in its various dimensions is delimited. Things, places, or persons that are beside one thus are compared to ears. In part for this reason, a low tonal variant of *to* (in contrast to the high tonal form designating "ear") is used to mean "people," "town," "city," "country," and "alignment," suggesting perhaps ever increasing rings of relational "besideness." So too, the idom *Kpe to*, "to fill the ear," means "to spread all over," indicating that news has reached many ears. Like the mortar (another word designated by *to*), sound is believed to have the ability to travel far both on its own and through the aid of humans. Certain character traits also

74. Gedevi-Fon *kuɖiɔ-bociɔ*.
Female figure. Bohicon area,
Republic of Benin. Wood,
cloth. Artist: Toboko.
Photograph: Suzanne Preston
Blier. December 18, 1986.

75. Fon. Abomey style.
Republic of Benin. (Collected
in Lome, Togo). Wood.
Kneeling female figure with
hands positioned on the
breasts. Fisted hand surmounts
the head. Said to represent
vodun priestess. The same
artist carved the figure in fig.
119. Donation: R. P. Wild.
British Museum, London. Cat.
no. 1937.4–16.3.

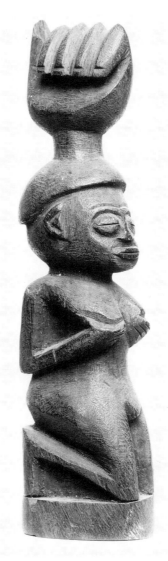

are associated with the ears. Someone who is attentive or listens well, for ex-
ample, is called ɖoto, "with ear." The term "dead ear" (*ku to*) in turn, is em-
ployed in reference to one who does not obey or listen to counsel. Someone with
a "hard ear" (*tri to*) is stubborn. Similarly, when someone does not heed what
one is saying, one frequently uses the idiom *ali non yi to towɛ me a*, "the road
does not go to your ear." Although the attention paid to the ear varies enor-
mously, in even the most basic *bociɔ* carvings, a hole often is cut into each side
of the head to suggest this important body part. Sometimes pegs are inserted
in the ear (fig. 71) of a sculpture intended to prevent another from hearing of
one's acts.[57]

The nose (*ahontin, awontin*) also is identified with a range of physiological and characterological concerns. In a general way the nose is associated with breathing (as an extension of this, health and vigor), but also with the protection afforded one through the sense of smell. One of King Guezo's (1818–58) subsidiary royal names refers to this body part because of its association with well-being and contentment (Agbidinukun 7.24.86): "Nose, it is you that is the happy part of the body," meaning that when Guezo arrives, all the country breathes easily. Of the appearance of a carved nose on a palace door, Nondichao noted (10.22.85) that "when the enemy comes at night the nose smells the odor." The nose, in this context, assumes a similar function to the eyes in guarding the palace. The aesthetic concerns expressed by the nose within *bocɔ* sculptural traditions have similar grounding in the importance of breath, life, and the body's protective olfactory functions.

Like the nose, the mouth (*nu*) is linked by many to ideas of breath and well-being. Accordingly, the gesture of putting a hand on the mouth, Agbidinukun suggests (7.4.86), serves to signify that "the mouth cannot breathe," and frequently is employed as an expression of shock or surprise. Speech, *gbɛ*—a term which also means life—is associated, not surprisingly, with the mouth as well. Rivière observes accordingly (1981:71) that "the mouth is appreciated as much as an organ for consumption as it is an organ for the emission of speech." In Kossou's words (1983:44), "The mouth permits food consumption but more importantly speech . . . and in turn communicates with other members of the society for good or bad." Pazzi suggests similarly (1976:156), "In humans, the mouth is the organ of speech, and because of this . . . the mouth also receives its part of honor." As the above suggests, like the eyes, the mouth plays a critical role in expressing various human desires and fears.

The mouth in addition is associated with the mysterious powers of *bo* and *bocɔ*. Thus the idiom "closed mouth" (*nusu*)[58] is employed as a euphemism for death and cadavers (Montilus 1972:17). "Open mouth" (*hunnu*) in turn means response. Montilus explains (1972:10) that "it is by this opening [of the mouth] that the mysterious power (*hlohlo*) is manifested which humans apply to things and by which they act on them and modify them. There is a *bo* called *nudida*— prepared mouth—which is intended to confer magical power (*hlohlo*) to the mouth. It is in this way that one can speak of *bo gbɛ* or . . . [*bo*] speech." Saliva (*nu gbɛ*) which has not been rinsed after a night's sleep is deemed to be an especially powerful attribute of the mouth. The same term, it should be noted, also is used to mean "quarrel" (Rivière 1980:9–10). The linkage between the mouth and *bo* is manifested additionally with respect to the metaphoric use of the phrase "to eat." As Montilus has indicated (1972:13), "To violate an interdiction is referred to in Fon as *su* . . . 'to eat the interdiction.'" Certain illnesses likewise are defined through metaphors of eating. As Rivière notes (1981:88) for the Evhe, "Sickness is conceived of as a force that 'eats.' To speak of a headache one

says *tadu,* 'my head eats me'; a stomachache is *xomɛ ɖu,* 'my stomach eats me.'" The term for "insane" in turn is *taɖunu,* "something eats the head."

Within associated sculptural traditions, the mouth is shown both gaping and closed, the latter generally in the form of a horizontal line or lips portrayed close together with little if any indication of emotive expression. The former seems to recall both the *nukuku* "open mouth," indicating speech which is in some way empowered, and the violation or "eating" of an interdiction. The opened mouth in some contexts also is associated with uncontrollable anger or rage. As Ayido asserts (5.5.86), "When the enraged person sees you he will try to bite you." Illness and sorcery similarly are identified with large, all-consuming mouths. As Rivière explains (1981:88), "Sickness often is expressed in terms of consumption and the language of vampirism identified with the sorcerer." The showing of teeth in the context of smiling has negative associations as well, in this case, with hypocrisy (*yɛmenu*), as evidenced in part by one of the subsidiary names of the lightning god, Hɛvioso (Xɛbioso), a name which translates as "the white tooth laughs and hypocrisy remains in the stomach" (Ayido 8.3.86).

The closed mouth in contrast may suggest a state of composure in the face of danger. At the same time it alludes to death, since the term "closed mouth" is employed as a metaphor for one who has died. As Montilus explains (1972:17), "When one closes the mouth (dies) the *yɛ* [spirit] goes out." According to Sagbadju (7.3.86), in *bociɔ* one carves the mouth this way to depict "a person who does not open his mouth because he is dead." As with eyes, this treatment of the mouth underscores the close identity between *bociɔ,* cadavers (*ciɔ*), and fears of death and demise.

When the mouth is shown bound or blocked in some way, its aesthetic and psychological importance is manifested in other ways. Of a *bociɔ* with a piece of iron inserted into its mouth, Sagbadju noted that "when one puts something in the mouth, this person cannot speak" (7.1.86). Ayido observed similarly for a *bo* made with a monkey skull and crocodile jaw (fig. 99), "They have tied your chin and mouth and you will not be able to talk. It means that when you think of something you will not say it" (5.5.86). As the above suggests, the mouth in its speech capability is seen to be a potentially serious weapon which can be used to thwart individual ambitions or desires. Through visual displays of silencing, *bociɔ* aesthetics convey both the great emotional stress that accompanies the silencing of one individual by another and the desire for the power to control another's ability to speak.

Gesture and Posture: Community Values through Body Movement

Bociɔ portrayals of the arms, hands, legs, and feet are central to the expression of psychological concerns as well, particularly vis-à-vis ideas of empowerment and action. According to Kossou (1983:45), "The arms [*awa*] . . . are instru-

ments necessary for the realization of all activity commanded by the organs."[59] Language use reinforces this. *Ke awa* ("open arm") means to strut or flaunt; *gla awa* ("forceful arm") is used to indicate one who is trying to act important. Savary suggests the same thing in inverse in his observation (1971:4) that in sculptural works "the absence of arms and legs proves the impotence of the victim." Although the arms are present in many *bociɔ*, they often are shown bound, attached, or flat against the body, thereby conveying a range of qualities such as restraint, difficulty, impoverishment, and enslavement. As with the treatment of other body parts, in these sculptures too the handling of the arms is linked in key respects to emotional concern.

Like the arm, the hand (*alɔ*) has important if often contradictory associations (fig. 75). According to Pazzi (1976:175–76), the hand "is especially the symbol of force, power, autonomy, responsibility."[60] The relation of the hand to these ideas can be seen in its treatment in other Fon arts. To Akalogun, an appliqué maker who created several hats with this motif, the hand suggest that "I will be something in life" (6.1.86).[61] Like the arms, the hands of *bociɔ* often are shown against the body or covered with a mass of additive materials. This treatment of the hand expresses both the inability to act and the desire to stop or restrain those malevolent forces or individuals that threaten one.

While most sculptures of the *bociɔ* type show little concern with emphasizing one hand over another (except in works of royalty), in certain nonroyal sculptures and in actual object use, key distinctions frequently are made. As Pazzi explains (1976:175), "The noble hand is the right (*aɖusi*), the hand that eats (*aɖu*). It is the right that one uses to give an object to the one who asks for it, and the one which one uses to receive the object. It is [also] the right hand that one clasps to greet another. The left is called *amyolo*. It is the hand of virile force (which is expressed especially in the left-handed person) and one uses it only in vulgar contexts (and in the rites of magic). It is also associated with dangerous situations."

As the above suggests, the left hand—the hand of greatest strength—is identified with danger, pollution, and death.[62] It is not surprising therefore that the making of *bociɔ* and the use of *bo* are closely identified with the left. Jewelry-form *bo*, for example, generally are worn on the left arm or hand. Skertchly wrote, a century ago (1874:150), of an incident in which a Legba priest gave him a charm against sorcery. This consisted of "a bag of some strong-smelling ingredients or other, encased in a leather pouch, and intended to be worn round the left arm above the elbow." Similarly today, as the court minister Migan explains (12.31.85), one wears one's *bo* rings on the left hand. This is because, he observes, when "one takes food with the right, if one puts the ring into the food, the ring will lose its power."[63]

The gestures conveyed in *bociɔ* sculptures also provide us with considerable insight into the roles which these works play in the expression of psychological and aesthetic concerns. As noted above, commoner *bociɔ* gestural forms gener-

ally are limited to two types: hands positioned along the sides of the body and hands placed on the stomach. (In rare cases, female figures are shown with their hands holding their breasts—see figs. 75, 87). Of the hands-on-the-stomach gesture (fig. 76) Ayido notes (5.19.86), "When one places the hands on the stomach, one is saying 'Here is my open stomach.' " In other words, I am without remorse or resentment. Such a gesture is seen to reinforce ideas of purity and clear conscience which are expressed additionally through the figure's nakedness. In the context of a Fa divination, Ayido indicates accordingly that the hands-on-stomach gesture signifies that "I told the inside of my stomach to Fa" (*un ɖo xomɛ ce nu Fa*)" (4.26.86). The stomach in this sense can be seen as the repository of one's innermost feelings. As the above suggests, the gesture of hands positioned on the stomach refers to a sort of psychological nakedness in which all that is held within is revealed. The frequent placement of hands next to the navel in many *bociɔ* serves to reinforce this idea. Since as noted earlier, the stomach is identified as the seat of one's emotions—anger and resentment among others—and since many sculptures are commissioned in contexts characterized by strong emotions such as these, this gesture adds to our understanding of the important transferential roles that objects of this type play.[64]

Hands positioned against the sides of the body, a gesture which is often implied even when arms as such are not shown, serve as a gestural complement to the common upright or standing postures discussed below. Such a gesture, as we will see, underscores values such as preparedness, confidence, and readiness in the face of life's difficulties. Ayido explains (8.3.86) that this position frequently is assumed by persons seeking to demonstrate their positions of relative strength: "When one is a powerful person . . . one stands with one's arms either placed along the body or else crossed in front of the chest." Both of these hand positions and the hands-on-the-stomach gesture, it should be noted, show striking differences with those of royal *bociɔ* discussed in chapter 9. Several *bociɔ* sculptures that have come to my attention (figs. 83, 84) which appear to be royal show the figure with outstretched arms and hands. This gesture (which is highly unusual within the commoner *bociɔ* corpus) is identified with gift-giving and the making of ritual offerings, as well as with acts of prayer for ancestral intervention or support.

Comparable in some respects to the hand and arm, the foot and leg (both of which in Fon are called *afɔ*)[65] are prominent symbols of movement, well-being, and comportment. When leaving the house in the morning, accordingly, a man usually will pass his foot over the Legba shrine in front of the compound. This is to help assure that his day will be propitious. The foot and leg also are integrally linked to independence of action. Agbanon explains (2.22.86) that "it is the foot that represents the person. If you do not have feet, you will not be able to do anything." The expression "one posed the foot on it" (*e ta afɔ ji*) in Fon signifies in turn that one has decided. Another popular Fon phrase, *n ɖo [a]fɔ te,* "I have placed the foot," conveys the ideas that "I am wholly upright," and "I

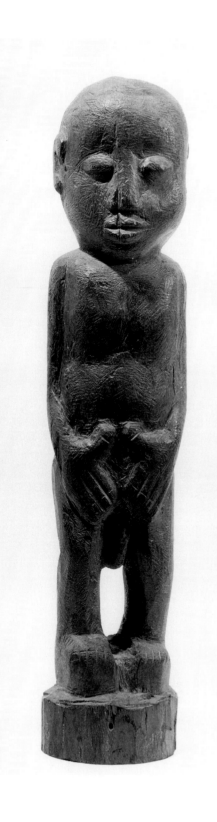

76. Fon male *bociɔ*. Abomey, Republic of Benin. Height: 41 cm. Positioned in front of the house to distance malevolent forces. Collected by Merlo in 1928. Musée de l'Homme, Paris. Cat. no. M.H.30.21.53. Published in Merlo (1977: fig. 4).

77. Gedevi-Fon female *kuɖiɔ-bociɔ*. Area of Bohicon, Republic of Benin. Photograph: Suzanne Preston Blier. May 19, 1986.

78. Ouatchi? female figure. Togo. Wood, cloth and miscellaneous additive materials. Height: 150 cm. Collected in the 1970s. Collection of Art Sherin and Sue Horsey. Photograph: Jack Sherin.

am totally ready," as well as "I am wholly sincere" or "wholly pure" (Bay 1985:20). Other foot-related idioms include *afɔ ɖagbe* ("good luck," literally "good foot"), *afɔ gnido* ("mistake," actually "his foot is in the hole"), and *afɔ ku* ("disgrace," "bad luck," "accident," literally "dead foot"). As Pazzi explains, "When one receives a stranger one asks him if he comes in peace by asking him 'Is the foot good?'" So too, the word for adultery is *afɔ gbe* "foot of the bush" (Rivière 1981:71). As signifiers of movement, life course, and decision-making, the feet and legs reinforce the roles that sculptures of this type play in enabling one to bring change to one's life.

While some *bociɔ* figures are carved to show the legs as straight, the majority portray them instead in a bent (or angled) knee position (figs. 77, 78). Ayido offers two views regarding the significance of this leg treatment. According to the first, the stance in which the knees are turned or twisted represents "the crippled world." He explains, "When we came into the world, we saw the world straight, thus it is we who made our world crippled" (8.3.86). In examples in which the legs are both bent and twisted, Ayido observed (5.2.86) that "when one says all things bend the feet for me, one is saying all bad things should remove themselves from me."

Notions of body ideation and aesthetics can be found in the context of distinctive postural forms displayed in *bociɔ*, the investigation of their treatment offering further insight into sculptural meaning. The majority of these sculptures depict the figure in an upright stance with the feet placed parallel to each other. Even those works without clearly delineated postural features suggest this form through their rigidly vertical, pole-like constructions. Pazzi suggests in this regard that for salutations between individuals of different ranks (1976:161) "the inferior bends the knees and bends the head profoundly, while the superior rests nearly immobile in his place."[66] The general emphasis on rigid upright postures within the *bociɔ* corpus underscores the vital roles of these sculptures in confronting and repelling various problems in life. Herskovits notes accordingly (1967, 2:275) of a *bociɔ* displaying this upright posture that vigilance is an important part of its identity: "The *gbo* is made to stand upright in the ground at the edge of the hunter's sleeping-mat where his head is placed . . . as is the case of all *gbo* used for similar purposes, it is believed to take the place of another hunter, keeping watch while the owner of the *gbo* is asleep." Attentiveness to danger is thought to be reinforced by this body position.

Nudity and Shaved Heads

In light of the importance of the body in expressing ideas of aesthetic and psychological consequence, the way the body is presented in terms of dress and coiffure is also of interest. Most *bociɔ* figures are carved to show the body naked.[67] Even in *kuɖiɔ-bociɔ*, where individual identity is important, often only a

small piece of cloth is attached to the figure—this to bring to the work the distinctive odor of the associated person. Throughout this area, nakedness is identified with a range of values and concerns. Hazoumé observes (1956:100) that for the Fon "nakedness is stressed [in oath-taking] because to wear clothing implies that one is tied to something. The [oath takers] want especially to signify by their nudity the rightness of the heart and the good faith which reigns in rapport with it." Nakedness also is identified with each person's spirit persona (sɛ), the incorporeal essence responsible for one's life, morality, and destiny. The word for nudity is sɛ gbeji,[68] literally "the voice [gbeji] of sɛ."

As in many African societies, nakedness for the Fon and their neighbors has clearcut religious associations. In the same way that infants and children often go naked,[69] so too, do individuals undergoing important religious ceremonies. Based on the idea that nakedness carries with it attributes of spiritual transition, insanity is linked to nakedness as well. As Ayido points out (5.5.86), an insane person frequently removes his clothes and goes naked in public. In political contexts, nakedness holds still other meanings. Thus, for example, in contrast to the way that the king marks his state of well-being and wealth through the richness and fullness of his attire, nakedness and near nakedness suggest a situation of relative impoverishment and weakness. Reinforcing this idea, royal bociɔ in some cases are fully clothed.

That many bociɔ are shown with shaved (or hairless) heads also may be significant.[70] Pazzi notes that the shaving of the head is closely identified with periods of personal transition. According to him (1976:150–51): "One shaves completely when one submits to a rite of initiation or widowhood, because one should in those moments, in a way, forget all that passed before, and the hair is a witness. [So too] at the day of death, the hair is shaved a last time."[71] The frequent absence of hair (da) in these sculptures underscores their association with situations and contexts at once transitional and stressful. The state of affairs that brings about a need to commission or activate a bociɔ in other words, is temporary, and eventually will be resolved. As is noted in a commonly cited Fon proverb: "Nothing is forever." The identification of hair as a witness is of interest both because of the antisocial attributes of many bo and bociɔ and because of the belief that most such works function within that invisible (witnessless) world of the spiritual persona. In this context as well, aesthetics and emotional concerns complement each other.

As we have seen in the above, important ideas about both anatomy and emotion are expressed through language and representational ideas associated with the body. Bociɔ, it is clear, are far less concerned with depicting beauty as such than they are with expressing a range of emotional qualities. The emphasis and elaboration given to key body parts—stomach, buttocks, genitals, back, chest, neck, fontanel, forehead, eyes, nose, mouth, hands, and feet—serve to underscore in turn essential values identified with the nature of being and the concomi-

tant ways that being is addressed vis-à-vis oneself and the world around one. Nakedness, coiffure, gesture, posture, and other aspects of body representation also are important. If, as suggested above, emotional concerns are the principal aesthetic values identified with these works, then the body in both its presentation and alteration through variant means of amplification, diminution, distortion, and constriction is a vital ground against which essential emotional concerns and expressions are both measured and addressed.

The I and Not-I in Artistic Expressions of the Self

"When one calls me, does one call you? What am I? The shadow"
(*E yolo mi o, hwui we e yolo a? Yε*).

—Fon riddle, from Alapini, *Les initiés*

"Le monde invisible est le maître du visible."

—Montilus, *L'homme dans la pensée traditionelle Fon*

There has never been a language, Marcel Mauss writes (1979:61), "in which the word . . . I-me . . . did not exist and did not express something clearly represented." How the idea of self is constituted within various cultures is a subject of considerable importance. The self, suggest Popplestone and McPherson (1988:293), is "a composite of a person's knowledge of and reactions to his or her individuality. This includes an awareness of the differences between the self and the not self." Concepts of the self/not self, the I/not-I, the individual and the other also are critical to understanding psychology and art, for they too are grounded in issues of interior and exterior, surface and depth, conscious and unconscious from the perspective of the individual looking within and without. As de Surgy suggests (1981a:22), for the Evhe "humans are not fundamentally alone in themselves; communication with the other is already accomplished."

From the viewpoint of self and other it also can be said that both art and the psyche share certain qualities of external signifiers or second persona. As Bakhtin observes (1986:138), "Just as the body is formed initially in the mother's womb (body), a person's consciousness awakens wrapped in another's consciousness." Issues of dramaturgical transposition and masking also come into play.[1] Gareth Griffiths explains that (1987:177) "the idea of persona as 'second self' incorporates the metaphorical roots of the 'mask' concept, implying the total of being presented to the audience, outside and beyond the actor who assumes it." Spitz reaffirms the importance of psychological masking metaphors by suggesting (1985:144) that in "the fusion of inner and outer, of 'I' and 'not-I'. . . the actor 'becomes' the character he is portraying." As with the masquerade and *bociɔ* arts generally, the psyche in this way is framed with respect to critical ideas of substitution and subterfuge.

This conceptualization of personhood from the perspective of the surface signifier, as something with clearcut features of internalization and externalization, is also central to the role of *bociɔ* arts as dynamic signs. In this sense *bociɔ* as signifiers of the I/not-I affect a place of both privilege and ambiguity; like masquerades, they seek both to hide and to reveal.[2] Through comparable processes of psychological masking and disclosure, a form of dialogue takes place within

bociɔ which bears significantly on notions of art and selfhood. Within this dialogue the individual not only is displayed outwardly, but becomes that which she or he is, not only for others but for oneself as well.[3]

This chapter is concerned in various ways with what Dilthey defines as (1976:90) "mental structure."[4] In the context of *bociɔ* arts, the aim is to bring to light the connection between surface and subsurface identity and expression. Addressed below for this reason are variant questions about what it means to be human and to express notions of selfhood through art, finding answers at once through sculptural form and verbal expression. First to be addressed is the etymological grounding of the term "human" with ideas of agency, direction, and control generally, and the ramifications of related terminology vis-à-vis *bociɔ* signification. Next I examine contexts of birth and familial relations and the similarities these share with sculptural values of enactment and substitution. Finally I take up the multivalent, interactive, and aggregate nature of the psyche among the Fon and Evhe and the means through which its features are conveyed in plastic form.

What It Means to Be Human: Mastery in Life

The Fon word for human, *gbɛtɔ* (alternately *gbɛɖotɔ; amɛgbɛtɔ*[5] in Evhe), finds its most frequent translation as "master of life," *tɔ* meaning "master," "father," "agent," "progenitor, " or "controller," and *gbɛ* designating "life" or "existence." Within this conception of the human is a view of each individual as an active participant in life's course, a director of sorts of the world in which one dwells. As Guédou explains (1985:227–28):

For the Fon, the human is first of all the one who directs the world and controls it. . . . [This person] is an orchestra leader who watches over . . . the world. . . . The word *tɔ* [of *gbɛtɔ*] connotes mastery, experience, art, domination, moral capacity physical capacity. . . . It is an aptitude, a potentiality, a dynamism which acts or makes what is around it act. . . . [The human] is the master of all that lives, of all that breathes. . . . All that exists in the universe should contribute to the life of this superior being . . . [who] kills creatures to safeguard life.

Montilus, translating the same term, emphasizes the role of humans as creators (1972:2–3): "For the Fon, the human is first of all the progenitor. The principal function of *gbɛtɔ* is to transmit life, to procreate. . . . The human is the master of all who live, that is, all who breathe (*gboje*). . . . [Humans] surpass all living things (*gbɛ*) by their energy (*hlohlo*). . . . the Fon vision of the world is anthropocentric. [The human] is at the center as master, the giver of all." This idea also is underscored by Agossou. As he explains (1972:43), "The *gbɛɖotɔ* is the source of life. . . . [The human] cannot *not* create. Creation is part of one's nature." Humans, the above suggests, are at once directors and creators who actively shape life around them.

79. Evhe figure. Lomé, Togo. Wood, cord, cowries, animal skull, and miscellaneous materials. Height: 19 cm. Employed to make one's enemy lethargic. Musée de l'Homme, Paris. Cat. no. M.H.32.78.13.

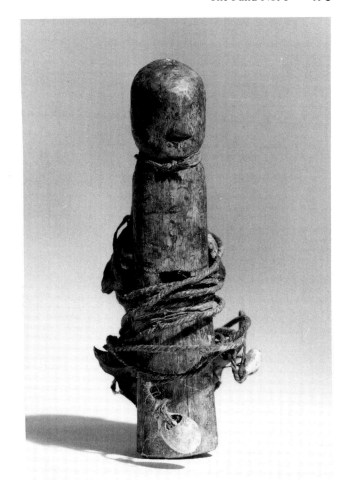

Bocɔ play a central role in this process, for implicit in this notion of human mastery and artistry is a concern with response and risk. According to Kossou (1983:59): "The human is considered as one who should live and claim the ownership (*tɔ*) of life. But living involves risks. It is at this level that the dynamic principle of life is manifested, a dynamic which is not without a great amount of aggression." Since concerns ascribed to *bocɔ* mirror those of humans, critical to each figure's overall functioning is its ability to aggressively pursue and counter risks in claiming ownership or mastery of life.

In addition to the above etymological concerns, the term for "human" (*gbɛtɔ*) also is associated with a complex ancillary semantic field which offers critical insight into issues of life, mastery, and art. Thus, for example, while *gbɛ* frequently signifies "life," in other contexts it means to "thread," "cord," "twist," or "braid." Human life in turn is perceived as sharing qualities of a cord, a material which has a privileged place in *bo* and *bocɔ* (fig. 79). Descent and relational

ties also are compared to cords, with each new generation being understood as offering a twist or braid to the overall family line (Bay 1985:15) (fig. 80). Spoken in a modulating tonal form, the term *gbɛ* designates "authorization," "society," and "refusal"; this same tone spoken with a closed *e* (*gbe*) in turn designates "grass," "field," "hunt," "outside," and "day." "Speech," "voice," and "language," in turn are designated by the closed-*e,* lowered tonal form of *gbe.* These qualities, which share conceptual as well as peripheral etymological associations with the human, are of interest as well.

As noted earlier, factors of speech, voice, authority, and society are essential both to human potentialities of mastery and action and to *bociɔ* functioning and power. *Bociɔ* sculptures, in their dominant emphasis on materials from nature (animals and plants among others), also find partial grounding in the identity of *gbe* with hunting, fields, and the world outside. Indeed, in many respects there is no clearer image of the person as hunter, cultivator and controller of nature in its diverse manifestations than that found within the *bociɔ* tradition. These sculptures in turn address the complex range of problems that accompany someone facing the risks, dangers, and traumas that attend variant struggles in the world.[6] The very concept of the human as actor and director, as well as creator, of life is predicted upon the effective use of objects such as *bociɔ* and *bo* which enable one aggressively to confront and counter obstacles that lie in the way of personal needs, well-being, or advancement.

The Role of Birth in Defining Being

The identity of the human as an active participant in life begins before birth. Each person's individuality and sense of self is based in part on the materials which are used in making the body. In this part of Africa, each fetus is said to be constituted of a mixture (mingling, fusion) of sand, clay, or earth which is modeled then placed in the womb of the mother by the sponsoring ancestor.[7] The relative purity or impurity of the earth which forms this body is said to determine the number and degree of sicknesses one will have in life. If this earth is taken from a rubbish heap, for example, it is said that one will suffer from continual illnesses. As Ayido notes (3.29.86), in this earth are found "all the difficulties and the sickness that you will have in your body."

Signs of one's individuality are manifested during delivery, with each baby defining herself or himself through distinctive birth-related postures, gestures, and attributes. "Birth with the Fon," explains Montilus (1979:33), "is conceived as a passage," a journey marked with numerous signifiers. One of the more important of these is the locale of the umbilical cord with respect to the body as the baby emerges from the birth passage. For example, if the child is born with the umbilical cord around the neck, it is thought to be especially gifted in the making of *bo.* One will name this child accordingly Bosi ("female *bo*"), Bosu ("male *bo*"), Bozenu ("*bo* raised the thing"), or some other *bo*-associated name

80. Fon royal *asεn* sculpture. Abomey, Republic of Benin. Identified with King Glele (1858–89). Shows a hand supporting a cord. Collection: Musée Historique, Abomey. Photograph: Suzanne Preston Blier. May 27, 1986.

(Gilli 1982a:31). The umbilical cords of such children visually echo the wrapping of cord around many *bociɔ*.

For the above "*bo* children" and others, the umbilical cord will continue to hold an important place as a marker of independent identity and control. As Gilli explains (1982a:28), "The placenta belongs to the mother, the umbilical cord to the child." Because of the umbilical cord's identity as a signifier of life, it often is buried at the foot of a palm tree which becomes the special property of the child.[8] According to Gilli (1982a:28): "This tree like its fruit belongs to the child. The child [thus] is in relationship with nature in its development and ways, sometimes unconsciously." The child's special palm tree, as a signifier of life's vicissitudes (in that it blows this way and that in the wind), also complements the role of *bociɔ* in anchoring or securing individual well-being through life's many difficulties.

During the course of each child's birth, another important feature that is noted is body positioning, that is, whether the baby is born head first, feet first, facing down or up, emerging with arms or legs raised or lowered. These delivery positions constitute active signs of individual identity. A tradition of differentially shaped ceramic pots based on these birth positions becomes the focus of special family shrines and offerings.[9] Because of their link to birth and identity, vessels of this type also occasionally are incorporated into *bociɔ*.

The child's gestural modes or hand positions during delivery, particularly the presence of closed fists or open palms, are of additional significance. The meanings of the latter gestures are linked to a belief that Sɛ (Sɛgbo, Sɛgbo-Lisa, Mawu), the high god, places in each baby's hand the unique destiny which it will hold in the world. According to Brand (1970:348): "If the child arrives with a closed fist, it has kept the wealth that Sɛ gave him; if not, [and the baby] arrives with open hands, its life will not be happy." With this in mind one also looks closely for the appearance of creases or lines on the baby's palms to locate the reverse traces of where Sɛ tapped the baby's fist (knuckles) in utero in testing its strength and determination to guard its destiny. As Brand notes (1970:348), these lines are called *sɛ hui (sɛ xui)*, "the road of Sɛ" (Sɛ referring here to both god and destiny): "If they are present, [the child] resisted the suffering brought about when Sɛ struck the hand with a stick, the *sɛ-bode*. [Thus] the importance of *sɛ* will follow the child all its long life." In most *bociɔ*, hands are positioned flat against the sides or stomach (figs. 81, 82), sometimes bound tightly to the body. Rarely in such works is there a concern either with palms or with fists. This is in striking contrast to the royal *bociɔ*, in which fists and palms frequently are displayed (figs. 83, 84), suggesting that with royalty one's destiny to rule is publicly acknowledged and valued, an idea reinforced by the fact that destiny is a central feature of both rulership selection and royal art. Among commoners, in contrast, perhaps because destiny is a more private and personal matter, it is not represented in the associated arts.

The distinctive destiny that is placed before birth in each child's hands takes

81. Gedevi-Fon female *kuɖɔ-bociɔ*. Area of Bohicon, Republic of Benin. Wood. Photograph: Suzanne Preston Blier. May 19, 1986.

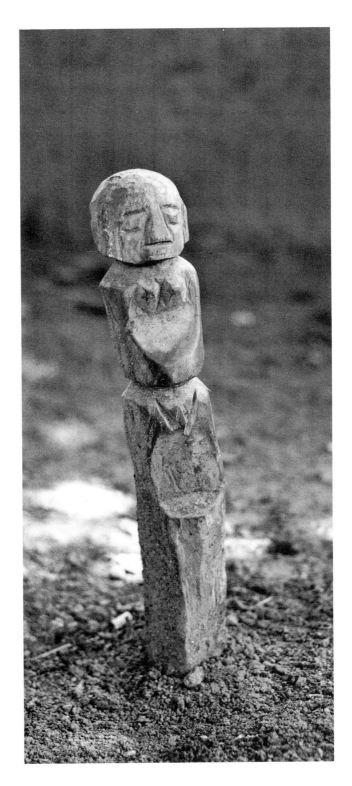

the form of one of the 256 signs (*du*) from the Fa geomancy system. As noted by Brand above, this sign "will follow" the child through life. Ayido explains the importance of this Fa sign (7.13.86) this way: "When Mawu [Sɛ] rolled up your earth into a ball [to shape the body], he called your Fa . . . Then he recounted what will happen to you when you go over there into the world. The misfortunes that will happen and the good things that will occur to you, he recounted every-thing to your Fa." [10] Migan concurs with this idea (2.18.86): "Mawu gave you the *du* [Fa sign] with which you walked to arrive in this world. When you come here, your *du* is already written in your head." Appropriately, while one's *se* or destiny is marked on one's hand, the forehead is the body part most closely iden-tified with the Fa sign itself (Ayido 3.29.86). The emphasis given to heads and foreheads in *bociɔ* sculptures may have its grounding in this tradition. Because destiny is thought of as something that each person chooses from god [11] (rather than accepts passively), the forehead also serves to signify personal empow-erment. As Montilus explains (1972:23, 18), "This destiny is not pure fatality but a choice humans make in *lo* [heaven] near Mawu. . . . One calls this destiny *byowa*, "to ask-to come" [*demander venir*]. . . . We and *se* chose before we ar-rived, before birth, what would happen to us." [12] Each individual in this way becomes a creator and director of his or her own life's script. [13] Similar dramatur-gical metaphors are important with respect to the relationship between parent and child.

Parent-Child Ties: Bridging Past and Present

Among the Fon, Evhe, and related groups, the relationship between child and parent is grounded in critical ways on ideas of enactment, reenactment, and sub-stitution in the context of which *bociɔ* play a vital part. Central to this view is a belief that each person incorporates essential features of an actor, wherein one both represents a new person and embodies an individual from another time or place. Each baby thus is at once a unique individual and a representative or substitute (replacement, mask) for an engendering parent(s). [14] This belief finds basis in the local tradition of reincarnation wherein each child is thought to come into the world through the aid of an ancestor (or occasionally an affiliated *vo-dun*). [15] Here, as elsewhere in sub-Saharan Africa, these ancestral sponsors as-sume critical roles as shapers of individual life and identity. Among the Fon, the sponsoring ancestor is called *jɔtɔ (mejɔtɔ)*, "agent of birth" (*jɔ*: born, arrive, remember; and *tɔ*: father, actor, agent, master). [16] In Evhe, the term for this spon-sor is *amedzotɔ*, "agent of the person's birth" (*tɔ*: agent; *dzo*: birth; *ame*: person) (de Surgy 1981a:38–39). Maupoil explains (1981:382) this individual's role as follows: "Each person possesses a *jɔtɔ*, kings as well as humble people. As soon as a child is born, one must ask Fa who it was that sent him [her] into the world—who it resembles, because all new children resemble a person who is de-ceased."

82. Fon? male *bociↄ* figure.
Republic of Benin. Wood,
cloth, cord, and miscellaneous
materials. Height: 49.5 cm.
Indianapolis Museum of Art.
Gift of Dr. and Mrs. Wally
Zollman. Cat. no. 1986.185.

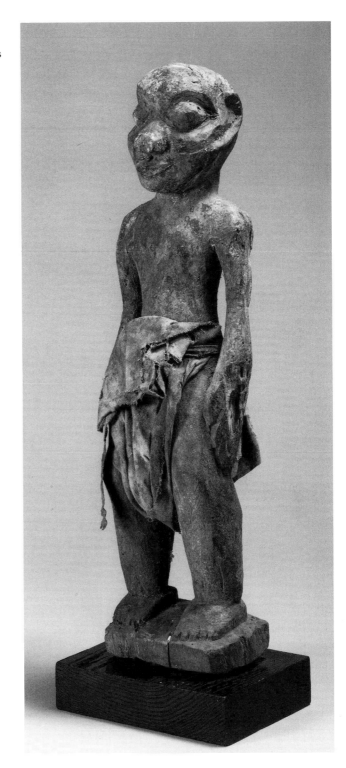

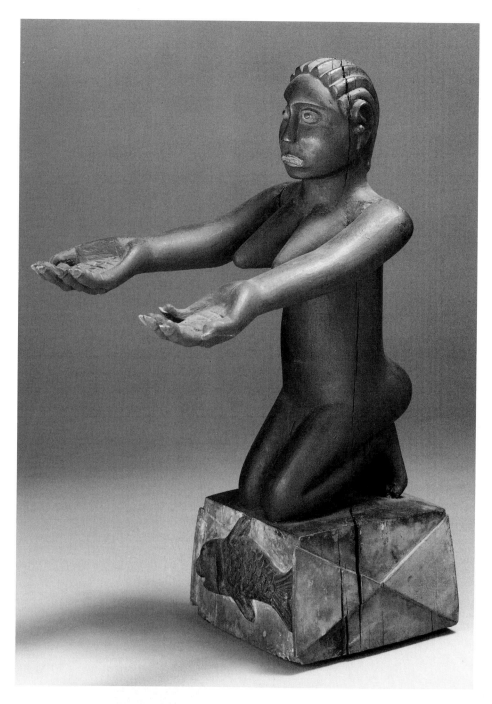

83. Fon royal *bociɔ*. Abomey, Republic of Benin. (See fig. 70.) Wood, pigment. Height: 54 cm. Kneeling female figure with outstretched arms. Identified with King Gbehanzin (1889–94) (note fish on base). Artist: Samissi Houndo? Indianapolis Museum of Art. Gift of Mr. and Mrs. Harrison Eiteljorg. Cat. no. 1989.682. Published in Savary (1978: fig. 15).

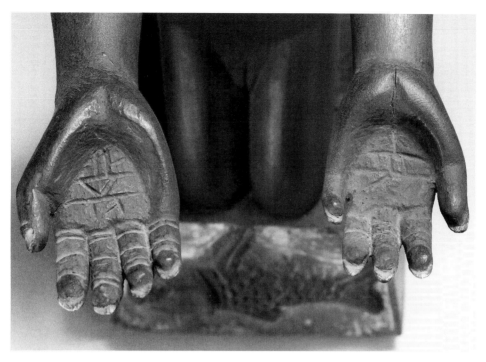

84. Royal *bociↄ* (detail of fig. 83) showing hands with lines of *sɛ*.

This resemblance is considered to be the result of the ancestor's "mixing the ball of earth" that is used to form the body of the fetus before it is placed in the mother's womb.[17] "One believes," Pazzi explains (1976:62), that "the formation of the body of the newborn is the work of the ancestor who cuts the primordial clay and models it." Ayido notes (3.29.86) that: "If someone has touched the mound of earth, and we see this, we will know that it is [this person's] work. . . . If [someone] did not touch the earth and one did not have children, we would not be able to remember [the person who died]." Through this process each infant comes to embody (represent) the ancestor responsible for her or his creation.[18] In a society without writing, this reincarnation process serves an essential function in retaining the memory of individuals now deceased. Each person in a sense both masquerades for the sponsoring ancestor and follows his or her own, distinct life course.

In the context of the present study, it is essential to emphasize that physical attributes are not the only ones believed to be passed on through this process. Character traits and emotional attributes are acquired through this means as well. Montilus observes (1972:28) accordingly that "one can say truly that the *jↄtↄ* fashions the physical and psychological person. This individual fashioned the body. . . . He [/she also] fashioned the character (*jijↄ*) in an educative milieu which recalls to the person the moral physiognomy of the engenderer." The term

for character or behavior in Fon, *jijɔ* has as a root *jɔ* ("birth"), underscoring the role that ancestral sponsors (*jɔtɔ*, "master of birth") play in the formation and conceptualization of the child's personality.[19] Each person's character is in part also framed by the stress placed on the relationship between individuals and their ancestral sponsors in everyday life.[20] According to Montilus (1972:28): "One will speak so much about this person to an offspring (*ati jɔtɔ*) [new tree] that a sort of diffuse education ensues that gives to the latter the moral, psychological, spiritual, and sometimes even physical attributes of the ancestor. . . . Through this means one traces a program of life for the child."

Not surprisingly, in addition to forming the fetus and fashioning one's character, ancestral sponsors also are said to play a part both in protecting the child and in overseeing his or her moral and physical development. Thus Montilus writes (1972:28), "The *jɔtɔ* also refers to a protective force. It is a dynamic element which intervenes in the constitution of the person and individual. This is why the *jɔtɔ* . . . is called *sɛ jɔtɔ* [*jɔtɔ* of destiny]." Guédou explains (1985:236) similarly that "the *jɔtɔ*, 'birth-[agent],' is the protector . . . of each person. . . . Everyone should know one's *jɔtɔ*, who is in some ways the furnisher of the first material of which the person is made. When an individual offends the *jɔtɔ* and commits a grave fault against the ancestors of the clan, the anger of the *jɔtɔ* can render one ill." The ancestral sponsor in this way not only assumes a vital role in each person's identity and sense of self, but also offers the individual protection, guidance, and, where necessary, correction.[21]

The identity of each individual as a representative or a quasi-substitute for the deceased also has a significant impact on generational and parental relations. This is important to the understanding of *bociɔ*, for such sculptures offer a source of alternative empowerment and protection in situations in which one lacks essential ancestral and familial accord. If one's parents and ancestral sponsors were always attentive and supportive, in other words, then these objects would have a less prominent role in the lives of local inhabitants. As Agbanon explains (2.24.86), "If the ancestors are behind you, and if you did not comport yourself badly toward your father and he did not damn you, no malevolent *bo* could reach you." In other words, *bo* or *bociɔ* would be unnecessary if relations between parents and their children were always positive. While the term "father" in the above statement refers as much to one's ancestor as it does to one's actual parent (since one's living parents or grandparents serve as intermediaries between those in the family who are alive and those who are deceased), the impact is similar for both. In this way *bociɔ* also can be said to have grounding in the difficulties which occur in the filial relationship between parents and offspring. These sculptures help to protect the child (or parent) in the course of related disharmony, division, and dispute. In addition to the above, works of this type support a degree of individual independence within the otherwise often highly bounded family and political structure. With such sculptures, individuals are able

to address those needs which are essential to their own well-being by assuaging fears of familial retribution.

This factor of ancestral sponsorship affects parent-child relations and *bɔciɔ* use in other ways as well. Here too one sees key ideas of substitution, simulacrum, and masquerade being expressed. In this light, it is important not only that the parent is believed to serve as a bridge between the child and the ancestor, but also that the parent (the older generation) is compelled to die in order for the new generation to spring forth. Each new baby is thought to be an object of exchange (*ɖiɔ*), a substitution that comes into the world to supplant and replace its parent. Montilus explains (1979:5–6) that "in Allada people say the child looks to supplant the parent of the same sex: *e na xule agba xe tɔ to alo no to,* 'One will discuss the place with one's father or mother.' The Fon are more explicit, saying *e na ɖiɔ tɔ to,* 'He will replace (exchange) his father; *e na ɖiɔ no to,* 'She will replace (exchange) her mother.' *Diɔ* here signifies change or trick. For a Fon, a child [thus] . . . disputes the hegemony (*acekpikpa*) of the house with its parents"[22] Particularly important in the above is the term *ɖiɔ*—exchange, change, trick. Like *bɔciɔ* of the *kuɖiɔ* type (*ku*: death; *ɖiɔ*: exchange) (figs. 85, 86), each child represents a replacement (or object of exchange) for the parent. In the above relationship, as with *bɔciɔ*, there is also an element of trickery and masking wherein each child is thought to be something other than what she or he appears to be on the surface. Montilus explains this phenomenon of generational exchange more fully (1979:6): "For the Fon, the child is thought to be given to the *henu* [family] in exchange for the father or mother. One of the two will 'leave,' i.e., die. In this birth is a hidden misfortune. That is why in the prayers of the Fon, the *dexotɔ* [prayer] often will ask for the following: *vi ɖiɔ tɔ mi gbe,* 'We do not want the child who comes to replace his father'; *vi ɖiɔ no mi gbe,* 'We do not want the child who will replace her mother.'" What the above suggests is that all children carry within themselves the death of their same-sex progenitors. This is an interesting alternative/complement to Western oedipal tensions.[23] Montilus's use of the term *ɖiɔ* to mean "replace" here reinforces ties with *kuɖiɔ* (death-exchanging) *bɔciɔ*, works whose principal role is to offer something (here the sculpture) which serves as a means of exchange for one's life. To understand the bond between *bɔciɔ* and psyche more completely, let us turn our attention to perceptions of the inner self.

Activators of the Mind: Spiritual Personification

Topographic diagrams of psychic geography, as Silverman calls them (1983:66), necessarily are complex and dependent on a diversity of forces.[24] In the area of this study, each person's psyche or spirit identity is conceptualized as a penumbra (shadow) composed of a diversity of independent incorporeal energies.[25] Like a masquerade, the psyche is at once visible and hidden, transitory and enduring,

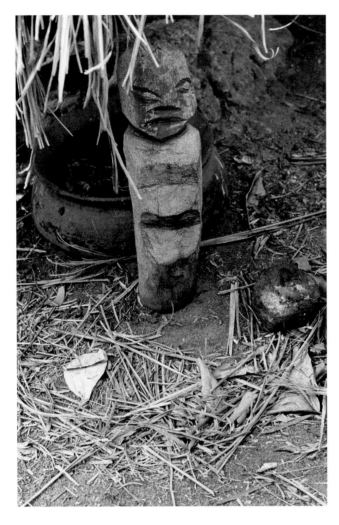

85. Gedevi-Fon *bociɔ*. Area of
Bohicon, Republic of Benin.
Photograph: Suzanne Preston
Blier. May 19, 1986.

86. Gedevi-Fon *bociɔ*. Area of
Bohicon, Republic of Benin.
Photograph: Suzanne Preston
Blier. February 20, 1986.

dynamic in itself but defined by another. To some extent *bociɔ* represent similarly
liminal forms, cadavers (*ciɔ*) or lifeless reflections of the living self. The identity
of the psyche as penumbra—"shadow," "shade," "reflection," "silhouette,"
"flickering," "specter," "soul"—here also conveys a critical link with Sɛgbo-Lisa,
the god of heavenly light and the ultimate source of all earthly shadows, shade,
and reflection.[26]

As with the *jɔtɔ*, or ancestral sponsor, each of the elements thought to inhabit
and define the psyche plays a vital part in the definition of individual persona.
Each also offers important insight into the understanding of *bociɔ*. Although
most local residents and scholars emphasize the pluralistic nature of the psyche's
"shadow," its identity and composition are the subject of considerable debate.
To some, the psyche is comprised of two primary elements—one a visible

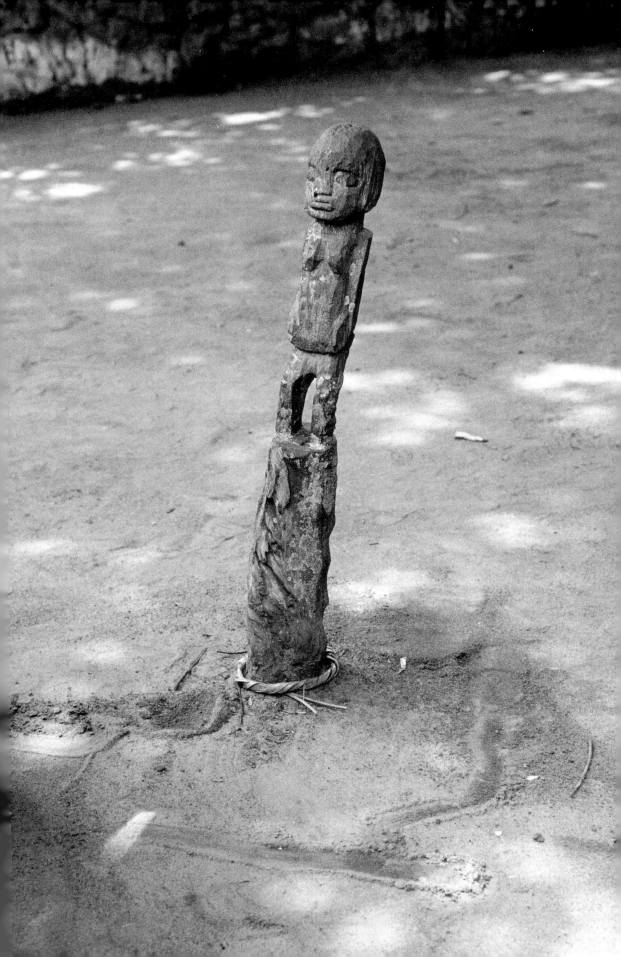

shadow, the other invisible. Quénum delimits (1938:90) these: "The shadow that follows us without being a soul is an image of it. Each person has two: one visible, which after our death, continues to live inside us and serves as the object of the imagination, the other invisible, which follows our soul." [27] Fiawoo also suggests (in de Surgy 1981a:31) that there are two primary components of the psyche, one identified with life, the other with death: "At the moment of conception . . . two souls, or better, two compositions of the soul, one associated with life, the other with death, unite. At death they undergo a permanent separation. The part associated with life goes to Mawu, the other to . . . the world of the spirits."

To other scholars working in the area, however, the forces which play a part in the constitution of each person's spiritual and psychological identity comprise a *mixtura* of four or more parts. While there is some diversity of opinion as to the conceptualization of these parts (some individuals include here the *jɔtɔ*, the body, the mother, and the father, among others),[28] most Fon scholars follow the model set forth by Maupoil (1981:378) in which "each living being, each animal, each plant, each thing that was created by Mawu possesses four souls: *yɛ, wensagun, lindon,* and *sɛ*." These shadows or souls, as Guédou explains (1985:239), "can be considered as invisible spirits managing the body." Because *wensagon* and *lindon* often are identified as subsidiary elements or properties of the *yɛ* (*wensagon* as the *yɛ gli* or short *yɛ*, and *lindon* as the *yɛ gaga* or long *yɛ*),[29] attention here will focus on the primary components, *yɛ* and *sɛ*. Both will be examined with an eye toward the impact they have and the roles they play both individually and together in the psychological definition of the person and the meaning of the associated *bociɔ* arts.

The Sɛ: Destiny, Conscience, and Reflection

One's *sɛ* (spoken generally in a high tone) is believed to be granted to each person by the creative and luminous god, Sɛgbo—"the Great (*gbo*) Sɛ" (known also as Sɛgbo-Lisa, Mawu, or Mawu-Lisa).[30] The role of the individual's *sɛ* is complex, involving everything from thought to foresight to reason. The late Fon court diviner Gedegbe explained (in Maupoil 1981:401) that "each person, in receiving a parcel of the great Sɛ, receives a part of the great thought." [31] Ayido reaffirms this (3.29.86; 7.27.86), suggesting that "*sɛ* gives one the ability to know or think [*lin*]. . . . [Through the *sɛ*] Mawu puts ideas in your thoughts. . . . Your *sɛ* . . . does what you envisage even before you yourself do it. If your *sɛ* does not do something, you cannot do it." [32] To Montilus likewise (1972:19–20), "The *sɛ* is the invincible force that directs life." As he explains (1972:19): "One cannot be poisoned if one's *sɛ* has not drunk the prepared poison. The *sɛ* is thus the conductor of humans. The Fon say *e co mi*—'It guards us'; *e he mi*—'It holds us.' *E do gudo mi to*—'It is behind us.' *E kpe nuku u mito*—'It watches over us.' All these expressions show that the *sɛ* is a force (*hlohlo*), an energy, a power

(*glagla*), which is charged with orienting the life of humans . . . [and] protecting them in the walk toward the realization of one's destiny (*byowa*)."

Sɛ, as the above suggests, is essential to each person's life and well-being. *Sɛ* represents the light that is the source of all vitality, constituting a force or power which supports and rests behind each individual, encouraging one's active participation in the mastery of life.[33] As Montilus asserts (1972:23), "The *sɛ* is the energy, the force (*hlohlo*) which orients the destiny[34] of individuals." As an energy which guides the individual, the *sɛ* plays a direct role in supporting and shaping one's life. Montilus's use of the term "force" (*hlohlo, hlonhlon*) with regard to the *sɛ* also is of interest here, for as we have seen the same word is employed in discussions of *bociɔ* aesthetics.

Other features of *sɛ* reinforce its importance to *bociɔ* sculptural traditions, particularly with respect to issues of morality and correct behavior. As Maupoil explains (1981:389), "In a sense, the *sɛ* represents the interior voice that gives us sage counsel." Montilus adds (1972:18): "For the person of the street . . . , the *sɛ* is the master that Mawu gave us from the moment he made (*blo*) us."[35] Extending from this, *sɛ* is also linked to ideas of a planned life's course. The ethical dimension of the *sɛ* is expressed in other ways as well. Thus to Maupoil (1981:381), "*Sɛ* constitutes the moral sense, the conscience of each being. It gives good advice to all who are living and opposes one if one does harm." Not surprisingly mood also is identified with the *sɛ*. A phrase from the Fa divination sign Aklan-Tula makes this clear: "When a man is happy he invokes his *sɛ*. If he is unhappy he also invokes it, because both happiness and unhappiness depend on *sɛ*" (Maupoil 1981:641).

Like other components of the psyche, the *sɛ* is represented in important ways in *bociɔ*. Several features stand out, the first being figural nudity. The word for nudity in Fon is *sɛ gbeji*, literally, "the voice (*gbeji*) of *sɛ*." Nudity in this sense is a key signifier of the *sɛ*. In *bociɔ* and life, nudity carries a range of associated values—purity, clear conscience, familial ties, and even poverty, each of which finds important grounding in the *sɛ*. While most such sculptures are carved without reference to clothing (figs. 87, 88), sometimes their nudity is covered with a range of additive materials. In these works there may be an interest in hiding or covering one's *sɛ* from general view.

After nudity, the *sɛ* is identified most closely with the hands and the head. The lines on one's palms, as noted above, are called *sɛhwi* "lines (*hwi*) of destiny (*sɛ*)" (see figs. 83, 84). As one of the Danhomɛ court songs observes (Agbidinukun 5.30.86), "We arrived in this world to see the lines of *sɛ* in the palms of our hands." Asogbahu, explaining the significance of a pair of hands painted on one of his family's temples, notes (5.8.86) that "these represent *sɛhwi*, the lines of *sɛ*. It is these lines that always remain in the hand; they never disappear."[36] In commoner *bociɔ* arts, as I have suggested, the hiding of one's palms (and "lines of *sɛ*") from view may indicate a desire to shield the specific path of one's *sɛ* from others.

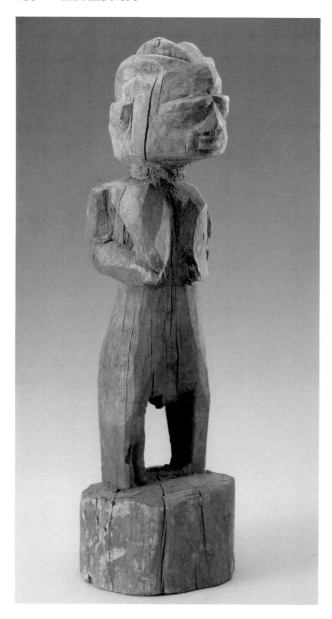

87. Fon *bociɔ*. Female. Republic of Benin. *Menovi* ("traveling figure"). Wood. Height: 33 cm. National Museum of African Art. Eliot Elisofon Archives. Smithsonian Institution. Cat. no. 68.32.12a. Gift of Michael J. Furst. Photograph: Franko Khoury. 1992.

88. Fon male *bociɔ*. Republic of Benin. Wood. Height: 37 cm. *Menovi* ("traveling figure"). Offered palm oil and chicken for protection when a traveler goes on trips. Collected by Michael and Shirley Furst, 1965–68. National Museum of African Art. Eliot Elisofon Archives. Smithsonian Institution. Cat. no. 68.32.12b. Gift of Michael J. Furst. Photograph: Franko Khoury. 1992.

The head is associated particularly with those qualities of the *sɛ* that offer protection in times of crisis or need. Maupoil notes in this light (1981:388) that "*sɛ* inhabits the human and is localized in the head." According to Ayido (4.30.86), "When something [bad] is about to happen to you, your head becomes swollen . . . [This is] so that you will be scared before the thing actually occurs." The emphasis given to the head within the corpus of *bociɔ* works underscores the protective functions that the *sɛ* assumes in the context of human life.

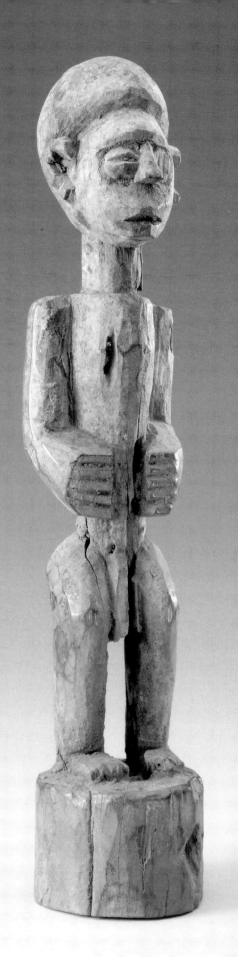

The importance of the head in many *bociɔ* sculptures additionally reflects the vital psychological roles that such works play in providing cathartic relief in situations of danger or concern when extra forms of vigilance are required. Furthermore, since in these sculptures the head often is shown to be proportionally larger and more fully articulated than other features of the body, the head may constitute a reference to situations in which "something is about to happen," that is, to occasions in which one needs to be especially alert. This coincides with the prominent identity of these works as ever alert guardians ready to counter danger.

Investigations into the etymology and root meanings of the word *sε* offer us additional insight into this feature of psychological identity and sculptural expression. As Guédou notes (1985:243), for the Fon, "the term *sε* has a vast semantic field." Segurola defines *sε* accordingly not only as spirit, vital principle, god, and destiny, but also as flower, straw, and the stinger of an insect." [37] Additionally, as a radical, *sε* is the root of a range of composite words such as menstruation (*sεla*, "menses of *sε*"), gentials (*sεlin*, "road of *sε*"), odor (*sεwan*, "smell of *sε*"), and baby hair (*sεɖa*, "hair of *sε*"). As Montilus notes of menstruation (1972:30), "The Fon situate this in the sphere of destiny, like the hair of the infant." Of the genitals, similarly, explains Montilus (1972:12), "the *sεlin* means the place where the *sε* begins the process of forming and giving life to humans." Kossou suggests (1983:135) that "the *sε* is presented thus as a power. . . . In effect sweat, hair, and nails contain *sε*. . . . This means . . . that the 'mark' of *sε* lives in and affects human existence." Thus *sε* is linked to those body parts that are most closely associated with growth, independent life, and vitality. These are also features of the body identified prominently with *bociɔ*. Hair, nails, and body secretions frequently are used as additive materials to empower a work and to direct (transfer) it toward or away from a particular person. Through such matter one can readily "address" or "touch" another's *sε*.

Yet another translation of *sε* which reinforces this link with individual identity is taken from a composite term (*sεma*) which refers to a particular type of leaf that plays a central role in ceremonies of birth. According to local Fon traditions, women in the area historically delivered their babies on a bed of fresh *sεma* [38] leaves. As a result of this practice, it is often said that "one arrives in the world . . . between the hands of *sε*" (Montilus 1979:4). According to Montilus (1979:4), "Among the Fon in ancient times one did not give birth on the earth itself. The mother was seated on a cushion (*sunuhle*) and the child came into the world on leaves of *akikoma*, also called *sεma* . . . 'leaf of *sε*.' The *sε* . . . is the energy that directs the destiny of man. . . . For the Bokonon, the *akiko* is the first grain planted by Mawu. It is also the first leaves among those of Fa. . . . One thus arrives in the world, so to speak, between the hands of *sε*, symbolized by the leaves of *akikoma*." [39] As is clear in the above, an important link exists between *sε*, destiny, and mastery beginning from the moment of one's birth. *Bociɔ* concerns with destiny and mastery in many respects are similar.

The use of the term *sɛ* in reference to straw or grass also has meaning in *bociɔ* contexts. Straw sometimes is used in such objects to represent and address particular persons in the course of empowering a *bociɔ* or directing it to take a course of action. Spiess (1902:316) describes a work which employed straw in this way: "Here one sees a corncob on which are placed grasses tied with cord. The person who intends to kill someone takes grass from his fields and places it on the corncob. Naming and expressing his wishes for the enemy, he wraps a thread around the corncob thereby binding the name to [it]." Ayido also discusses the use of straw (4.26.86): "The sorcerers do not poison with regular powders; they use straw and put powder on the straw and call your name. They put this in a pottery container with water. This then becomes meat and they eat it. When they eat this meat here, you who are over there will die." Grasses or straw also frequently will be mixed with oil and added to *bociɔ* as a means of thwarting sorcerers and assuring in turn that they, in the words of Ayido (5.18.86), "no longer will be able to see clearly into the stomach." As noted earlier, this belief in the danger which sorcerers present when they are able to see into one's interior is one of the reasons why so many *bociɔ* include masses of material covering the stomach area. Like the *sɛ*, for which it is a signifier, straw thus assumes essential characteristics of a mask, conveying at once ideas of transformation and distancing.

Yɛ: Personality and Reflections of the Self

In addition to the *sɛ*, each person also is identified with an ephemeral, spirit component known as *yɛ*. While the former is linked to each person's distinctive identity as a living being, the latter reflects that part of one's persona that both preceeds one and succeeds one after life is over. Stated another way, *sɛ* is that vitality or force given by god (Sɛbgo) which makes one's life unique; *yɛ* is the spiritual essence that serves to connect each person to his or her family of the past, present, and future. As Agossou explains (1972:60–61): "*Yɛ* is the principle of liaison between the dead and the living: *yɛ to mɛ* is the land of the dead. The *yɛ* appears to us as the shadow of the body and finally as the principle of liaison of the two worlds."[40]

Like the *sɛ*, the *yɛ* has important and complex linguistic roots. Maupoil notes in this regard (1981:334) that *yɛ* means "shadow, unbelievable [untouchable, untestable], symbol, and soul."[41] While identified with death, the *yɛ* also is considered to be essential for human life and well-being. As Montilus explains (1972:24), for the Fon, the element behind the human is the *yɛ* because it is this that permits one to survive. In addition to these associations, Segurola suggests that the word *yɛ* also signifies "spider,"[42] and the red powder which derives from the *sotin* tree ("tree of thunder," *latex euphrobe*). These meanings too offer insight into concepts of psyche and complementary features of *bociɔ*.

The *sotin* powder will be taken up first because it has so important an effect on *bociɔ* empowerment and use. *Sotin* powder is a vital component of Fa divina-

tion; a coating of it is dusted over certain offerings to indicate the appropriate *du* sign. Following divination, individuals often will eat a bit of the *sotin* powder. In consuming this powder (which commonly is referred to as *yɛ*), one is thus ingesting part of a divinely sanctioned "sign" designating the specific path one should follow to assure that one has a full and complete life (Maupoil 1981:194). This same powder also is sprinkled on certain *bociɔ* as a means of empowerment.[43] Whether consumed or added to the sculpture, this powder becomes a primary signifier of the individual and her or his destiny as determined in the prelife period. And, like the possessive adjective "my" (which is also called *yɛ* in Fon), both the *yɛ* (as psychological component) and the *bociɔ* are identified as properties and reflections of individual identity. As Montilus explains (1972:24), "The *yɛ* constitutes the fundamental and last element of humans."

In appearance, interestingly enough, the *yɛ* often is described as a mirror image (though in miniature) of the person. Asked to characterize the *yɛ*, Agbanon suggests (2.27.86): "if I stick out my tongue, . . . my *yɛ* will stick out its tongue. If you laugh, your *yɛ* also will laugh. If you dance, it dances." The *yɛ* in this way assumes essential qualities of a shadow.[44] As was explained to Montilus (1972:18), "Where there is sun, we see the *yɛ* behind us." According to Agossou, the *yɛ* in its intangible qualities additionally is identified in important ways with the unseen world of the spirits and the dead (1972:60–61): "If the body is accessible to the touch, the *yɛ* is not. *Yɛ* carries a notion of mystery. *Yɛ si* means invisible." Mysterious, and a liaison between the dead and the living, the I and not-I, the *yɛ* is identified with *bociɔ* in numerous ways. Perhaps most significantly, both are identified with the dead (the *ciɔ* of *bociɔ*, we recall, means "cadaver").

Features of the body associated with the *yɛ* also are of interest in this regard. Most important are the head (especially the summit and the eyes) and the blood. According to Montilus, (1972:21) the long *yɛ* (or *lindon*) "is seated on the head, above the brain."[45] In some *bociɔ* the head is shown to be enlarged at the summit or crown in part for this reason (fig. 89). A person's *yɛ* also is said to be reflected on the surface of one's eye, taking the form of the bright, shiny, spot of light reflected on the pupil.[46]

This eye-form *yɛ* is artistically represented in many *bociɔ* through the enlargement of the eyes. In some *bociɔ*, in addition, a horizontal line is incised across the center of the eye to represent the *yɛ* (figs. 89, 90). Ayido explains (5.5.86) that within such sculptures, "we make this line across the eye because of the *yɛ*. We cannot (carve the eye) so that the *yɛ* actually stays on it . . . [Instead] we took something that is comparable." Sagbadju concurs (8.2.86) that "the line one draws on the eye refers to the *yɛ*." Marking as it does a medium, horizontal plane across the eye, and suggesting the closed lids of someone who is sleeping, the horizontal eye line connotes the protective powers and abilities of the *yɛ* to guard one even when one is asleep.[47] As Sagbadju explains (8.2.86), "We do this because if one closes one's eyes, one can no longer see." One of Maupoil's sources noted (1981:386) that the *lindon* (long *yɛ*) is "the eyes of humans," suggesting

89. Hwla figure. Republic of Benin. Wood. Height: 33 cm. Positioned in front of the house to distance malevolent forces. Collected by Edouard Foa in 1891. Musée de l'Homme, Paris. Gift of Foa. Cat. no. M.H.91.22.41. Published by Merlo (1977: fig. 7).

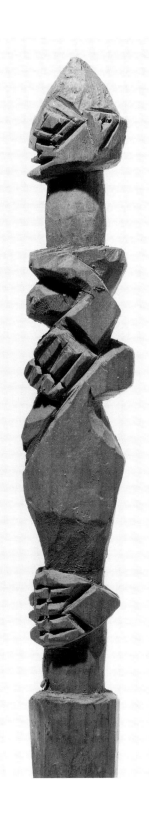

to this scholar that it affects all the organs, announcing danger.[48] The bisecting of the eye in many *bociɔ* works reaffirms in this way the critical protective roles of sculptures of this type.

As noted earlier, in addition to alluding to the closed lids of sleep, this horizontal eye line is an important signifier of death. As such, associated closed-lid eye forms also refer to a range of powerful emotions centered on dying or potential demise. Like the *yɛ*, the *bociɔ* is linked at once to the preservation of life (as guardian of one's being) and to the inevitability of one's death. The bisecting of the eye in many *bociɔ* at the same time is said to recall the horizontal line which cuts across the surface of cowrie shells, the precolonial currency in the area. Like the *yɛ*, cowries are key signifiers of human life and death, alluding both to properties of well-being (wealth) and to the inevitable transference and transformation of one's life. Certain *bociɔ*, particularly "call *bo*" and those empowered by vodun, are defined in turn by their cowrie-shell eyes (fig. 91).

The *yɛ* also is associated in essential ways with blood. The link between the *yɛ* and the life-giving (and life-depleting) properties of blood is of critical significance for many *bo* and *bociɔ*. Maupoil notes in this light (1981:334) that "the blood contains *yɛ* . . . [and, for this reason] the life force or *yɛ* of one entity is transferable to another." Many *bociɔ* accordingly are characterized by a thick patina of sacrificial blood—evidence of the years of offerings employed to activate and reactivate the sculpture. This blood serves as a means of transferring the vital *yɛ* powers of a living being to an inanimate object (the *bociɔ* sculpture) in the course of its empowerment as an object to be used in the service of humans.

Where blood is not used for this transfer, a similar result is achieved by sprinkling *yɛ* powder—the fine red dust employed in Fa divination—onto the surface of the sculpture. In both cases, a red substance (the color of life, danger, death, and power) assumes the role of transferring medium. This feature is critical, for many such *bociɔ* sculptures address concerns and fears raised vis-à-vis the ability of one being or power to take the life of another by transferring or sequestering its spirit essence. The *yɛ* as a source of transferential and transformative power shares in this way qualities of a mask. So too in *bociɔ*, powerful results are meant to be achieved through a process of exchange, transference, and substitution. Both the *yɛ* and the *sɛ* as liminal, life and death–associated complements of the psyche play an important role in the context of this exchange. As visible and invisible shadows which delimit and frame the person, the *yɛ* and *sɛ* have a critical function in individual identity and well-being.

Aziza: Agents from the Spiritual Wilderness

In addition to the liminal penumbra complements described above, each individual also is identified with a range of agents external to the person which influence identity and life course in significant ways. In the context of these agents of indi-

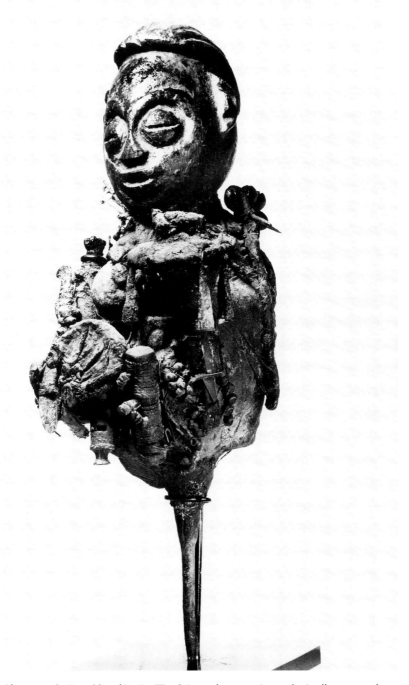

90. Fon *bociɔ*. Abomey style. Republic of Benin. Wood, iron, glass, cowries, and miscellaneous surface materials. Height: 46 cm. Among the materials added to the surface are a knife, a glass bottle, a miniature *asεn* memorial staff, miniature slave manacles, and an iron axe. Probably collected in the 1960s. Former collection of Ben Heller. Photograph courtesy of Ben Heller.

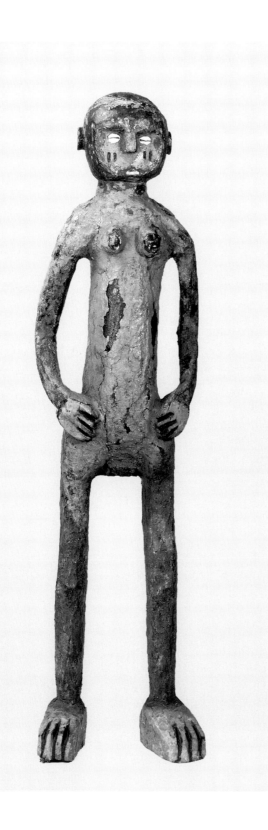

91. Gen female figure. Aneho, Togo. Wood, cowrie shells, pigment. Height: 91.7 cm. The marks on the cheeks are sometimes found in the lower Mono River area in association with priestesses. Collected by Preil in 1907. Linden Museum, Stuttgart. Cat. no. 48 990. Published in Cudjoe (1969: fig. 31).

92. Fon male *bociɔ*. Abomey, Republic of Benin. Wood, beads, cord, cloth, pigment. Height: 58.4 cm. Amputated leg and outstretched hand. Mid- to late twentieth century. Carved by Benoit Houndo, the same artist as in figs. 68, 118, and 125. Indianapolis Museum of Art. Cat. no. 1986.188. Gift of Dr. and Mrs. Wally Zollman.

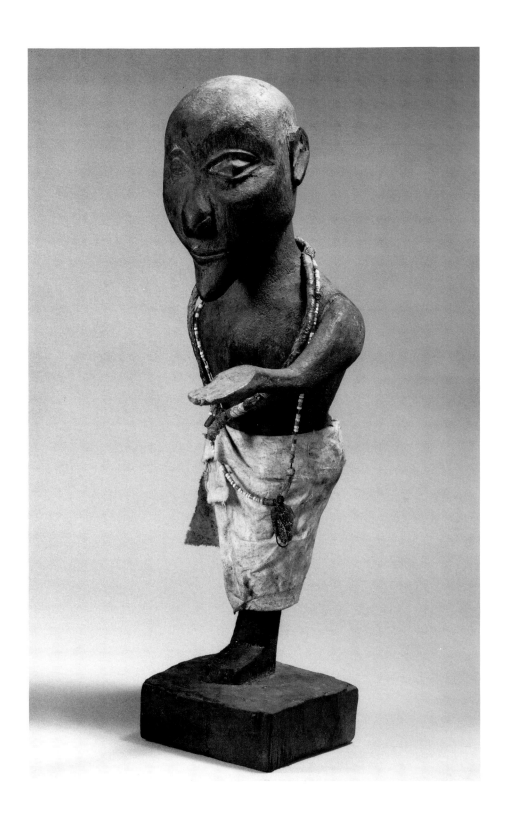

vidual action and empowerment, ideas of mastery and masquerade again come into play. Each person is identified with a diversity of such forces, which individually and together provide humans with the "gifts" which enable them to assume particular roles in life. Among the more important of such spirits are the forest beings known as *aziza* (figs. 31, 92).

As noted earlier, the *aziza* are identified at once with the forest (specifically with the place of humans within the natural realm) and with the discovery of *bo* and *bociɔ*. They also play a part in human conception and creativity. Agbanon explains (3.18.86) that "it is the *aziza* who create humans so that they can come into the world. . . . A man has sex with a woman without any idea that she will get pregnant, but later a baby is born. The *aziza* brings [the fetus] to the *tɔhuiɔ* [*tɔxuiɔ*, clan ancestor], and the *tɔhuiɔ* brings the fetus to the mother." [49] Conception cannot take place, in other words, without the participation of *aziza*. The role of the *aziza* in the psychological identity of the person also is considerable. Not only are the *aziza* linked to the origins of life, but also they are seen to bring to one essential skills and abilities. According to Agbidinukun (5.3.86), "*Aziza* is the good fortune which you have in your head." To Hazoumé (1956:138), "*Aziza* represents for the Dahomeans the summary of the perfection of the things of the world." Gifts or talents are believed to derive from the *aziza* as well. Asked whether a child could become a diviner when his father was still alive, Ayido answered (3.9.86), "Only if his *aziza* gave him this." One of the means of designating that a singer is gifted is to suggest that "he sings like an *aziza*" (Hazoumé 1956:138). [50]

In addition to the roles described above, the *aziza* are seen by some to constitute a unique "spirit" component of the person. Like the *yɛ*, the *aziza* is said to be visible as a reflection on one's pupil. As Ayido explains (5.2.86), "The *aziza* resembles a small person on the eyes." This identity of the *aziza* coincides with the idea that the eyes reflect one's soul. *Bociɔ* sculptures also enter into this, as Ayido remarks (4.25.86), "For your *aziza*, when you look in the mirror, you will see your real self inside. It is like that, that the *bociɔ* sculpture also is."

Important too is the belief that the *aziza* as externalizations of the psyche are a source of both individual strength and potential demise. In part this is based on the *aziza's* association with the empowerment of words through names and naming, a function context that is considered vital to the efficacy of *bo* and *bociɔ*. Ayido explains (4.25.86) that "*Aziza* created each person. Thus if one takes something and calls your name on it, and says that it is you who put the thing on it, even if you are in Europe and one says that it is you who put it on it, you will die." The mere fact of saying one's name in conjunction with *bo*, therefore, can have a disastrous impact on one's well-being.

The *aziza*, through its association at once with human conception and names, thus is able to maintain and control important facets of individual life. [51] In this too there are vital sculptural complements. Ayido asserts accordingly (5.5.86), "When the sorcerers make a *bo* they treat you as if you were a statue and they

call your *aziza* in it. In doing this it is the *aziza* that they trick and take to eat at their house." Particularly significant in the above are the references made to sculpture, speech, trickery (subterfuge), and consumption (internalizing, trans-forming),—all concepts central to *bociɔ* functioning. Essential here as well is the idea that *aziza*-derived powers, especially talent, skill, good fortune, and incep-tion, constitute the intangibles in each individual's life that *bociɔ* most frequently address. And, in the same way that the *aziza* is identified as an invisible being that resides deep within the recesses of the forest, so too are *bociɔ* believed to draw on and reflect the invisible, deeply recessed world of human emotions.

Vodun: Individual Empowerment from the Realm of Gods

Each person, in addition to being identified with various *aziza*, also is associated with a range of empowering divinities or *vodun* which bring to one special bene-fits. Many of these gods play a critical role in the activation and functioning of *bociɔ*. While certain of these *vodun* are thought to participate in the lives of all humans, others select only certain individuals and make themselves known to such persons shortly after birth through divination. With respect to the latter, Falcon explains (1970:137), "Each individual possesses a god [gods] to whom he owes a particular devotion. From the birth of the child on, Fa reveals this god and lets one know the laws that the newborn must follow." These individual sponsoring gods stand apart in key respects from the universal deity sponsors who are identified with the safeguarding of human life regardless of one's divina-tion sign. While deities play a range of individual and universalized roles in the lives of humans, most display both identities, but in different contexts and at different times. Because individual deities are discussed in greater detail in chap-ters 2 and 8, here we will address only key universal deity sponsors and the insight they offer into the identity of the person and the functioning of *bociɔ*.

One of the most important of the universal deity sponsors in the context of both life course and psyche is Fa, the patron god of divination. Through the aid of this god, individuals learn not only of their prebirth destiny and deity sponsors but also the means to dissipate or resolve particular problems which occur in the course of daily life. To understand the role of Fa in the individual psyche, one needs to know something of the divination system itself. As with the Yoruba tradition of Ifa, the Fon and Evhe system of Fa divination contains 256 signs, or *du*, each consisting of a pair of elemental signifiers which have unique identities and deity correspondents. Not only is each individual associated with one of the 256 *du* signs,[52] but additional signs also are brought to one's attention through-out life in conjunction with divination sessions pertaining to particular events or incidents that affect one's well-being. Both types of *du* functions are important, for each sign is encoded with the phrases necessary to address problems that stand in one's path.

Listed below are eight of the sixteen elemental *du* signs. In the accompanying

shorthand summary (after Amouzou 1979:222–25, based on Evhe terminology) we see something of the range and potency of concerns which are expressed in each *du*.

Gbe: life, existence. *Gbe* is associated with fragile health but longevity. Also, luck, happiness, creativity, and family accord.

Woli: heat, evil, hostility. *Wo* signifies "sun" and "noon." *Woli* means "there is heat."

Sa: magic, sorcery. *Sa* means "make a knot" and by extension, "make oneself by magic, master of something." In Evhe *gbe sa* ("speech knot") means "incantatory speech."

Abla: the power to attach. *Abla* means "to attach." Linked to the serpentine god Dan, dispenser of the wealth of the world, this sign is thought to bring riches.

Fu: creation, birth. *Fu* means "white" and "pregnancy." This is a sign of the forces of Mino*na*, goddess of childbirth and sorcery (*na*).

Tula: speech, dispute. *Tu* means "spit" or "detach." *La* means "the one who does something." *Tula* controls speech, the saying of both good things and bad.

Lete: oppression, compression. *Le* means "you"; *Te* means "oppressed," "compressed," "blocked." Thus *lete* signifies, "You compressed me, you blocked me."

Yeku: death. *Yɛ* means "shadow" and "soul"; *Ku* means "death." *Yeku* refers to the souls after death.

Every *du* sign additionally is associated with a series of proverbs, songs, and tales which underscore its salient themes. As noted above, each *du* sign is a combination of two of the sixteen elemental signs. The *du* sign Abla-Lete, which combines essential features of its two elemental signifiers, *abla* and *lete*, is a case in point.[53] This sign refers to a full, rich, prosperous life, but also to an existence sometimes marked by oppression and difficulty. Other signs similar draw on the essential concerns of their primary signifiers.

Even in the very partial and summary accounting of Fa presented here, what stands out are the range and potency of psychological values expressed herein. Among other ideas addressed in the above eight *du* are the following: life, fragility, creativity, happiness, heat, evilness, hostility, magic, sorcery, knotting, attachment, wealth, creation, birth, speech, dispute, oppression, and compression. Taken together, the 256 *du* signs convey the full range of human fears, hopes, and concerns.

Legba, the trickster and messenger god, also is an important universal deity sponsor whose impact on individual identity is strongly felt. Although Legba's sculptural representations often are distinctively phallic, this god provides critical empowerment to both men and women. Like *bociɔ*, Legba is closely associated with human emotions and with the revelation of those potent feelings which are

generally left unsaid. Maupoil notes in this regard (1981:78–79) that "Legba is to the divinities and Fa what the shadow is to the person, that which the reverse is to the inverse. . . . Legba symbolizes at the same time vice and the revenge of repressed instincts." As noted earlier, among the emotions most closely associated with Legba are anger and sexual desire. According to Ayido (3.29.86), "Because of his anger, Legba presses people to make others mad." A number of *bociɔ*, through their emphasis on the tieing of cords around the stomach, refer in a direct way to the heat of anger identified with this god. Frequently Legba's anger also takes on a sexual identity. As Maupoil explains (1981:79), "The anger that Legba represents is equated with the erection, and both are manifested by the flow of blood." Male *bociɔ* figures, as we have seen, sometimes display an enlarged or erect penis. Pegs, pins, or other penetrating elements are also an important feature of many *bociɔ* works (fig. 93).

Yet another of the universal deity sponsors critical to each individual's identity is the serpent-resembling god of wind and motion, Dan (Dangbe). According to Maupoil, this god plays a central role in providing humans with the power of mobility (1981:74):

Materially [Dan's] role in the world is to assure the regularization of the forces producing movement.[54] . . . Life is one of the mysterious movements . . . that Dan has as a mission to maintain. . . . Charged with conducting [the souls] from the sky to their residences on earth, one says that he divided these powers between two subordinate Dan. The popular cult of *hon-dan*, the serpentlike umbilical cord, materializes this belief. The umbilical cord brings in effect the child all the way to the earth where the mother gives birth. But that which one worships in honoring the palm (*hon-de*) at the foot of which his *hon-dan* was buried is the work of another Dan, the masculine organ that assures his birth.

What the last sentences refer to is the tradition described earlier in which the umbilical cord of each infant is buried under a palm tree, which in turn becomes the child's special property and sign. Dan, like the palm tree, is a locus of identification for the child, representing this person's capabilities in life.

In addition to the umbilical cord, the *vodun* Dan also is associated closely with cord-related anatomical features such as the navel, veins, and ligaments. Ayido explains (3.29.86) that "the navel is the person's Dan; everyone has one." Dan's association with the veins that carry blood through the body and the ligaments that allow movement also is important. Both ligaments and veins share the same Fon name, *kan* (cord), a form of some significance to *bociɔ*. Ayido's comments are interesting in this regard (6.29.86): "When these ligaments are working for you, you are able to move around normally. The *kan* of the body are like the spokes of the bicycle." Like *bociɔ*, in other words, the ligaments enable one to move effectively in the world. Because many *bociɔ* sculptures are bound with cord (fig. 94), they convey visually both the importance of locomotion and the immobility which often traumatizes individuals as a result of fear, disease, or other difficulties which such works address.

Gu, the god of metal, war, and technology, also is a vital universal deity spon-

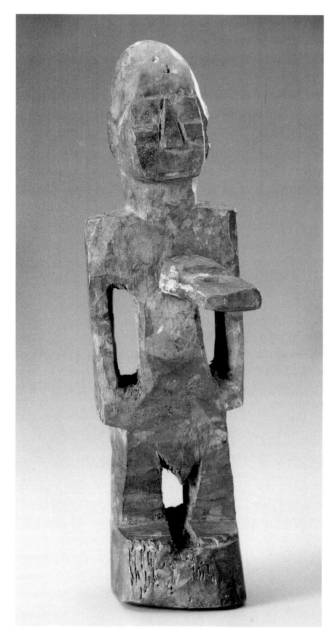

93. Aja *podohome-bociɔ.*
Bopa (on Lake Aheme),
Republic of Benin. Wood.
Height: 18 cm. Peg inserted
into chest. Figure called
Tsakatou. Collected by
Michael and Shirley Furst,
1965–68. National Museum of
African Art. Eliot Elisofon
Archives. Smithsonian
Institution. Cat. no. 68.32.14.
Gift of Michael J. Furst.
Photograph: Franko Khoury.
1992.

94. Agonli *bociɔ.* Female
figure. Agonli (area of Cove-
Zagnanado), Republic of
Benin. Wood, fiber. Height: 20
cm. Called *Soh* and used to
solve female disputes.
Collected by Michael and
Shirley Furst, 1965–68.
National Museum of African
Art. Eliot Elisofon Archives.
Smithsonian Institution. Cat.
no. 68.32.11e. Gift of Michael
J. Furst. Photograph: Franko
Khoury. 1992.

sor. As Ayido explains (4.19.86), "Gu opens the road for you. He is looking to
see where you will go." This god is introduced to one at birth when the midwife
cuts the umbilical cord with a metal knife[55] (theoretically with the aid of a *gubasa*
knife consecrated to Gu). As Brand notes (1976:46), "In cutting the cord, the
midwife . . . invokes Gu." Because this *vodun* is said to bring to each individual
essential features of strength, another body feature closely identified with Gu is

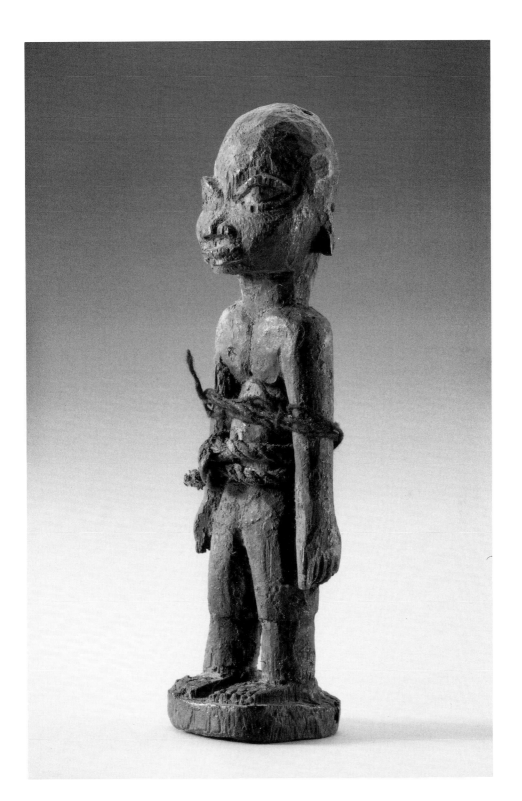

the arm. The raised arm accordingly serves to signify both the force and the power which this god offers. For this reason, raised arm gestures are particularly prominent in royal *bociɔ*. Within commoner *bociɔ*, the arms are rarely shown in this raised gesture. References to Gu are made in these works instead through the use of iron in the carving process, the killing of sacrificial animals, the cutting of associated cords, and the insertion of pieces of iron into the work along with essential empowering materials. Like the other deities discussed here, Gu thereby helps to assure individual empowerment in fulfilling life's potential.

Conclusions

In this chapter we have seen the central place of the psyche in defining the human as someone who is at once an actor and director in the larger performance of life. Not only does each person select his or her own destiny before birth, but each comes into the world with destiny's mark imprinted on the palm of the hand. At once a figure of the past (a reincarnated ancestor) and a bearer of death in the family, each infant represents within itself a paradox, someone both more than and less than what she or he appears to be. Every child enters the world as a cover, replacement, substitute, and mask for someone else.

Each person in turn is associated with a range of incorporeal forces which individually and together form a critical part of one's identity and means of mastery. From the high god, Sɛgbo-Lisa, come the *sɛ* and its association with destiny and morality; from the ancestors derives the *yɛ* with its connections to thought, protection, and creativity. Together these energies or shadows serve at once to distinguish persons and to define them within the larger framework of an interactive, spiritually empowered universe. Added to these variant powers in the construction of the psyche is the sponsoring ancestor (*jɔtɔ*), who functions not only as a critical link with the past but also as a vital source of individual character and physical appearance. The forest-dwelling *aziza* are important in this *mixtura* too, for these beings not only play a part in conception but also bring to one particular talents and skills.

Finally, to the formation of each individual's psyche one must add a range of *vodun*, including, among others Fa (holder of destiny, knowledge, and the advice necessary for survival), Legba (the quixotic bearer of instincts and emotions who stokes the passions of anger and sexual drive), Dan (conveyer of energy, the powers of movement through life, and nature's blessings), and Gu (provider of the courage and strength necessary to attain one's desires). Emerging from the above is a clear if complex picture of the psychological framing of the person. In this conceptualization we discern both the essential identity of humans as active participants seeking mastery in life and the critical role of *bociɔ* in providing one with the means of achieving these ends. We also see in the above the important identity each shares with respect to the I/not-I, self/other, and masker/mask of the human persona.

Alchemy and Art: Matter, Mind, and Sculptural Meaning

"Art is the objectifying of the will in a thing or performance, and the provoking or arousing of the will."

—Susan Sontag, *Against Interpretation*

"Listen more to things than to words that are said."

—Birago Diop, *Leurres et lueurs*

Just at that moment the healer appeared. Never had I seen Zannou so diligent. No muscle in his face moved. He crouched before the fire and spilled there a bit of the contents of two bottles. He chewed some kola and a few grains of pepper, spit them onto the egg that slid under the embers. He planted the tail of the goat on the mound of fresh earth, grasped the twinned gong with its wand, and began to walk around the fire from left to right reciting the magic formulas.—Pliya 1971:84[1]

In the quiet of their laboratories alchemists believed they had all the elements of creation at their beck and call. They dazzled themselves with their power to transform matter into new forms, shapes, smells and colours. They dreamt that they could pull the strings of the universe and harness nature to human needs. Tending their flasks and furnaces, they pondered the magic of chemistry and interpreted the wonders they beheld on many different levels, the physical, the spiritual, and the psychological. For them science and religion were still one, and they epitomized the discoveries they made in their laboratories in bizarre symbols which speak to the soul as well as the body.—Coudert 1980:145–46

Alchemy, the speculative study of material transmutation, has been identified in its various settings with a farrago of concerns, ranging from the manipulation of matter in order to form new substances, to the seeking of cures for particular physiological problems, to the discovery of methods to cleanse the soul or prolong life. The practice of alchemy in this way assumes attributes of a text resultant from and reflecting the distinctive features and circumstances of its reading. Because there is a correspondence between the conceptualization of the universe at large and perceptions concerning the inner world of the human mind, the variant qualities which come to be identified with matter in alchemical discussion offer critical insight into the understanding of the mind and the emotions.

Although rarely explored in the context of sub-Saharan Africa, alchemy's roots in the West and Near East are held by scholars to lie in Egypt, the term "alchemy" itself deriving either from Khem, the Hebrew name for the land of Ham, or from *keme*, designating Egypt's black earth and alchemy's *materia prima* (Read 1947:2; Burckhardt 1986:16). Associated practices in turn were transmitted to Islam under the moniker of *al khem*. As Burckhardt explains

(1986:16–17): "In favour of an Egyptian origin of Near-Eastern and Western alchemy is the fact that a whole series of artisanal procedures, related to alchemy and furnishing it with many of its symbolic expressions, crop up as a coherent group, from late Egyptian times onwards, finally making an appearance in medieval prescription books." One Greek writer in the early part of this century has dated the birth of alchemy in Egypt to around 718 B.C. following the invasions of Ethiopia (see Stéphanidès 1922:192). If this is true, it suggests the possibility of a sub-Saharan African influence on the development of Western and perhaps Near Eastern alchemy. While the question of the possible Ethiopian roots of Near Eastern and Western alchemy has no real relevance for the arguments presented here, since the alchemical principles discussed below appear to have developed independently of both, the finding is important to the extent that it allows us to see the tradition in a global and more deeply historical perspective. In the following analysis of *bociɔ* alchemy, I wish neither to overemphasize sameness between African and other world alchemies, nor to propose a source for African traditions in alchemical practice elsewhere, but rather to suggest that complementary issues are raised in these various areas and important related questions of matter and mind need to be addressed accordingly.

While alchemy as practiced among the Fon, Aja, Evhe, and related groups, clearly is different from that in the Near East and West in that no single primary material (such as gold or lapis) is privileged, it does share a number of features in common with alchemy traditions elsewhere.[2] Most striking (if fortuitous) is the prominence of a serpent biting its tail, an image which is both alchemy's ancient symbol (the *ouroboros*) and a gloss for the name Danhomɛ (fig. 95), the latter translating as "in the middle of the serpent" (*mɛ*: in; *ho*: stomach or interior; *dan*: serpent—Dan also being the name of an early royal rival). Coudert writes (1980:142) with respect to the *ouroboros* as alchemical sign, that "The serpent has no beginning and no end; it devours itself and renews itself. Life and death, creation and destruction are an unending circular process; out of the one comes the other." Although the Danhomɛ serpent symbol undoubtedly was invented independently, the concerns are in many respects similar.

Through the years, the sources and signs of alchemy have been a focus of considerable scholarly interest in fields as diverse as the history of science, psychology, medicine, comparative religion, and the history of art, to name but a few. Among the better known and more comprehensive of such studies is C. G. Jung's analysis of alchemy and psychology (1953). In this work he suggests[3] that whatever the alchemists' other intentions, they necessarily also project features of their own unconsciouses onto the understanding of the materials with which they are working. As Jung notes (1953:231), "The alchemical *opus* deals in the main not just with chemical experiments as such, but with something resembling psychic processes expressed in pseudochemical language." While many scholars rightly have voiced disagreement with Jung's ahistorical mixing of data and his underlying thesis of universality, clearly any study of matter and the means and

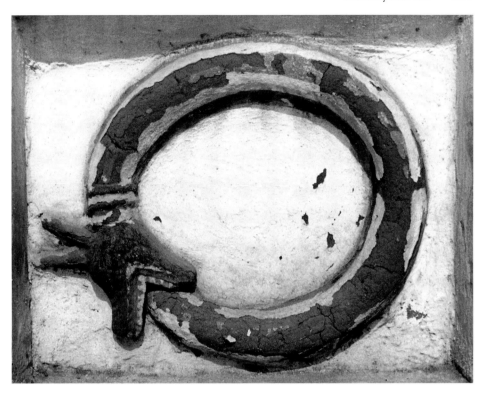

95. Bas-relief from the palace of Guezo. Abomey, Republic of Benin. Symbol of the kingdom of Danhomɛ, a serpent biting its tail. The kingdom's name means "in the middle of [homɛ, xomɛ] the serpent [dan]." Photograph: Suzanne Preston Blier. January 31, 1986.

ends of its transmutation carries with it insight into the variant features which constitute the mind. Burckhardt suggests accordingly (1986:103) that alchemy's *materia prima* is "both the primary substance of the world and the basic substance of the soul." As Needham explains it (1983:5, 6–7):

[I]n the ancient and medieval laboratories the adepts had certain psychological experiences which they attributed to the chemical processes, not realising that these had nothing to do with material elements and compounds as we know them today, but were projections from themselves. . . . In changing Nature [the alchemist] . . . was, more importantly, changing himself, and [when] engaged in transmuting ignoble substances . . . he was in fact walking along the path of an enobling salvation of himself. Individual mental health, in psychological terms, was what he was really after, the integration of the personality, with freedom from fear, depression, oppression, and "all evil thoughts which may assault and hurt the soul."

In Western alchemy, pseudoscientific and spiritual qualities thus were closely integrated.[4] This cojoining of matter and mind was also true in the Arabic world and in the East. As Habibeh Rahim writes regarding Islamic alchemy (1987:196), "The terminology and procedures of alchemy were allegorized and

applied to the transformation of the soul from its base, earthly, impure state to pure perfection. Elementary psychological postulations were allegorized as chemical properties." In China, similarly, as Coudert explains (1980:83), "By the thirteenth century Chinese alchemy had become almost exclusively a technique of meditation, and alchemical processes took place in the body of the adept, rather than in a laboratory." [5]

Question of complementary psychological concerns also are important in African alchemy as contextualized in *bo* and *bociɔ*. One frequently finds in associated traditions that practitioners draw on a range of emotions in the course of creating related objects.[6] In the cojoining of alchemy and mind in this way, important features of projection come into play.[7] Moreover the various animal and plant parts incorporated into *bo* and *bociɔ* as additive surface matter are identified with a range of psychologically potent powers and properties having grounding in the expression of human desires and fears. The following list of animal attributes provided by Mehu (7.7.84), a seller of *bociɔ* and their empowering surface materials in the Be market in Lome, makes this clear.

Chameleon: to change one's life
Goat: to treat headaches
Hornbill: to have force
Hedgehog: to protect oneself or others
Bat: to prevent stomachaches
Parrot: to promote memory and to help in exams
Duck: to attack other individuals
Sheep: to treat headaches and stop another from talking
Turtle: to distance bad things from oneself
Crocodile: to protect one from malevolent forces
Owl: to promote sorcery, also to protect one from it
Frog: to protect children
Pangolin: to protect one from gunshot

Like alchemical forms everywhere, *bociɔ* sculptures place a primacy on natural signs and related means of signification. As Kossou notes (1983:60, 62–63), "In a general way the Fon always wants to know what something (*nu*) serves (*wa*) for. . . . The world is a place of signs. It is experience in life . . . that gives spirit knowledge . . . to these signs." The secret of each *bociɔ* sculpture's power, potency, and psychological expressiveness accordingly can be found in the reading of its multiple surface signifiers. Essential to alchemy generally (and *bo* or *bociɔ* alchemy specifically) is the care given to incorporated matter (fig. 96)[8]. As Jakobson suggests for linguistic signs (1987:98) each involves two modes of arrangement, selection and combination. In alchemy this process of selection and combination is guided by a belief in an underlying order in the natural world.[9] In *bo* and *bociɔ* these qualities can be observed not only in the care taken regard-

ing the choice of additive plant and animal parts (the subject of this chapter), but also in the incorporation of supplemental containers, cords, beads, metal, and other surface materials (the subject of the next chapter).

Related sculptural forms also can be seen to complement alchemy in expressing what John Dewey calls (1934:18) a concern with dissolving categories of time and space, physicality and spirituality. As transformative by-products, *bociɔ* address and illuminate perspectives of the self as well as the variant means and ends of personal change. In this way, they represent a form of "metaphysical consciousness," to use Wilhelm Dilthey's term. These arts, like alchemy generally, are grounded not only in an imaginative vision of the world but also in a search into critical issues of life's meaning. Through comparable processes of deconstructing and reconstructing reality, *bociɔ* sculptures are defined through related alchemical values.

Alchemy's dual valuation of constancy and transmutability additionally corresponds with the principal orientations and aims of *bociɔ* sculptures in maintaining life and encouraging well-being, particularly by transforming and dissipating situations of difficulty or potential trauma. Elemental and transmutable materials, in the context of additive surface motifs, in this way also reinforce key psychological values regarding the power of the individual to bring about change.[10]

As objects of force, *bociɔ* often express through surface matter selection a related concern with individual identity, emotions, and the senses. This personal and proprioceptive quality of additive sculptural materials in turn affects user perception in important ways. The following example provided by Sagbadju (7.1.86) suggests the ways in which related concerns are emphasized: "When the *bociɔ* maker attaches the thing, he . . . puts dirt in it, cords in it, pieces of mat, a person's hair in it, cloth in it. He gives it salt and alcohol and water and passes soap over it and a piece of comb as well as a piece of broken mirror. If the person is using any one of these things, my *bo* will go see him." Personal and sensory factors, however, are but a few of the divergent issues factored into the choice of particular additive parts (fig. 97).[11]

In this chapter a range of concerns of significance to alchemy and art are taken up, beginning first with ideas of medicinal and religious complements, then turning to the primacy of parts (the role of division, dislocation, and dissolution), anthropomorphism (and related oppositional values), and artistic organicism, materiality, and production. Next to be addressed are linguistic complements (wordplay, metaphor, indexical relationships), modes of meaning (metonymy, myth, material condensation), and textual density. In this analysis greater attention will be paid to art than to science (or pseudo-science). The intent is not to be encyclopedic; accordingly only animal and plant parts as additive alchemy materials are treated in this chapter, and these with an eye toward issues raised rather than comprehensiveness.[12]

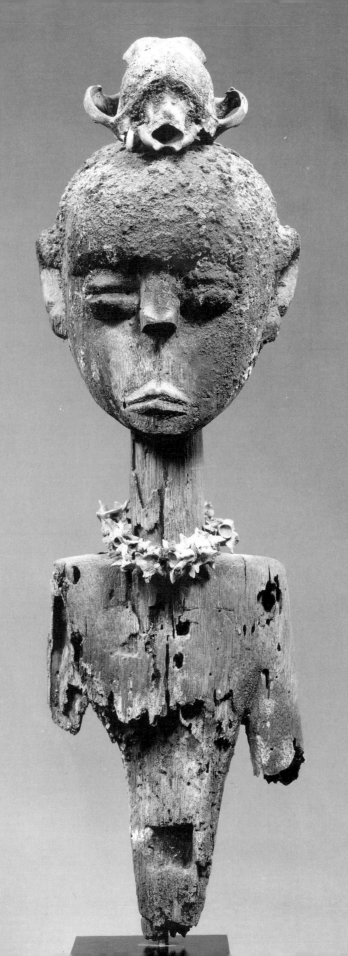

96. Fon *Janus*-form *bociɔ*. Republic of Benin. Wood with dog skull and serpent bones. Height: 50 cm. Probably collected in the 1960s. Former collection of Ben Heller. Metropolitan Museum of Art. Cat. no. 1984.190. Purchase, the Denise and Andrew Saul Philanthropic Fund Gift, 1984. Published in Leuzinger (1971: fig. H9).

97. Atinwulise Sagbadju, of Abomey, Republic of Benin, preparing a *bo*. Photograph: Suzanne Preston Blier. July 7, 1986.

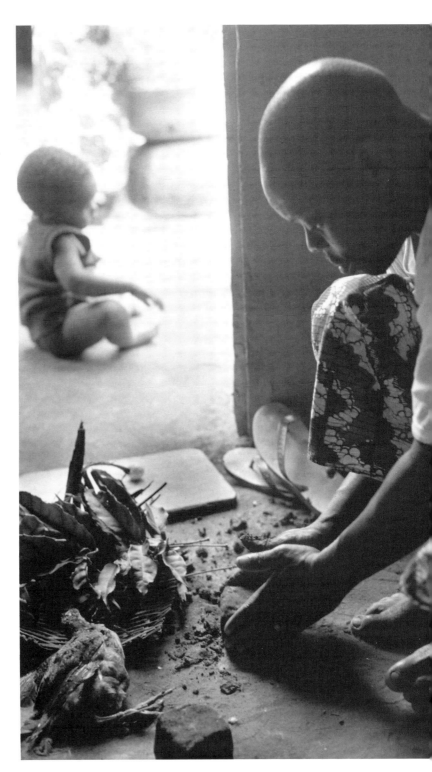

Alchemy in the Context of Doctoring and Deities

Alchemy wherever practiced shares important concerns and features with medicine and religion. In Africa, many alchemy traditions historically have been labeled and discussed under rubrics of "herbalism," "traditional medicine," and "magic." William Siegmann's comments on the Fon generally (1980, pl. 28) are of interest in this light: "There is relatively little sculpture in the region. That sculpture which does exist is largely associated with what is often called 'Voodoo' but which might be better understood as 'the Science of Prevention.' . . . What we might call 'magic' is seen as a science, and one not easily scorned. Traditional medical practitioners know many medicines, but even their 'charms' are not ineffective. At the very least they offer a much needed sense of security." Not surprisingly, in the Fon *bociɔ* arts, as in alchemy, great emphasis is placed on knowledge and practice and what Coudert calls (1987:187) "the esoteric transmission of alchemical doctrines and techniques."

In turn, striking similarities exist between Fon medical and ritual practice and the *bo* and *bociɔ* alchemical arts. In the making of a shrine, suggests Brand (1981:18), "material ingredients such as a piece of stone, earth, bone, iron, animal part, or cloth serve as catalysts of forces that they represent or signify." The same features characterize the fabrication of *bo* and *bociɔ*. Plant selection is especially interesting vis-à-vis ritual or religious complements. As Brand has observed (1981:19), "To know plants is to know also the functioning of cults and the powers of such and such a god. Each god has its liturgical plants." [13] To Agossou similarly (1972:136), "Pharmacopia is one of the forces of the convent. The plants that grow there are selected. They are not there by chance."

Plants also are incorporated as additive surface matter in *bociɔ* because of their significance at once to alchemy and to local medicinal practice. The Fon term for medication (*atin* or *atinkɛn*) means also "tree" or "tree root." This same term additionally signifies "powder" and "poison," substances which play a vital role in *bo* and *bociɔ* aims or orientations. Another term for medication, *amasin*, signifies "leaf water." The link between alchemy, religion, concepts of healing, and trees was observed in this area as early as the beginning of the eighteenth century when Bosman noted (1705:382), "The Trees which are the second rate Gods of this Country . . . are only pray'd to, and presented with Offerings, in time of Sicknesses, more especially Fevers, in order to restore Patients to Health." [14] Today among the Fon and Evhe, plants and the botanical realm function as signifiers of life and longevity. "Sickness," Pazzi explains (1976:182), "is conceived as a malevolent force . . . which can be rejected by the intelligent use of leaves."

Related to the above, the Fon word *amablotɔ* (*ama:* leaves; *blo:* assembling; *tɔ:* master) often is employed to designate both the one who prepares medications and, in a general sense, the one who makes *bociɔ* and *bo* (Maupoil 1981:143). [15]

While most leaves and plant materials are placed in packets or calabashes on the figure's exterior, sometimes, instead, the work is washed in special plant solutions during preparation or use. As Brand explains of one *bociɔ* example (1981:25), "The statue in wood or earth [is] . . . bathed in a leaf solution on which the efficacious words were pronounced." As noted earlier, the Fon word for vegetation, *gbe,* means also "life" and "speech" (Pazzi 1976:108). The word for human, *gbɛtɔ,* thus translates not only as "father (master) of life" but also as "master of vegetation"[16] and "master of speech." Appropriately in contexts of *bociɔ* and *bo,* grass (also called *gbe*) is a frequent sculptural signifier for life and speech. As Spiess notes for one Evhe work (1902:315), "If the thief denies his theft, then the grasses bound to this [work] . . . will shrivel and thus bring the truth to light." Here as in many other examples, ideas of vegetation, life, speech, and humanity are closely bound up with *bociɔ* meaning and use.

The selection of animal features for *bociɔ* surface matter reflect issues of religion, medicine, and alchemy as well. By far the most frequently employed species in contexts of *bociɔ* and *bo* are chickens (*koklo*) and goats (*gbɔ*). Both are identified at once with religious sanctification and with alchemical concepts of spirit liberation and reinvestment. For this reason, chicken feathers or a goat's head (fig. 98) or fur often are applied to sculptures as a means of signaling that empowerment rites have been completed. As Spiess notes for one work (1902:314), "The chicken feathers and the blood-smeared cowrie shells serve to appease the gods." Such features function in turn as a visual cue to their commissioners that future empowering rites require similar offerings. As Sagbadju explains (7.1.86), "One puts the skull of the animal one killed on the figure's head . . . because . . . if you are no longer living, your children will come to see it, and will know that it is the goat that one kills for it." These offerings become a part of the larger sculptural dialogue between the maker, the forces of activation, and the work's sometimes changing corpus of viewers. Sagbadju writes (7.3.86): "As [the sculpture] ate the chickens and goats, one put them on its body, and it will be eating that always. When all the goat is finished, the sculpture will ask for another. Thus the owner knows it has already eaten a goat and he will give it one immediately." So frequently is the goat used in *bo* and *bociɔ* alchemy that a small bone from the head of a goat (which as noted earlier is called *gbɔ*) serves as a symbol for these sculptures in divination (Maupoil 1981:205). This practice finds basis not only in that *bo* and *gbɔ* share a similar name (and are linked through a form of wordplay) but also in the association of goats in local legends with human death and demise. According to a Fa account: "A goat and a dog were sent among humans to bring, one death, and the other life. It was agreed that they would race and the one who arrived first would determine human fate. The two set off together but on the road, the dog found a bone, and stopping to eat it, forgot his mission. Thus it was that the goat, the bringer of death, arrived first, and ever since that time humans have known death" (after Amouzou 1979:63).[17]

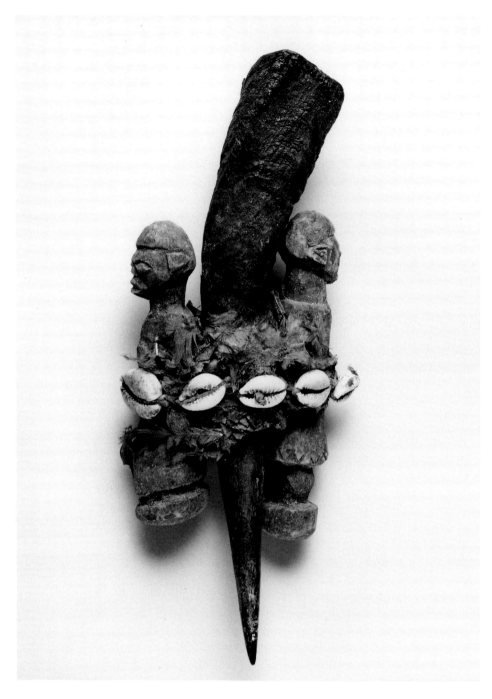

98. Fon horn-form *bociɔ* with two figures. Republic of Benin. Wood, cowries, guib harnaché horn, feathers, fibers, and miscellaneous additive materials. Height: 23.5 cm. Called *Ekpĕ*. Horn is licked in the morning, and the user then spits in the direction of one's potential enemy. Collected by Michael and Shirley Furst, 1965–68. National Museum of African Art. Eliot Elisofon Archives. Smithsonian Institution. Cat. no. 68.32.1. Gift of Michael J. Furst. Photograph: Franko Khoury.

Bociɔ as "empowered corpses" (*bo-ciɔ*) allude in important ways to the existence of death (and deadly illness) among humans, having been borne by the stalwart and steady goat.

Chickens have an equally important role as *bo* and *bociɔ* alchemical signifiers. The hen is identified in this area as the "bird of the ancestors" and for this reason is thought to "sweep bad things from the house" (Agbanon 3.17.86). At the same time, in the words of Ayido (7.27.86), "The chicken is first for Fa," the divination god, through whom deities communicate their desires to humans. Chicken feathers and blood are incorporated into many *bo* and *bociɔ* forms for this reason.[18] The rooster which announces each day's inception with the rising sun, for its part, shares an identity with Lisa and Mawu, the gods of heavenly light (Ahanhanzo 8.12.86). As Agbanon explains (3.5.86), "Mawu speaks to the rooster so that it will sing the arrival of the day." In this way, the rooster like the chicken is associated with human life and well-being. As with the plants discussed above, these birds bring crucial alchemical grounding to each work based on their association with religious and metaphysical empowerment.

The Primacy of Material Parts: Division, Dislocation, and Dissolution

Factors of selection are important in *bo* and *bociɔ* alchemy not only because the materials themselves have religious and/or medicinal attributes, but also because of the powerful ontological properties they are believed to possess. Both in their own right and when manipulated and cojoined in certain ways, these properties are thought to create a dynamic or field of power which can then be employed to offset, counterbalance, or oppose other forces or powers at play in the world. As Brand notes for such works among the Fon (1970:290): "The use of leaves is not enough to make a *vodun* act. [The work] also needs ingredients that permit its installation. . . . The role of material ingredients such as a piece of stone, earth, cloth, bones, iron, etc., is to serve as catalysts of the forces which they represent and signify." *Bociɔ* additive materials in this way function as catalysts of change.

Bociɔ, like alchemy forms generally, are also intended to achieve results which are at once more than and different from the sum total of the material elements which constitute them. With regard to this feature, important parallels to artistic organicism and perception can be made.[19] Central to this organic identity is a concern with material selection, dislocation, and reconstruction. Needham explains the centrality of related processes to alchemy (1983:9–10): "[A]lchemy was always recognised as the art of taking to pieces and putting together again. *Solve et coagula* was one of the great watchwords. Separation and analysis . . . was followed by synthesis and consolidation. . . . [I]n every chemical reaction the properties of the two reacting substances disappear as those of the product or products take their place."[20] In *bociɔ* alchemy this process also is important. As de Surgy points out for Evhe *dzo* (*bo*) forms (1981b:97): "The principles of

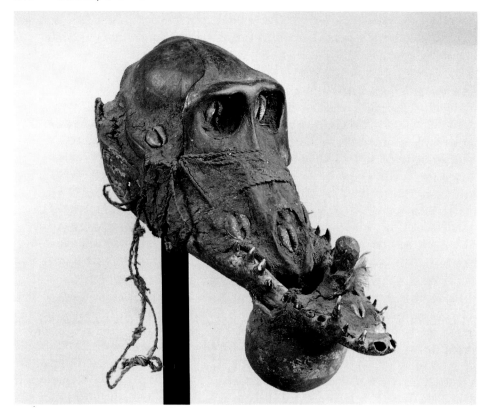

99. Fon? *bo*. Republic of Benin. Baboon skull, crocodile skull, wood, pottery, cord, cowries, and miscellaneous additive materials. Probably collected in the 1960s. Former collection of Ben Heller. Current Collection of Arnold Crane. Photographer: Arnold Crane. Published in *Primitivism in Twentieth Century Art: Affinity of the Tribal and the Modern,* ed. William Rubin (New York: Museum of Modern Art, 1984).

this medicine cannot but be compared to a celebrated alchemy saying: *solve* and *coagula,* because for it also . . . general dissolution . . . must always precede the agglomeration and coagulation of elements."

In additive *bociɔ* and *bo* plant materials, the primacy of parts (and concomitant features of division, dislocation, and reconstruction) is contextualized in various ways (fig. 99). Although every aspect of the plant is of value in *bociɔ* and *bo* manufacture, certain features are emphasized over others for particular purposes. As Sagbadju notes (8.2.86), "The tree that is standing, all that is in it constitutes a *bo*. Some people look for its roots, others look for the bark, others for the leaves, still others for the flowers." [21] In contexts of *bo* and *bociɔ*, leaves have a particularly important role.[22] Stated simply by Sagbadju (7.3.86), "All the *bociɔ* have leaves." Megbe Legonou explains similarly (11.7.85), "The leaves that one puts on the mouth of the *bociɔ*, it is this that you want the *bociɔ* to do."[23] Pazzi suggests in turn (1976:89) that "the leaf holds a privileged place

where the (beneficial or malevolent) forces of nature are concentrated: knowledge of the virtue of leaves opens to humans all the possibilities of action."

In the animal world the privileging of particular parts or features also finds numerous examples. The duck is especially interesting in this regard[24] and the blood and bill are frequently included in *bo* and *bociɔ* (fig. 100). Duck blood is thought to contain elements which make it an apotropaic poison. As Hazoumé notes (1956:98), "The blood of ducks is poisonous. This protects them from both birds of prey and serpents." In its alchemical use in *bociɔ*, duck blood is purported to bring to humans analogous protective results. The relative silence of ducks in turn is a primary factor in the recurrent inclusion of duck bills in *bociɔ* and *bo* sculptures. A well-known Fon proverb explains that "the duck cannot flap its wings and say cock-a-doodle-do" (Akpakun 2.18.86).[25] Accordingly, duck bills as additive surface matter are used to assure a person's silence. In the words of Mehu (7.7.84), ducks help "to trap someone and attach him so he cannot speak." Akpakun explains similarly that with the duck bill, "The person who thinks badly of you cannot look you in the face and talk." Moreover, because of the duck's association with water, it is identified closely with Tɔhɔsu (Tɔxɔsu), the gods of the springs and rivers. When duck features are incorporated into sculptures, therefore, they usually connote empowerment as derived from this source (Savary 1971:4).[26]

As is evident in the above, the privileging of parts and their necessary division and dislocation from the associated animals or plants bring about the death and dissolution of the associated species. This is also a widely held feature of alchemy. In the words of Needham (1983:10): "[T]he alchemist . . . often had to destroy the pleasing properties of one substance or metal in order to gain the still more pleasing properties of the other which he was preparing." At the heart of this destructive process is a vital element of transmutation and transformation.[27] Various themes of putrification and renewal also are found in alchemy.[28] As Coudert explains (1980:114), "Birth and death are the two most powerful sources of alchemical imagery, as they are for all the images man has devised to make sense of his brief passage through life." In *bociɔ*, emphasis similarly is given to themes of pollution, swelling, and putrification in the identification of death with the eventual enhancement or advancement of life.[29] Nowhere is this theme of pollution more clearly conveyed than in the name *bociɔ* itself, with its pointed reference to corpses (*ciɔ*). In additive surface matter, themes of putrification also are prominently expressed through the use of various forms of charred plants, dissected animal parts, and body effluents. One *bo* described by Agbanon (7.3.86), which consisted of a special soap believed to help to protect one from premature death, included among its materials the feces of a duck, chicken, dog, and pig. The dirt and defilement associated with these feces, it was explained, help to ward off danger. Excrement also is employed occasionally in sculptures intended to "render the room and all in it dirty," in the words of Sagbadju (9.7.86)—that is, undesirable to potential thieves.

Heightening the identity of excrement as alchemical signifier, the Fon word for feces, *ada,* is sometimes conceptually linked to the term for both accident and force (*adan*).[30] The selection and meaning of other *bociɔ* additive surface materials similarly are grounded not only in a keen awareness of the role of pollution in nature, but also in an understanding of the processes wherein ideas about the material structure of the world are transferred to the realm of the human psyche.[31]

Anthropomorphism in Alchemy and Art

Within alchemy and art, one frequently finds a shared belief that features in nature have complements in the world of humans.[32] As Bataille has observed (1988:108), "To know means: to relate to the known, to grasp that an unknown thing is the same as another thing known." In *bociɔ,* alchemical anthropomorphism is expressed in essential ways through the selection and signification of plant and animal additive materials. As Kossou explains of the Fon (1983:150), "One considers the individual in relation to . . . nature; his biological being is affected by the power of vegetation." The following examples of plant use as *bo* and *bociɔ* additive matter and anthropomorphic signifiers are in many respects typical:

adjikuin: a marbled grain which represents the birth of beautiful children because the grain, when green, is enclosed in a spiny shell and is very ugly, but when ripe, is beautiful and smooth (Le Herissé 1911:153). In divination this same grain is the symbol for both humans and birth (Maupoil 1981:205, 211).

vɛ: a grain that symbolizes a symbol of social gatherings because it is used in the children's game of "capture" (Pazzi 1976:128).

banana leaf: signifies human birth and regeneration because if you cut the banana, in two or three weeks another grows back (Nondichao 12.23.85).

rozɔ: this parasitic vine is associated with human malevolence and demise because it is so powerful that it eventually strangles and kills the tree that supports it (Herskovits 1967, 2:281).

akpaku: bean leaf; this leaf is used in a *bo* to assure that the person will prevail in a quarrel, because the stalk of this plant climbs any nearby pole or tree "without asking permission" (Herskovits 1967, 2:278).

For animals, a range of anthropomorphic properties also is stressed. As with plants, behavior often is a key component of this identity. In the case of mice (*adjaka*), for example, it is human-valued qualities of stealth that are stressed. According to Sagbadju (7.9.86), one makes "*bo* with mice because they can hide in the room and we will not see them."[33] Human faculties such as speech also are significant in *bociɔ* alchemy and surface material selection. Lizards of various types frequently are introduced into *bociɔ* additive matter because (like ducks)

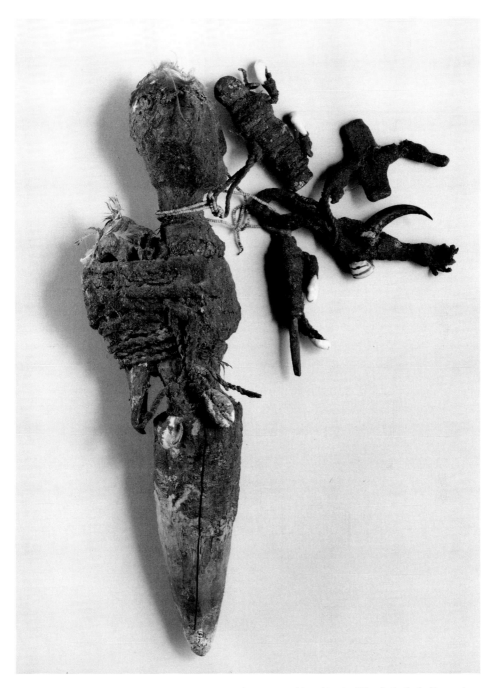

100. Hueda *bociɔ* figure with duck skull. From Dekame, Republic of Benin. Wood, duck skull, cowries, beads, and other materials. Height: 33.5 cm. Called *fiohotse*. Planted in land which has been disputed, or to protect land from false claimants. Offerings of alcohol and rooster blood. Collected by Michael and Shirley Furst, 1965–68. National Museum of African Art. Eliot Elisofon Archives. Smithsonian Institution. Cat. no. 68.32.5. Gift of Michael J. Furst. Photograph: Franko Khoury.

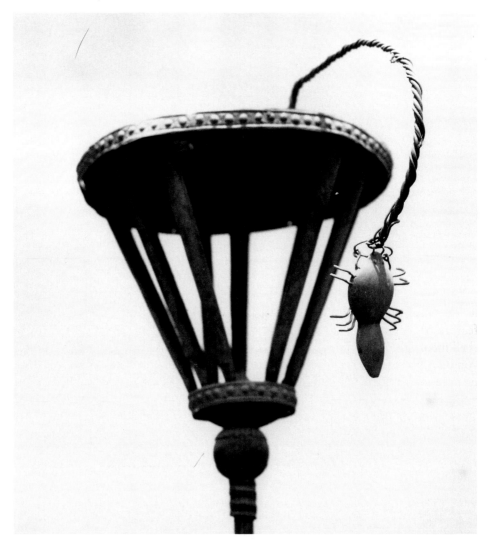

101. Fon royal *asɛn* memorial staff. Abomey, Republic of Benin. Iron, brass. Musée Historique. Depicts a spider attached to a cord. Nineteenth century. Photograph: Suzanne Preston Blier. May 27, 1986.

they generally are silent. The head of a margouillat (gray lizard, *alotrɔ*) is used in works intended to disempower one's enemy by making him or her unable to speak against one. As Le Herissé explains (1911:151), "The margouillat shakes its head as if to speak, but does not." Similarly with the red house lizard (*danlien-lien*), according to Agbanon (3.7.86): "If you do a *bo* [with this lizard] against someone, he will not open his mouth. When he falls ill, he will die. The lizard gives strength to the house. It is that strength which makes the *bo* powerful." The latter, death-associated properties of the lizard find additional grounding in

the Fon use of terms such as "silent" and "closed mouth" to refer to death and the dead.

Spiders (*yɛgletete*) also offer an example of the importance of anthropomorphism in *bociɔ* alchemy with respect to material choice. Central to their signification is the spider's distinctive use of "thread" and unique ability to weave "cloth." As Agbanon explains (3.3.86), the spider web is employed because spiders "weave the cloths of the dead."[34] Spider-associated *bo* accordingly often are identified in some way with the ancestors and the idea of family descent, the spider's thread suggesting the metaphoric cord which unites one generation to the next. In Fon art, spiders frequently also signify the close relationship between a mother and her young. As Ayido notes (6.15.86) of a spider figure which appeared on an *asɛn* memorial staff (fig. 101), "If one attaches oneself to the wall of one's mother one will never go hungry." Agbidinukun explained (7.13.86) the appearance of a spider on *asɛn* works similarly. "The spider carries its egg on its chest; it is for the entire family. . . . In this way the children and women are entrusted to all of the ancestors; they are suspended from their chests."

The turtle (*logozo*) also has special anthropomorphic importance in the context of *bo* and *bociɔ* alchemy (Quénum 1938:87–88). The most frequently cited feature of the turtle is its distinctive, permanently attached "home." Of a turtle shell incorporated into one sculpture, Agbidinukun explained (7.17.86), "When you do a *bo* with the turtle, if someone else throws a *bo* at you it will disappear [i.e., be ineffective]." The identity of the turtle's shell as a protective "house" is important to *bo* and *bociɔ* signification in other ways as well. Discussing the appearance of a turtle on a royal *satɔ* drum, Agbanon cited the following proverb (2.27.86): "I may have nothing, but I am proud of my shell." In other words, even the humble and very poor have something that is important to them. Longevity and wisdom constitute another anthropomorphic feature frequently linked to turtles in *bo* and *bociɔ* contexts. Because they can reach great ages, popular lore and divination texts identify the turtle as a sage and diviner within the realm of the animals (Maupoil 1981:283).[35] An interest in anthropomorphically grounded sensorial experience also is shared in *bociɔ* and other alchemy traditions (for the latter see Silberer 1917). Essential elements in *bociɔ* sculptural activation thus address the senses—sight, hearing, touch, smell, and taste. Body secretions or excretions such as saliva, blood, feces, urine, and menstruum are also important in this regard.

Heat, Cold, and the Alchemical Role of Opposites

The conjunction of opposites is another feature of alchemy, as noted by Read (1947:17) and Needham (1983:10), which have complements in *bo* and *bociɔ* alchemy practice. Pazzi explains (1976:89) that throughout this larger area one divides "hot leaves" (*ama zozo*) from "cool leaves" (*ama fifa*). "The former," he explains, "are used to dry and disperse the malevolent influences, while exciting

the organism to react; the latter are intended to bring the organism back to a state of equilibrium." Similar properties or typologies of "hot" and "cool" coincident with *bocɔ* use and material selection are discussed by Brand. He notes (1981:24–25) that complementary human values of aggression (or malevolence) and protection (antimalevolence) have a critical role in the selection of additive plant parts:

The first category of magical plants—called defensive—serve to immunize the individual against malevolence. The plant employed in this way plays the role of defensive charm. . . . In this category, one [also] includes counter-poisons or antidotes. . . . The second category of magical plants—[those that] attack—serve to set malevolence into action. The plant employed in this way is identified with attack *bo.* . . . In this grouping one adds poisons." [36]

These differences between cool, protective plants and hot, aggressive ones are reinforced in associated physical attributes; prickly or irritating plants often are labeled as hot, while moist or aromatic plants are characterized generally as cool.[37] Like plants, animals also are divided into cool and hot species, the latter commonly including both males of warm-blooded animals and dangerous reptiles, the former consisting primarily of female animals along with birds, fish, and "benevolent" reptiles—such as the lizards discussed above (Pazzi 1976:82).[38] It is important to emphasize with both plants and animals, however, that this dualistic division represents but part of the larger alchemical framework within which objects are considered for inclusion. Two examples from the animal world, the leopard and the snail, convey this in striking ways. Skin from the leopard, a prototypically hot animal, sometimes is wrapped around objects associated with aggression and danger (Agbanon 3.8.86). A host of other hot values also are identified with the leopard in the context of *bo* and *bocɔ*; royalty is one, and tradition maintains that Fon kings descended from a leopard.[39] One *bocɔ* figure cited by Savary (1976) accordingly incorporated leopard skin as a means of bringing royal power (and its concomitant values of authority and might) into the work. In other cases, because of the unusual, spotted patterning of the leopard's fur, this animal's association with Sagbata (the hot, vengeful, illness and death-bearing smallpox deity) is given primacy in leopard signification.[40] All of these properties are important to its *bocɔ* meaning.

Like the leopard, the snail also is identified with qualities of alchemical opposition, but in this case with characteristic values of coolness and freshness (Pazzi 1976:124). The priest of the ocean god, Hu, observed (Hunon 1.9.86) that "when the snail rests on you it is cool. It calms you and you become still." Maupoil suggests similarly (1981:110) that the body of the snail contains a cooling liquid: "This liquid is used to make [a *bo*] with which one washes the eyes in certain circumstances to protect against saying something dangerous." Snail shells, Pazzi notes (1976:124), also are suspended on or buried in mounds as a means of isolating malevolent forces.[41] Because the snail, like the duck, is identi-

fied with Tohɔsu, the gods of the springs and rivers, small snail shells are used to make necklaces for associated devotees (Nondichao 11.25.85). Shells are important to the snail's identity in other ways as well and, as with turtles, are primary signifiers of "home," "safe return," and "security." Referring to the snail, a well-known proverb asserts that "no matter what one does, one returns home. One never stays in a foreign place" (Agbidinukun 6.13.86). In this respect too, the snail is a prototypically cool being who helps to counterbalance things which are hot.

Alchemy and the Arts of Language: Wordplay, Indices, Similitude, and Organicism

In alchemy traditions everywhere, essential qualities addressed in language are an important part of signification. Martin Luther's comments on European alchemy in the sixteenth century make this clear: "The science of alchemy . . . I like very well, and indeed it is truly the natural philosophy of the ancients. I like it not only for the many uses it has in melting and alloying metals, and in distilling and sublimating herbs and extracts . . . but also for the sake of [its] . . . allegory and secret signification" (in Needham 1983:1). Within *bo* and *bociɔ* alchemy, wordplay and verbal punning have a vital role. The following are examples of plants used in Fon *bo* and *bociɔ*:

azoncocwekwin: a grain employed in works to represent sickness (*azon*), because both share the same phoneme (*azon*) (Maupoil 1981:211)

hunsokwin: a plant used in *bo* identified with the gods because another name for *vodun* is *hun* (Maupoil 1981:211)

yiro (*yelo*): a seed from a plant whose name means "leaves of money." This is used in works intended to call (*yiro*) or attract money to the person (Herskovits 1967, 2:273).

azezo: (literally "witch fire") this plant is employed because its strength is said to cause sorcerers (*aze*) to have tears which flow so copiously that they cannot work their spells (Herskovits 1967, 2:265)

vɛ seed: *vɛ* means "difficult" or "bitter." This red seed is identified with heat, fire, and acts of sorcery (Pazzi 1976:128).

In the animal world, verbal punning also is important in alchemical material selection. One of the more striking examples is the dove. While a range of features are vital to the dove's signification as additive *bociɔ* matter, of special importance is its name, *ahwannɛ* (*ahwanlen*), a word which in a slightly different pronunciation (*ahuan, ahwan*) means "war." [42] In Fon communities, accordingly, the dove is believed to use its prescient talents to announce to the king the arrival of war (and enemies) in the kingdom (Agbanon 2.28.86). Reinforcing this idea, dove's blood is believed to be a powerful, apotropaic poison. As Agbanon explains (2.28.86), "The blood of the dove is very dangerous. . . . This blood gives

power to one's words."[43] For this reason, powdered dove blood often is consumed both to empower oaths and as a means of protecting one from the malevolent incantations of one's enemies.[44]

Also significant to the dove's warfare associations is its assumed ability to see into the world of spirits and gods and to report what it observes there back to humans. Agbanon notes in this regard (2.28.86) that "the dove sees both into the land of the dead and into the land of the living. If a death is about to occur, all the pigeons will flee because they know it is a bad thing that will happen." This feature also finds support in the dove's special talents in signaling the hours of the day and night, identified here as the result of a partnership with Lisa and Mawu, the gods of heavenly light. In foreseeing danger and death, the dove thus draws on both its distinctive faculties of vision and its links, through linguistic punning, to war and death-accompanying battles.

Indexical relationship, or material positioning, also is an important factor of signification in *bociɔ* alchemy, with matter often being selected because in nature it lies next to (or in some other relation to) something of special value (a road, a corpse, a temple). In choosing *iroko* wood for the carved figure, for example, different parts of the tree are selected as sculptural media based on their indexical associations with particular aims or orientations. As Glessougbe notes (6.23.84), with respect to a carving made from the root of an *iroko* tree, "This sculpture likes underground things" (fig. 102).[45] In another example described by Sagbadju, it is not just the root of this tree that is important, but also where it is growing. As he explains (7.3.86), "It is the root of the *iroko* that crosses the road that one will use. . . . people pass by there and bring money. . . . As they carry their various goods with them, when one uses [this tree] all those things will pass to the person."

Questions of similitude also are of interest. Most relevant here are what Foucault designates (1970:18–19) as *convenientia* and *aemulatio,* the former referring to things thought to be comparable because they occur together or occupy the same locale (i.e., they are indexically related), the latter designating things selected because of perceived qualities of similarity. The properties, potencies, and principles identified with *bociɔ* additive materials are interesting in light of both. Contexts of emulation can be seen in numerous plant examples; many are chosen for inclusion as additive matter not only for their particular attributes and "behaviors" in nature, but also for the complementarity (emulation) they share with specific alchemical aims and desires. Selected plants, furthermore, are thought to grant viewers and users comparable qualities or abilities. Among the many plants that are employed in this way are the following:

Loko (silk cotton) seed: utilized because it remains hard and never bursts
(Herskovits 1967, 2:275)[46]
Heti wood: a thorny bush held to have strong properties for stopping
malevolent power (Herskovits, 1967, 2:269)

102. Fon *bociɔ* made from the root of an *iroko* tree. Carved by Adibou Glessougbe. Nineteenth century. Abomey, Republic of Benin. Photograph: Suzanne Preston Blier. June 23, 1984.

Dekpa (palm): a thorny wood used to injure the one against whom the power of *bociɔ* is directed (Herskovits 1967, 2:269)[47]

Zoma (leaf of fire): employed because it burns with a crackling sound and therefore "clears the eye of the *bo*" (Herskovits 1967, 2:265). According to Maupoil (1981:101) this plant burns when touched and must be collected with tongs.

Mustard plant seeds: small red seeds incorporated because when dropped in boiling water these seeds rise to the top and do not soften (Herskovits 1967, 2:265)

Sweet potato, millet, and sorghum: because these are avoided by serpents. A person identified with them, therefore, will not be bitten by snakes (Herskovits 1967, 2:265).

Zama leaves: used to wrap balls of *akassa*. They are employed because this tree grows only in the wild; thus it is thought to promote insanity by making

a person always wander and never come home (Herskovits 1967, 2:281).

Togbo: a river grass important because though a river is strong, it cannot uproot this grass (Herskovits 1967, 2:284)

Atinken; atikoun (black pepper) grains: are not destroyed by bush fires; therefore they represent the force of resistance (Savary 1971:5). According to Le Herissé (1911:151) pepper is used to avoid fire and various forms of trauma (heat).

Akpakwuin seed: a red seed used in association with Legba because this deity is closely identified with the color red (Maupoil 1981:205)[48]

What is striking in this list is the prevalence of terms, values, and characteristics which have psychological complements. A cursory look at the above reveals such variant and emotionally charged themes as hardness, bursting, malevolence, injury, thorns, heat, burns, redness, crackling, clarity of vision, dropping, boiling, rising to the surface, insanity, hate, snakes, wild, wandering, power, killing, uprootedness, strength, prevailing, force, and resistance. When added to *bociɔ* as surface materials, these plants bring to the works equally potent meanings and concerns.

Organic models of art[49] and theories of materiality have special relevance to alchemical discourse.[50] *Bociɔ* creation and meaning are bound up in important ways with ideas of production and the transformation of raw materials into empowered artistic products. What is particularly significant in this alchemical metaphor in the context of art is the emphasis which it places on the real, or *tuché,* as Lacan calls it (1981:53).[51]

A *bociɔ* figure which included the head of a rat and a squirrel among its surface materials illustrates this particularly well. This work, a Fa *bociɔ*, was intended to prevent a particular judgment from being made which was likely to go against the object's user. As Agbanon explains (3.7.86), "The rat and the squirrel do not fix the judgment day in the same place. The rat goes out at night; the squirrel goes out in the day. How will they meet? If someone convokes you for justice, and you make this object, one will never be able to judge the affair." The bringing together of a squirrel and rat, two animals active in distinctively different times of day, in this way was seen to help assure a favorable response to the *bo* or *bociɔ* commissioner in the form of a nondecision by the judge of court.[52] In this example, as in many others, alchemical materialism is a key determinant of *bociɔ* meaning and use.

Frogs (*bese*) as additive *bociɔ* matter also offer insight into issues of artistic materiality and alchemical signification. Frogs, in both life and *bociɔ*, are linked to fresh water and its associated god, Tɔhɔsu, "king (*hɔsu*) of the water (*tɔ*)." Cool and wet to the touch, frogs are believed to "bring freshness to the spring. With the frog living in the spring, nothing [bad] will happen there" (Mivede 12.19.85). Thus when incorporated as additive sculptural material, frogs are associated with ideas of peace and well-being. Frog identity in *bo* and *bociɔ* has

additional ontological grounding in the great numbers of offspring which frogs produce. Pazzi notes in this regard (1976:125) that "the frog is a symbol of fecundity. That is why one offers it to the invisible powers when one asks for female fertility." [53] The slippery surface of frogs is the basis for still another feature of their sculptural identity. In some *bo*, Agbanon explains (1.3.86), frogs are employed "because with frogs, one will never be able to fix the day of judgment," thereby providing one with hope. Yet another beneficent material feature which promotes the inclusion of frogs in *bo* or *bociɔ* is their association with the fabrication of a protective or apotropaic poison. Agbanon notes in this light (2.19.86) that "the stomach of the frog is used to make a *bo* finger ring which keeps one safe from poison because the frog has a poison inside its stomach which protects it from snakes." Because of this latter feature, frogs serve additionally as signifiers of optimism in the face of grave danger.[54]

Modes of Meaning: Metaphor, Metonymy, Myth, and Material Condensation

Equally critical in the context of alchemy language signification is the role of metaphor and the identity of a given object or action as having properties which ordinarily are associated with another.[55] *Bociɔ*, like alchemy traditions everywhere, employ a range of metaphorically grounded, substitutional forms which in the selection of additive materials are conveyed in numerous ways. Pangolin skin, for example, which is known for its impenetrability, is incorporated into works intended to protect one from gunshot wounds (Mehu 7.7.84). Likewise it is maintained that porcupine quills, when used as additive *bociɔ* materials, provide users with courage and security. As Spiess suggests for the Evhe (1902:315), "Porcupines . . . are frequently mentioned because though they are small they have no fear." The tooth of the hippopotamus, in turn, is incorporated into works intended to provide one with invincibility (Rivière 1981:182). Lions, for their part, are credited with conveying to humans enormous force. Herskovits notes (1967, 2:275) accordingly that a piece of lion skin sometimes is added to *bo* in order to give the wearer lionlike strength.

With birds the importance of metaphor and conceptions of human-animal conflation are equally striking. The following examples are typical.

Owl (*azehe, azexe*): "sorcery bird"; a raptorial bird of the night associated with sorcery, but often used as a protection against the acts of sorcerers (Mehu 7.7.84)[56]

Weaver bird (*hensuvɔ*): this bird, which weaves an elaborate nest, is identified with intelligence and children. If it makes a nest in one's house, it is a sign that there will be many children (weaving is a common metaphor for descent). The bird and its nest also are used to make *bo* to increase memory. (Agbanon 2.28.86)

Guinea hen (*sonu*): the prominent crest of this bird is used to treat headaches. (Mehu 7.7.84)[57]

Cattle egret (*adɔwe*): "a white bird that travels far but always returns to the place from which it started" (Herskovits 1967, 2:269)

Partridge (*aso*): this bird is used in *bo* to prevent drowning "because the bird can fly across water without falling in." (Herskovits 1967, 2:278)

Roiterlet bird: this is such a small and rare bird, that any hunter who traps it must send it to the king, therein gaining a generous recompense. (Pazzi 1976:131)

In the selection of plants and plant parts, as with birds, metaphor is an essential concern of alchemical use and meaning. A weed that grows around fireplaces for example will be added to works which promote resistance, since these weeds are seen to withstand considerable heat (Le Herissé 1911:151–52). A branch from a plant whose leaves open in the day but close at night is incorporated into sculptures which encourage this ability in associated viewers. To cite another example from Le Herissé (1911:151–52), a stem of a squash sometimes is applied to works identified with resilience, since when squash stems are placed in water, they float.

The alchemical importance of metaphor also is demonstrated saliently in the context of wood choice for the *bociɔ* figure itself. Wood that is used for carving is identified with a range of metaphorically defined alchemical properties which are seen to effectuate particular responses and courses of action in associated sculptures (fig. 103). As Dewui notes (6.30.86) with respect to one figure, its role "depends on the wood with which one made the thing." For this reason, some *bociɔ* makers themselves will select a particular piece of wood and bring it to the carver. One of the most sought-after materials for *bociɔ* figures is *iroko,* a wood characterized not only by its material hardness but also by its association with the ancestors and *vodun.* Sagbadju explains (7.3.86) accordingly that "the *iroko* is a living wood for the *vodun*";[58] thus strength of action and ancestral support are incorporated into *bociɔ* sculptures made from it. Another type of wood that has a privileged position in *bociɔ* carving is *karité* (*kake*), a hard, red wood identified with significant medicinal properties. One employs this wood, Agbanon suggests (2.19.86), because "one also uses it to prepare solutions so that the body will be strong." Furthermore, as Agbanon explains (3.4.86), because "*karité* wood lasts a long time, those who work [and use] it also will live a long time." To Ayido in turn (7.27.86), this wood accords permanent solutions. One "wants to do things that will last; thus one says that necessarily it must be done with this hard wood."[59]

In other wood varieties, a complex mix of ontological and metaphoric qualities which often have concomitant psychological and social grounding are factored into the selection process. Sagbadju notes (7.3.86) with respect to one sculpture, "I made this for myself so that no one would argue in front of my

room, so that no one coming here would fight. In the past the children looked for fights or began to make noise. . . . I used this wood because the *alabwe* [tree] does not dance in the wind. With this, no one will make noise in front of my room."

Sometimes, as in alchemy processes more generally, the specific type of wood is less important than metaphoric properties associated with it as a result of outside forces. Certain *bociɔ* accordingly are made from wood identified in some way with human actions or acts of nature which complement in key respects the intended aims of the object. In one sculpture, the wood was selected because it had once been part of a bier to carry a person who had been killed by lightning (see fig. 14)(Glessougbe 6.1.86). In another case, a branch from a tree which itself had been struck by lightning was chosen for a *bociɔ* carving (Savary 1971:4). Both sculptures assumed a close identity with and empowerment through Hɛvioso (Xɛbioso), the deity of thunder, lightning, and rain.

Metonymy (the figure of speech wherein the part is seen to represent the whole, and the container stands for the contained) also plays a vital role in *bociɔ* signification.[60] The importance of metonymy in *bo* and *bociɔ* alchemy is exemplified in numerous ways, among these, the use of animal horns (fig. 104). Of central interest in the selection of horns as *bociɔ* surface signifiers is the animal species from which the horn was taken. As Agbanon notes (2.19.86) of the horns of the dangerous bush cow (the forest buffalo), when "one uses bush cow horns . . . if one says to the horn that your car will break, your car will break." Horns taken from the ram, an animal which shares with the bush cow both its name (*agbo*) and its associations with force (particularly defensive), also have metonymic significance in *bo* and *bociɔ* alchemy. According to Sagbadju (8.2.86), "The ram horns indicate that the one who came is cornered, can do nothing, and thus must go elsewhere. The force of the ram chases danger away. If you wound the ram, all that are there have to flee."[61]

Horns also are identified with metonymic values grounded in their general function as instruments (weapons) of animal aggression and defense in the wilds, and so when used in contexts of *bociɔ*, horns carry similar associations. Additionally horns take on essential signifying properties of the additive materials enclosed within them in conjunction with their roles as surface containers. Linguistic wordplay offers still further insight into horn metonymy. The Fon word for "horn," *zo*, also means "fire," which as noted above is key both to *bociɔ* functioning and to conceptualizations of individual heat, suffering, and social disharmony. As parts which signify the whole, such horns thus also convey to *bociɔ* alchemical qualities of heat, difficulty, and danger.

In alchemy—and specifically *bociɔ* alchemy—we also find important features of myth and mythic representation being expressed. As Roland Barthes explains for myth generally (1989b:65), it succeeds by "turning culture into nature, or at least turning the social, the cultural, the ideological, the historical into the 'natural.'" At the same time, myth can achieve its ideational ends by according things

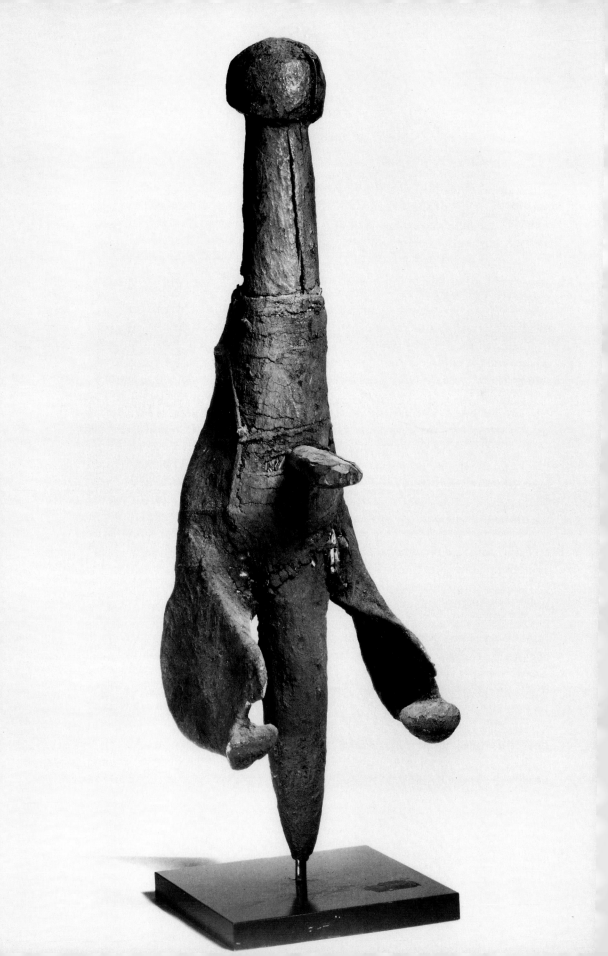

103. Fon? *bo*. Republic of Benin. Wood, animal jaw, cord, and miscellaneous materials. Height: approx. 25.5 cm. Wooden peg inserted into stomach. Probably collected in the 1960s. Former collection of Ben Heller. Photo courtesy of Ben Heller.

104. Power object. Togo. Cow horn, cowries, fiber, and miscellaneous materials. Height: 18.5 cm. Collected by Michael and Shirley Furst, 1965–68. National Museum of African Art. Eliot Elisofon Archives. Smithsonian Institution. Cat. no. 69.3.29. Gift of Michael J. Furst. Photograph: Franko Khoury.

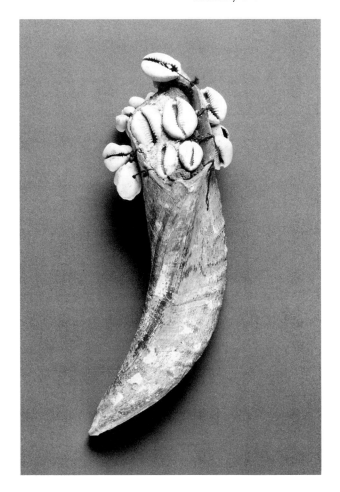

in nature certain cultural attributes.[62] Within the *bocɔ* corpus not only is an animal's or plant's identity with a specific proverb, legend, or Fa divination account often essential to its signification, but also in such works, ideas from the cultural and natural realms are frequently conflated.

Exemplifying such mythic features in a particularly striking way are horns from the cob and roan antelopes. The signifying qualities of each are grounded in a Fa divination text which discusses the fluctuations in human and animal death (Agbanon 3.20.86). According to this account, each year a race is held between a roan antelope (*afianku*) and a cob antelope (*agbanli*). In years in which the cob antelope reaches the designated termite hill first, animals will die in great numbers in the course of the annual hunt. If, however, the roan antelope arrives before the cob antelope, many people will die that year instead. The distinctive identities of the cob and roan antelopes with human life (animal meat) on the one hand and human death on the other is reinforced through linguistic punning

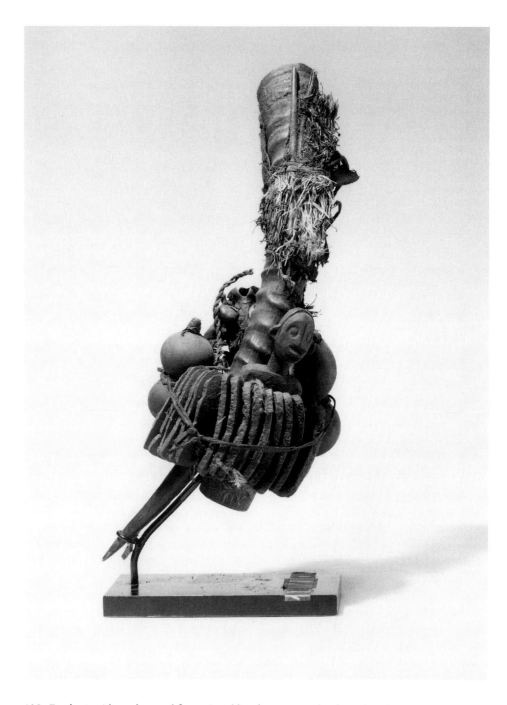

105. Fon *bociɔ* with antelope and figure. Republic of Benin. Wood, cob antelope horn?, cord, calabash, iron, feathers, and miscellaneous materials. Length: 40.5 cm. The pierced calabash plaques identify the work with Fa. Herbert R. and Paula Molner. Photograph: Courtesy of Sotheby's. Published in *Primitivism in Twentieth Century Art: Affinity of the Tribal and the Modern* (New York: Museum of Modern Art, 1984.)

106. Evhe power object with horns and figure. Amelame, Togo. Antelope horns, cowries, cloth, wood, and miscellaneous substances. Length: 46.4 cm. The large horn is from the roan antelope (*Hippotragus niger*), the small horn from the bush buck (*Tragelaphus scriptus*). Used to promote a successful hunt. Collected by Hans Meyer in 1900. Linden Museum, Stuttgart. Cat. no. 14 078. Published in Cudjoe (1969: fig. 27).

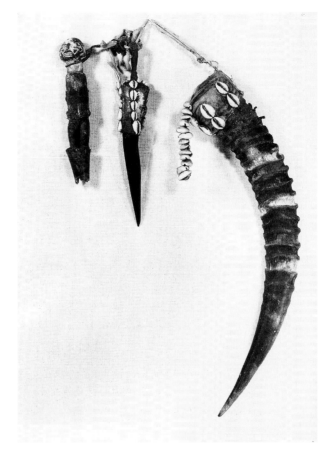

and wordplay. *Ku,* the suffix of *afianku,* means "death"; the suffix *li* of *agbanli* means "to mill" or "to grind," that is to say, the action of preparing millet and other grains for human consumption.

Accordingly, *agbanli* (cob antelope) horns often are associated with works identified with Fa, the divination god whose function it is to help humans in life.[63] Roan antelope horns, in contrast (figs. 105, 106), frequently are included in sculptures associated with death, human demise, or the resolution of issues which could have similarly disastrous ends.[64] Herskovits points out (1967, 2:283) that one such *bo* which incorporated a roan antelope horn was used to protect its owner from potentially dangerous spirits or ghosts.[65] Of another roan antelope, *bo*-form drinking horn, created for protection at funerals, Ayido explained (5.2.86), "Even if you only drink from the roan antelope horn without making it into a *bo,* if someone else does something against you, or throws things at you, they will not reach you. If you make a *bo* with the roan antelope horn, it will be a powerful thing that will be there with you."[66] In this work, too, are evidenced essential mythic attributes which bring together the social and natural realms.

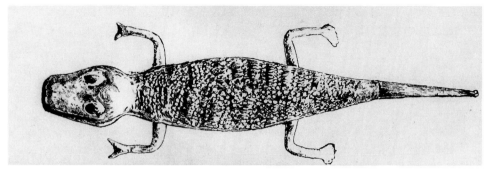

107. Fon chameleon *bo*. Republic of Benin. Published in d'Albeca, *La France au Dahomey* (1895), p. 212.

Condensation is another attribute which traditions of alchemy and art share in vital ways.[67] In *bo* and *bociɔ* alchemy, various forms of condensation find expression in the selection and signification of additive materials. The chameleon provides a particularly good example of condensation concerns through its conflation of values within a single form (fig. 107). The most frequently discussed feature of chameleons, their seeming ability to change the color of their skin, is the basis for their contextualization in objects identified with human life course, transition, and transformation (Mehu 7.7.84). Stated simply by Agbanon (2.15.86), "The chameleon is used in works to change the body."[68] Related qualities of adaptability and ambiguity also are important. According to Pazzi (1976:132): "One values [the chameleon] as a mysterious being, because of its ability to imitate others in adapting its color to the place it crosses. This ambiguity appears to be the reason why one forbids pregnant women to look at it, because 'the chameleon can seize the embryo.' "

Another feature of alchemical condensation identified with the chameleon is its assumed power to attract other matter (colors) to itself (Atinwasunu 10.31.85). Stemming from the above, the chameleon also is a primary signifier of wealth. As Sagbadju explains (7.18.86), "The chameleon is incorporated into works because it brings a lot of money." Renewal is associated with chameleons because of this feature as well. With this in mind, Lisa, the deity of life and perpetual renewal, selected the chameleon as its animal avatar (Pazzi 1976:84).

While living, the chameleon signifies life, well-being, and plenty; once dead, the chameleon conveys ideas of danger and demise. As Agbidinukun suggests (5.30.86), "If you see a dead chameleon, something will happen to you." Likewise if one tries to capture this reptile and it bites one, there will be problems. Agbanon notes accordingly (2.19.86) that "if the chameleon bites you, you will get a sickness called *bo*, and your feet will swell,"[69] suggesting that even good things carry risks. Through this and related forms of metaphoric condensation, additive materials bring to each figure qualities of alchemical richness and power.

Textual Density: Multiplexity in Material Meaning

Yet another feature of alchemy with important artistic complements is that of textual density, or what Stewart calls in literature (1984:4–5), a "mapping of sign upon sign, world upon world, reality upon reality." Related works also incorporate vital features of what I have called (1987) "multiplexity," in that like telephone lines they carry multiple messages simultaneously. Rivière explains (1981:175–81) the Evhe use of *dzo* (*bo*) accordingly, as works that share features of multiplicity, dispersion, ubiquity, multipresence.[70] Four animal species, each identified with a different natural realm, exemplify the above concern with textual density and multiplexity in *bo* and *bociɔ* additive materials. These are the dog, the crocodile, the parrot, and the mudfish. In each, as we will see, a diversity of signifying elements come into play in their alchemical roles.

Dogs (*avun, cuku, aglavu wesu*) offer a particularly good example of this (fig. 108). In one *bociɔ* work made for a pregnant woman, the head of a dog was incorporated because, in the words of Ayido (4.25.86), "the dog does not need a midwife to deliver." The dog, in other words, is a model of easy childbirth. In other examples, it is the dog's loud bark which serves as the basis for its inclusion in *bociɔ*—especially those objects whose roles are identified in some way with noise. As Glessougbe suggests (4.1.84) of one Legba-empowered *bociɔ* with a dog head, it assures the silence of the owner's opponents. Another work, this one containing dog bones, was intended to "wake one up" if danger arrived (Agbanon 2.25.86).[71] In still other alchemical contexts, dog parts are incorporated into *bo* and *bociɔ* because of the canine's association with attributes of loyalty. Explaining the presence of a dog head on a *bociɔ* sculpture, Agbanon noted (3.7.86), "The dog does not take the fish which is grilling over the fire so that its owner will need to take a stick to beat it." In other words, the dog, unlike most other animals, domesticated and wild, generally can be relied on not to steal from its owner. In certain works, dog parts are important because of the dog's role in providing house protection and security. Discussing one work which included dog features, Ayido explained accordingly (5.11.86) that "the dog surveys the house." A final example of this animal's multiplex alchemical role in *bociɔ* is the dog's well-known swimming abilities. One object containing a dog's jaw thus was believed to protect one from drowning. According to Herskovits (1967, 2:278), in this figure, the dog's jaw was used "because when a dog falls into the water he is able to swim, and does not drown." Because of the dog's close identity with Legba, many works which contain dog parts are linked in some way with this god. Appropriately, the account discussed above of the dog stopping to eat a bone in the race to determine human fate is in many ways characteristic of Legba's identity as a messenger who is at once erratic and unreliable.

My second example of textual density and multiplexity, the crocodile (*lo*), also is identified with a large range of alchemical signifiers. The association of the crocodile with water is one of its most important features. As Agbobonon

suggests (1.30.86), "The crocodile represents the river; if there is not a crocodile, it is not a river." Agbanon suggests (2.13.86) that the head of a crocodile frequently is placed on works which help to prevent water accidents and drowning. In another association with water, crocodiles are closely identified with Tɔhɔsu, the deities who rule the springs and rivers. Accordingly many works which include parts of the crocodile are said to be empowered by this god.[72]

As an aquatic being, the crocodile additionally is thought to be knowledgeable. As Maupoil explains (1981:199), "The animals who live in the water are thought to know truth or to be good revealers of truth." Appropriately, the term for crocodile, *lo*, also refers to the metaphoric form of wisdom that is imparted in proverbs. In a number of proverbs, the crocodile itself is a major character. Although the crocodile is portrayed in these proverbs in divergent ways, in many we see a concern with power and the necessity not to cause problems with those who, like crocodiles (and by extension one whose *bo* has crocodile properties), are forceful and dominant. One proverb notes accordingly: "A fish is a small thing for the crocodile" (Agbanon 3.24.86). Another asserts: "If a fish wishes to start a quarrel with the crocodile, it is the fish that will die" (Agbanon 2.27.86). Still another observes: "The scales of the crocodile do not kill the crocodile" (Ayido 5.5.86). Small problems, in other words, are nothing to this animal. In a somewhat related context, Pazzi explains (1976:127) that the crocodile stands for the "inevitable loss accompanying . . . those who dare to oppose magical power." Of another work Atinwasunu suggests (10.31.85) that "the crocodile is a power (*glo*). If someone is looking for you, you can use it to avoid him."

Our third example of textual density in the context of alchemy signifiers is the African gray parrot (*kɛsɛ*) with its distinctive red tail, the feathers of which are incorporated into a large number of *bo* and *bociɔ*. With the parrot, as with the two preceding animals, multiplexity is critical to understanding associated signifying features. Explaining the role of the parrot's red feathers generally, Le Herissé notes that (1911:152) they convey qualities of resistance, because their color does not disappear in water. When applied to sculptures, these feathers are said to offer comparable resistance and longevity to associated users. The bright red hue of these feathers is identified with other *bociɔ* qualities as well. As explained by Agbodjenafa (12.16.85), "Red is the color of fire and fire is an indispensable element in something's power."

The parrot's ability to replicate human speech also serves as a ground for *bociɔ* and *bo* signification. Because of this ability, the parrot is assumed to have extraordinary faculties of memory. For this reason, certain *bo* and *bociɔ* which incorporate parrot feathers are employed by students as a means of achieving good grades in exams. "This bird gives one a good memory," explained Mehu (7.7.84). The parrot is also thought to be able to communicate through speech with the animal, human, and spirit realms. As a result, parrots are identified with the powers of *vodun*, and sculptures which include red feathers or other parrot features are believed to be empowered by one or another of the gods.

108. Fon *bociɔ*. Female figure.
Republic of Benin. Wood,
calabash pieces, iron, cord,
dog skull, and miscellaneous
additive materials. Height: 37
cm. Probably collected in the
1960s. Former collection of
Ben Heller. Current collection
of Don H. Nelson.
Photograph: Jerry Thompson,
courtesy of the Museum for
African Art. (For another view
see fig. 138.)

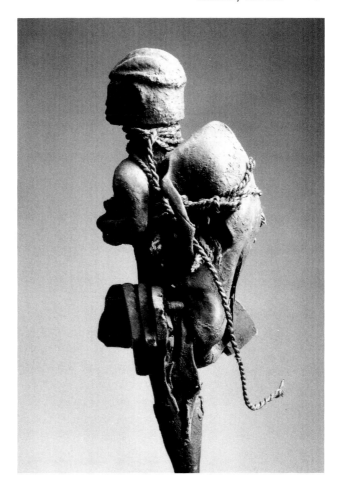

My last example of alchemical multiplexity in *bociɔ* is the mudfish (*eboli,
aboli*), several of whose features are important. First is the resemblance which
the bone in the mudfish's head has to a stone celt. Because of this, Pazzi notes,
the black mudfish is associated with Hɛvioso, the god of lightning (1976:126),
and mudfish bones frequently are included in *bo* and *bociɔ* identified with this
deity. Well-being and plenty also are linked with the mudfish, ideas which find
their basis in the widely held belief that mudfish add water to rivers or springs
by means of their characteristic moisture-laden "whiskers" and concomitant
"drooling" (11.8.85). Because of this distinctive drool, the mudfish is also
thought to be talkative and is employed in *bo* and *bociɔ* meant for achieving this
attribute in humans (Ayido 7.27.86).

Based on this drooling feature as well is the identity of the mudfish with age,
elders, and family heritage generally. As Katala observed with regard to one
mudfish-empowered work (12.31.85), "The house will obligatorily have its his-
tory." In this association, we can also see the use of wordplay, for the Fon terms

for history (*huenu*) and fish (*huevi*) share the same phoneme. Another feature of the mudfish important to its *bociɔ* signification is this fish's unique defensive abilities. According to Pazzi (1976:126), whenever a mudfish is swallowed by a crocodile it "brings out its 'thorns,' choking the crocodile, [and] making it drink water until it dies." Because of this ability to protect itself from other fish or predators, the mudfish also is identified in *bo* and *bociɔ* with longevity. As noted in a mudfish-related proverb (Zinflu 7.15.86): "A fish that knows how to swim dies from an accident, not from natural causes." Here too we see the role of multiplexity and textual density at play in *bociɔ* additive part selection.

As we have seen in the above discussion, *bociɔ* surface materials are associated with a diversity of alchemical properties. These range from the prominence of medicinal and religious attributes to the centrality of anthropomorphism and psychological projection. Oppositional concerns, language arts (punning, positioning, similitude, organicism, materiality), modes of meaning (metaphor, metonymy, mythic representation, condensation) and multiplexity or textual density also are important. In the selection and transmutation of additive surface materials, we can observe the complex and diverse orientations that are played out with respect to associated features of sculptural identity and empowerment. With their encyclopedic complement of incorporative materials, *bociɔ* figures offer a unique ground against which to examine the interrelationship between alchemy and art.

An overview of essential concerns addressed in animal and plant selection also bears out the primary psychological grounding of *bociɔ* alchemy. If we take reptiles as an example, the range of psychological qualities expressed in species and part selection is striking. Among other reptilian qualities referred to in this chapter are truth, domination, quarrels, killing, loss, avoidance, drowning, freshness, coolness, fecundity, poison, swallowing, home, calmness, danger, sight, talking, thorns, death, family, history, longevity, accidents, life change, ambiguity, attraction, renewal, swelling, hiding, disappearance, and attachment. With birds a similar range of ideas is expressed, including sorcery, children, headache, obstacles, home, drowning, poison, silence, thinking badly, trapping, attaching, disappearance, resistance, fire, power, memory, speech, sight, death, fleeing, war, incantation, anger, and craziness. Mammal and plant signifiers are equally striking and psychologically poignant.

In this chapter, we have evidenced the complexity of signifying elements taken into account in plant and animal selection as *bociɔ* additive matter. In some cases a specific being or material is chosen because of its appearance. In others, linguistic features are important. In still others, it is their assumed strength or force in the wilds or their place in particular legends, proverbs, or accounts that is the basis of their incorporation in *bociɔ* and *bo*. However selected, these animals and plants become provocative alchemical signifiers of a range of human hopes and fears, through which personal and powerful concerns are addressed in *bociɔ*.

Surface Parergon and the Arts of Suturing

"Thread pierces the needle and the needle pierces the cloth"
(*Kan we no don gni bo gni non don avɔ*).

—Fon proverb

"[E]ach thread, each code, is a voice; these braided . . . voices form
the writing."

—Roland Barthes, *S/Z*

A variety of attachment modes are utilized to secure the diverse extrafigural materials to the surfaces of *bociɔ* and *bo*. The most important include cords (*kan*), pegs (*so:* picket); chains or ringed forms (*gan:* chain, iron, metal); bottles (*go:* bottle, gourd); and cloths (*avɔ*). These diverse means through which matter is applied to the surface, a number of which may be found within a single object, can be said to constitute sculptural *parergon*—supplements outside the work which intervene on the interior—to use Jacques Derrida's (1987: 56) term (taken from the Latin, meaning a supplemental ornament in art). With such fastening forms, we also find expressed essential qualities of sculptural suturing, a concept developed by Jacques Lacan in reference to the joining of the imaginary with the symbolic and the privileging of mind in the conceptualization of matter.[1] In the act of suturing, as Kate Linker points out (1984:392), "the subject is 'bound in' to the representation, filling its constitutive absence or gap so as to complete the production of meaning."[2]

The correlation between artistic creation, and textual meaning of supplements and subjectivity is poignantly expressed in *bociɔ* suturing forms. In *bociɔ*, additionally, there is a direct and more literal applicability of the notions of *parergon* and suturing, since to a large degree sculptural significance is delimited by extrafigural surface materials and the diverse methods through which they are affixed. This chapter explores the signifying roles of *bociɔ* attachment modes, focusing at once on the forms themselves and on the qualities attributed to them in the context of language. *Bociɔ* attachment means are identified at once with physical values (the properties accorded particular methods of affixing one form to another) and key psychological concerns, values linked to ideas such as affinity, negation, and desire, which are often equated with attachment. To comprehend the powerful suturing and *parergon* dynamics of these *bociɔ* attachment modes, it is necessary first, however, to examine the vital role of material states in *bociɔ* signification.

The Signifying Role of Transformative States

Five distinctive transmutative states are identified with *bociɔ* and *bo* in the context of additive materials. All related elements in turn are applied to the surface in one of these following forms: (1) liquid (*sin*: water); (2) solid (*sien, siensien*: solid, hard, strong, resistant); (3) cord (*kan*: cord—here understood as a state which is at once fluid and solid); (4) pommade (*nusisa*: salves, ointments, perfume, soaps; from *sa*, "to crawl"); and (5) powder (*atin*). As should be evident in the above, a given attachment means is defined to a considerable degree by each material's associated transmutative state.[3]

The first of these material states, liquid, includes such diverse *bo* and *bociɔ* substances as water,[4] liquor, perfume, and medicinal plant solutions. Because of their fluidity, these materials generally are enclosed in small gourds or bottles which are tied to the surface of the work with cord or cloth. While many such liquids are intended to be consumed by the *bociɔ* user, some—perfumes for example—are washed over the body externally because of their fragrant qualities and perceived ability to attract other persons or things. The second of these states, solids, is comprised of matter which shares the ability to retain its hardness and shape even when wet. Solids of various sorts are lashed to the surface of *bociɔ* or *bo* or are secured in holes penetrating the interior. In *bociɔ*, the solids also include certain materials (notably chains and bottles) employed to affix other additive surface matter. The third material state, cord, is identified in *bociɔ* both with respect to its unique character as solid-fluid and because of the vital roles cords play in suturing other extrafigural materials to the surface. In *bociɔ* contexts, pommades, the fourth material state, include soaps and salves which are applied to the body to protect the user from various forms of danger or harm. Like liquids, pommades generally are enclosed in small gourd or pottery containers affixed to the work. The fifth and final state, powders, includes smaller particles derived from empowering materials, either alone or in admixture. Powders of various sorts generally either are secured in special gourds, pots, horns, and textile containers, or are inserted into holes in the surface of the work which then are closed (sutured) through the use of peg stoppers.

Each of these states of matter carries its own, unique valuation and significance. The word for liquid, *sin*, for example, also means "to attach," "to entangle," and "to bother." The term "solid," *sien* (*siensien*), is employed in turn to mean "severe" or "hardened." In other contexts *sien* is used to suggest such psychologically potent concepts as "to be tenacious" (*sien ta*), or "to apply oneself" (*sien u*). The word *kan*, "cord," is associated with signifiers of strikingly positive and negative orientations linked at once to death and life. Pommade, *nusisa*, also conveys through its root (*sa*), provocative psychological concerns: *sa lele*, "to be without support"; *savo*, "to plead." *Sa gbe* in turn is employed to designate the speaking action used to empower a *bo* or *bociɔ*.[5] The word for "powder" itself, *atin*, refers at once to "medication" and to "poison," potent

substances of strikingly opposed orientations. In this way among the Fon, "powders" complement Western concepts of *pharmakon*, that is, a drug which is both remedy and toxin (Derrida 1981:78).[6]

While powders are one of the least visible of the transmutative states employed in *bociɔ* and *bo,* they also are in many works the most important. As Dewui explains (7.3.86), "The *bociɔ* does not work alone. It is the powder that one puts in the thing that is critical."[7] In some cases powders identified with *bociɔ* are consumed by the person the work is intended to protect.[8] In other examples, the powder is taken out and blown onto a sculpture, an individual, or into the air at large. Ayido explained (5.5.86) that "one can eat the powder to save a person's life or one can blow it onto the particular sickness that she is suffering from so that she will live." Powders—like pommades, solids, liquids, and cords—derive from a diversity of materials. Among the more common ingredients are pulverized beads, earths, minerals, and processed animal and plant parts. Earths, to discuss but one of the above, are derived from sources as varied as tombs, termite hills, army ant houses, springs believed to reflect lightning, and temples of particular *vodun.* As Sagbadju noted of one work (7.1.86), "One goes to the temples of the associated *vodun* and takes from each such place some of the earth found there." In choosing earth (or other matter), care also is taken to gather it at special times of the day or while facing particular directions.

The means by which powders are acquired are essential to their signifying roles as well. Ayido describes this process for one work as follows (7.25.86): "It is the powder (*atin*) that one looks for. One grills the leaves and puts them in a pottery vessel such as the one used ordinarily to bathe with. Then one lights a fire beneath it and grills the plants until they become black powder." The resultant charred matter in this case was employed in an object intended to make a person's opponent unsuccessful in his endeavors (Sagbadju 7.1.86). The link between signifier and signified here finds basis in the identity of cinders (used wood) as matter which has had its vital powers removed. In other words, cinders represent wood which is "dead" and thus devoid of its life and efficacy (Sagbadju 7.1.86).[9]

Color may play an important part in the meaning accorded powders as well. As Herskovits points out in the context of one work (1967, 2:280), red kola is chewed and spit into the hole in the heads of female *bo,* and white kola is secured in the heads of male *bo.*[10] Color also may be identified with specific *bo* and *bociɔ* functions. A description of one Janus work by Dewui (7.3.86) illustrates this clearly: "Those works which have several heads have holes in the surface and one puts powders in them. One places there powders of different colors—especially black or red. The same object accordingly can have several holes and you will not know it. If it has one hole, one will reverse the figure and a black powder will come out and everyone will eat it. In other cases, three, four, or five different powders of different colors may come out of the same work." Material form and attachment means in this way share an immediate and direct relation with the

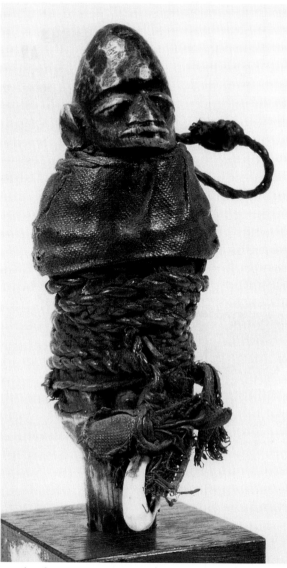

109. Agonli-style *bociɔ*. Republic of Benin. Wood, fabric, cord, cowrie, and miscellaneous materials. Height: 10.2 cm. Nineteenth or twentieth century. Former collection of J. Müller. Musée Barbier-Müller, Geneva. Cat. no. 1011–43.

110. Fon male *bociɔ*. Abomey, Republic of Benin. Wood, cloth. Musée de l'Homme, Paris. Cat. no. M.H.30.21.52.

work's larger suturing and *parergon* roles. In the above example, the diverse powder-containing holes function as constitutive supplements outside the work which intervene on its interior reading. Other attachment modes play equally important roles.

Cords and the Binding of Meaning in Bociɔ

Cords (*kan*), the first and in many respects most prominent of these *bo* and *bociɔ* suturing means, represent at once a vital transformative state (solid-fluid) and a critical method of affixing other additive matter to the figure (figs. 109, 110).

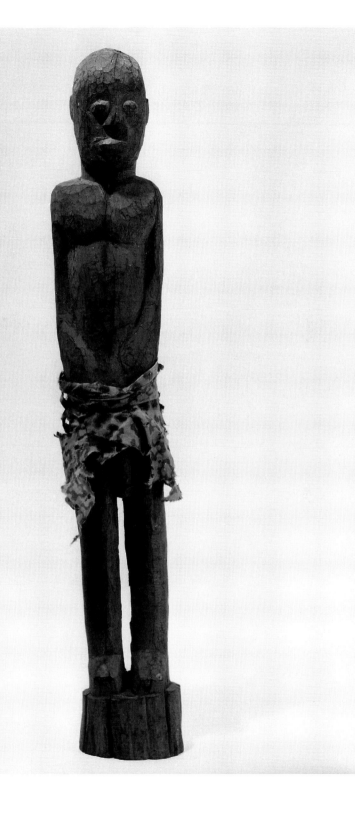

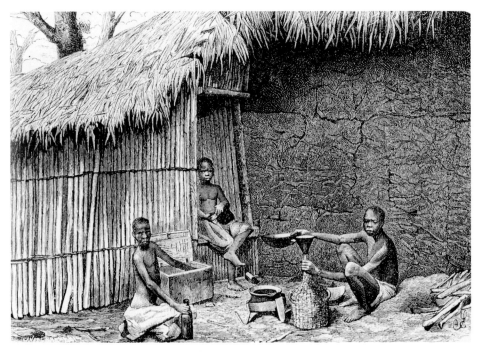

111. House in Porto-Novo, Republic of Benin. Published in Anonymous, *Les missions catholiques* (1875), p. 563.

Cords in this way provide an interesting material ground from which to explore central issues of surface *parergon* and suturing. As with other states of matter, cords serve to direct the object toward particular courses of action. Dewui explains in this light (7.3.86) that "it is the cord with which one attaches [a substance] that determines its functioning." One also employs the word "cord" to designate powerful incantations (called *bokan,* literally the "cord of *bo*"), which serve at once to activate sculptures of this type and to bring about specific results. As Pazzi notes (1976:73), the person who pronounces a "cord of *bo*" (incantation) is "obliging something to produce the wanted effects."

Cords are of added interest in the context of directed meaning and suturing discourse because of their local identity with such potent and conflicting values as family, tradition, and construction on the one hand, and force, danger, demise, and death on the other. Language plays an important role in this regard. The word for slave (*kannumon*) translates as "the person in cords." *Kan* (cord) thus is associated with a state of disempowerment and demise.[11] Reinforcing this idea, cords also are identified closely with death. Not only are cords used to tie corpses before burial, but the dead in turn are said to harm the living by attaching or binding them with cords. As Ayido explains (7.6.86), "When one speaks of cord, one speaks of the dead (*kulitɔ*) who will take the cords to tie people."[12] The

112. Street in Porto-Novo, Republic of Benin. Published in Badin, *Au Dahomey* (1895), p. 197.

frequent appearance of cords in the context of *bociɔ* suggests in this way both the threat that one will become a prisoner of forces beyond one's control and the psychological need to imprison (and effectively terminate) harm that may come one's way.

Even while displaying these negative associations, cords also are identified in this area with strikingly positive values. Maupoil suggests accordingly (1981:482) that cord "expresses the force representing the durability of all that humans accomplish. . . . [The cord thus] has the power to attach everything."[13] Pazzi reinforces this idea, pointing out (1976:113) that in the past "all construction was realized by tieing the parts with cords" (figs. 111, 112). Rivière notes similarly (1979a:197) that "in [Evhe] society, the cord retains a very great importance uniting objects that are by nature disparate. . . . In brief, the cord manipulated by humans represents the means of mastering at once the forces of nature and those of culture." The cord thus serves to signify security and life, a notion reinforced by the tradition that among the Evhe, as among the Fon, "Life is conceived as a cord (*kan*)" (Rivière 1981:84). The term *gbɛ kan*, "cord of life," in turn designates "life's course." Of an Evhe object which included a boar's tusk wrapped with cord, Spiess (1902: pl. 2, fig. 11) noted accordingly, "This protects against attacks by boars."

Cords additionally are important because of their close identity with ideas of family and continuity. As asserted in a well-known Fon proverb: "It is at the end of the cord of the father that the son begins to braid." An Evhe proverb says similarly: "On the cord of the ancients one weaves the new" (Pazzi 1976:276).[14] According to Gilli (1976:103–4), "One employs this proverb when one wants to say that a thought or action is in conformity with the tradition of the ancestors." Underscoring this idea, not only are veins called *jikan*, "cords of the heart," but a piece of cord often is used in the making of *bo* for pregnant women to symbolize the attachment of the child to its mother (Le Herissé 1911:153).

In a related tradition, pregnant women often will wear special *bo*-cords around their hips as a protection against miscarriage. In the words of Rivière (1979b:132): "The Evé, Watchi, and Mina woman, when she fears the misdeeds of sorcerers or malevolent spirits, wears a special belt made with herbs, vegetable seeds, shells, chicken feathers, or the bark of trees selected for their protective virtues and braided by a *bokɔnon* [diviner]. This belt remains knotted around the hips of the woman until one week before birth, when one lets it descend by way of the feet—a symbol of the advance of the hour of delivery." The use of cord imagery here alludes both to the desire for ties between mother and child and to a need to attach securely to each special types of protection. The Fon term *vi ɖokpo kanta* ("head of the cord of the child"), which means "inheritance" or "heritage," reinforces this idea (Pazzi 1976:292). In the words of Pazzi (1976:113), "At the level of personal relationships . . . the braiding of cord becomes the image of tradition which ties one generation to another."

In addition to the above, cord-form suturing is identified with ideas of temporal transition, that is, the passage of time. The association of cords with these concerns has primary grounding in traditions wherein the chameleon-resembling deity Lisa (Sɛgbo-Lisa) not only helps to assure human life but also is the bearer of heavenly light. According to Ayido (7.13.86), Lisa has a special life-giving cord which not only pulls the sun and moon across the sky, but also promotes both family ties and the acceptance of change in humans. In the words of Ayido:

When the chameleon lays an egg, there is a cord attached to it. This cord is called *gbɛ kan*, "the cord of life." If you are passing and you hit this cord, the chameleon will fall down on you. This cord holds life as well as life's changes. It is this cord also that is attached to the sun and moon and changes [moves] them. The cord of the family [*henu kan*] is the same thing. It is a sign. One says "cord of the family" because the parents of the father of my grandmother are all cords of our family. Thus it is the family that creates one's cord. It is this that one talks about in saying "cord of life," *gbɛ kan*.

The cords so prominently displayed in *bociɔ* sculptures can be said to allude to similar ideas of life, family continuity, and the inherent changes that occur through time. Such cords, in their identification with the ever-changing chameleon, convey the idea that life is a vacillating phenomenon in which periods of difficulty are both followed and preceded by periods of good fortune. Cords in

this way suggest in striking visual terms not only life's problems and rewards,[15] but also its constant variation.

Historically, the important place of cords for record keeping in this area also is of interest. Marchais observed in the early eighteenth century (in Hardwicke and Argyll 1746, 3:71) that at Ardrah, "the people can neither write nor read. They use small Cords tied, the Knots of which have their Signification." Time and space similarly were identified with the measurement of cords. Forbes noted in Abomey, in 1851 (2:125), that "[t]here was a method of keeping time . . . measured by paces, the measurer having a thread, which, at a slow pace, he passed round two sticks, at a certain distance apart. After the manoeuvre these threads were measured." Counting, not surprisingly, also has grounding in the use of cords. *Kan* (cord) is the word for "forty," and is derived from "the cord of forty cowries" which constituted the traditional money in the region. Still today, in the Fon numeration system, mathematical progression is determined in multiples of forty. *Kan we* (40 times 2, or two cords) accordingly means "eighty." [16]

Religious affiliation is an important feature of cord signification as well. Gilli notes (1976:102) that "one of the distinctive signs of the appearance of *vodun* is the manifestation of a cord which the [devotees] wear regularly around the neck. The [devotees of Hevioso] are obliged to wear this cord during the course of initiation. These . . . [devotees] receive two cords, the first is called *anyaka,* or the cord of the *anya* plant. The second cord which one wears . . . is called *vodu-kan* [*vodun* cord] or *hukan* [*hun* cord]. For the adepts of Heviesso [Hevioso] it consists of a white cotton cord." Association with a particular *vodun* also is marked in some cases with special cord-form tattoos.[17] As Gilli explains (1976:128–29),

The real tattoo which is reserved solely for the *vodussi* is made on the forehead. . . . [One] takes a piece of cord covered with wet cinders and applies it to the forehead of the *vo-dussi,* leaving a visible semicircular sign. One then takes the knife and incises the skin with numerous small vertical cuts side by side. Then one puts in black soot. . . . The tatoo, once made, maintains its black color on the forehead. . . . This tattoo is called *ngonu-kan,* "cord of the forehead." This cord, like that which the *vodussi* wear around the neck, [refers to] the line of continuity and religious fidelity with the ancestors. This tatoo is the sign of marriage with the *vodu* and distinguishes the Hevioso initiates from others and the profane.[18]

Here too we see an important link between cords, family, and spiritual commitment.

Bociↄ cords are fabricated from various things, and as with other materials, the sources and appearance of cords determine the reasons for their inclusion in a given work. The most frequently used cord forms include cotton thread,[19] twisted feathers or plant parts, and strips of animal hide.[20] Each form has its own distinct meanings; as Sagbadju notes (8.2.86) of one object, "If you use another type of

cord, it will not work. One looks for the cords of different things. In using these different cords, one is saying for them to come and battle for you."[21] Savary cited (1971:4) an example wherein the properties of the source object from which the cords are made are clearly central to their textual reading. He explained that "the cords which surround it and which are made with a toxic vegetable fiber add to the vulnerability of the person acted on by the statue." As to the importance of a cord's place of origin, several examples were given. One highly sought-after cord was made from a tree which bends when the wind blows. The use of such a cord, asserts Sagbadju (8.2.86), assures that "all that one thinks of you will pass." The significance of cord color is demonstrated in turn by a work in which both black and white cords were used. Asked why, Sagbadju explained, "Some will be saying good things, others will say bad things."

Other properties of cord materials also are essential to object meaning. Although cord made from the fibrous bark of the *bo* tree (*bokan*, "*bo* cord") is sometimes still used for this purpose, other types of commonly employed fiber cord include *hokan* ("speech cord") and *hunsikan* ("drum spouse cord"),[22] both of which are identified as having considerable internal strength—indeed capabilities which far surpass the particular weight-support requirements of associated *bociɔ* sculptures.

Another frequently employed cord in *bociɔ* contexts is raffia. Raffia cord (*dɛkan*), asserts Pazzi (1976:97), is associated with "the properties of solidity and resistance," the raffia tree itself being prized for its relative impenetrability and resistance to termites.[23] At the same time, Pazzi notes that "raffia is a symbol of distress and poverty." The latter stems from the fact that raffia bark once was made into textiles in the area. In recent history, such cloth has been used only by the very poor, since all who could afford it have employed imported cotton cloth instead. In works which incorporate raffia cord, primary counterposed values of despair and hope thus are bound into the sculpture's larger text. Another frequently employed cord, latex (*asogbokan*), carries similar emotionally charged associations in its suturing, for the latex plant is poisonous (and can be fatal), causing a violent reaction in the intestines when it is consumed. The chemical identity of latex both as a poison (an active means of bringing about something's or someone's death) and as matter which affects the intestines serves additionally to reinforce ideas of anger, rancor, and danger. These conditions are at once identified with the stomach and linked in key respects with ideas of individual demise. Works made from this cord accordingly are believed to be able both to convey to others life-threatening problems and to stop related difficulties from reaching the associated sculpture's user. The use of latex cords as sculptural signifiers also is important, according to Le Herissé (1911:152), because in nature this plant grows rapidly and in strikingly different environments. The resilience of the latex offers a model for individuals, and thereby a source of empowerment which enables them to combat perceived threats to their own physical and mental well-being. Latex cords, like cords from other sources, serve in this way as a

means of bringing into the work values which transcend standard functional or action-defined associations.

Surface Pegs: The Ideation of Piercing

Another means frequently employed in affixing materials and meanings to *bociɔ* are pickets (*so*) of diverse forms—pegs, pins, and nails, especially. As with cords, surface-piercing elements of this type also play critical suturing roles. When applied as figural *parergon*, such forms help to affix thoughts, values, and actions to *bociɔ* in various ways. The larger suturing function of such pegs is reinforced through language. The term for peg or picket, *so*, is employed to mean, among other things, "obstacle," "weight," "load," and "power."[24] As part of a compound verb, this term, when pronounced with a dulled *o* (*sɔ*), also is an important emotive signifier: *sɔ hue* means "to humiliate" and "to debase"; *Sɔ ke* designates "to pardon," and "to absolve"; *Sɔ nu* signifies "to prepare for," "to do something deliberately," and "to act with premeditation."[25] In these various examples, we see some of the forceful empowerment, activation, and psychological associations of pegs and related picket forms (*so*) among the Fon, concerns also critical to understanding the prominent use of peg or piercing elements in *bociɔ* arts (fig. 113). Cut into the surface of the work is a small hole where each peg or picket is placed. In Fongbe, the term "hole" (*do*) is used to mean "the bottom" or "the origin" of something. Thus, to indicate that someone is trying to find the root of a problem, one will say *a non ba nudo,* "you are looking for the bottom of the thing." The act of piercing (and then filling) a hole in the context of *bo* and *bociɔ* suggests in this way primary values of getting at the root of an issue, difficulty, or dilemma, then actively responding to it.

Questions of response also come into play in contexts of material choice in regard to pegs, nails, and other means of surface piercing. Wood and iron are the most frequently employed materials for this use. Because the properties of particular varieties of wood were discussed in considerable detail in the preceding chapter, attention here will focus instead on the signifying features of iron. As with wood, iron imparts to each work key associated qualities. Most important, iron conveys to such objects the power and strength of Gu, the god of iron, war, force, and technology.[26] As Dewui explains with regard to one such sculpture (7.3.86), "On puts iron on it and it is for Gu." The empowerment properties of iron also are emphasized by Sagbadju (7.1.86): "If iron is on it, and we order it to do something . . . it is like one imprisoned you, one attached you with iron, and you can no longer move." Dewui notes similarly, "When the iron is in it, there is already Gu; that will give strength to the work. . . . The iron pieces that are in it are like needles. . . . As it is attached so strongly, . . . it is a *so* [picket]. When one removes that and one puts it in the mouth . . . if one says something it will happen" (7.3.86). The complementarity here between form (the *so* picket) and language (*so* as verbal signifier of action) is striking.

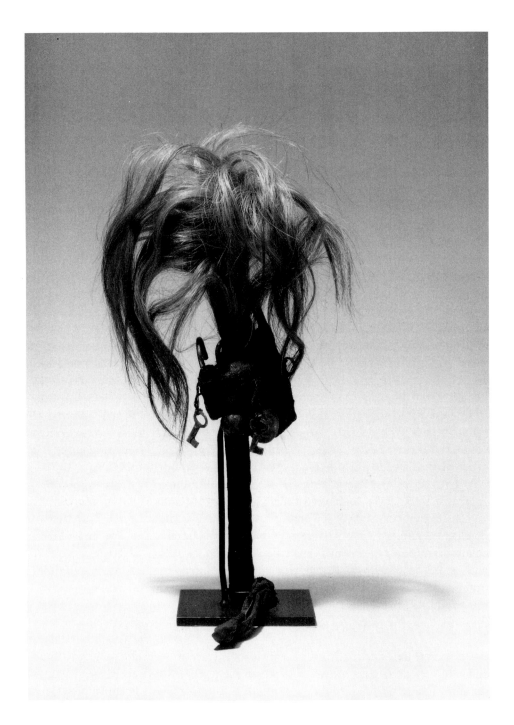

113. Fon *bo* in the form of a fly whisk. Republic of Benin. Cow tail, two padlocks with keys, calabash, bird's bill, cloth, and miscellaneous materials. Height: 34.9 cm. Probably collected in the 1960s. Former collection of Ben Heller. Photograph: Courtesy of Sotheby's.

Sharp or pointed objects made from iron carry with them additional signifying identities based on specifics of shape and use. Iron arrowheads frequently are applied to works associated either with death or with the need to protect one from it.[27] Discussing a sculpture which included an arrowhead among its additive materials, Blaise Mehu noted (7.7.84), "It is used to kill the bad spirit." Spiess observed similarly (1902:316) among the Evhe that "the bad spirits flee just by looking at the poison arrow; and snakes out of fear will not enter the hut."[28] Iron nails also are identified frequently with malevolent power. As Sagbadju observed (7.1.86): "It is those who kill people who employ [nails] in order to assure that the ghost of the person one kills does not bother them. . . . If you kill someone, he will seek revenge against you or he will go to the *vodun* and the *vodun* will begin to bother you. Thus if one brings the things together in a *bo,* one can trap the ghost, and it will no longer be able to move. . . . Termites cannot devour iron. Thus the ghost can no longer do something bad."

The pain associated with the prick of metal arrows, nails, and needles of this type is an important part of each object's protective and aggressive functioning. Describing a work whose surface was covered with sewing needles, Sagbadju noted (7.1.86), "As the needles are on it, and you think poorly of me, it will throw needles into your body. You will begin to feel pain all over. . . . As the needles are there, if you thought badly of me, the needles will begin to prick you. Holes like those the tailor pierces with his needle will appear on your body, penetrating your skin." Of a needle-covered sculpture identified with the Fa sign, Guda-Fu, Sagbadju noted in turn that these signifiers give to the work the power of impenetrability (7.3.86): "When you take the needle, you say: the accidents should not hit me; I should not have problems. The sorcerer should not meet me; no one should think poorly of me. With needles, nothing can reach me. One does not see the entry of the needle, thus one cannot see an opening on me. When you tell [the sculpture] everything, you press the needle in it. You give it oil, alcohol, chickens. If it accepts, everything will come to pass." Paradoxical qualities of penetration and impenetrability, killing and protection from death thus are associated with surface-piercing objects. In these and other examples, transference and catharsis clearly are important to each work's suturing and *parergon* identities.

Body Encirclement Concerns in Ring-Form Signifiers

Rings, bracelets, chains, and other encircling forms—called generally *gan* ("ring," "metal")—also are of critical significance as *bociɔ* attachment means (fig. 114). These objects not only are important in affixing supplemental surface matter but also serve vital suturing and signifying roles in their own right. One of the most emotionally potent of the objects used as *bociɔ* sculptural *parergon* is the leg iron, a miniature version of the restraints historically placed around the ankles of slaves and war prisoners. Such objects convey to associated works

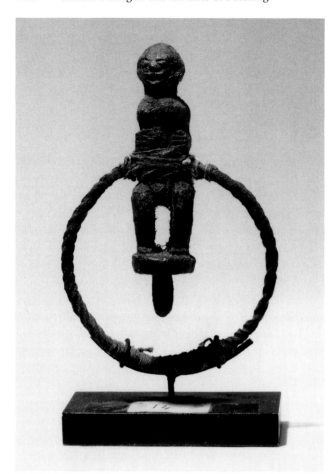

114. Fon? bracelet-form *bocɔ*. Republic of Benin. Wood, iron, cord, and miscellaneous materials. Height: 15.5 cm. Cavity carved in figure's abdomen. Probably collected in the 1960s. Former collection of Ben Heller. Photograph: Courtesy of Sotheby's. Published in Kerchache, et al (1988, pl. 408).

powerful ideas of imprisonment, impoverishment, despair, and death. Leg irons, however, also are understood as having positive suturing identities based on their assumed ability to hold one's enemies at a safe distance or to ensnare for oneself particular advantages. Other encircling forms also have important emotional grounding. The term for "chain" (*wɔlɔ*) signifies as a verb "to crumple," "to hurt," "to bruise," "to offend," "to wound," and "to twist."[29] *Gan* ("ring," "metal") conveys at the same time ideas of mastery, the word *gan* also being employed to mean "lord" or "chief."[30]

Like other additive surface elements, miniature leg irons and other chain or ring forms draw their power simultaneously from the material of their manufacture and the shape into which they are forged. Ring or chain forms of copper or brass for example generally are identified with qualities of coolness. For this reason, copper chains sometimes are employed in *bo* used to counteract fever. Le Herissé explains (1911:152) accordingly that "reddened in the fire, a chain of copper does not take long to regain its normal temperature. It can thus hurry the end of the period of heat of the fever." With ring forms of iron, qualities of

115. Agonli-style *bociɔ*. Republic of Benin. Female figure. Wood, iron chain, and miscellaneous materials. Height 23 cm. Probably collected in the 1960s. Former collection of Ben Heller. Current collection of Don H. Nelson. Photograph: Jerry Thompson, courtesy of the Museum for African Art.

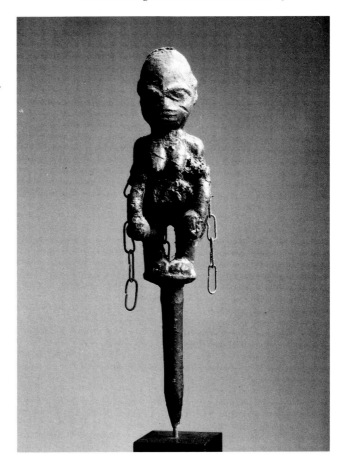

hardness, strength, and heat more frequently are emphasized. Like the iron pins and nails discussed above, chains, rings, and bracelets of iron frequently draw on the power of Gu (fig. 115). As Sagbadju explains by way of a question (8.2.86), "Is the chain not Gu? Does Gu not have force? With this you trapped the ghosts and enchained them."

Ring-shaped elements also are associated with a complex variety of meanings—malevolent and protective—based on their distinctive visual properties of encirclement. As Ayido explains: "It is those who kill people who make works with these chains. They will imprison you in the iron prison. . . . They will say, 'I will kill him by imprisoning him; I will trap him in the iron and he will enter into the chain'" (5.2.86). In other *bociɔ* sculptures, however, iron jewelry is thought instead to help one in entrapping those who would bring one harm. Sagbadju notes in this light (8.2.86) that "one uses this chain to distance sorcerers . . . serpents, and ghosts (*kulitɔ*)." As with the iron piercing forms discussed above, encircling shapes suture to the work paradoxical qualities of protection and demise.

Because of their close identity with the human body, the rings, bracelets, anklets, neck chains, and other jewelry forms also assume poignant roles as *bociɔ parergon*. Concomitant signifying roles frequently rest on associations of jewelry suturing forms of this type with the village corporate body and the dead. As one *bociɔ* maker explained, "If someone wore a ring and was buried a hundred years ago, and if one no longer knows who he was, when one sees the ring or bracelet one will bring it to me to use" (7.3.86). Another *bociɔ* maker noted similarly (7.1.86) that "it is the bracelet that the ancient persons wore that one attaches to the work . . . With such a bracelet . . . what you thought of doing to me, you will not be able to do. You no longer will be able to take your hand and give me a blow; this bracelet will hold your arm." Herskovits also identifies (1967, 2:267) *bociɔ* jewelry forms, particularly bracelets, with the dead, suggesting that they help to prevent problems caused as a result of ancestral disapproval. Bracelet-form *bo*, he notes, are "worn by participants at funerals as a protection against the spirit of the dead. The iron is used because ghosts hate this metal. . . . The spirals and the 'knot' worked into the metal strengthen the efficacy of the *gbo*; in fact, at least half of any iron used to protect against ghosts must be corrugated, since a ghost has no fear of well-polished iron." In other cases it is the circularity of the form that is especially important to its suturing role. Of one bracelet to which a small figure was attached it was explained, "This thing, one traps people with it. . . . It can be a protection and it can be a bad thing. If a bad thing comes toward you, this bad thing will fall into the iron, like this person that is inside" (Dewui 7.3.86).

Chains of beads also have important identities as suturing elements and surface *parergon* within *bociɔ* (fig. 115, 116). The signifying values of such beads are complex. In one work intended to stop the action of malevolent *bo*, beads were included because of their characteristic resilience. Le Herissé explained their role (1911:152) by referring to a well-known proverb: "Beads lost on the path do not derive from human fears. They fear nothing." In other words, beads are in little danger of being harmed or damaged. In other contexts, religious concerns come into play in bead signification. Sagbadju noted of one *bociɔ* example accordingly (7.3.86) that the figure "wears this necklace so that one knows it is a *vodun*." Maupoil explains similarly (1981:205) that "each *vodun* is symbolized by a small string of beads." Color again is important, this time in regard to deity signification. Red usually is associated with the gods Sagbata, Legba, and Hɛvioso; white with Mawu and Lisa; black with Gu, Legba, Hɛvioso, and Age; green and yellow with Fa;[31] blue with Dan (Maupoil 1981:97, 482; Brand 1970:70). The rationales behind these *vodun* color associations are discussed more fully below.

Like beads, chains of cowries (*akue:* money) also are important as *bociɔ parergon* (fig. 117). These shells, which originate in the Indian Ocean, were employed in the precolonial era throughout West Africa as currency and still today constitute a form of ritual money. They carry with them a range of other associational

values as well. In the context of Fa divination, for example, cowries generally represent femaleness and the right, in contrast to the *adjikwin* grain (caesalpinia) which alludes to the male (specifically the testicles) and the left (Brand 1981:9).[32] In other contexts, cowries refer to the tribunal. Explaining the above, Maupoil noted (1981:212) that "no matter how the process turns out, one must pay, before, during, and after."

In this area, because cowrie shells once were employed in slave procurement, they also historically have been identified with human life (Savary 1971:5; Ayido 7.15.86). In contemporary contexts, this linking of cowries with human life is defined in several ways. Sagbadju, for example, indicates (7.1.86) that cowries signify "the person in the *bo,* the money he will take to eat with." A Fon tradition noted by Agbanon (3.11.86) reaffirms this association. In making the raised *atɔ* platform for royal funerals and the annual princely ceremonies, he suggests, "We use cowries in counting the number of people who have died. If you have five relatives who died, you thread five cowries." New births also are identified with cowries and, accordingly, cowries frequently are used in *bo* for women trying to conceive.

In *bociɔ* cowrie use, a range of signifying properties drawn from these and other contexts come into play. Spiess noted (1902:314) that cowries secured to an early Evhe work "serve not only as jewelry but also make [the work] . . . more valuable." Because of their association with money, cowries also are believed to add to the work's overall efficacy. Sagbadju suggests (8.2.86) of the incorporation of these shells that "one puts the cowries around the object's neck to say that it is with money that one bought it." He notes furthermore (7.2.86) that since "the *bo* knows that it is bought with money if cowries are on it, it should do what one asks of it." Sagbadju explains in turn (7.18.86) that cowries were placed on a *bociɔ* from a Nana Buruku shrine because "if one wants to buy something, one buys it with money." In order for the *bociɔ to be* something, in other words, money has to enter into the work.

A related concern in *bociɔ* cowrie signification is that of longing or desire. According to Ayido, one uses cowries on sculptures "for beauty [*acɔ*]—so that one will see it and want it" (4.25.86). For similar reasons, cowries frequently appear on call (*yɔlɔ*) sculptures intended to attract particular items or persons to one. Of one such work Sagbadju suggested (7.1.86): "It is the cowries that make the *bo.* Thus if [one desires another person and if he] sees the cowries, he will return." Sagbadju noted with respect to another *bociɔ* call sculpture, this one having cowrie eyes, that (8.2.86) "when one carved the *bociɔ,* one took the cowries to open its eyes in order to ask it for more . . . to ask money of it."

Other *bociɔ* sculptures in which cowries appear frequently as monetary surface signifiers include *kuɖiɔ-bociɔ* (which help to exchange one's impending death for life)[33] and *vodun-bociɔ* (whose powers rest on the gods). According to Ayido (5.5.86), one often attaches cowries around the necks of the death-exchanging *kuɖiɔ-bociɔ* statues because "as you changed the death of a person,

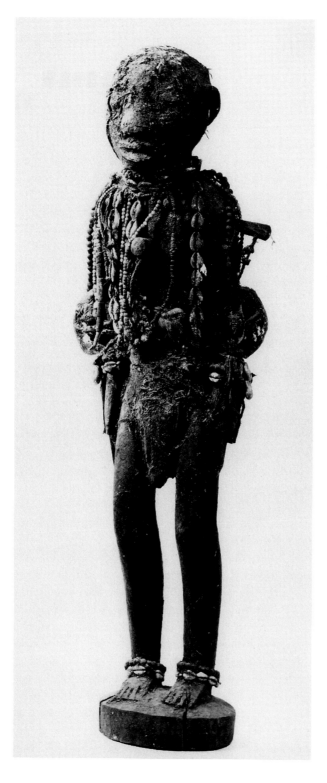

116. Fon *bociɔ*. Republic of Benin. Male figure. Wood, cowries, beads, cords, feathers, and miscellaneous materials. Wooden peg inserted into shoulder. Nineteenth or twentieth century. Musée Barbier-Müller, Geneva. Cat. no. 1010–33.

117. Ouatchi? figure. Togo. Wood, iron, cloth, cowries, cord, and miscellaneous materials. Height: 53.3 cm. Figure holds an iron staff of the type used in memorial shrines of Fa diviners. Indianapolis Museum of Art. Cat. no. 1986.184. Gift of Dr. and Mrs. Wally Zollman.

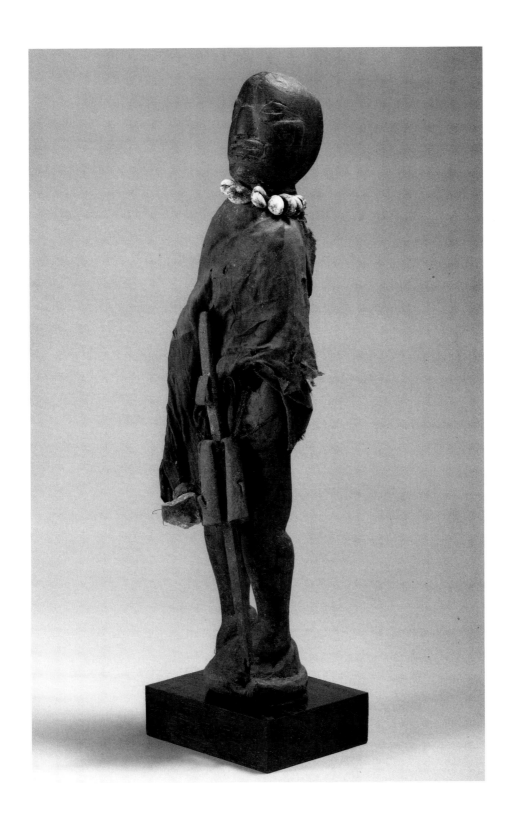

when he will go to the land of the dead he will be hungry and will need cowries for payment." Of the cowries placed on *vodun-bociɔ,* Dewui explains (7.3.86) in turn: "The cowries serve as objects of beauty for the *vodun.* One takes cowries to represent the *vodun* because it is with cowries that one buys things here. It was a form of money. . . . Before, when one wanted to make an offering [*sa vɔ*], it was with money that one did it. . . . Because the *vɔ* buys back the person who made it, one says that it is with money that one bought the person. This is the money of exchange." [34]

Cowries also are integrated into *bociɔ* sculptures because of their associations with Fa divination and its complement of signs (*du*). In such works, cowries sometimes are positioned according to a visual code wherein the shells are secured either face up or down depending on whether the particular *du* sign depicted is identified with single-line or double-line markings. As Sagbadju explains (8.2.86), "One takes the cowries and writes the *du* on the figure's body." Savary suggests (1976:240) in turn that in one *bo* of this type, cowries represent the destiny transferred by Fa. Of a leather-covered *bo* with a cowrie decoration, Savary asserts similarly (1976:242) that "the sign of Fa is on it." Here too we can see the importance of the cowries' surface suturing role in the creation of sculptural meaning.

Containers: The Suturing Roles of Vessels

In many *bociɔ* forms, empowering materials are incorporated into the work after being placed in vessels of varying sorts—horns, small pots, and gourds (*ka go,* "gourd bottle")—are the most important—which are secured to the surface by cord or cloth. Each such container or enclosure may represent a different type of problem or response. As Ayido explains with respect to one sculpture incorporating multiple gourd containers (4.25.86): "One can eat the powder in this container and say that cloth will exist, money will exist, well-being will effectively come. One can eat the powder [from another container] to prevent well-being from entering into the house, room, or family of such and such a person. One can eat still other powders and . . . no bad thing will happen to one that day." The comments of Spiess (1902:314) are also of interest: "With the Evhe fetish objects we often find these small gourds whose contents are either blown into the enemy's eyes or are rubbed on the forehead or hands of the carrier of the string to protect from accidents." In a form of visual synecdoche, contained and container frequently are conflated, with the vessel assuming its own potent signifying role not unlike that of the laboratory receptacle in a Western experiment. As Ayido explained (4.25.86): "When one looks at the sculpture one also sees the gourd in which the powder is placed. . . . Different powders stay in different containers." Surface containers suggest in this way the potentiality of sculptural

action. That small glass medicine bottles of various forms and sizes sometimes are used today for this purpose—particularly as containers for liquids—serves to underscore the central place of *pars pro toto* ideation in the signifier-signified relationship.

While sharing an identity with the materials enclosed within them, *bocɔ* containers also are associated with a range of distinctive qualities in their own right. To Dewui (7.3.86), "It is the gourd which does the work. The gourd is nature's bottle.[35] For the *bo* what is important is what has been living. . . . The leaves, trees, things that come from the earth in one way or another, it is these things that one takes for the *bo*, because the *bo* is something that is born." Language here too is important. The tiny gourd most frequently employed in contexts of *bo* and *bocɔ* (figs. 118, 162) is called *atakungue* (*atakun: piment de guinée*, pepper; *gue*: avarice), a reference to the bite, sting, and ritual power of *bo* and the psychological potency of related concerns. The general term for "gourd," *go*, also offers insight into the suturing signification of related objects. The idiom *ka kpo do go kpo*, "the calabashes [*ka*] and the gourds [*go*]," thus is frequently employed in reference to one's earthly possessions, material and otherwise (including children).[36]

An essential part of gourd conceptualization also finds grounding in the role that gourds play locally as offertory vessels in religious rituals (Maupoil 1981:211) (fig. 119).[37] Signifying features of the gourd in everyday and ceremonial life add to their prominent place in *bocɔ* in other ways as well. Brand identifies many related gourd qualities vis-à-vis concepts of gender,[38] the gods, and cosmology (1981:7). As he explains: "The *vodun* or gods are often born inside a calabash or make themselves known to humans by installing themselves inside a calabash. In Wemenu cosmology and in that of southern Dahomey, one finds . . . the two deities who created the other gods residing in a calabash. The calabash thus takes on the value of the womb of life for the gods. Moreover, all installations of a *vodun* necessitate the employment of a calabash."

Gourd forms also serve in key respects as models for the human body; many anatomical parts accordingly refer to gourds through associated names (figs. 120, 121).

Like gourds, pottery vessels (*zɛn*) are associated with a range of worldly and religious signifiers (figs. 122, 123). Many such pots are linked to *vodun* because of the prominent place of terracotta vessels in temples and shrines, each deity being identified with a distinctive vessel shape or pattern (see Savary 1970; Blier, forthcoming). Moreover, accounts of deity origins frequently refer to the gods as having been born in clay pots (see Blier, forthcoming a and b).[39] With both gourds and pots, ideas of engendering thus are important.[40] Appropriately in Fon, the word for "birth" is *e gba go*, "the gourd has broken." This association of pots and gourds with ideas of life, regeneration, and supernatural empowerment coincides in key respects with the roles of *bocɔ*.

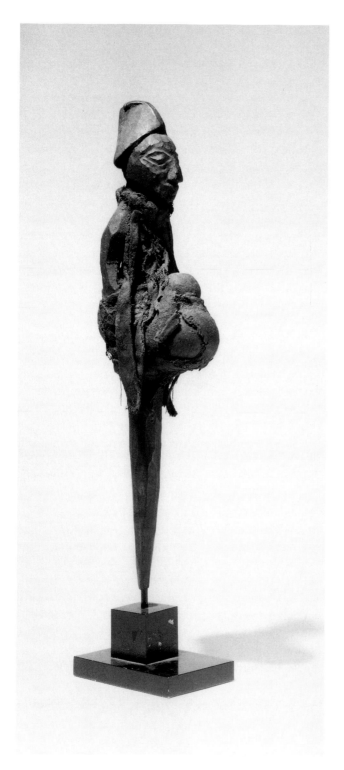

118. Fon *bociɔ* with gourd. Abomey, Republic of Benin. Wood, gourd, cloth, cord, and miscellaneous materials. Height: 39.3 cm. Artist: Benoit Houndo, the same artist who carved the objects in figs. 68, 92, and 125. Probably collected in the 1960s. Former collection of Ben Heller. Photograph: Courtesy of Sotheby's.

119. Fon *bociɔ*. Standing female figure. Height: 30 cm. Abomey style. Republic of Benin. She supports a calabash container on her head. An iron chain is around her neck. Wood, metal, cloth. The same artist carved the figure in fig. 75. Gift of Mr. and Mrs. Stephen Weiss. National Museum of African Art. Eliot Elisofon Archives. Smithsonian Institution. Cat. no. 75.5.8. Photograph: Franko Khoury. 1992.

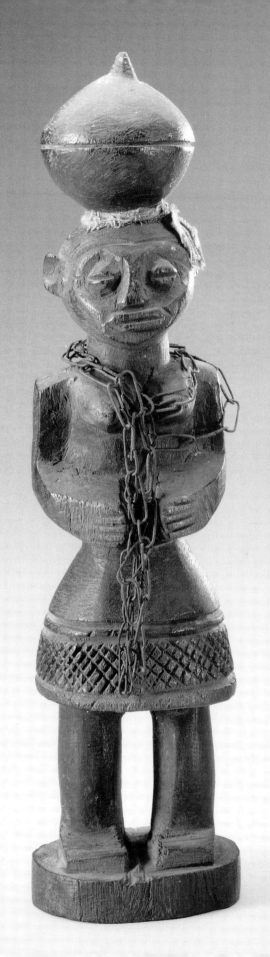

120. Agonli-style gourd-form *bociɔ* with carved head. Republic of Benin. Wood, gourd, cowries, cord, and miscellaneous materials. Length: 23.9 cm. Probably collected in the 1960s. Former collection of Ben Heller. Photograph: Courtesy of Sotheby's.

Soft Covers: Tension and Tone in Contexts of Wrappers

Cloth and leather also play important roles in *bociɔ* suturing. As with cords, pegs, ring forms, and hard containers, such coverings have features which offer critical insight into the meaning of associated works. Because animals (and their skins or leathers) were discussed in some detail in the preceding chapter, attention here will be centered instead on the signifying role of cloth (*avɔ*). Cloth and other soft covers (fig. 124), as we will see, have grounding in indexical values, and the concurrent privileging of features of position and/or placement. Related concerns such as body dirt and odor also are critical. Certain cloths are selected for *bociɔ* inclusion because they had been worn in life by a particular individual (fig. 125). Through use of such cloths in *bociɔ*, the sculpture's protective and

121. Ayizo-Fon *bo* with gourd body attachments; called *Houlou Dzenou*. Hevie, Republic of Benin. Wood, gourds, cowrie shells, cord, and miscellaneous materials. Height: 21 cm. Empowered powders are stored in calabash containers. Collected by Michael and Shirley Furst, 1965–68. National Museum of African Art. Eliot Elisofon Archives. Smithsonian Institution. Cat. no. 68.32.3. Gift of Michael J. Furst. Photograph: Franko Khoury. 1992.

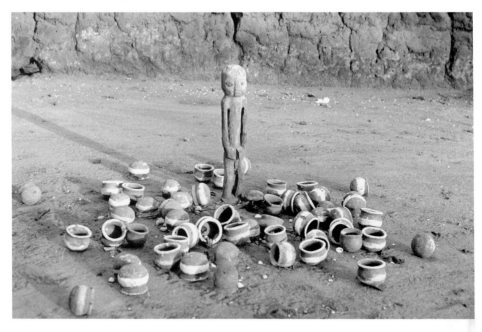

122. Gedevi-Fon *kuɖiɔ-bociɔ*. Bohicon region, Republic of Benin. Set up with *lobozɛn* pots during a memorial ceremony. Photograph: Suzanne Preston Blier. April 6, 1986.

aggressive powers are directed away from or toward that person. As a result of cloth's close association with a person through contact with the body, related materials are often used to call a man or woman's individual spirit (*yɛ*) into the work in order to achieve particular ends. In *bociɔ* cloth contexts, the placement of a cloth also comes into play. Accordingly, one *bociɔ* maker requested that the client bring to him a cloth which had previously been placed on the face of a corpse. As the maker explained later (3.7.86), "It is the cloth used to wrap the face of the cadaver that is employed to make the object work." Herskovits (1967, 2:265) also provides insight into the privileging of indexical properties of cloth use in *bociɔ*.[41] Of one work he asserted, "The bit of cloth . . . is from a funeral cloth, and its use here is to ward off death from the man's wives and children."

With leather coverings, as noted earlier, it is the source animal that is of greatest importance to the material's suturing role.[42] With cloth, it is both thread type and color that are stressed. The most frequently employed materials are cotton and raffia. Like raffia cord, raffia cloth is identified with ideas of both poverty and resilience. Cotton, an imported material, is associated instead with monetary value, means, and status. The concern with color comes into play more frequently in cotton cloth as well, particularly with regard to issues of religious grounding. According to Sagbadju (8.2.86), "In the same way that it is the different cords of the *vodun* that one attaches around the figure's body, the different colored cloths the sculpture wears are those of the different *vodun*." Sagbadju's

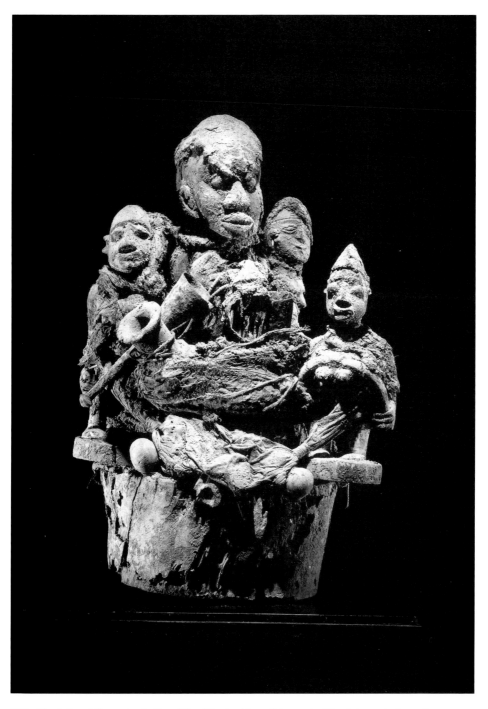

123. Hueda? multifigure *bociɔ*. Republic of Benin. Mono River style. Wood, iron, cloth, cord, pottery, gourd, and miscellaneous materials. Height 53.5 cm. Note the range of styles of associated figures. Probably collected in the 1960s. Former collection of Ben Heller. Photograph: Courtesy of Sotheby's.

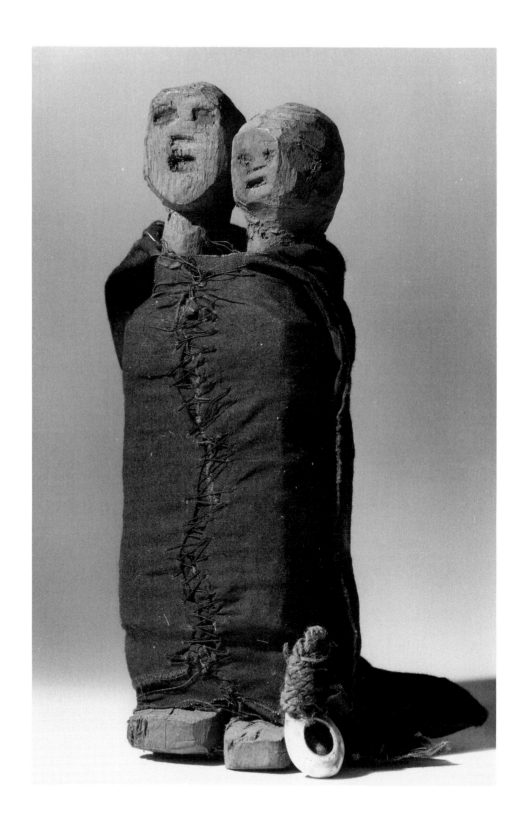

124. Evhe figural power
object. Lome, Togo. Wood,
cloth, cowrie, cord, and
miscellaneous materials.
Height: 23 cm. Object used in
divination. Reportedly
acquired from a group of
thieves. Musée de l'Homme,
Paris. Cat. no. M.H.32.78.23.

125. Fon *bociɔ*. Republic of
Benin. Wood, cloth, cord,
leather, and miscellaneous
materials. Indianapolis
Museum of Art. Artist: Benoit
Houndo, the same artist who
carved the objects in fig. 68,
92, and 118. Cat. no.
1986.187.

description of *bociɔ* manufacture brings this out clearly: "One takes the earth and places it in white, red, and black cloths. Next, one looks for the leaves of the *vodun* and places them in the different cloths. Following this one takes a piece of thread and attaches the filled cloths to the figure. Finally one kills the animals which one has been asked to offer—the goats and chickens. With this, all that disturbs you in life, all that you battle against will be gone, for now you have something in the house to combat them and they will leave" (7.1.86).

Red (*vɔ*, *vɔvɔ*) is one of the colors most frequently employed in *bociɔ* cloth coverings. Explaining the making of a *bociɔ* figure, Sagbadju noted (7.3.86), "After pounding the leaves I put them in a cloth and sew it onto the *bociɔ*. I use red cloth. The red will make it quickly resolve the thing because your blood is red." Since most cloths (regardless of color) are soaked in the blood of goats or chickens offered to the sculpture during the process of activation, the added power of red blood also plays a vital role. This blood not only empowers the work but also serves to fix the cloth and its enclosed materials permanently to the sculpture.

Besides its correlation to blood, red also invokes ideas of danger and desire within *bociɔ* coverings. "That is why," explains Pazzi (1976:45), "one does not dress in red; it would attract attention and envy." In other contexts, the color red is linked to life, sunlight, and fire. In Pazzi's words (1976:37), "The red indicates the sun which arrives on the horizon like fire, then climbs, reheats and gets enflamed. The sovereign and dispenser of all energy: [red] is the color of life." Women, as supporters of life, also are closely identified with the color red and from this, female *bociɔ* sometimes are made to wear this color. Red, as we will see in the concluding chapter, is linked to kings in important ways as well.

As a cloth suturing signifier, red additionally is identified with the *vodun*. According to Adande (1976–77:61), "The *vodunsi* have a profound sense of this symbolism of colors and it is not surprising that the *vodunsi* use it frequently, whereas in ordinary life one repudiates the use of red." Certain key deities are especially associated with the color red; most important is Sagbata, the often violent, sickness-bringing god of the earth (in this area the color brown is referred to as "red")(Pazzi 1976:45; Maupoil 1981:546). Other important deities identified with this color are Legba[43] (the sometimes vengeful deity who brings accidents, anger, and envy), Gu (god of the red-hot forge, metal, and war), and Hɛvioso (controller of thunder, and most important here, lightning).

Black (*wi*, *wiwi*) is identified with similarly important *bociɔ* powers and values, particularly ideas of strength, family, ancestors, mourning, death, nighttime, and fertile earth. According to Pazzi (1976:37): "Black, . . . the color of suffering, announces the night, the color where the freshness of the earth and the falling shadows bring each being into the house, at the heart of the family, in common with the deceased, where the vital equilibrium is restructured." Appropriately, the color of mourning cloths here is a deep blue-black (Pazzi 1976:49). Herskovits notes (1976, 2:276) of one *bo* that the reason the "cord is black is

because this is the color used in the funeral." Hunters and warriors often will cover themselves with black pigments and cloths both as a means of reinforcing values of force and courage in themselves and in order to frighten others. As with red, black is identified with certain gods. One is Gu, the deity of iron and war. Another is Hεvioso, the thunder deity. Still another is Age, god of agriculture. The ontological grounding of these deity-color signifieds is obvious: black not only is the color of iron, but also of storm clouds, and the rich, dark earth preferred by farmers.[44]

White (*we, wewe*) is associated with a diversity of meanings in the context of *bociɔ* signification as well. Pazzi explains that (1976:42) "the color white (*we*) is the color of astral light. . . . It is the symbol of peace in the cosmic equilibrium. This is why one covers the body with kaolin during religious rites of pacification. The color white recalls the heavens and the ancestors; this is why the ritual cloths of cults are white. White-gold is the symbol of victory."[45] Protection and abundance also are expressed in meaningful ways by the color white. According to Pazzi (1979:35), one puts a white cloth around the trunk of the *iroko* tree in years of abundance and a black cloth in years of drought. As with other colors, white is closely identified with religious rites and with the *vodun*. According to Na Djebo (10.30.85), "Devotees wear it so that the *vodun* will come onto their heads." One also uses it "so that the life of the initiate will always be white, that is, cool, happy," asserts Maupoil (1981: 320). While white is associated with all the *vodun*, the deity most closely identified with this color is Lisa, who with Mawu serves as god of heavenly light (Maupoil 1981:505).

Another "color" important in contexts of *bociɔ parergon* and suturing is polychrome, described locally as any multicolored material characterized by stripes, spots, or patterns in a combination of red, white, black, or other colors. According to Pazzi (1976:46), this color "symbolizes the plenitude of the vital dynamism and its manifestation because it recalls the rainbow." As such it is closely associated with the deity Ayidohwedo, the rainbow serpent (Pazzi 1976:460). Adande notes similarly that (1976–77:60) "the abundance of colors [of the rainbow] is the symbol of abundance of riches which this serpent can bring." Because of this wealth association, polychrome is a frequently requested color in *bociɔ* cloth coverings. As Sagbadju explains in one example (7.3.86), "All the cloths that humans wear in this life, I will have the *bo* wear them—white, red, and black." Through their incorporation of multicolored or polychrome cloths, *bociɔ* at the same time allude to the diverse worlds and multivalent identities of their viewers and users.

Conclusions

A large range of properties are accorded the diverse *bociɔ* attachment means. With cords, the psychological potency of related signifiers is particularly striking. Among the multiple values attributed to cords as discussed in the above text are

the following: functioning, family, tradition, construction, force, tieing, obligation, effects, durability, accomplishment, mastery, manipulation, life course, generation, conformity, tradition, heart, pregnancy, inheritance, measurement, religious affiliation, fidelity, life changes, work, passing, strength, solidarity, resistance, impenetrability, and resilience. Although the attributes are generally positive, cords also have profoundly negative associations, including ideas of death, slavery, danger, demise, miscarriage, misdeeds, sorcery, battle, toxicity, vulnerability, bending, poverty and poison. Noteworthy here is both the contrast of ideas expressed vis-à-vis cords and the potency of their psychodynamic grounding.

For pegs, a variety of equally potent values are conveyed in various *bo* and *bociɔ* examples cited in this chapter, including ideas of weight, load, obstacle, power, piercing, sting, bite, seizure, strike, humiliation, debasement, pardon, absolution, preparation, killing, bad spirits, flight, poison, snakes, fear, revenge, trapping, devouring, penetration, thinking badly, accidents, hitting, problems, entrance, openings, pressing, acceptance, and coming to pass. Likewise with rings, gourds, and cloth suturing forms, the concerns are diverse and emotionally powerful, including references to injury, bruising, offense, wounds, twisting, prisoners, slaves, impoverishment, despair, death, killing, chains, traps, serpents, ghosts, the dead, burying, blows, restraints, protection, hate, calm, falling, living, offering, sexuality, fecundity, gods, creation, wombs, funerals, derangement, combat, and battle.

In *bociɔ* sculptures, as we have seen, it is not only the attachment form itself that is important, but also the material from which it is made. Iron, to take but one example, is identified with such variant and opposed values as power, strength, imprisonment, death, impoverishment, beating, traps, fever, heat, fire, cool, sorcery, bothering, fear, problems, killing, revenge, attack, devouring, needling, pricking, penetrating, opening, pushing, protection, wish, evil, success, and journey. For cowries and beads, a complex range of meanings also is conveyed, including, in this case, ideas of repulsion, danger, immunization, accidents, sight, refusal, looking, money, eating, death, funerals, slavery, pregnancy, desire, asking, destiny, fear, loss, attachment, blood, and violence. In these and other ways, *bociɔ* attachment or suturing means offer vital insight into the signifying properties of each work. At once apart from (ancillary to) and a part of (integrated in) each *bociɔ* object, these attachment forms provide unique perspectives into the ways that power and psychological features find expression in *bociɔ* sculptural representation. Finally, as elements external to the work which have an impact on its internal reading, these suturing and *parergon* devices also reinforce the critical roles that *bociɔ* play as objects of and about desire.

The Force of Genre: Sculptural Tension and Typology

"No bird lays its eggs on a branch without first making a nest" (*Xe ma ɖo adɔ d'atin de ji a, e na ɖo asi do fine a*).

—Fon proverb, from Quénum, *Au pays des Fons*

"Each element's constructive meaning can only be understood in connection with genre."

—M. M. Bakhtin/P. N. Medvedev, *The Formal Method in Literary Scholarship*

"Of all the codes of our literary *langue*," writes Alastair Fowler (1982:22), "I have no hesitation in proposing genre as the most important, not least because it incorporates and organizes many others." Genre theory, with its underlying valuation of typology, taxonomy, and teleology, has been explored in fields as diverse as literary criticism, film theory, anthropology, and art history by scholars who are concerned with the framing of discourse with respect to variant issues of sameness and difference. The term "genre," from the Latin *genus,* meaning birth, species, class, or kind, is employed in contexts of art to designate particular formal groupings of creative work.[1] In literature, investigations have focused on differential modes of writing—fiction, nonfiction, drama, short story, biography, and autobiography, among others. In art history, period paintings depicting subjects such as interiors, still lifes, and family scenes have been the principal topic of genre discourse.

Because they offer critical interpretative clues for the reading of works of art, genres have been an especially provocative subject of recent scholars interested in questions of signification. As Jan Trzynadlowski explains (in Fowler 1982:23), genres serve "as 'instructions' for interpreting other coded information." In the words of Bakhtin/Medvedev (1985:131), "Every genre has its own orientation in life." Genres, Bakhtin explains (1986:5), "accumulate forms of seeing and interpreting particular aspects of the world." Related discussion, accordingly, often has been elaborated with respect to traditional taste canons and the establishment of classificatory hierarchies in which certain genres are privileged over others. A number of scholars in their analyses of artistic typologies have criticized the viability of rigid historical genre designations. They argue not only that major genre shifts occur throughout time, but also that critical artistic breakthroughs often have been a result of some form of genre transgression. Genre violations of this type, as Thomas Kent suggests (1986:34), have made "it possible to communicate the unknown through the known."

Bociɔ are relevant to this discussion in that while these works do display certain genre distinctions, they also are defined in essential ways by features of genre violation, deformation, mixing, and overlapping. *Bociɔ* for this reason frequently belie easy genre classification with regard to formal attributes and functional concerns, with many such works drawing their features and potency from several genres simultaneously. Every *bociɔ* figure in this respect carries within itself both the potential and the actuality of multiple intersecting genres, these introducing in turn new texts and subtexts into the reading of the work. *Bociɔ* genre transgression of this type adds not only to the complexity and richness of these works but also to the inherent danger and tension which they convey.[2] When one genre text is made to converge with another (or several others), the end result is a form far denser in meaning, content, and power than a particular genre would have been independently.

Bociɔ also are set apart from many others genre forms because they demonstrate little if any hierarchical concern with respect to object typology. Not only are simple nonfigural *bo* sometimes as important as those more fully defined artistically, but also every *bociɔ* genre is seen to have the potential of equally great empowerment capability. *Bociɔ* genres in this sense are defined more by qualities of parataxis than syntax. They constitute what Adorno (1984) would call a corpus (series) without hierarchy; each is based on a set of horizontal as opposed to vertical distinctions.[3]

Among the Fon, the word employed most frequently to designate the idea of "genre," *donu* (*donnu*, class, group), derives from the verb *do*, meaning "to arrange by groups," and the noun *nu*, signifying "thing" or "object." The same verb, *do*, denotes "to place," "to plant," and "to establish." Suggested in the above is the grounding of genre classification in the very notion of doing and creating. Variants of *do* also are of significance in composite words, with *ɖɔhun*, spoken retroflexively and in a lowered tone, referring to things that are "like" or "similar." *ɖoɖo*, also spoken retroflexively and in a high tone, means "entirely," "really," "without mixture," and "uniquely."[4] *ɖokpo*, spoken retroflexively, designates "one" or "only one."[5] Fon genres in this sense can be seen to provide an orientation to the world, a means through which concepts of sameness and difference are made manifest. Just as "genres" imply a sense of oneness or similarity, they also express the widespread human predilection for grouping, coupling, and cojoining. Each *bociɔ* genre at once constitutes a unique corpus of works and a locus for contextualizing objects identified with multiple related but distinct attributes and elements. Interpretive considerations for this reason are an essential part of any genre discussion.

Most significant in regard to *bociɔ* is the issue of their sociopsychological grounding. "[T]he literary genre," as suggested by Stewart (1984:7), "determines the shape and progress of its material; but . . . the genre itself is determined by the social formations from which it arises."[6] Similarly, to Fowler (1982:31), the formative roots of literary genres are central because such genres "offer room,

as one might say, for [one] to write in—a habitation of mediated definiteness; a proportioned mental space; a literary matrix by which to order his experience during composition."[7] Fon, Evhe, and other sculptural genres, I argue here, offer unique insight into a work's underlying matrix and sociopsychological grounding. These genres "offer room" within which experience is ordered and expressed.

Each *bociɔ* sculptural grouping displays certain key elements of emotional tension. In *bociɔ* figures as in other art forms, the nature of the tension is complex. According to Natan Zach (in Fowler 1987:245–246), tension is "located wherever opposing forces, impulses or meanings could be distinguished and related to one another." Adorno also emphasizes the importance of tension in art (1984:407): "Tension highlights dissonant experience and antinomial relations in the artistic object, thus stressing precisely the substantive moment of 'form.' It is through its inner tensions that the art work defines itself as a field of force, even when it has already come to rest, i.e. when it is objectified. A work of art is as much a sum total of relations of tension as it is an attempt to desolve them." Although tensions are displayed within *bociɔ* genres in a diversity of ways, most such sculptures address what Ehrenzweig has called (1967:173) themes of containment (trapping) and expansion (liberation).[8]

Some *bociɔ,* death-exchanging sculptures for example, are identified with trapping and propelling danger by presenting a surrogate body or corpse. Others are predicated on such tension-defined formal attributes as binding (bondage), piercing (pegging), deformity (multiheadedness especially), and swelling (or pregnancy).[9] Still other genres share common internal features of tension through the sources of their empowerment in the context of divination, deity intervention, and sorcery. In this chapter, genre typologies are explored as a background against which issues of tension within the larger corpus of *bociɔ* sculptural texts can be addressed. Each genre will be treated accordingly with an eye toward the complex interweaving of factors of expression and sculptural form. Because, as noted above, many of these works incorporate features of several genres simultaneously, their expressive power is all the more poignant and provocative.

Art as Target: Death-Exchanging Sculptures

Fear of death is the predominating psychological concern addressed within the first sculptural genre explored here, *kuɖiɔ* or "death-exchanging" (*ku:* death; *ɖiɔ:* exchange) *bociɔ* (fig. 126). *Kuɖiɔ-bociɔ* generally are thin, polelike forms with often only minimal indication of body features. Explaining the frequent lack of concern for sculptural detail in *kuɖiɔ-bociɔ* works, Ayido notes (4.25.86), "This is not something one will go and buy at the market [from a professional artist]. It is we diviners who do it and we generally make only signs for the eyes, nose, and mouth." While such objects usually also include indications of sexual

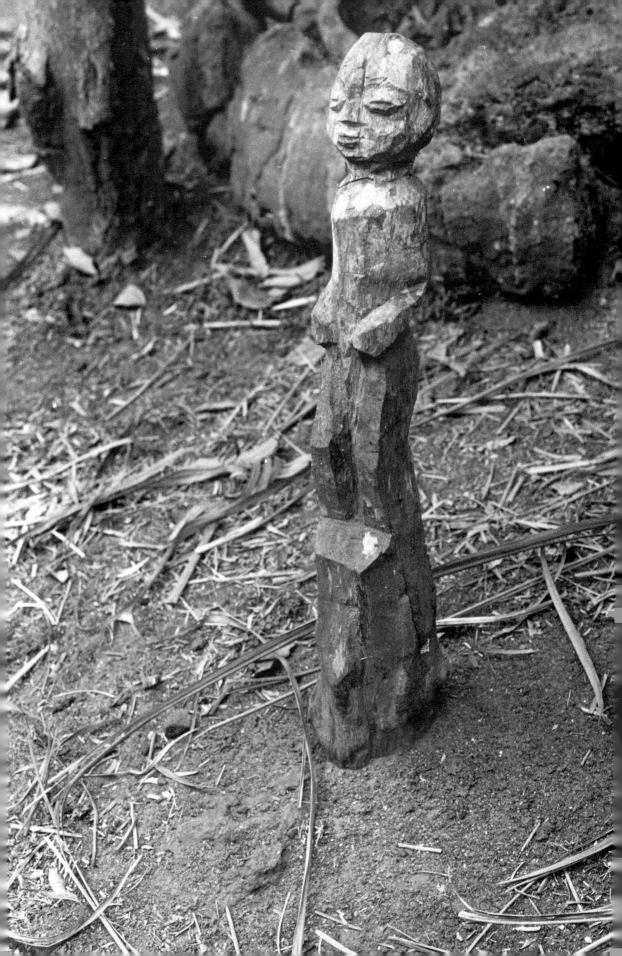

126. Gedevi-Fon *kuɖiɔ-bociɔ*. Bohicon area, Republic of Benin. Photograph: Suzanne Preston Blier. May 19, 1986.

127. Aja figure from Gbele, Togo. Identified with Legba. Wood, red-striped cloth, pigment. Height: 27.8 cm. Carved for women whose children die soon after birth. Placed at the edge of a path outside the village, to help prevent the problem from reoccurring. Collected by Mischlich, 1911. Linden Museum, Stuttgart. Cat. no. 74 270. Published by Cudjoe (1969: fig. 16).

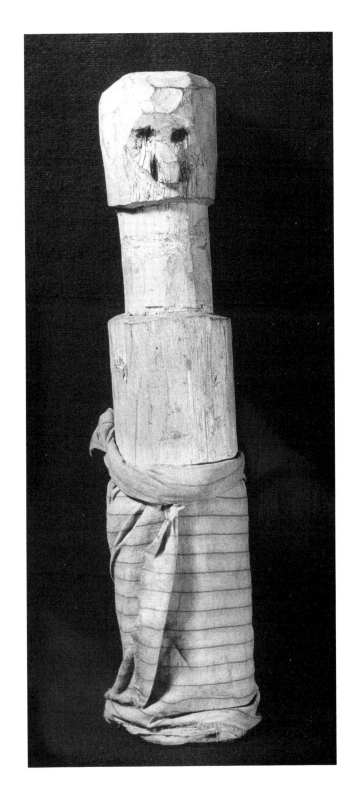

anatomy, other distinguishing human features generally are lacking. Other than a small piece of cloth tied around the figure's neck or waist,[10] these sculptures incorporate few if any of the diverse additive materials applied to the surfaces of most other *bociɔ*. A few works, however, have cowrie-shell eyes. Weathered surfaces, the result of long-term positioning out-of-doors, distinguish many works of this genre as well.

Kuɖiɔ-bociɔ are used to help individuals avert various traumas or difficulties in life, principally by tricking malevolent forces into attacking the figural representative instead of the living person. Through associated forms of sculptural deception, an individual is said to exchange his or her impending demise (death) for life. As Ayido observes with respect to these figures (5.18.86), "In some ways such works are like a snake that changes its skin." He explains further (5.5.86): "If one makes a *kuɖiɔ*, death will not arrive, sickness will not arrive. If death or sickness comes, it is the statue that it will take instead of the person. We replace death in this way and give it to someone else." Projection and substitution are critical to the functioning of the *kuɖiɔ-bociɔ* figures. Maupoil notes for these works (1981:363–64) accordingly that

the statue represents symbolically the one that is being kept from the death which was announced by Fa [the divination god]. One dresses it in a piece of cloth worn by the menaced person—generally a sick person. . . . It is in this way that certain people say that death, distracted . . . will accept the exchange, which one explains by the words *ku dyo dyo* (death-exchange or replaced). Once the *bociɔ* is installed, the one that it represents should not believe that he is shielded from all death: he will only avoid death before the fixed moment. Only premature death . . . can be tricked by the *bociɔ*.

Ayido, reaffirming the above, suggests that (4.25.86) "if the bad thing that was looking for you came and saw the sculpture, it would say, it is this one I am looking for; I will take him away with me. If this thing takes the sculpture, the bad thing will not come again to your house."[11]

All *kuɖiɔ-bociɔ* are commissioned in conjunction with Fa divination consultations (fig. 127). They are empowered through this deity and serve in some respects as offerings (*vɔ, vɔsisa*).[12] Following a Fa session, the diviner will recommend that a person obtain a sculpture to serve as a "target" for the animosity perceived to be directed against this individual. Related works in turn are closely identified with Legba, the messenger deity, who moves between humans and the various forces at play in the universe. The divination God, Fa, also is associated with this *bociɔ* genre through the sprinkling of *yɛ* powder taken from the Fa divination board (into which the appropriate *du* sign was marked) onto the surface of the sculpture. As Ayido explains (4.25.86), "We take our finger to make the lines for a *du* and then one overturns this powder from the board onto the figure" (see fig. 38). It is through this means that destiny is believed to be set or modified. In this and in other ways, *kuɖiɔ-bociɔ* incorporate essential attributes of the Fa-*bociɔ* discussed below, even though the formal characteristics of the

two genres differ markedly in terms both of body articulation and additive surface materials.

In view of the fact that representational qualities are given so little attention in *kuɖiɔ-bociɔ*, it may be surprising to learn that these sculptures are linked closely to themes of psychological projection and substitution. Yet in these death-exchanging *bociɔ*, other personalizing elements such as height, divination sign, dress, and odor are emphasized. The size of *kuɖiɔ* sculptures often varies vis-à-vis the age and relative stature of the person represented.[13] Death-exchanging *bociɔ*, for this reason, are among the most varied in size. Another critical personalizing feature is the divination-sign powder (*yɛ*) which is added to the object's surface in the course of its empowerment. Ayido explains (4.25.86) that by sprinkling the powder from the divination board onto the sculpture, one is "calling this *du* [divination sign] onto the statue . . . [and] transforming it into a person. . . . It is your destiny that one put on the sculpture that day." The close association of this *yɛ* powder with the *yɛ* (spirit agent) of each person is important in this regard.

Yet another unique, personal reference critical to the sculpture's role in psychological projection is the small piece of cloth acquired from the individual for whom the work has been commissioned. As noted above, this cloth is usually tied around the figure's neck or waist. According to Ayido (5.2.86): "The cloth carries the odor of the person. But that is not the only thing. As he already had worn the cloth and everyone saw the cloth on him, if he rips this cloth and puts a small piece of it on the sculpture, when misfortune sees this sculpture, it will think that it is this person."[14]

The tieing of this cloth also helps in key respects to activate the figure, and this tieing action, in turn, signals a link between these death-exchanging sculptures and works of the genre known as *bla-bociɔ* (bound *bociɔ*; see below). Perhaps more than any other surface feature, it is this piece of cloth and its association with the odor (*sɛ-wan*) or dirt of the person suffering a particular trauma which delimits the sculpture's function as *simulacre*.[15]

The critical role of death-exchanging *bociɔ* in psychological projection also is reinforced by the emphasis given to the circumstances of their placement in the earth. Often such sculptures are positioned at daybreak (a time of transition) by a member of the individual's family (Ayido 4.25.86). Before planting the work, according to Maupoil (1981:363–64), certain ceremonies undertaken first require that: "one digs a hole and one buries the head of a goat, the head of a chicken, or the leaves of Fa. . . . One installs the *bociɔ* on top of the hole as an extra guarantee. Once the sacrifice is made and the *bociɔ* has been put into place, one is not concerned with anything else."[16] These ceremonies serve additionally to direct and empower the sculpture.

The location of the sculpture also is important. In some communities carvings of this type are positioned in front of the homestead to represent the family head and other key family members. Often such works are aligned with the entry. In

other cases, Siegmann explains (1988: pl. 29), the figures are "placed at the sides of a door of a hut (the male to the right, the female to the left) to prevent thefts or the interference of malevolent human agents in the affairs of their kin." Age is significant to their positioning as well. As Djido notes (6.17.86), "The one who is the elder is in front; the new family head is behind." Family children sometimes are represented by another (smaller) sculpture in back of the others. The senior woman of the house sometimes will have her own sculpture in the center of the homestead's interior.

In addition to the above figures, which are linked to an individual's personal (and lifelong) Fa sign, others are carved and positioned in conjunction with specific geomancy sessions held in response to various problems. In the latter works, locale is linked to the particular sayings of the sign. As Maupoil explains (1981:357) of the whole corpus of offerings done at this time:

Nothing is left to chance. . . . Where does one abandon them . . . most often? In the sea, on the beach, beside the river, in the river. . . . Fa can also ask that the sacrifice will be placed in front of the To-Legba [village Legba shrine] . . . or at the entrance of a town, in a place in the forest, under a sacred *iroko* tree, at a crossroads . . . behind the village, on the access road; on a garbage pile (*zaxaglo*) or on an elevated area (*so*). In certain cases, the sacrifice is buried either in the bush or in a hole dug expressly for this, or in the room of the consultant, under his bed. . . . [17]

Each Fa sign and each associated contextualization of a problem accordingly is identified with a distinct sculptural placement or locale. Thus, when one creates works for the sign Gbe-Tumila, explains Ayido (6.21.86), "we put the statue in a mat and rolled it up and left it by the road." For the sign Woli-Tula, on the other hand, the sculpture is placed in the cemetery (Ayido 4.30.86). With Gbe-Medji, two sculptures are used: one is positioned at the house portal, the other on a garbage pile (Ayido 4.30.86). In contrast, for Gbe-Guda, the sculpture is set up beside a river (Ayido 5.11.86).

These locales play an important role in both sculptural meaning and psychological projection. The riverbank placement of sculptures commissioned in conjunction with the sign Gbe-Guda offers interesting insight into this process. The text of this geomancy sign recounts the following story (here reported in summary form):

In a certain kingdom, the ancient king dies. The oldest son sets out on a journey to complete the final enthronement rites. On this journey he must cross a wide river whose only means of crossing is a boat ferried by a wicked and dangerous boatman. In the course of this boat trip, both the prince and his young wife are killed. News travels back to the kingdom, and the second prince sets out on the same mission, where he and his wife meet a similar fate. When news of this most recent death reaches the kingdom, the youngest and remaining prince decides to seek advice through Fa geomancy to avert a similar death when he journeys to complete the enthronement rites for his own part. In the course of this geomancy session the sign Gbe-Guda appears and the prince is told to

dress his young wife as an old woman and to commission and clothe a statue to represent his wife as her youthful and attractive self. The geomancer also indicates that the prince should bring with him a caged dove.

When the prince and his wife attempt to cross the river for the enthronement ritual, they too are ferried to the middle of the river. Here the evil boatman indicates his intentions to violate the prince's wife. As the dove coos "Keep calm, keep calm," the boatman lasciviously attacks the beautifully carved and dressed statue representing the prince's young wife. While the boatman is molesting the statue, the royal couple are able to continue their voyage unharmed. The prince successfully completes the rites and becomes king. (Ayido 5.11.86)

In this way, through the wisdom of Fa, the young prince was able successfully to address a life-threatening adversity, not only saving his and his wife's lives, but also preserving his succession to the throne. The moral of the story, however, also has broader implications. Keep cool and calm when facing danger; sit back and let things run their course; have faith. This constitutes good advice in many life situations.

This sign, Gbe-Guda, also appeared in the context of a geomancy consultation I observed which had been arranged by a person who was troubled because his daughter was refusing a prearranged marriage, an action which the father felt would result in considerable financial and social difficulties for himself and his family. After narrating and explicating the above text, the geomancer (diviner) advised the father to acquire a sculpture and to dress it in a raffia cloth wrapper. After the client had made the appropriate offerings, the figure was to be positioned next to a river. When this was completed, the geomancer explained (5.1.86): "Now no one who sees your daughter will desire her. When she speaks, her voice will no longer please others. If she visits [her intended husband] it is he alone who will desire her. Only his words will sound good to her ears. One uses the raffia cloth so that she will look poor and unattractive to other suitors because raffia is the cloth that poor people wear."

Through this *kuɗiɔ-bociɔ* or death-exchanging sculpture, accordingly, a man troubled and even traumatized by the potential difficulties of a daughter acting against what he perceives to be his best interests and those of his family, projects his desires (and fears) into an art form which provides him in turn with a degree of cathartic relief. The variant problems addressed through figures of this genre, while not always life-threatening (as the name *kuɗiɔ* would suggest), often do relate in significant ways to tensions associated with fears, ill-fortune, and individual demise.

Bearing Life's Burdens: Swollen or Pregnant Bociɔ

Swollen or pregnancy works (*wutuji-bociɔ*, from *ji,* meaning "swelling," "engendering," "giving birth," or "creating") comprise another important genre of *bociɔ* sculptures[18] (figs. 128, 129, 121). These figures are characterized by their

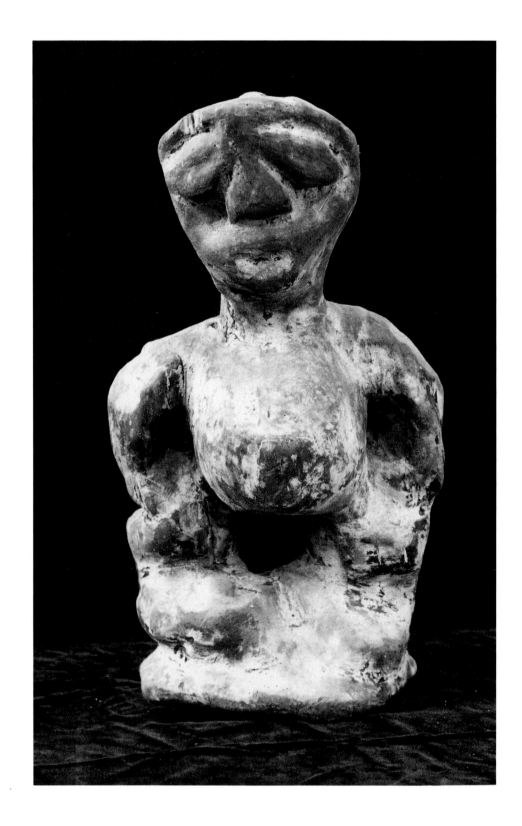

128. Ouatchi? figure. Togo. Wood, chalk. Height: 49.5 cm. Collected 1970s. Art Sherin and Sue Horsey. Photo: Jack Sherin.

129. Fon bound *bociɔ*. Abomey style. Republic of Benin. Wood with additive surface materials, including animal skulls, rope, and cloth. Height: 33 cm. Former collection of Ben Heller. Photo courtesy of Ben Heller.

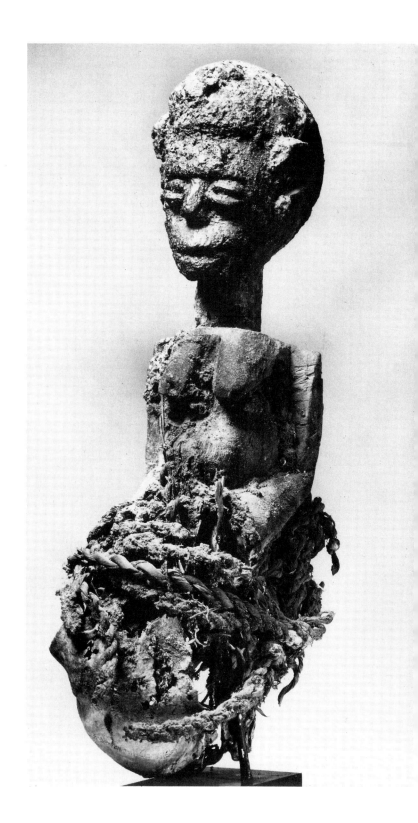

inclusion of variant bulges, humps, or mounds of empowering materials secured to diverse parts of the body. Called sometimes *nyandohwe*, "pregnant woman of the house" (Savary 1971:4), such sculptures most often display these protrusions on the stomach and back. As Savary explains (1971:4), "the hump on the stomach recalls pregnancy and the burden on the back is identified with a child later carried by the mother." While alluding to childbearing, works of this genre, like those of other genres discussed below, additionally are rich in psychological meaning. Body swellings are identified not only with infections, disease, and death, but also with emotional stress. The term *wutuji*, "swelling of the body," is employed accordingly to "designate the shivering . . . the swelling of the pores that provoke respect, dread, and fear" (Guédou 1985:314). Language reinforces this idea. The Fon word *ji*, "to swell," is also the root for such terms as *jijɔ*, "character"; *jijro*, "desire," "wish," "ambition"; *jidotɔ*, "confidence"; *jididɔ*, "longevity," "accusation"; *jijo*, "restitution"; and *jijodo*, "abandon."

The word for pregnancy, *ɖo ho (ɖo xo)*, "to be with stomach," or *ho (xo) huenu*, "time of the stomach," also offers insight into works of this genre since in these sculptures special visual emphasis often is given to the stomach area. As we saw in chapter 4 the word stomach (*ho, xo*) is the root for many terms identified with the emotions. Other provocative stomach-associated words include: *ho*, "to hit," "to chastise," "to dirty oneself"; *hon kan* (literally, "stomach cord"), employed sometimes to mean "troublesome"; *ho kpon* (literally, "to look at the stomach"), designating generally "to hesitate" or "to wait it out"; and *ho lo* ("infraction of the stomach"), signifying "infamy."

As with the stomach, the emphasis in "swollen *bociɔ*" on the mounding of materials on the back also is an important part of their conceptualization and meaning. Because the back often is linked to immobility and antisocial acts, this body area is identified with emotions left unresolved. Many of the swollen-*bociɔ* figures are identified with sorcery acts or protection thereof. Savary suggests (1971:4) accordingly that the various humps, bumps, and surface swellings found on works of this genre indicate their "ability to receive and send malevolence." Sculptures of this type, he adds (1976:241), "permit one to avoid or communicate malevolence at a distance." Such swellings convey through visual metaphor the difficulties associated with one who carries the added weight of psychological burden (*agban*). Works of this genre for this reason sometimes are referred to as *agbandjayi*, "the burden has fallen (been removed)."[19] The association of body swellings with such contradictory concerns as disease, infection, malevolence, sorcery burdens, and death, on the one hand, and birth, regeneration, motherhood, creativity, and gifts, on the other, clearly adds to the psychological tension that these objects elicit. Equally important, works of this type draw considerable emotional power from the fact that their surfaces have dense, opaque protrusions of rare, powerful, and "secret" materials which, when activated can affect the world in significant ways.

Two Heads are Better Than One: Deformity Sculptures

Deformity sculptures (*bociɔ-bigble; bigble* meaning "completely malformed") also constitute a distinct genre of *bociɔ*. The visual and emotional power of these objects rests on their multiplication or deprivation of key body parts. While some such figures show missing legs or arms (figs. 130, 31), by far the most common works are those incorporating two heads, faces, or bodies (figs. 131, 96, 98). Called variously "owner of two heads" (*tawenon*), "owner of four eyes" (*nukun ene non*), or "eye in front, eye in back" (*nukun do gudo nukun do nukon*), multiheaded sculptures draw on the potent expressive qualities accorded deformity or preternatural forms and features generally. In some such works, facial features are carved on both the front and back; in others two or more heads are positioned on a single pair of shoulders; in still others a single pair of legs and hips supports two torsos. An early description of a Janus object in southern Danhomɛ is provided by Répin (1863:78):

It was double, male and female, of natural height and sitting with its legs crossed like certain Chinese or Indian divinities. The two busts, carved in the same block of wood, were united, like Siamese twins, by the side, each having its eyes and members distinct. The female idol, emblem no doubt of fecundity, wore a triple row of breasts of ancient Cybele. These two divinities were decorated with bracelets and collars of glass beads and coral, offerings of their worshipers, surmounted with small vases of red earth, still one half full of palm oil with a carbon wick, attesting to a making of fire for them.

Questions of psychological and social difference often are addressed through aberrant visual imagery of this sort. As Brand suggests (1978: 337), for the Fon "monstrosity is a sign of the unruliness of society and often a lack of respect for the law." [20]

In these figures, as in other genres, emphasis also is given to related expressions of tension and danger. In discussing a sculpture characterized by the positioning of two heads side by side on the same neck, Sagbadju noted (7.1.86), "The heads that are side by side, if you arrive and see such a work, you will be frightened and will want to escape." Sculptures identified with this genre accordingly often are employed as guardian figures to protect the house, compound, temple, or city. Janus *bociɔ*, because they are associated with two-directional sight, play an important role in safeguarding residents from evil regardless of its directional source. The perceived ability of multiheaded works to observe activity both inside and outside the compound is of considerable interest in this regard, for sorcery sometimes is identified with discord within the family.

An additional factor of psychological significance in such works is their frequent identification with ideas of sexual conflation. Discussing one such figure, Sagbadju observed (7.3.86), "It is both male and female, for it has a vagina on one side and a penis on the other. If the man uses it, it will work for him; if the

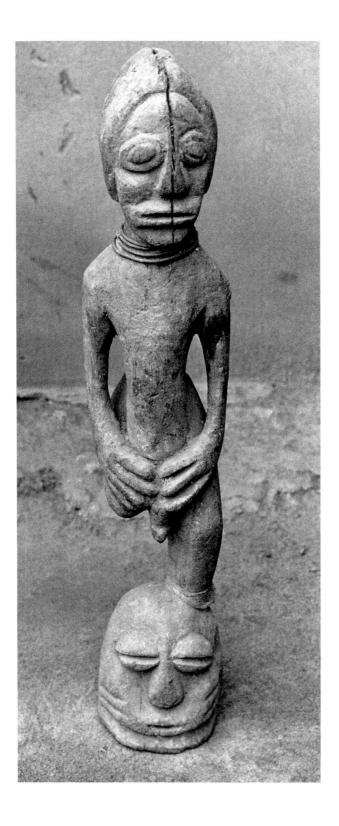

130. Fon deformity *bociɔ* in the form of a one-legged male figure. Abomey, Republic of Benin. Called *zumenu,* "thing of the forest," in reference to *abiku,* or children who die soon after birth. Money is offered to the work to prevent young children from dying, as well as to encourage successful trade for market women, and to prevent nightmares and talking in one's sleep. The head on which the figure's foot is planted has Nago (Yoruba) facial marks because the artist's family is Nago. Carved by Sagbadju, d. 1980s. Photograph: Suzanne Preston Blier. August 1, 1986.

131. Ouatchi? figural pair, Togo. Wood, cloth, cowries, pigment. Height: female, 70 cm; male, 63.5 cm. Both figures are surmounted by supplemental heads. The same artist carved figures 7 and 117. Collected in the 1970s. Art Sherin and Sue Horsey. Photograph: Jack Sherin.

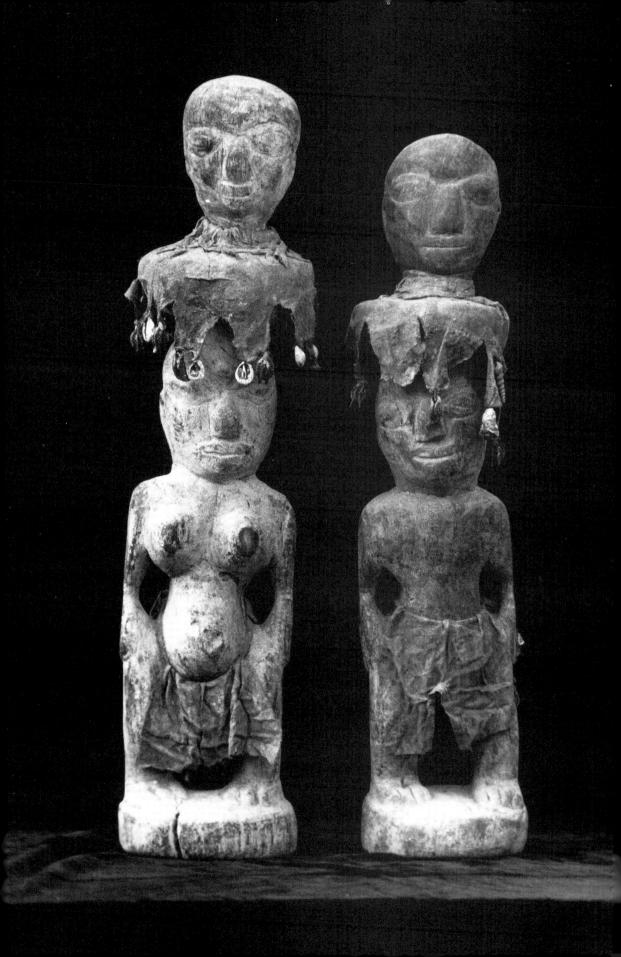

woman uses it, it will work for her." Remarking on another Janus figure, Glessougbe noted in turn (6.25.84) that "one asks the female side for things at night; one asks the male for things in the day." Here too, concepts of individuation and body part multiplication are grounded in important psychological and social concerns.

The sources of empowerment of deformity sculptures vary considerably. One such empowering force is the deity of geomancy, Fa, a god often described as having four eyes.[21] Janus works for this reason frequently are associated with particular Fa divination texts and draw on powers and features otherwise associated with the Fa-*bocɔ* genre. One sculpture I observed in Abomey which was characterized by the presence of four heads had an identity with four such signs. According to its owner (7.1.86):

It is called *wɛkɛ*, "world." . . . it has four heads so that if you are in the east it will look at you from there. In the west it also will watch over you—the same with south and north. It goes with the four first *du* [Fa divination signs]. . . . It is these *du* that have gathered around it. The east is Djo-Gbe, the west is Yeku-Meji, the south is Di-Meji, the north is Woli-Meji. With this work, what you thought in the morning by night you will have forgotten. If someone thinks poorly of me at night I will send this *bo* and the one who is thinking badly of me will begin feeling panic in his heart.

In the above, as we can see, physiognomic and spatial multiplicity are employed as a ground against which a range of emotions—insecurity, loneliness, fear, and panic among others—are visually addressed.

Deformity sculptures are identified with other external empowering forces as well. In the Be market in Lome in 1984, a seller of one Janus work said it was linked to Age, the god of the hunt. This sculpture was believed to be able to protect an individual from the anger of others (Mewu 7.7.84). The merchant identified another multipartite sculpture for sale at the same market, this one incorporating two figures attached at the back, with the empowerment forces of the twins' *vodun* (*hoho, hoxo*). Of this work he explained (7.7.84) that "if the child has bad dreams and one puts this in his room, things will change." Yet another sculpture, this one missing an arm and a leg, was identified by its seller with the forest-dwelling spirit powers known as *aziza*.[22] De Surgy notes similarly (1981a:145) that "like the trees that have but a single trunk, the statues which represent [*aziza*] have a single foot and arm, the left, [and sometimes are] half-masked under long hair." It is evident that Janus and related imagery carries with it important psychological values ranging from protection (and a wish to see both in front and in back at the same time), to projection, to the desire to control one's personal and social landscape through the fragmentation and replication of key body parts.

Important to the empowerment functions, signification, and psychological roles of these various deformity sculptures is the all-powerful solar god, Mawu, a deity who also is believed to have multiple heads and concomitant capabilities

of multieyed sight. As Ayido explains (4.26.86), Mawu has four eyes because "it is Mawu who commands things—bad things as well as good,"[23] suggesting here too that power is projected through ideas of body expansion. Janus imagery in this sense also can be seen to express concerns of divine sanction and retribution, values identified as well with works of the *vodun-bociɔ* genre which are empowered by similar sources.

Another means of sculptural activation associated with deformity works, particularly those objects linked in various ways with aggressively antisocial activities, is sorcery; many such works thus also form part of the sorcery-*bociɔ* genre. Like the omnipotent creative god, Mawu, sorcerers are believed to have the capabilities of four-eyed vision. As Ayido explains (4.25.86), associated *bociɔ* are called "eye in front, eye in back" [*nukun do gudo nukun do nukon*] and have four eyes because the sorcerers also have four eyes. Sorcerers look in this direction and in that direction at the same time. They observe things in front and in back." Rivière concurs with the above (1981:193). "Sorcerers," he writes, "are identified with double vision—four eyes—two in front and two in back, day and night." As with other works of this deformity genre, we can see here the conflation of ideas of body part replication with feelings of social and individual harm.

Political power (particularly royal) also is associated with multiheaded figuration. Although royal *bociɔ* are discussed in greater detail in the concluding chapter, it is important to note here that in the past, Danhomɛ kings are said to have owned a number of Janus and multiheaded sculptures. Still today it is strongly maintained that such works are associated with concepts of political empowerment. As Sagbadju notes (7.1.86), "Because the kings employed them in the past, today no one dares to use them. The kings placed them in a *bo* house [*bohɔ*] whose key was kept by the person whose role it was to watch over the king." The linking of royalty with four-eyed sculptures is of considerable importance, for like certain gods and witches, kings are believed to have the capabilities of supernatural sight. As with Fa, the god of geomancy, kings help to determine one's destiny; like Mawu, kings are associated with both the taking and giving of life; similar to sorcerers, rulers can metamorphose into animals, travel by mystical means at night, and destroy the lives of enemies. Multiheaded *bociɔ* of both commoners and kings in this way reinforce the provocative interconnections between art, power, and fantasy.

Penetrating the Surface of Desire: Pierced or Pegged Bociɔ

Bociɔ which incorporate features of piercing or pegging constitute another important sculptural genre. As Ayido explains (5.2.86), "This *bo* exists for everyone." Called generally *kpoɖohonmɛ*, "place the wood in the door" (*kpo*: stick; *do*: in; *honme*: entry),[24] sculptures of this genre are characterized by the cutting or piercing of holes in the figure's surface into which pegs, pins, or other objects of closure are inserted (fig. 132). This piercing process constitutes an important

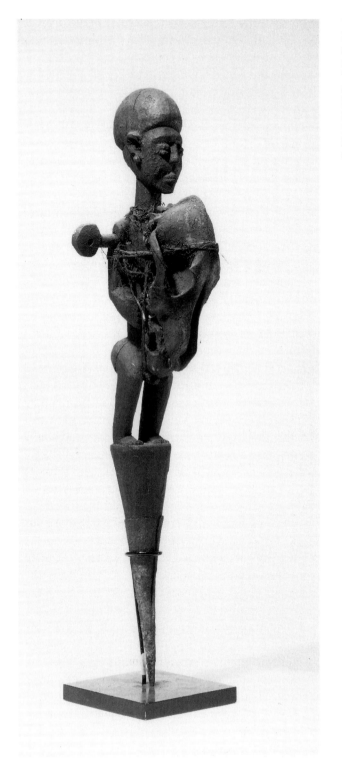

132. Fon *kpoɖohomɛ-bociɔ*. Republic of Benin. Wood, iron and multimedia surface materials. Height: 55.9 cm. Wooden key is inserted in the shoulder. A dog's skull is lashed to the stomach. Probably collected in the 1960s. Former collection of Ben Heller. Photograph: Courtesy of Sotheby's.

form of *bociɔ* suturing. Like other *bociɔ* genres, such works also convey ideas of striking psychological power, poignantly signaling what Foucault calls (1973:150) the dangers of the "penetrable" body. As Mary Douglas suggests (1969), transgression of the body is necessarily filled with danger.

Bociɔ figures associated with this genre, as their name and imagery reveal, also are linked in various ways to ideas of penetration, closure, internalization, containment, and barred access. Explaining the larger corpus of such sculptures, Sagbadju asserts (7.1.86), "It is like when one puts the key in the door and closes it so that you will not be able to open it." As with the locked door, so also with these *kpoɖohonmɛ-bociɔ,* he adds, "when one puts the peg in its chest or foot, the person will not be able to move or do anything."

Noteworthy in this regard is that the name *kpoɖohonmɛ* derives from early architectural practices in the area in which doors, gates, and other means of access were closed (and opened) by wooden logs or long sticks. Significantly, while the majority of works of the *kpoɖohonmɛ* genre are characterized by the presence of pegged or other penetrating elements, an important subset today includes those objects with padlocks (fig. 133) (a prevalent contemporary means of barring access). The latter works thus form part of a temporal continuum of *bociɔ* sculptures which address, through changing architectural metaphor, ideas of protection and penetration.

In all figures of this genre, the act of closure—whether through pegs, pins, or padlocks—also is seen to have ancillary associations with ideas of capture and containment. Ayido explains accordingly (5.5.86) that "people close the padlock and thus trap and kill the thing inside." Agbanon describes the function of these objects similarly (2.19.86): "If someone did something to you, and it really troubled you, you will call his name and close the padlock. Then you will make a knot and will take the padlock and put it in a duck's bill and all sorts of problems will happen to him. It is this that is called *kpoɖohonmɛ,* 'the stick is put in the door.'"

The association of closure, capture, and containment with the *kpoɖohonmɛ* works also is important in terms of their power to secure the spoken word. As Yemadje explains (6.23.84), "The peg is used to hold the words inside." Dewui describes the function of these works in comparable terms (7.3.86), in that "the peg represents something that one says. One speaks to this peg and closes the door with it—thus the pegs represent promises" (fig. 134). These works are believed to have the capability of activating or deactivating speech through the process of sculptural penetration. As with Kongo power figures, each peg signifies a particular idea or wish. Agbanon explains this function of *kpoɖohonmɛ-bociɔ* most clearly (3.7.86): "After you speak, you will close the hole with a small stick. When you put this stick in the door, the problem will be terminated."

Like pegs, padlocks also are described as objects through which desires are made firm or brought to fruition. Explaining one *bociɔ* which incorporated a padlock, Akpakun noted (2.18.86) that "if something is bothering you, one will

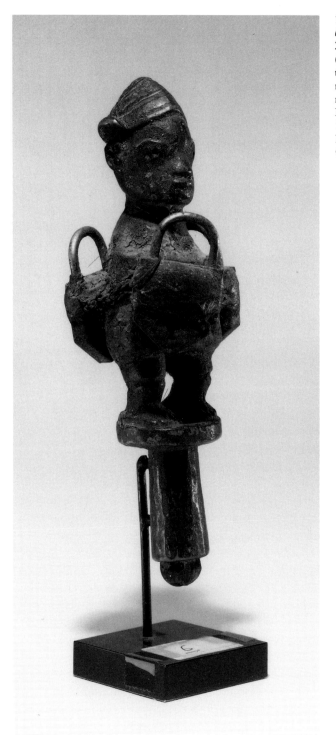

133. Agonli-style *kpoɖohomɛ-bociɔ*. Area of Cove: Zagnando, Republic of Benin. (Compare fig. 94). Wood with three iron padlocks and miscellaneous additive surface materials. Height: 21.6 cm. Probably collected in the 1960s. Former collection of Ben Heller. Photograph: Courtesy of Sotheby's.

134. Fon Legba shrine. Cana, Republic of Benin. Wooden pegs inserted into the ground in front indicate individual promises and desires. Note the dog inside the temple consuming the remains of offerings to this god. Photograph: Suzanne Preston Blier. February 20, 1986.

buy a padlock and come and close the lock." Dewui asserts similarly (7.3.86) that "one says the thing and closes the lock. . . . It is what one asks when closing the lock that [the *bociɔ*] will do. If the work is powerful it will be done." Associated action serves an important cathartic function. As Sagbadju observes (7.1.86): "If something bothers you, when you close the padlock, nothing more will bother you. . . . When I close it . . . if someone meets me, he will no longer frighten me." Each peg and each padlock, the above suggests, is identified with a distinct desire or fear (undesire) which the sculpture is assumed to help promote or negate. For this reason works of many other genres also incorporate piercing features. In addition, pegs and related piercing forms sometimes are inserted into the earth at certain temples, sacred trees, or shrine areas by persons desiring particular benefits or ends. When the wish is granted offerings are made.

Not surprisingly, through this sculptural means a range of psychologically potent concerns are expressed. Fear of failure and loss are among these. Of one *kpoɖohonmɛ* work Akpakun explains (2.18.86): "If you are a merchant, you will come and close a padlock, saying that you are not selling well. Afterward, you will begin to sell well. Or if you have problems at work, if your boss does

not like you, you also can come and close the padlock." By utilizing the images of penetration and closure, the therapeutic efficacy of these objects is reinforced.

They are, furthermore, similar to the death-exchanging, deformity, and pregnancy sculptures discussed above in that they are closely associated both with the expression of individual emotions (tension) and with the delimitation of specific desires. From this perspective, the number of piercing or closure elements incorporated into the surface is of considerable significance. Bociɔ with multiple pegs or padlocks are thought to be more potent than those with but a single closure. In works with several pegs, explains Dewui (7.3.86), "If one peg did not complete its work, one can open the other and the problem will end." If, in such figures, powders are placed in the hole before closure, the potential efficacy of this action is underscored.

The precise placement of particular piercing forms within the body also is essential, each locale having grounding in the distinctive emotional values attached to a given anatomical feature.[25] According to Ayido (5.2.86), "A work with a peg in the neck will do bad things; however, when the peg is in the chest and you ask for well-being, well-being will arrive." Discussing a sculpture with a peg in its chest, Sagbadju observed similarly that works of this type help to calm one. As he explains (7.1.86), "If your heart is pounding and you see [a maker of this type of object], your heart will become calm. You will not need to say anything more."

As one might predict, when pegs are placed in the head, associated works are meant to promote diverse and emotionally charged responses such as speechlessness, loss of memory, and lack of awareness (Savary 1976:241). Not surprisingly, in the thighs or buttocks such pegs are said to lead to immobility or incapacity of movement. Secured to the arms, Savary notes, the pegs serve to stop another's offensive action. When pegs are positioned in the stomach area, they convey emotions identified with anger, jealousy, and fear (to name but a few of the associations of this body part). Thus pegs, padlocks, and other piercing means serve visually to underscore primary emotional concerns by locating and penetrating anatomical features which are rich in psychologically grounded, symbolic content.

Sculptures of this genre, as we have seen, constitute a distinctive grouping of works characterized by a shared emphasis on piercing, puncture, penetration, and closure, features also addressed in the active use of related sculptural forms. Moreover the act of closing or locking objects of this type is critical to their functioning, because of each individual's personal participation in the closure process. Dominant architectural metaphors of transition and barred passage play a significant role in pegged-bociɔ meaning as well, since transition from a difficult or unacceptable situation is believed to be promoted or stopped through the active intervention of sculptures of this type.

Ties That Bind: Bound or Bondage Bociɔ

Sculptures whose surfaces have been bound tightly with cord, cloth, fur, chains, vines, or other wrapping materials comprise the largest of the *bociɔ* genres (fig. 135). These sculptures (called generally *bla-bociɔ* in Fon, and *sesao* in Evhe)[26] are also in many respects the most prototypical, for as discussed in other chapters, not only does part of their empowerment come from actions of tieing and knotting,[27] but variant cord suturing forms also are central to their overall functioning and meaning. With any corpus of works whose salient formal qualities are defined so closely by expressions of bondage, there can be little doubt of their psychological primacy and power.[28] In such figures, binding materials drawn tightly around particular body parts serve both to attach meaning (desire, pain, energy) and to heighten (and dissipate) associated tension.[29]

Throughout the geographical area studied here, bondage forms in life and art are identified with a range of emotionally charged ideas. One of the most powerful is death. Regarding one Togolese work of this type, Spiess notes (1902:316) that "the person bound to this [*bo*] will die." This linking of bondage (tieing) imagery with death is grounded in part in the local practice of binding corpses before burial. The cord used in such contexts is called *adɔblakan* ("cord to bind the stomach"),[30] primarily because the most frequent place of *bociɔ* figural bondage is the stomach. As we have seen, this term underscores as well the extent to which the stomach is considered to be a principal locus of the emotions. Used *adɔblakan* cord[31] is for this reason frequently tied around the waists of sculptures of this genre, especially works intended to overcome problems related to death.

Actions and objects of bondage also have clear-cut political associations in this area. As noted earlier, the term for "slave" (a class of persons identified primarily as war prisoners; today the term also is used to mean servant) is *kannu-mon* (*kannunmon*), "the one who remains in cords." Works identified with the larger bondage-*bociɔ* genre similarly evoke ideas of imprisonment, impotence, and personal pain, all of which—like slavery—are powerfully suggested by situations of bondage and acts of binding. It is important also to look at Fon traditions of war bondage. In the past, following battle, the Fon war general Gaou was tied tightly with rope and chain as he returned from battle—even when the Danhomɛ forces were victorious. As Ahanhanzo Glélé explains (1974:132), "It is in this position of being attached, weighed down with rope and iron . . . that he had to give the outcome of the campaign, cite the facts concerning the war and exhibit the trophies. Only then could the king untie him." This ritual (which visually recalls many *bociɔ* forms) suggests that for Gaou, the battle (*blasɛ*, "bound destiny") was not officially over, the threat of death had not yet been removed, until this leader was cut from his bonds.[32] Through visual and linguistic bondage metaphors, variant restraints placed on one's life (even as regards one's professional obligations) similarly are addressed in *bla-bociɔ*. Bondage sculp-

tures of this type are identified not only with life's battles, but also with the constraints on general well-being.

Illness and suffering also are associated closely with images of bodies constrained through bondage. Language underscores this linkage. As noted above, the Fon word for "battle," *blasɛ*, means "bound (bondage) destiny." The term for "pitiable thing," *nublawu*, translates literally as "the body is bound with

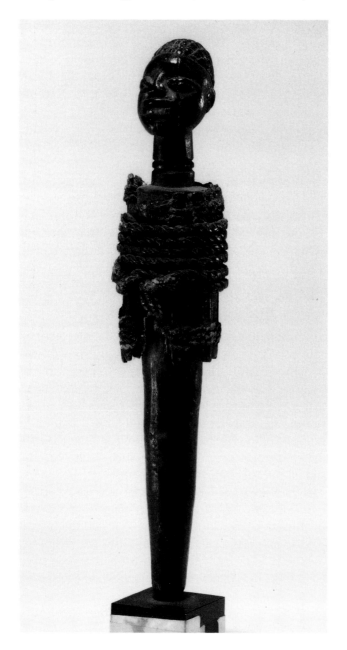

135. Gun-style bound *bociɔ*. Area of Cove-Zagnanado, Republic of Benin. Wood, cord. Height: 16.2 cm. Probably collected in the 1960s. Former collection of Ben Heller. Photograph: Courtesy of Sotheby's.

something." The verb "to bind" or "to attach," Kossou explains (1983:247), "is used . . . to convey immovability . . . [and thus] the process that leads to death." Language in this way offers critical insight into bondage-*bociɔ* sculptural meaning.

Bondage imagery and actions are compared with mental illness in important ways as well. People suffering from serious psychological disorders often distinguish themselves from others in the society by tying masses of cord or cloth around their various body parts (fig. 136). To some extent such individuals, whose suffering and illnesses are often attributed to the effects of dangerous *bo*, suggest the image of a living *bociɔ*. The linkage drawn here between bondage and insanity is important additionally because these sculptures often are said to act in ways evocative of mental illness. In the words of Sagbadju (7.1.86), "If the *bo* is not like an insane person, it could not do the work one asks of it." Bondage terminology frequently is employed when speaking of life-threatening problems caused by agents—sorcerers among others—who lie outside one's control. As Ayido has observed in his discussions of the nature of sorcery (5.5.86), "When witches want to kill people they encircle them with ropes."

In the context of situations of personal difficulty, the action and imagery of bondage may suggest a range of problems. The following is an interchange recorded at a *vodun* offering ceremony in a town outside Bohicon (4.28.86), in which a rope serves as a metaphor for individual constraint.

Diviner: The *vodun* are the ones who tied you up.
Patient: I am always in ropes. Will these *vodun* untie me?
Diviner: They say that if death attacks you and sickness attacks you . . . Fa [the god of divination] will cut the rope for you. He is the one who cuts the rope on the road of death. He says he will cut the ropes for you. Death will no longer tie you up. Sickness will no longer tie you up. Dispute will no longer tie you up. It is he [Fa] that cuts the rope for one on the road of death.

In the above we see a clear linking of bondage ideation with such personal traumas as sickness, dispute, and death.

Restraint, enslavement, lack of freedom, pity, constraint, battle, illness, suffering, death—these are but a few of the concerns and emotions that works of the bound-*bociɔ* genre convey through visual emphasis on binding and bondage. These works elicit with striking poignancy the range and degree of psychological tension and stress that the individuals who commission and employ such objects are undergoing. Since such sculptures primarily portray the features of their users—while at the same time incorporating attributes which address the aims, actions, and orientations of persons or powers which would harm one—these works present a striking visual depiction of both psychological distress and empowerment.

In accordance with this dualistic emphasis, strongly positive values also are associated in important ways with bondage themes in this area. In the case of

the Fon war minister, we saw how bondage serves to underscore a relationship of obligation and dependence between two people. In other contexts, bondage symbolism is closely identified with family tradition. Life, mastery, culture, home, security, and protection are linked to bondage actions and ideas as well.

Adding to the textual richness of each such bondage-*bociɔ* are the particular body locales selected for binding features. As Cudjoe explains of one work used in the context of illness (1969:63), "The areas of the figure which correspond to those parts of the body where the sick person is experiencing pain are bound up with cloth which has been soaked in chicken blood." Discussing another sculpture, Dewui commented similarly (7.3.86) that "one attaches the thing [and] . . . all the problems that this person has, these things will end." Stomach, chest, arms, and head are the principal areas of *bociɔ* bondage; each such part in turn

136. Togolese man suffering from psychological disorder. Photographer: Gert Chesi.

is identified with important emotional concerns which affect the meaning of associated bound *bociɔ*. Sometimes ambivalent in orientation, always provocative, emotionally charged, and replete with tension, these works reveal much about the role of bondage *bociɔ* in the context of key social and psychological issues.

Geomancy Bociɔ: Art and the Power of Divination

Figures whose formal features are grounded in the particular signs and powers of Fa geomancy (divination) comprise another important sculptural genre. These works, which are called Fa-*bociɔ* (Fo, Fa-*bo*), take a wide variety of forms but, unlike those genres discussed above (including the Fa-associated death-exchanging *bociɔ*, or *kuɖiɔ-bociɔ*), Fa-*bociɔ* share in common few if any formal features. In such works, surface matter is selected in accordance with specific Fa signs, but often is applied in ways characteristic of other genres, including the use of cords, pegs, pins, padlocks, swellings, and surfeit body attributes.[33] As an indicator of their distinctive Fa activation source, *yɛ* dust taken from the Fa divination board is sprinkled over the surface of the object to signal the work's association with a particular divination sign (*du*). This powder, which also is used to empower objects of the *kuɖiɔ-bociɔ* genre, becomes an invisible signifier; although it soon dissipates, it remains a marker of Fa power and potential. The diviner Dewui explained the empowerment role of this power in works of the Fa-*bociɔ* genre as follows (7.3.86): "I look at what one wants the sculpture to do, and I look at the Fa sign that does this work. Then I will draw the sign on the Fa board and place it on the figure and will give to it whatever this sign eats. It is through this means that the sign will be made to inhabit the work."

The making of Fa-*bociɔ* sculptures often is complex, for as noted above, both essential features and additive surface matter are linked to specific geomancy legends and proverbs.[34] Describing one such work identified with Yeku-Meji, a sign closely associated with death, the diviner Ayido asserted (5.5.86) during the consultation, "I now will ask you for a statue. . . . I then will take a black cloth that was paid for with money of another person and will tear up this cloth and will dress the statue with it. Then I will take the other things—the seeds and cowries—and will dress the statue with them. This I do because your *vodun* is complaining and saying that 'my person will die.'" Each Fa sign in this way is associated with distinctive sculptural attributes. One Fa-*bociɔ* shrine which I observed in the family compound of a diviner conveys some idea of their variety. In this shrine (fig. 137), whose walls were painted with the single and double-line marks of the diverse Fa signs (*du*), were found five works: (1) a multiheaded sculpture associated with the sign Djo-Gbe; (2) a sculpture with a large phallus linked to the sign Guda-Fu and its sponsoring god, Legba; (3) a sculpture in rudimentary human form identified with the *vodun* Dan; (4) a figure covered with pins which was associated with the sign Guda-Wlen; and (5) a work based on the sign Guda-Sa comprised of a figure dressed in a funeral cloth and carrying

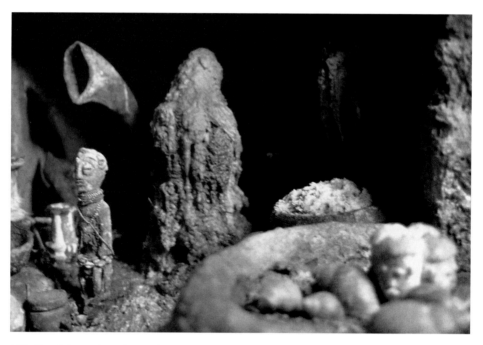

137. Fon shrine with Fa-*bocɔ*. Abomey, Republic of Benin. Photograph: Suzanne Preston Blier.
July 2, 1986.

a pipe and tobacco bag. These latter features were said to suggest poverty and
the dead (*kulitɔ*). As is clear in the above, these sculptures derive their power
(and imagery) not only from Fa, but also from the *vodun*. In this regard they
also are linked in important ways to works of the *vodun-bocɔ* genre.

While figures identified with the Fa-*bocɔ* corpus are diverse and generally
devoid of distinguishing formal genre attributes, a subset of this genre incorpo-
rates small calabash chips, some of which have been inscribed with the linear
markings of the Fa *du* signs (figs. 138, 139). Of one such object which included
a number of these calabash pieces around its neck, the geomancer Dewui noted
(7.3.86), "This is a sculpture that is a Fa-*bocɔ*. When one wants to do something
[in life] one stands it up." Sagbadju noted (7.1.86) that works of this type often
incorporate four, eight, or sixteen such calabash pieces, usually each marked
with one of the Fa geomancy signs.

As with *bocɔ* use generally, these calabash signifiers bring to each figure an
element of psychological empowerment. As Ayido explains (5.2.86), "The one
who made it, he alone knows the sign that belongs to the person. . . . If he has
these signs on his sculpture, even if he is in the process of doing bad things in
life, nothing more will reach him." In contrast, when a calabash fragment turns
up in the sack of Fa divination objects, it serves to represent poverty, loss of
money, accidents, or danger brought on by Legba (Maupoil 1981:205). Calabash

138. Fon *bociɔ*. Female figure.
Republic of Benin. Wood,
calabash pieces, iron, cord,
dog skull, and miscellaneous
additive materials. Height: 37
cm. Probably collected in the
1960s. Former collection of
Ben Heller. Current collection
of Don H. Nelson.
Photograph: Jerry Thompson.
Photo courtesy of the Museum
for African Art.

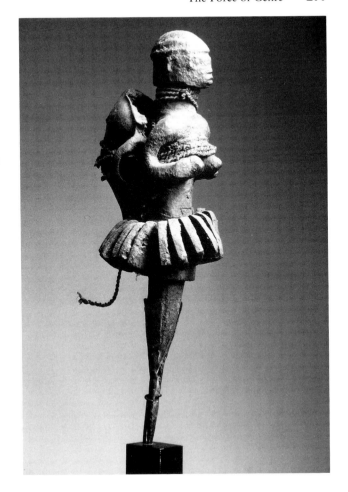

pieces in this way appear to be identified at once with personal difficulty and
with the potential of problem resolution through Fa.

Although works incorporating calabash fragments inscribed with geomancy
signs can be owned and used by anyone, they are frequently the special property
of the diviners themselves. Explaining one such sculpture from whose neck were
suspended a number of calabash pieces, Ayido noted (5.2.86), "This is for the
bokɔnon diviner. He is in the process of saying 'It is I the *bokɔnon* who is doing
things.'" The psychological impetus for these and other Fa-*bociɔ* sculptures is
linked to beliefs about destiny and the assurance that particular responses or
effects will result from particular actions. One Fa-*bociɔ* sculpture consisting of
a horn to which a number of incised calabash pieces were attached was described
by Dewui as follows (7.3.86): "This work incorporates the signs. On the cala-
bash pieces one will write all the major signs—the mother [principal] signs and
also some derivations. Then one kills the requisite animals for the sculpture and

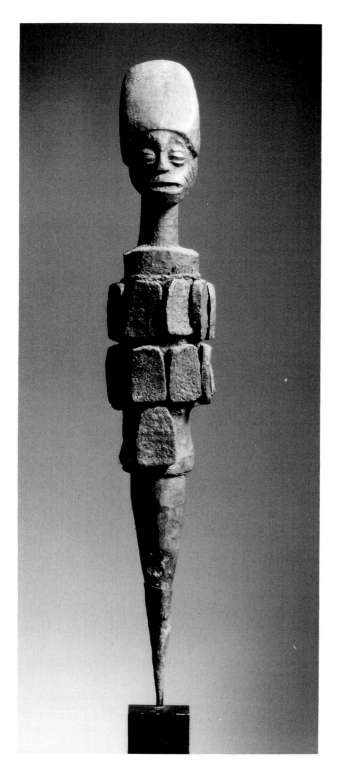

139. Fon *bociɔ*. Republic of
Benin. Wood, calabash pieces,
iron. Height: 51 cm. Probably
collected in the 1960s. Former
collection of Ben Heller.
Current collection of Don H.
Nelson. Photograph: Jerry
Thompson. Photo courtesy of
the Museum for African Art.

places alcohol on it. Through this action, one is feeding the geomancy signs. The way this works is that if you want to do something you will stand it up and pour alcohol in it. In consuming this drink the power of the signs will pass to you." Like other *boci* works, Fa-*boci* provide in this way an important impetus for action, an idea underscored by the fact that sometimes the wooden tappers used to gain the attention of the deity in Fa divination are transformed into *bo*. Knowing that related endeavors find support within the local geomancy system (indeed within destiny itself) affords associated individuals an important psychological ground from which to confront the variant problems or traumas that affect their lives.

Sculptures Empowered by the Gods: Vodun-boci

Another distinctive sculptural genre defined through shared empowerment features comprises those objects whose underlying imagery and orientations have grounding in the *vodun*.[35] An aphorism cited by Herskovits (1967, 2:256) is of interest with respect to these works: "Without *gbo* [*bo, boci*], the gods cannot cure." As Rivière explains for the Evhe (1979b:201), "The *vodu* themselves are materialized by a support of magical objects . . . that one calls *ebo* of the *vodu*." The unique powers of these gods in other words are brought into play in the corpus of associated sculptures. To Savary (1971:3):

Vodun give to Dahomé magic their specific activity. Dan, the rainbow serpent who fashioned the mountains of earth, has the ability to "loose" his victims (he renders them crazy). Gu . . . , master of metal and war, is the *vodun* that is characteristically violent. . . . Toxosu are the aquatic divinities presiding over the fecundity of humans and animals. . . . Other great *vodun* like Sakpata [the Earth and smallpox God] and Xebioso [God of lightning] also participate because their vengeful power is used to strike the imagination, the first in inflicting illness of an epidemic character, . . . the second through attacking the victims in different ways with lightning.

Herskovits also makes insightful observations (1967, 2:259–60) on the relationship between *vodun* and *bo*. As he notes, "Supernatural beings have a knowledge of *gbo*. Thus, Da [Dan] is regarded as a giver of *gbo*, and one of the reasons why he is believed to be able to give wealth to a man is because he possesses *gbo* which insure success. Sagbatá is said to have 'so many *gbo* that a person cannot call the names of all of them' . . . So important, indeed, are *gbo* that no cult practices for any of the gods are carried on without their aid." Each *vodun*, as Savary suggests (1971), is identified with distinctive identities and powers, many of which are of importance to the psychological functioning of sculptures of the *vodun-boci* genre. In the words of de Surgy (1981a:19), "*Vodu* practices concentrate psychic energy on material compositions." For this reason, earth from the particular deity temples sometimes is secured in cloth containers which are attached to the surface of the work as a means of *vodun* empowerment.

Although *vodun-bociɔ* (like Fa-*bociɔ*) vary considerably in form[36] and often incorporate bulging, piercing, or bondage features of other genres, those sculptures identified with this genre sometimes are distinguished by their inclusion of cowries both as ornamental chains and as decoration for the eyes.[37] According to Ayido (5.11.86), this latter feature "represents the *yɛ* (spirit) of the *vodun*." He adds: "When we represent the *vodun* we take cowries for the eyes. We know that it is a white thing like cowries that resembles the white of the eye. . . . We know that even if they are not eyes, they will go to buy eyes from Mawu. It is with this that we ask Mawu to look with his eyes after his wives [priests] and children [devotees]." In a general sense sculptures which incorporate small pottery vessels also are identified as *vodun-bociɔ* because, as Sagbadju explains (8.2.86), "pottery does the things of *vodun*."

While cowries and pottery vessels make reference to *vodun* generally, in certain cases deity-specific elements also are included. Beads are important in this regard, for each deity is associated with particular colors and types of beads. Of one work associated with the serpentine wind and rainbow god, Dan, Ayido noted (5.5.86) that "it has Dan's beads around his neck, and cowries on his face." In addition to beads, a number of other sculptural features have *vodun* signifying roles as well, for example, images (or actual bodies) of chameleons or lizards often are found in works identified with Lisa (the god of heavenly light). Spotted surfaces or raffia skirts (the latter called *avlaya*) frequently distinguish the works of Sagbata, the earth (and smallpox) god (fig. 140). Shells and duck or frog features signify Tɔhɔsu, the deity of springs and rivers (fig. 141).

Sculptures associated with Hɛvioso (Xɛbioso, the god of lightning) for their part often hold or have attached to them small iron celts or axes (*sosiɔvi*) similar to those Hɛvioso is believed to send to earth when lightning strikes (Ayido 4.25.86) (fig. 1). As Herskovits notes (1967, 2:283), thunder axes are "actuated by the power of Xɛvioso gods. . . . If one puts this in his mouth and pronounces a wish it will come true the same day." Iron serpents called *dansɛ*, "*asɛn* of Dan," in turn sometimes are added to sculptures associated with or empowered by Dan (fig. 142). Of one such iron serpent, this one attached with a feather, Herskovits noted (1967, 2:282), the serpent form is used so that "all the chiefs [will] love me, . . . all men and women [will] love me."[38]

Other pieces of iron (especially those taking the form of weapons or tools) generally signify works associated with Gu (the god of iron, war, technology, and strength). Miniature hammers (*zu*), small iron swords (called *gusɛ*, "*asɛn* of Gu"),[39] tiny pincers (*gbekpe*), each are identified with this god. The small iron swords and pincers, suggests Herskovits (1967, 2:283), are intended "to drive away the evil in Gu." Whistles or miniature rifles in turn are identified with some sculptures of Age, the god of the hunt. As de Surgy suggests (1981a:169), "Age expresses himself by whistles."[40] Those works associated with *vodun* identified in some way with deceased family members (*kulitɔ*) instead frequently incorpo-

140. Gen sculpture. Aneho, Togo. Wood, cowrie shells, cloth, twine, twigs, and miscellaneous material. Height: 97 cm. Compare with figure 91. Collected by Preil in 1907. Linden Museum, Stuttgart. Cat. no. 48 991. Published in Cudjoe (1969: fig. 32). Spots of paint on the body indicate an association with the god of smallpox. The marks on the cheeks are sometimes found in the lower Mono River area in association with priestesses.

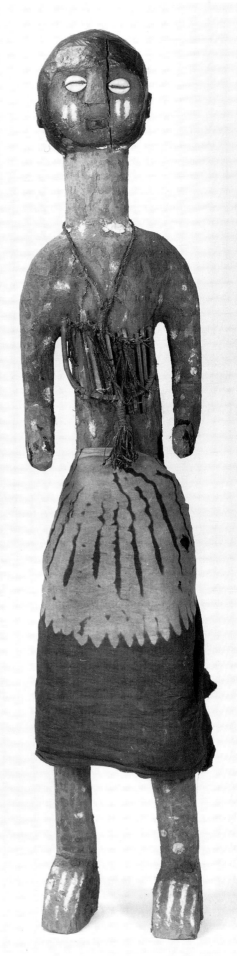

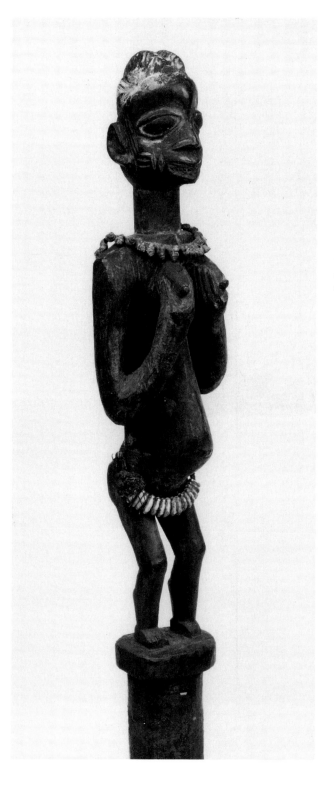

141. Gun-style female figure. Republic of Benin. Cord of cowries around hips; string of shells around neck. Height: 44 cm. Harn Museum of Art, University of Florida. Gift of Mr. and Mrs. Stephen A. Spear. 5–74–89. Face marks are characteristic of the lower Oueme River area around Porto-Novo.

142. Fon *bociɔ*. Republic of Benin. Wood, cord, iron, miscellaneous materials. Attached to the sculpture is a crocodile's skull and twin iron snakes. Probably collected in the 1960s. Former collection of Ben Heller. Photograph courtesy of Ben Heller.

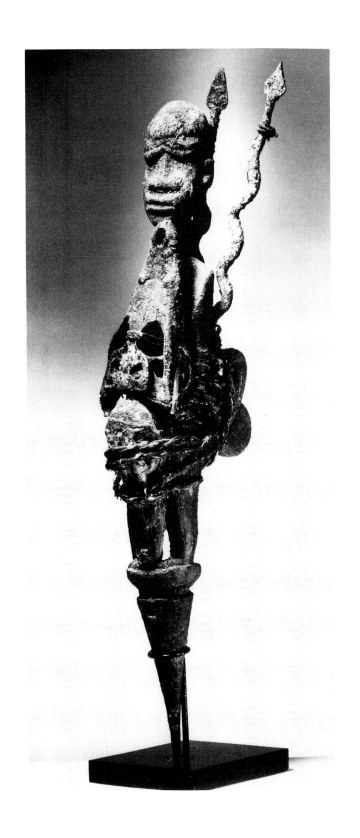

rate small *asɛn,* the umbrella-resembling altar of iron which serves as an ancestral memorial.

Minona, god of both childbirth and sorcery, also is associated with special *bociɔ* features. Certain works of this god include breasts made of large snail shells (fig. 21), while others have attributes otherwise characteristic of sorcery *bociɔ* (see below). On the role of Minona generally with regard to *bo* and *bociɔ* Herskovits explains (1967, 2:260):

Minona—"our mother Na"—is variously described as the mother of Mawu and Legba, as the sister of Legba, and as the mother of Fa. . . . She is the protecting deity of women, and every woman has a shrine to her at which this goddess is worshipped. She is given the first fruits to eat before human beings eat of them so that the fields may remain fertile. But she also occupies herself with the welfare of the makers of *gbo,* even the makers of evil *gbo,* so that sorcerers obtain from her their power to exercise black magic. [She is] . . . protectress of the makers of evil magic.

Legba, the trickster and messenger god whom many identify as Minona's male counterpart, is often characterized in sculptural form either by a prominent (generally erect) phallus or by the inclusion of additive dog parts.[41] In the Abomey area today, sculptural groups comprised of multiple figures positioned together in a basket also sometimes serve as offerings to village Legba shrines (see fig. 123). Ayido describes one such work as follows (5.2.86): "We take the sculptures for the women and children and put that in a basket. With this one does the *kuɖiɔ.* We put all the *bociɔ* in the basket and give them to Legba, and tell Legba, 'my wife and all my children have gathered together to do the *kuɖiɔ.'* "[42] Carved figures (often in female form) also frequently are found near altars to Legba and are identified as Legba's collaborators or wives (Beier 1958:29). These latter figures generally are small and without the additive surface materials that characterize other *vodun-bociɔ* (fig. 143).

Similar figures without the complex additive surface matter of most other *vodun-bociɔ* also are found in, on, or near many *vodun* temples (fig. 144). As their sometimes dark (palm oil or gruel-covered) but otherwise unencumbered surfaces suggest, these latter sculptures are the focus of ceremonies intended to feed (support, recompense) the *vodun.* Of one such sculpture Sagbadju noted (7.9.86), "It is a simple *bociɔ* used in ceremonies for Hɛvioso, Agasu, Sakpata. One goes there to give the *vodun* something to eat." Many *vodun-bociɔ* of this offering type are positioned next to temple entryways. There they are believed to guard the shrine and the families of associated priests and devotees. One figure placed beside the temple of Nana Buruku was described by Sagbadju accordingly as "the guardian. If someone wants to steal from there, this thing will frighten him and he will flee" (7.18.86). One example associated with the god Tɔhɔsu ("king of the spring") is described by Herskovits (1967, 2:280) as consisting of two figures, one male and the other female, each with a cavity in the navel and

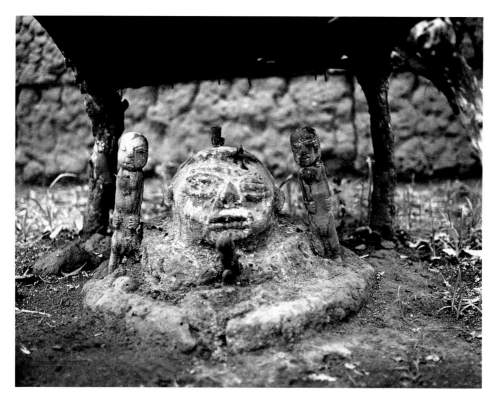

143. Aja Legba shrine with carvings representing Legba's "wives." Sinwe area, Republic of Benin.
Photograph: Suzanne Preston Blier. March 16, 1986.

head through which they are fed. These objects, Herskovits notes, are positioned
in front of the house as guardians and as protectors against thieves.

The above *vodun-bociɔ* offering sculptures also frequently are used both to
commemorate deceased *vodun* priests and to situate and focus the powers of
such individuals. As Ayido explains one of these figures (4.25.86), "This sculp-
ture represents the *vodun* priest and stays beside the *vodun*. When one wants to
do ceremonies, one gives food to the sculpture and one says 'You are the priest.
No matter what you are doing, no bad thing can happen any more.' Those who
have already done it and are already dead, their places are there [in the sculp-
tures] and one guards the place for them." [43] Often it is said that when one makes
a *bociɔ* of this type, one does so in order to "bind" its head (*gbla ta*), a reference
to the white cloths tied around the crowns of priests as a mark of their position
and sacramental role in the society. Accordingly, a number of these sculptures
are displayed with a cloth-bound head (Ayido 4.25.86).

Yet another grouping of works identified with the *vodun-bociɔ* genre are em-
ployed in *vodun*-empowered (and generally not Fa-related) geomancy consulta-
tions. These objects often serve as a medium through which recommendations
regarding courses of action take place. Sculptures of this type frequently are used

144. Fon *bociɔ* roof finial on the Kpo-*vodun* temple. Abomey area, Republic of Benin. Photograph: Suzanne Preston Blier. January 21, 1986.

to determine the cause of specific malevolent actions against an individual (theft for example) and then to punish the associated culprit.[44] Regarding one of these sculptures, Sagbadju explains (7.1.86) that "if someone wants to do you harm, Hɛvioso will beat up the person, or else Dan can take him on. . . . Because Hɛvioso is stronger than all others, if the thief does not return the thing, often it is Hɛvioso who will come and punish him." Of a sculpture of this type identified with the *vodun* Dan, it was explained by Sagbadju similarly that (7.1.86) "if you come to its house, this thing talks. It sees. If you stole something it will tell on you, saying, 'It is a tall person.' It is the priests [of Dan] who have this in their room. Not all the priests have this, only those who do geomancy with the *vodun*."[45]

As varied as the works associated with the larger *vodun-bociɔ* genre are with respect to form, function, and sources of empowerment, these figures all share important emotional concerns with regard to issues of vulnerability, viability, efficacy, and control. In the same way that Fa-*bociɔ* draw on the assumed force

of destiny and divination, these works, because they are grounded in beliefs of divine sanctity and supernatural power, encourage one to have faith in deity response and intervention and to project related feelings onto the functioning of associated objects. This factor of belief is important, in turn, to the psychodynamic roles assumed by sculptures of this type.

Sorcery and Antisorcery Sculptures: Consuming Desires

Sorcery *bociↄ* (fig. 145) constitute one of the most feared yet most esteemed of the variant figural genres, since these works are believed both to be able to protect one from the malevolent effects of sorcery and to promote a sorcerer's own, often malevolent ends.[46] Brand suggests (1981:24) that the power of sorcerers (*azetↄ, kennesi*) "needs a visible expression and must actualize itself in . . . diverse objects to which individuals attribute a power over human destiny." According to Quénum (1938:82), sorcery in many respects functions in ways analogous to *bo:* "*Aze* is like a superior *bo.* . . . There are *aze* to drown one's adversaries, *aze* to protect one's property." This factor of difference and destruction with regard to the powers of sorcery also is addressed in associated sculptural forms. De Surgy notes in this regard (1981a:273) that with *kennesi* sculptures "one obtains an ambiguous protection in pact with the sorcerers." Although many such works are employed to counter the effects of sorcery, the most dangerous ones are said to be made and owned by sorcerers able to use their power at the behest of others for both malevolent and benevolent ends. As Ayido explains (5.2.86), "One sees these things in the rooms of the sorcerer. . . . A sorcerer can enter into this thing and then come to your house." Agbanon suggests in like fashion that (3.7.86) because "the sorcerers do things to make one afraid . . . *bociↄ* fill their rooms."[47]

A number of psychological concerns expressed with regard to sorcery find visual translation within the corpus of sorcery *bociↄ*. While there are hardly any formal features which can be said to be distinctive of this genre as a whole, several dominant themes or traits stand out. As with works identified with the genre of swollen *bociↄ* (figs. 128, 129), sorcery sculptures frequently are characterized by a large stomach—in this case, partly a reference to the sorcerers' all-consuming natures. The link between stomachs (interiors) and sorcery is discussed in the divination texts of Sa-Meji, a sign having many sorcery references. "Sa makes the blood flow. All the *kennesi* expand over the earth thanks to it. It commands all the internal organs of the body" (Maupoil 1981:509). Some such works include small pieces or fragments of pottery, objects associated with poverty and destruction (Maupoil 1981:205). Additional visual references to sorcery occasionally found in this *bociↄ* genre include large mouths, prominent teeth, and knives. As Sagbadju suggests of one such sculpture (7.9.86), "As the mouth is wide open, it will take you to eat and will push the knife in your body. The

next day you will see that the knife passed into your body. When you begin to pass blood your parents will then hurry to consult Fa." Perhaps the most frequently discussed feature of both sorcery and antisorcery sculptures, however, is the inclusion of four eyes or two quite large eyes.[48] As noted above, a number of Janus or deformity sculptures are identified with the sorcery genre for this reason. Of one such Janus sculpture, it was noted, "those sculptures which are called 'owner of two heads' (*tawenon*) . . . send the sorcerer away because if the sorcerer arrives at the house and sees the person that has two heads, the sorcerer will flee" (Sagbadju 7.1.86). De Surgy describes another work of this type (1981b:100) as being "installed in the compound of *dzisa* diviners during the ceremonies at the end of initiation to protect them from the actions of sorcerers who were suspected of being able to see both in front and in back." Works of this type clearly allude to fears of sorcerers' superhuman powers of malevolence. As Ayido explains (4.26.86), the sorcerer's second pair of eyes are known as "the eyes that destroy" (*nukun nu hɛn gble tɔ*). These eyes, he adds, are there "because the sorcerer wants to do things in reverse."

In sculptural form and in life, perhaps the most feared power identified with sorcerers is that of transformation. Pazzi points out (1976:183) that "at the moment of profound sleep, one believes that the spirit of the sorcerer removes itself from the interior of the body and goes out (by the summit of the head) to act on its victims." Because certain animals and birds are believed to be used by sorcerers as agents of transformation, they frequently are added to these works as a means of empowering surface matter. Pazzi explains (1976:303) that "one believes that [sorcerers] have the power to act at a distance, in liberating their own spirit during sleep and in taking the form of the cat, vulture or owl." Other prominent sorcery-associated species include the bat, rat, mouse, hyena, mosquito, and fly, as well as the *kolele* bird (distinguished by its loud cry), and the *agbidi* bird (which consumes rats), all of which either are nocturnal or are known to attack humans.[49] As Agbanon explains (2.19.86), "All animals that eat humans are sorcerers."

Because pigs sometimes consume their young, and consequently are identified with sorcerers, their features too are incorporated into works of this genre[50] (fig. 146). One such sculpture featured the jawbone of a pig attached to a human-form figure. Ayido explained (5.5.86): "The sorcerers can transform into pigs; thus we took the chin of the pig and tied it to this object." Dewui and Agbanon, each discussing works incorporating a pig's jawbone, noted, "This will not be a good *bo*. It will be a *bo* that does harm" (7.3.86), and "If you take the pig jaw and put things on it, then if someone makes a *bo* against you, he will die" (7.3.86).

In the end, what makes works of this genre so provocative and potent is that they address concerns about misuse of power within the family and community, a type of abuse often associated with sorcery. As one diviner explaining the local concept of power to Bruno Gilli observed (1976:221), "Don't you see that large

animals eat little ones, large fish eat small fish? The same thing happens among humans. Some humans are more powerful and ferocious and eat smaller ones. It is the sorcerers who eat the others . . . Yet while sorcery is created by god, god also gave the means to combat it." *Bo* and *bociɔ* are identified by many as this means.

Besides its association with power abuse, sorcery is linked frequently to issues of otherness as expressed with regard to women as well as elders and strangers. Although both men and women are said to have sorcery capabilities, more often it is women who are accorded this power. To the degree that elders, strangers, childless people, the poor, or those who live alone are similarly disenfranchised, they too often are associated with sorcery capabilities and desires. Sagbadju notes (7.9.86) that usually "the person who possesses sorcery powers is old. Her breasts are old and her body is old." Not surprisingly, many sculptures identified with this genre are said to represent people (usually women) who are elderly, childless, or strangers to the family or community.

Word etymology offers us further insight into the complex emotional and social concerns identified with and addressed in works of the sorcery genre. As noted above, the root of *kennesi* ("sorcerer"), *ken*, signifies "malice," "grudge," and "rancor." *Ne* translates as "this" or "here is," and *si* means "spouse" or "wife." Taken together, *kennesi* is generally translated as "here is the spouse of rancor." This translation underscores the prevailing association of sorcery and related sculptures with gender discord, social dispute, and uncontrolled emotions (rancor) as well as with the psychological impact these have on the individual. *Aze*, another word for sorcerer, is employed in certain contexts to mean "spiteful" and "disorder." This term suggests a comparable concern with issues of resentment and social difficulty. Among the Evhe, sorcerers are referred to frequently as *dzo*, a word meaning "fire." According to Pazzi (1976:303), "One compares witchcraft to fire, the unstoppable forces of destruction." In each of these terms for sorcery, as well as in the associated genre of *bociɔ*, a connection is drawn between disenfranchisement, social or political discord, and fears of psychological revenge.

In concluding this chapter it is important to emphasize the ways in which sculptural genres offer insight into psychological issues addressed within the larger corpus of *bociɔ* works. Whether defined primarily by formal features or empowerment sources, these genres provide important clues as to both the reading of associated works, and the psychological and sociological dynamics that frame their artistic meaning. With death-exchanging *bociɔ* one finds expressed both fears of demise (death) and potent psychological issues of projection and substitution. Swollen-*bociɔ* works delimit through formal and functional means similarly divergent values ranging from reproduction and increase to putrification and demise. Deformed and Janus works point to equally provocative emotional qualities of enhanced or decreased sight and preparedness through features of amplification and diminution.

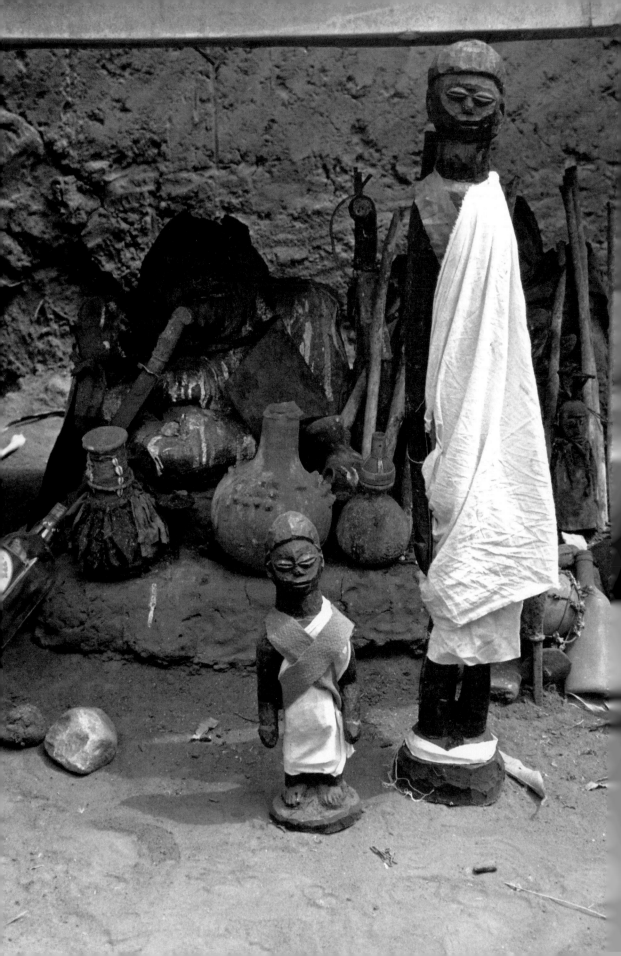

145. Fon *kennesi* shrine with associated sorcery *bociɔ*. Abomey area, Republic of Benin. Also note earthen anthropomorph, pots, and knives. Photograph: Suzanne Preston Blier. January 26, 1986.

146. Fon sorcery *bociɔ*. Republic of Benin. Wood with pig's jaw, twine, cowrie shell, and miscellaneous materials. Height: 14.6 cm. Probably collected in the 1960s. Former collection of Ben Heller. Photograph: Courtesy of Sotheby's.

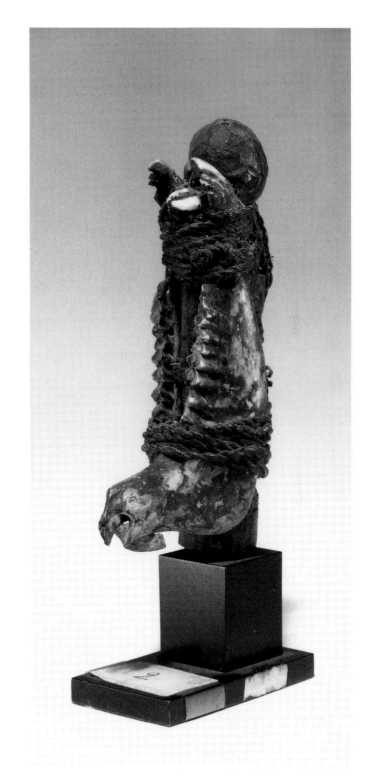

Pierced or pegged *boci* for their part convey critically powerful ideas about penetration, secrecy, and closure on the one hand and speech and empowerment on the other. Addressed within the larger corpus of bondage *boci* are variant concerns ranging from restraint, repression, imprisonment, and death, to life, family, mastery, culture, and well-being. Works of the Fa-*boci* genre, in turn, promote catharsis via underlying associations with destiny and life course. *Vodun-boci* build on ideas of religion and spiritual empowerment in achieving psychological relief. With sorcery *boci,* it is especially the fear of destruction through all-consuming revenge by disempowered individuals in the family and community which is conveyed. *Boci,* while less concerned with canon rigidity and hierarchy than many types of artistic genre, communicate ideas of tension and catharsis through variant genre categories and widespread forms of genre transgression and cross-currency.

Power, Art, and the Mysteries of Rule

"... the gallant monarch is in arms,
And like an eagle o'er his aery tow'rs,
To souse annoyance that comes near his nest."

—Shakespeare, *King John*, act 5, scene 2

"The rooster has a comb for purposes of intimidation"
(*Din e ɖo kokloasu ta lo, mɛ ble din wɛ*).

—Fon proverb

Scholars have long recognized the integral relationship between social status and artistic expression. "The stratification of every society is reflected in the stratification of its taste," Wellek and Warren have argued (1956:89). As Pierre Bourdieu explains (1984:6) "Taste classifies, and it classifies the classifier." The linkages between state hierarchy and the divergent artistic expressions of both policy makers and their subjects also can be seen to play a critical role in contexts of *bociɔ* manufacture and use. Like two challengers on opposite sides of a battlefield, kings and commoners each promoted their unique artistic agendas and identities through a variety of *bociɔ* arts.[1] In contrast to many traditions elsewhere in the world, however, commoner *bociɔ* are not to any degree derived from court art traditions, nor are the aesthetic values of the royal arts defined vis-à-vis the many commoner works. Both traditions in key respects remain autonomous, standing apart from and in contradistinction to each other, each typology at once confronting, contradicting, relativizing, and, in the end, revitalizing the other in carnivalesque reversal. Although the sculptural counternarratives or visual *vox populi* of those who have been politically disenfranchised in the state have been privileged within this study, the *bo* and *bociɔ* of royalty, the subject of the present chapter, raise equally provocative social, psychological, and art historical questions.

Danhomɛ royalty used various traditions of *bo* and *bociɔ* to confront issues of personal and political difficulty, promoting through this means both their own agendas and those of the state. In this chapter, my aim is to locate differences in textuality and taste in royal and commoner works and to show the variant signifying attributes expressed in each. I begin with an examination of royal authority and the ways that prerogatives of power are manifested in the use of empowered arts. Next I take up the *bo* attributes of individual kingly names and the latter's sculptural signifiers. The importance of *bo* empowerment in royal regalia (crowns, sandals, dress, scepters, coiffures, and furniture), palace decoration,

and landscaping also are explored. Finally I look at royal arts identified with war
and the range of emotional and political concerns which these works address.

The Aura and Art of Majesty

One of the most salient concerns of rulers the world over is that of sustaining an
aura of majesty and mystique.[2] This mysterious power conveys to royal leaders
variant qualities of danger and distance, without which such persons would be
little different from others in the realm. In Danhomɛ as elsewhere, the office of
the king imparted key attributes of difference and deference to its successive
occupants. The manner in which related mystique is promoted in royal art and
ritual is of considerable interest.

Critical to the processes of creating rulership mystique in the Danhomɛ king-
dom were local perceptions of royal empowered speech—a faculty which, as we
saw in chapter 2, also is closely identified with commoner *bo*. When a ruler
spoke, it was believed, his or her words were held to have ontological efficacy.
Everything that the king said, in other words, was believed to come to pass.

Like a *bo,* a ruler's words constituted real (in contrast to metaphoric or sym-
bolic) power. As Ayido explains (6.9.86): "In the past the king did not speak to
the people. He spoke, but he did not open his mouth to tell you what he wanted
to tell you. He never would tell you *okudeo,* 'Hello.' If he said that to you, you
would die, for *ku* [in *okudeo*] means death. You would die because his mouth is
prepared (*eɖa*).[3] He has a *bo* already in his mouth." Agbanon elaborated on this
idea (2.25.86): "If a tree is standing and the king tells the tree to die, it will die.
If he wants to go conquer a country and he says, 'Now my chiefs, I want you to
conquer such and such a country,' when they go there, there is no doubt but that
they will defeat that land." Because royal speech retained vital properties of *bo,*
this power gave to the king a constant sense of danger and distance.[4] The belief
that Danhomɛ rulers had related *bo* attributes is evidenced in the simple state-
ment by Nondichao (1.3.86): "The king does not worship the *vodun;* it is the
vodun who worship the king." The king, in other words, had a form of mysteri-
ous power that was comparable and in some ways superior to that of the gods.[5]

Another *bo*-related attribute associated with Danhomɛ kings was that of
metamorphosis—the ability to change oneself into another being. As Sagbadju
explains (7.9.86): "The *bo* reside with the king. If he wants he can transform
himself into a hyena. Or, he can transform himself into a mosquito in order to
look at the plan of your house. He can change into a fly, a bee, a mouse, an
elephant, or a lion. And if you are shooting at the king, the blows will not reach
him, for he will be fleeing across the land. When he transforms into a lion he
will be controlling the country."[6] This feature of animal metamorphosis, a trait
otherwise identified primarily with sorcerers (who, as discussed earlier, are
thought to be able to transform themselves into owls, cats, and other nocturnal
beings), served to set the kings and their *bo* identities further apart from ordinary

147. Bas-relief from the Palace of Huegbadja, Abomey, Republic of Benin, showing a fish and a basket-form cage, a pictograph of King Huegbadja's name ("the fish escaped the cage"). Photograph: Suzanne Preston Blier. July 28, 1986.

individuals. Through their ability to transform themselves into various insects, birds, and animals, the kings could travel freely both inside and outside the realm. Royal *bociɔ* arts helped to promote the kings' special powers of transformation.

Kings were identified with important *bo* powers not only with respect to qualities of actuated speech and metamorphosis but also vis-à-vis key features of individual identity.[7] Part of their personalized power was manifested in the *bo* names which they assumed.[8] That such names were referred to as "strong names" (*gni siensien*) reinforced the importance these royal monikers had as signifiers of kingly destiny and domination. Although not all the *bo* derivations of the Danhomɛ kings' names are known, oral accounts maintain that this tradition goes back to the state's founder, Huegbadja (ca. 1645–80), a ruler whose name (meaning "the fish that escaped the cage") is itself the term for an important *bo* (Ayido 6.15.86). As Dewui explains of the *bo* which is called *huegbadja* (7.3.86), "This is a protection that one makes and places either on the body or in one's pocket when one is traveling. With this *bo*, when one does something to you, the thing will not come to pass. This is made with a bone from the head of a mudfish because this fish does not go into any net." As a signifier of this ruler's name and *bo* powers, an image of a fish escaping a cage appears on his palace (fig. 147).

King Huegbadja's son, Agaja, the powerful, early eighteenth-century ruler (1708–40), similarly had a prominent *bo*-derived appellation. The Fa phrase which serves as the source for this monarch's strong name (*atin dja agadja, ma'g-*

non zo ɖo, "the multibranched log does not go into the fire" [one cannot nullify me]) is identified with a *bo* which protects one from unexpected danger (Lanwusi 6.16.86). Related images appear on memorial *asɛn* associated with this king. With King Agonglo (1789–97), similarly, there exists a striking correlation between royal strong name and the use of *bo.* As Agbanon explains (3.7.86), "The *bo* which this king made is called *agonglo.* He planted a ronier tree [*agon*] on this *bo.*" References to the ronier tree *bo* in this case too are found in Agonglo's divination sign, a phrase of which states "lightning will strike the oil palm tree (*de*) but will not touch the ronier tree (*agon*)," *so dje de bɔ agon glo* (see fig. 70). Because of the importance of King Agonglo's name *bo,* nuts collected from his ronier tree (which is still standing in this king's princely palace in Abomey) are prized for the making of *bo.* Since the word *agon* also means "pineapple" (a plant more easy to depict visually than the ronier),[9] images of pineapples appear prominently in bas-reliefs, appliqués, and *asɛn* memorial sculptures identified with King Agonglo, both as a gloss for his name and as a reference to his divination sign and royal *bo.*

The famous early nineteenth-century ruler King Guezo also had a strong name and associated arts with important *bo* identities.[10] As Adande explains (1976–77:143), when Guezo was still prince (and known as Gankpe), the guardian who "took care of [him] not only consulted Fa for him, but better yet, made him a charm whose formula was *gue di zo ma si gbe,* 'The *gue* [bird's tail] resembles fire, but it does not strike [burn] the forest.' This charm was supposed to turn events in his favor, and did. Upon his return, Gankpe was judged favorably by all in his bid for the throne. . . . Once king, in remembrance of the *bo* which permitted him to accede to the throne, he took the name *gue di zo ma si gbe.*" This same *gue* bird with its red, firey (*zo*) tail (hence the name Guezo) is identified with several types of *bo.* According to Agbanon (2.17.86), "It is made into a medicine used in pregnancy. Also, if one wants to do an important ceremony in one's family in order to assure that everyone will survive, one will make this *bo.*" Images of the *gue* bird appear prominently in Guezo's art. As with the frequent royal use of the color red (see below), so too here, it is clear that in the context of kings, *bo*-related power and imagery serve as visual signifiers of status and political difference.

In addition to a royal *bo* strong name, each king also had a distinctive Fa divination sign. For most kings, the royal strong name (*bo* signifier) and Fa sign were interrelated, the former being grounded in the latter. In conjunction with the above, a number of Fa-*bociɔ* sculptures were created in accordance with each king's divination sign. While such objects form part of the larger Fa-*bociɔ* genre, they contrast markedly with commoner Fa-*bociɔ* examples in both form and function. Not surprisingly, because one of the greatest threats to the king was defeat in war, many of the royal Fa-*bociɔ* were used on the field of battle. Accordingly, they are taken up in conjunction with other royal war *bociɔ* below.

Kings often manufactured for themselves a range of *bo* empowerment objects

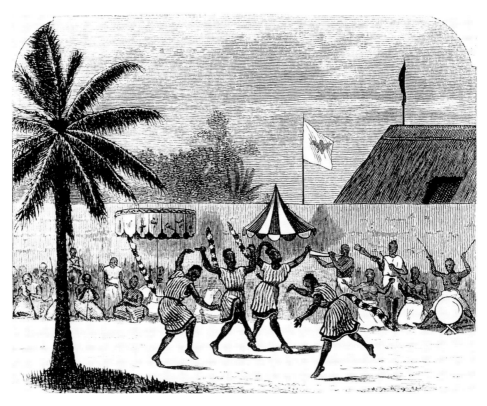

148. Royal "tail dancers" at the court of King Glele. Published by Skertchly (1874:264). Similar dancers, under the direction of Glele's grandson, Prince Agbidinukun at Sinwe, perform in the area today.

(among these Fa-*bociɔ*) which were used both for their own benefit and for that of their families and supporters.[11] As Agbidinukun explained (4.19.86), "When a king comes to the throne, he will make his own *bo*."[12] Each king also employed a group of specialist *bo* makers known as *kpamɛgan*, "chief of secrets" or "chief of the enclosure" (*gan*: chief; *kpamɛ*: secret, literally "inside the fence").[13] Although many royal *kpamɛgan* became famous for their *bo* and *bociɔ* creations,[14] undoubtedly the most celebrated were Zenhwen and Gblo, two men who came into prominence during the reign of King Tegbesu (1728–74). Several *bo*-related royal art forms are said to have been initiated by these men. One was a ram-horned mask (see Verger 1957: fig. 139; Blier 1991a) which appears during the processions of the once annual *huɛtanu* (or *xuɛtanu*, "thing at the head of the year") new year's rites (generally referred to by Europeans as the "customs"). As Adjaho explains (3.3.86), "It was Zenhwen and Gblo who made *bo* for the kings;[15] they first introduced this mask." Another royal art *bo* identified with Zenhwen and Gblo is the famous "tail dance" (referred to as *gblo*) which was described and illustrated in the mid-nineteenth century by Skertchly (fig. 148)—

and which is still performed on special occasions in the palace today.[16] These art forms served at once to enhance the power of the king and the potency of his office.

Bo of the King's Person: The Power of Regalia

Royal regalia also played a critical role in creating an image of royal majesty and power. So important were various regalia *bo* to Danhomɛ royalty that one of the first actions that was taken when the crown prince was selected was to reveal to him a special *bo* pendant which conveyed the power of rule. Le Herissé explains (1911:8) in regard to this object that after choosing his successor, the king "showed him the Dahomey, a small object that, no one, other than the king, had ever seen." This royal *bo* was called *ɖesinsen*. According to Agbanon (2.25.86),

> When someone ascends to the office of his father, one gives him [something] called *ɖesinsen* [*sinsen*: worship, adore]. It is a true *bo*. It is this that the king holds in order to do the work of the country. . . . This *bo*, the *ɖesinsen*, is why the king does not greet you when you are on your knees and have put dirt on your forehead. If he greets you, you will die. *ɖesinsen* is a *bo* that one makes and when one has finished it, one puts it in a piece of cotton cloth. Then one takes a needle and begins to sew completely around it so that it will be strong.

Taking the form of a cloth-covered pendant, the *ɖesinsen* appears similar in outward appearance to *bo*-form pendants historically worn by many residents of the area.[17] Although comparable to the latter visually, what distinguishes the *ɖesinsen* from these other works is the importance attributed to it as suggested by its name (implying public worship of its wearer), contexts of use (exclusive identity with the king), and features of individual empowerment (perceived ability to turn speech into action and life into death). Like the king, the *ɖesinsen* was thought to contain within itself the mystery of rule.[18]

Kings' crowns (fig. 149) among the Fon consisted of elaborate multicolored beaded constructions similar in essential ways to those of the nearby Yoruba (see Thompson 1973; Fagg 1980; Beier 1982). These crowns also functioned as *bo*, bestowing to the king and his office key attributes of power.[19] According to Agbidinukun (5.12.86), "the beads in the king's crown constitute a *bo*. There are also things that are strong (*sien sien*) inside the crown. There is a *bo* in its interior and also *tila* ['power objects' of the Moslems]." Ayido reaffirms the important *bo* associations of these crowns[20] (6.15.86): "The crown is the *bo* of their fathers. When they take that and put it on their heads, the different things—the money, the pearls that are on it—[these things will be plentiful]. Because it is a *bo*, the king will do that which is necessary so that money will come. This *bo* is on his head to give him power. With this hat you will not look at his face. And if he says he will kill you, you will no longer have the strength to say anything." Crowns of this sort (which appear not to have been worn publicly since the early nineteenth

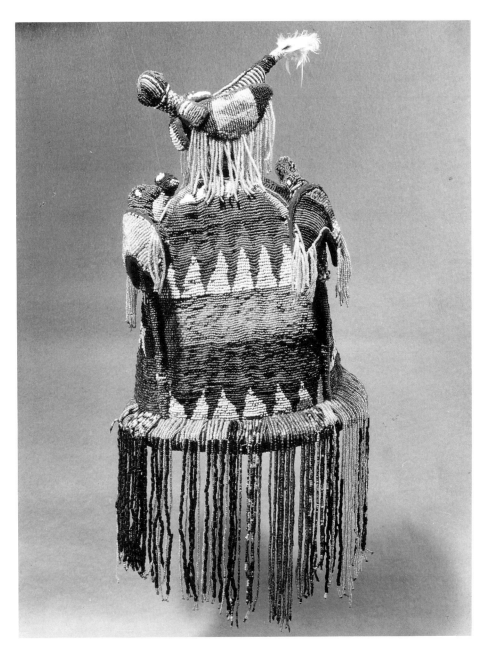

149. Fon royal crown. Republic of Benin. Beads, basketry, cloth. Height: 40 cm (30 cm without fringe). From the reign of King Glele (1858–89). While the style of this crown is distinctly Yoruba, the tradition of beaded crowns in this area is said to date back to the beginning of the dynasty. The priestly head, Daho, also wears such a crown, as do high-ranking members of the royal Agasu priesthood. A somewhat similar beaded crown (now in a private collection in France) once belonged to King Gbehanzin (1889–94). Crowns of this sort appear to have been rarely worn in public, for early descriptions or illustrations of the kings do not mention them. Musée de l'Homme, Paris. Cat. no. M.H. 36.21.62. Published in Savary (1975: pl. 5).

century)[21] added to the majestic aura of the king by according to him critical ancillary *bo*-related attributes. These crowns, with their eye-covering beaded fringes, visually separated and depersonalized the king, creating a heightened sense of mystery and power. Agbidinukun notes in this light (5.12.86) that the reason Fon kings wore beaded crowns with face-covering veils was so that they would not "look at your eyes and trick you." The importance of this crown in psychologically distancing the king so that he could not unwittingly hurt those who came in contact with him is striking, adding to the sense of fear and fantasy associated with the king through other faculties, such as empowered speech and metamorphosis.

The Danhomɛ royal sandals (fig. 150) also are identified in critical ways with the power of *bo*. Into these sandals, according to Agbidinukun (5.12.86), "one puts a *bo* that can last the reign of the king." Leather made from the skins of various powerful animals—the lion, elephant, and buffalo among others—was sewn into their soles. Similar types of leather also were employed in the making of certain commoner *bo*, but their prominent use here in the context of foot regalia identified exclusively with the king (only he could wear sandals) helped to underscore critical power differences between rulers and ruled. Appropriately, *bo* sandals of this sort empowered the king's feet, that part of the ruler most closely associated with mobility. Royal jewelry forms had similarly striking *bo* identities, their power being demarcated both by the materials of their construction and by other visual signifiers. The dance staffs and scepters of the king (the latter called *makpo* and referred to generally in the literature as "recades") were prepared as *bo* as well (Blier 1988a). Perhaps the most visually provocative works of this sort, however, were royal fly whisks which incorporated the mandibles or skulls of slain enemies.[22] Here too the psychological potency of related forms helped to convey both to the court and to the populace at large the dominance, danger, and distance of the king.

Certain types of hairstyles or coiffures likewise served as royal *bo*. As Sagbadju noted of one such coiffure (7.3.86), "This is a *bo* of kings. . . . [With this coiffure], if one goes to war, whatever one thinks will happen will come to pass." Royal coiffures which functioned as *bo* usually consisted of small rounds of hair left on an otherwise shaved head. King Glele's *bo* coiffure appears to have been typical. Skertchly observed (1874:141) that this king "wore his head shaved with the exception of two thimblefuls of [hair] . . . on the left side, decorated with small strings of beads." A coiffure of this type can be seen on a wooden figure of a king holding in his outstretched hand the head of a slain enemy (probably an opposing ruler vanquished in war) (Pemberton 1981: pl. 44).[23] As noted above, royal coiffure-form *bo* such as these were meant to assure the success of a ruler's actions.[24] These coiffure forms along with the other examples of royal regalia not only contributed to the majestic aura of the king but also helped to transform him into a living *bo*, someone whose will and words had efficacy.[25]

150. Fon royal sandal.
Republic of Benin. Leather,
cloth. Historically, only the
king could wear sandals. Said
to incorporate the leathers of
powerful animals. Made by
Djotowu, the king's shoe
maker. Musée Historique,
Abomey, Republic of Benin.
Photograph: Suzanne Preston
Blier. August 14, 1986.

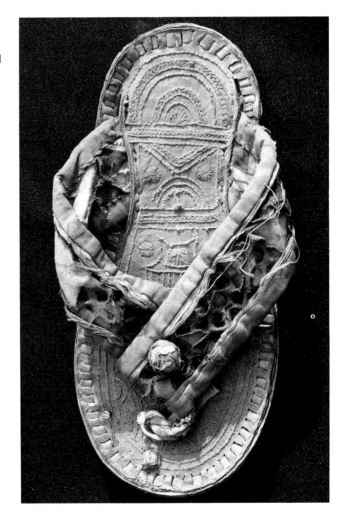

Seeing Red: Color Strategies in Delimiting Royal Power

Bo prerogatives associated with the office of the king also were linked in vital ways with color, in particular the use of the color red. This color, which was a favorite of kings because of its *bo* potency, is identified with everything from regal robes, vehicles, furnishings, appliqués, and bas-reliefs, to palace landscaping. The prominence of red in these royal forms was made all the more striking because of the tradition that few persons other than the king (or his family) would dare to employ this potent color for fear of attracting attention (and envy).[26] The linking of red with royalty seems to have had a long history in this area. As Bosman notes (1705:350) for the inhabitants of coastal Fida (Ouidah),

which would eventually come under the Danhomɛ hegemony, "None are permitted to wear red, except those of the Royal Family only."[27]

Accounts of the early Danhomɛ kings at Abomey suggest that they also were partial to this color. The late eighteenth-century ruler Kpengla sat before the court in an elegant crimson chair (Norris 1789:107). The early nineteenth-century ruler Guezo rode around the capital in a bright red hammock (Forbes 1851, 2:84, 232, 236) accompanied by wives who were dressed in crimson tunics and caps. King Glele's abundant use of red in royal tents, sofas, hammocks, and carriages also was noted by visitors of the period (see especially Skertchly 1874:276, 352–53). The elaborate tunics (called *kansa wu*) worn by Danhomɛ rulers and high-ranking military officials likewise are characterized by their prominent red patterning (fig. 151). According to Nondichao (6.26.84), the more red included in these robes, the higher the status of its wearer. Kings and high-ranking members of the royal military in this way promoted their special *bo* attributes through the color of their attire, furnishings, and modes of conveyance. While nonroyal *bo* and *bociɔ* frequently incorporated red (blood) as an element of activation, in the context of kings this color became a poignant signifier of royal *bo* potency. The psychological power of this color display no doubt also added to the sense of majesty and power of the king.

Red played an equally important *bo* signifying role in palace bas-reliefs and *appliqués*. Within associated tableaux, warriors identified with the Danhomɛ state generally are shown in red (their skin color is crimson) while enemies of the king usually are portrayed with light pink or white bodies (fig. 152). The king's warriors, it is suggested here, had special royal *bo* powers of protection and destruction. Like the bright crimson tunics of the royal military leaders, state warriors in this way drew on the potent attributes of kingly *bo* to combat the ever present danger of war. In local geomancy contexts, the Danhomɛ state often is called *hun* (blood), the body substance most closely associated with life, death, danger, health, and of course *bo*. That this word also is used to mean *sacra* may suggest added forms of protection for the king and those associated with him. This too would have afforded the king a certain sense of power over others in the state.

The importance of red in the context of the royal *bo* also comes into play in the frequent use of the bright red tail feathers of African gray parrots as objects of power and *bo* signification by the Danhomɛ kings.[28] As Agbanon explains (3.1.86), "The king always had to wear a parrot feather." Agbidinukun suggests in turn (4.19.86) that "This was a *bo* for him. Parrot feathers were attached to a cord which he would wear around his neck. Any time he wanted to do something important, these feathers played a part in it." The crown of Daho, the Danhomɛ high priest and sacred kingly counterpart,[29] similarly is said to incorporate a wealth of bright red parrot feathers along with a sizable portion of crimson *lankan* beads (Zonatchia 4.21.86), the significance here too having grounding in red's association with both power and well-being.[30] With these and other kingly

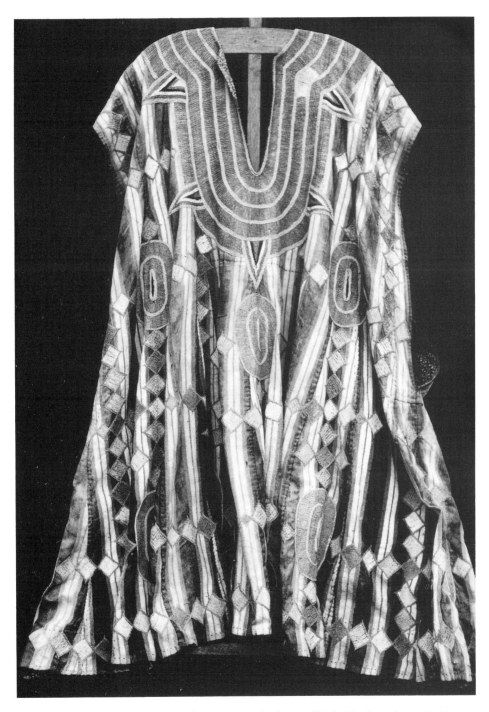

151. Fon *Kansa wu* tunic worn by Danhomɛ rulers and military officials. The five points and wide band around the neck indicate that this robe was worn by a king. Musée Historique, Abomey, Republic of Benin. Photograph: Suzanne Preston Blier. August 14, 1986.

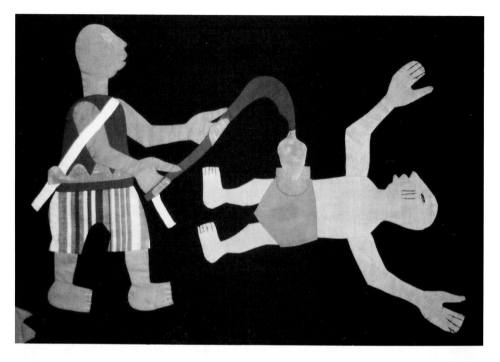

152. Detail from the royal appliqué of King Glele showing a Danhomε warrior attacking an enemy soldier with a hoe. Musée Historique, Abomey, Republic of Benin. Photograph: Suzanne Preston Blier. May 29, 1986.

bo, the visual display of attributes of majesty and might again come into play.

Court landscaping traditions also have important *bo* associations because of their prominent use of red. *Lisε* (false cashew) trees, characterized by their abundant red flowers, fruit, and sap, were planted in front of each royal palace (fig. 153). These trees, in part as a result of their prominent red coloration, serve as a powerful form of royal *bo.* Describing the role of these trees, which demarcate local palaces and homes of the elite still today, Agbanon asserted (1.23.86), "The *lisε* tree in front of the palace is a *bo,* something one will do to be strong, to rule." Na Huedahu reaffirmed this idea (1.13.86): "The *lisε* tree is a thing of power for the kings."[31] This tree is thought to bring to palace residents essential attributes of life (longevity), strength, and well-being, as identified principally through its redness and symbolic links to ample blood. Because of this association, various parts of the tree are made into health-promoting medicines intended to increase the strength and quantity of an individual's blood.[32]

Clearly central to the *lisε* tree's underlying symbolism and importance to the kings is the red color of its essential parts. This color, with its prominent associations with blood, life, fire, danger, and death, thus complements ideas of both kingly and *bo* power. Seeing the giant *lisε* trees in full flower or fruit at the entries to royal palaces conveys in a strikingly visual way the idea that kings are benefi-

ciaries of potent *bo* attributes which provide them with increased strength, well-being, and longevity. A critical part of every royal enthronement and annual *huɛtanu* ceremony accordingly included the king being carried in a hammock around the palace *lisɛ* tree. In this way too the *bo* power and potency of the king was publicly acknowledged and displayed.

Royal Bociɔ and the Arts of War

In addition to promoting majesty through the use of *bo* regalia and palace decoration, Danhomɛ kings also used *bo*-empowered works to protect and advance their positions of authority within the state and beyond its borders. Like commoners, kings were threatened by a range of dangers directed both against them personally and against the kingdom at large. Not only were there enemies within

153. *Lisɛ* tree in front of the palace of Fon King Akaba (1685–1705). Abomey, Republic of Benin. Photograph: Suzanne Preston Blier. July 28, 1986.

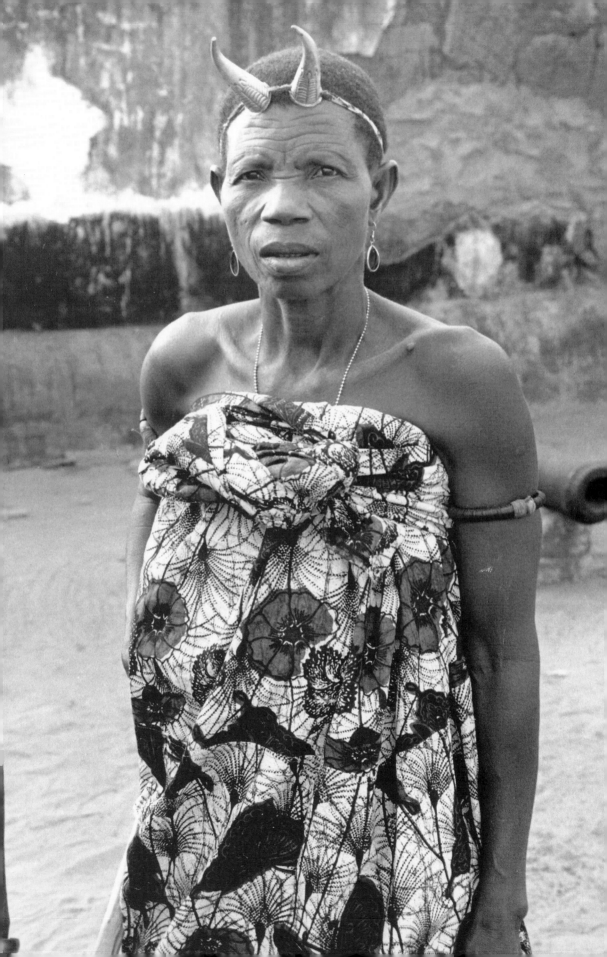

154. Descendant of female warrior performing during annual ceremonies at the palace in Abomey, Republic of Benin. Note silver animal horn headdress and upper arm bracelets, each a form of *bo*. Photograph: Suzanne Preston Blier. February 1, 1986.

155. Cover of *Le Petit Journal*, 26 November 1892, showing royal Fon war *bociɔ* found by French troops in Cana during the wars of colonial conquest ("les fétiches de Kana—le dieu de la guerre"). Other war *bociɔ* probably also were transported to the field of battle on wagons.

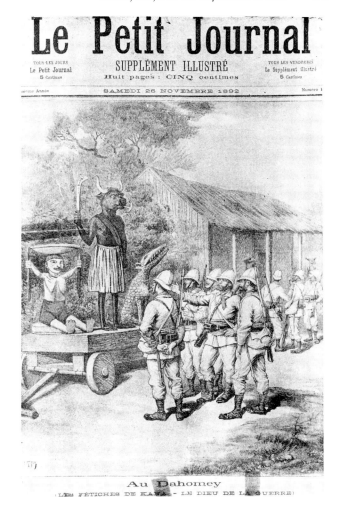

Le Petit Journal

SUPPLÉMENT ILLUSTRÉ

TOUS LES JOURS
Le Petit Journal
5 Centimes

Huit pages : CINQ centimes

TOUS LES VENDREDIS
Le Supplément illustré
5 Centimes

quatrième Année SAMEDI 26 NOVEMBRE 1892 Numéro 1

Au Dahomey
(LES FÉTICHES DE KANA - LE DIEU DE LA GUERRE)

the court, but many persons both inside and outside the realm sought the king's demise. Because war was perceived to be one of the greatest dangers both to the king and to the state, one of the most important functions of royal *bo* and *bociɔ* was in aiding the king and his forces on the field of battle. The greatest number and most artistically important of the royal *bo* thus were those employed in war. As Nondichao noted (10.17.85), "When each king comes to power he finds his own means to defend himself in battle."[33] Some of the royal war *bo* were simple objects—cords, small calabashes, special finger rings, pendants, or headdress elements (fig. 154). What Skertchly suggests (1874:256) for the Danhomɛ royal elephant hunters also was true of warriors: they were always "profusely ornamented with magic relics."[34]

Other royal war *bo* took the form of carved figures (fig. 155). Sculptures of this sort frequently were brought to the scene of battle or placed at strategic

defensive points in the realm. In times of peace these works generally were housed in special war temples (*bohɔ, boxɔ*) in the capital. As Akati explains of these works generally (7.21.86), "It is the kings who ordered them; they are the *bo* that one carried into war." The royal *bociɔ* additionally were displayed in the course of the long and lavish parades undertaken by the king in the course of the annual *huɛtanu* ceremonies which served, among other things, to honor the royal dead and to promote the power of the king.[35] This no doubt also helped to further distance and enlarge the works in the eyes of local viewers.[36]

While a range of animals and humans are said to have been depicted in these royal war sculptures, images of monkeys, hyenas, dogs, and birds are mentioned most frequently. Drawing on the powers of metamorphosis, Danhomɛ kings were said to have been able to transform themselves into these animals in order to spy on state enemies or flee a battle that was turning against them. As Asogbahu explains (5.8.85) for wooden monkey figures of this type (fig. 156) (generally called *ato gblada; gblada:* fierce; *ato:* monkey), "In the past one carved monkeys because the king had power and all these things were employed in war as *bo*."[37] Through the use of monkey and other wild animal sculptures such as these, Asogbahu suggests, the kings were saying, "We have control over the land" and those who reside there.[38]

Figures of hyenas played a similar role in protecting the royal troops and promoting military success. As with the figures of dogs, royal metamorphosis was an important part of their overall functioning. As Sagbadju explained of one such work (7.9.86), "It is the king who possesses all the *bo*. When he wants he can transform into a hyena." Mikpohani noted similarly (1.14.86), "When the king goes to war, he has certain [*bo*] so that he can set a tree on fire or trap a hyena and ride it like a horse." Dogs and dog imagery had important identities as royal war *bo* as well, and a potent solution of dog blood was consumed before battle so that the warriors would be stronger and more aggressive.[39] While metamorphosis was vital in nonroyal works as well, with commoner images, as we have seen, this consisted primarily of alchemical transformations of dangerous substances aimed at bringing about particular ends, or of the sculptural metamorphosis of deadly forces in order to protect particular persons. In the case of royal arts, kings (and their warriors) were thought to metamorphose into an external power. In this practice, too, art can be said to have a critical psychological role in advancing the affairs of state.

In addition to these generic war *bociɔ*, most kings also utilized a range of works created in conjunction with their unique Fa divination signs. In part as a result of their Fa identity, the sculptures discussed below display a diversity of imagery quite different from that of other royal war *bociɔ*. One of the most famous of these kingly Fa *bociɔ* sculptures linked to war is a giant standing figure of a man-shark (fig. 157) created by the late nineteenth-century artist Sosa Adede (Thompson 1983:169; Blier 1990:94, n. 41). This work, which today is housed in the Musée de l'Homme, is identified with the last of the Danhomɛ preconquest

156. *Ato gblada* royal Fon *bociɔ* in the form of a male monkey with a shackle around its neck. Republic of Benin. Wood, iron. Height: 48.5 cm. Musée d'Ethnographie, Geneva. No. 12874. Published by Merlo (1977: fig. 39). Purchased in 1930.

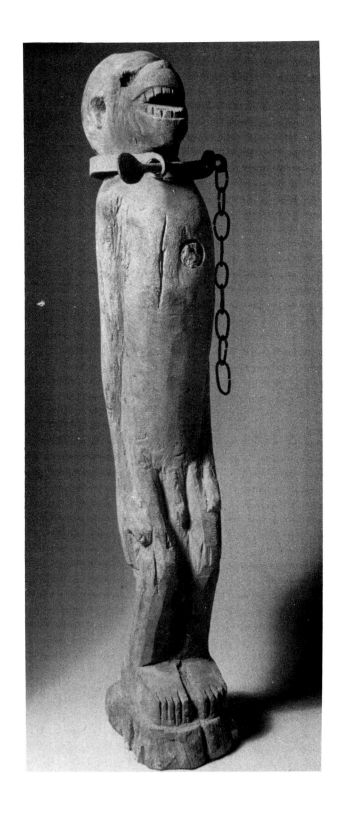

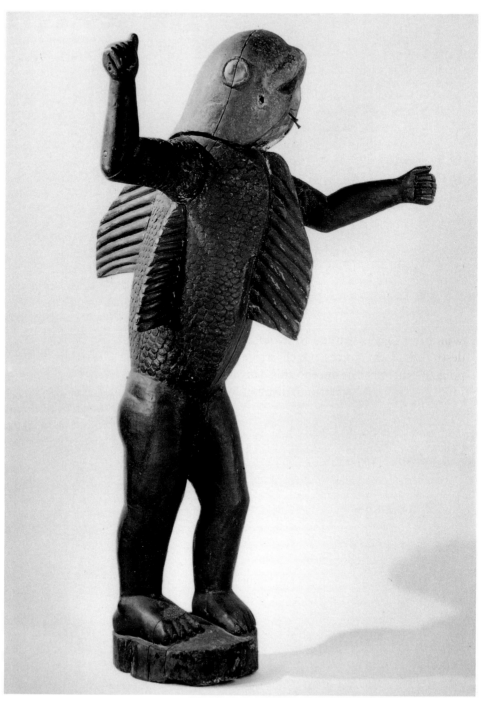

157. Royal Fa-*bociɔ* of the Fon King Gbehanzin (1889–94) showing the king in the guise of his animal avatar, the shark. Abomey, Republic of Benin. Wood, pigment. Height: 1.60 m. Artist: Sosa Adede. Collected in 1893. Musée de l'Homme, Paris. Cat. no. M.H.93.45.3. Extensively published.

kings, Gbehanzin (1889–94). As Nondichao explains in regard to this sculpture (10.17.85), "The shark is for Gbehanzin; it was used to defend him" (see also figs. 70, 83, and 84). One of Gbehanzin's court songs alludes to the importance of this royal *bociɔ* in the context of war:

> Gaou [the war minister] made a *bo* for me, the shark
> I will try the *bo* to see
> If I try this *bo* in the land of no matter whom
> I will take his child as my child
> I will take his wife as my wife
> I will take his country as my country
> I will suppress all who are there
> And if someone is there
> He will say what happened.[40]
>
> —Agbidinukun 7.10.86

As with other royal Fa-*bociɔ*, this work was closely associated with the ruler's divination sign, in this case, Aklan-Winlin. References to the dangers of the ocean appear prominently in this *du* sign, one of whose verses portends: "The *alɛ* bird will lose itself in the ocean while singing." Anyone holding the Aklan-Winlin Fa sign is warned to avoid the sea so as not to be swallowed up and destroyed by the forces which reside within.[41] The shark-man sculpture is a poignant reference at once to this danger and to the ferocity of King Gbehanzin. In its massive size, overt animalistic power, fighting gesture, forward movement, and polychrome surfaces, this work contrasts markedly with commoner *bociɔ* forms. As noted in preceding chapters, the latter generally are small in scale and emphasize static poses and natural wood hues. In addition, whereas the commoner works frequently are characterized by striking attributes of emotional power, the shark figure displays marked attributes of physical power, qualities of vital importance to the kings in conveying both to the public and to their enemies the strength of the king and the state.

The Fa-*bociɔ* sculptures commissioned by Gbehanzin's father, King Glele (1858–89), are more numerous than those of King Gbehanzin.[42] The rest of this chapter will discuss some of the more important of King Glele's Fa-*bociɔ* and their underlying political and psychological functions. Among these works are the famous lion and iron warrior in the Musée de l'Homme, a brass warrior in the former collection of Charles Ratton, and several sculptures which, while no longer extant, appear in royal histories, appliqués, and bas-reliefs. One of the better known of Glele's many Fa-*bociɔ* depicts a large, upright anthropomorphic lion (fig. 158). This figure, like the previously discussed rampant shark, was carved by the late nineteenth century artist, Sosa Adede. In 1874, Skertchly appears to have observed this lion during the annual *huɛtanu* parade of war *bociɔ* at the royal palace in Abomey (fig. 159). He explains (1874:254) that "a gang of twelve men . . . appeared dragging a dray of native manufacture, upon which

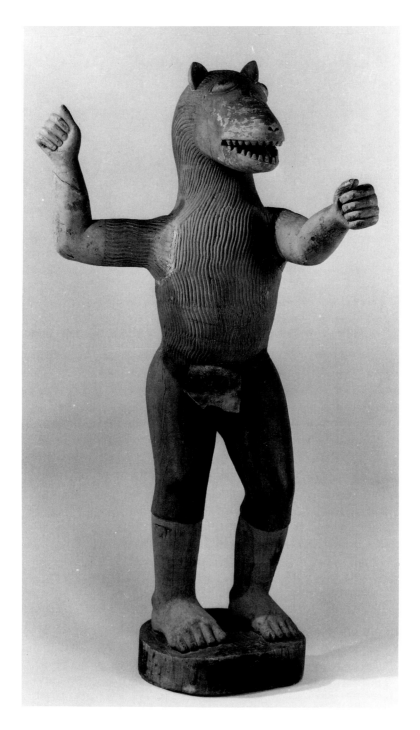

158. Royal Fa-*bociɔ* of the Danhomɛ King Glele (1858–89) showing the king in the guise of a lion. Abomey, Republic of Benin. Wood, pigment. Height: 1.70 m. Artist: Sosa Adede. Musée de l'Homme, Paris. Cat. no. M.H.93.45.2. Extensively published.

159. Illustration of the annual ceremonies or "customs" in Abomey, Republic of Benin (from Skertchly 1874:353). A carving of a heraldic animal appears in the foreground.

was the wooden figure of a very heraldic lion, rampant, and carrying a sword in either hand. . . . this gang halted before the king, danced, bowed, and were dismissed with a present of cowries and rum."

The sculpture's large scale and readied swords (now lost) no doubt created an impressive image of royal ferocity and force. The prominent forward movement of its feet added further to this visual power, a reference to the sculpture's ability to advance into the heat of battle. As Nondichao explains for this and other royal war *bociɔ* (10.17.85), "These statues of wood walked like men and were the height of men. They were war *bo* and accompanied the army to war, staying at the front of the troops." As a work of the Fa-*bociɔ* genre, this sculpture derives its powerful lion imagery from the ruler's divination sign, in Glele's case Abla-Lete. One of the phrases of this sign asserts, "No animal displays its anger like the lion." Like the previously discussed shark figure, the lion's animalistic features, deadly weapons, and aggressive pose contrast markedly with works of the commoner Fa-*bociɔ* genre.

Another distinction between this sculpture and most commoner figures is that the empowering materials were enclosed within the lion's interior rather than being placed on the surface—a feature also characteristic of other royal *bociↄ*. In the case of this rampant lion, these empowering materials were believed to enable the work not only to move about freely on its own, but also to talk. As Sagbadju explains for this royal Fa-*bociↄ* (7.3.86), "After having carved the wood, one will dig into its chest and put everything inside. Then one closes it. When this is done, it will open its mouth, and will begin to speak." Unlike the mute and motionless commoner *bociↄ*, these works reveal the full potentialities of human action and response.[43]

Other sculptures identified with Glele's divination sign are equally interesting in terms of form and significance, offering unique insight into the nature and role of royal Fa-*bociↄ* in the context of kingly display and war. The most important of Glele's Fa-*bociↄ* include the famous iron war god in the Musée de l'Homme and a brass warrior formerly owned by Charles Ratton and now in the Musée Dapper. Eva Meyerowitz's eloquent description (1944:148) of the brass warrior (fig. 13) captures a sense of this figure's potent military identity. She writes: "Never has war, in the confines of the human figure, been illustrated so terrible: with scimitars in both hands this god marches, ready to strike blindly at whatever stands in his way. His powerful jaws are taut with the intensity to kill and his teeth are bared, like those of a wild animal, ready to charge. But most terrifying of all are his big flat feet: wherever he marches everything will be trampled underfoot and squashed." The sculpture that Meyerowitz is describing stands barely a meter high, yet its power and monumentality belie its relatively small size. In part, this is achieved by the figure's striking naturalism, in particular in certain features of its face, chest, back, stomach and arms.[44] Augmenting this naturalism, the work originally was dressed in an array of human clothing (see Thompson 1983: pl. 108).

The feet, large, flat, and boney, also stand out, alluding to the role of the deity Gu in actions related to war. The left foot, as in many other royal Fa-*bociↄ*, is positioned in front of the right, this referring to the god of war, and suggesting the special strength accorded a person by Gu.[45] The sculpture's large feet also may make reference to King Glele, for one of this king's court songs refers to the power of his feet. According to this song, "The feet of Glele are more than 200." Explaining the above phrase, Agbidinukun noted, "Glele's feet are numerous. When one foot is removed, another foot is already there, and he has taken it to walk with" (7.10.86). This king's reign, in other words, was identified with movement and expansion.

Adding to these rulership qualities is the brass material of the figure's manufacture. This metal is said to derive from the shells of spent bullets. The use of such a potent material underscores the work's close association with the iron god, Gu (in Fongbe, the terms for iron and brass have the same root—brass is called "red iron," *gan-vo*). The purported dusting of this sculpture with gunpow-

der in the course of related war ceremonies also is important in this regard (Sag-badju 7.3.86). As an expensive imported metal, the brass here additionally serves to underscore essential differences in kingly and commoner economic power.

Positioning was a vital aspect of the political and psychological potency of this brass warrior figure. Maupoil explains (1981:422) that the sculpture was kept near the Dosumwengbonu gate in the Ahwaga quarter in Abomey. There it was placed close to one of the main entrances leading into the capital where, undoubtedly, it played a part in the protection of the city. The sculpture's name, *du su mon majeeto,* "The hole prevents the enemy from passing" (Maupoil 1981:422) alludes both to the above city gate (which shares the prefix *dosu*) and to the dry moat (*do:* hole) that surrounded and protected the city at that time. According to Agbidinukun (6.20.86), "There were many *bo* at Dosumongbonu [Dosumwengbonu] at the entry into this city. There at the tollhouse one kept *bo* so that bad things would not enter the land." While the prominent position of this work near the entrance to the city complements the location of commoner *bociɔ* forms, the sculpture's striking warfare symbolism suggests battle contexts which are more closely identified with state rather than individual or family concerns.

The famous iron warrior from Danhomɛ now in the Musée de l'Homme (fig. 160) shares many iconographic features with the brass figure of Gu. In the iron warrior, however, we are presented with a striking individual of enormous height who strides forward on long, lean legs, his war tunic (*kansa wu*) billowing around him as he rushes into the fray.[46] The figure's gnarled hands, which once held a bell and *gubasa* sword,[47] are readied for the shock of battle. Obscuring the features and expression of the face is the brim of an enormous headdress of iron weapons and tools—knives, swords, pincers, hammers, and axes of various sorts. These recall both the tools and weapons of the metal and war god, Gu, and the enormous bladed weapons (which also functioned as *bo*) that once surrounded the figure in the palace war temple (*bohɔ,* "house of *bo*") where offerings were made to the iron warrior prior to combat (fig. 161).

Agbidinukun explains that this iron figure originally was known in Danhomɛ as *agojie* ("watch out above"; *ago:* watch out; *ji:* above) and served an important role in the protection of both the king and the kingdom at large in contexts of war. As he explains (5.3.86), "The sculpture stayed next to the king. If something was about to happen to the king [it announced], 'Watch out! It is I who will be there first of all, and you will have to see me first.' . . . [With its spiky crown of weapons and tools] we designed how the country is—all these things that you see [on its head] show that the country is awake and full of courage." Like the larger grouping of royal Fa-*bociɔ,* this work was intended to assure military success. Records at the Musée de l'Homme indicate that the sculpture was found by the French on the coast at Whydah; it was identified at the time as representing Ebo or Gbo, god of victory (Vogel and N'Diaye 1985:137). The figure, probably brought to this port city by the Danhomɛ troops in anticipation of the arrival of

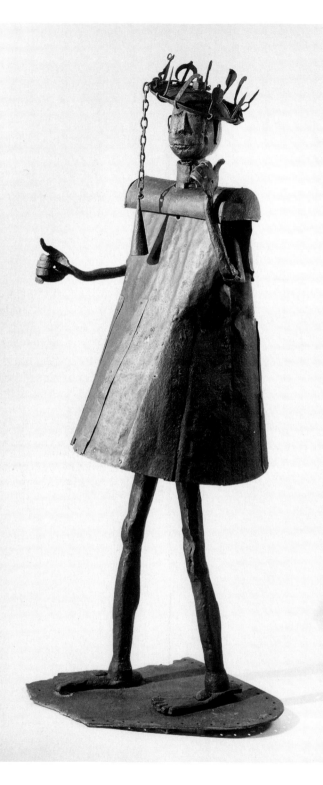

160. Royal Fa-*bocis*
commissioned by the Fon King
Glele (1858–89) in the guise of
a warrior, wearing a war tunic
(see fig. 151) and a headdress
comprised of various war
implements and tools.
Abomey, Republic of Benin.
Iron. Height: 1.65 m. Artist:
Akpele Kendo Akati. Musée de
l'Homme, Paris. Cat. no.
M.H.94.32.1. Extensively
published.

161. Gigantic weapons of iron
displayed in the *bo* house of
King Glele. Musée Historique,
Abomey, Republic of Benin.
Artist: Akpele Kendo Akati.
Photograph: Suzanne Preston
Blier. February 1986.

the French, no doubt was intended to help protect the kingdom at one of its most vulnerable points of entry.[48]

Essential to the aggressive and protective military functions of both the brass and iron warrior figures is the source of their power and imagery, namely King Glele's Fa divination sign, Abla-Lete. Both warrior figures represent visualizations of a phrase from Glele's Fa divination sign, in this case: "The audacious knife [*basagla* or *gubasa*][49] gave birth to Gu and the vengeance continues." In these sculptures, a *gubasa* sword is (or was) grasped in the warrior's hand(s). These swords, following the above Fa phrase, are said to have given birth to (empowered) the god of war and metal, Gu, and by extension King Glele himself. Both sculptures allude in this way simultaneously to Gu, King Glele, and to the man who fathered this ruler, King Guezo (Agoli Agbo 8.12.86). Through these powerful figures, as Nondichao explains (10.17.85), "Glele found the means to defend himself." Like commoner *bocio*, the two warrior figures provided the king, his family, and his troops with security in times of trouble. These two relatively naturalistic sculptures stress ideas of violence (weapons, iron, bullet shells), active response (enlarged scale, animated postures, and gestures), and financial well-being (the prominant display of imported metals).[50]

Another Fa-*bocio* commissioned by King Glele also expresses in important ways the potency of rulership.[51] Although no longer extant, this work (figs. 162 and 155, center) is depicted both in palace bas-reliefs and in the appliqués associated with King Glele's rule. Said by Waterlot (1926: pl. 16) to represent a force or power called *Daguesu* (*Daghessou*; alt. *sogblagada, soflimata*), the figure's head took the form of a ram or buffalo (both are called *agbo* in the Fon language) and its arms and legs supported small *bo*-containing gourds. Waterlot describes the work as a "fabulous warrior . . . created by King Glele to commemorate his celebrated corps of *soflimatan* 'furious antelope' military troops." Like the iron and brass warriors discussed above, this sculpture was identified with Glele's divination sign, constituting here too a royal Fa-*bocio*. According to Adande (1976–77:155), the sculpture represents a thunder ram which "was placed in front of the army [in war] and announced victory. As he marched alone, nothing but his image was necessary to scare the enemy troops." At once animal and human, this figure incorporated essential features of the god of thunder, Hεvioso, the ram-resembling deity whose force was said to provide the flare, booming noise, and killing power of guns.[52] This god not only played a critical role in war, but also was believed to offer special protection to Glele and other holders of the Fa sign, Abla-Lete. Because like many royal war *bocio*, the *Dagueso* figure was thought to have the power of independent locomotion, it too presented an image of combined military and mystical power to enemies of the king.

King Glele also commissioned a Fa-*bocio* in the form of a female figure which held a crescent moon in one hand and a round disk signifying the sun in the other (fig. 163). This sculpture derived its essential imagery from the following phrase of Glele's divination sign, Abla-Lete: "Sεgbo-Lisa said he is king and the

great one of the universe. Thus at daybreak, everyone will see him" (Sagbadju 7.3.86). Sometimes identified as the female *Daguesu* (Daghessou) (Adande 1976–77:153; Yemadje 6.26.84; Sagbadju 7.3.86), this royal Fa-*bociɔ*,[53] is known to us through diverse portrayals in palace bas-reliefs and textiles. Adande describes this figure as it appears in Glele's appliqué as follows (1976–77:153):

> a one-legged divinity in anthropomorphic form wearing both the skirt like that of a *vo-dun* devotee and the attributes of Abomey soldiers: bullet pouches and sandals. This divinity holds perches in its hands which are surmounted by a round object and a convex form. The round form is the sun, the convex form is the moon. These are the two principles on which creation depended. The sun is the source of life and light, life which it transmits everywhere. The moon, after having received the light of the sun, reflects it, and its rays have well-known effects on natural elements and on humans. The hair of this divinity is a bit reminiscent of the feathers of a bird.

Like many Fa-*bociɔ*, this figure played an important role in war. "This is the *bo* that we give to those who fight against our enemies. The moon and the sun constitute *bo*. They are not emblems [symbols]; they are protections, they are *bo*" (Nondichao 10.17.85). Self-propulsion also was a vital feature of its military identity. "When one went to war," asserts Nondichao (10.17.85), "every time one praised the statue, it walked like a human." Other qualities accorded the work by Nondichao (10.17.85) also offer insight into its battle significance. As he explained, "This figure represents a woman holding both the sun and lunar crescent. If the enemy is attacking the army of our king, the figure raises the moon and it will become black and the enemies will not be able to see well. However if our army is defeating the enemy, the figure will raise the sun and it will be light enough for our army to push on." The association of this sculpture with day and night time periods in war is also discussed by Adande (1976–77:153). "When the king went to war, he asked this divinity about the most propitious moment to leave. If the night was the best moment, Daghessou raised the moon, and if day was better, it was the sun." King Glele and his military forces thus were able to draw on the powers of this royal Fa-*bociɔ* in order to alter key atmospheric conditions, through this means promoting military victory over the enemies of the state.

A grouping of animal sculptures carved in wood and covered with expensive imported metal—usually brass or silver—also functioned as Fa-*bociɔ*, aiding the king in war and other affairs of state. Eva Meyerowitz, who visited the Abomey palace in the early 1940s, describes metal animal figures of this sort as important war icons. In her words (1944:147), the "fetishes of the god of war [consist of] fairly large sculptures of animals, the majority carved in hard wood and covered with thin beaten sheet brass or silver alloy, the latter now so tarnished that it has become indistinguishable from the brass. Most of these are, in one way or another, symbolic of the god of war, or connected with the rites and ceremonies at the outbreak of war. . . . The large animals were placed in front of the altars

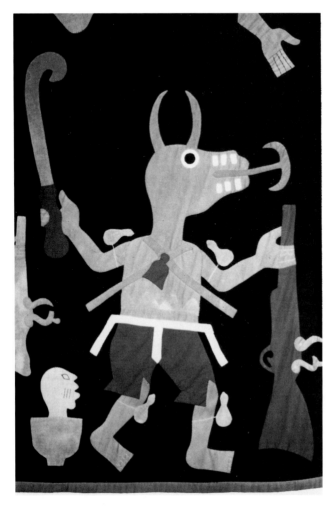

162. Detail from an appliqué associated with King Glele's reign showing the Daguesu war *bociɔ* with its ram-form head, weapons, *bo* gourds, and lightning axe blade extending from the mouth. Musée Historique, Abomey, Republic of Benin. Photograph: Suzanne Preston Blier. May 29, 1986.

163. Detail from an appliqué associated with King Glele's reign showing a royal war *bociɔ* in the form of a one-legged female who raises sticks holding the sun and the moon in her hands. Musée Historique, Abomey, Republic of Benin. Photograph: Suzanne Preston Blier. May 29, 1986.

during prayers and sacrifices to the god in time of war." [54] Because of their frailty, these sculptures were not taken to the field of battle; instead they were displayed in the annual *huetanu* rites and other royal memorial contexts.[55] As with the figural war *bociɔ* described above, empowering materials generally were inserted into the inner wooden core rather than secured to the surface as was usually done in commoner *bociɔ*. As Sagbadju explains (7.3.86), "The sculptures that one put metal on, one digs into their interior and puts things inside and then closes it again with wood. It is the things of *bo* and *vodun* that one puts inside. Leaves and all the other things that make one know that it is a *vodun* go into it. Oil and alcohol are there, and one will kill animals as well." [56] Often key parts of the animals represented also were incorporated into the work.[57]

Metal-sheathed animal sculptures of this type took various forms, often derived from the distinctive divination sign of a particular king. One such work, a

lion made from sheets of silver secured to a wooden core (fig. 164), served as a Fa-*bocɔ* for King Glele. As Sagbadju explained (7.9.86) with regard to this sculpture (which is now in the Musée Dapper) and others sheathed in silver depicting an elephant and a buffalo (currently in the Metropolitan Museum of Art), "they are *bo*. The buffalo represents King Guezo [1818–58]. . . . [The lion is for] Glele, the lion of lions. If you see this you will flee. But it is not looking for you; it is controlling the land." Through a form of zoomorphic metamorphosis, the king was thought to be able to transform himself into associated animals in order to survey and govern the state.

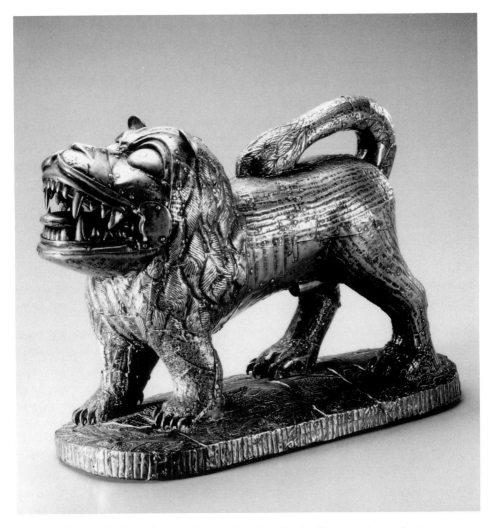

164. Royal *bocɔ* in the form of a lion. Abomey, Republic of Benin. Silver, wood. Length: 45 cm. Commissioned by King Glele (1858–89). Artist: Allode Huntondji? Former collection of Charles Ratton. Dapper Museum, Paris. Extensively published. Photograph: Bruno Albertoni—Arts 135.

165. Royal *bociɔ* in the form of a hornbill bird (1894–1900). Wood, brass, iron. Height: 64 cm. Artist: Tahozangbe Huntondji. Musée Historique, Abomey, Republic of Benin. Photograph: Suzanne Preston Blier.

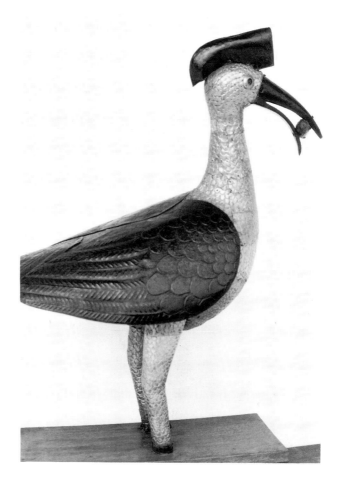

Hornbill birds were a frequent subject of precious metal war *bociɔ* commissioned by King Glele as a means of metamorphosis and empowerment in war. According to Sagbadju (7.9.86), such birds constitute "a *bo* which enable the king to transform into a bird." In Herskovits's words (1967, 2:264), empowering objects of this type "permit[ted] kings to change into birds, and while so transformed to check upon the activities of the kingdom, or to escape from danger." Since the hornbill appears in Glele's divination sign, royal sculptures of this bird also function as a form of Fa-*bociɔ* (fig. 165). Several such bird images sheathed in brass are in the Musée Historique in Abomey. They also are displayed on Glele's palace bas-reliefs. The related phrase of Glele's Fa divination sign notes, "Hornbill, it is to you that Sɛ [Sɛgbo-Lisa, destiny, god of heavenly light] gave a burden to carry. If Sɛ gave it to just any bird, it would not be able to hold it. But when Sɛ put it on the head of the hornbill, this bird supported the weight" (Nondichao 10.22.85). Agbanon also discusses the meaning of this divination

phrase in the context of *bo* (2.28.86): "One makes a *bo* out of the great hornbill, saying: 'The baggage of life does not stay on the head of just any bird.' [This means that] there are a lot of people, but there is only one person who receives all the glory. It is the king who made the *bo*. The head of the hornbill is used to make some; the bird itself [the body] is employed to make others."[58]

These and other royal *bociɔ* appear prominently in court bas-reliefs (fig. 165).[59] Compared with commoner works of this genre, not only is the royal Fa-*bociɔ* imagery more varied—showing a range of animals, birds, and humans— but these sculptures often feature rare imported metals, emphasize interior (rather than surface) empowerment, and address state problems, most important, war.

In concluding this chapter it is important to reiterate the vital roles that royal *bociɔ* played as complements and counterfoils to commoner traditions. Works of this sort helped to promote an aura of majesty and mystique while at the same time protecting the king and his troops from a range of dangers, among these insurrection and war. What is striking in the royal sculptures and regalia forms is both their visual power (and distinctiveness vis-à-vis commoner works) and their importance both to the identity of the king and to the viability of the state. Through a range of royal *bo* and *bociɔ* arts, status difference and deference were continually promoted. Whether taking the form of regal strong names, kingly regalia, palace enhancements, or life-size sculptures taken to the field of battle, these works offer provocative insight into the aura, arts, and artifices of rulership.

Conclusions, Concomitants, and Comparisons

"The squirrel, seeing the leopard's footprints in the sand, prostrates itself as a sign of respect"

(*Awasagbe mo kpɔfɔ bo de kɔ nusisi lɔ si e non si*).

—Fon proverb

"Wit consists of knowing the resemblance of things which differ, and the difference of things which are alike."

—Madame de Staël, *Germany*

A range of issues central to the understanding of *vodun* empowerment arts have been explored in the preceding chapters. The following pages constitute less a conclusion than a discursive closure and peroration which draws together essential concerns raised in earlier chapters and reexamines them vis-à-vis contrasting features of commoner and royal *bociɔ* traditions. As suggested in the title of this book, the sculptures treated here are bound up in various ways with ideas of psychology and power. Associated arts play a central role in both defining and countering various personal anxieties and problems. Each chapter takes up different methodological and material concerns with respect to these works, focusing on the interpenetration of art, society, and psychology.

The introduction and first chapter discuss the aesthetic and sociohistorical grounding of *bociɔ* and *bo*. Created in a milieu of difficulty defined by war, colonial upheaval, and various forms of personal trauma, commoner *bociɔ* address a range of emotional issues. Emotionally jarring imagery sometimes verging on the grotesque and themes of exterior and interior reversal are a significant part of *bociɔ* representation. Sorcery beliefs and issues of gender difference also play a part in *bociɔ* conceptualization. Underlying philosophical and religious traditions of *vodun* are essential to their sculptural form and function as well. *Bo* and *bociɔ*-related forms in the Americas suggest in turn the continuing importance of this artistic tradition in helping to mitigate circumstances of distress and difficulty as experienced by disempowered persons in a range of contexts.

Addressed in chapter 2 are the diverse means through which *bociɔ* arts are empowered and perceived. Here I focus on the different roles of artists, users, and producers. The modes of sculptural empowerment also are taken up. In the associated analysis, emphasis is given to the symbolic as act. Discussion thus is concerned less with the sign as signifier than with the process of signification itself. Central to the above is how audiences, agents, and energies "act on matter" (in this context art), transpose its features, and transfer its properties. The

artistic process, it is suggested here, is both much larger and richer than standard artist-focused models historically have acknowledged.

The primary therapeutic orientations of *bociɔ* arts are explored in chapter 3. Special attention is given to the part such works play in the context of a myriad of personal struggles. The important place of emotional projection and transference in *bociɔ* conceptualization also is treated. Transference, an often overlooked but vital feature of the psychoanalytic understanding of art, is viewed as having an impact on and yet standing apart from interpretation, the principal concern of most other psychologically grounded art explorations. In examining the range of forms and functions that *bociɔ* assume, the prominent roles such works have in the expression of deep-seated feelings and concerns are each explored. Whether placed at the gates of the city or in one's private sleeping chamber, objects of this type incorporate at once the desires and fears of the individual and the hopes and anxieties of the community. Assuming vital psychotherapeutic roles, related objects help to harness (counter, enclose) debilitating fears, while propelling the individual into taking action.

Within chapter 4, anatomical discourse serves as a locus from which issues related to bodies and being are analyzed. Among other things, this chapter addresses questions of how, what, and why bodies reveal. It is clear that commoner *bociɔ* are far less concerned with the depiction of anatomical correctness and beauty as such, than they are with expressing a range of emotional qualities through various forms of body abstraction. Because artistic representation here is more focused on what the mind envisages than what the eye may see, concepts of bodiness and being often display attributes of anamnesis, with key body parts being privileged over or against the whole. In both its presentation and its alteration by variant means of amplification, diminution, distortion, and constriction, the body also serves as a frame against which essential emotional concerns are both measured and defined. The elaboration of anatomical attributes in associated discourse in this way is linked with vital features of emotional display and the reading of figural abstraction as sign.

Concepts of the self/not self, and the I/not-I, in the understanding of issues of psychology and art are the principal focus of chapter 5. Associated concerns have grounding in ideas of interior and exterior, surface and depth, and conscious and unconscious expression from the perspective of the individual looking both within and without. *Bociɔ* are seen to have a central role in defining the human as someone who is at once an actor and director in the performance of life. Not only are people here believed to select their destinies before birth, but they also come into the world with these destinies defined on their hands. At once a figure of the past (a reincarnated ancestor) and a bearer of death in the family, every human represents a paradox; individual identity is thought to be both more than and less than what it appears to be. *Bociɔ* not only assume a critical part in the delimitation of each person's identity and destiny, but also help to define the human persona vis-à-vis notions of replacement, substitution, and masking.

In chapter 6 attention turns to the discussion of *bocɔ* properties and poten-
tials within the context of alchemical models of material transmutation. Because
there is a correspondence between the conceptualization of the universe at large
and perceptions of the inner world of the human mind, the variant qualities
which come to be identified with matter within traditions of *bo* and *bocɔ* offer
critical insight into the understanding of the mind, the psyche, and the emotions.
In this chapter these issues are discussed in the context of the distinctive signi-
fying roles of the surface materials applied to these figures. In the selection and
transmutation of this surface matter, the complex meanings which these elements
convey to each object's larger sculptural identity are brought out. It is argued
here that *bocɔ*, with their encyclopedic complement of incorporative materials,
offer a unique view of the role of alchemy in the conceptualization of empow-
ering arts. The animals and plant parts which are added to the surface serve as
vital agents through which complex ideas of material and personal transition
and transformation are made manifest.

The diverse attachment means used to secure extrafigural materials to the sur-
face of *bocɔ* constitute the primary subject of chapter 7. These variant forms are
discussed from the point of view of sculptural *parergon*—supplements outside
the work which intervene on the interior. In *bocɔ* traditions a variety of such
attachment modes are employed, the most important including cords, pegs,
chains, gourds, and textile containers. With these attachment means one also
finds expressed essential qualities of sculptural suturing wherein the imaginary
is joined with the concrete. *Bocɔ* attachment or suturing forms offer critical
insight into the psychodynamic properties inherent in each work. At once apart
from (separate, ancillary to) and a part of each sculpture, these attachment
modes provide unique perspectives into the impact of power and psychological
signification on artistic meaning. As elements external to the work which help
to define its internal reading, associated suturing and *parergonal* features also
reinforce the vital roles that *bocɔ* play as objects of and about desire.

Genres of *bocɔ* empowerment figures are the primary subject of chapter 8.
Associated genres, it is argued here, offer important insight into essential psycho-
logical issues raised with respect to sculptural typologies. Whether defined pri-
marily by formal features or by more difficult-to-discern attributes identified
with distinctive empowerment sources, these genres offer illumination into the
emotional and sociological dynamics that frame artistic meaning. With works of
the death-exchanging *bocɔ* (*kuɗiɔ-bocɔ*) genre, one finds expressed both fears
of demise (death) and potent psychological issues of projection and substitution.
Swollen-*bocɔ* works delimit, through diverse formal and functional means, val-
ues ranging from reproduction and increase to putrification and demise. Sculp-
tures of the deformed-*bocɔ* genre point to equally provocative emotional quali-
ties of enhanced or decreased sight and preparedness through features of
amplification and diminution. Pierced or pegged *bocɔ* for their part convey criti-
cally potent ideas about penetration, secrecy, and closure on the one hand and

speech and empowerment on the other. In contrast, within the larger corpus of bondage *bociɔ*, variant concerns—from restraint, repression, imprisonment, and death, on the one hand, to life, family, mastery, culture, and well-being on the other—find expression. With other genres, a range of similarly provocative, psychodynamically grounded issues are addressed.

The book's final chapter addresses contrasting traditions of royal *bociɔ*, examining the range of concerns defined within these works and the diverse ways they are represented in artistic form. Royal *bociɔ* and *bo* of various types help to convey essential attributes of majesty, mystique, and might. Whether comprising forms of empowered regalia (crown, sandals, dress, coiffure, jewelry) architectural elaborations (bas-reliefs, landscaping), or various forms of sculpture, related works played an essential role in courtly and popular perceptions of kingly power. Sumptuary arts of this sort offer critical insight into the social and psychological dynamics of power. Many such works assumed active roles in the private and public wars that characterized royalty and the state. In the same way that commoner *bo* played a part in numerous battles of individual, family, and community life, royal *bociɔ* figure centrally in the various battles of the monarchy.

Focusing on the fundamental differences in royal and commoner traditions, the remainder of this overview will address salient comparative issues in kingly and popular *bociɔ* typologies. Before examining key differences in the arts, it is important to note that a variety of complementary features exist in royal and commoner forms. As suggested in chapter 9, both types (statuses) of *bociɔ* are used for protection and to fight personal battles (although with kings, military conflict was often a central concern). Additionally each *bociɔ* typology, in its role in helping persons address problems encountered in life, employs a range of alchemical signifiers. Both royal and commoner *bo* forms also are intended to help their users through supernatural faculties such as empowered speech and metamorphosis. Whereas in royal *bociɔ*, individuals are said to transform themselves into an animal, bird, or warrior form, in commoner contexts, *bociɔ* figures served as objects of transformation for incorporeal energies and powers acting at the behest of the empowering person.

Despite these similarities, the differences which exist between royal and commoner *bociɔ* and *bo* are striking. Among these are distinctions in contexts of display. As we have seen, royal *bociɔ* not only were taken to war (most were thought to move on their own accord) but also were shown publicly in the lavish annual *huɛtanu* (*xuɛtanu*) parades as icons of royal wealth and power. In their association with militarism, mobility, and lavish display, royal *bociɔ* contrast markedly with commoner works, which by and large were shown in static, somber, and rather humble contexts along roadsides or within family shrines and compounds. The private and personal contexts of commoner *bociɔ* use and significance are conveyed in clear-cut ways within these settings.

Commoner and royal works also exhibit striking formal differences. In commoner *bociɔ*, humans generally are shown in immobile or passive poses, whereas in royal sculptures, figures in active postures predominate. Most royal *bociɔ* also are considerably larger than the commoner works; indeed many of the kingly works stand life-size or bigger. Commoner sculptures in this way share characteristics of the miniature; royal figures often incorporate features of the gigantic. Susan Stewart could well have been describing traditions of *bociɔ* in her general comments on these two scale typologies (1984:xii): "The miniature is considered . . . as a metaphor for the interior space and time of the bourgeois subject. Analogously, the gigantic is considered as a metaphor for the abstract authority of the state and the collective, public, life." [1] The identity of commoner *bociɔ* with interior (psychological) space and royal *bociɔ* with exterior (political, public) space makes Stewart's comments all the more salient.

Material differences in *bociɔ* works of kings and commoners offer additional insight into status hierarchies. The royal works frequently emphasize expensive European materials such as brass, silver, or imported paint. In commoner *bociɔ*, on the other hand, materials may be rare, costly, and difficult to attain, but most have a more localized identity. Added to these differences, attributes of physical power—fierce animals and weapons—are central to royal *bociɔ*. These features of overt aggression present a striking contrast with the signifiers of covert violence (swelling, silencing, bondage, deformity, pegs, etc.) and suggestions of emotional power which characterize commoner *bociɔ*.

Many of the royal *bociɔ* additionally are distinguished by their emphasis on more naturalistic means of representation (in both anthropomorphic and zoomorphic examples). This attribute sets them apart stylistically from commoner works where variant forms of body distortions are stressed. That relative naturalism is a more characteristic feature of royal work is made clear in the following description of a life-size *bociɔ* sculpture still owned by the royal family: "When one sees this one will think that it is a man standing there. Whenever this comes out and people see it, they kneel in front of it" (Agbidinukun 5.3.86). The reasons which lie behind the greater stress on naturalism in the royal art corpus are as fascinating as they are complex. [2]

Most important perhaps, is the idea that as political arts, royal *bociɔ* stressed relatively naturalistic forms as a means of propagandizing kingly power. The emotional emphases and private orientations of commoner *bociɔ* in contrast were expressed more provocatively through forms of body distortion which stand apart from naturalistic values in essential ways. Additionally, there may be suggested in the more naturalistic kingly *bociɔ* an idea that only rulers could display human attributes to their fullest degree. Fon language terms offer support for this idea. Thus while the king, the ministers, and various free individuals bore the label of "person" (*mɛ*), slaves, peasants, and others who were politically disenfranchised were identified through the nonhuman moniker of "thing" (*nu*). If the former term suggests a conceptual orientation toward human representa-

tion with a certain degree of naturalism, the latter conveys ideas of depersonalization which coincide more closely with abstract form.

The emphasis accorded naturalism within the royal *bociɔ* corpus is underscored in turn by a range of additional human qualities associated with these works. Royal *bociɔ* as noted above were thought to be able to walk like humans. The forward-stepping foot positioning and active gestures in these sculptures visually support this idea. Kingly *bociɔ*, in addition, are said to have had the ability to communicate through human speech. Striking here is the belief that while nonroyal *bociɔ* are mute (indeed one of the explanations of their name is that like cadavers they cannot speak), the royal *bociɔ* have a fully articulated voice. Comparable to kings, royal sculptures in this way were entrusted with the full potentiality of human representation, action, and expression.[3] Commoner figures to the contrary suggest a certain diminishment of key features of human identity, action, and speech. Just as the red flowering *lisɛ* trees in front of each palace signify the health, well-being, and fullness of life identified with royalty, commoner *bociɔ* with their emphasis on silence, passivity, and the emotions convey an image of life defined in important ways by difficulty and danger.

Another significant difference between commoner and royal *bociɔ* which at once is grounded in and offers insight into representational concerns is that of dress. Commoner *bociɔ* generally show the body (however minimally defined or covered with materials of empowerment) as naked; royal figures, in contrast, frequently are depicted wearing clothing comprised either of real garments or artistically rendered examples thereof. This distinction reflects not only a concern in royal contexts with showing the human in a more true-to-life way (as a person would appear in public) but also a desire to portray status difference through dress-associated signifiers. Royal *bociɔ* clothing accordingly complements kingly attributes of wealth, privilege, and well-being. The lack of clothing in nonroyal *bociɔ* parallels a view that the commoner is someone conditioned by circumstances of poverty and difficulty on the one hand, and ritual purity on the other.

In addition to attributes of movement, speech, and clothing, royal *bociɔ* are distinguished from nonroyal works by their inclusion of essential empowering materials inside the object rather than outside (on the surface), as is characteristic of most commoner *bociɔ*. In this way too, striking aesthetic distinctions are expressed within the royal and commoner sculptural typologies. If the commoner figures suggest an image of the person turned inside out, the emotions prominently displayed on the surface, royal figures present a view of the king as someone who hides inner feelings and seeks instead to display an image of defiance and domination. In the striking juxtapositions of emotionality and physicality within these two art typologies, it is tempting to suggest that the salient psychological values expressed in commoner *bociɔ* images are at least in part a result of the overt and covert violence perpetuated by the king in the name of the state.

The important gestural and postural differences shown in royal and nonroyal *bociɔ* are of poignant interest in this regard.[4] Whereas in commoner *bociɔ*, ges-

tures often display the hands flat against the stomach or sides, royal sculptures generally portray one arm, usually the right, held high, a weapon clenched in the tightened fist (figs. 13, 155, 157–60). Throughout this area, the raising of the hand is a prominent signifier of authority. Agbidinukun suggests accordingly that the raised arm gesture means (7.18.86): "If you look for a quarrel with me, I will beat you. If you get up and come to my house, I am ready for you. Danger does not come into the house of the strong man so that he will be afraid. . . . If you ask for wood, I will beat you with wood. If you ask for fists, I will fight you with fists." The gesture of raising the hand above the head is discussed in other contexts of domination and authority as well.[5] As expressed in a common Fon saying, "If the hand rises above the head, it rises above it always." Another Fon saying notes similarly, "God created the arm longer than the head" (Alapini 1952:226). Royal might, in other words, will always endure. In a parallel example of the above, images of raised hands appear prominently in royal tomb reliefs. That of King Agonglo is said to signify, "It is with the hand that I broke the country of the enemy" (Nondichao 10.22.85). The image of a hand on King Agoli Agbo's royal appliqué was explained similarly: "If the hand holds something forcefully, one cannot remove something from it" (Bokpe 6.3.86).[6] Raised hand gestures in royal *bociɔ* convey similar ideas of the need for force in state governance.[7]

Feet positioning also is of considerable interest in the context of royal and commoner *bociɔ*. In royal works, as we have seen, the feet generally are shown in a fashion which suggests a forward striding or stepping. Most frequently it is the left foot that is positioned in front of the right. Like the raised hand, the extended left foot is a well-known signifier of power. Through its identity with Gu, this foot is thought to provide individuals with the necessary strength and determination for advance and success in life.[8] Decision making also is associated with this forward positioning of the foot. As noted in chapter 4, the expression "pose the foot on it" (*e ta afɔ ji*) indicates that one has made a decision (Pazzi 1976:178; Adjaho 7.31.86).[9] The prominence of the forward-moving foot in royal *bociɔ* offers visual support to the identity of kings as state decision makers. Also underscoring this idea is the local tradition in which kings alone were allowed to wear shoes (sandals). Today the prerogative of covering one's feet has been extended to the public at large, but the wearing of shoes in many local residences is still a privilege accorded only to the family head. As Agbanon explains (2.22.86), "I wear shoes at my house, but the others do not. This is to say that my foot has more power than others." In royal *bociɔ*, the visual emphasis given to the foot may have similar associations.[10] As Montilus notes (1972:12), "The feet (*afɔ*) are tied to the destiny (*byo wa*) of man."

Commoner and royal *bociɔ* in these variant ways can be seen at once as complementary, contrasting, and competing visual texts whose diverse forms and meanings move simultaneously together, against, through, and away from each other. In this way royal and commoner *bociɔ* reveal as much about each other as

they do about themselves and the distinct political concerns that they represent. Although commoner *bociɔ* discourse has been privileged in this book, it is not only because commoner arts often are overlooked (or devalued) in art historical analyses generally, but also, and equally important, because commoner *bociɔ* offer unique insight into provocative issues of emotional expression, power, and sculptural representation. Looking at commoner *bociɔ* traditions alongside kingly works reveals the potent ways in which art, politics, and psychology at once inform and reinforce each other at every level of society.

Appendix
Collections and Stylistic Features

I have sought to include examples of *bociɔ*-related sculptures from a broad range of cultures in southern Benin and Togo. Objects which have been photographed by me in the field primarily are from areas around Abomey and Bohicon. With some regret, I follow the example of other African art scholars in not providing specific provenience information in order not to encourage the theft or sale of these works. Related sculptures in public and private collections in Europe and the Americas come from five principal sources. Generally among the earliest works collected were those acquired by German travelers in the Evhe, Adja, and Gen areas of southern Togo around the turn of the century. A number of these sculptures, along with important information on provenience and function, are found in the Linden Museum in Stuttgart and have been published by Cudjoe (1969). Another major grouping of *bociɔ* illustrated here were collected by Christian Merlo in 1928 (see Merlo 1977) in southern Benin and coastal Togo. These objects today are housed in the Musée de l'Homme in Paris and in the Musée d'Ethnographie in Geneva (the latter collection having been augmented by the Fon scholar Claude Savary in the 1950s). A number of the Merlo examples are accompanied by important provenience and stylistic information. Other data regarding specific meaning or function, however, often is lacking; some of these works also appear to have been cleaned at some point of additive surface materials.

Bociɔ collected in 1931 by Melville and Francis Herskovits in Abomey, Allada, and nearby areas in southern Benin also constitute an important grouping. Some of these sculptures were published by Melville Herskovits in his book *Dahomey: An Ancient West African Kingdom*. Most of this collection is located in the Schomberg Center for Research in Black Culture in New York City. Information with respect to provenience and meaning is generally quite good. I have illustrated one work from the Herskovits collection, a work now in the Indiana University Museum of Art. Yet another significant grouping of *bociɔ* was acquired between 1965 and 1968 by Michael and Shirley Furst in southern Benin and Togo. This collection, which was given to the National Museum of African Art in Washington D.C., includes quite good information on both provenience and function.

The final corpus of *bociɔ* which has been important for this study comprises works collected in the 1950s or 1960s by the Paris art dealer Jacques Kerchache during his travels to southern Benin. Some of these works were published in Elsy

Leuzinger's *Afrikanische Kunstwerke: Kulturen am Niger* (an exhibition catalog for the Villa Hügel Essen, Zurich) and in the more recent *L'art africain*, by J. Kerchache, J. -L. Paudrat, and L. Stéphan. A significant number of Kerchache *bociɔ* were owned until recently by Ben Heller of New York. These works came up for auction at Sotheby's in 1983 (see Sotheby's *The Ben Heller Collection*), and subsequent years. While I have attempted to locate the current owners of these works, with the exception of the Metropolitan Museum of Art, and private collections such as those of Arnold Crane, Herbert Mulner, and Donald Nelson, this task has been virtually impossible. The works sold by Kerchache appear to have come from a range of areas in southern Benin. Unfortunately, unlike the early German collections, and the more recently collected objects of Merlo, the Herskovitses, and the Fursts, those purchased by Kerchache are missing essential information on provenience and function.

The objects published in this book come from eleven cultural-style areas in southern Benin and Togo: Fon (Abomey)/Gedevi (Bohicon), Mahi (Savalou), Dassa (Dassa Zoume), Agonli (Cové-Zagnanado), Ayizo (Allada), Hwla (Cotonou), Gun (Porto-Novo)/Ouemenu (Tori-Cada), Hueda (Ouidah), Aja (Adja Tado), Gen (Aneho), Ouatchi (Vogan), and Evhe (Lome, Kpalime). The following overview comprises my all too tentative impressions of the complex stylistic dynamics at play in southern Benin and Togolese works. As noted in the text, movement of peoples and objects in this area over the course of the last centuries has made the question of style a very complicated one. While Merlo's analysis of *bociɔ* style (1977) is informative, the area I cover here is broader and some of my findings are different from his.

Fon style is centered in the Danhomɛ capital of Abomey. The history of dynastic wars and the polyglot nature of Fon society, with its prominent incorporation of Aja, Gen, Ayizo, Mahi, and Yoruba cultural forms make this style quite diverse. In its most "classic" elements, this style is characterized by large circular eyes with a prominent horizontal eyeline across the center. An important Fon substyle displays Yoruba-like elliptically shaped eyes, sometimes with a double line around the perimeter. In still other Fon works the eyes are oval or bead-shaped. Mouths frequently are shown by a horizontal line, and the works are contained, with arms held tightly to the body. In Fon commoner *bociɔ*, the surfaces frequently are rough, showing the marks of the adze. There is also a certain sense of austerity or severeness in many of the Fon works (figs. 1, 9, 26, 32, 33, 40, 45, 64, 66, 67, 69, 72, 75, 76, 82, 88, 90, 92, 96, 98, 105, 110, 116, 129, 132, 137, 138, 139, 141, 144, and 145). The auchthonous Gedevi who once dominated the Abomey plateau today live principally in the area of Hwawe and Bohicon. Gedevi and Fon styles are almost indistinguishable (figs. 30, 34, 58, 74, 77, 81, 85, 86, 122, and 126). See also Herskovits (1967, 2: pls. 76, 79, 97–99, 101); and Merlo (1977: figs. 1, 2, 3, 5, 8).

Mahi style is centered around Savalou in west-central Benin. The original peoples of this area are thought to be of Nago (Yoruba) origin. Savalou's ruling

Baguidi family, however, are from the southern Hueda area (from the area of Lake Aheme), having moved here after an interim period of residence in Wasa (near Abomey) during the reign of the Danhomɛ king, Huegbadja (ca. 1645–80). The mountainous Mahi area, a place of refuge for various peoples during the Fon dynastic wars of the eighteenth and nineteenth centuries, has been heavily influenced by Gen, Fon, and Yoruba traditions. In Mahi works, the arms are characteristically carved along the sides, with angled forearms, and the fingers splayed outward near the hips. Heads tend to be small, with coffee bean–like eyes, and minimally defined noses and mouths. Necks tend to be wide, torsos flat, with small breasts on female works. See figures 25, 63, 65 (see also Merlo 1977: figs. 11, 12, 13, 15; Herskovits 1967, 2: pl. 80, left figure).

Dassa style (Egba), centered in the mountains of Dassa Zoume, gives evidence of the importance of this ancient Yoruba center as a crossroads and place of refuge for Fon and Mahi groups fleeing the dynastic wars of the Danhomɛ kings in the nineteenth century. Dassa figures tend to be quite tall with flattened facial features, bent elbows, and rectilinear or splayed fingers (figs. 35, 46). See also Merlo (1977: figs. 20, 21).

The Agonli style, centered along the heavily forested Zu River area around Baname, Cove, and nearby Zagnanado shows important Yoruba traits. Agonli culture is said to have developed as a result of Mahi and Dassa populations traveling down the Zu River where they met with both Ayizo groups (the latter moving into this region following the eighteenth-century conquest of Allada by the Fon) and various Yoruba peoples. This area also has had significant Yoruba influence from Ketu, and today is known for its striking Gelede masking forms. Yoruba families originating in Oyo once also resided here, the latter receiving annual tribute from the Fon kings from the early eighteenth to the mid-nineteenth centuries. Since Zagnanado also was the locale of an important Fon military camp, the area is populated by a number of Fon families from Abomey as well. Not surprisingly, Agonli style shows both Fon and Yoruba features, the latter including compact bodies with thickly lidded, elliptically shaped eyes, and triangular noses. The application of additive materials to the surface of the work, however, is characteristic of Fon, Mahi, and other cultures to the west (see figs. 94, 109, 115, 120, and 133; see also Merlo 1977: fig. 19).

Ayizo style is centered in Allada and communities occupying the plains of central southern Benin between the Kufo and Wo rivers. Ayizo influence extends down to Lake Nokoue and the towns of Abomey Calavi (Agbome Kada) and Gbessou. Once a rich and powerful state, whose ambassadors visited the courts of Europe, Allada was defeated by the Fon King Agaja in 1724. Following this defeat, the Ayizo were heavily colonized by the Fon. Ayizo style is characterized by round (beadlike) or elliptical eyes, rectilinear noses, horizontal mouths and concave facial planes. Ayizo works also frequently combine the round facial and body features of works of the Hueda style with the austere features and sense of containedness of the Fon (see fig. 121). See also Merlo (1977: figs. 9, 10, 31,

32); and the Ifa board in Ulm which was collected in Allada in the seventeenth century, published by Sieber and Walker (1987), among other places.

Porto-Novo (Hogbonu) is the capital of Gun (Gunu, Djedji)/Ouemenu culture. Peopled by Aja, with important Ayizo and Egba-Yoruba influences, this area is associated with works which show strong Aja, Ayizo, and Yoruba features. Gun works are distinguished by a long (generally thin) torso, full shoulders, and arms separated from the body. Hands usually either are attached to the body at the hips or flare outwardly as in Hueda and Evhe examples. Eyes characteristically are elliptically shaped. The head sometimes projects at the top; the mouth is often slightly opened (see figs. 47, 135). Ouemenu (Wemenu) culture extends along the lower reaches of the Oueme River to the north of Porto-Novo. Centered on the town of Adjohon, this area is believed to have been originally peopled by Abeokouta Yoruba, but became increasingly populated with Ayizo in the eighteenth and nineteenth centuries. During this era, the region was frequently the subject of Danhomɛ conquest, and as a result it has also been heavily influenced by the Fon. Ouemenu language, while showing important influences of the Fon and Yoruba, is closest to Gun.

Hueda (Xweda, Hweda, Houeda, Peda) style is centered in the lower Mono River and adjacent coastal region of southwestern Benin and Togo, in the towns of Ouidah, Godome, Athieme, Lokossa, and Come. Hueda civilization is said to have its ancestral roots among the Aja of southeastern Togo. Once the center of the powerful Sahe or Savi state, this kingdom was defeated by the Danhomɛ king Agaja in the early eighteenth century. Since that time the area came under the colonial control of the kings of Danhomɛ. The town of Glehwe (Ouidah), which developed as a trading center for European commerce in the area, also served as a point of embarkment during the era of the slave trade. Hueda style shows distinctively full cheeks, strong shoulders, and upper arms. Woods often are light (or are lightened with kaolin) and the hair, eyes, eyebrows, nostrils, lips, and cicatrization forms sometimes are picked out in a darker color. The head is prominent, with eyes which are often almond-shaped, mouths which are full-lipped, and a chin which extends prominently forward. Shoulders and upper arms often are very full and heavy. The arms are carved separate from the body with hands which frequently are fisted, or like Gen, clawlike in form. Breasts and buttocks often are large and pointed. Bodies tend to be short and compact. (See figs. 100, 123. See also Cudjoe 1969: figs. 19, 20; Verger 1954: pls. 54, 96, 125; and Verger 1982: pl. 125.)

Extending from the right bank of the Mono River to the backs of the Kufo River in eastern Togo and western Benin, Aja (Adja) style is identified with the towns of Tado, Aplahwe, and Sinwe. There were important Aja components in the predynastic Abomey as well. Tradition maintains that the Fon and Porto-Novo kings descended from Aja nobility. In the eighteenth and nineteenth centuries, much of the Aja area came under Fon influence through dynastic wars and colonialization. Aja style is characterized by its rectilinearity, with arms and

hands often creating a square. Necks are frequently broad. Heads often are square, with minimally defined physiognomy. (See figs. 49, 60, 93, 127, 143; see also Herskovits 1967, 2: pl. 80, right figure; Cudjoe 1969: figs. 16, 17; and Merlo 1977: figs. 11, 24, 37, 38.)

Like the Hueda, the Hwla (Xwla, Houla, Pla) trace their ancestors to the Aja. Occupying the coastal region of Benin from Grand Popo to Cotonou and Godome, they superceded autochthonous Ayizo peoples living in the area. Cotonou, which originally had important Hueda elements, came under the influence of the Fon in the nineteenth century. Hwla style is strikingly dynamic, characterized by sharp shifts within the bodily planes. Breasts often are tubular, and positioned somewhat low on the torso. Arms tend to be angled with elbows extending toward the back. Toes sometimes are pointed inward. The head, which is relatively small in relation to the body, often is pointed at the top. Noses tend to be triangular. (See figs. 36, 37, 89. See also Merlo 1977: figs. 16, 17, 18.)

Centered around Aneho in the coastal area and lower Mono River area of eastern Togo, the Gen (Popo, "Mina") are said to have originally come from the Fanti region of coastal Ghana. Gen art suggests influences both from this area and from the Ouatchi region in the lower to middle Haho and Mono rivers of Togo. Gen style, amply illustrated in the works published here, is distinguished by its preference for relatively small round or oval heads, small oval or cowrie eyes, arms carved away from the body (often joined at the hips), separated legs, and somewhat muscled bodies. (See figs. 42, 48, 56, 57, 61, 62, 73, 91, and 140.)

Located in the lower Mono River area of eastern Togo and the towns of Vogan, Attitigin, Afagnan, and Kouve, the Ouatchi are thought to have migrated from the Nuadja region in the seventeenth century. Their language has close ties with Evhe. Ouatchi style shows the bold geometry of Aja traditions but the more rounded features of Hueda, Gen, and Evhe works. Ouatchi sculptures often are characterized by triangular shaped heads and a concave face with protruding, bold features, the latter including prominent eyes, nose, and mouth. The arms frequently are carved close to the body. Fingers often are large and attached to the hips. Feet frequently are turned inward, showing three or four toes. In a number of works, surfaces are covered with kaolin. (See figs. 2, 20, 23, 71, 78, 117, 128, 131.)

Living in the coastal and lower regions of central and western Togo and eastern Ghana, Evhe (Ewe, Eve) issued from Notse, and today are centered not only in that town but also in the communities and areas around Kpalime (Palimé), Athieme, Keta, and Lome. In Evhe figures, the face often is flat or concave, with smallish (or minimized) eyes and facial features. Sometimes the lips are shown smiling. Arms either are not represented (alternatively, minimized) or are carved separately from the body, with the hands angled inward in a clawlike form. Bodies, which are nearly always very contained (sometimes peglike), frequently are covered with kaolin. (See figs. 22, 31, 39, 51, 79, 106, 124. See also Cudjoe 1969: figs. 3, 4, 7, 8, 9, 10, 11, 12, 14, 15, 18.)

Sources

Adido, Jean (Abomey). Blacksmith (b. 1922).

Adiha, Adjaho (Abomey). Diviner (b. circa 1940).

Adjaho, Humase (Abomey). Minister of the palace interior (b. 1904).

Adjakota, Aaisuno (Cana). Blacksmith (b. 1955).

Agbanon, Ayidonukbokunkunglo (Sodohome). Descendant of Huegbaja (b. 1936).

Agbidinukun, Kplankun (Sinwe). Glele descendant and royal historian (b. 1906).

Agbodjenafa, Sonon (Abomey). Hɛvioso priest (b. 1950).

Agbobonon, Kpohonsi (Agbobo). Priest (b. circa 1940).

Agoli Agbo, Ahande (Abomey). Descendant of King Agoli Agbo (b. 1940).

Agon, Gilbert (Abomey). Zangbeto spokesman (b. 1971).

Ahanhanzo, Vigan (Abomey). Descendant of Glele (b. 1912).

Ahonangbaso, Bodjreno (Cana). Botonon (b. 1921).

Akalogun, Catherine (Abomey). Appliqué maker in the Yemadje family (b. 1944).

Akati, Gunon (Abomey). Blacksmith and descendant of royal smiths (b. 1923).

Akpakun, Michel (Tendji-Zeko). Botonon (b. 1941).

Alladamabu, Paul (Hwawe). Diviner (b. 1965).

Asogbahu, Vigan (Abomey). Elder in Sosaadede family (b. circa 1925).

Atinsunon, Kpodohouegbe (Lokozun). Vodun priest (b. 1936).

Atinwasunu, Roger (Abomey). Botonon (b. circa 1955).

Avanhundje, Mahinon (Abomey). Botonon (b. 1895).

Ayido, Gnanwisi (Sodohome). Diviner (b. 1924).

Awesu, Heje (Dokon). Family head (b. circa 1915).

Bagbonon, Michel (Bohicon). International development specialist.

Bokpe, Tanmanbu (Abomey). Descendant of court minister in the reign of Kpengla. Museum guide (b. 1954).

Danon, Na Huenu (Abomey). Vodun priestess (b. 1921).

Dakodonu, Da (Hwawe). Royal placeholder for King Dakodonu, who is said to have ruled between circa 1626 and 1645 (b. circa 1942).

Dangban, Djonto (Allahe). Family chief (b. 1949).

Dewui, Donatien (Abomey). Diviner (b. 1948).

Djido, Antonin (Zuzunme). Family leader (b. circa 1915).

Djebo, Na (Abomey). Nesuhwe priestess (b. 1923).

Dle, Sagbo (Zado-Wasako). Sculptor (b. 1897).

Glessougbe, Da (Abomey). Diviner (b. 1926).

Huedahu, Na (Abomey). Hεvioso priestess (b. circa 1950).

Hueglo, Marcellin (Tendji). Sculptor (b. 1940).

Hunon, Dedji (Cana). Priest of Hu (b. 1935).

Katala (Tendji). Sagbata priest (b. circa 1925).

Kposin, Totida (Agnangnizou). Woodcarver (b. 1955).

Lanwusi, Da (Abomey). Diviner (b. 1945).

Legonou, Megbe (Dokon). Sculptor (b. 1935).

Mehu, Blaise (Lome). Seller of *bo* materials in the Be market (b. circa 1954).

Mewu, Vincent Sevinu (Hwawe). Kpaligan of Guede (b. 1936).

Migan, Zingla (Tendji). Court minister (b. 1915).

Mikpohani, Norbert (Cana). Hεvioso priest (b. 1970).

Mivede, Da (Abomey). Priestly head of Zomadunu temple (b. 1916).

Nondichao, Basharu (Abomey). Kpengla descendant and museum guide (b. 1941).

Sagbadju, Atinwulise (Abomey). Diviner and Glele descendant (b. 1957).

Sodokpa, Rene (Abomey). Kpamegan (b. 1925).

Tavi, Da (Abomey). Chief of royal grave diggers (b. circa 1949).

Toboko (Tendji). Wood sculptor (b. 1945).

Yemadje, Menongbe (Abomey). Head of appliqué maker's compound (b. 1895).

Zenhwen, Azoassi (Abomey). Kpamegan (b. 1911).

Zinflu, Nestor (Abomey). Head of palace tailors (b. circa 1926).

Zomahoun, Etienne (Dassa Zoume). Chief and traditional healer (b. circa 1920).

Zonatchia, Agasunon (Hwawe). Agasu priest and spokesman for Daho (b. 1918).

Notes

Introduction

1. Or as Julia Kristeva suggests (1982:53): "It is as if the skin, a fragile container, no longer guaranteed the integrity of one's 'own and clean self' but, scraped or transparent, invisible or taut, gave way before the dejection of its contents." Marc Augé also encourages us (1988) to pay attention to the materiality of the object.

2. To Russo similarly (1986:219), "The grotesque body is the open, protruding, extended, secreting body, the body of becoming, process, and change." In her view: "The grotesque body is opposed to the classical body, which is monumental, static, closed, and sleek, corresponding to the aspiration of bourgeois individualism; the grotesque body is connected to the rest of the world."

3. Compare Stewart (1984:105). Not only do commoner *bociɔ* convey the image of a body turned inside out, against itself, but the aesthetic concerns of commoner and royal images are also in key respects opposed.

4. See also Harari (1979:49), Suleiman (1980:11), and Jameson (1988:14).

5. For a discussion of early collections and styles see the Appendix.

6. Among the Evhe these works also are called *ebo* or *dzo*, "fire." Other names include *aklama*, "deity," and *ame weluvo*, "soul of the people" (Schurtz 1901: pl. 111, fig. 3). According to Merlo (1977), in the more northerly areas of Benin around Dassa-Zoume sculptures of this type are called *ope*; to the southeast around Porto-Novo and Tori they generally are referred to by the French name *garde-cercles* ("guardians"); among the Aja and other peoples along the Mono River in the Togolese-Benin border area they are often called *atignɛmɛsron* (*atignɛ*: wood; *me*: in; *sron*: spirit, husband, companion), a term linguistically related to the general Fon term for sculpture, *atinmɛso* (see chapter 3).

7. The modern nation-state known as the Republic of Benin (which was once called Dahomey) should be distinguished from the famous kingdom of Benin which is found in the neighboring country of Nigeria.

8. Other forms of *vodun* arts include various types of pottery vessels (Savary 1970; Brand 1973; Adandé and Métinhoué 1984), ceremonial dance staffs (A. P. Adandé 1962), appliqué cloths (C. Adande 1976; Adams 1980), jewelry, anthropomorphic shrines of earth (Beier 1963), and temple bas-reliefs (C. Adande 1976). In this book, the latter arts along with the well-known iron memorial staffs (called *asɛn*—see Bay 1985), are referred to only peripherally. See also Blier, forthcoming.

9. Dahomɛ or Dahomey is the name which has often been used by Western travelers and scholars to refer to the kingdom. Dahomey in turn was taken up as the country's name after the independence of this area from the French.

10. Because royal concerns have a significant impact on the lives of commoners, kingly traditions are examined in this study as well. As Arens and Karp point out (1989:xxii),

"Power is not only created and controlled in separate domains, but it acts on those domains as well."

11. On the role of art as instruments of power see Patterson (1982).

12. The most important accounts include those of Sieur d'Elbee (1671, in Hardwicke and Argyll 1746), Marchais (1725, in Labat 1956), Barbot (1732), Snelgrave (1971 [1734]), Atkins (1737), Répin (1863), Burton (1966), Lafitte (1873, 1875), and Skertchly (1874), Ellis (1970), Spiess (1902), Spieth (1906, 1911), Le Herissé (1911). More recent scholarship, which has included the writings of Herskovits (1967 [1938]), Beier (1958), Cudjoe (1969), Savary (1971), Merlo (1966, 1977), Rivière (1980, 1981), and Pazzi (1976), has focused on the form, functioning, meaning, and manufacture of associated works.

13. This term appears to have been first used by the Portuguese in reference to sculptures from this Guinea Coast area. Thus the Oxford English Dictionary suggests that the Portuguese word *feitiço* referred to "originally any of the objects used by the negroes of the Guinea coast and the neighboring regions as amulets or means of enchantment or regarded by them with superstitious dread." On related discussions in early travel accounts in West Africa see Gates (1988:140). For fetish generally see White (1978) and Blier (1993a).

14. As Merlo suggests (1977:97) by way of a query: "The 'marmousets' that the voyagers of the seventeenth and eighteenth centuries comment on throughout the Slave Coast do they not designate the Dahomey statues called *botchio*? The *marmouset* was, according to the definition of the period 'a small statue representing an idol,' then 'a small grotesque person.' 'Grotesque,' 'hideous,' 'ugly,' etc. were the epithets which the chroniclers called these statues. Publicly exposed at the entrances to villages, they are the only ones that one could see while traveling, these voyagers who rarely penetrated into the house."

15. In Labat (1956 [1725]:56). My translation is from Hardwicke and Argyll (1746:26–27). Other early descriptions of *bociɔ* from this area include those of Répin (1863), who visited the region in 1856 (see his chap. 2, pp. 96, 104; and chap. 7, p. 127), and an anonymous writer who published his finding in *Les missions catholique* in 1875 (see chap. 1, p. 96).

16. Other early travelers to Danhome such as René Répin (1863), Richard Burton (1966 [1864]), and J. A. Skertchly (1874) also discuss a diversity of *bociɔ* arts. A description of a Fon shrine complex with a number of *bociɔ* is provided by Burton (1966 [1864]:178):

> There were two sets of grotesque figures ranged in a row opposite one another. That to the south numbered six. 1) A bit of iron stone clay stuck round with feathers and planted on a swish clay step a couple inches high. 2) A little *Bo*-doll, in a cullender or perforated pot. 3) An earthenware basin with a circular base, surrounded with the *azan* or fetish palm girdle, and the *asen* or twin iron stuck in the ground before it. 4) a *Nlon-gbo* or Sheep fetish. . . . 5) an *Avun*, or canine provided with a number of claws. Finally, No. 6) was an awful-looking human face in alto-relief, flat upon its base, a swish square with a short stake planted behind it, three small earth pots rising from its wrinkled forehead; its huge gape of cowrie teeth, and eyes of the same, set in red clay, were right well calculated to frighten away, as it is intended to do, witchcraft from the devotee.

Bociↄ-like forms in clay also are discussed by Ellis in the late nineteenth century among the Evhe (Ewe). According to him (1970 [1890]:68), "*Bo* has a variety of objects particular to his worship such as 1) *Bo-sio*, small clay images representing the human figure, male or female indifferently, with the distinguishing characteristic made prominent. They are painted black, red, or blue, and some of them are attired with white caps and waistcloths."

17. Himmelheber noted in this regard (1960:246ff) that the art of the western Evhe was a deteriorated form of Yoruba. This is clearly wrong.

18. R. I. Rosaldo also takes up (1984) Bourdieu's concept of positioned subject in the discussion of emotion.

19. On popular challenges to hegemonic power see Comaroff (1985), Gregory (1986), Taussig (1987), Gates (1988), Brown (1990), and Lipsitz (1990). For a discussion of popular culture and art see Gans (1974), Hall (1981), Samuel (1981), Vlach (1978), Fabian (1978), Fabian and Szombati Fabian (1980), Jules-Rosette (1984, 1987), Brett (1986), Barber (1987), Nunley (1987), Drewal (1988), Jewsiewicki (1989), Moxey (1989), and Grossberg et al. (1992). For a recent study of "high art" and "low art" considerations in the West see Varnedoe and Gopnik (1989).

20. As Susan Stewart explains (1984:20), "The carnival presents . . . an inversion, an intensification, and a manipulation of . . . life, for it exposes and transforms both pattern and contradiction, presenting the argument and the antithesis of everyday life in an explosion that bears the capacity to destroy that life." To Stewart accordingly (1984:20), "carnival marks the intensification and display of all other textual scenes of social life."

Several recent studies have focused on the political potency of arts linked to inversion (and the carnivalesque) in conveying themes of social protest. As Natalie Z. Davis writes in her historical examination of carnival in early modern Europe (1975), it "undermined as well as reinforced" the existing social structure. Stated simply by David Hall (1984:13), "The play of carnival inverts the ordinary rules of social order." Other studies dealing with issues of carnival and inversion include Babcock (1978), Augé (1978), and Ladurie (1979). On comparable trickster symbolism see Radin (1971) and Pelton (1980).

21. In analyzing unpredictability and demonstrating its prevalence in nature, chaos theory offers models for conceptualizing the unpredictability of human affairs. See especially the writings of Prigogine and Stengers (systems which are self-organizing) (1984), Shannon and Weaver (information theory) (1949), Mandelbrot (1983), Gleick (1987), and the Santa Cruz group (fractal geometry and nonlinear systems). Related writings are perceptively explored by Hayles (1990) and Lyotard (1984). As Kenneth Burke explains (1964:96), "In a sense, incongruity is the law of the universe; if not the mystic's universe, then the real and multiple universe of daily life."

22. When first discussed by William James in the nineteenth century, "psychology" referred to that branch of philosophy which addresses the full range of problems deriving from the human condition. Although this emphasis on the sociological framing of psychology has long been important in the West, it has been particularly the followers of Freud in other disciplines who have stressed what Silverman calls (1983:73) "the *social* nature of both the preconscious and the unconscious—the degree to which both parts of the inner economy are structured by an outer one." As Wilhelm Dilthey explains (1976:95), "The inner mental structure is conditioned by the person's situation within an environment."

Art plays an important role in the above. To Dilthey (1985:56–57), the basis of all art "is a lived or living experience. . . . [T]o understand the work of art as an expression of life, we must examine it within a concrete psychohistorical context." Of vital concern is the relationship of related arts to the textuality of self and society and each work's distinctive intertextuality as grounded at once in the environment, the emotions, and artistic expression. As Spivak explains (1987:78): "This human textuality can be seen not only *as* world and self, *as* the representation of a world in terms of a self at play with other selves and generating this representation, but also *in* the world and self, all implicated in an 'intertextuality.'" Related to this is Henry Louis Gates, Jr.'s concept of the Talking Book in American traditions (1988), specifically his discussion of narratives and the ways that their writers have sought to insert local (black) voice into the written text. He argues (1988:131) that forms reveal the "tension between . . . the spoken and written word, between the oral and the printed forms of literary discourse." In *bociɔ*, similar tension exists between verbal visual expression vis-à-vis the articulation of experience. Dan Sperber's discussion (1985:77) of the epidemiology of representations also is of interest.

23. A number of studies in comparative (cross-cultural) medicine, psychology, and mental life have been undertaken. Among these are the writings of Malinowsky (1954), Hildred Geertz (1959), Field (1960), Briggs (1970), Bateson (1972), Clifford Geertz (1973), Evans-Pritchard (1976), Mauss (1979), Szasz (1970), Kiev (1972), Levy (1973, 1984), Myers (1979, 1986), Rosaldo (1980, 1984), Kleinman (1980, 1986), Obeyesekere (1985), Abu-Lughod (1986), and Crapanzano (1989). Several related anthologies also have been published. The most important include those of DeVos (1976), Heelas and Lock (1981), Shweder and LeVine (1984), Carrithers et al. (1985), Kleinman and Good (1985), White and Kirkpatrick (1985), Lutz and White (1986), and Tedlock (1987).

Studies which address related issues in Africa specifically also include several anthologies and overview analyses. Most important are Ngubane (1977), Corin and Murphy (1979), Corin and Bibeau (1980), Jacobson-Widding (1983), Feierman (1985), Riesman (1986), and Jackson and Karp (1990). A special volume published by the Centre National de Recherche Scientifique in Paris titled *La notion de la person en Afrique Noire* (1973) is of interest as well.

Recent individual case studies in Africa which offer important models include those of Fortes (1949, 1959, 1970), Wilson (1951), Horton (1959, 1961), Bisilliat et al. (1967), Abimbola (1973), Gollnhofer and Sillans (1975), Berglund (1976), Turner (1967), Janzen (1978), Jackson (1978, 1982), Beidelman (1980), Riesman (1986, 1990), Fernandez (1974), Gottlieb (1982), Makang Ma Mbog (1972), Mudimbe (1982), Ortigues and Ortigues (1984), Lienhardt (1985), Ottenberg (1988, 1989), Jacobson-Widding (1990), and MacGaffey (1991).

Relatively fewer studies have dealt cross-culturally with issues of art, identity, psychology, or the emotions. Among the more interesting are those of Hanna (1983), Schieffelin (1976), Feld (1982), and Abu-Lughod (1986). African art studies specifically include those of Ottenberg (1982), Sieber and Walker (1987), Armstrong (1981), and Blier (1987).

24. The Frankfurt school of social philosophy which emerged in Germany in the 1920s and 1930s also has offered provocative insight into the interrelationship between politics and artistic expression. Associated scholarship by Max Horkheimer, Theodor Adorno, Erich Fromm, Herbert Marcuse, Otto Kirchheimer, Leo Lowenthal, Walter Ben-

jamin, and (somewhat later), Jürgen Habermas, among others, in what is now generally called critical theory has raised questions of vital importance to *bociɔ*. These works, in their expression of difficulties, doubt, and disorder, reveal the impact of social conflict on artistic form. As Adorno, one of the key members of this group, explains (1984:57), for autonomous art traditions in the West, art "is not just an echo of suffering . . . it neutralizes suffering."

To Marcuse similarly (1978:xii–xiii), "The more immediately political the work of art, the more it reduces the power of estrangement and the radical, transcendent goals of change." He continues (1978:55): "Art draws away from this reality, because it cannot represent this suffering without subjecting it to aesthetic form, and thereby to the mitigating catharsis, to enjoyment. Art is inexorably infested with this guilt." Although Adorno's and Marcuse's arguments are focused on late capitalist and European art contexts, in many respects the concerns are equally valid for contexts of social disorder and disequilibrium in other periods and places as well.

25. Notable work on more general topics of psychology and art has been done by Kris (1967), Spitz (1985), Erikson (1963), Gombrich (1973), Gay (1976), Steinberg (1983), Spector (1988) and Freedberg (1989). For a discussion of the role of feeling in aesthetic contexts see Langer (1942, 1953).

26. The observations of Kris (1967:22) here are apt: "Instead of accepting the division of form and content, maintained in many areas of the history and the criticism of art, psychoanalytic orientation suggests the value of establishing their interrelation."

27. With respect to African art discourse generally, to a large degree, the sculptures of differing status groups within the state have been treated as relatively undifferentiated and homogenous units. Primary distinctions between courtly and commoner, capital and countryside, empowered and disempowered peoples often have been left unexplored with respect to associated differences and their artistic significance. In this study I take up the challenge posed by Douglas Fraser and Herbert M. Cole's groundbreaking anthology, *African Art and Leadership* (1972), but broaden the arguments.

28. The latter objects, like *bociɔ*, function according to Wyatt MacGaffey (1977:175) as "both avenger and victim; [their] . . . appearance reflect[ing] this ambivalence." While it may be tempting to suggest that *bociɔ* forms are derivative of the better known (in the West) Kongolese sculptures, that the latter is the source of the former is highly unlikely. Indeed historians generally trace African migration from West to East, thus making any early influence more likely to have flowed in the opposite direction.

29. Many of the royal wives also were foreign war prisoners. It is maintained that the best makers of *bo* are of foreign birth. Thus Agbanon notes (interview of 2.25.86) that "it is those prisoners who were captured during war who made the best *bo* for the king. For this reason the king did not kill them. He would enthrone them as chiefs and use their *bo*."

30. As Max Weber has written (1962:117), power is that which "permits one to carry out one's own will even against resistance and regardless of the basis on which this opportunity rests."

31. See Nooter (1993).

32. The data of other scholars, while critical to my study, unfortunately do not allow for anything but perfunctory comparisons. Other than a greater emphasis in the early twentieth-century studies on objects used in war, and references in recent studies to mo-

torcycles, school exams, and shop security, many of the problems addressed in these diverse publications seem remarkably similar.

Chapter 1

1. This was used as a general term for those who left the Guinea Coast area through the port of Ouidah.

2. Slavery never was a royal monopoly, however. For a theoretical discussion of slavery in Africa see Meillassoux (1986). On issues of slavery and art in Africa elsewhere see Blier (1993c:395–96) and MacGaffey (1986:265).

3. As Manning explains (1982:39), "Those enslaved through capture or condemnation, however, were disposed of in several ways. Most of the men and many of the women were exported. The remainder of the men and most of the women were allocated among royalty, notables such as state officials and merchants, and the common people. Slaves of royalty included those who worked the fields to supply the palace, those executed in human sacrifice, household servants, wives and concubines, and state officials. Merchants and officials with large land holdings used slaves to produce for and serve their families, as concubines, and in their commercial operations."

4. See Packard (1980) on the relationship between misfortune and social change.

5. Members of the royal family also for a time monopolized educational opportunities for their family by restricting others from entering schools (Manning 1982:268–69).

6. The aggressive system of colonial taxation also had its effects. During this period, numerous individuals and sometimes whole villages were reported to have moved in order to avoid paying (or to diminish the cost of) the hated *impôt* (Manning 1982:206). The use of colonial "recruits" to build (and repair) roads during this time sometimes also involved large numbers of people. Manning cites (1982:206–7) one example of recruits in Savalou and Savé in 1906 who numbered 13,181 men, while the census reports for 1907 from those same areas listed a local male population of 13,682.

7. In the poststructuralist writings of Deleuze and J. F. Lyotard, we see in turn what Jameson calls (1988:168) "the ideological significance of the refusal of the negative . . . with its valorization of absence and contradiction." As Sartre notes in his introduction to Fanon (1963:17), "We only become what we are by . . . deep-seated refusal of that which others have made of us."

8. As Wellek and Warren suggest (1956:90), "Art not merely reproduces life but also shapes it." Kris is even more adamant (1967:51): "The artist does not 'render' nature, nor does he 'imitate' it, but he creates it anew. He controls the world through his work."

9. Such works constitute potent visual complements to what Bastide calls (1972) the sociology of mental disorder. The observations of psychoanalyst Karen Horney (1939:194) are insightful and relevant here as well: "Anxiety is an emotional response to danger, as is fear. What characterizes anxiety in contradistinction to fear is, first, a quality of diffuseness and uncertainty. Even if there is a concrete danger, as in an earthquake, it has something of the horror of the unknown."

10. Theodor W. Adorno's posthumous *Asthetische Theorie* (1984) takes up complementary traditions of negative aesthetics in the West. He argues in this work that art which participates in the process of social emancipation shows two qualities of negativity: one in relation to the social reality which conditions it, and the other in its historical

construction. According to Adorno (1984:68), "In art itself, dissonance is the technical term for what ordinary language and aesthetics call ugliness." He associates (1984:21) dissonance in art with feelings of pain and alienation.

11. Ayido adds (4.15.86), "The *bociɔ* does not need to resemble a person exactly. If a person does not have the money to buy a sculpture he can make something from a piece of wood that suggests a person. It too will become a *bociɔ*." Certain aesthetic criteria also come into play in the incorporation of additive materials. As Ayido asserts (5.18.86), "If we simply tie the body it is a *bociɔ*, but it is there where [the cord] should stay so that it will look right that he will tie it." Herskovits notes similarly (1967, 2:272) of one sculpture, "The black cord [around the neck] has no magic powers, but is used to give to this *gbo* a pleasing appearance . . . red strands . . . are also only there to make *gbo* attractive." While I would disagree with Herskovits regarding the exclusively aesthetic role of red (or any other colored) threads, what is clear is that appearance is important. Like many other religious arts around the world which are seen to serve a vital intermediary role in bringing about change both individually and for society at large, aesthetic concerns are of vital importance, for it is through this means that difficult emotions find expression. The differing ways societies and eras express these emotions in art are of considerable interest for this reason.

12. For other studies of African aesthetics see Memel-Fote (1966), Fernandez (1966), Crowley (1973), Thompson (1973), Lawal (1974), Rubin (1974), Blier (1976, 1989a), Warren and Andrews (1977), Borgatti (1979), Cannizzo (1979), Silver (1979), Drewal (1980), Ravenhill (1980), Aniakor (1982), Cole (1982), Abiodun (1984), Appiah (1984), Cole and Aniakor (1984), Smith (1985), Glaze (1981), Vogel (1986, 1980), Arnoldi (1986), Boone (1986), Van Damme (1987), and Adams (1989). The early anthropological study of Leach (1954) also is of interest.

13. The designation "youthful," it should be noted generally, is employed for those individuals who are between the ages of sixteen or seventeen and forty, i.e., persons at the prime of their lives (Segurola 1963:127). The term *ɖiɖi*, in its emphasis on qualities of shininess and glitter, also implies a valuation of things which are "new," and "fresh," an important aesthetic principle elsewhere in Africa as well. As an adjective used to describe an individual's character, however, *ɖiɖi* sometimes has perjorative associations. To say that someone is "polished" or "smooth" (*e ɖiɖi wutu*—literally, "he has a smooth body") is to suggest that he is affable but has a bad heart. A related proverb asserts: *Atin wutu ɖiɖi xomɛ kacakaca*, "the body of the tree is smooth but its interior (stomach) is rough (harsh)" (Segurola 1963:140).

14. For a discussion of the importance of ugliness in other African art contexts see Horton (1963, 1965), Cole (1969), McNaughten (1979), Messenger (1973), Hommel (1974), Ottenberg (1972), Philips (1978), Brain (1980), Cosentino (1982), Biebuyck (1986), Picton (1986), and Van Damme (1987). As Van Damme points out in his overview study (1987:57–66), ugliness in African art is often associated with the expression of values such as evilness (greed, self-interest, etc.), fear (terror, danger, sinister circumstances, disease, death), and comic relief. Aesthetic emphasis on concepts of wilderness and the world of animals are also of interest. See Ben-Amos (1976), Bourgeois (1984), and Anderson and Kreamer (1989) among others.

15. Taking their theoretical moniker, subaltern studies, from the term employed by Antonio Gramsci to refer to those who are subordinate or of lower rank (subaltern, from

the Latin *sub*: under, and *alternus*: alternate), associated scholars, in the words of Guha and Spivak (1988b:35), focus on issues of "subordination . . . whether this is expressed in terms of class, caste, age, gender and office or in any other way." Stated simply by Gayatri Spivak (1987:246), we "need to make the subaltern classes the subject of their own history." Particularly significant for those engaged in subaltern studies is the insistence that the subaltern must be explored not in isolation, but always in relation to the dominant class. As Said suggests (1988:viii): "Subaltern [and] elite . . . are different but overlapping and curiously interdependent territories. This, I believe, is a crucial point. For if subaltern history is construed to be only a separatist enterprise . . . then it runs the risk of just being a mirror opposite the writing whose tyranny it disputes. It is also likely to be as exclusivist, as limited, provincial, and discriminatory in its suppressions and repressions as the master discourses of colonialism and elitism."

While my study privileges commoner *bociɔ* traditions, it also addresses the complementary kingly arts, not only because they offer insightful comparatives, but also because elite and subaltern traditions in this area inform each other in critical ways. Additionally, many subaltern studies are characterized by their promotion of change (Spivak 1987:3), as are *bociɔ* traditions which propel their users and viewers to actively confront life's difficulties. Finally, the comprehensive interests of subaltern scholars in moving across and beyond common academic boundaries (see Said 1988) also find expression here, with this analysis extending outside what many may feel are traditional art historical concerns.

In some respects, however, as will become clear, my discussion of *bociɔ* sculpture also deviates from many subaltern studies. While I may privilege art within the larger discourse (rather than include it primarily for illustrative purposes), my interests lie more with local (indigenous) conceptualizations of the psyche than with the applicability of Western psychoanalytic theories to *bociɔ* art and cultural expression. Sheflen remarks in this light (in Kristeva 1971:271–72) that: "The question is whether the middle-class Western European's behavior, deviant or not in his own group, is representative of the people of other classes and other ethnic traditions. . . . They imagine that people are the same no matter what border or breed has separated them. . . . It is true, of course, that all cultural divisions of people eat, sleep, walk, speak and mate. But the form of these behaviors varies greatly. Even the affective and cognitive activities are culturally relative. . . . we are left with the conclusion that psychoanalytic constructs are at present ethnically and class bound." This book also offers little by way of self-conscious or self-reflective discourse. What I hope to offer in this analysis instead are the distinct voices, languages, and idioms of their many users and creators.

16. Military camps also are perceived to be places where fury or force predominate. As Agbidinukun explains (5.23.86), "In . . . a military camp there is also force." So too the most important criterion in selecting a royal strong name is that it is "forceful." This is because, as Migan points out (5.21.86), "one wants to select a name so that people will be scared of him." Fear is also an essential feature of *bociɔ* aesthetic response.

17. In *bociɔ*, attractiveness is far less valued than is internal strength. As expressed in Lete Medji, one of the Fa divination signs: "The *honsukwekwe* tree is pretty, but there are holes on the interior."

18. In this discussion the terms "witchcraft" and "sorcery" are used interchangeably.

19. As Ivor Kopytoff explains for Africa generally (1987:19), "Internal tensions . . . commonly expressed themselves in mutual suspicions and accusations of witchcraft."

Evans-Pritchard's discussion of sorcery in Azande here is apt (1976:18): "If blight seizes the ground-nut crop it is witchcraft; if the bush is vainly scoured for game it is witchcraft; if women laboriously bale water out of a pool and are rewarded by but a few small fish it is witchcraft; . . . if a prince is cold and distant with his subject it is witchcraft; if a magical rite fails to achieve its purpose it is witchcraft; if, in fact, any failure or misfortune falls upon anyone at any time and in relation to any of the manifold activities of his life it may be due to witchcraft."

20. Clyde Kluckhohn suggests (1944:45–47) in this way that witchcraft accusations allow for the displacement of social aggression and anxiety in contexts where there were few other means of expressing aggression. Sociologists accordingly have argued that witchcraft accusations often are both indices of social tension and vehicles of social change. As Paul and Laura Bohannan note for the Tiv of Central Nigeria, "The power which is effective in witchcraft is one that can also produce socially approved results" (in Mair 1969:61).

21. See also Malinowsky (1970) on witchcraft and misfortune.

22. As Beidelman observes (1963:96), "Witchcraft is anti-social and often explicitly or symbolically expresses the conflict between society and an individual. This conflict is expressed through powerful motifs which deal with the reversal of physical and social normality and perhaps with certain fantastic, suppressed desires of the individual."

23. Beidelman suggests similarly (1963:74) that although anyone might be a witch, certain types of persons are suspected more frequently than others: economically successful persons, powerful chiefs, nonconformists, a wife who cannot be controlled, a woman envious of her co-wives, persons who do not meet obligations of kinsmen, tribal outsiders.

24. Similar symptoms were identified by Fanon with Algerians during the difficult period of its war for independence. Beiser thus suggests (1985:279–80) that Senegalese people experiencing depression complained of a heavy head, nightmares, constipation, upset stomach, loss of appetite, nausea, and dizziness.

25. That psychological factors are important in this area with respect to sorcery accusations there can be no doubt. As Kossou explains (1983:228–29) in discussing the Fon: "The immediate experience that a person has of sorcery derives often either from a dream in which he sees himself the subject of aggression by a sorcerer, or from a hallucination, in which he sees all except the sorcerer who attacks him."

26. In early modern Europe, according to Fisiy and Rowlands (1989:82–83), elites strenuously tried to suppress peasant popular cultures through witchcraft accusations.

27. For comparable associations elsewhere see Karlsen (1987).

28. The deities *Na* Buruku (Na Buluku) and *Ana*, who are described variously as "Mother of the World" and "Goddess of Birth," also are associated with the power of sorcery (Gilli 1982a:59).

29. The extraordinary ambivalence with which sorcerers are regarded in this area stems not only from the above, but also from the tradition of creating the Minona shrine at the death of the senior woman of the compound in honor of her power. These associations additionally may lie behind the common linking of menstruation difficulties with witchcraft. Although there are sociological reasons for this type of female scapegoating (most important, a kinship system in which women remain outsiders in their husbands' homes), this does not obviate the belief that often it is the women themselves (or their

children) who are said to be the subjects of the most heinous sorcery acts. While women in Fon society have a certain degree of power, due in large part to their prominent religious roles and market preeminence in the area, in social and political contexts, their positions have been clearly secondary to those of men. As in many places, a woman's status and identity were largely determined by her father and then her husband. Thus, even during the course of the kingdom when female ministers assumed key roles in the running of the court and the state at large, their positions were defined largely by their marriage to the king.

30. According to Middleton and Winter (1963:14): "In a number of societies in which residential groups are based upon patrilineal principles, specific accusations of wizardry are made against women . . . women . . . come from the outside as the consequence of the rules of exogamy. They act as divisive factors in terms of the solidarity of the agnatically related core of men."

31. As Natalie Z. Davis explains (1975:131) for the "unruly woman" in European carnival, associated themes had important sociopolitical benefits:

> [T]he image of the disorderly woman did not always function to keep women in their place. On the contrary, it was a multivalent image that could operate, first, to widen behavioral options for women within and even outside marriage, and, second, to sanction riot and political disobedience for both men and women in a society that allowed the lower orders few formal means of protest. Play with the unruly woman is partly a chance for temporary release from the traditional and stable hierarchy; but it is also part of the conflict over efforts to change the basic distribution of power within society.

32. Women also are makers of *bo*. Toboko explains, however (12.18.85), that "they do not do all the *bo* that men do. . . . There is not a person who has not made a *bo*." In the words of Ayido (5.5.86) "Each person had their *bo*."

33. The use of the term *si* however can refer to both men and women. In amorous contexts, *kennesi* sometimes is used in reference to a female lover.

34. If, as Erikson argues, shifting community boundaries tend to encourage witchcraft accusations, then the relative stability of the current era also may be important. To Erikson (1966:68–69): "[W]henever a community is confronted by a significant relocation of boundaries, a shift in its territorial position, it is likely to experience a change in the kinds of behavior handled by its various agencies of control. . . . the crisis itself will be reflected in altered patterns of deviation . . . perceived by the people of the group as something akin to what we now call a crime wave."

35. The situation appears to have been similar in Bunyoro (see Beattie 1963:55).

36. As Mitchell suggests (in Marwick 1970:380) of witchcraft circumstances elsewhere, these kinds of accusations decrease where it is "possible for hostility and opposition to be expressed openly rather than supernaturally, and . . . where tension between intimate associates arises, [there is] an alternative to mystical projection."

37. The above finding has interesting complements elsewhere in the world, for it has been argued that the prosecution of individuals accused of practicing witchcraft and magic in England decreased when formal institutions for the relief of the poor were developed and conditions for these persons saw related improvement (Macfarlane, in Mair 1969:215). Macfarlane argues that this accompanied a "move away from the conceptualization of charity as a general Christian duty to the idea that it should not be given indiscriminately, paralleled by the development of formal institutions for the relief of the

poor" (in Mair 1969:215). As difficulties in life have diminished, so have the arts that served to counter associated problems.

38. While *vodun* often is translated as "god" or "supernatural power," its meaning is far more complex. For Parrinder (1969:212), *Vodu* is something that one cannot touch and which must remain apart. To Gilli, it is the idea of mystery that is most important (1982a: 2–3). According to him, *vodu* include water, fire, wind, certain plants, the python, and certain animals and springs, some beings (humans), the stranger, and the head of each individual. (See Blier, forthcoming.)

39. Where within this language family the word first appeared is unfortunately impossible to determine.

40. Nonetheless, Segurola provides (1963:552) information on the constitutive radicals, *vo* and *dun*, noting that *vo* means "to supplicate," "to be at ease," and "to be apart or different." *Dun*, Segurola suggests, has but a single meaning, "to draw water."

41. Gilli goes on to note (1976:12–13) that in the case of *vodun* "in general, it is not a question of a purely material interpretation but rather the authentic symbolism around it." As the above suggests, the idea of secrecy is of considerable importance for the meaning of *vodun*. Although the term *vo* means "hole" or "opening" in this language, its ontological significance lies more in the belief that *vodun* powers usually must remain closed and away from gaze. The relationship between "hole" and *vodun*, although not etymologically grounded in the same way among the Fon, nonetheless constitutes an important religious component here. The diviner, Ayido, observed similarly (4.25.86) that "all the *vodun* in this world go under the earth; they cannot stay in the open air in the view of everyone."

42. Segurola however does not include "unseizable" or "invisible" among the Fon definitions of *vo,* although two of his associated words, "apart" and "to the side," may suggest something of this idea. Nonetheless, Maupoil's definition does find general (if not strictly etymological) support in Segurola's observation (1963:552) that *vodun* "evokes an idea of mystery and designates that which derives from the divine." Furthermore, as Segurola notes, the word *vo* appears in the term *Vovolivuɛɛ* in reference to a place at once mysterious and distant. As to the exclamation *hun*, Segurola identifies it with a very different meaning than that supplied by Maupoil. Segurola writes that *hun* is an affirmation signifying "thus," "certainly," or "of course."

43. The Fon term for pool, *do* (that which one should sit calmly beside in waiting for what life offers) also means "hole," "grave," "depth," "bottom," and "origin." In this there may be a linking of Evhe and Fon notions about the nature and meaning of *vodun*, since as we recall, the Evhe word *vo* also means "hole." The use of the image of the hole metaphorically is tied into this idea. Thus, for example, to know something in all its profundity is expressed in Fon through the phrase *ba nu do,* "to look in the hole of the thing" (Ayido 4.30.86). Similarly the Fon employ the expression *eba nu do* ("he looked in the hole of the thing") to mean "he deepened his search" (Pazzi 1976:65).

44. Meaning daughters or sons.

45. In this they share much in common with Nisei, or second-generation Japanese in the United States. As Stanford Lyman suggests for the Nisei (1970:92): "Nisei character places its greatest emphasis on composure, including all its ramifications of physical and mental poise during any act, calmness in the face of disruptions and embarrassing situations, presence of mind and the avoidance of 'blocking' under pressure, emotional control

during sudden changes of situation, and stage confidence during performances before audiences."

46. This theme of changeability is also an important subsidiary subject in Fon depictions of chameleons in sculpture, appliqués, and wall paintings. One of the phrases in the Fa divination sign Yeku Meji relates how "life does well to alternate itself; Sɛgbo-Lisa [symbolized by the chameleon] will never dress in one cloth." As Maupoil notes in discussing this passage (1981:447), "It means the one who is rich today will be poor tomorrow and vice versa."

47. Looking more closely at linguistic usage of the term *hun,* we are able to see other associations as well. As a verb, *hun* means "to open" (and figuratively both "to be content" and "to spoil"). The Fon identity of *hun* as "opening" is of interest since the Evhe radical *vo* also means "opening" or "hole." For the Fon, according to Ayido (5.18.86), "One says *vodun hun* because that which you cannot see the bottom of [that which is closed to you] the *vodun* will be able to see."

48. Both Ketu and Savé were defeated and destroyed by the Danhomɛ forces the nineteenth century.

49. Reinforcing this idea, according to Agbidinukun (5.3.86), "one is referring to the Gedevi [the autochthonous residents of the Abomey plateau] in saying the inhabitants of *hun.*"

50. Amplifying on the above, Agbanon remarked (2.27.86), "It is because their blood did not terminate that they are called *vodun hun.*"

51. In part for this reason, costumes worn by *vodun* initiates frequently emphasize red. As Adande explains (1976–77:61), "The *vodunsi* had a profound sense of this symbolism of colors and it is not surprising that, whereas in ordinary life one repudiates the use of red, the *vodunsi* use it more frequently." So too the red tail feathers of the African gray parrot (*kɛsɛ*) are a central component of *vodun* shrines and regalia. The red bead called *lankan* is closely identified with *vodun* as well. As Agbanon notes (5.27.86), "We use it for the *vodun.* All *vodun* that are in this life use this *bo.* It is a *vodun* bead (*vodun djɛ*) made by Mawu." Appropriately the crown of Daho, the sacred head of the Agassu cult, is said to be composed of red parrot feathers and *lankan* beads. Parrot feather headdresses also are identified with the gods. In the Fa divination sign Lete Gbe, we learn that "Loko's wife bought three red feathers from the tail of the parrot and came to her husband with them [to assuage his anger at her]. She placed these feathers in his . . . hair . . . , one above the forehead, one above each ear, saying: I crown you today. You are king" (Maupoil 1981:666). Religion, rulership, and regalia, as we can see, are closely linked. What is also clear, although expressed in this passage much more subtly, is a message concerning valued forms of human conduct, expression, and philosophy.

52. Witchcraft accusations here as elsewhere appear to have coincided with certain features of social disequilibrium. According to Boyer and Nissenbaum (1974:180): "The problems which confronted Salem Village . . . [included] the resistance of back-country farmers to the pressures of commercial capitalism and the social style that accompanied it; the breaking away of outlying areas from parent towns; difficulties between ministers and their congregations; the crowding of third-generation sons from family lands; the shifting locus of authority within individual communities and society as a whole; the very quality of life in an unsettled age."

53. The method used, however, which involved an egg and a glass, is said to be English rather than West Indian in origin (Hansen 1969:31).

54. According to Herskovits (1964:237): "While the nature and forms of . . . magic that have been thus far discussed show a characteristic African pattern, the presence of the factor of medieval European magic is evident."

55. As Moreau de Saint-Méry explained at the end of the eighteenth century, "it is the Aradas Negroes (that is to say the Blacks from Dahomey) who are the real devotees of Voodoo, keeping up its spirit and rules" (in Metraux 1972:29).

56. Herskovits adds (1964:335, n.2), "The term *garde* is almost entirely absent in later writings, the more sensational *wanga* (*ouanga*) being preferred." Herskovits's discussion of the making of these objects (1964:228–38) suggests marked similarities with *bo* and *bociɔ* traditions.

57. Karen McCarthy Brown (personal correspondence, 8.5.92). They may also take their name from the Fon term *kpe*, meaning "to solder" or "to join" (*kpen*, in Fon, means "to attach solidly").

58. Also complementing West African *bo* forms is Brown's description of the *pwen* as something which "represents the condensation and appropriation of spiritual powers." In Yonker's words (1985:5), *pwen* constitute "gatherers of force."

59. Although Thompson argues that they have a Kongolese source (1983:143–45), their origins can also be found in southern Benin and Togo.

60. Other Fon terms also are linked to the meaning, use, manufacture, and religious base of Haitian *bo* forms. Among the most important are the *sacra* (*hun*), the priest (*hungan*), the devotée (*hunsi*), the altar (*kpe* [mound]), and the special ritual designs which are made with a mixture of cornmeal and red palm oil (*ami vɔvɔ*).

61. Thompson suggests (1983:166) that the term may also have its roots in the Yoruba word *l'awo,* "mystery."

62. See Brown (1987) on sorcery in Haiti.

63. Like sorcerers in the Fon area, those in Haiti are said to be distinguished by their red eyes (Herskovits 1964:238–39).

64. Deren links Petro *vodun* (1953:64) to Carib-Indian sources.

65. Contexts of presentation and display also are similar. As Thompson notes in reference to a Port-au-Prince Petro room (1983:182), "Such rooms are striking for the touches, sometimes of deliberate horror, meant to suggest the moral terror of this fiery side of *vodun*." Compare this with the descriptions of *bociɔ* shrines in chapter 2.

66. According to Dantes Bellegarde, in Metraux (1972:41), in Haiti "voodoo had become less a religion than a political association."

67. According to Tallant (1971:19, 20): "As early as 1782 Governor Galvez of Louisiana prohibited the importation of Negroes from Martinique because he believed them to be steeped in Voodooism and that they 'would make the lives of the citizens unsafe.' A decade later Negroes from Santo Domingo were likewise banned. It was only with the arrival of the American authorities after the Purchase of 1803 that . . . the prohibition against Negroes from the West Indies was lifted." Tallant suggests with this in mind (1971:22) that "so far as was known there was only an occasional voodoo gathering in New Orleans until the arrival of these Santo Domingo Negroes." Although Tallant is generally not a very reliable source, the above statements are intriguing and need to be further studied.

68. She died in 1881, but her identity was subsumed by that of a daughter who had the same name. Charms made by the two Maries in conjunction with *vodun* show striking similarities with *bo*. According to Tallant (1971:99):

> The *gris-gris* [charms] sold by Marie II included small bags to be worn for protection or for good luck. These were bits of cloth into which were placed such articles as bits of bone, colored pebbles, goofer dust—dust from the graveyard—some salt and some ground red pepper. Others were more elaborate, one being a tiny vest woven from horse hair. . . . These were sewn to the hem of a skirt or to a garter for the purpose of warding off evil. . . . Still others were made of red flannel and contained a lodestone; these were—and still are—considered very helpful to gamblers. Another sort held gunpowder and red pepper; these were *wangas* to be thrown into somebody's path to cause them to fight. . . . One . . . encouraged a miser to spend every cent he possessed on the one who did the ablution.

One of Marie II's followers published a book called *The Life and Works of Marie Laveau*, which includes fifty descriptions of how to perform "Voodoo magic." The concerns of many of the instructive paragraphs suggest the psychological and social importance of related acts (Tallant 1971:235). Among the problems discussed were the following: "The Lady Whose Lady Friends Spoke Meanly of Her," "The Lady Who Cannot Face Her Landlord," and "The Man Whose Wife Left Home." Like Haitian and West African *vodun* priests, Marie also was considered to be knowledgeable in medicine; accordingly her business card read "Healer" (Tallant 1971:102).

69. Possibly this term *hoodoo* is derived from the Fon word *hun* or *hu*.

70. Part of the propaganda campaign against Manuel A. Noriega, the fallen Panama leader, involved accounts that he "practiced voodoo with vats of blood and animal entrails" (*Los Angeles Times*, Sunday, December 31, 1989).

71. Several excellent works have been published on complementary early African American Hoodoo or "conjuring" practices in the United States and the Caribbean. Among the most important are Puckett (1926), Hurston (1931, 1935), Hyatt (1970), Bell (1980), Brandon (1990), and Brown (1990). During the slave era, related traditions served as a means of psychological survival and empowerment (Genevese 1976:221–24; Levine (1977:55–80). I thank David Brown for pointing these sources out to me.

Chapter 2

1. Adding to the above, Benjamin notes (1978:305–6) that "the external world that the active man encounters can also in principle be reduced, to any desired degree, to his inner world and his inner world similarly to his outer world, indeed regarded in principle as one and the same thing."

2. See also Blier (1988a:79–80).

3. Or in the Platonic trinity, the imitator (one who "copies" or "forges" from life).

4. The producer can be seen to be identified with such diverse roles as the art patron, dealer, distributor, editor, and critic. Harari notes (1979:70) that "the critic is, as well, a *producer* of text." For an analysis of the production imperative in art generally see Becker (1982).

5. On textual thickness in the context of ritual see Clifford Geertz (1973). For related issues in African architecture seen Blier (1987). In literature Roland Barthes's writings have been influential. As stated somewhat tersely by Barthes (1989b:59), "The text is

plural." He adds (1989b:53–54): "In multiple writing, in effect, everything is to be *disentangled,* but nothing *deciphered,* structure can be followed, 'threaded' (as we say of a run in a stocking) in all its reprises, all its stages, but there is no end to it, no bottom; the space of writing is to be traversed, not pierced. . . . Thereby, literature (it would be better . . . to say *writing*), by refusing to assign to the text . . . a 'secret,' i.e. an ultimate meaning, liberates an activity we may call countertheological." See Bakhtin (1981) on the importance of the polyphonic.

6. Barthes, who has played a central role in decentering the author/artist, argues (1989b:53), "Once the Author is distanced, the claim to 'decipher' a text becomes entirely futile. To assign an Author to a text is to impose a brake on it, to furnish it with a final signified, to close writing." As Eagleton has observed (in Fowler 1987:46), by "decentring" the individual author (artist), he or she "can then be seen not as the unique, privileged and perhaps mysterious 'creator' of the text, but as a particular analysable element in its constitution, a 'code' or ideological sub-formation in itself."

7. Linker (1984:391–92) notes similarly in the context of literature that "over the past decade there has occurred, across a body of discourses, a significant shift in the way we conceive of the text. The demise of the author as transcendent self or bearer of meaning has borne along a rejection of the text as discrete or self-contained object. . . . The movement from analysis of artistic products toward consideration of the production of meaning, then, can be seen to stem from awareness that consumption completes production— that there is, in any discursive situation, a 'reader in the text.'"

8. As Stewart observes, in allegory (1984:3) "the vision of the reader is larger than the vision of the text." Or in the words of Coiffi (in Spitz 1985:36), "A reader's response to a work will vary with what he knows." This is not to say as do some critics that all "reading" is a question of "misreading," nor need we reject all possibilities for "correct" readings. The point is to emphasize readings and readers in the plural. In other words, there is not one but multiple "correct" readings and readers.

9. These communities of viewers range from local *bo* or *bociɔ* activators or users, to missionaries proselytizing in the region, to African art connoisseurs, to those who are completely unfamiliar with these objects.

10. Nonetheless at the time, many people supported this move at least nominally, for most knew of someone who had been harmed in a minor or major way by some form of action or event attributed to the power of *bo* or *bociɔ.*

11. On the issue of audience participation see Alfred Schutz (1951).

12. On the importance of audience interaction see Schutz (1951).

13. For a discussion of *kudiɔ-bociɔ* see chapter 2.

14. As Jauss points out (1982:10), "[T]he poet who transforms his experience into literature also finds a liberation of his mind which his addressee can share."

15. As in T. S. Eliot's idea of "objective correlative."

16. Some makers seeking the renown which accompanies such adoration go so far as to advertise their expertise through the selection of special names. As one man noted (1.12.86), "I gave myself the name Avanhundje because I made *bo.* My name means "no matter who looks to reach me by way of the *bo,* he will never arrive."

17. While in some cases, it is the client who procures the needed materials for a *bociɔ,* in other cases, the specialist will purchase the items with money provided by the client (Maupoil 1981:143).

18. The high prices charged by *bo* makers also reveal the fact that there are no owner-ship rights as such for particular *bociɔ* and *bo*. Herskovits notes (1967, 2:263), "The *gbo*, once given, is the property of him to whom it has been revealed. Yet once given, the knowledge of a *gbo* spreads rapidly, for anyone who pays for the use of it becomes its owner, and may sell it if he desires. As long as its power is not vitiated by violations of the taboos which accompany it, its potency will be retained."

19. Other centers of *bociɔ* carving discussed by Merlo (1977) in Benin and Togo in-clude Porto-Novo (Lake Nokoue), Allada, Tori, Zagnanado, Dassa-Zoume, Tado, and Grand Popo.

20. See Blier (1988b and 1989b) for a discussion of Herskovits and princely artists in Danhomɛ.

21. For a detailed discussion of *bociɔ* styles see Merlo (1977).

22. Sometimes it is the activator or user who provides the wood.

23. The *azɔndotɔ* themselves disagree with this characterization, arguing that they also create works which protect individuals from the malevolent effects of sorcerers. Clearly as with *bociɔ*, so too with their creators are striking features of ambiguity at play.

24. As noted in the Introduction, both men and women are known as makers of *bo*.

25. Other individuals also are involved actively in the process of making *bo*. Leather workers are one example. Agbanon notes that in making *tila* for war (2.19.86), "one brings things to the leather workers and they will sew it together. One needs a pigeon, a duck, a chicken without feathers, *golo, vi, ahowe* [three different types of kola nuts]." Those who sell various materials in the markets similarly have critical roles in the creative process. Of such individuals Nondichao explained (11.15.85), "They sell the necessary things for *bo*."

26. Rivière adds (1981:181): "The *dzo* in effect abandons its keeper or turns against him if two conditions of efficacy are not respected: 1) strict observation of the taboos which belong to it; 2) the maintaining of the *dzo* by its keeper through means of rites and offerings of food. Without upkeep *dzo* deserts the object where its power is concentrated. Devitalized, . . . empty, the object returns . . . to profane use." Once one has acquired a *bo* there is also a danger that if one does not treat it correctly with respect to particular offerings, it can act against its owner. "We mostly think about saving our heads. We do not want someone to say 'it did such and such a thing, but then he died,'" asserts Ayido (5.2.86). It also is thought that unscrupulous *bo* makers can intentionally bring harm to their clients: "When the consultant comes to ask help of the diviner against someone, the latter can put at his disposition diverse powers . . . if the diviner is less scrupulous [this will include] the irritation of a sign against the denounced enemy. . . . The irritation of a sign, . . . is a mobilization of the magical forces susceptible to becoming a 'war,' that is to say the ruin or death of the aggressor" (Maupoil 1981:150). This quality of risk is important both in the sense of the materials that go into the preparation of *bo*, and with respect to the power which another will have in owning such a *bo*. Asked whether he had made a similar *bociɔ* for another in his community, the owner of a powerful *bociɔ* ob-served, "No. I cannot . . . because if I give it to someone he could harm me" Migan (2.18.86).

27. As Dewui explains of one such object: "One attaches it, one suspends it from a cord, and one spits on it that which it does not eat. When one does this, the thing will happen. . . . It destroys things" (7.3.86). Ideas of opposition and reversal also have an

important social parallel. Pazzi notes (1976:98) that "the trunk of the ronier tree has a strange form; it gets larger towards the summit, in giving the idea of a reversed thing. It is from this that the expression *ejɛ agɔn* comes to signify "he committed an infraction to the social order, he sinned." Things which are opposed in nature, in other words, carry with them ideas of antisocial expression.

28. Alchemists were similarly aware of the risks inherent in their work (Coudert 1980:81).

29. Spieth's example (1906:526–27) indicates the importance of these factors as well.

30. Several scholars have called for a closer look at the importance of the senses in art and culture. They include, among others, Carpenter (1969), Flam (1970), Kaufmann (1979), Fabian (1983), Howes (1987), and Van Damme (1987).

31. Odor (*wan*) is perceived as critical to sexual drive. One says *yi wan nu mi,* "your smell attracts me," to indicate that one desires another (Brand 1976:40).

32. *Bociɔ* sculptures through this means privilege the perceptual—the "hyle," to use Husserl's term (see Coward and Ellis 1977:131). *Aisthesis,* as Bourdieu calls it (1984:486), and the "orectic," Victor Turner's preferred word (1967), also are emphasized within the *bociɔ* corpus.

33. In this way, in Kristeva's words (1980:88) (following Bakhtin) one is "establishing the status of the word as the *minimal unit* of the text." Speech, I would suggest, is also identified as a minimal unit of *bociɔ.* As Répin noted in 1863 (p. 97) "All objects can become [*bo*] fetishes if the priest attaches some supernatural property to them by his magic words."

34. The process of activating a work, I would suggest, in this sense is dependent on the skill of *ekphrasis,* the ability to transform what is visual (or as is often the case here, invisible) into what is essentially verbal.

35. Rivière notes (1979b:126) that "the voice (*gbe*) is not only a sound emitted by the lips but also a mysterious expression of destiny that each one receives from god before birth." Herskovits gives an account (1967, 2:258) of Awe, the first man to make *bo* (*gbo*). Awe cut down a tree, and out of the wood he made a figurine. He carved the head, the face, the hair, the arms, and all the members very well, but the figure could not talk. Then Mawu (God) said to him that his knowledge was not enough. Speech in other words is important to both human identity and *bociɔ.*

36. Although he is referring here to *vodun,* the same is true of *bo* and *bociɔ.*

37. One ceremony which I observed to activate a *bociɔ* was accompanied by the following speech (2.18.86). Because it suggests the range of roles that *bociɔ* fulfill I cite it in full:

> It is because of this that they arrived. It is your child. It is your house. As you guard them closely, they said that you guarded them well, so if the calabashes [daughters] do not split and the bottles [sons] do not break, and if you do not send the birds of the night [sorcerers] to me, at the end of the year, I will come and bring a sheep, a hen, imported liquor, millet beer, fresh water, and I will ask after the house. Thus hold my calabashes, my bottles, all my family. Guard the road.
>
> Today I bring imported liquor, millet beer, kolas, fresh water, a sheep, a chicken, so that you will send away the birds of the night. So that nothing happens to the children, to the women, so that no one gets sick. Keep us so that we can see the years that follow. Let bad things pass on the left side. And, if I am on the left, let them pass on the right.

Keep me well, so that nothing happens. And at the end of the year you will see what I will bring. Send away death from them and sickness from them. You will keep the family and relatives in good health. You know him and his children. You will guard his wives. We will live forever. The hairs on our feet and hands will become white. Thus you will bring good things to the house. You will never bring a bad wind in the house. The stranger of death will not come in the house. The stranger of sickness will not come to us. The bad things will never come to us. The bad things, you will reject them. The bad things that you see, you will give them to Minona and to Sɛgbo Lisa.

Our wives will not become pregnant and abort. We will never give birth to a dead child. It will only be good things that we will see. No bad things will come to pass here. If we go in front or behind we will participate only in good things. If we speak it will only be the truth. . . . We will always have good strangers who come here and not bad ones. We will not see the money of death nor the money of sickness. . . . Thus hold these calabashes and these bottles so that nothing happens to them. If you do not hold them correctly and something happens to them, I will no longer come here.

In the above we can see both the range of problems addressed in the context of *bociↄ* empowerment and the commitment to renew such objects with associated offerings.

38. The term for an adult person, *meho* (*mexo*), carries in it the importance of speech (*ho, xo*). As Agossou explains (1972:83) "Humans from birth, even in the womb, are thought of as *xo*, speech. . . . Thus before birth, the Fon individual already has a history."

39. On the significance of saliva in Africa see Ellenberger (1956) and Spieth (1906:517). On the importance of words and naming in African American contexts, see Marks (1987).

40. According to Pazzi (1976:305), "The conception of the *bo* blends with that of an incantation. The latter is done especially on a drink, while the *bo* consists generally of a solid object . . . the two conceptions are easily confused and their effect is substantially the same."

41. Rivière notes (1981:71) that "the mouth as an organ of speech charged with power, should, to expulse the harmful magical forces that accumulate in the saliva at night, be vigorously rinsed in the morning before addressing the greetings to no matter whom. The filth of the mouth (*nugbe*) designates the words of quarrel between adversaries."

42. The importance of fire and knots is also noted by the early Evhe scholar Spieth (1906:516).

43. Life is also associated with fire. Thus images of matches on the Sato drum refer to the proverb "my fire will not be extinguished" (Dangban 2.26.86). Agbanon notes of this same motif (2.27.86), "It means my fire is standing. That which we are in the process of doing, we are in a good way beside it. We are not in obscurity." The depiction of a flint on a hat is described similarly as a symbol of fire (Agbanon 2.27.86). Rituals reinforce this idea. After someone in the family dies, one puts out the family fires for three days (Agbidinukun 5.12.86). Breath also is linked closely to fire, for as Guédou suggests (1985:328–29), in creation myths breath is associated with the beginning of life: "Mawu made man, but one day Legba wanted to do the same thing. After Mawu finished, Legba made a man who looked just like the man that Mawu had created. At this point, Legba tired and went off to get something to eat. Mawu meanwhile breathed on his new creation, giving life to man. When Legba returned he did not know how Mawu had transformed the statue into a living being. Legba decided to make a hole in the figure and

blow into it. After he did this, the man took a few steps and fell. Mawu watched the frustrated Legba, but never shared his secret." In another version, Mawu spoke into the ear of his new creation to bring him to life.

44. Rivière notes (1981:86): "Peace, coolness, whiteness and . . . water are associated in the symbolism of moral well-being. Peace—called coolness of the body (*nutifafa*)—is marked by the external and internal purity that water aids in conserving. In rites of purification, washing with water can be completed by a coating of kaolin on the body. The white of kaolin represents the peace of cosmic equilibrium, the calm of the ancestors."

45. Lakoff points out (1987:383), "The [Western] folk theory of physiological effects, especially the part that emphasizes HEAT, forms the basis of the most general metaphor for anger: ANGER IS HEAT."

46. Cudjoe explains similarly (1969:52–53), "One comes in possession of a magic charm either by buying it or through an exchange with another person. The new owner must swallow several grains of pepper and swear that he will not reveal the secrets of the charm to anyone."

47. Spiess provides several examples of binding or knotting among the Evhe (1902:318). The first work, called *fuka* and named "fertility thread," consisted of a rope on which knots were fastened at close intervals. This was worn around the necks of pregnant women in order to have a smooth delivery and a healthy baby. Spiess describes the second example this way (1902:316): "The person who intends to kill someone takes grass from his fields and places them on the corncob. Naming the enemy and his wishes for the enemy, he wraps the thread around the corncob, thereby binding the name to the amulet. In one or two weeks when the thread has withered, the person named and wrapped in the magic object has also died."

48. Similarly the myth of the staff of Hermes is dependent on what Burckhardt calls (1986:135) "the theurgic power of 'binding' and 'loosing.' This means the transmutation of chaos into cosmos, of conflict into order."

49. Through the intercession of their patron god, Minona, sorcerers are believed to be able to empower various objects.

50. According to Ayido (6.15.86; 7.13.86), *aziza* is also "the king that was put beside the animals in the forest. When you go to the forest to hunt, if *aziza* does not open the path for you, you will not see any animals to kill. Even if you see an animal . . . if *Aziza* has not removed its stone, the animal will escape."

51. Similar descriptions were given by people with whom I spoke. Ayido notes (6.15.86) that hair covers the face of the *aziza*. These hairs have an important role in the making of *bo*, for they are said to be very powerful (Agbanon 3.7.86).

52. *Azizonon* is a type of sickness sometimes linked to the *aziza*. Vapor, smoke, and cloud likewise are called *azizo*, "smoke of *azi*."

53. Megbe Legonou, responding to the question "Where does the power of *bociɔ* come from?" answered (11.7.85), "The leaves of the elders [i.e., the leaves selected by the ancestors]. It is the power of the greats, the elders, that gives power to the *bociɔ*." Thus for Legonou, leaves constitute a central feature of *bociɔ* power. Herskovits points out the importance of leaves as well (1967, 2:280): "[*Bociɔ*] called *alimagba* ('road not twisted') . . . is worn on the belt of a man or woman when on a journey. The power of this *gbo* is derived from the leaves placed in the water in which the figure is washed. It is made in

human form because in accordance with the rule . . . two 'men' are safer than one, and since if evil comes to the wearer, the power of the figure will act as a preventive.'"

54. *Aziza* are associated closely with the human psyche, for they are said to represent the spiritual identity of each person. According to Ayido (5.5.86), "Someone can call your *aziza*. They trick the *aziza* and it goes to eat at their house." How are these invisible forest dwellers able to have power within the realm of humans? According to Agbanon (3.18.86), it is because they also have some control over pregnancy. "The *aziza* give pregnancy to the woman so that she will give birth, and if a man is without a second wife, the *aziza* can transform an antelope into a woman for him." Ayido explains (4.25.86) that "because an *aziza* created each person, if one takes something and calls your name on it, and says that it is you who put the thing on it, no matter where you are, you will die."

55. As Ayido explains (7.13.86), "Legba possesses many powers. No one can know all the *bo* that he made in this life, all the *bo* that the *sε* possesses."

56. Savary notes similarly (1971:3) that "among the divinities the most frequently solicited (in contexts of *bo*) is Legba—who in the religious tradition is known as the agent of execution for all other *vodun*."

57. The relative importance of Fa, Legba, and *aziza* in the empowerment of *bo* is the subject of some debate. Ayido observed (7.13.86) that Legba and *aziza* were created on the same day. "[Mawu] gave all the humans to Legba and all the animals to *aziza*." Asked about the role of *aziza* and Legba in the functioning of *bo*, he observed (7.1.86), "Legba is more powerful than *aziza*. If *aziza* does a *bo* and Legba does not eat in it, it will not succeed." Sagbadju suggests however that Legba came to possess *bo* in a less admirable way (8.14.86), in that "Legba stole the *bo* from Mawu. He stole that with which Mawu used to call his people. He stole the power of *bo* which Mawu possessed."

58. Several alternative explanations also were provided for the distinctive base shapes, however. Some individuals maintain that there is no difference at all between these two forms. Others suggest that flat bases are a more recent phenomenon, an innovation created in response to the increasing use of cement floors. In view of the prominence of works with flat bases in early collections, however, the latter explanation seems unlikely.

Chapter 3

1. As Deleuze explains (1990:258–59), "the observer becomes a part of the simulacrum itself, which is transformed and deformed by his point of view. In short, there is in the simulacrum a becoming-mad, or a becoming unlimited . . . a becoming always other, a becoming subversive of the depths, able to evade the equal, the limit, the Same, or the Similar: always more and less at once, but never equal. To impose a limit on this becoming, to order it according to the same, to render it similar—and, for that part which remains rebellious, to repress it as deeply as possible. . . ."

2. Displacement of this sort, according to Silverman (1983: 115, 91), "can only occur between two [forms] which are either similar or contiguous. Thus desire is in effect nothing more than a series of metaphors and metonymies. . . . The accompanying process of displacement makes possible the fulfillment of a repressed desire through a series of surrogate images, since it transfers to the latter the affect which properly belongs to the former." Certain qualities of projection play a part in the displacement process. Projection

refers generally to the process of ascribing one's own drives, feelings, and sentiments to other people or to the outside world as a defensive means that permits one to be unaware of these "undesirable" phenomena in oneself (Arnheim 1986:54). According to Coward and Ellis (1977:142) in the course of projection, art "gives the outside (the Other) the possibility of holding signification."

3. Marcuse, discussing (1956:145) Aristotle's concept of artistic catharsis, argues that art's dual function is "both to oppose and to reconcile; both to indict and to acquit; both to recall the repressed and to repress it again." He continues (1978:58–59): "The aesthetic form, by virtue of which a work stands against established reality, is, at the same time, a form of affirmation through the reconciling catharsis." Through related forms of catharsis, asserts José Limón (1989:477), "the aggression of the world is transformed into mock aggression, mock fighting . . . which does not deny the existence of aggression but inverts its negativity."

Other art theorists have examined related concerns. John Keble, for example, speaks of art as giving "healing relief to secret mental emotion" and functioning as "a safety valve, preserving man from actual madness" (in Spitz 1985:29). For Keble, art involves not simply the direct spontaneous expression of feeling, but *internal conflict* between the artist's need to give utterance to his emotions and his "instinctive delicacy which recoils from exposing them openly." To Kris similarly (1967:45) art releases unconscious tensions and "purges the soul." For other discussions of the relationship between art and psychology see Kris (1967), Spitz (1985), Erikson (1963), Gombrich (1963), Gay (1976), Steinberg (1984), Spector (1988), and Freedberg (1989).

4. Dilthey's comments on tragedy and catharsis also are important here (1985:211): "Art helps us interpret destruction as a parable. For that reason the only real artist is one who can advance our ability to interpret reality."

5. While Freud, Lacan, and Obeyesekere identify the analyst (individual) as the primary support for the transference process, in the African settings discussed here, this role is split between the therapist (here principally the *bociɔ* activator or diviner) and the empowered object (here the *bociɔ* figure).

6. In psychological terms, transference also is associated with experiencing in the present feelings or fantasies derived from the past which have been grounded in early object relations. The importance of emotional transference is stressed by Collingwood (1977:117): "an unexpressed emotion is accompanied by a feeling of oppression; when it is expressed and thus comes into consciousness the same emotion is accompanied by a new feeling of alleviation or easement, the sense that this oppression is removed." Thus a central part of the overall transference process is emotional displacement. As Dewey notes (1934:42), "[E]ven an 'objectless' emotion demands something beyond itself to which to attach itself."

7. What Gallop suggests for psychoanalysis is equally true of *bociɔ* arts (1985:43): "It is the necessary precondition for any cure and yet the cure depends upon getting rid of the transference, for the transference is itself a sickness." Citing analyst Hanns Sachs, Spitz notes that (1985:20) "a successful work of art can restore to its perceiver aspects of experience that were previously unavailable, invisible."

8. In Fongbe, the Fon language, *bociɔ* is not the only term employed in contexts of figural representation. Although another word frequently used is *atinmɛso*, "person taken from wood" (*atin:* wood; *mɛ:* person; *so:* take), *atinmɛso* is a more general term than

bociↄ, encompassing all figures of humans in wood, not just those which serve as *bo.* "The *atinmɛso* is different from the *bociↄ,*" the diviner Dewui explained (6.30.86), "for *atinmɛso* one needs simply to take a piece of wood and make the nose and eyes." *Bociↄ,* in other words, unlike *atinmɛso,* are more than figures; they are works which constitute within themselves considerable power, and which through this means have increased interactive roles. This idea is further reinforced by the fact that the terms *bo* (object of empowerment) and *bociↄ* often are used interchangeably. Empowerment is essential to their overall functioning.

9. Because Janus works generally are said to represent both the male and the female, they project an identity appropriate to viewers and users of both genders.

10. Ulli Beier provides (1958:29) two alternative definitions of the term *botchio:* "charm that rests on the spirit" and "medication on a dead corpse." Like Merlo (1977:99), I find these translations to be problematic.

11. Although commoner *bociↄ* are seen as mute they are not wholly without the power of speech. Gadamer's comments on speechlessness are of interest in this regard (1986:83):

> When we say that someone is "speechless" we do not mean that they have nothing to say. On the contrary, such speechlessness is really a kind of speech. In German the word *Stumm* (mute) is connected with the word *stammeln* (to stutter or stammer). Surely the distress of the stutterer does not lie in the fact that he has nothing to say. Rather, he wants to say too much and is unable to find the words to express the pressing wealth of things he has on his mind. Similarly, when we say that someone is struck dumb or speechless (*verstummt*), we do not simply mean that he has ceased to speak. When we are at a loss for words in this way, what we want to say is actually brought especially close to us as something for which we have to seek new words.

12. Merlo recounts an interesting tradition which suggests to him a possible evolution of *bociↄ* form (1977:100–101):

> In the past, the animist priest when called near to the sick person in danger made a slave sleep against or near the patient, giving them a mixture of red beans, thus transferring the harm from one to the other. The slave did not wait long to die: He became a "cadaver of evil." It should be noted that the same bean mixture is found both in the hole where one places the *botchio* stake and in the "food" one gives to the statues. . . . Did a simulacre in wood one day substitute for a sacrificial human? . . . If this hypothesis is verified, a scheme evolved according to which one would successively have: the exchange of the death (or more generally harm) of one person for another; the substitution of a human simulacre for a living man, the decoy destined to trick death (Segurola); a guardian spirit fixed to a picket sculpted in anthropomorphic form and holding the power of a *vodoun-orisha* (Beier); and finally a *bo* among other talismans in picket form (Herskovits). It is possible that certain ethnicities or groups . . . received their *botchio* from one of these stages of evolution, which justifies these different explanations.

Intriguing as such an evolutionary schema is, I prefer a multiplex or multiplistic model wherein *bociↄ* fulfill a range of roles simultaneously. As we will see in chapter 9, the tradition of employing living people instead of sculptures is associated particularly with kings, suggesting among other things that social circumstances are central to sculptural signification.

13. An emotionally charged equation between corpses, cesspools, and fears of decay also is suggested by Kristeva (1982:3). Taussig observes similarly (1987:4, 7) that: "the space of death is important in the creation of meaning and consciousness, nowhere more so than in societies where torture is endemic and where the culture of terror flourishes. . . . Yet this space of death is preeminently a space of transformation: through the experience of coming close to death there well may be a more vivid sense of life; through fear there can come not only a growth in self-consciousness but also fragmentation, then loss of self-conforming to authority."

14. While some scholars (principally Herskovits) use the alternative *gbo* spelling in reference to this object, I follow here the more standard spelling of Segurola (1963). The Yoruba term *ebo* means "offering or sacrifice" (Abraham 1958:172), a word which also appears in Afro-Cuban contexts (Brandon 1990:124–27). As we saw in chapter 2, offerings (or *vɔ*, as the Fon would say) sometimes come into play in the activation of *bo*. Ultimately, however, *bo* are seen to be more complex than religious offerings as such.

15. I have chosen to avoid such terms, as well as others frequently used by early observers, such as "fetish," "magic object," or "charm," not only because they often have derogatory associations but also because they reveal more about Western perceptions of African use of objects of this type than about how such forms are perceived locally.

16. Gilli however insists that strong connections exist between *bo* and *vodun* (1982a:14, 16). He refers to *bo* as *bo-vodun* and differentiates these from cosmic *vodun* in that the former "do not enter into the system of knowledge and structuration of the world."

17. On the term "magic" see Blier (1993a).

18. On the term "fetish" see Blier (1993a).

19. The lion and fish represent Glele's strong names. See Blier (1990, 1991b).

20. On the primacy of material content, Jameson comments (1988:14) that "*content does not need to be treated or interpreted because it is itself already essentially and immediately meaningful. . . .* Content is already concrete, in that it is essentially social and historical experience."

21. In the text below, the terms "divination" and "geomancy" are used interchangeably. See Blier (1987) for a discussion of the differences. On divination in Africa generally, see Peek (1991).

22. Although royal history credits Agaja with Fa's introduction, Fa divination probably was used here much earlier.

23. As Sagbadju explains (7.1.86), "On the stomach [front of the board] it is the good thing that one does; on the back, it is the bad thing."

24. Divination in the context of the serpentine god Dan is particularly identified with the use of mirrors, water, and other reflecting materials.

25. According to de Surgy (1981a:210), "Water or mirrors [in divination] play only an accessory role in aiding the diviner in ridding his conscience of memories of perceptions." However of a *bociɔ* identified with the Fa divination sign Guda-di, it was explained that the mirror helped one "to see things at a long distance" (Maupoil 1981:648).

26. Tonal variants of words also are important in contexts of representation in other art forms. Often an image approximating the sound of a particular name or word will be depicted as a means of recalling an individual, place, or idea. Thus for example King Agonglo often is referred to through the image of a pineapple (*agon*), King Kpengla by

the *kpɛn* bird, King Huegbadja by a fish (*huevi*) and net (*adja*). These images also are identified with historic events in the kings' lives.

27. When used as a conjunction, a dulled *o* pronunciation of *bo* (as in *bɔ*) designates "and." The same phoneme also means "to bring together" or "to assemble." This additive or assemblage denotation of the term also is of interest; a critical part of *bociɔ* sculptural form and power rests on the composite nature of these figures (fig. 36). They are works which by definition draw considerable vitality from the interaction of the multiple elements incorporated within them or applied to their surfaces.

28. See Blier (1993b).

29. Also reinforcing this idea, the term *bo* is employed in reference to a particular type of tree whose fibrous bark is used in making cords to attach and "close" things (de Surgy 1981a:167). Cords, as we will see, play a vital role in *bociɔ* activation, aesthetics, and meaning.

30. The necessity of fire for life is also central. Among both the Fon and Evhe, "respiration" and "breath" are translated by composite terms, *gbɔgbɔn* or *gbɔje* (*gbɔdje*), each having as a root the word *gbɔ* (*bɔ*).

31. Among the Fon, as Pazzi notes, in the context of agriculture, the word *gbo* (pronounced in a lowered tone) is used less to mean "forest clearing" than to designate a great cultivated expanse.

32. On the importance of wilderness in African art see Anderson and Kreamer (1989).

33. Certain *bo* jewelry forms however do have decorative qualities. One such work frequently worn in the Abomey area is made of iron and copper strands twisted together in the form of a serpent.

34. Pazzi notes (1976:305) that "to each charm there is a corresponding immunizer [*glo*] or benevolent *bo* which will annul the harmful effect."

35. Thus Sagbadju suggests (6.7.86) that "one can send a *bo* to ask that your enemy will fall sick, or die, or so that his child will succumb, or so that his car will break down, or so that if it rains, he will be struck by lightning, or so that there will be a fire and his things will burn."

36. Catharsis takes place on many different levels. One is through reinvention, or what psychologists call "reemplotting." As Hayden White notes (1978:87): "The problem is to get the patient to 'reemplot' his whole life history in such a way as to change the *meaning* of those events for him and their *significance* for the economy of the whole set of events that make up his life."

37. Or as Deleuze and Guattari point out (1987:287), "Every secret is a collective assemblage."

38. In a few cases, humans themselves are considered to be *bo*. For example a child born with the umbilical cord around the neck is called *bojɔ* (*jô:* born, i.e., "the *bo* is born") (Ayido 3.29.86). So too, infants who die in the first years of life (*abiku*) are sometimes described as *bo*.

39. One of the more unusual types of cicatrization of this sort among the Evhe, Rivière notes (1981:178) "consists of an incision at the end of the index finger [which allows the individual] to point the finger toward someone and make him fall ill [or, alternatively, allows this person to] send pins or pieces of broken bottles into another's body."

41. Jewelry *bo* serve a variety of functions. As Migan explains (12.31.85): "Some rings chase away bad things (*nu gnan gnan*). Some, no matter what you do, no one will ask you about it. Others if you step on a snake it will not bite you. Still others if a person wants to poison you, the ring will alert you of this." An iron toe ring in the form of a *bo* which is described by Herskovits is also of interest in this regard (1967, 2:278). This ring, called *yɛgbɔgba*, "close the jaw," is (according to Herskovits) worn on the second toe of the left foot for Da [the snake]. The ring, made of twisted iron strands, is said to resemble a snake, and thus protects the wearer against serpents. If while wearing it the possessor steps on a snake, he will not be bitten, since the ring has been steeped in the poison of many snakes, and a serpent smelling this will not strike. Anklets also often function as *bo*. According to Agbanon (3.20.86), "The *bowatɔ* [makers of *bo*] trap the *abiku* [babies who may die as infants] by putting an iron anklet around their feet. One attaches an *abiku*'s foot with this iron so that this infant will no longer want to die."

41. One soap made by the diviner Sagbadju (7.18.86) incorporated among other things parts of chameleons, leaves, clothing of a dead person, a dog skull, a chicken, Naira (Nigerian money), and European soap.

42. Some such building *bo* are hidden from view. Stones placed in front of house or palace doors often mark the spot where such *bo* have been buried. Of a building *bo* of this type, Dakodonu, descendant and placeholder of the seventeenth-century ruler of the Abomey plateau, noted (6.11.85): "The stones [in front of my entry] recall that we buried something here. If we bury something, we put a stone on top as a marker. What is buried over there is a *bo* to protect the palace. These are things to protect oneself and to protect the lives of those who live in the palace. They are not *vodun*. They are mystical powers. They are there to protect the lives of those who pass the night here." Certain trees likewise serve as markers where *bo* have been buried.

43. Often some form of enclosure is critical to *bociɔ* functioning, since certain works must always be kept shielded from the sun. Herskovits notes (1967, 2:281) that "the *gbo* loses its potency if it is placed in the sun, and is therefore not only kept inside a house, but a large cloth is always over it as it rests there."

44. *Bociɔ* names are of interest in this regard. One example provided by Spiess (1902:316) is a work called "*ko neku, ne wu na mu. . . .* 'If the termite queen is missing from the hill then the mound collapses.' To the extent that this word is fulfilled, it becomes true that the person bound to this magic will die." Of another *bo* Spiess writes (1902:315), "The thief carries this amulet with him and believes himself to be secure. The work which is called *golovi golokpa* (boldly onwards) gives him comfort that all will go well." Yet another name documented by Spiess (1902:317) is "*Adjii*, 'beware,' a word meaning 'It is highly poisonous.'" Another Evhe work, discussed by Schurtz (1901: pl. 1, fig. 3), was known as *gboni*, meaning "to bounce off," or "to rebuff." This work, he suggests, was used to guard against enemies, especially thieves. It also was sometimes used to keep strangers away from the house.

45. Silverman after Lacan asserts (1983:176) that "desire is fueled by drives which can never be satisfied because they have been denied any expression within the subject's psychic economy." Caughie notes that the term "desire" (1981:298) in the psychoanalytic literature had a much different meaning historically: "In the first place, the word [desire] translates the German *Wunsch*—'wish,' which has a weaker sense, and a less specifically erotic connotation than the English 'desire,' or the French *désir* which is used

by Lacan." The original German meaning of *Wunsch* ("wish") is closer to that expressed in contexts of *bo* and *bociɔ* use.

46. Of one *bo* of this type Rivière explained (1981:184): "Granaries of corn, coconuts, fruits, and other crops are placed in the fields. If something disappears, the owner goes to the Hevioso priest, who takes an action so that the thief is struck by lightning. This thief however can also avoid lightning by spilling a part of what he stole— corn especially—into a well. Since the water is for all, the [*bo*] will not kill all the village."

47. A special *bo* to encourage commerce called *asitsadzo* is also noted by Rivière (1981:184). Other works were used to keep mice at bay (Spieth 1906:522).

48. In the words of Rivière (1981:184), "As artists do ceremonies to assure their success and to prevent accidents, and the fishermen bless the fishing trip in order to get fish . . . so too a fruitful and problem-free hunt is prepared by magical process." See also Spieth (1906:522).

49. See Spieth (1906:518).

50. Répin describes several related *bo* objects observed in southern Danhomɛ in 1856 (1863:98). These included "a small scapular of worked and colored leather, a tiger [*sic*] claw fixed on a section of elephant horn formed into a bracelet [and] the horn of an antelope [which] preserves one from death by gun, sword, or poison. Other grigri are also powerful against the bites of serpents; with others one can send away elephants or tigers."

51. *Bo* and *bociɔ* identified with the king and his palace also fit within this grouping in many respects. During the annual "customs" ceremonies of the kings (called *huɛtanu* or *ganyiahi* [*ganyiaxi*]) a range of such *bociɔ* were in evidence.

52. Savary describes (1976:240) another work intended to protect one from accidents which consists of a small gourd with a cow or goat tail attached to it by means of a lizard or serpent skin. Yet another travel aid discussed by Ellis (1970:68) is called *bo-kpo* ("*bo* cane"), and includes a crutched stick which is "supposed to ward off all the evils incidental to travelling."

53. One object of this type appropriately was called *azon-gble-bo* (*azon:* sickness; *gble:* break). For other works see Spieth (1906:518). Mental illness, as Spieth points out (1906:524), also was an important concern.

54. Rivière notes (1981:183) that one such *bo* "is used against sickness caused by the spirits of the dead, one renders sight to blind people and removes it from others . . . One treats sterility, another makes one fertile, others prevent miscarriage, or are . . . used against rheumatism and articulation blockages." Rivière lists other *bo* employed to counter sicknesses as well (1981:178). These include a *bo* used against "bad eyes" (*nkuvɔdzo*), and another used in cases of difficult birth. Savary cites (1976:240–41) still other *bo* commissioned in contexts of mental illness. One such work was called *sibisava* and consisted of a fly whisk made of a white goat tail which was employed to treat the mental illnesses attributed to the *vodun* Dan (especially hysteria and possession). Another called *asudo kpleton* consisting of a cow tail and a lizard or snakeskin handle was employed to treat individuals suffering from fears of intrigue. The important role of *bociɔ* in contexts of health is based to some extent on the belief that, in the words of Allado (1986:25), "Sickness also can be provoked against someone by subtle forms, thanks to mysterious powers of a *grigri* (*ebo*) and sorcery (*adze*)."

55. Infertility *bo* and *bociɔ* sometimes are referred to as *vi-bo* ("child *bo*") and *gnonou-mon-ho-bo* ("pregnant woman *bo*").

56. Some such works are intended to aid oneself and thwart one's opponents in arts such as singing and dancing (Spieth 1906:522, 524). Other works are thought to mortally wound individuals without their knowing the source or antidote. Quénum explains that an object called *chakatou* allowed one to poison persons at a distance. Pazzi discusses (1976:305) a work with a similar name (*cakacu, tsakatu,* "gun of the mix") which was believed to have the effect of a projectile entering into the body. Here too we can see the significant cathartic functions of such objects in the expression of powerful emotions such as hate or anger.

Chapter 4

1. To quote Maurice Merleau-Ponty (1964:52), "Anger, shame, hate, and love are not psychic facts hidden at the bottom of another's consciousness: they are types of behavior or styles of conduct which are visible from the outside." As with Isenberg's metaphor, we are offered "both an oyster and a pearl" (Spitz 1985:30).

2. According to Derrida (1973:32), "Ex-pression is exteriorization. It imparts to a certain outside a sense which is first found in a certain inside." "Expression," he adds (p. 33), is "voluntary exteriorization." In this context it is important to examine bodies not only as comprising matter and form but also as constituting actions and movement. As Deleuze suggests (1990:5): "[Bodies] . . . are not things or facts, but events. We can not say that they exist, but rather that they subsist. . . . They are not substantives or adjectives but verbs."

3. Studies concerned with body conceptualization are numerous. Early anthropological models for such explorations include those of Mauss (1979), Douglas (1969), Clifford Geertz (1973, 1980), Bourdieu (1977), and Ellen (1977), all of whom have discussed the body as a symbol of society and its variant organs and dangers. Influential studies centered on the body in other disciplines include those of Barkin (1975), Davis (1981), Foucault (1978–), Rousselle (1988), Brown (1988), Butler (1990), and Bynum (1991). In Africa analyses of the body as societal model have been explored by a range of scholars including Wieschoff (1938), Griaule (1965), Lebeuf (1961), Jackson (1983a, 1983b, 1989), Devisch (1983, 1990a), Comaroff (1985), Beidelman (1986), and Blier (1987).

4. For this reason the body has become an important subject in many gender studies.

5. Stewart's further perspectives of the body also are insightful (1984:xiii): "Although [the] body is culturally delimited, it functions nevertheless as the instrument of lived experience, a place of mediation that remains irreducible beyond the already-structured reductions of the sensory, the direct relation between the body and the world it acts upon." As Clive Bell explains, "The starting-point for all systems of aesthetics must be the personal experience of a peculiar emotion" (Arnheim 1967:302).

6. Language plays an important role in this regard. Stated simply by Benjamin (1978:320), "Language is . . . the mental being of things." To Gramsci (1971:325), similarly, "Every language contains the elements of a conception of the world and of a culture." Coming at the importance of language from a somewhat different perspective, Abu-Lughod and Lutz argue (1990:11) that "speech provides the means by which local views of emotion have their effects and take their significance."

7. From the Greek "recalling to mind," "reminiscence," or "remembrance." The following discussion addresses, in this way, a critical issue in aesthetic semiotics, the reading of figural abstraction as psychodynamic sign. Questions of body distortion in art are of further interest in light of the ability of the mind to censure (distort) unacceptable phenomena or impulses in order to make their manifest content recognizable and thereby acceptable.

8. According to Montilus (1972:13), the Fon distinguish between the body as physical entity (*agbaza*) and the body as part of one's exterior identity (*u, utu, wu, wutu*). In his words (p. 14): "The body considered in its totality is thus *agbaza*, but at its surface, the part accessible to touch, is the *u* or *utu* [which] . . . is intimately tied to the psychic, moral, and spiritual life of man." This interpretation is not supported by Segurola (1963:19), who translates *agbaza* as meaning both body and skin, but particularly that part of the person (or animal) that is visible.

9. Pazzi notes (1976:145) that "one uses the word body to mean 'against,' the word head to mean 'above,' the mouth to mean 'in front,' ear to say 'to the side,' etc. . . . man, the 'father of life,' thus transposes onto all reality the characteristic categories of his own body." A similar means of spatial delimitation is used by the Batammaliba (Blier 1987).

10. See also Devisch (1990a).

11. Kossou explains (1983:42–43): "The body is the measure of the individual which permits others to know him, and he contains and reflects with his body his own physical and psychological capacities. . . . It is by rapport with his body that man evaluates the world. That which he discovers, in the measure where it exceeds all conceivable proportions of him, the extraordinary, the unexplainable, can rapidly find rank in the mysteries." The body, Montilus explains in turn (1972:15), "in its exteriority is the privileged element from which man establishes and conceives his relation with the *milieu*, environment, and even the world." On the role of the body as social mediator see Bourdieu (1977:89) and Comaroff (1985:6–7).

12. The Fon term for "gourd," *go*, also is used in certain contexts to refer to the body.

13. So important is this belief that the above saying serves as the name of a particular *bo*. The stomach also is closely associated with this belief.

14. Large stomachs often have negative associations for this reason. Sagbadju explains (7.9.86), "When you are eating, your stomach becomes big. The people who have this—their houses break, their children do not come to any good." Conversely, thin stomachs generally are identified with equilibrium and the lack of problems. Ayido elaborates (7.6.86), "In the rainy season, when the food terminates and there is famine, there are fewer problems."

15. In Tahiti, similarly, the intestines are associated with anger (Levy 1973:214).

16. The link between the stomach and feelings of anger also appears in songs such as the following created for the mother of King Tegbesu (1740–74) (Agbidinukun 5.30.86):

> Adonwandjele it is the drum that is sounding.
> The malice (*ken*) is in the stomach.
> If the malice is in the stomach,
> It should remain there.
> If the malice come out, one will tell the king.
> It should stay in the stomach and be lost there.

17. In the same way that somatization (physiological affect; *soma:* body) is an important means of expressing psychological and social ill, so too key forms of body representation reveal much about a culture's or period's perspectives on psyche and social well-being.

18. A woman having difficulty giving birth accordingly often is told to declare the words that are in her stomach. An adult who is gravely sick is invited in like manner to reveal his stomach in order to be cured. Not surprisingly stomachs also are associated with the retention and revelation of political secrets. Asked about the reign of Adandozan, the banished nineteenth-century king whose name has been removed from court history, Adjaho replied (5.21.86), "No one says anything. It is in their stomachs."

19. That the kingdom's name, Danhomɛ, "in the stomach of Dan," also makes reference to the stomach is of interest. On the one hand, this alludes to an act of aggression—the killing of Dan (an enemy of the kingdom's founder) and the driving of a house stake into his stomach. At the same time, however, this word also underscores the importance of the stomach as a seat of human emotion. Dan had refused a request of the new king, Huegbadja, for land on which to build a palace. The reference to the stomach thus may be seen as a poignant symbol of the rage that marked the relations between the two.

20. "Phantasm" is Melanie Klein's term (1975) for surface phenomenon; "simulacrum" is Gilles Deleuze and Felix Guattari's designation (1990:216) for objects of depth.

21. King Guezo is credited with the following saying: "The interior of my stomach, if I open it for someone, the person will pass by there to see what he wants. If I close it for someone and I do not have an open stomach for the person, the person cannot see what is in my stomach." The above was quoted to me by Sagbadju (7.18.86) in response to a carving representing a padlock. The lock in this sense was to keep others from knowing one's feelings.

22. The term for "navel," *hon* (*ahon*), is also the word for "door," "sill," and "entry." Thus in the same way that stomach and room are metaphorically tied, so too are the navel and the door. And, in the same way that the kingdom, Danhomɛ, means "in the stomach of Dan," the name for the royal palace, *hon mɛ*, means "inside" (*mɛ*) the "navel" (*hon*).

23. Gilli explains (1982a:19) that "it is forbidden to cut the umbilical cord with a knife or metal instrument. Instead of these deadly arms, one uses a blade of straw or a cutting piece from a palm branch." In other areas, however, iron and other metals appears to be widely used for this purpose.

24. Among the Fon and related groups there is a tradition of burying the umbilical cord and sometimes planting on it a palm tree which will belong to the newborn. According to Rivière (1979b:139), it is "by this gesture that one underlines the identical destiny of the life of things and the life of humans."

25. One of the more important of these is the bile. Ayido explains (7.6.86) that "those who do not laugh, it is because they have too much blood and their bile overflows." The *abi* (gall?), a part of the stomach near the bile, in turn is viewed as a key source of anger and disputes. The taste of bitterness associated with the bile appears to complement emotional bitterness.

26. This term also means "earth," and the "large bean" (*ayikun*). The word *ayi* in many Fon texts is translated as "heart" because in the West it is this organ which is most closely identified with the conscience and the sentiments. However, as here, the word is more accurately translated as "kidney."

27. Pazzi asserts (1976:168) that to the Fon one's own *vodun* is believed to reside in the kidneys. According to Rivière (1980:10), "In the twinned kidneys are supposed to concentrate the sensations which penetrate the body."

28. Ayido reaffirms the important associations of the kidneys with thought, noting that "words leave by the *ayi*" (4.30.86).

29. Similar images of kidneys also are worked into appliquéd cloths worn by the king (or princes) on ceremonial occasions. Of one such cloth with a kidney-form leaf, Ayido noted (7.13.86) that the leaf "gives coolness to the kidneys."

30. These terms are used generally for an adult's genitals. A girl's vagina is usually referred to as *titi*, a boy's penis as *atɔtɔ* or *adjaka* ("mouse").

31. *Yo* also is the name of a great ogre spider, characterized as being notoriously gluttonous and immortal, but also able to escape all traps. This spider incarnates cunning, perfidy, ingratitude, and insatiability.

32. The phallus is additionally identified with Dan, the serpentine deity associated with whirlwinds and motion generally.

33. Because of the back's association with misfortune, the Fon court minister Adjaho explains that when one wishes to dethrone the king, one "holds his neck and gives him a slap on the back; in this way one has changed him. He will never again be ruler" (7.26.86). Appropriately in the palace bas-reliefs most of the enemies are shown with their backs to the Fon troops: "They are always fleeing the king and the Danhomɛ army. Their lack of courage makes them deserve to receive the blows, not in the face but in the back" (Adande 1976–77:191).

34. Accordingly, one of the royal funeral ceremonies is called *Asiplata* (*asi*: hands; *pla*: hangup; *ta*: head; one puts the hands in back of the head entwined), in reference to this gesture (Agbidinukun 5.3.86). The front in contrast is associated with progress and positive attributes. At the ceremony of Dehiho, Ayido noted (4.7.86) that "your work will go in front. Mawu will keep you and your work will go forward."

35. Because of this association too, the solar plexus (*akonu*, "mouth of the chest") is an important place of ritual unction (Pazzi 1976:163).

36. In addition to its association with life and emotion, the chest also is identified with both beauty and movement. Kossou notes (1983:45) that "the heart's rhythm of beauty seems to instruct the body with the cadence to follow, for its movements are like a drum."

37. Of the gesture of holding one's breasts, Sagbadju notes (7.9.86), "You cross your hands on the chest because the breasts are precious."

38. The Fon word for the male or female devotee is *vodunsi*—literally "wife of the *vodun*."

39. For this same reason, heart-shaped forms frequently are placed on *asɛn* (memorial staffs). According to Bokpe (5.29.86), in these works "one is saying to all the country to calm down." Such heart shapes, however, are almost indistinguishable from the kidney-shaped *ayi*.

40. To give an accolade to one of equal merit, one says, "he joined the hands to the neck" (Pazzi 1976:176). The neck also has an important association with beauty. Thus a pattern of scars incised around the neck in a necklace-form pattern called *ala* is described as a means of "rendering one beautiful" (Kposin 6.1.86). In life, the neck also is

closely identified with *bo*, for it is around the neck that many leather *bo*-form packets are placed.

41. Guédou notes (1985:267) that because of its identity with life and well-being, "numerous sacrifices are made periodically [to the head] to reinforce the power of the head or to protect it against attack."

42. For this reason he notes, one never appears in front of someone of higher author-ity with one's head covered.

43. Because of the association of this body part with success, a commonly expressed desire is that no matter what one does "it will have a head." This phrase appears fre-quently in prayers, such as the following recorded in a Gu ceremony: "The money will have a head. Cloths will have a head, the grains in the field will have a head" (4.28.86). The annual ceremonies at the palace similarly make reference to the head. These are called *huɛtanu*, "yearly head thing," a reference to the numerous decapitations occurring at this time. Of this name Adjaho notes (8.6.86) that "that which one thinks in one's head is what one does for the king each year." Another way of translating *huɛtanu* is "ceremony (thing) at the head of the year" (5.29.86), thus signaling the association of this rite with the New Year.

44. Maupoil notes (1981:240) that "the head (*ta*) is a *vodun*: each individual makes a yearly sacrifice to his head, independent of the sacrifices in other circumstances." Guédou adds (1985:265–66), "One should never put one's hand on the head of an adept without speaking the formula to excuse oneself. Also it is forbidden to hit an adept on the head. This is an affront to the *vodun*, for whom the adept is the wife." Because of the association of heads with sacredness, images of heads appear occasionally in temple bas-reliefs representing men and women who, before their deaths, were *vodun* adepts (12.31.85).

45. Asked what the head represents in ceremonial contexts, Ayido noted (5.2.86), "It means no bad thing will take its head to come in my direction." In part because of the head's importance in divination, diviners confect for their clients ritual representations of the head called *tagba* ("headache") (Pazzi 1976:149). This head, which is thrown away with the *vo* offering, is called *ta towe me vɛ*, "the misfortune is in your head" (Ayido 3.29.86). Likewise when one casts kola nuts to determine one's fortune one says *ta* ("the head of destiny") (4.28.86).

46. The summit accordingly is one of three places on the head where one receives ritual unction, the others being the forehead and nape (Pazzi 1976:148).

47. Pazzi notes in turn (1976:183) that during one's sleep the sorcerer is believed to exit the body by the summit of his head.

48. As Ayido explains (4.28.86), "humans ate for a long time in the stomach of the mother before coming into the world. We ate by way of the head and not by the mouth." For the importance of similar coiffures on royalty see chapter 9.

49. As with the Yoruba, Agbanon explains (3.3.86) that "when someone dances well one will put a coin on the forehead."

50. In one such ceremony, the diviner in charge explained as he placed the *yɛ* powder on the foreheads of those participating: "Sickness, death, poverty, and misfortune will stop. All the good things—money, clothes, children, wives will come. Misfortune will strike our enemies" (4.28.86).

51. The forehead also is associated with life generally. Nondichao explains the common courtly practice of sprinkling dust on one's head or shoulders as follows (10.22.85), "If you put earth on your shoulders you are greeting a dead person; if you put dirt on the forehead, it is a greeting for the living."

52. According to Pazzi (1976:152), "The eye is the organ which lets the thoughts and the emotions of the person breathe. That is why shame makes the eye heavy, and affront makes it shine." The eyes of *bociɔ* sometimes are the focus of special ritual actions. Herskovits observed (1967, 2:280–81) that a particular *bociɔ* "can perform evil as well as good, for though it protects a man while he sleeps, it can also drive an enemy of its possessor to madness. . . . If the owner has had a quarrel with another person and in his anger, wishes to do him harm, he goes home, takes seven peppers and some strong drink, and rubs each over the eyes of the *bocie*. He calls the name of the other person while he stands before it, and at once the magic takes effect and his enemy goes insane."

53. In sculptures in which cowries are secures to the eyes, the horizontal eye line presented through this means is said to represent the *yɛ* of the sponsoring *vodun*.

54. One god, Aremeh, was believed to confer piercing sight upon its worshipers, and its emblem—an eye among other things—was one of the marks of the Fon military's Blue company (Skertchly 1874:150). So too the court minister Migan was sometimes called the "eye of the country," and the distinctive breast patch of his robe bore the image of an eye (Agbidinukun 3.8.86).

55. Sagbadju noted for this same portal image of an eye (7.3.86) that "All that you are doing I can see; do you think that I am resting?" The eyes on this door also appear to refer to Glele's divination sign (see Blier 1990).

56. When one is making a *vɔ* offering, one often takes earth and rolls it into a ball and places images of eyes in it. Of this action Ayido explains (4.30.86), "All these eyes are in the process of guarding one's good fortune. As we spilled some of the powder from divination on it, the one who looks with a bad eye will no longer look with a bad eye."

57. The word "hole" is used additionally to refer to a hollow in the earth, for example, a well, river, spring, or lake.

58. *Nusu* also means "closed thing."

59. Powerful gods accordingly are said to have powerful arms. Agon explains (2.27.86) that "the arms of Legba are its powers." Ayido notes similarly (8.3.86) of the god Sagbata, that his arms are important. One of the praise names associated with this god asserts, "I open my arms, my arms cover all the country." Another god whose arms are identified closely with force is Gu.

60. Rivière notes similarly (1981:90) that for the Evhe "autonomy and independence are designated by the expression 'He is in his own hand' (*ele e dokui si*); mutual accord is evoked by saying 'He took the hand of his brothers' (*ele novi si*); generosity is conveyed by the words 'He opened his palms' (*eke asime*) in the manner of giving a gift . . . with two hands." A variety of other proverbs also emphasize the hand. One such expression, "One rejoined the good hand," is said by market women to the first buyer of the day, the significance of this being that this person brings one luck. A well-known expression of religious sentiment is "One is in the hand of god." The phrase "One turned the hand" means "One disentangles oneself." Another saying, "One is on the hand," means "One is in order, in security" (Pazzi 1976:176).

61. Of an appliqué hat bearing the image of a hand, Tavi notes (5.20.86): "When I

did my ceremonies, . . . one of my friends gave this to me to say that one cannot diminish my hand in this land. . . . If one wants to do something here, necessarily one must see me." The hand also appears in Fon art as an important sign of work and creativity. For this reason, the image of a hand can be seen in the bas-reliefs at the Hɛvioso temple of Na Houedehun in honor of the artist who created these relief programs. "One says it is her hand that did all of this," noted the artist's granddaughter in reference to this hand image (6.9.86). Fingers, particularly the thumb, also are important to hand ideation. As Montilus explains (1972:8), "One considers [the thumb] as the husband of the hand." Of a hat with a depiction of a hand with prominent thumb, Akalogun explained (6.1.86), "When we do not have a thumb, we can do nothing. . . . without me (the thumb) you can do nothing." Pazzi suggests in turn (1976:176) that because the thumb commands the other fingers, it receives special ritual unction. Ritually and in the context of *bo*, fingernails also are important, because in the words of Montilus (1972:12), "They are animated by a movement which makes them grow."

62. According to Ayido (6.15.86), Legba was placed at Mawu's left hand because he did not obey Mawu's edicts. Because of their association with danger and pollution, bodies are buried on their left sides (Maupoil 1981:390). Illicit or illegal actions also are identified with the left hand. Important gender differences are expressed vis-à-vis left and right as well. Pazzi notes accordingly (1976:224) that in local traditions of dress "the men pass the cloth over the left shoulder, the women do so over the right."

63. Foot symbolism also is of interest. Frequently the foot is associated with personal accomplishment or success. A twin accordingly will place his or her foot three times in the market before entering.

64. In life, gestures are identified with a range of emotions. The gesture of raising one's hand means, according to Ayido (5.18.86), "I raised my hand; I am in the process of doing." The gesture of presenting something with two hands is employed in the context of gift-giving or the making of ritual offerings (Pazzi 1976:176). Placing the hands together in a bowl shape, in turn, is a gesture of supplication (Pazzi 1976:175). The gesture of closing one hand on an object signifies that one wants to hide something (Lanwusi 6.16.86). When both hands are displayed facing the sky, a request is being made of the ancestors (Agbidinukun 7.4.86). A single raised fist with the thumb extended toward the sky signifies power (Pazzi 1976:176). The gesture of supporting the head with the hand is identified with discouragement, intense reflection, and sadness (Pazzi 1976:175). Rubbing the hands together, Hwawenon suggests (5.17.86), is a sign that one is asking for grace.

Greetings also are displayed through hand gestures. The snapping of the fingers three times is done when meeting a person who is superior to one (Adjaho 7.9.86). Skertchly described one such greeting (1874:10): "The head fetiche priest came out and saluted by snapping fingers with us three times, after which, he filliped his little fingers and thumbs together a like number of times."

Few of the above gestures appear in commoner *bociɔ* arts. The richness of gestures in life makes this lack all the more significant.

65. The thigh in turn is referred to in Fon as *asa*. The word for knee is *koli*. Ankle is called *afɔgo*, "gourd of the foot."

66. The upright posture furthermore is identified with ideals of both mental and physical preparedness and strength. As Agbanon notes (2.27.86), "Straight things do the thing

of force." Kneeling postures in contrast suggest subservience. Agbidinukun notes accordingly (7.17.86) that "with us, when a woman wants to give drink or food to her husband, she kneels." Ayido suggests (5.11.86) in turn that "if a woman kneels and holds her breasts she is in the process of asking pardon." Ayido adds (6.2.86), "When people arrive who are afraid, they will kneel down, showing their fear of you." When seeing the king, kneeling or prostrating postures generally are assumed for this reason. Even when the king is not present one prostrates oneself in the presence of objects identified with royal authority. Adjaho observed (8.6.86): "You must kneel to take the royal *makpo* [recade, scepter]. You never take it simply with the hand. The one who brings it will kneel. When he calls you, you also will kneel before you take it. If you did not kneel to take it you did not respect the king. You did not accept the king as someone to respect." (See Blier 1988a.) Religious reverence also is associated with kneeling postures. As Akati explains (7.18.86), "When we feed the *vodun* we kneel." So too, according to Ayido (7.13.86), when a priest arrives to tell one that one's child has become a devotee, "you kneel and kiss the earth." Standing upright in this sense can be seen as a posture of striking contrast to the kneeling posture and its general associations with subservience. As one of Gbehanzin's court songs notes: "the lord of Djime, Gbehanzin; his *sɛ* does not kneel for the *sɛ* of the enemy" (Agbidinukun 7.10.86).

67. In some, however, hats and cicatrization marks are represented.

68. This term also means "virginity."

69. According to Pazzi (1976:173), "In the past the pubescent girl did not wear a cloth until marriage; the belt of beads formed her habit. It is thus her husband who covered her nudity."

70. Where coiffures are shown they vary markedly.

71. The general absence of hair in *bociɔ* depictions is interesting in light of hair's close association with life force. Rivière notes (1981:70–71) that "the hair and nails are believed to contain a high degree of vital force—one buries them to purify or create a harm. One venerates them as suitable for the body of a deceased who died abroad." Pazzi notes similarly (1976:150–51) that "hair is seen to contain a high degree of vital force which animates the body because it does not cease growing during life." In part for this reason, hair is sometimes incorporated into *bociɔ* and *bo* as additive empowering material.

Chapter 5

1. Whereas Marcel Mauss sees (1979) this masking attribute of the psyche as developmentally grounded, I would argue that masking concerns in psychological conceptualization find significance at every level and type of society.

2. As with Bakhtin's model of the carnivalesque (1986), what we see here is a turning inside out. Suggested as well is what Deleuze describes (1990:224) as "symptoms of corporeal depth and the sublimations of the incorporeal surface."

3. See Marshall (1987:58–59).

4. Wikan refers to similar concerns (1989:299) as "emotion work," that is, the linking of various mental processes and the person. As Dilthey explains (1976:92), "The structure of fully developed mental life must . . . deal with the architectonic structuring of the complete edifice; it does not enquire about the stones, the mortar and the labour first but about the inner connection of the parts."

5. *Amɛ* in Evhe means "person."

6. Throughout this area, the present is privileged over all other times. As Montilus has observed (1979:2), "Traditional Fon society accords the greatest attention to present life. The earth is called accordingly, the land of life (*gbɛtomɛ* [*gbe:* life; *to:* country; *mɛ:* in])." *Bociɔ* are similarly concerned with life in the present. They are a means of countering obstacles lying in one's path.

7. For a discussion of a similar tradition among the Batammaliba in northern Benin and Togo, see Blier (1987).

8. The placenta, in contrast, generally is buried in proximity to the area where the mother showers.

9. The birth order of twins also is documented through this means.

10. As Ayido explains (7.20.86), "Fa brings the *sɛ* [destiny] of the child." He adds (3.29.86), "When you came here, . . . the accidents that you will have, the sickness in your body, one already had written that down."

11. Brand explains the process of acquiring one's destiny this way (1970:348): "The child is still inside the mother when Sɛ gives it this advice: 'You will soon enter life; it will be only a passage for you. You must leave and return to the ancestors—follow the road I trace for you, or else I will put you to the side.' He also asks 'How long do you want to stay on earth? Do you want to see your children or grandchildren?' The child answers. Mawu in turn puts wealth and well-being into the protege's hands . . . [which will be used in] the life which it will soon enter."

12. The Evhe make small human figures called *nuxexe* (from *xefe*, "a thing to pay") at the birth of children. As Schurtz notes (1901: pl. 3, fig. 4), "The parents form a small child from clay. If one does not do such a thing, the child would fall to the cause of the gods. . . . The actual sense of the small figure is, happy is he who offers Mawu a compensation for the children's soul, which descended from him, as well as to induce him not to call it back again." Figures of this sort, in their roles as compensation and substitutes, thus also complement *bociɔ*.

13. Gramsci's comments are of interest in this regard (1971:351): "[W]e can see that in putting the question 'What is man?' what we mean is: what can man become? That is, can man dominate his own destiny, can he 'make himself,' can he create his own life? We maintain therefore that man is a process, and, more exactly, the process of his actions."

14. See Mauss (1979:81) for comparable Roman traditions.

15. Each *vodun*, explains Montilus (1979:35), is sufficiently tied to the nuclear or extended family to be considered to be nearly a member. If the *jɔtɔ* is a *vodun*, the child must at some later time enter the deity's convent and become consecrated as a devotee.

16. Not every dead person, however, joins the ancestors and becomes a *jɔtɔ*. Amouzou notes (1979:161–62) that "people who died good deaths join the ancestors. People who died bad deaths leave for the *zogbe* [field of fire, "bad bush"] and haunt the places of the living, deranging them without hope of reincarnation. They can inhabit a living person, making him sick." *Bociɔ* are intended in part to protect one from these dangerous ghosts.

17. Because of this role, the *jɔtɔ* also is called *mɛkɔkantɔ*, "person-earth-take-father," that is, the ancestor who takes the earth from which one makes the body of another person" (Guédou 1985:236). Sometimes, Ayido explains (4.26.86), more than one *jɔtɔ* is involved in this process: "one will touch the earth, another will enter into the stomach

to watch the ball of earth." Often the *jɔtɔ* and Mawu are said to work together in creating each child. Montilus explains accordingly that (1979:33) "the body is 'mixed' with earth, and 'cut' by the *jɔtɔ* [ancestral sponsor], the latter bringing the earth to Mawu, who makes the body." Reinforcing this idea, Guédou notes (1985:236) that frequently one says "his *jɔtɔ* threw uncooked earth," meaning that the *jɔtɔ* selected the earth, but it is not he who cooked it" [brought it to life]. Kossou concurs (1983:41) that both the *jɔtɔ* and Mawu play a part in creating the body. According to him, "In the 'myths' of creation, one notes that the body is made of sand or clay mixed by the creator aided by one of the ancestors of the one who will be born." Views of the conception process also are interesting in light of both *bociɔ* and the persona. In procreation as in reincarnation, an impression is created that the resulting child has certain androgynous qualities. As Pazzi notes (1976:260): "In religious thought, the child is conceived as an incarnation of the ancestors, a reincarnation which remains at the outset dualistic: Each baby carries the potentiality of the two sexes. But in the course of childhood, the asexual envelope that they have carried since conception is removed thanks to the circumcision of the boy and the first menstruation of the girl." Gestation traditions reinforce this androgynous identity. According to Montilus (1979:34), "During the gestation process, Mawu inserts the child first in the body of the father, then in that of the mother."

18. The preconception and pregestation period of human identity also is important in this regard. According to Rivière (1979:127), "The Mina believe that the soul . . . of a newborn prepares for birth in a subterranean garden . . . where it receives its destiny (*sɛ*). . . . It climbs to earth by a well and enters the . . . woman." Rivière recounts a related tradition from the Evhe. This account has important additional ramifications for the meaning of *bo* and *bociɔ* (1979:125). He writes:

> According to a version of the Eve groups near Ghana . . . new births in this world are prepared in the *bo* (a sort of field hidden by the ambient bush) by the Bomeno (the mother in the *bo*), who plays the role of ancestor, cutting the clay to form the newborns. . . . Of a person who is foolish or stupid, one says she never left the Bome. . . . As to Bomeno, herself sometimes designated as sterile, she does not engender herself but only gives form to the body. . . . One believes that the Bomeno, who is a big sister of the ancestors, does not put the child in the material breast until humans have supplicated the ancestors.

19. Pazzi notes accordingly (1976:141) that each person's "personality preexisted birth because each is carried by the begetting ancestor."

20. It is for this reason, explains Montilus (1979:35), that "one also refers to the newborn as *e le,* "he has returned." Montilus also notes (1972:27–28) that "When the *jɔtɔ* is a *daa* [family head], or any other honorable member, [the child] is given the veneration due the person whose place it holds. One must think of the [child] as a representative or *wesagu,* messenger. The latter is sent by a chief or a person of high rank. . . . Accordingly one sometimes refers to the current person reincarnating the ancestor as being in the hole of someone, *mɛ e do mɛ do mɛ e* (person who is in the place of someone)." For an analysis of the roles that *jɔtɔ* play in the course of royal history, see Adande (1976–77:195). He discusses one example in which King Agonglo (1789–97), whose *jɔtɔ* was King Agaja (1708–28), was obliged to bring war against the town of Gbowele because King Agaja earlier had been vanquished there. When King Agonglo was unsuccessful in this endeavor, King Guezo (1818–58), whose *jɔtɔ* also was Agaja, similarly was

obligated "to revenge the cause of his father" by bringing war to this town. Numerous artworks also were commissioned by kings in honor of their *jɔtɔ*. A wide range of such objects were made for King Glele (1858–89) with this in mind (see Blier 1990:91). Architectural forms reflect this tradition. Thus one of the strong names of King Guezo's *jɔtɔ*, King Agaja, was *Kpovesanudo ko me adantɔ; ko gbato adantɔ*, "Kpovesa being present in the mound is capable of rage; the breaker of the mound is also capable of rage" (Adande 1976–77:140). Guezo accordingly had a special mound of earth called *adanzun* [mound of rage] built in front of his palace on which he made various war pronouncements.

21. In addition to the above, the ancestral sponsor serves as intermediary between the child and the invisible world of *vodun*. De Surgy explains (1981a:40) accordingly that for the Evhe "the tutelary ancestor is the one who 'poses the hand on my head,' and in this contact, makes of the head a sort of receptive antenna, putting the person directly in relation with [the forces] . . . that he does not see and never knows."

22. A related Fon tradition maintains that if a child digs the earth with his or her toes, this child is preparing the tomb of the mother (Alapini 1952:244).

23. In a classic study in Senegal, Marie-Cecile and Edmond Ortigues suggest (1984) that the oedipal complex needs modification in Africa because of the privileged place of the ancestors here. Through the ancestors, they suggest, much of the authority function of the Western father figure is absorbed: "It is the collectivity which [in Senegalese society] takes the death of the father upon itself. . . . Society, by presenting the law of the fathers, thus in a sense neutralizes the diachronic series of generations. . . . Instead of developing vertically or diachronically, conflict between generations strongly tends to be restricted to a horizontal expression within the limits of a single generation, in the framework of a solidarity and rivalry between collaterals" (in Felman 1982:348). While it is impossible to generalize about the world into which African children are born and nurtured, there seem to be some parallels between the above and the populations examined here.

24. An interesting summation of issues of personality and emotion in Africa appears in LeVine (1976). Other scholars who have written in provocative ways about these or related concerns include Beidelman (1986), Kopytoff (1987:38), Murphy and Bledsoe (1987), and Fernandez (1971). Outside Africa, see among others, Geertz (1959), Basso (1985), and Abu-Lughod and Lutz (1990).

25. Issiaka Laleye (1970) emphasizes the complexity of factors identified with the person in the adjacent Yoruba culture.

26. On the importance of the shadow metaphor elsewhere in Africa see Jacobson-Widding (1990). Jung uses this same shadow metaphor (1953:31) in discussing the psyche as the "dark half of the personality."

27. This duality also has important architectural ramifications. Thus when Danhomɛ kings die, they are memorialized in two different structures: the *adɔhɔ* (*adɔxɔ*), "sleeping room," or tomb—where the body rests—and the *djɛhɔ*, "house of beads," where the king's spirit and head reside. Migan explains (2.18.86) that for nonroyals these two dimensions of the person are worshiped in the form of the *sinuten* or *asɛn* memorial sculptures.

28. One *vodun* priest explained to Montilus accordingly (1972:16), "For us blacks there are five *sɛ*: one says *sɛ jɔtɔ* (the *sɛ* which gives birth), *sɛ akikomaji* [the person's

master while in this world], *tɔ* (the father), *no* (the mother), *sɛ kpoli* (the Fa)." Pazzi (1976:285) also argues that the spiritual persona have a rather broad identity which includes a number of forces. As he explains: "The human is conceived as the bringing together of four elements: (1) the ancestor, which presides over the birth and maintains one while remaining rooted in the heavens. . . . (2) The spirit that is the source of life for the new individual. . . . (3) The body which develops and manifests itself with the visible elements of the world . . . and (4) the soul, which, like the shadow accompanies the individual and [serves as a] mirror in which one can see one's personality reflected." While Pazzi's choice of terms such as "spirit" and "soul" are confusing, nonetheless he is correct in emphasizing the range of forces within the context of each individual's inner empowerment.

29. With regard to these internal *yɛ* elements, Montilus explains (1972:18, 21–22; 23): "Mawu gave us two *yɛ*, one long and one short. . . . It seems as if the short *yɛ* (*yɛ gli*) is in accord with the principle of physical life, the life of the body. . . . The *yɛ gaga* . . . the long *yɛ*, is the principle of spatial dynamism of the body. That is why it assures the continuity of the person, i.e., because it is attached to space." The short *yɛ* (*wensagon*) often is described as the darker and closer shadow which serves as messenger to Sɛgbo-Lisa (Mawu), telling this god of the person's acts in life (Falcon 1970:193).

Lindon (*lidon, lido,* or *Sɛ-lidon*) is a more distant shadow that maintains looser ties with Sɛgbo-Lisa but which returns to this god after death. As Agossou suggests (1972:61–62): "The *lido* is what is far, there. Although we can touch the *wu* (the body), and see the *yɛ* (the shadow) movements of man, *lido* remains inaccessible to all our senses. [*Lido*] is the pure immaterial. It is far over there. . . . Speaking of the 'far over there' is a way of expressing the abstract, in a very concrete and imaginary language. Not knowing how to say how *lindon* is, the Fon localize it as being very far in space." According to Segurola (1963:308), *lin* means not only "to think" and "far away" but also "to dream" and "to imagine." This part of the *yɛ* accordingly can be seen in many respects to incorporate essential features not only of intelligence but also of creativity.

Among the Evhe, the *yɛ* (here generally referred to as the *luvho*) is similarly bipartite. According to de Surgy (1981a:30), "Humans possess two *luvho*." The first of the *luvho* (*agbe luvho*), de Surgy explains (1981a:33), is associated with breath. Of the second, or *ku luvho*, he suggests (1981a:30, 33), "Its function is to double the physical reality of humans by an interior reality developed privately in the imagination. Its manifestation remains perpetually invisible, and one estimates that it does not disappear from the world after death but continues to subtly influence the thought and comportment of the survivors. . . . [It] reserves for the individual a point of insertion in the universe, altering the ancestral path, in particular in the acquisition of memory and language."

30. Mawu (Mawu-Lisa), explains Maupoil (1981:399), "is the soul of the world." In addition (1981:221), each person's "destiny or *sɛ* is . . . a part of the great Sɛ, Sɛgbomɛdo, the name which Fa initiates call Mawu." Maupoil notes further that (1981:388) "Sɛ and Mawu are a single entity and the same principle. One sometimes hears one say: My Mawu, in the sense of 'my *sɛ*.' One hears that each possesses an individual Mawu that derives from the great Mawu, common to every being, to all animals, to all the things." A song composed by the diviner Gedegbe (Maupoil 1981:399) suggests:

> This life where we are awakening
> Is a thing of mystery

> Man has a *sɛ*
> The wild animal has a *sɛ*
> The bird has a *sɛ*
> The tree has a *sɛ*
> All these *sɛ*, who knows them?
> It is Mawu-Gbe [Mawu-life] who is their *sɛ*.

31. In this respect *sɛ* recalls the Greek *noema* (perception, thought) which, as Derrida points out (1973:117), plays a critical role in the conceptualization of meaning.

32. Agossou observes in turn (1972:61) that, "*Sɛ* is the transcendent reason of all, the vital principle of humans." Falcon suggests of the *sɛ* (1970:135–36) that "Many call it the guardian angel. . . . *Sɛ* is immortal, infallable, a participant of the character of God." This feature of *sɛ*'s guardianship is also stressed by Fon diviners (Maupoil 1981:388):

> The *sɛ* is that which follows humans in order to guard them. *Sɛ* is our second, *awetomi-ton* (the second that belongs to us), our guardian that the great god gave us. It is that which helps us to avoid falling into difficulty; it is that which turns away death. As long as the day of our death has not arrived, our *sɛ* protects us invisibly. There exists a great *Sɛ* which is Mawu. The individual *sɛ* is only a small parcel of the great *Sɛ*, into which it is absorbed at death; there is nothing that remains of the body that it animates, except the earth (*kɔ*).

While one's *sɛ*, or destiny, as the above suggests, does not remain with one after death, it is believed to play an important role in protecting the children that a particular person may create and sponsor within the family after death. According to Maupoil (1981:381), "*Sɛ* does not know either life or death; it is permanent because it does not follow one into the tomb. Once dead, it will guard the one that the dead person brings back as a *jɔtɔ* [sponsoring ancestor]; its activity is eternal."

33. According to Pazzi (1976:296), one makes "a small white statue which one will keep in secret in one's room to [pay hommage to] at difficult moments of life." Rivière describes (1980:14) this small white statue, which one calls *sɛ xo tɔ xo no* ("destiny having a mother and father"), similarly. He notes that "one acquires it after consultation with a diviner and places it in one's own room to worship in difficult moments, to suppli-cate one's destiny to be favorable." This work, he adds (1980:17), is the "material repre-sentation of one's *sɛ*."

34. According to Maupoil (1981:388), "When one speaks of *sɛ* when referring to Fa, one means by this term, the *du* [sign] under which one comes into this world." Pazzi also emphasizes the close relationship between *sɛ*, divination, and destiny. He notes accord-ingly (1976:296) that "*sɛ* is destiny. It is to god that one attributes the notion of destiny. From him comes the original *kpoli* [life destiny] which orients the concrete destinies of each human being in this world." Rivière reaffirms this idea but cautions (1981:74–75) that: "The translation of *sɛ* by the word 'destiny' is only approximate. . . . *Sɛ* designates a law. . . . But it is applied especially to god, Mawu-Sɛ, understood as destiny and su-preme law of beings. . . . Applied to man, the word *sɛ* indicates the concrete destiny of the human being in this world. . . . Associated with *kpoli*—as in *sɛ-kpoli*—it designates one of the 256 archetypes of Afa [Fa]. . . . *Sɛ* is in reality the spiritual element, guide of all destiny, especially human."

35. Spiess notes in turn (1902:316) that "the word Sɛ in Evhe language means the 'law' which binds it to godliness, because the early meaning of Sɛ as law states: god rules, god instates."

36. Images of hands also appear on *asɛn* sculptures dedicated to the memory of past family members. Of one such work, Agbanon noted (3.31.86) that when "one represents the hand, making the lines of destiny, one is saying all the hands are open and face the sky."

37. Explaining the connection between flowers and destiny, Pazzi observed (1976:89): "Sɛ (flower) is the same word that expresses destiny. It appears that one conceives the flower to be like the expression of the destiny of the tree itself, because it is the flower that prepares the success of the fruits." Amplifying this idea, Rivière suggests (1981:74) that "the same word [sɛ] designates in effect the stinger that insects take out at the critical moment to assure their survival, and the flower which is an expression of the destiny of the plant." Other meanings of the word *sɛ* in its tonal variants also are of importance with respect to both the definition of the self and the signifying features of *bociɔ* arts. In a lowered tone, *sɛ* means to "send," "to move," or "to make place for." Spoken in this same tone but with a closed *e*, *se* is used as a verb signifying among other things, "to hear," "to know," "to discern," "to feel," and "to be adept." These terms are linked in key respects to powers of perception and to those abilities which allow a person to safeguard himself or herself from danger. As with the words "menstruation," "odor," and "genitals," such verbs are associated in key respects with ideas of individual identity. These actions are central to the functioning of *bo* and *bociɔ*. Such sculptures are intended to activate the forces of the universe to send, move, or displace particular persons, powers, or objects.

38. Montilus adds (1972:16), "The *sɛ akikomaji* [*sɛma*] is the master of the person, because one came into the world on it."

39. After birth, the placenta is enveloped in the *akikoma* leaves and buried in the shower. Brand's description (1976:45) of the tradition suggests that banana leaves also are used. In being born, he notes, the child does not touch the ground directly but is placed both on banana leaves, symbolizing the father, and on leaves of the *akikon jɔflo*, symbolizing the *sɛ*. In this area banana plants signify regeneration and growth.

40. According to Ayido (3.29.86), the *yɛ* enters the body through the earthen ball out of which the body is shaped—symbolizing perhaps the body of the ancestor now changed back to earth. As he explains (3.29.86), "Sɛ made the *yɛ* and put it in the great skin [body] of humans. Thus when the *sɛ* calls the *yɛ*, no matter when, the *yɛ* goes away." This transferability of the *yɛ* is seen as a source of potential danger and anxiety. According to Maupoil (1981:397), if the users of "black magic" want to harm someone, "they 'call' his *yɛ* after having gathered up a bit of earth on the place where the person left the shadow of his foot." If this happens, the person's life is believed to be effectively over. As Le Hérissé notes (1911:158): "The definitive separation [of a person and his or her *yɛ*] constitutes death. The *yɛ* goes to the land of the dead, *mɛkoutomɛ*. It finds there the *yɛ* of the family and lives next to them as on earth. If it is the *yɛ* of a king or chief on earth, it will continue to be a king or chief; if one was a slave, it will remain a slave. The *yɛ* of a criminal will rejoin the criminals. The *yɛ* of one's wives and children will come to join the husband."

The *lindon* in this sense is thought to represent the *yɛ* of the person once he or she has died. With this in mind, during the presentations of funerary cloth, it was explained that one must show it to all the family so that *lindon* ("those over there") can accept the death. Explaining the difference between *yɛ* and *lindon*, Ayido observed that "we say *lindon* because if you die here, we will see you in Kutonu. You are dead here and went to appear over there" (*lin:* far; *don:* over there) (3.29.86). To Quénum (1938:90), similarly, the *lindon* is "an immaterial, immortal [essence] which, after its separation from the body, is found in the land of the dead (*lon, kouto-me*) in the company of its relatives and friends who died before." Unlike the *yɛ*, suggests Maupoil, Mawu does not return the *lindon* to earth in the form of another person "because, in doing this, he would create identically the same person."

41. Segurola defines (1963) the *yɛ* in turn as "shadow," "the double of someone," and "spirit."

42. In part this is because the spider's web shares with the shadow qualities of ephemerality, lightness, and movement.

43. Segurola's secondary translation (1963) of *yɛ* to mean "symbol" is interesting in this regard.

44. To Kossou the qualities of light and shade associated with *yɛ* are of critical importance (1983:52), "All creatures have a shadow-like *yɛ* . . . the unseizable form of the object projected on the ground when the object is in light." Guédou also focuses on the vital role of this shadow metaphor (1985:239):

> All beings created by Mawu have a shadow, *yɛ*, which is the reflection of its body. This reflection is a reduced world, a projection of their being. The word *yɛ* . . . means the shadow projected from the body. It is created by light. The Fon believe that an opaque body in the universe of light absorbs a part of this light and leaves to the side a projection of this being. It is the shadow that follows one all over. This shadow thus is but the reflection of the being. That is why we translate the term as shadow-reflection.

45. The court diviner Gedegbe accordingly stresses the association of *lindon* (*lidon, lido*) with memory and intelligence: "When one makes a sacrifice to the head, it is to the *lindon* that it is destined, to one's individual intelligence, to that which makes us speak, react, to that which pushes one ahead. *Lin* means 'think'; *don* means 'far'; we don't know the origin of our thought, and say that this comes from there, from afar, from above" (in Maupoil 1981:387).

46. When one dies and the pupils become dull it is viewed as a sign that the *yɛ* has departed. As Ayido explains (3.29.86): "The *yɛ* is on the eyes. If you die today, the *yɛ* will leave your eyes, and will go to another country. . . . When we look at your eyes we will see that it is gone."

47. As Ayido asserts (3.29.86), "If something that is grave is about to happen to you, your *yɛ* will fly away and what remains is no longer yourself."

48. Maupoil amplifies on this idea (1981:387): "The *lindon* watches over the sleep of humans. Installed on the pillow, it never sleeps. When humans wake up, it resides invisibly in one and accompanies one, encouraging one to work, and permitting one to breathe. It is in a way the spirit of life for each person. . . . The *yɛ* is the *lindon* rendered visible, notably by life and light. *Lindon* is the abstract shade: the shade of death, the shade of black night."

49. According to Ayido (5.2.86), "When you die, your *aziza* leaves . . . and goes into the stomach of another woman and that woman becomes pregnant." Perhaps it is for this reason that the word for egg is *azi* (*azin*). In turn, as de Surgy notes (1981a:27), "The final point of disparation of souls is called *azizanu*, 'in front of the *aziza*,'" suggesting that it is from this place that the *aziza* leave to give life to the fetus. This aspect of the *aziza* also is important in the context of ceremonies for the dead. According to Ayido (5.18.86), in making offerings to the ancestors, "we call the *aziza* of all the people to pray with us."

50. Segurola identifies the *aziza* accordingly (1963:81) as the "genie of music."

51. *Aziza* "hairs" thus are highly sought after as materials of *bo*. According to Ayido (5.11.86), "All the *bo* that are in this life, all the powers, all that you thought to do, if an *aziza* hair enters into it, it will have a mysterious power that will make this happen."

52. Made in conjunction with each one's personal Fa sign is a square cushion called *kpɔli* which is made from white cloth and contains the earth in which one's divination sign was marked. As Maupoil explains (1981:319):

> [The] Kpoli designates . . . in an abstract way, the sign of the forest where the soul is, and in a concrete fashion, the sack given to the Favi [child of Fa] in the sacred forest. . . . In the Kpɔli is the earth where the sign of the initiate was inscribed. It is in this that the symbol of the *sɛ* resides. Also enclosed are the leaves of Fa of the [person's] sign, a bit of earth from the bottom of a [spring] (because of its freshness), and white chalk, so that the life of the initiate will always be white, i.e., cool, and happy. A bit of Danmi, excrement of the rainbow serpent—a symbol of prosperity—as well as the mysterious wood of *gila* are added too. On the exterior of the bag one sews small cowries, and the beads of *lankan, nana, azaun ketu, tutuokpon.*

53. For a more thorough discussion of this Fa sign see chapter 9 and Blier (1990, 1991b).

54. Dan, in addition to providing each person with the power of movement, also plays an important protective role. According to Ayido (6.2.86), "One says 'Dan stay behind me, give me courage and if I go to war, do not let the people of the country kill me.' It is Dan that gives this. . . . Even if people arrive, they will be afraid, they will kneel down and will be afraid of you."

55. Gilli asserts (1982a:19) however that iron never is used to cut this cord.

Chapter 6

1. Jean Pliya is a Fon historian and writer of fiction.

2. According to Coudert (1980:41), "Most alchemists were against the use of anything but minerals and metals." In Africa, however, metal is but one of the many types of matter which plays a part in this process. In Fon and Evhe cultures, taxonomies of matter into water, earth, air, and fire correspondences are in many ways comparable to the Platonic tetralogies used by Western alchemists (see Maupoil 1981 and de Surgy 1981a).

3. One of the major influences on Jung, according to Needham (1983:15), was Silber-er's 1917 book on symbols of mysticism which was published in Vienna. Henry and Renée Kahane note (1987:195) that "enticed by the resemblances between the dreams of his patients and alchemical symbols, C. G. Jung read this belief from his psychoanalytic standpoint as the projection of inner experience onto matter, and thus as the identifica-

tion of matter with the Self. 'Matter' evolved as a name for the 'self.' It represented an unconscious archetype, primordial images, and the alchemical *opus*, aiming at freeing, saving, and perfecting matter, and was a symbolic replica of the universal quest for the Self."

4. As Dodds notes (1975:27), in Europe "the older alchemy never was, and never was intended to be, solely a study of matter for its own sake." Needham observes similarly (1983:1–2) that "[B]eside the . . . Western proto-chemistry . . . there was, perhaps from the beginning, a parallel current of mystical, allegorical, symbolic, ethical, even psychological exegesis. . . . Thus Western psychological alchemy was concerned not so much, if at all, with actual chemical operations as with states of mind, catharsis, sublimation, purification and the attainment of unity and equilibrium." The essence of the Western alchemy in this way involved what Goodwin calls (1972:360) "a two-way relationship between the adept and Nature, both undergoing transformation together, as occurs in a true dialogue."

5. Chinese alchemy, while different from both that in the Islamic world and that in the West, is nonetheless of interest because of its important links to medicine and curative means in the widest sense. In the end, Coudert suggests (1980:161, 163), "In China the alchemical quest was for eternal life. . . . The Chinese view of immortality was radically different from the West's because the Chinese never made the same invidious distinction between matter and spirit. They considered the two as part of one organic continuum and could not imagine life existing once a body was separated from the different souls they believed existed within it." In this concern, Chinese and Indian alchemy differed from Arabic, European, and (as we will see) African forms in significant ways. As Needham explains (1983:23), "The Western companion of metallurgical-chemical alchemy was psychological [while] its Chinese companion (*nei tan*) was essentially physiological." According to Needham (1983:2), "We are now fully assured that . . . a radical distinction must be made between the two kinds of 'alchemy' in the West and the two kinds of 'alchemy' in China. Needham asks in this light (1983:297): "Why was there nothing in Christendom corresponding to Indian yoga and Chinese physiological alchemy? . . . one obvious factor was the very different conceptions of immortality. Insofar as it was solely thought of as a life 'after' death, in some entirely different 'place,' there could be no envisagement of a preparation of the present physical body for indefinite continuance, however etherealised the form." African *bociɔ* alchemy in many respects can be seen to combine features of both forms.

6. See Silberer (1917) on the relationship between fantasy and alchemy.

7. Jung's comments on the subject are of interest in this regard. "Projection," he writes (1959:59), "is an unconscious, automatic process whereby a content that is unconscious to the subject (the person) transfers itself to an object, so that it seems to belong to that object. The projection ceases the moment it becomes conscious, that is to say, when it is seen as belonging to the subject."

8. The skull on the head of this figure has been identified as that of a dog.

9. According to Burckhardt (1986:34), in alchemy one sees a "logical coherence of the world . . . which makes its manifold appearances a more or less graspable whole."

10. As D'arcy Thompson explains in the context of physics (1966:14), "Morphology is not only a study of material things and of the forms of material things, but has its

dynamical aspect, under which we deal with the interpretation, in terms of force, of the operations of Energy."

11. As Prigogine and Stengers point out (1984:136), "It is a way of rendering more precise the ancient affinity described by the alchemists, who deciphered the elective relationships between chemical bodies—that is, the 'likes' and 'dislikes' of molecules."

12. (For a discussion of transformative states as well as metals, minerals, beads, and other matter, see chapter 8; the complex alchemical processes of transmutation and empowerment are explored in chapter 2.) Of interest here is the special place that knots have held in both *bociɔ* and alchemical contexts. Burckhardt points out that (1986:136–37), in alchemy, the knot's significance "lies in the fact that the harder one pulls on the knot, the more firmly its two constituents hold together. This illustrates *inter alia* the mutual paralysis of the two forces when in a state of 'chaos.'" *Bociɔ* alchemy also is closely identified with attributes of fire. As Coudert suggests of alchemy generally (1980:38), "The fire was the most important and tricky part of the alchemist's technique." Read also discusses (1947:5) the importance of fire in Western alchemy.

13. Brand explains in turn (1981:19) that "to know the *vodun* is to know plants and their use. . . . Each installation demands the employment of liturgical leaves without which the existence of a god is compromised and even, we can affirm, impossible." De Surgy notes similarly (1988:159) that "the leaves make the *vodu* . . . because it is these that characterize them or their powers. . . . The magical art which results depends on the knowledge of these and the ritual techniques which make them work."

14. For similar reasons the tree also was a favorite symbol in Western alchemy. Coudert explains (1980:124) that "when alchemists used it they were conscious of the many associations it invoked. Trees seemed to embody the illusion of eternal life."

15. Maupoil notes (1981:143) that "one can say that all medications are *bo* but the reciprocal would be false."

16. Pazzi explains accordingly (1976:93) that "the forest (*zun*) is respected as the sacred place where life comes from. This is why it is forbidden for humans to have sexual relations there." He adds (1976:82), "The forest thus signifies the plentitude of the universe."

17. While associated with death, the goat also is identified with fecundity, and tradition maintains that in order to have a favorable year, one must offer a goat to *iroko* trees.

18. Eggwhite is believed to bring coolness. According to Agbanon (5.3.86), "When eggwhite is put on something, everything becomes cold—all anger will cease."

19. As Cluysenaar explains (1987:168), organic modes in literature place an emphasis "on the overall structure of the work and consequently, on the *relationship* of the parts and aspects to each other and to the whole. The whole is thought of as being 'more than the sum of its parts' in the sense that the whole provides impressions which cannot be traced back to the parts in isolation. The validity of this notion, as applied to the non-biological world of art, receives support from modern perceptual psychology."

20. Needham adds (1983:9–10), "This is the origin of the seventeenth-century Latin word '*spagyrical*' for alchemical, for . . . *spao, sparottein,* means to rend, tear, separate or stretch out, while . . . *ageirein,* is to bring, unite, or collect together. . . . Hence they [the Alexandrian protochemists] (and many alchemists in subsequent centuries after them) thought in terms of a 'deprivation of forms' (*solutio, separatio, divisio, putrefactio*) of the *materia prima,* . . . followed by a progressive 'addition of forms.'" This process

is also singled out for emphasis by Burckhardt (1986:123): "In this way too the alchemist works. Following the adage *solve et coagula,* he dissolves the imperfect coagulations of the soul, reduces the latter to its *materia,* and crystallizes it anew in a nobler form."

21. Agossou suggests however (1972:101) that in treatment contexts four principal plant or tree parts are employed: the juice (*amasin*), the roots (*atindo*), the skin (*atingodo*), and the plant itself in powder form (*atin*).

22. Sagbadju points out that (7.3.86) "strong leaves [are used] for the *bo* because Mawu already gave them power to do a particular thing."

23. The power of plants in the context of *bociɔ* rests not only on their medicinal values and *vodun* identity but also on their association with particular geomancy signs. Dewui explains (7.3.86) that "it is not just any leaf; one chooses the leaves because they are for this *du* and do its work."

24. Another salient example is the cat. One *bociɔ* sculpture which was created to assure that its owner would prevail in quarrels included a cat heart because, it was explained (Quénum 1938:87), "if a cat goes into a house and the rat is there, it does not ask permission to catch its prey." In this way, through a single body part, the heart, courage is conveyed to the whole. More commonly, the cat's nocturnal habits and secretive natures are the basis for its inclusion in *bociɔ* sculptures—particularly those intended to thwart (or promote) the actions of sorcerers.

25. Or, as Le Herissé explains (1911:151), "The duck does not speak like the rooster."

26. Herskovits notes however (1967, 2:280) that "if a duck is killed for [a *tohɔsu*-empowered *bociɔ*], [it is] only when these *tɔxɔsu* are to be instructed to do injury, for the blood of a duck is used for black magic."

27. As Coudert notes for alchemy generally (1980:17): "Transmutation is a fact of life. Caterpillars turn into butterflies, ice melts to water, little acorns grow to mighty oaks and food turns into all too solid flesh. Endless other transmutations occur naturally or in the laboratory. The question people asked long before there were alchemists was 'why?'"

28. See also Silberer (1917).

29. In the words of Bataille (1990:9), "The animal dies. But the death of the animal is the becoming of consciousness."

30. Mary Douglas's comments on the pollution and danger associations of body effluents are of interest in this regard. As she explains (1969:121): "[A]ll margins are dangerous. . . . Any structure of ideas is vulnerable at its margins. We should expect the orifices of the body to symbolise its specially vulnerable points. Matter issuing from them is marginal stuff of the most obvious kind. Spittle, blood, milk, urine, faeces or tears by simply issuing forth have traversed the boundary of the body." Drawing on Douglas's work, Julia Kristeva notes in turn (1982:71) that "excrement and its equivalents (decay, infection, disease, corpse, etc.) stand for the danger to identity that comes from without: the ego threatened by the non-ego, society threatened by its outside, life by death."

The frequent inclusion of sacrificial blood in *bociɔ* also illustrates the use of secretions as signifiers. Whether applied to a work in the context of offerings and empowerment, or used because of the special properties of a particular species' blood, this substance also necessarily carries with it values linked to life force and pulsing heat. Language plays a vital role in this process, for the word blood, *hun,* designates at the same time "religious power" (*hun* frequently is employed as a synonym for *vodun*), "drum" (with its rhythmic,

throbbing heartlike sound) and "vehicle" (or means of locomotion and mobility). As a sign within *bociɔ*, blood has associations with a similar range of animating qualities.

31. John Dewey's suggestion for art generally (1934:63), that "only where material is employed as media is there expression and art," also is applicable to *bociɔ*.

32. Coudert's insights on alchemical dimensions of anthropomorphism (1980:146) are of interest in this regard. "They [the old alchemists] did not compartmentalize their knowledge as neatly as we do, but saw the whole of nature in human terms, as a vast commonwealth of living, feeling, thinking and, finally, dying entities."

33. The case of monkeys is similarly complex. A number of works made from monkeys (or associated parts) are used to protect hunters. Herskovits describes (1967, 2:275) one powerful *bo* identified with the *ya* monkey which travels in troops and occasionally attacks hunters. Popular belief in turn credits the large *ato* monkey with augmenting life. Based on this identity, the head of the *ato* monkey is used in a work called *hue un ko* (year plus one) which, according to Agbanon (7.3.86), "adds a year so that the length of your life will augment for you." Popular belief also maintains that monkeys are similar to and have an affection for infants. Because of this feature, Agbanon suggests, monkey skin is used to make objects which serve to protect the child from attack. For this reason also, pregnant women sometimes will wear monkey skin *bo* to protect the fetus. The small monkey, *zio*, for its part is identified with twins (Quénum 1938:87).

34. The spider's name, *yɛgletete*, with its *yɛ* prefix, also reinforces this tie with the dead, for the *yɛ* is the spirit persona of the person which derives from the land of the dead.

35. With this in mind, turtle shells frequently are ground into a powder and made into a solution which is washed over the body when one is in need of insight. According to Mehu (7.7.84), "If something bad is happening to you, the turtle will explain why."

36. According to Brand (1981:25), "A third category of magical plants . . . serves to aid moral enterprises, individual, physical, and material. The plant employed in this way plays the role of an amulet which is both defensive and malevolent."

37. Brand suggests (1981:23) that plants in *vodun* rites also can be either tranquilizing or stimulating. Describing the nature of sickness, Pazzi notes that (1976:82–83)

> sickness is not only cured by the application of leaves (*ama*). It is in effect the visible manifestation of a profound disordering of the vital equilibrium, a disorder that one must resolve by ritual interventions which can reach its depths. That is why the diviner, when utilizing the virtue of leaves, prescribes the [offerings] which generally comprise . . . an animal sacrifice according to the category of leaves in question: with the hot leaves one sacrifices males of warm-blooded animals, and with the cool ones, the females. Birds and fish, without distinction of sex, accompany cool leaves.

38. While the python generally is identified with well-being and "coolness" (Rivière 1981:86), many other serpents are classed among the "hot" animals. Subsequently their bones, venom, and skin are incorporated into a number of powerful *bo* and *bociɔ*. Of one such snake it was explained, "It is the way that they are furious" that is important (Agbanon 2.27.86). Agbidinukun notes in turn (7.17.86) that a *bo* made with parts from the very poisonous green (*amanunu*) serpent helps to protect one from the bites of other dangerous serpents. The skins of other snakes are used in *bo* to remove the threat of snakebite as well (Sagbadju 8.2.86).

39. For an in-depth discussion of this tradition see Blier, forthcoming.

40. According to one Sagbata priest (12.31.85), "Sagbata hunts and traps animals

and rips up and devours them—like leopards devour animals." The powerful and danger-ous elephant also is identified with Sagbata (Agbanon 2.6.86).

41. Seashells (*huken, xuken,* "stone of the sea") are identified generally with coolness, although links to the dead and to the deity Minona also are made. Large seashells are used as breasts in Minona shrines (Agbanon 2.21.86). Of the appearance of smaller shells around the neck of a figure, Ayido noted (5.2.86), "That is *na* [Minona]. One is asking for peace (*fifa*)." Ayido further explained (7.6.86) that seashells also are identified with ancestors (*kulitɔ*) because, it is maintained, they go to the sea.

42. The term *ahwan* also is employed to mean a large group of something, this based on the fact that doves often flock together in large numbers.

43. Because of this quality, doves are employed in the manufacture of finger-ring *bo* intended to protect persons from poisoning (Agbanon 2.19.86).

44. Agbanon notes that the dove (2.28.86) "does a lot of work. The dove is used to make *bo* that are consumed. One eats this when one is calling the name of something powerful [i.e., making an incantation]. One prepares the dove with kola and pepper. One cuts the neck of the dove to take its blood. One dries this blood and then eats it so that if someone pronounces an incantation you will not be touched. Conversely, if someone said something to make you angry, if you take this thing in your mouth and pronounce an incantation, he becomes crazy."

45. An important source of this *bociɔ*'s power thus is found beneath the ground.

46. According to Maupoil this grain is also associated with twins (1981:205).

47. Agbanon explains (3.4.86) that "when we put it around something nothing can penetrate it. When one does a *bo* with it no bad thing can happen." According to Adido (12.2.85), the palm frond also is used to indicate when ceremonies are taking place and when there has been a death in the family. In addition, if one is discussing a land, suggests Adido, "one puts it to show that the land belongs to me." Palm leaves also frequently are used to dress *vodun* and their devotees because of their assumed cool, pacific properties (Agbanon 3.4.86).

48. Other plants used in the context of *bo* and *bociɔ* include charred grains of corn, millet, and beans (this combination is held efficacious because these grains constitute gifts to *vodun;* Herskovits 1967 2:273), and *de,* or raffia palm (used historically in the making of garments. Today it symbolizes distress and poverty, since anyone who can afford to will wear imported cloth; Pazzi 1976:97).

49. Cluysenaar (1987:168).

50. As Pierre Machery points out (in Eagleton 1987:45), for artistic production gener-ally there are "1) certain specific raw materials to be transformed; 2) certain determinate techniques of transformation; and 3) a definite product." In the words of Terry Eagleton (1987:45), "Raw materials are never 'innocent' or easily pliable: they come to the literary productive process with specific degrees of resistance, particular valences and tendencies of their own." Collingwood's point on materiality and art (1977:16) is likewise of inter-est: "The matter is what is identical in the raw material and the finished product; the form is what is different. . . . To describe the raw material as raw is not to imply that it is formless, but only that it has not yet the form which it is to acquire through 'transfor-mation' into finished product."

51. In the words of Adorno (1984:252), "The experience of art is adequate only when it is live [*lebenig*]."

52. In other *bociɔ* contexts, squirrels are believed to provide one with speed, vigilance, or success (Rivière 1981:182).

53. The toad in contrast is identified as something without value.

54. Of the image of a snake swallowing a frog which appeared on the royal *satɔ* drum, Dangban explains (2.26.86): "If all the world has decided to swallow me, the person who will save me will come."

55. For a discussion of metaphor in the context of African architecture see Blier (1987).

56. Agbanon notes in this regard (2.28.86) that one grinds the owl into a powder and children eat it so that no sorcerer will be able "to see" into their stomachs. Other birds appearing frequently in *bo* and *bociɔ* include the fishing eagle (*hon*), a raptorial water bird associated with the Tɔhɔsu gods of springs and rivers. This bird is believed to have given birth to all the other birds (Agbanon 2.19.86). Vultures (*aklasu*) used in *bo* and *bociɔ* also are identified with sorcery, for sorcerers are believed to be able to transform into them (Agbanon 2.19.86). The vulture additionally is identified as a signifier and messenger of the gods (Quénum 1938:87–88).

57. The hornbill also appears frequently in contexts of *bo*. With its prominent red beak and loud beating wings, as Agbanon explains (2.28.86), "it shows how the world is. If it is flying it will open its wings well and close them. The hornbill is in the process of saying that *gbɛ* [life] is well open. There are no obstacles on the road of life, but it will not continue like this, because soon life will close."

58. It should be noted that the *iroko* also is associated with the land of the royal dead (Fe, Ife) and with the powerful *aziza*.

59. One of King Gbehanzin's court songs notes the importance of *karité* wood as well: "This tree is harder than all the other trees." (Agbidinukun 7.10.86). Another court song associated with Gbehanzin notes, "I cut the *kake* [*karité*] tree and I will go close to the door there, and nothing will be able to pass" (Agbidinukun 7.17.86). This tree also is associated with the ancestors. Agbanon suggests (2.21.86) that "*karité, iroko*, and *kpasa*—these are the trees created a long time ago. One saw them at birth."

60. Dilthey suggests more generally (1961:107) that "meaning is the special relation which the parts have to the whole within life."

61. One of the Danhomɛ court songs says, "The war does not surprise the horns of the ram" (Agbidinukun 7.17.86). The ram, also identified with the thunder and lightning deity, Hɛvioso, is associated with a number of *bo* used in conjunction with war (Nondichao 10.17.85).

62. Other alchemical features of myth are discussed in the structuralist texts of Claude Lévi-Strauss. As he explains (1963:210), "If there is [individual] meaning to be found in mythology, it cannot reside in the isolated elements which enter into the composition of a myth, but only in the way those elements are combined."

63. Thus the skin of the *agbanli* antelope is used to make *bo* for pregnancy (Agbanon 2.19.86). The horn of this antelope in turn is employed in a *bo* to stop action of another *bo* bearing sickness. "The horn is called *zo* like fire, but the cob horn cannot light fire in the bush," explains Le Herissé (1911:152).

64. It is maintained that roan antelopes are animals of prey who sometimes consume human flesh (Agbanon 2.19.86). Reinforcing both this belief and the above legend is a popular proverb which says: "When the roan antelope makes a path somewhere others

will not dare to follow it" (Sagbadju 7.1.86). Another proverb similarly emphasizes the dangerous attributes ascribed to this antelope: "The roan antelope said, 'Even if I die now, my severity will be in my death. Even if I am living, my severity is not mild. No animal can trap and eat me. Man cannot trap and eat me without my bothering him. My severity is in death; my severity is in life'" (Ayido 5.2.86).

65. This work, Herskovits notes (1967, 2:283), was placed either on the ground near the man's sleeping mat or under his pillow.

66. Another roan antelope horn *bo* of this type called *flu*, "miss," was used as a drinking vessel. Dewui noted with regard to this object (7.3.86) that "one puts powder and water in the horn. With this horn, even if you do something wrong, nothing will harm you."

67. Silverman explains (1983:100) the processes of condensation in literature as follows: "Condensation . . . can portray a person, place, or thing, while giving it another's name; create a representation out of features drawn from a group of people, places, or objects; project a person, place, or object into a context which 'belongs' to another; or fabricate a person, place, or object which bears a 'family resemblance' to those it represents."

68. Ayido suggests similarly (7.13.86) that "when you see the chameleon it will transform itself into the cloth you are wearing. . . . It is for this reason that one says that 'life is a chameleon's cloth.'"

69. Agbanon adds (2.19.86), "You can get a cough if you spit somewhere and the chameleon eats it."

70. They suggest Kristeva's Ideologeme (1980:36) in that "intertextual function [is] read as 'materialized' at the different structural levels of each text . . . which stretches along the entire length of its trajectory, giving it its historical and social coordinates."

71. Yet another *bo* called *avu mi yi wɔ* ("the dog takes the *pate*") which employs the skin of both a dog and a hyena is believed to help one avert danger. The source for this latter work is a proverb: "the dog does not stay outside in view of everyone to bark at the hyena." Explaining this proverb, Dewui noted (7.3.86) "The dog does not trap the hyena. No matter what the force of the dog, it can never trap the hyena." As Lakoff points out (1987:394), anger often is linked to animalistic features of snapping, growling, snarling, and hackles.

72. Another water denizen associated with aggression is the crab. According to Agbanon (3.11.86), "The crab is able to block the path of the serpent who tries to enter its hole. Moreover it is angry like the leopard; thus princes do not eat it."

Chapter 7

1. See Jacques-Alain Miller (1977–78:25–26) on the role of suture in relation to the chain of discourse. Roland Barthes's concept of textuality (1974:160) as braid—as something in which different levels of ideas intersect at multiple points—also is of interest for these surface parergon and the means of their suturing. In Barthes's words (1974:160), "The grouping of codes, as they enter into the work, into the movement of the reading, constitute a braid (*text, fabric, braid. . .*)."

Notes

2. For cinematic texts, Kaja Silverman suggests (1983:195), " 'Suture' is the name given to the procedures by means of which . . . texts confer subjectivity upon their viewers."

3. This emphasis on the transmutation of materials also has an important alchemical base. As Burckhardt explains (1986:118), "With regard to the outward work of alchemy, nature is the driving power behind all transmutations—the 'potential energy' of things." Herskovits similarly groups *bociɔ* materials into distinct categories or states, many of which complement in key respects those discussed here (1967, 2:263): "1. *amasi:* a leaf and water solution used frequently for washing, rather than internal use. 2. *ati:* powdered ingredients, consumed or used externally. 3. *kan:* ingredients which are wrapped and tied. 4. *sa:* bits of smooth wood [more generally *sa* is an ointment]. 5. *defife:* substances reduced to powder. 6. *alɔgan:* rings of iron or brass."

The principal differences between Herskovits's material states and my own is his separate listing of *atin* (*ati*) and *defife* as powders. He also employs the more specific term, *amasin,* "medicinal water," rather than its more generic root, *sin,* "water," "liquid." In addition he employs the term *alɔgan* ("finger ring") instead of the more general *gan* ("ring").

4. Water from the Atlantic Ocean sometimes is used in making *bo.* "That gives power to the *bo,*" Agbanon notes (2.27.86).

5. Another term is *gbɛ kan* ("cord of life").

6. As Derrida notes (1981:70) in his discussion of the Platonic and Socratic writings on the *pharmakon:* "This charm, this spellbinding virtue . . . can be—alternatively or simultaneously—beneficent or maleficent."

7. Ayido asserts accordingly that (5.2.86) "because all the *bo* are not the same, the powders are not the same."

8. "Sometimes one is sick and one sends this powder and one eats it to survive," explains Ayido (5.2.86). He observes (4.25.86) in turn that "if you eat that, the bad things in what you are doing will no longer look for you. They will not look for your children. They will not look for your wife. If we want we can give some to our wives and children and they will eat it."

9. Noteworthy here and in other examples are the alchemical principles at play.

10. In local cache sex forms (*godo*), according to Pazzi (1976:180), a white band is used for men, while a short band of red percale is used for women.

11. See also Spieth (1906:516).

12. Sorcerers also are believed to bind individuals with cords.

13. In his discussion of the Fa divination sign Abla-Meji, whose symbol is the cord, Maupoil notes that cords are used "to tie [*bla*, the linguistic root of Abla] everything" (1981:482).

14. Gilli cites a similar proverb from the Ouatchi area (1976:103–4): "It is at the end of an old cord that one weaves the new."

15. The divination sign Abla-Meji, whose visual sign is a cord also is closely identified with the *vodun,* Dangbe. According to Maupoil (1981:482), "The *vodun* Dan [is] the dispenser of the benefits of the world, [and his sign] is thought to bring wealth to its children."

16. Counting is done here by fives until forty, by forties until 200, and by 200s until 4,000. Pazzi notes that (1976:113) "forty is considered the royal number; thus the tribute

that the Agbome kingdom had to pay to the king of Ayo in the eighteenth century was 40 slaves . . . 40 guns, etc." My sources more often mentioned forty-one (*kanɖe lisa*), a number identified with surplus (i.e., one more than the full complement) for such purposes.

17. According to Gilli (1976:129): "Tattoo is translated as *de kan,* the substantive *kanɖede* signifying 'alliance pact,' an alliance which ties many individuals into the same social group, requiring them to acquire an exterior mark which facilitates the mutual recognition of the members. . . . The tattoos are the distinctive signs by which 'brothers' manifest themselves . . . and make the members feel like part of a big family of a particular *vodun*."

18. See also Bay (1985:15).

19. Ayido suggests (5.2.86), however, that in general, "cotton string is not good" in *bo.*

20. Thus, for example, a piece of red monkey skin is used to make a cord employed in *bo* for pregnant women because this species of monkey is believed never to abort (Le Herissé 1911:153).

21. In the same way that plants are associated with different *vodun,* some cords also are identified with them. Accordingly, Sagbadju suggests (8.2.86) that cords represent "the different *vodun* that are attached around its body."

22. Because the *hunsikan* also is used to attach drums, its identity with funerals and certain religious rites may also be important. The one type of cord that is said never to be used in *bo* and *bociɔ* is cord made from palm. This, according to Ayido (5.2.86), is because of the palm leaf's close association with peace.

23. Pazzi suggests (1976:97) that from the word raffia (*de*) is derived the expression which designates "masculine beauty." Raffia's importance in *bo* and *bociɔ* is also grounded in its close identity with *vodun* rituals. In this, raffia also alludes to a vital source of *bo* or *bociɔ* power.

24. Of interest as well is the use of the verb *so* in combination with other verbs to convey ideas of sustained action. As a verb, *so,* when pronounced with a dulled *o* (as *sɔ*), signifies "to pierce," "to sting," "to bite," "to pound," "to take," "to seize," "to shoot," and "to strike."

25. The adverb *sohuihue* (*soxuixui*) for its part designates "calm" and "patience."

26. While iron is most often associated with Gu, it is also identified with other *vodun* such as Tɔhɔsu (Tɔxɔsu). Explains Ayido (5.2.86), "It is because Tɔhɔsu has pieces of iron that we call this god by the praise names *Gan kpoge non* (owner of the iron cane) and *Gan za non* (owner of the iron hat)."

27. When hoe blades are incorporated into *bociɔ* sculptures it is the power of this object's pushing ability which is given primacy. "When you use [the hoe] . . . nothing can push one from here," asserted Sagbadju (7.1.86). Bells, for their part, draw on the power of sound. It was explained accordingly that "if a bad thing wants to arrive and sees the bell, it will turn back. If this is in the house, the thief will not come. The bell is used in a *bo* to protect the house. One places it at the door" (Sagbadju 7.1.86). One bell discussed by Spiess (1902:314) is called *Awaga,* "war bell," from *awa,* "war," *ga,* "bell." As he explains:

> The war bell is found only on fetish priests and thus is named fetish bell. If someone passes by a priest's hut, he may be fortunate to hear the deep, muffled sound of the

bell. . . . Everything is quiet when the *awaga* is rung. It is used as a war bell if the priest has a revelation that a war will break out. The priest . . . also rings the bell on special occasions such as sacrifices, treating the ill or to provoke special attention from the gods. In judicial proceedings the bell is also tolled or when someone wants to make a public address. Only in that case, the king holds the bell.

The roles of whistles in *bo* are of interest as well. Savary describes a *bo* made with a whistle of European manufacture as follows (1976:240): "*Bokanzo* (amulet, cord, fire) is a whistle of European manufacture attached with lizard skin which has leopard fur and is marked with eight cowries on its face. In using the whistle it is possible to call the rich man to one or give him orders at a distance." An important feature of the whistle, Savary suggests, is its association with the police and their ability to call (and stop) citizens. The god Age also is associated with whistles. The leopard here is identified with royal power, while the cowries are associated with the destiny of Fa.

28. Iron arrowheads and spear shapes accordingly also are identified with the serpent deity, Dan.

29. *Wɔlɔ* is used to describe the action of bringing a coup d'état. The term *wɔlɔ gede* means "trapped."

30. On the importance of rings, see also Spieth (1906:517).

31. And as Maupoil notes (1981:118), diviners will often wear on their necks or wrists the "pearls of Fa"—alternating yellow and green colors.

32. Ayido disagrees, suggesting instead (6.16.86) that it is cowries which represent man, money, and strength, while the *adjikwin* seed is identified with woman, material lack, and disappointment.

33. With *kuɖiɔ-bociɔ* one sometimes attaches cowries around the neck, hands, and feet, Sagbadju notes (8.2.86), because "if a person dies, one puts money on the head, middle, and feet."

34. Mirrors share with beads and cowries an identity with monetary value and foreign origin. As surface signifiers in *bociɔ*, mirrors generally are associated either with the repelling of danger or with prognostication.

35. Dewui adds (7.3.86), "There are no glass bottles in real *bo*. The real bottles of *bo* are the gourds."

36. The Fon word for "horn," *zo*, also has interesting linguistic complements, for *zo* not only means "fire," but also is used in reference to acts of sorcery.

37. The use of calabashes for the empowerment of *bo* and *bociɔ* also has important grounding in their association with Legba, the deity who brings offerings to the other gods. His role in *bo* and *bociɔ* is key. Sagbadju suggests (7.1.86) that "when Legba is standing, all the *bo* are at his hip. He has a calabash in which he has white powder and red powder. When he takes the red and blows it, everyone begins to get sick."

38. One uses the term *ka* ("calabash") for one's daughters, but *kago* ("bottle-form calabash") to refer to one's sons. Brand suggests (1981:7) that the calabash additionally "serves a role as intermediary for love messages between boys and girls. This love message is engraved on the calabash and is sent to the woman loved."

39. Savary notes (1976:242) that a pottery vessel associated with twins was used in a *bo* called *agojeli* ("nut fall body"). This work was ornamented with vegetable fibers and cowries and was believed to grant one impunity for wrongful acts.

40. Certain types of these pottery vessels, called *lobozεn,* are associated with the dead and are used in ceremonies to call the ancestors.

41. Clothlike cord is used locally to designate space. Skertchly observed that (1874:73) "our passage beneath the joji was secured by my stick, which, being wrapped in a white cloth, indicated our being upon state business." Norris noted a similar incident a century earlier (1789:110): "We proceeded through Ajawere market. . . . We then entered a large parade [ground] inclosed with different kinds of cloth extended on rails, to keep off the populace; adjoining one end of it was a higher inclosure of finer cloth for the king."

42. Sometimes the surface of the leather (or cloth) container is decorated with signs indicating the power sources of the object. A work described by Le Herissé (1911:153), one intended to protect against lightning, was made of a combination of leaves and other materials enclosed in a leather packet decorated in such a way as to identify the means of empowerment, including the most important attributes of thunder and *vodun:* an axe, red parrot feathers, and cowries. According to Le Herissé, the principal materials in the packet consisted of mud from a spring in Cana whose water was believed to reflect lightning, along with a leaf called *zunkuzui* which is described as being so small that it cannot be touched by gunshot.

43. Maupoil explains accordingly (1981:335) that the red rooster is associated with Legba.

44. The geomancy sign Yeku-Meji is identified with the color black. Maupoil asserts (1981:445) that this sign is associated with "a black disk representing the opposite of the symbol of Gbe (life). It is the reverse of day, the reverse of life. . . . It represents Lisaji, the west, *zan,* the night, *ku,* death. . . . It takes care of the funeral cults, and . . . war. It commands the celestial vault during night and twilight. Yeku has a rapport with agriculture because those born under this sign, one says will be good farmers. One recognizes in Yeku-Meji a power over the earth."

45. The identity of white with the ancestors is explained further by Pazzi (1976:224–225): "With white fibers one weaves 'percale,' which one utilized especially for ancestral rites. One suspends it against the wall of the building where one sacrifices to the deceased and sprays it with blood. One also uses it to receive the sacred nuts of the oracle and suspends it at the summit of a pole, as a flag in the interiors of the *vodun* temple. It is in addition the cloth with which one traditionally dresses the *vodunsi.*"

Chapter 8

1. On the importance of speech genres in East Africa see Corinne Kratz (1989).

2. See Douglas (1969) on the danger inherent in typological transgression.

3. Royal *bociɔ* genres generally are not considered to be more powerful than the works made for members of other social classes.

4. Another word identified with genres, *kple,* means "to assemble," "unite," or "group"—but almost uniquely in the context of people or animals.

5. Also of interest in this regard, the term *do* when used as a preposition designates "in," "among," and "against."

6. See also Stephen Neale (1980) on genre theory in film.

7. Significantly, Dugalt Stewart's dominant genre paradigm is the family, an institution of both social and psychological import.

8. *Bociɔ* genre orientation suggests in this way what Volsinov calls (in Stewart 1984:6–7) "an orientation at once from outside in and from inside out." See also Wellek and Warren for a discussion of the internal and external dynamics of genre (1963 in Fowler 1987:105).

9. In nonfigural *bo* many of these genres also apply. Some consist of tieing cord or other materials around a particular body part. Others include the insertion of empowered materials into an object or area. Still others involve the spreading of materials over the surface of a form or body in a manner which recalls the process of making swelling *bociɔ*. Another grouping of works combines elements or features from several objects in a manner recalling deformity or multiple-imagery *bociɔ*. Others are empowered by Fa, the *vodun*, or sorcerers and serve in some way as simulacre in order to "exchange death" for life.

10. Often however such cloths are missing or removed when the works find their way into museums or private collections.

11. Ayido suggests (4.25.86) that *kuɖiɔ* works sometimes also play an active role in repelling other forms of harm: "If a bad thing is about to happen at your house, this will get up to chase it away."

12. Such a work serves accordingly as an offering (*vɔ*) to the various *vodun* associated with a given divination sign (Ayido 3.29.86). Maupoil says (1981:363), "In effect, the *bociɔ* enters into the category of *adra* (*vɔ* sacrifice)." As Ayido explains (4.25.86), "All these *vɔ* [offerings] go to Kotonou [Cotonou, traditionally called Kutonu, "town of dead things"]. . . . The sculpture will accompany him in death [*ku*]. If you did not do a *vɔ* with a sculpture it is you he would have taken." It is this tradition of sculptural *vɔ*, more than any other, that distinguishes Fa (Ifa) divination among the Fon from that of their neighbors, the Yoruba. As Sagbadju explains (7.1.86), "The practice of using sculptures in Fa offerings is found only with the Fon." He adds (7.1.86), "The Yoruba take animals in exchange for the deaths of humans. We Fon instead use wooden figures. In order to exchange someone's death we take the cloth of the person, and rip it and have [the sculpture] wear it." Clay figures also are used for this purpose among the Evhe. Pazzi notes accordingly that (1976:303) "one calls *vɔ* the deceitful representation that one gives to the malevolent forces (Na) in substitution for the person. This deceitful representation is generally made up of a clay statue in which the diviner imprints the features of his client (he contents himself in marking a ball of clay with the eyes and mouth of a human head because this representation is purely symbolic)."

13. Because *bociɔ* left in the earth often are eaten by termites, the height of a statue is never an exact indicator of status.

14. Ayido explains in turn (5.2.86) that "that is why we diviners take the remainder of this cloth and bring it to the house." If a statue is intended to serve as surrogate for a child, one will place the cloth of its mother on the carving instead, since infants generally do not have their own clothing (Ayido 4.28.86). The importance of cloth in ceremonies "to change death" also occurs in royal contexts. During the ritual of the annual royal bath, a child was selected to assume the sins of the monarch, and was given the old cloths of the king to wear (see Cornevin 1981:99; and Bertho 1945).

15. Other materials placed on or associated with *kuɖiɔ* sculptures include tobacco, tobacco pipes, tobacco containers, and small baskets (Ayido 4.25.86). These materials serve generally as gifts for the dead (Ayido 5.5.86). Similar objects play an important role in funerals.

16. Sometimes other food offerings are made instead. Ayido suggests that offerings are not always employed on this occasion however (4.25.86): "Before planting the death-exchanging sculpture one does not need to put anything in the earth, because one called the *du* onto the sculpture and it represents in this way you who did the *vɔ*. It is not a *vodun;* thus we will not place leaves beneath it. Nor will we put red oil beneath it."

17. Sculptural offerings are positioned in similarly diverse locales.

18. Works of this type overlap with pierced or pegged *bociɔ* in a number of cases. Indeed it is in the course of placing the pegs in the holes and pronouncing the desired words that many "pregnant *bociɔ*" are made to act (Savary 1976:241). One such pregnant-*bociɔ* work described by Savary (1971:4) incorporated a piece of a branch taken from a tree struck by lightning, the bone of a person who had smallpox, the head of a male duck, and the skin of a civet cat. These were tied to the work with a cord from the highly toxic latex plant. The whole was activated in turn in a rite consisting of having it absorb the taboos of the associated empowering gods. In this way the work also was identified with the *vodun-bociɔ* genre.

19. Since *agban* also signifies "gift," *agbandjayi* carries the additional meaning of "the gift has fallen."

20. Stewart points out (1984:108) that "the history of the aberrations of the physical body cannot be separated from this structure of the spectacle. The etymology of the term *monster* is related to *moneo*, 'to warn,' and monstro, 'to show forth.' "

21. Ayido explains (4.26.86) that "Fa has four eyes because the palm nuts with which we consult have four eyes. That is why Fa does not say only the words of today but also the words of the future and past." Ayido adds (4.27.86), "Even if you don't see the four eyes in Fa . . . it is with these eyes that Fa sees." One of Fa's strong names asserts, "Remain calm; the eyes are side by side" (Ayido 8.3.86).

22. The *aziza*, as noted elsewhere, are closely associated with Age, god of the hunt.

23. The importance of Janus imagery with respect to deities appears prominently in Fa divination texts. Maupoil notes that according to one such text (1981:190), Meto-lofin, the king of Ife, had a goat with four eyes, two in front and two behind. The two in front served as interior house guards, the two others as exterior house guards. This goat, Maupoil asserts, represents the sun which guards the world of Metolofin.

24. *Kpo* also means "hump."

25. Often different types of powders are placed in holes in different body areas.

26. The Evhe root of *sesao* is *sesa*, which derives from the verb *sa*, meaning "to bind" or "to fasten" (Ellis 1970:92). Another frequently employed term in Evhe is *dzoka* ("cord of sorcery"). Spiess translates this term as "magician's thread" (1902:314) and describes such *bo* as "magic strings which give assistance." The names of individual objects similarly incorporate bondage imagery. One such work consisting of quills and grasses tied together with string was called *atiblewo* (*ati*: stem; *ble*: tie), "the tieing of stems"; another is known as *gbesa*, "binding the forest" (*gbe*) (Spiess 1902:315).

27. The way *bociɔ* are bound also is given considerable importance. In many types of *bo* and *bociɔ*, cords and other binding materials frequently are knotted or tied. In other

cases, according to Herskovits, knots are avoided. As he explains (1967, 2:269–70), "No knots may be used in fastening the cord, because if these are employed in *gbo* used for or against black magic, it would lose its efficacy. . . . The cord is a '*gbo* cord' used in all kinds of *gbo*. When employed in an evil charm such as this the cord is never twisted, otherwise the misfortune that is sent to another would not have a straight path to follow, and would therefore never reach its objective."

28. Freud employed bondage metaphors in his discussion (1953, 28:63) of primary process and the production of feeling (the "binding" of excitation behind every wish).

29. As we have seen, the use of cord within *bociɔ* also recalls Barthes's metaphor of braiding, which is utilized to suggest the intersection of ideas at multiple levels of textuality. As Barthes explains (in Silverman 1983:241) "Each thread, each code, is a voice; these braided—or braiding—voices form the writing." In bound or bondage sculptures of this type considerable importance is placed on the selection of tieing or binding materials; these range from simple cords, to toxic vines, to the skins from dangerous animals, to ropes used to attach cadavers.

30. A cord is tied around the waist of a woman when she is giving birth to assure that her waist will return to its original shape. This cord also is referred to sometimes as *adɔblakan*.

31. As Agbanon notes (3.5.86), "This cord is used for all the *bo* which help to avoid death, because one does not put this cord in the tomb. . . . When the grave digger sets the corpse down in the tomb, he removes the *adɔblakan*." In turn, one often wears a piece of this cord as a *bo* to avoid having dreams about the dead. "If you sleep and you see the ancestors (*kulitɔ*) you will wear this cord around the waist, and will no longer see them" (Agbanon 3.5.86). This cord is thus at once linked to death and to overcoming dangers or fears associated with the dead. Of a *bo* which incorporated a roan antelope horn wrapped with such a cord, it was explained by Agbanon (3.7.86), "In these works one includes the cord used to wrap the dead—you take that from the grave digger. You say that no one will be able to speak badly of you, that no *kulitɔ* will turn against you. You will be saying this while you attach the roan antelope horn with it. You attach it and it will be finished."

32. The traditional use of this term also suggests the idea that the battle results cannot be held against one.

33. With their encrustations and accumulations of additive surface materials, however, most sculptures identified as Fa-*bociɔ* look strikingly different from the generally thin, austere polelike *kuɖiɔ* works which also are empowered by Fa. Furthermore, most of the more standard works identified with the Fa-*bociɔ* genre have roles which lie outside the somewhat narrowly defined death-exchanging concerns of the *kuɖiɔ* sculptures. Nonetheless, psychological projection and catharsis here too are important, for the assurance that comes to one in the course of associated sculptural empowerment is a critical part of their identity. Of one such work, Sagbadju explained that "with this no one will close the door on me, no one will trap me. If I travel, nothing will happen to me. When I arrive, no one will tell me anything" (7.1.86).

34. Diviners are the principal makers of these works, although they often commission associated sculptures from specialist artists. Because of the obligations of diviners to work for the benefit of humankind, many people maintain that Fa-*bociɔ* are always protective objects. As Maupoil notes (1981:151), Fa forbids sacrilege and black magic, but

more so direct action against another person. In reality, however, like other *bociɔ*, some Fa-*bociɔ* also are identified with aggressive concerns. In the words of Sagbadju (7.1.86), "Because Fa has power, it can do both good things and bad." A small hole called *gede* commonly is cut into the backs of Fa boards for the latter purposes. Maupoil suggests in this light that (1981:150) although all signs can be made to irritate others, some are especially malevolent. Lete-Ce and Ce-Lete are the most important—"so dangerous that they are called only by euphemisms." When making a malevolent Fa-*bociɔ*, materials antithetical to a particular *du* often are incorporated into the work. As with *bociɔ* generally, pollution thus in an important activation means. Maupoil explains (1981:150–52) that certain particularly "hot" things are forbidden to Fa—the blood of a dog or rooster, hot pepper, red flowers of certain types, as well as crocodile bile, leopard whiskers, the extracted juice of venomous plants or roots, and cadaver parts. Dewui suggests of one work of this type (7.3.86) that "if it is a bad thing that one wants it to do, one will say to it that it is not I but someone else who is adding these things to it."

35. In the same way that Fa diviners generally are responsible for the making of any Fa-*bociɔ*, so too, it is the *vodunon* (*vodun* priests) who make many of the *vodun*-related *bociɔ*.

36. Many works of the *vodun-bociɔ* genre incorporate few if any elements indicative of the particular god that empowers it. Many individuals maintain accordingly that the only effective way to tell which *vodun* the sculpture is identified with is to see the ceremonies of its installation. As Sagbadju explains (8.2.86), "Only if I do it in front of you, will you know." Ayido notes similarly (5.2.86) that "all the sculptures are the same; it is the *name* that one will call on them that differentiates them."

37. Eyes are closely associated with supernatural power in other ways as well. The heavens are called *jinukusu*, "eye of the sky." Lightning, *sokewun*, means "the sky opens its eyebrow." Likewise if one digs a hole, it is said that one has dug an "eye" in the earth (Agbanon 3.5.86).

38. Herskovits also suggests (1967, 2:282) of one work with "a small piece of iron shaped like a snake . . . [that] a man who [goes] on a journey . . . inserts the *gbo* into the ground . . . 'feeds' it some palm oil, alcohol, and red kola, and drinking water, and says '. . . give me all I wish for in this country. Let all the chiefs love me, let all the men and women love me.'" Another Dan-associated *vodun-bociɔ* is described this way: "Bound to the figure are two small terra cotta pots called *gozon* in which are placed two iron spears which are said to represent Dangbe [Dan]. The pots are filled with leaves which are associated with this particular *Voodoun* or deity" (Siegmann 1980: pl. 28). This work was collected in the Adjara area near Porto-Novo.

39. Miniature iron swords also are identified with the god Dan.

40. Of a figure identified with the god Age (Agae) which was collected in 1908 in Togo and which is now in the Linden Museum, Cudjoe writes (1969:64) that "this figure is dedicated to the god Agae who is worshipped on Tuesdays and Saturdays, when pigeons, chickens, goats and dogs are sacrificed. A part of the meat is laid at the feet of the god and the rest is eaten by the priest."

41. Some Legba-*bociɔ*, however, show no such distinguishing features. A series of Legba-*bociɔ* from Togo now in the Linden Museum are typical. Sharing the rudimentary polelike form of *kuɖiɔ* or death-exchanging *bociɔ*, these works have similar functional and placement features as well. Cudjoe describes (1969:60–61) this corpus of Legba fig-

ures as having tasks ranging from courtyard and door guardianship, to the scaring away of "evil spirits," to the protection of newborn infants. Of one of the latter figures which was collected in 1908, Cudjoe writes (1969:61): "Women whose children die shortly after birth ask their husbands to carve them such a figure which is then placed at the edge of the path outside the village with the hope that it will prevent any future children from dying." These works thus combine essential features of both the *kuɖiɔ-bociɔ* and *vodun-bociɔ* genre, drawing on the power and potentialities of both.

42. This work also is identified as a *kuɖiɔ-bociɔ*.

43. Explaining one such *vodun* sculpture, Ayido noted that (5.19.86) "this is the *vodunon* of Sagbata. It represents the ancient priests of Sagbata who are already dead." Generally it is not a specific priest that is represented in such sculptures but rather the category of deceased *vodun* priests at large. Sometimes nonpriestly ancestors also are identified with *bociɔ* of this type. Siegmann explains (1980: pl. 29): "The Fon deified their ancestors, whose cult was almost as important as those of the great gods. Believed to be vitally involved with the immediate affairs of men and a great spiritual influence upon them, paired figures were carved to represent the ancestors. They would have been placed at the sides of a door of a hut (the male to the right, the female to the left) to prevent thefts or the interference of malevolent human agents in the affairs of their kin."

44. Some *vodun-bociɔ* in turn serve to protect the crops or agricultural fields. Often such works take the form of bottles secured to trees or bushes growing nearby. These *bo* are believed to bring divine protection to the crops. Of one such work it was said, "I put *vodun* in so that you will get sick if you take it" (Ayido 7.27.86). Crop-protecting *bociɔ* of this type often are associated with Hevioso or Sagbata.

45. De Surgy suggests (1988:132) that "those who died a violent death or from other openly aggressive causes are assimilated into the followers of the vodun Da [Dan]."

46. See Deleuze and Guattari (1987:239) on the potency of sorcery accusations.

47. Dewui notes similarly (7.3.86) of sorcery temples near Abomey, "When one goes there one finds many *bociɔ*."

48. A figure identified by Sagbadju (7.9.86) with witchcraft was characterized by large eyes because, he explains, "with its eyes, when night falls, the [sorcerer] lights fires to see clearly."

49. Different parts of the body also are identified with sorcery-related animals. According to de Surgy (1988:265), correlations are made between the head and the owl, the ears and the *avesikpui* bird, the kidneys and the ram or goat, the stomach and the pig, the palms and the cat, the back of the knees and the dog, and the pad of the foot and the white chicken. The rat's identification with sorcery is based on its entering graves to consume the flesh or bones (Agbanon 2.19.86). Flies, because of their association with corpses, and hyenas, as consumers of human flesh, are associated with sorcery as well (Agbanon 2.19.86). The dried intestines of hyenas are used in *bo* to protect one from sorcery. This is because, in Herskovits's words (1967, 2:269), "the hyena is the enemy of all enemies."

50. According to Agbanon (2.19.86), "Those who create altars for the witches to protect against witchcraft, kill pigs." Ayido suggests (8.3.86) that the pig also is identified with Sagbata. One of Sagbata's praise songs states that "I am the animal, the pig, the king of male animals."

Chapter 9

1. As Jameson argues (1988:52), art "articulates the *ethos* of its . . . classes." Also see Veblen's theory of the leisure class (1979) and T. J. Clark's discussion of class and art (1985:6).

2. There is an important literature on the subject. See especially: Frazer (1890, 1968), Figgis (1896), Bloch (1961), Hocart (1927, 1936), Marshall (1939), Nadel (1942), Coomaraswami (1942), Kuper (1947, 1964), Dumezil (1948, 1977), Evans-Pritchard (1948), Kantorowicz (1957), Wittfogel (1957), Hooke (1958), Beattie (1960, 1971), de Heusch (1962), Vansina (1962), Geertz (1963, 1980), Southall (1963), Bayard (1964), Beidelman (1966), Gluckman (1940), Goody (1971), Yamaguchi (1972), Francastel (1973), Vincent (1975), Tambiah (1976), Packard (1981), Willis (1981), Adler (1982), Price (1984), Dumont (1984), Feeley-Harnick (1985), Valeri (1985), Sahlins (1958), Cannadine and Price (1985). On art and rulership rhetoric generally, see Winter (1981, 1989) and Marin (1988).

3. Literally, "cooked."

4. Parrots, in part because of their association with empowered speech, frequently were kept in the royal palace. According to Agbanon (2.28.86), such birds would inform the king if anyone in the realm spoke against him. The red tails of these birds also were important to royal *bo* identity.

5. Agbidinukun explains in turn (5.3.86) that "One makes [*bo*] because the king has the power of a *vodun*. All the kings have the power of *vodun*. The kings make these so that nothing will happen to the country. Like *vodun* they protect the country."

6. This *bo*-associated power of metamorphosis is said to have been important to the kings historically in wresting control of the area. As described by a member of the family of the famous Dan whose defeat by an early Danhomε king gave the kingdom its name, "The kings made war by transforming themselves into chameleons or other animals. Our ancestor was a simple cultivator. He did not use *bo* in this way in battle" (Awesu 1.4.86).

7. The power of family heads similarly was attributed to the use of *bo*. Agbanon asserts (2.25.86) that "the one in charge of a responsibility must make a *bo*. If you are enthroned as family head (*da*), you will depend on the *bo* to survive. [This is because some of those] who kneel before you do not like you." The types of *bo* and *bociɔ* which such family heads make are diverse. The only restriction is that such individuals cannot make *bo* that will have a negative impact on their own family members. As Agbanon explains (2.19.86), the "*da* is not allowed to make *bo* that will kill members of his family because he is responsible for them." In part with this in mind, when a Fon man is enthroned as family head he is required to drink a special "oath" solution. According to Adjaho, the Abomey court minister responsible for administering this oath (5.21.86), "One drinks the oath in a skull. The *da* brings liquor and I put it in a skull. Both he and I drink. I say, 'If you make a *bo* you will die. If you prepare something as a sorcerer you will die. If you pray [in a Christian church] you will die.' The *da* can make *bo* but they cannot make bad *bo* to kill someone in the house. This is because if he argued with a person and wanted to kill him, if he ever says this, the person would die."

8. "The names that the kings take," explains Agbanon (2.25.86), "are the names of the *bo*." Adjaho reaffirms this idea (8.11.86), "When they come to the throne, the kings make powerful *bo* and these *bo* [become their] strong names." Because many of these

names also are grounded in a ruler's Fa divination sign, they serve as nomenclature complements to works of the sculptural genre called Fa-*bociɔ*. These Fa-derived names became an important source of artistic imagery in royal *bo* and *bociɔ,* conveying the image that the king was in essence "destined" to rule (see Blier 1990, 1991b).

9. This is because the ronier tree and the oil palm tree look very similar.

10. With Guezo's grandson, Gbehanzin, similarly, as Dewui explains (6.30.86), "nearly all his names come from his *bo*." Perhaps the most famous of his *bo* was called Kondo, Gbehanzin's princely name. As Agbanon explained (2.17.86), "Gbehanzin's name Kondo derives from a *bo* he made by putting the umbilical cord of a baby in a mortar and pounding it."

Court ministers and artists also frequently derived their names from *bo*. The well-known court appliqué artists, the Yemadje family, thus are believed to have acquired their name through a *bo* identified with King Agonglo. As Adande explains (1976–77:76), "The name [Yemadje] derived from one of King Agonglo's *bo* which had as its formula of actualization a phrase which ended in the word *yemadje*." This power object, Adande points out, was intended "to guard the house and to prevent all harm and difficulty from occurring there."

11. The wives of kings were important in the process of royal *bo* manufacture. Thus many of Gbehanzin's *bo* were said to have been made in Dassa-Zoume, the home of one of his wives (Agbanon 2.17.86).

12. The most powerful *bo* the kings made are said to be identified with the mystical land of Fe (Ife—the Yoruba sacred capital), which the kings (and others) are thought to visit through mysteriously placing their backs against an *iroko* tree and passing into it. Because of the association of *iroko* trees with ancestors, such *bo* are seen as especially powerful. As Ayido explains (6.15.86), "The kings go to Fe to talk to their fathers. . . . And when they return, they use these *bo*. . . . The *bo* that says 'today one will do something and it will happen and it happens,' they do this *bo*. The *bo* that says today 'there will be death and today there is a death,' they do this *bo*. They bring these *bo* from Fe."

This tradition of kingly *bo* manufacture is said to date to the period of the founding ruler, Huegbadja, a man who, according to Ayido (6.15.86), "liked *bo* and was a serious maker of them." Huegbadja's son and successor, King Akaba, also was known for his knowledge of *bo*. Agbidinukun notes with regard to this ruler that (4.19.86) "he made more *bo* than all of the other kings because he was a twin." King Akaba's most widely known and powerful *bo*, Agbidinukun suggests, was called *yewunmɛn* ("spirit trapped inside"). "If someone has this *bo* and says to a tree to die, it will die; if one says to a person to die, this person will die."

Undoubtedly the most famous early royal *bo* maker, however, was King Tegbesu (1728–75), a ruler whose skill in these arts is said to have helped him both to survive an extended period of time in his youth as tribute captive among the Yoruba and to win the Danhomɛ throne despite considerable opposition by his brothers to his rise to power. Tegbesu's mother, Naye Wandjele, is also credited with considerable *bo*-making abilities. The last preconquest king, Gbehanzin, also purportedly was a man with great knowledge of *bo*. In Dewui's words (6.30.86), "Gbehanzin was a true man, he made a lot of *bo*." Opinion varies as to the power of King Agoli Agbo (the puppet king established by the French in 1894) and his *bo*. According to Agbanon (2.25.86), by this time, "there were no more royal *bo*. There had already been an earthquake and all the *bo* were destroyed.

Gbehanzin had taken the *bo* to the foreign land." Akalogun noted similarly (7.1.86), "Gbehanzin did not pass *bo* on to Agoli Agbo. As a result his statutes became simple wood." Adjaho on the other hand notes (8.11.86) that one of Agoli Agbo's strong names, "Adoke Yeko . . . is a *bo* name." The successful making and use of *bo,* as we can see, was thought to be essential at once to rulership and to assumptions of authority and power.

13. As Sodokpa noted (12.19.85) with regard to individuals of this profession: "The *kpamɛgan* is the guardian of charms. He makes *bo* for the king to use when he goes out." The tasks which the *kpamɛgan* fulfilled for the king were diverse, involving everything bearing on the king's well-being, from health problems, to family difficulties, to potential conflict in the state. Nondichao describes the role of the *kpamɛgan* this way (11.4.85): "[The kings] have magical powers and they use priests called *kpamɛgan* who know these powers and who are charged with the king's magic. If the king wants to overcome a difficult obstacle he first consults with his *kpamɛgan* because it is this person who has knowledge about all forms of supernatural power." Ayido explains in turn (6.9.86) that it is "the *kpamɛgan* [who] prepares medications for the king. If the king's children are sick he will treat them. And if one needs a *bo* to go to war he does that as well." Thus there developed around the king a whole institution which helped to maintain the power of the king and to keep his enemies at bay.

Because of their importance with regard to the king's welfare, the selection of the *kpamɛgan* was a critical concern to each new king. Agbidinukun explains in turn (6.20.86), "It is your friend who is your *kpamɛgan.* It is the one in whom you have confidence." Nonetheless many of the individuals who held this position were foreigners. According to Agbanon (2.25.86), "It is the prisoners who were captured in war who made the best *bo* for the king. The person who was good, the king did not kill him but instead enthroned him as chief." The principal *kpamɛgan* during the reign of Guezo was a Yoruba man named Babadjiwu.

Foreigners, it was explained, lacked the local ties with individuals who might compete with the king for the throne. In addition the foreigners had potent (foreign) knowledge about empowered objects and both a desire and need to make effective works so that they would be spared the enslavement or death faced by other war prisoners. As Ahonangbaso explained (1.9.86) with regard to the history of his own family, "King Guezo brought [the first] Bodjreno here to Cana and told him to stay so that he could make *bo* to maintain the country of the king. Thus our name means 'make the *bo.*'" Moslems also were known for their special abilities in making royal *bo.* As was explained by the current Moslem chief in Abomey (a man named Malehosu: *male:* Moslem; *hosu:* king), early Moslems in the area fulfilled *kpamɛgan* functions from the time of King Agaja (1708–28) using both prognostication and Koranic verse (12.17.85): "At the palace [my ancestor] took a paper and made a knot on it and wrote the name Allah, and said that the year must be good, and that all the world would be well. We gave this *tila* to the king as a protection. We began with the king; he was the first one who buried it. We said that each house would have this thing; each would bury it in the middle of the house."

14. The names of many of these persons have been retained in the Danhomɛ court histories (Agbidinukun 6.20.86). The *kpamɛgan* of King Akaba (1680–1708) was one. His name, Ahomandegbe, refers to the role his family played during the period when the kingdom was being established by Akaba's father, Huegbadja (also called Aho). The *kpamɛgan* of King Kpengla (1774–89), a man named Bokpe, also is recalled in court

histories. His name derives from one of the *bo* he made which had enabled this king to come to power. The descendant and namesake of this *bo* maker discussed his ancestor's role in the life of the king (Bokpe 2.13.86): "At the time when one wanted to enthrone Kpengla, there was a dispute and his brothers wanted to drown him by using *bo*. The name Bokpe comes from this time and the saying 'their small [*kpe*] *bo* will do nothing [against our *bo*].'"

15. According to Zenhwen's namesake and descendant, Zenhwen (8.6.86), "Tegbesu named him *kpamɛgan*, saying no bad things will happen to me that would ruin the country. If night falls, stay during the night so that no bad thing happens. . . . The names of Gblo and Zenhwen today are called whenever one wishes to make a princely *bo*, particularly those placed in front of compound entrances to avoid discord during important ceremonies." As Nondichao explains (1.3.86), "When you place *bo* in front of the princely house, you will pronounce certain things to put the thing in power. And you will say, 'I give hommage to Gblo the great *kpamɛgan* and to Zenhwen the great *kpamɛgan* of the princes.'"

16. Discussing the origins and significance of this royal dance-form *bo*, Prince Agbidinukun, the person who is in charge of associated performances, explained (4.28.86), "Tegbesu did it for the country, so that the country would have coolness and peace. This is an enormous *bo*; it comes out and turns around and around when it dances in front of the king."

17. Skertchly recounts (1874:159) similarly that King Glele had "Round his neck . . . a fetiche chain, encased in a square leather bag, ornamented with leopard skin." That Glele's pendant *bo* was square rather than round may have grounding in the fact that round things were forbidden to him within his divination sign (see Blier 1991a). What this *bo* contained by way of empowerment substances is not clear—elements taken from the natural environment or Islamic script are both possibilities. What was essential, however, was that the inner matter remain close to the king's body.

18. The *ɖesisen* and other royal *bo*-form regalia conveyed their power in equally provocative visual ways. Bokpe, a member of the family which once served as official court *bo* maker (or *kpamɛgan*), has asserted (2.13.86), "When a king dies and another wants to come to the throne, there are always problems because everyone wants to become king. It is for this reason that there were *bo*." Successful coups d'état similarly were attributed to the effective use of *bo*. King Guezo, who came to power in 1818 by overthrowing his predecessor, King Adandozan, is said to have made extensive use of objects of this type. As Migan, the namesake and current placeholder of Guezo's famed court minister, noted (12.31.85), "When Guezo wanted to do the coup d'état, he made a *bo*." The person he defeated, Adandozan (1797–1818), also was said to make extensive use of *bo*, although his proved less forceful than those of Guezo. Asked how Adandozan was able to rule for such a long time if there was such deepseated opposition to him, Agbidinukun stated (4.28.86), "He had *bo*." Adandozan, like a number of kings, had a *bo*-derived name, in this case deriving from the phrase "Anger placed the mat and it is not easy to reroll it" (*adandozan man gnon mlan*) (Lanwusi 6.16.86).

19. Foreign hats also came to be identified as kingly *bo*. Explains Nondichao (11.15.85), "King Gbehanzin has in his palace in Ouidah a metal casque, offered by the Germans. Because he was king and he could not wear a metal casque, instead he made a *bo* with it."

20. Beaded crowns with their prominent wealth signifiers (foreign beads) also were seen to demarcate the ability of a given king to "buy the kingdom" (*hɔ [xɔ] Danhomɛ*), the Fon term for coming to the throne.

21. Despite the importance of these beaded crowns, European travelers appear never to have witnessed them. King Adandozan (1797–1818) is said to have been one of the last Danhomɛ kings to have worn a beaded crown of this type. Although he was removed from the throne by Guezo in an 1818 coup d'état, Adandozan—an alcoholic—is said to have resided in one of the royal palaces as ritual king throughout Guezo's reign. He thus remained the legitimate wearer of the crown until his death sometime during the reign of King Glele (1858–89). A crown purportedly worn by King Glele was acquired by French troops during the conquest and is now in the Musée de l'Homme; another owned by King Gbehanzin also was collected by the French troops at this time. It is now in a private French collection.

22. The latter staffs were decorated with horse tails and served as a form of protective *bo;* their display was intended to discourage enemy attack or entrance into the palace. As Nondichao explained (6.25.84), the head means that "those who try to enter will die." Skulls or partial skulls serve as prominent signifiers of authority and dominance in other royal *bo* and *bociɔ* contexts as well. So important were enemy heads to the identity of the king, that no ruler could be said to have really assumed the throne until he had brought back the head of an enemy in battle. According to Adande (1976–77:106), "Without the decapitation of another chief, the king of Agbome was not really [king]." Hazoumé explains accordingly that (1956:163) "when the Abomey kings went to war against a country, they looked especially for the head of an enemy king." Hazoumé explains in turn that "one decapitated the enemy, if he was captured alive, in [Abomey], his head being placed in a basin of copper which was then covered with red cloth and deposed at the base of the throne." Ellis notes in this regard (1970:80) that "When Captain Snelgrave witnessed the sacrifice of the Whydah prisoners in 1727 . . . the interpreter told him 'that the blood was devoted to the Fetische [*sic*], the head to the king, and the body to the common people.' The latter part of this meant that the heads, or skulls, were the king's perquisite, to be used for the decoration of his palace walls." Of special significance in the above is the tripartite division of the body: the head being compared to the king, the body to the commoners, and the blood to the gods.

The events surrounding King Agoli Agbo's assumption of power and early reign provide an interesting example of the above importance of enemy heads as royal *bo* signifiers. After being placed on the throne by the French in 1894, subsequent to the overthrow and exile of King Gbehanzin, Agoli Agbo was obliged to meet certain French conditions of rule, most important, the cessation of all war activity. No doubt feeling the pressure of never having fully succeeded to the throne in the traditional sense of war victory, Agoli Agbo decided to wage a small battle in the area east of Abomey in 1900, bringing back the head of a chief named Vendo. A decapitation scene identified with this event appears prominently in Agoli Agbo's appliqué in the Musée Historique in Abomey (Adande 1976–77:165). Ironically, while this action was intended to assure Agoli Agbo's acceptance as Danhomɛ monarch, in the end it lost him the throne, for the French responded to his aggression by exiling him to Gabon.

Because of the critical link made between heads and authority, severed-head imagery also appears frequently in the arts of kings, particularly in bas-reliefs, appliqués and *asɛn*

(memorial altars). The actual heads of enemy rulers also were incorporated into thrones and palace wall decorations (Nondichao 10.17.85). The action of severing enemy heads appeared prominently in court dance gestures as well (Adjaho 7.23.86). Within the royal art corpus, heads served in this way as vital signifiers of both royal power and disempowerment capabilities. It is of some interest in this regard that royal oaths are administered by having the person drink from a skull. The importance of heads in the context of kings also finds expression in the name selected for the yearly memorial festival, *huɛtanu*, "yearly head thing" (*hue:* year or festival; *nu:* thing; *ta:* head or summit), a rite held in honor of the royal dead (Guédou 1985:279). On this occasion enemy captives and those guilty of capital offenses were killed in the capital by decapitation. As Adjaho bluntly notes (7.23.86), "If someone is turbulent and wants to take the kingdom, one cuts his head." For a further discussion of the importance of heads in the context of Danhome royalty see Robin Law (1989).

An interesting though quite different concern for heads within Fon royal traditions is found in the practice of unearthing (in principle each generation), the heads of the royal dead from their dispersed tombs (Pazzi 1976:149). At associated rites, the skulls were washed and then brought together again in a special temple along with the heads of royal ancestors of the preceding generations.

23. This figure, according to my sources, represents a king because the gesture is a distinctively royal one (see also Pemberton 1981).

24. In addition to the king, many members of the royal family also wore *bo* coiffures of this type, their lesser rank being defined by the different number and placement of the circles of hair. One of Glele's senior nephews was described by Skertchly (1874:70) accordingly as having his head shaved except for a single round of hair on the left side. The coiffure of the young crown prince, Ahanhanzo, also consisted of a unitary circle of hair. Ahanhanzo, Skertchly observed (1874:159) had "[h]is head shaven, leaving but a single tuft on the right side." The above placement variations coincide with conceptions of social difference conveyed through left and right positioning: Left is the side generally accorded royalty and individuals of greater authority or age; the right is associated with persons of lesser age or power.

The center of the head for its part seems to have been especially important in the coiffures of women. Some of the king's wives, therefore, particularly those with dangerous occupations such as elephant hunting, wore *bo* coiffures in the form of small circles of hair located on the middle of the head. Skertchly asserts that these women (1874:257) "[a]ll wore their hair cut close, save a circular patch on the top of the poll, where it was combed out like a brush." The significance of this coiffure placement is not known, but as suggested above, the summit of the head is identified in important ways with ideas of destiny and well-being. Although circular coiffure forms also were worn by commoners (especially as protective *bo* for children), the association of related hair styles with royalty suggests the increased security concerns that both the nobility and the elite warriors were felt to face.

25. In this example as in others, *bo* effectiveness is thought to be independent of size, means of articulation, and elaboration. Agbanon notes accordingly (2.19.86) that one of the more powerful royal *bo* consisted of a solution called *akpoweda* with which the king rinsed his body each day: "This is the *bo* of kings. The king washes with this when he gets up in the morning. In doing this he will die only on the day his destiny indicates."

26. Red also is a color associated closely with the *vodun*.

27. Hardwicke and Argyll in their account of the area (based on earlier sources) observed similarly with respect to the wearing of this color in Ouidah (1746, 3:47) that "the Colour of Red is so peculiar to the Court, that none but the King, his Wives, or Domestics, are allowed to wear it, either in Silk, Cotton, Wool, or Thread."

28. The association of parrots with mystical speech also is an important part of their identity.

29. See Bay (1979) and Blier (forthcoming) for discussions of this "bush king."

30. Daho's spokesman and public intermediary bears the title Zonatchia, a name which translates as "the fire will not go out." This name, according to Agbanon (4.8.86), suggests that "Daho will stay there for a long time. It is for this reason that we say 'Zonatchia.' Even if Daho dies, the one who is in his palace will always talk [one will always have his representative]."

31. That the *lisɛ* tree is identified with royalty is made clear by Nan Huedahun. She asserts (1.13.86) that "the first *lisɛ* tree sprang up after King Agaja placed his cane in the ground in front of his palace saying that 'it is here I will put my child,'" a reference to his son Tegbesu, who had been sent in tribute to the Yoruba. According to Nondichao (1.3.86) this tree became especially important during Tegbesu's reign (1728–74):

> It is Tegbesu who invented [the use of] the *lisɛ* tree when he refused to eat and drink in Oyo [the Yoruba city where he had been taken]. During this period he refused to sleep inside, passing the night instead under the *lisɛ* tree. When he returned to Abomey he planted this tree in front of the palaces of Huegbadja, Akaba, and Agaja, and then in front of his own palace, because it had aided him to return from the land of the enemy. He said "My successors also can do this." This is why those who followed him also planted this tree in front of their palaces.

Whether "invented" by Agaja or Tegbesu, the tree came to be integrally linked to Danhomɛ rulership.

32. Accordingly Agbanon suggests (2.19.86 and 2.28.86) that

> If you pound the *lisɛ* you will see a foamy medicine. This is used to make a soap with which the kings' wives would do the washing. It was a protection for the king. . . . One also washes babies with the bark. It gives them a strong body and protects them from illness. . . . If one washes the children with this, they will have good blood. It passes through the pores and the small holes in the bones, augmenting the blood. Its bark is used as a medication for coughs and the unripe *lisɛ* fruit is employed to make *bo* to protect one from leprosy.

Agbanon notes in turn (2.19.86) that the wood of the *lisɛ* tree is employed to make a fire for cooking a solution for a *bo* against itching.

33. A century ago, Ellis identified Evhe *bo* (1970:68) as "the protector of persons engaged in war." Ellis links (1970:68) this war god with Legba and notes that his temples (called *bo-we*, "house of *bo*") are found at town gates, markets, and other public places." Ellis notes further (1970:69) that since "Dahomi [is] essentially a military kingdom, Bo, as the guardian of warriors, is much honoured throughout the kingdom, and is perhaps worshipped more than any other god." In his words (1970:68), "In Dahomi, soldiers, who are under his special protection, wear horse-tails and strings of cowries in his honor."

34. Spiess describes (1902:317) a range of war *bo* employed by the Evhe. One called *akpozo*, he suggests, "is worn on the arm during war or peace. It protects the wearer from any harm. As soon as he yells *Akpo!* 'I am protected,' no spear or knife can harm him." Another armlet-form *bo* called *nedi negba* incorporates a gourd filled with ground leaves. According to Spiess, "The soldiers paint themselves with this [powder] and when they sight the enemy they blow some in the direction of the enemy and yell *nedi negba!* 'Fire, rifles, the enemy must be vanquished.'" Still another Evhe war *bo* called *awudza* took the form of a fan made from a cow's tail or grass. As Spiess explains, "When the warriors are prepared to fight, they swing *awudza* in the air to thwart the bullets or weaken their impact." Spieth (1906:518) also discusses the importance of war *bo*.

35. For this reason descriptions of royal *bocio* are found with some frequency in the accounts of various European travelers to the court.

36. Except for these prescribed conditions of war and annual ceremonies, royal *bocio* generally were kept out of public view. Asked why there were no *bocio* sculptures in front of the king's palace (in contrast to other dwellings in Abomey or in the provinces), Sagbadju explained (8.2.86): "There are no *bocio* in front of the king's palace because if those who want to harm the king see the *bo* they can negate them by putting things on them."

37. Sometimes monkeys of this sort are linked to King Adandozan (1797–1818), a ruler who mocked the Yoruba of Oyo through reference to this animal.

38. Reflecting the tradition that war *bocio* frequently were displayed along with other royal war *bo* in the annual *Ganyiahi* or *huɛtanu* "customs" ceremonies, Ayido remarked (5.11.86) with respect to one such monkey figure: "It is one of the various *bo* of the king that came out in the ceremony of Ganyiahi."

39. According to Adjaho (7.9.86) this drink was called *azoga;* "When one gives this to you, your head gets up and you can kill a man. When one drinks it one becomes nearly crazy." Dogs are also important in other arts identified with royalty. Accordingly an image of a dog appears on the club of the first minister, Migan (Migan 5.18.86); another can be seen on the cane of the priest of Zomadunu, the royal Tohosu temple. Sculptures of dogs also are identified with King Kpengla.

40. Other of Gbehanzin's court songs also make reference to his identity with *bo* (Agbidinukun 7.10.86).

> My father made a *bo* with Mawu inside
> The *bo* that my father Glele made
> If the *bo* swallows me.
> Like each year the tree gives flowers. I also will give flowers
> I will never die. . . .
> My father made a *bo*
> That will save me.

41. It is one of the ironies of Danhomɛ history that Gbehanzin was both defeated by French forces who arrived by the sea, and was forced into exile across the Atlantic on the island of Martinique.

42. Parts of this section were published previously (see Blier 1990).

43. As Asobahu Agonglo, a descendant of the famous court artist Sosa Adede, explained (5.8.86) for the larger category of war *bocio*, "In the past, the *bocio* went to war

with the king and opened their mouths to speak. Now that the kingdom no longer exists, and no one respects the *taboo*s of the *bo*, they are silent."

44. As Meyerowitz points out (1944:148), "Surprising in this statue is the very naturalistic treatment of the body, the modelling of the breast; the ribs and the abdomen is as fine as it possibly could be in this far from facile technique."

45. For this reason, this foot is sometimes referred to as the foot of Gu.

46. The work is said to have been commissioned by Glele for the *huɛtanu* or *ganyiahi* ("customs") ceremonies that he presented in honor of his father, Guezo, soon after the former's ascent to the throne (Akati 7.21.86). According to Akati (a direct descendant of the artist), when Guezo died Glele called upon this artist to forge the work in memory of his father. "Glele said that if he was to complete the burial ceremonies for Guezo, he had to have something with which to represent him" (Akati 7.11.84).

47. The *gubasa* sword of the iron god was separated from the figure sometime after its collection (Palau-Marti 1969).

48. Ironically, the French, surmising that the Danhomɛ troops would expect them to land at Ouidah, disembarked instead near Porto-Novo to the east.

49. *Basagla* (literally, "audacious thigh-baton") is more widely known as *gubasa*, "sword (*basagla*) of Gu."

50. The iron employed in the Musée de l'Homme figure was imported from Europe. In earlier eras the iron came primarily from local sources.

51. Yet another royal war *bociɔ* which appears to be no longer extant was known as *djajobosu*. Sagbadju describes this work as (7.3.86) "a wood carving with bumps (mounds) all over the body. It is like a sick person. He eats until his stomach is full. One carved it as a thin person but with a large stomach. When one would stand it up and the world would see it, the king would trap everyone." This sculpture, according to Sagbadju, stood about a meter and a half in height.

52. This sculpture is usually shown in the bas-reliefs and appliqués with a sword in one hand and a gun in the other.

53. See Blier (1991a) on the possibility that this sculpture survives.

54. One of the objects which she illustrates in this regard is a hornbill sculpture now in the collection of the Musée Historique in Abomey (see text below).

55. Some of these works also appear to have been identified with the royal Nesuhwe rites dedicated to the glorification of past rulers (see Blier 1988a:134).

56. Where exactly in the sculpture these insertions are made is not clear, but on some anthropomorphic images, Sagbadju suggests (7.3.86), the additive materials were placed in the arms. Sagbadju indicates in addition (7.3.86) that in the past, one spread gunpowder and kaolin on the surfaces of these works, the former being a "hot" substance, the latter being "cool."

57. In Sagbadju's words (7.9.86), "The skin of the lion is already in the bo." As a personal and portable corollary to such works, kings also frequently wore pendant-form *bo* incorporating the skin of the associated animal. These pendant *bo* were said to give the kings the ability to metamorphose into the associated animals. Of one such object Sagbadju explains (7.9.86), "This is a *bo*. One puts it around the neck and when one pronounces the incantatory words one will transform into an animal or into an insane person and will enter the house to ask to eat. When this happens you will flee."

58. Like the lion, the ruler of the animal realm, so too the hornbill as "the largest bird of all" is identified as king of the birds (Herskovits and Herskovits 1958:205). The hornbill's specific "burden" to which the Abla-Lete sign refers is the hornlike extension at the top of its beak. Comparing himself to this bird, King Glele purportedly said, "I am called the hornbill. The baggage of life does not stay on the head of just anyone. The baggage of the whole country is on my head" (Bokpe 6.5.86). Because of its prominence in the Fa sign Abla-Lete and its close identity with Glele's "burdens," the hornbill became a frequent subject of the arts of Glele's reign.

59. Another hornbill image is incorporated into the roof finial of Glele's *djehɔ* (*djexɔ,* "spirit house," literally "house of beads"). In all the associated hornbill sculptures three features dominate. First is the prominent hornlike protrusion at the top of the beak. Second is the frequent placement of a grain in the bird's bill. This latter detail makes reference to another unique feature identified with the hornbill in Danhomɛ, its ability to eat raffia seeds. In this feature, too, the bird is an appropriate metaphor for Glele, a king able to crush difficult seeds that other persons are not able to handle. A third feature of these hornbill images is the emphasis given to the size and power of the beak itself. Discussing these hornbill sculptures, Sagbadju observes (7.9.86), "The palace [bas-reliefs] portray a bird with a child's hand on its beak. King Glele said, 'I am the bird which takes things and I will take the child and its mother.' When the woman brought her child outside to fight in the battle, the hornbill bird was on the house looking. As it was hungry it took the child. . . . The child started crying and the mother too. The hornbill returned to the king and said, 'There where you sent me, I found a child.'"

Conclusions

1. See also G. Bachelard (1969).

2. Other factors in the greater emphasis on naturalism include local traditions of artistic specialization. Royal sculptures tended to be made by professional artists working for the court. Most nonroyal *bociɔ* in contrast were made by nonspecialists, with talent and experience varying considerably. Foreign models in the court also may have been important. Royal artists were encouraged to include ideas and imagery derived from European sources in their works for the king. Related European arts included prints, ceramics, textiles, furnishings, and religious statuary, all of which in the eighteenth and nineteenth centuries emphasized a degree of naturalism.

3. This feature is in some ways ironic, for the king was often silent, speaking only through the voice of his minister. To most people, similarly, he never moved but was carried in a royal hammock to different palaces and areas of the realm.

According to one tradition, "objects" of power employed by the king are said to have sometimes taken the form of living people. Maupoil describes a Fa-related royal *kuḍiɔ-bociɔ* of this type as follows (1981:364):

> When the royal Fa demanded a *bociɔ,* a foreign slave was brought to the king by the dignitary, Binazon. Does this mean a real sacrifice? No one could affirm it and it is doubtful that this process was put into action. The victim, man or woman, according to the prescription of Fa, was placed in front of the king's door. The diviner poured water on his head. This had been mixed with corn flour and the yɛ of the [divination] sign. Then one gave him a bit of the yɛ powder to eat. Next one put around his neck a

necklace of three or seven cowries and installed him near a *vɔkɔ* [clay offertory figure] or *bociɔ*. The victim remained living, but the statue underwent a remarkable transformation. Before the sacrifice, [the victim] was the thing of the king, and with this title a certain dignity was attached. The sacrifice consisted of a royal gesture [in which the king] ... touched his former subject with his finger and pushed him away. ... he was no longer for the king. He was thus for Legba, like all that was claimed by no one, because, all that was not a "thing of Dahomey" was abnormal.

Of particular importance in the above is the similarity between essential details of object activation and sculptures of the *kuɖiɔ* (death-exchanging) *bociɔ* genre. As we have seen in chapter 2, *kuɖiɔ-bociɔ* sculptural signification also is grounded in specific Fa divination signs. In addition associated works are intended to trick death into taking a substitute instead of the real person.

4. Another royal gesture, called *basagla*, although rarely seen in royal sculptures, is characterized by the placing of the hands on the hips. According to Ayido (8.3.86), "It is the person who is prince who does the *basagla*. *Basagla* means to be too proud, to be an egoist. One is showing off with the hands on the hips, head high."

5. Of the representation of a hand on King Gbehanzin's palace reliefs it was explained similarly that the raised hand is a mark of superiority (Danon 8.13.86).

6. The association of the left hand with power is found in other local contexts as well. For example, in royal ceremonies, the left side signifies the king while the right designates the populace. For this reason, commoners presented their right hands to the king and moved from right to left in the palace performances (Burton 1966:50). Ideas of supremacy also are associated with the left. Accordingly, hunters often will place their left hands on the game they have killed as a means of showing their greater power (Agbidinukun 7.31.86). The left hand also has important gender associations for it is seen to be distinctively male. As Agbidinukun explains (7.4.86), "The left hand is the hand of man. If your father dies, you put your left hand on his head before weeping, if your mother is dead, you put the right hand on her head." Because the hand (and arm) are important symbols of royal authority, images of hands or arms appear prominently in many of the royal bas-reliefs.

7. Images of hands holding objects also are important in other contexts. Related forms appear prominently in the arts of kings Agonglo, Guezo, and others (Nondichao 10.17.85). Sculptural portrayals of hands carrying objects, especially jars (*gben*), are identified with Glele. Of one *asɛn* memorial staff associated with Glele's reign, Bokpe explains (5.29.86) that "life (*gbɛ*) cannot be held with only one hand." Another *asɛn* identified with Glele also shows a hand holding an object, in this case a rope. Glele is said to have remarked in this regard that "the cord is in my hands, Danhomɛ is the cord in my hands" (Bokpe 5.29.86). Another example of the prominence of hands in royal iconography is found on the palace of the seventeenth-century King Dako Donu in Hwawe. Mounted on the roof of his entryway are two hands forged in iron. Explaining the meaning of these hands, the descendant and namesake of the king noted (11.6.85), "These hands worked on the house. Even if I die, five fingers are on that hand" (see also Blier, forthcoming). This latter phrase in turn is said to recall a proverb which appears on certain calabash engravings: "One says, it is the five fingers of the hand that worked for me" (Agbanon 3.8.86). In other words, one's work survives one. Taken as a whole, these various representations of raised or independent hands appearing in the larger cor-

pus of royal arts suggest a concern with values of individual creativity, might, and domination.

8. Although this position—which in some works assumes a *contrapposto* identity—may derive from European sources, it clearly reflects royal sculptural concerns with action and mobility.

9. The extending of the foot, particularly the left foot, is an important signifier of kings. As Adjaho notes (8.6.86, with regard to a figure whose foot is placed on the image of a severed head), "It was only kings who cut heads and placed the foot on it." Hazoumé noted in regard to this position similarly (1956:163) that "the vanquishing king placed his left foot (the foot of Gu) on the head." Elaborating on this same action, Agbidinukun observed (7.4.86), "The king puts the enemy's head on the ground and places his left foot on it, then he takes the head with his left hand and dances with it. Only the king does this—not the Gaou or Migan." This same foot position also is associated with hunting and the *aziza* spirits. Sagbadju notes in this regard (7.2.86) that "when the *aziza* kills animals they will put their left foot on them and cry out that one knows that it is the *aziza* who puts his left foot on the animal."

10. The image of the unattached or dismembered foot for this reason also appears prominently in other Danhomɛ arts of rulership. The foot is a particularly important signifier for King Agoli Agbo, appearing prominently in both his name and his royal appliqué. The phrase which is the basis of his strong name asserts: *Ago-li-Agbo, Allada klen afo, ma dja i, France, oue gni mon*, "Take guard Agbomé; Allada hit its foot but did not fall because of [thanks to or owing to] France" (Adiha; Pliya 1970:127). "Allada" here refers to the ancient kingdom of Allada from which the Danhomɛ dynasty is said to have come. In the above legend, the obstacle that Danhomɛ ran up against was the French and the defeat of the Abomey forces by the colonial troops. In Agoli Agbo's appliqué and in related depictions, the foot usually is shown positioned against a rock or round object. This positioning suggests at once the loss of mobility (the lack of foot power) as a result of the removal (denial) of royal authority by the French and the idea that despite this change Danhomɛ will remain preeminent. The saying "He should not knock his foot against something" in turn is used to signify that nothing will stop one.

Bibliography

Abimbola, Wande. 1973. "The Yoruba Concept of Human Personality." In *La notion de personne en Afrique Noire.* Paris: Éditions du Centre National de la Recherche Scientifique, pp. 73–89.

Abiodun, Rowland. 1984. "Der Begriff des Iwa in der Yoruba Aesthetik." *Tendenzen* 146: 62–68.

Abraham, R. C. 1958. *Dictionary of Modern Yoruba.* London: University of London Press.

Abu-Lughod, A. Lila. 1986. *Veiled Sentiments: Honor and Poetry in a Bedouin Society.* Berkeley: University of California Press.

Abu-Lughod, A. Lila, and Catherine Lutz. 1990. "Introduction: Emotion, Discourse, and the Politics of Everyday Life." In *Language and the Politics of Emotion,* ed. Catherine Lutz and Lila Abu-Lughod. New York: Cambridge University Press, pp. 1–23.

Adams, Monni. 1989. "Beyond Symmetry in Middle Africa Design." *African Arts* 23, no. 1: 34–43.

———. 1980. "Fon Applique Cloth." *African Arts* 13, no. 2: 28–41.

Adandé, Codjovi Etienne. 1976–77. "Les grandes tentures et les bas-reliefs du Musée d'Agbome." Memoire de Maitrise d'Histoire Année Académique U.B. Abomey-Calagi.

Adandé, Alexandre P. 1962. *Les récades des rois du Dahomey.* Dakar: IFAN.

Adandé, Alexis, and Goudjinou Métinhoué. 1984. *Potières et poterie de Se: Une enquête historique et technologique dans le Mono Béninois.* Republique Populaire du Bénin: Ministère de l'enseignement supérieur et de la recherche scientifique.

Adler, A. 1982. *La mort est le masque du roi: La royauté sacrée des Moundang du Tchad.* Paris: Payot.

Adorno, Theodor W. 1984. *Aesthetic Theory.* Trans. C. Lenhardt. London: Routledge and Kegan Paul.

Agossou, Jacob-Medéwàlè. 1972. *Gbɛtɔ et Gbɛdótɔ; L'homme et le Dieu créateur selon les Sud-Dahoméens: De la dialectique de participation vitale à une théologie anthropocentrique.* Eglise ancienne: Christianisme et Cultures: 2, Paris: Beauchesne.

Ahouansou, Martinien. n.d. *Mythologies et traditions religieuses africains: Les Vodoun et les Orisha dans la sociétés beniniennes et le reinter pretal à Haiti et au Brésil.*

Alapini, Julien. 1952. *Les initiés.* Avignon: Maison Aubanel Père.

———. 1950. *Les noix sacrées: Étude compléte de Fa-Ahidégoun génie de la sagesse et de la divination au Dahomey.* Monte-Carlo: Regain.

Allado, Kokouvi Ganke. 1986. "Santé maladie et initiation principale chez les Ewe-Ouatchi" (Togo). Diplome de l'École des Hautes Études en Sciences Sociales, Paris.

Althusser, Louis. 1984. *Essays on Ideology.* London: Verso.

Amouzou, Koami Azigbede. 1979. "Religion et sociale: Les croyances traditionnelles chez les Be du Togo." École des Hautes Études en Sciences Sociales. Thèse doctorate de 3' Cycle, Paris.

Anderson, Martha G., and Christine Mullen Kreamer. 1989. *Wild Spirits, Strong Medicine: African Art and the Wilderness.* Ed. Enid Schildkrout. New York: Center for African Art.

Aniakor, C. 1982. "Igbo Aesthetics (An Introduction)." *Nigeria Magazine* 141: 3–15.

Anon. 1875. "La côte des esclaves: Idoles et fétiches." *Les Missions Catholiques* 7: 592, 589.

———.1875. "La côte des esclaves: Factoreries Françaises à Porto Novo." *Les Missions Catholiques* 7: 563, 568.

Appiah, A. 1984. "An Aesthetics for the Art of Adornment in Africa." In *Beauty by Design: The Aesthetics of African Adornment,* ed. M. Brincard. New York: African-American Institute, pp. 15–19.

Arens, W., and Ivan Karp, eds. 1989. *Creativity of Power: Cosmology and Action in African Societies.* Washington: Smithsonian Institution Press.

Aristotle. [1953] 1968. *Aristotle on the Art of Fiction: An English Tradition of Aristotle's Poetics.* Trans. L. J. Potts. Cambridge: Cambridge University Press.

Armstrong, R. P. 1981. *The Powers of Presence.* Philadelphia: University of Pennsylvania Press.

Arnheim, Rudolf. 1989. *Parables of Sunlight: Observations on Psychology, the Arts, and the Rest.* Berkeley: University of California Press.

———. 1986. *New Essays on the Psychology of Art.* Berkeley: University of California Press.

———. 1967. *Toward a Psychology of Art: Collected Essays.* Berkeley: University of California Press.

Arnoldi, M. J. 1986. "Puppet Theatre: Form and Ideology in Bamana Performances." *Empirical Studies in the Arts* 4, no. 2: 131–50.

Atkins, John. [1737] 1970. *A Voyage to Guinea, Brasil, and the West Indies in His Majesty's Ships, The 'Swallow' and 'Weymouth,' 1735.* London: Frank Cass.

Augé, Marc. 1988. *Le dieu objet.* Paris: Flammarion.

———. 1978. "Quand les signes s'inversent." *Communications* 28.

Babcock, Barbara A., ed. 1978. *The Reversible World: Symbolic Inversion in Art and Society.* Ithaca, NY: Cornell University Press.

Bachelard, Gaston. 1987. *On Poetic Imagination and Reverie: Selections from the Works of Gaston Bachelard.* Rev. ed. Trans. Colette Gaudin. Dallas: Spring Publications.

———. 1969. *The Poetics of Space.* Trans. Maria Jolas. Boston: Beacon Press.

Badin, Adolphe. 1895. *Jean-Baptiste Blanchard au Dahomey: Journal de la Campagne par un Marsouin.* Paris: Armand Colin and Co.

Bakhtin, M. M. 1986. *Speech Genres and Other Late Essays.* Trans. Vern W. McGee. Ed. Caryl Emerson and Michael Holquist. Austin: University of Texas Press.

———. 1981. *The Dialogic Imagination: Four Essays.* Ed. Michael Holquist. Trans. Caryl Emerson and Michael Holquist. Austin: University of Texas Press.

———. 1973. *Problems of Dostoevsky's Poetics.* Trans. R. W. Rotsel. Ann Arbor: Ardis.

———. [1965] 1968. *Rabelais and His World.* Trans. Helene Iswolsky. Cambridge, MA: MIT Press.

Bakhtin, M. M./P. N. Medvedev. 1985. *The Formal Method in Literary Scholarship: A Critical Introduction to Sociological Poetics.* Cambridge, MA: Harvard University Press.

Barber, Karen. 1987. "Popular Arts in Africa." *African Studies Review* 30: 1–78, 113–32.

Barbot, John. 1732. *A Description of the Coast of North and South Guinea.* London.

Barkin, Leonard. 1975. *Nature's Work of Art: The Human Body as Image of the World.* New Haven: Yale University Press.

Barrett, Michèle. 1983. "Psychology." In *Dictionary of Marxist Thought,* ed. Tom Bottomore. Cambridge, MA.: Harvard University Press, pp. 402–4.

Barthes, Roland. 1989a. *Empire of Signs.* Trans. Richard Howard. New York: Noonday Press.

———. 1989b. *The Rustle of Language.* Trans. Richard Howard. Berkeley: University of California Press.

———. 1974. *S/Z.* Trans. Richard Miller. New York: Hill and Wang.

———. 1972. *Critical Essays.* Trans. Richard Howard. Evanston, IL: Northwestern University Press.

Bascom, William. 1969. *Ifa Divination: Communication between Gods and Men in West Africa.* Bloomington: Indiana University Press.

Bassani, Ezio. 1977. "Kongo Nail Fetishes from the Chiloango River Area." *African Arts* 10, no. 3: 36–40.

Basso, Ellen. 1985. *A Musical View of the Universe.* Philadelphia: University of Pennsylvania Press.

Bastide, Roger. 1978. *The African Religions of Brazil: Toward a Sociology of the Interpretation of Civilizations.* Trans. Helen Sabba. Baltimore: Johns Hopkins University Press.

———. 1972. *The Sociology of Mental Disorder.* Trans. Jean McNeil. New York: David McKay.

———. 1971. *African Civilizations in the New World.* New York: Harper and Row.

Bataille, Georges. 1990. "Hegel, Death, and Sacrifice." *Yale French Studies,* no. 78: 9–28. Trans. Jonathan Strauss.

———. [1954] 1988. *Inner Experience.* Albany: State University of New York Press.

———. 1986. *Erotism: Death and Sensuality.* Trans. Mary Dalwood. San Francisco: City Lights.

Bateson, Gregory. 1972. *Steps to an Ecology of Mind.* San Francisco: Chandler Publishing Co.

Baudrillard, Jean. 1983. *In the Shadow of the Silent Majorities: Or, the End of the Social, and Other Essays.* New York: Semiotext(e).

Baxandall, Lee. 1983. "Literature." In *Dictionary of Marxist Thought,* ed. Tom Bottomore. Cambridge, MA: Harvard University Press, pp. 284–87.

Bay, Edna L. 1985. *Asen: Iron Altars of the Fon People of Benin.* Atlanta: Emory University Museum of Art and Archaeology.

———. 1979. "On the Trail of the Bush King: A Dahomean Lesson in the Use of Evidence." *History in Africa* 6: 1–15.

Bayard, J. P. 1964. *Le sacre des rois.* Paris: La Combe.

Beardsley, Monroe C. (with W. K. Wimsatt). 1973. "The Intentional Fallacy." In *Issues in Contemporary Literary Criticism,* ed. Gregory T. Polletta. Boston: Little Brown.

Beattie, John H. M. 1971. *The Nyoro State.* London: Oxford University Press.

———. 1963. "Sorcery in Bunyoro." In *Witchcraft and Sorcery in East Africa,* ed. J. Middleton and E. H. Winter. New York: Praeger, pp. 27–56.

———. 1960. *Bunyoro: An African Kingdom.* New York: Holt, Rinehart and Winston.

Becker, Ernest. 1967. *Beyond Alienation: A Philosophy of Education for the Critics of Democracy.* New York: George Braziller.

Becker, Howard. 1982. *Art Worlds.* Berkeley: University of California Press.

Bednarski, Joyce. 1970. "The Salem Witch-Scare Viewed Sociologically." In *Witchcraft and Sorcery: Selected Readings,* ed. Max Marwick. Middlesex, England: Penguin Books, pp. 151–63.

Beidelman, T. O. 1986. *Moral Imagination in Kaguru Modes of Thought.* Bloomington: Indiana University Press.

———. 1980. "Women and Men in Two East African Societies." In *Explorations in African Systems of Thought,* ed. Ivan Karp and Charles S. Bird. Bloomington: Indiana University Press, pp. 143–64.

———. 1966. "Swazi Royal Ritual." *Africa* 36: 373–405.

———. 1963. "Witchcraft in Utaguru." In *Witchcraft and Sorcery in East Africa,* ed. J. Middleton and E. H. Winter. New York: Praeger, pp. 57–98.

Beier, Ulli. 1982. *Yoruba Beaded Crowns: Sacred Regalia of the Olokuku of Okuku.* Ethnographic Arts and Culture Series, 1. London: Ethnographica.

———. 1963. *African Mud Sculpture.* London: Cambridge University Press.

———. 1958. "The Bochio." *Black Orpheus* 3 (May): 28–31.

Beiser, Morton. 1985. "A Study of Depression among Traditional Africans, Urban North Americans, and Southeastern Asian Refugees." In *Culture and Depression: Studies in the Anthropology and Cross-Cultural Psychiatry of Affect and Disorder,* ed. A Kleinman and B. Good. Berkeley: University of California Press.

Bell, Michael Edward. 1980. *Pattern, Structure, and Logic in Afro-American Hoodoo Performance.* Ann Arbor: University Microfilms International.

Ben-Amos, Paula. 1976. "Men and Animals in Benin Art." *Man,* n.s. 11: 243–52.

Benjamin, Walter. 1978. *Reflections: Essays, Aphorisms, Autobiographical Writings.* Trans. Edmund Jephcott. New York: Harcourt Brace Jovanovich.

———. 1976. *Illuminations.* Trans. Harry Zohn. Ed. Hannah Arendt. New York: Schocken Books.

Berglund, Axel-Ivar. 1976. *Zulu Thought Patterns and Symbolism.* Bloomington: Indiana University Press.

Bertho, Jacques P. 1945. "Le bain rituel du roi d'Abomey: Houé hou li-la." *Notes Africaines* 27: 14–15.

Bhaba, Homi K. 1992. "Postcolonial Authority and Postmodern Guilt." In *Cultural Studies,* ed. Lawrence Grossberg et al. New York: Routledge.

———. 1983. "The Other Question . . ." *Screen* 24, no. 6: 18–35.

Biebuyck, Daniel. 1986. *The Arts of Zaire.* vol. 2. *Eastern Zaire: The Ritual and Artistic Context of Voluntary Associations.* Berkeley: University of California Press.

Bisilliat, Jeanne, et al. 1967. "La notion de iakkal dans la culture djerma-songhai." *Psychopathologie Africaine* 3, no. 2: 207–63.

Black, Max. 1962. "Metaphor." *Proceedings of the Aristotelian Society* 55 (1954–55).

Reprinted in *Philosophy Looks at the Arts: Contemporary Readings in Aesthetics,* ed. Joseph Margolis. New York: Charles Scribner's Sons, pp. 218–35.

Blier, Suzanne Preston. 1993a. "Truth and Seeing: Magic, Custom, and Fetish in Art History." In *Africa and the Disciplines,* ed. Robert Bates. Chicago: University of Chicago Press.

———. 1993b. "Art and Secret Agency: Concealment and Revelation in Artistic Expression." In *Secrecy: African Art That Conceals and Reveals,* ed. Mary Nooter. New York: Museum for African Art.

———. 1993c. "Imaging Otherness in Ivory: African Portrayals of the Portuguese, ca. 1492." *Art Bulletin* 75, no. 3: 375–96.

———. 1991a. "Faces of Iron: Media, Meaning, and Mastery in Danhomε." *Bulletin Barber-Muller:* 19–39.

———. 1991b. "King Glele of Danhomε, Part II." *African Arts* 24, no. 1 (January): 44–45, 101–3.

———. 1990. "King Glele of Danhomε: Divination Portraits of a Lion King and Man of Iron." *African Arts* 23, no. 4 (October): 42–53, 93–94.

———. 1989a. "Moral Architecture: Beauty and Ethics in Batammaliba Building Design." In *Dwellings, Settlements, and Tradition,* ed. Jean-Paul Bourdier and Nezar Alsayyad. Lanham: University Press of America, 335–55.

———. 1989b. "Field Days: Melville J. Herskovits in Dahomey." *History in Africa* 16: 1–22.

———. 1988a. "Words about Words about Icons: Iconologology and the Study of African Art." *Art Journal* 47, no. 2: 75–87.

———. 1988b. "Melville J. Herskovits and the Arts of Ancient Dahomey." *Res* 16 (Autumn): 124–42.

———. 1987. *The Anatomy of Architecture: Ontology and Metaphor in Batammaliba Architectural Expression.* New York: Cambridge University Press.

———. 1982. *Gestures in African Art.* New York: L. Kahan Gallery.

———. 1976. *Beauty and the Beast: A Study in Contrasts.* New York: Tribal Arts.

———. Forthcoming (a). "Vodun Philosophical and Artistic Roots in West Africa." In *Sacred Arts of Vodu,* ed. D. J. Cosentino. UCLA Museum of Cultural History Pamphlet Series, vols. 1, 2. Los Angeles: UCLA Museum of Cultural History.

———. Forthcoming (b). "The Path of the Leopard: Motherhood and Majesty in Early Danhome." *Journal of African History.*

Bloch, Marc. 1961. *Les Rois Thaumaturges.* Paris: Armand Colin.

Boone, Sylvia Ardyn. 1986. *Radiance from the Waters: Ideals of Feminine Beauty in Mende Art.* New Haven: Yale University Press.

Borgatti, Jean. 1979. *From the Hands of Lawrence Ajanaku.* Exhibition Catalogue Museum of Cultural History. Los Angeles: Museum of Cultural History.

Bosman, Guillaume. 1705. *A New and Accurate Description of the Coast of Guinea.* First English Edition. New York: Barnes and Noble.

Bourdieu, Pierre. 1984. *Distinction: A Social Critique of the Judgment of Taste.* Trans. Richard Nice. Cambridge: Harvard University Press.

———. 1977. *Outline of a Theory of Practice.* Cambridge: Cambridge University Press.

Bourgeois, Arthur P. 1984. *The Art of the Yaka and Suku.* Meudon: A. and F. Chaffin.

———. 1979. "Mbwoolo Sculpture of the Yaka." *African Arts* 12, no. 3: 58–61, 96.

Bourgeot, André. 1975. "Rapports esclavagisles et condition d'affranchissement chez les Imuhag." In *L'esclavage en Afrique precoloniale,* ed. Claude Meillassoux. Paris: François Maspero.

Boyer, Paul, and Stephen Nissenbaum. 1974. *Salem Possessed: The Social Origins of Witchcraft.* Cambridge, MA: Harvard University Press.

Brain, Robert. 1980. *Art and Society in Africa.* London: Longman Group.

Brand, Roger-Bernard. 1981. "Rites de naissance et réactualisation matérielle des signes de naissance à la mort chez les Wéménou (Bénin/Dahomey)." *Naître, Vivre et Mourir: Musée d'Ethnographie Neuchâtel:* 37–62.

———. 1976. "Les hommes et les plantes: L'usage des plantes chez les Wéménou du Sud-Dahomey." *Genève-Afrique* 15, no. 1: 37–62.

———. 1973. "Notes sur des poteries rituelles au Sud-Dahomey." *Anthropos* 69: 559–68.

———. 1970. "Dynamisme des symboles dans les cultes Vodu au Sud-Dahomey." Thèse de 3ième cycle. Paris: Ethnologie, Paris V, EPHE, 6e section.

Brandon, George. 1990. "Sacrificial Practices in Santeria, an African-Cuban Religion in the United States." In *Africanisms in American Culture,* ed. Joseph E. Holloway. Bloomington: Indiana University Press.

Brett, Guy. 1986. *Through Our Own Eyes: Popular Art and Modern History.* Philadelphia: New Society Publishers.

Briggs, Jean. 1970. *Never in Anger: Portrait of an Eskimo Family.* Cambridge, MA: Harvard University Press.

Brown, David H. 1990. "Conjure/Doctors: An Exploration of a Black Discourse in America, Antebellum to 1940." *Folklore Forum* 23, nos. 1/2: 3–46.

Brown, Karen McCarthey. 1991. *Mama Lola: A Vodou Priestess in Brooklyn.* Berkeley: University of California Press.

———. 1987. "Alourdes: A Case Study of Moral Leadership in Haitian Vodou." In *Saints and Virtues,* ed. John Stratton Hawley. Berkeley: University of California Press, pp. 144–67.

Brown, Peter. 1988. *The Body and Society: Men, Women, and Sexual Renunciation in Early Christianity.* New York: Columbia University Press.

Buck-Morss, Susan. 1989. *The Dialectics of Seeing: Walter Benjamin and the Arcades Project.* Studies in Contemporary German Social Thought. Cambridge, MA: MIT Press.

Burckhardt, Titus. [1967] 1986. *Alchemy: Science of the Cosmos, Science of the Soul.* Trans. William Stoddard. Dorset: Element Books.

Burke, Kenneth. 1968. *Counter-statement.* Berkeley: University of California Press.

———. 1966. *Language as Symbolic Action: Essays on Life, Literature, and Method.* Berkeley: University of California Press.

———. 1964. *Perspectives by Incongruity.* Ed. Stanley Edgar Hyman. Bloomington: Indiana University Press.

Burton, Richard. [1864] 1966. *A Mission to Gelélé, King of Dahomey.* Ed. C. W. Newbury. London: Routledge and Kegan Paul.

Butler, Judith. 1990. *Gender Trouble: Feminism and the Subversion of Identity.* New York: Routledge.

Bynum, Caroline Walker. 1991. *Fragmentation and Redemption: Essays on Gender and the Human Body in Medieval Religion.* New York: Zone Books.

Cannadine, D. N., and S. R. Price, eds. 1985. *Rituals of Royalty: Power and Ceremonial in Traditional Societies.* London: Cambridge University Press.

Cannizzo, Jeanne. 1979. "Alikali Devils in Sierra Leone." *African Arts* 12, no. 4: 64–70, 92.

Carpenter, Edward. 1969. "Comments." In *Tradition and Creativity in Tribal Art,* ed. D. Biebuyck. Berkeley: University of California Press, pp. 203–13.

Carrithers, Michael, et al., eds. 1985. *The Category of the Person: Anthropology, Philosophy, and History.* Cambridge: Cambridge University Press.

Caughie, John, ed. 1981. *Theories of Authorship: A Reader.* London: Routledge and Kegan Paul.

Centre National de Recherche Scientifique, Paris. 1973. *La notion de personne en Afrique Noire.*

Certeau, Michel de. 1986. *Heterologies: Discourse on the Other.* Trans. Brian Massumi. Minneapolis: University of Minnesota Press.

Clark, T. J. [1984] 1985. *The Painting of Modern Life: Paris in the Art of Manet and His Followers.* New York: Knopf.

Cluysenaar, Anne. 1987. "Organic." In *A Dictionary of Modern Critical Terms,* ed. Roger Fowler. London: Routledge and Kegan Paul, pp. 168–69.

Coiffi, F. [1964] 1978. "Intention and Interpretation in Criticism." In *Philosophy Looks at the Arts,* ed. J. Margolis. Philadelphia: Temple University Press.

Cole, Herbert M. 1982. *Mbari: Art and Life among the Owerri Igbo.* Bloomington: University of Indiana Press.

———. 1970. *African Arts of Transformation.* Santa Barbara: University of California, The Art Galleries.

———. 1969. "Art as a Verb in Iboland." *African Arts* 3, no. 1: 34–41, 88.

Cole, Herbert M., and C. Aniakor. 1984. *Igbo Arts: Community and Cosmos.* Los Angeles: University of California Press.

Collingwood, R. G. [1938] 1977. *The Principles of Art.* London: Oxford University Press.

Comaroff, Jean. 1985. *Body of Power, Spirit of Resistance: The Culture and History of a South African People.* Chicago: University of Chicago Press.

Coomaraswami, A. K. 1942. *Spiritual Authority and Temporal Power in the Indian Theory of Government.* American Oriental Series, no. 22. New Haven: American Oriental Society.

Corin, Ellen, and Gilles Bibeau. 1980. "Psychiatric Perspectives in Africa. Pt. II: The Traditional Viewpoint." *Transcultural Psychiatric Review* 17: 205–53.

Corin, Ellen, and H. B. M. Murphy. 1979. "Psychiatric Perspectives in Africa. Pt. I: The Western Viewpoint." *Transcultural Psychiatric Review* 16: 142–78.

Cornevin, Robert. 1981. *La république populaire du Benin: Des origines dahoméennes à nos jours.* Paris: G. P. Maisonneuve and Larose.

———. 1962. *Histoire du Togo.* Paris: Éditions Berger-Levrault.

Cosentino, Donald J. 1982. "Mende Ribaldry." *African Arts* 12, no. 3.

Coser, Lewis. 1967. *Continuities in the Study of Social Conflict.* New York: Free Press.

————. 1956. *The Functions of Social Conflict.* New York: Free Press.

Coudert, Allison. 1987. "Alchemy." In *The Encyclopedia of Religion*, vol. 1. New York: Macmillan Publishing Co., pp. 199–202.

————. 1980. *Alchemy: The Philosopher's Stone.* Boulder: Shambala Press.

Courdioux, E. 1878. "La côte des esclaves excursions et récits: Le tatouage" *Les Missions Catholique* 10: 551, 547, 595.

Coward, Rosalind, and John Ellis. 1977. *Language and Materialism: Developments in Semiology and the Theory of the Subject.* London: Routledge and Kegan Paul.

Crapanzano, Vincent. 1989. "Preliminary Notes on the Glossing of Emotions." *Kroeber Anthropological Society Papers*, nos. 69–70: 78–85.

Crowley, Daniel J. 1973. "Aesthetic Value and Professionalism in African Art: Three Cases from the Katnagan Chokwe." In *The Traditional Artist in African Societies*, ed. Warren d'Azevedo. Bloomington: Indiana University Press, pp. 246–70.

Crozier, W. Ray, and Antony J. Chapman, eds. 1984. *Cognitive Processes in the Perception of Art.* New York: Elsevier Science Pub. Co.

Csordas, Thomas. 1990. "Embodiment as a Paradigm for Anthropology." *Ethos* 18, no. 1: 5–47.

Cudjoe, Dzagbe. 1969. "Ewe Scupture in the Linden-Museum." *Tribus-Veröffentlichungen des Linden Museums* (Stuttgart) 18: 49–72.

Curtin, Philip D. 1969. *The Atlantic Slave Trade: A Census.* Madison: University of Wisconsin Press.

————. ed. 1967. *Africa Remembered: Narratives by West Africans from the Era of the Slave Trade.* Madison: University of Wisconsin Press.

d'Albéca, Alexandre L. 1895. *La France au Dahomey.* Paris: Librairie Hachette and Co.

Dalton, Elizabeth. 1979. *Unconscious Structure in "The Idiot": A Study in Literature and Psychoanalysis.* Princeton, NJ: Princeton University Press.

Damme, Wilfried Van. 1987. *A Comparative Analysis Concerning Beauty and Ugliness in Sub-Saharan Africa. Africana Gandensia* 4. Gent: Rijksuniversiteit.

Davis, Natalie Z. 1981. "The Sacred and the Body Social in the Sixteenth Century." *Past and Present* 90: 40–70.

————. 1975. "Women on Top." In *Society and Culture in Early Modern France.* Stanford: Stanford University Press, pp. 124–52.

Davis-Roberts, Christopher. 1981. "Kutambubwa Ogonjuwa: Concepts of Illness and Transformation of the Tabwa of Zaire." *Social Science and Medicine* 15B: 309–16.

Deleuze, Gilles. 1990. *The Logic of Sense.* Trans. Mark Lester. New York: Columbia University Press.

Deleuze, Gilles, and Félix Guattari. 1987. *A Thousand Plateaus: Capitalism and Schizophrenia.* Trans. Brian Massumi. Minneapolis: University of Minnesota Press.

Deren, Maya. 1953. *Divine Horsemen: The Living Gods of Haiti.* Documentext. London: McPherson and Co.

Derrida, Jacques. 1987. "Restitutions of the Truth Pointing [pointure]." In *The Truth in Painting*, trans. Geoff Bennington and Ian McLeod. Chicago: University of Chicago Press.

————. 1981. *Dissemination.* Trans. Barbara Johnson. Chicago: University of Chicago Press.

———. 1973. *Speech and Phenomena, and Other Essays on Husserl's Theory of Signs.* Trans. and Intro. David B. Allison. Evanston: Northwestern University Press.

Devisch, Renaat. 1990a. "The Human Body as a Vehicle for Emotions among the Yaka of Zaire." In *Personhood and Agency: The Experience of Self and Other in African Cultures,* ed. M. Jackson and I. Karp. Uppsala Studies in Cultural Anthropology, 14. Uppsala Sweden.

———. 1990b. "From Physical Defect towards Perfection: Mbwoolu Sculptures for Healing among the Yaka." *Iowa Studies in African History* 3: 63–90.

———. 1983. "Le corps sexué et social ou les modalités d'échange sensoriel chez les Yaka du Zaire." *Psychopathologie africaine* 19: 5–31.

DeVos, George A., ed. 1976. *Responses to Change: Society, Culture, and Personality.* Berkeley: University of California Press.

Dewey, John. 1934. *Art as Experience.* London: George Allen and Unwin.

Dilthey, Wilhelm. 1985. *Poetry and Experience.* Vol. 5 of *Selected Works.* Ed. Rudolf A. Makkreel and Frithjof Rodi. Princeton: Princeton University Press.

———. 1976. *W. Dilthey: Selected Writings.* Ed., trans., and intro. H. P. Rickman. Cambridge: Cambridge University Press.

———. 1961. *Pattern and Meaning in History: Thoughts on History and Society.* Ed. and Intro. H. P. Rickman. New York: Harper.

———. 1954. *The Essence of Philosophy.* Trans. Stephen A. Emery and William T. Emery. Chapel Hill: University of North Carolina Press.

Dodds, Betty Jo Teeter. 1975. *The Foundations of Newton's Alchemy.* Cambridge: Cambridge University Press.

Douglass, Frederick. [1883] 1972. *The Life and Times of Frederick Douglass.* New York: Bonanza Books.

Douglas, Mary. [1966] 1969. *Purity and Danger: An Analysis of Concepts of Pollution and Taboo.* London: Routledge and Kegan Paul.

Drewal, Henry John. 1988. "Performing the Other: Mami Wata Worship in Africa." *Drama Review* 32, no. 2: 160–85.

———. 1980. *African Artistry: Technique and Aesthetics in Yoruba Sculpture.* Atlanta: High Museum of Art.

Drewal, Henry John, and Margaret Drewal. 1983. *Gelede: Art and Female Power among the Yoruba.* Bloomington: Indiana University Press.

Drewal, H. J. Pemberton III, and R. Abiodun. 1989. *Yoruba: Nine Centuries of African Art and Thought.* Ed. A. Wardwell. New York: Center for African Art.

Dumezil, G. 1977. *Les dieux souverains des indo-européens.* Paris: Gallimard.

———. 1948. *Mitra-Varuna: Essai sur deux représentations indo-européennes de la souveraineté.* 2d ed. Paris: Gallimard.

Dumont, L. 1984. *Homo hierarchicus.* Chicago: University of Chicago Press.

Eagleton, Terry. 1987. "Marxist Criticism." In *A Dictionary of Modern Critical Terms,* ed. Roger Fowler. London: Routledge and Kegan Paul, pp. 141–45.

———. 1976. *Marxism and Literary Criticism.* Berkeley: University of California Press.

Ehrenzweig, Anton. 1967. *The Hidden Order of Things: A Study in the Psychology of Artistic Imagination.* Berkeley: University of California Press.

Eliot, T. S. 1932. *"Hamlet": Selected Essays, 1917–32.* London. Reprinted New York: Harcourt Brace Jovanovich, 1950.

Ellen, R. F. 1977. "Anatomical Classification and the Semiotics of the Body." In *The Anthropology of the Body*, ed. J. Blacking. London: Academic Press.

Ellenberger, Victor. 1956. "Le role de la salive des crachotements et des crachats dans la vie sociale des noirs africains." *Le Monde non Chrétien* 38: 326–37.

Ellis, A. B. [1890] 1970. *The Ewe-Speaking Peoples of the Slave Coast of West Africa*. Oosterhout, Netherlands. Anthropological Publications.

Erikson, Eric. 1963. *Childhood and Society*. New York: W. W. Norton.

Erikson, Kai T. 1966. *Wayward Puritans: A Study in the Sociology of Deviance*. New York: John Wiley and Sons.

Evans-Pritchard, E. E. 1976. *Witchcraft, Oracles, and Magic among the Azande*. Oxford: Oxford University Press.

———. 1948. *The Divine Kingship of the Shilluk*. London: Cambridge University Press.

Ezra, Kate. 1986. *A Human Ideal in African Art: Bamana Figurative Sculpture*. Washington, DC: Smithsonian Institution Press.

Fabian, Johannes. 1983. *Time and the Other: How Anthropology Makes Its Object*. New York: Columbia University Press.

———. 1978. "Popular Culture in Africa: Findings and Conjectures." *Africa* 48, no. 4: 315–34.

Fabian, Johannes, and Ilona Szombati Fabian. 1980. "Folk Art from an Anthropological Perspective." In *Perspectives on American Folk Art*, ed. Ian M. G. Quimbly and Scott T. Swank. New York: W. W. Norton, pp. 242–92.

Fagg, William. 1980. *Yoruba Beadwork: Art of Nigeria*. Ed. Bryce Holcombe. Descriptive catalog by John Pemberton. New York: Rizzoli.

Falcon, P. R. P. 1970. "Religion du Vodun et superstition." Thèse de doctorat, Toulouse 1964; published as *Religion du Vodun by Études Dahoméennes*, n.s. 18–19: 1–211.

Fanon, Frantz. 1968. *The Wretched of the Earth*. Trans. Constance Farrington. New York: Grove Press.

Feeley-Harnick, Gillian. 1985. "Issues in Divine Kingship." *Annual Review of Anthropology* 14: 273–313.

Feierman, Steven. 1985. "The Social Origins of Health and Healing in Africa." *African Studies Review* 28, no. 2/3: 73–147.

Feld, Steven. 1982. *Sound and Sentiment: Birds Weeping, Poetics, and Song in Kaluli Expression*. Philadelphia: University of Pennsylvania Press.

Felman, Shoshana. 1982. *Literature and Psychoanalysis: The Question of Reading; Otherwise*. Baltimore: Johns Hopkins University Press.

———. 1977. "To Open the Question." *Yale French Studies* 55–56: 5–10.

Fernandez, James W. 1974. "The Mission of Metaphor in Expressive Culture." *Current Anthropology* 15, no. 2: 119–45.

———. 1971. "Bantu Brotherhood: Symmetry, Socialization, and Ultimate Choice in Two Bantu Cultures." In *Kinship and Culture*, ed. Francis L. K. Hsu. Chicago: Aldine, pp. 339–66.

———. 1966. "Principles of Opposition and Vitality in Fang." *Journal of Aesthetics and Art Criticism* 25, no. 1: 53–64.

Field, M. J. 1960. *Search for Security: An Ethno-Psychiatric Study of Rural Ghana*. Evanston: Northwestern University Press.

Figgis, J. N. 1896. *The Divine Right of Kings*. Cambridge: Cambridge University Press. (2d ed., 1922).

Fischer, J. L. 1965. "Psychology and Anthropology." In *Biennial Review of Anthropology*, ed. Bernard J. Siegel. Stanford, CA: Stanford University Press: 211–61.

Fisiy, Cyprian, and Michael Rowlands. 1989. "Sorcery and Law in Modern Cameroon." *Culture and History* 6: 63–84.

Flam, J. D. 1970. "Some Aspects of Style Symbolism in Sudanese Sculpture." *Journal de la Société des Africanistes* 40, no. 2: 137–50.

Forbes, Frederick Edwyn. 1851. *Dahomey and the Dahomans; Being the Journals of Two Missions to the King of Dahomey and Residence at His Capital. . . .* Reprint. London: Frank Cass and Co., 1966. 2 vols.

Fortes, Meyer. 1970. *Time and Social Structure and Other Essays*. New York: Humanities Press.

———. 1959. *Oedipus and Job in West African Religion*. Cambridge: Cambridge University Press.

———. 1949. *The Web of Kinship among the Tallensi: The Second Part of an Analysis of the Social Structure of a Trans-Volta Tribe*. London: Oxford University Press.

Fortune, R. F. 1970. "Sorcerers of Dobu." In *Witchcraft and Sorcery: Selected Readings*, ed. Max Marwick. Middlesex, England: Penguin Books, pp. 101–7.

Foucault, Michel. 1978. *The History of Sexuality*. 3 vols. Trans. Robert Hurley. New York: Pantheon.

———. 1973. *The Birth of the Clinic: An Archaeology of Medical Perception*. Trans. A. M. Sheridan Smith. New York: Pantheon Books.

———. 1970. *The Order of Things: An Archaeology of the Human Sciences*. London: Tavistock.

———. [1961] 1965. *Madness and Civilization: A History of Insanity in the Age of Reason*. Trans. Richard Howard. New York: Pantheon.

Fowler, Alastair. 1982. *Kinds of Literature: An Introduction to the Theory of Genres and Modes*. Oxford: Clarendon Press.

Fowler, Roger. [1973] 1987. *A Dictionary of Modern Critical Terms*. Rev. ed. London: Routledge and Kegan Paul.

Francastel, G. 1973. *Le droit au trône: Un problème de prééminence dans l'art chrétien d'occident*. Paris: Kliensieck.

Frankfurt Institute for Social Research. 1972. *Aspects of Sociology*. Preface by Max Horkheimer and Theodor W. Adorno. Boston: Beacon Press.

Fraser, Douglas, and Herbert M. Cole, eds. 1972. *African Art and Leadership*. Madison: University of Wisconsin Press.

Frazer, J. G. 1968. *The Magical Origin of Kings*. London: Dawsons.

———. 1890. *The Golden Bough*. London: J. Murray.

Freedberg, David. 1989. *The Power of Images: Studies in the History and Theory of Response*. Chicago: University of Chicago Press.

Freud, Sigmund. 1953. *The Standard Edition of the Complete Psychological Works*. 23 vols. Trans. James Strachey. London: Hogarth Press.

Friedman, W. B. 1956. "Changes in Property Relations." *Transactions of the Third World Congress of Sociology* 1–2.

Gadamer, Hans-Georg. [1967] 1986. *The Relevance of the Beautiful and Other Essays.* Trans. Nicholas Walker. Cambridge: Cambridge University Press.

Gallop, Jane. 1985. *Reading Lacan.* Ithaca: Cornell University Press.

Gans, Herbert J. 1974. *Popular Culture and High Culture: An Analysis and Evaluation of Taste.* New York: Basic Books.

Gates, Henry Louis, Jr. 1988. *The Signifying Monkey: A Theory of African-American Literary Criticism.* New York: Oxford University Press.

Gay, Peter. 1976. *Art and Act: On Causes in History—Manet, Gropius, Mondrian.* New York: Harper and Row.

Gbekobou, Kofi N. 1985. "Traditional Religion among the Ewe." *Actes du Seminaire UCLA–UB sur les Sciences Sociales* 2 (July 1984): 45–50.

Geertz, Clifford. 1983. *Local Knowledge: Further Essays in Interpretive Anthropology.* New York: Basic Books.

———. 1980. *Negara: The Theatre State in Nineteenth Century Bali.* Princeton, NJ: Princeton University Press.

———. 1973. *Interpretations of Cultures.* New York: Basic Books.

———. 1963. *Peddlers and Princes: Social Change and Economic Modernization in Indonesian Towns.* Chicago: University of Chicago Press.

Geertz, Hildred. 1959. "The Vocabulary of Emotion: A Study of Javanese Socialization Processes." *Psychiatry* 22: 225–37.

Genevese, Eugene D. 1976. *Roll Jordan Roll: The World the Slaves Made.* New York: Vintage Books.

Gilli, Bruno. 1982a. *Naissances humaines ou divines? Analyse de certains types de naissances attribués au Vodu.* Thèse de 3ème cycle. Paris: École des Hautes Études en Sciences Sociales.

———. 1982b. "Approches de la notion du Vodu et des rites de naissance chez les Ouatchi au Sud-Togo." Mémoire du D.E.A.: Formation d'Études du 3e Cycle en Ethnologie, Paris.

———. 1976. *Heviesso et le bon ordre du monde: Approches d'une religion africaine.* Memoire d'École des Hautes Études en Sciences Sociales. Paris: École des Hautes Études.

Glaze, Anita J. 1981. *Art and Death in a Senufo Village.* Bloomington: Indiana University Press.

Gleick, James. 1987. *Chaos: Making a New Science.* New York: Viking.

Glélé, Maurice Ahanhanzo. 1974. *Le Danxomè: Du pouvoir Aja à la nation Fon.* Paris: Nubia.

Gluckman, Max. 1970. "The Logic of African Science and Witchcraft." In *Witchcraft and Sorcery: Selected Readings,* ed. Max Marwick. Middlesex, England: Penguin Books, pp. 321–31.

———. [1955] 1969. *Custom and Conflict in Africa.* Oxford: Oxford University Press.

———. 1940. "The Kingdom of the Zulu of South Africa." In *African Political Systems,* ed. M. Fortes and E. E. Evans-Pritchard. London: Oxford University Press.

Gollnhofer, Otto, and Roger Sillans. 1975. "Cadres, éléments et techniques de la médecine traditionnelle Tsogho: Aspects psychothérapiques." *Psychopathologie africaine* 11, no. 3: 285–321.

Gombrich, E. H. 1963. *Meditations on a Hobby Horse and Other Essays on the Theory of Art.* Chicago: University of Chicago Press.

Gombrich, E. H., Julian Hochberg, and Max Black. 1973. *Art, Perception, and Reality.* Baltimore: Johns Hopkins University Press.

González-Wippler, Migene. 1989. *Santeria: African Magic in Latin America.* New York: Original Publications.

Goodman, Nelson, and Catherine Z. Elgin. 1988. *Reconceptions in Philosophy and Other Arts and Sciences.* Indianapolis: Hackett Publishing Company.

Goodwin, B. 1972. "Science in Alchemy." In *The Rules of the Game,* ed. T. Shanin. London: Tavistock.

Goody, Jack. 1971. *Technology, Tradition and the State in Africa.* London: Oxford University Press.

Gottlieb, Alma. 1982. "Sex, Fertility, and Menstruation of the Beng of the Ivory Coast: A Symbolic Analysis." *Africa* 52, no. 4: 34–47.

Gramsci, Antonio. 1971. *Selections from the Prison Notebooks of Antonio Gramsci.* Ed. and Trans. Quintin Hoare and Geoffrey Nowell Smith. New York: International Publishers.

Gregory, Stephen. 1986. *Santeria in New York City: A Study in Cultural Resistance.* Ann Arbor: University Microfilms International.

Griaule, Marcel. 1965. *Conversations with Ogotemmeli: An Introduction to Dogon Religious Ideas.* London: Oxford University Press.

Griffiths, Gareth. [1973] 1987. "Persona." In *A Dictionary of Modern Critical Terms,* ed. Roger Fowler. London: Routledge and Kegan Paul, pp. 176–77.

Grossberg, Lawrence, et al., eds. 1992. *Cultural Studies.* London: Routledge.

Guédou, Georges A. G. 1985. *Xó et gbè langage et culture, chez les Fon (Bénin).* Paris: Société d'Études Linguistiques et Anthropologiques de France.

Guha, Ranajit, and Gayatri Chakravorty Spivak. 1988a. Preface to *Selected Subaltern Studies,* ed. R. Guha and G. C. Spivak. New York: Oxford University Press.

———. 1988b. "On Some Aspects of the Historiography of Colonial India." In *Selected Subaltern Studies,* ed. R. Guha and G. C. Spivak. New York: Oxford University Press.

Habermas, Jürgen. 1971. *Knowledge and Human Interests.* Trans. Jeremy Shapiro. Boston: Beacon Press.

Halbwachs, Maurice. 1930. *Les causes de suicide.* Paris: Alcan.

Hall, David. 1984. Introduction to *Understanding Popular Culture: Europe from the Middle Ages to the Nineteenth Century,* ed. Steven L. Kaplan. New Babylon Studies in Social Science. New York: Mouton.

———. 1981. "Notes on Deconstructing 'The Popular.'" In *People's History and Socialist Theory,* ed. Raphael Samuel. London: Routledge and Kegan Paul, pp. 227–40.

Hanna, Judith L. 1983. *The Performer-Audience Connection: Emotion to Metaphor in Dance and Society.* Austin: University of Texas Press.

Hansen, Chadwick. 1969. *Witchcraft at Salem.* New York: Braziller.

Harari, Josué, ed. 1979. *Textual Strategies: Perspectives in Post-Structuralist Criticism.* Ithaca: Cornell University Press.

Harding, D. W. 1976. *Words into Rhythm: English Speech Rhythm in Verse and Prose.* London: Cambridge University Press.

Hardwicke, C. Grafton, and Tweeddale Argyll. 1746. *Voyages and Travels to Guinea and Benin*. Vol. 3 of *A New General Collection of Voyages and Travels*. London: Thomas Astley.

Harris, Grace G. 1978. *Casting Out Anger: Religion among the Taita of Kenya*. Cambridge: Cambridge University Press.

Hayden, Ilse. 1987. *Symbol and Privilege: The Ritual Context of British Royalty*. Tucson: University of Arizona Press.

Hayles, N. Katherine. 1990. *Chaos Bound: Orderly Disorder in Contemporary Literature and Science*. Ithaca: Cornell University Press.

Hazoumé, Paul. 1956. *Le pacte de sang au Dahomey*. Trauvaux et Mémoires de l'Institut d'Ethnologie, vol. 25. Paris: Institute d'Ethnologie.

Heelas, Paul, and Andrew Lock, eds. 1981. *Indigenous Psychologies: The Anthropology of the Self*. London: Academic Press.

Hegel, George. 1965. *La raison dans l'histoire*. Paris: Plon.

Herissé, A. Le. 1911. *L'ancien royaume du Dahomey: Moeurs, religion, histoire*. Paris: Emile Larose.

Herskovits, Melville J. [1938] 1967. *Dahomey: An Ancient West African Kingdom*, vols. 1 and 2. Evanston, IL: Northwestern University Press.

———. [1937] 1964. *Life in a Haitian Valley*. New York: Octagon Press.

Herskovits, Melville, and Francis S. Herskovits. [1933] 1964. *An Outline of Dahomean Religious Belief*. Memoirs of the American Anthropological Association, no. 41. New York: Kraus Reprint Corporation.

———. 1958. *Dahomean Narrative: A Cross-Cultural Analysis*. Evanston, IL: Northwestern University Press.

Heusch, Luc de. 1989. "Kongo in Haiti: A New Approach to Religious Syncretism." *Man,* n.s. 24: 290–302.

———. 1962. *Le pouvoir et le sacré*. Brussels: Université de Bruxelles, Centre d'Études des Religions.

Himmelheber, Hans. 1960. *Negerkunst und Negerkunstler*. Braunschweig: Klinkhardt and Biermann.

Hocart, A. M. 1936. *Kings and Councillors. An Essay in the Comparative Anatomy of Human Society*. Cairo: Paul Barbey (1970 ed.: Chicago: University of Chicago Press).

———. 1927. *Kingship*. Oxford: Clarendon Press.

Holquist, Michael. 1981. *Dialogic Imagination: Four Essays*. Austin: University of Texas Press.

Hommel, William. 1974. *Art of the Mende*. College Park: University of Maryland Press.

Hooke, S. H., ed. 1958. *Myth, Ritual, and Kingship: Essays on the Theory and Practices of Kingship in the Ancient Near East and Israel*. Oxford: Clarendon Press.

Horney, Karen. 1939. *New Ways in Psychoanalysis*. New York: W. W. Norton.

Horton, Robin. 1965. *Kalabari Sculpture*, Lagos: Federal Republic of Nigeria, Dept. of Antiquities.

———. 1963. "The Kalabari Ekine Society: A Borderland of Religion and Art." *Africa* 33, no. 2: 94–114.

———. 1961. "Destiny and the Unconscious in West Africa." *Africa* 31, no. 2: 110–16.

———. 1959. "Social Psychologies: African and Western." In *Oedipus and Job in West African Religion*, ed. Meyer Fortes. Cambridge: Cambridge University Press.

Howes, David. 1987. "Olfaction and Transition: An Essay on the Ritual Use of Smell." *Canadian Review of Sociology and Anthropology* 24: 327–45.

Hurston, Zora Neale. 1931. "Hoodoo in America." *Journal of American Folklore* 44: 326–93.

———. 1935. *Mules and Men.* Bloomington: Indiana University Press.

Husserl, E. 1970. *Logical Investigations.* London: Routledge and Kegan Paul.

Hyatt, Harry Middleton. 1970. *Hoodoo-Conjuration-Witchcraft-Rootwork: Beliefs Accepted by Many Negroes and White Persons, These Being Orally Recorded among Blacks and Whites.* Hannibal, MO: Western Publishing.

Iser, Wolfgang. 1980. "The Reading Process: A Phenomenological Approach." In *Reader-Response Criticism: From Formalism to Post-Structuralism,* ed. Jane P. Tompkins. Baltimore: Johns Hopkins University Press, pp. 50–69.

———. 1978. *The Act of Reading: A Theory of Aesthetic Response.* London: Routledge and Kegan Paul.

Jackson, Michael. 1989. *Paths toward a Clearing: Radical Empiricism and Ethnographic Inquiry.* Bloomington: Indiana University Press.

———. 1983a. "Knowledge of the Body." *Man,* n.s. 18: 327–45.

———. 1983b. "Thinking through the Body." *Social Analysis* 14: 127–49.

———. 1982. *Allegories of the Wilderness: Ethics and Ambiguity in Kuranko Narratives.* Bloomington: Indiana University Press.

———. 1978. "The Identity of the Dead." *Cahiers d'Étude Africaines* 66/67: 271–97.

Jackson, Michael, and Ivan Karp, eds. 1990. *Personhood and Agency: The Experience of Self and Other in African Cultures.* Uppsala Studies in Cultural Anthropology 14. Uppsala: Uppsala University.

Jacobson-Widding, Anita. 1990. "The Shadow as an Expression of Individuality in Congolese Conceptions of Personhood." In *Personhood and Agency: The Experience of Self and Other in African Cultures,* ed. Michael Jackson and Ivan Karp. Uppsala Studies in Cultural Anthropology 14. Uppsala: Uppsala University, pp. 31–58.

———. 1983 "Problems of Identity and Person." In *Identity: Personal and Socio-Cultural,* ed. A. Jacobson-Widding. Uppsala Studies in Cultural Anthropology 5. Uppsala: Academiae Upsaliensis, pp. 571–87.

Jakobson, Roman. 1987. *Language in Literature.* Ed. Krystyna Pomorska and Stephen Rudy. Cambridge, MA: Belknap Press.

James, William. 1890. *Principles of Psychology.* 3 vols. New York: Dover.

Jameson, Frederic. 1988. *The Ideologies of Theory: Essays 1971–1986.* Vol. 1. Minneapolis: University of Minnesota Press.

———. 1982. "Imaginary and Symbolic in Lacan: Marxism, Psychoanalytic Criticism, and the Problem of Subject." In *Literature and Psychoanalysis: The Question of Reading; Otherwise,* ed. Shoshona Felman. Baltimore: Johns Hopkins University Press, pp. 338–95.

Janzen, John M. 1978. *The Quest for Therapy: Medical Pluralism in Lower Zaire.* Berkeley: University of California Press.

Janzen, John M., and Wyatt MacGaffey. 1974. "Nkisi Figures of the Bakongo." *African Arts* 7, no. 3.

Jauss, Hans Robert. 1982. *Aesthetic Experience and Literary Hermeneutics.* Minneapolis: University of Minnesota Press.

Jewsiewicki, Bogumil. 1989. "Présentation: Le langage politique et les arts plastiques en Afrique." In *Art and Politics in Black Africa,* ed. B. Jewsiewicki. Ottowa: Canadian Association of African Studies, pp. 1–10.

Jules-Rosette, Bennetta. 1987. "Rethinking the Popular Arts in Africa: Problems of Interpretation." *African Studies Review* 30, no. 3: 91–97.

———. 1984. *The Messages of Tourist Art: An African Semiotic System in Comparative Perspective.* New York: Plenum Publishing Corp.

Jung, Carl G. 1959. *The Archetypes and the Collective Unconscious.* Vol. 9, pt. 1 of *The Collected Works.* Trans. R. F. C. Hul!. London: Routledge and Kegan Paul.

———. 1953. *Collected Works.* Ed. Herbert Read, Michael Fordham, and Gerhard Adler. New York: Pantheon Books.

Kahane, Henry, and Renée. 1987. "Hellenistic and Medieval Alchemy." In *The Encyclopedia of Religion,* vol. 1. New York: Macmillan, pp. 192–96.

Kantorowicz, E. H. 1957. *The King's Two Bodies: A Study in Medieval Political Theology.* Princeton: Princeton University Press.

Kaplan, Steven L., ed. 1984. *Understanding Popular Culture: Europe from the Middle Ages to the Nineteenth Century.* New Babylon Studies in Social Sciences, no. 40. Amsterdam: Mouton.

Karlsen, Carol F. 1987. *The Devil in the Shape of a Woman: Witchcraft in Colonial New England.* New York: W. W. Norton.

Kaufmann, R. 1979. "Tactility as an Aesthetic Consideration in African Music." In *The Performing Arts: Music and Dance,* ed. J. A. Blacking. The Hague: Mouton, pp. 251–53.

Kent, Thomas. 1986. *Interpretation and Genre.* Lewisburg, PA: Bucknell University Press.

Kerchache, Jacques, et al. 1988. *L'art africain.* Paris: Éditions Mazenod.

Kiev, Ari. 1972. *Transcultural Psychiatry.* New York: Free Press.

———. 1961. "Folk Psychiatry in Haiti." *Journal of Nervous and Mental Disease* 132, no. 3: 260–65.

Klein, Cecilia F. 1990. "Editor's Statement." *Depictions of the Dispossessed.* Guest Editor: Cecilia F. Klein. *Art Journal* 49, no. 2: 106–9.

Klein, Melanie. 1975. *"Love, Guilt, and Reparation" and Other Works, 1921–1945.* New York: Delacorte Press.

Kleinman, Arthur. 1986. *Social Origins of Distress and Disease: Depression, Neurasthenia, and Pain in Modern China.* New Haven: Yale University Press.

———. 1980. *Patients and Healers in the Context of Culture: An Exploration of the Borderland between Anthropology, Medicine, and Psychiatry.* Berkeley: University of California Press.

Kleinman, Arthur, and Byron Good, eds. 1985. *Culture and Depression: Studies in the Anthropology and Cross-Cultural Psychiatry of Affect and Disorder.* Berkeley: University of California Press.

Kluckhohn, Clyde. 1944. *Navaho Witchcraft.* Cambridge, MA: Harvard University Press.

Kopytoff, Igor, ed. 1987. *The African Frontier: The Reproduction of Traditional African Societies.* Intro. Igor Kopytoff. Bloomington: Indiana University Press.

Kossou, Basile Toussaint. 1983. *Se et Gbe: Dynamique de l'existence chez les Fon.* Paris: La Pensée Universelle.

Kratz, Corinne A. 1989. "Genres of Power: A Comparative Analysis of Okiek Blessings, Curses and Oaths." *Man,* n.s. 24: 636–56.

Kreitler, Hans, and Shulamith Kreitler. 1972. *Psychology of the Arts.* Durham: Duke University Press.

Kris, Ernst. [1952] 1967. *Psychoanalytic Explorations in Art.* New York: Schocken Books.

Kristeva, Julia. 1986. *The Kristeva Reader.* Ed. Toril Moi. New York: Columbia University Press.

———. 1982. *Powers of Horror: An Essay on Abjection.* Trans. Leon S. Roudiez. New York: Columbia University Press.

———. 1980. *Desire in Language: A Semiotic Approach to Literature and Art.* Trans. Thomas Gora, Alice Jardine, and Leon S. Roudiez. Ed. Leon Roudiez. New York: Columbia University Press.

———. 1974. *La révolution du langage poetique: L'avant-garde à la fin du XIXe siècle.* Paris: Éditions du Seuil.

———. 1971. *Essays in Semiotics (Essais de sémiotique).* The Hague: Mouton.

Kuhns, Richard Francis. 1983. *Psychoanalytic Theory of Art: A Philosophy of Art on Developmental Principles.* New York: Columbia University Press.

Kuper, H. 1964. *The Swazi: A South African Kingdom.* New York: Holt, Rinehart and Winston.

———. 1947. *An African Aristocracy: Rank among the Swazi.* London: Oxford University Press.

Labat, R. P. 1956. *Le voyage du Chevalier de Marchais en Guinée, Isles voisines, et à Cayenne, fait en 1725, 1726 et 1727.* Reprinted in *Études Dahoméennes* 15: 69–107; 16: 47–96; 17: 50–72.

Labouret, Henri, and Paul Rivet. 1929. *Le royaume d'Arda et son évangélisation au XVIIe siècle.* Paris: Institut d'Ethnologie.

Lacan, Jacques. [1973] 1981. *The Four Fundamental Concepts of Psycho-Analysis.* Ed. Jacques-Alain Miller. Trans. Alan Sheridan. New York: W. W. Norton.

———. 1968. *Speech and Language in Psychoanalysis.* Trans. A. Wildern. Baltimore: Johns Hopkins University Press.

———. 1966. *Écrits 1.* Paris: Éditions du Seuil.

Ladurie, Emmanuel Le Roy. 1979. *Carnival in Romans.* New York: George Braziller.

Lafitte, M. L'Abbé. 1875. "Excursions et récits Qouenou, Cabécère du Commerce a Whydah," *Les missions catholiques: Bulletin de la propagation de la foi* 7: 539, 542–44.

1873. *Le Dahomé: Souvenirs de voyage et de mission.* Tours: Alfred Mame et fils.

Lakoff, George. 1987. *Women, Fire, and Dangerous Things: What Categories Reveal about the Mind.* Chicago: University of Chicago Press.

Lakoff, George, and Mark Johnson. 1981. *Metaphors We Live By.* Berkeley: University of California Press.

Laleye, Issiaka. 1970. *La conception de la personne dans la pensée traditionelle Yoruba, approache phénoménologique.* Berne: Herbert Lang.

Langer, Susanne. 1953. *Feeling and Form.* New York: Charles Scribner's Sons.

———. 1942. *Philosophy in a New Key: A Study in the Symbolism of Reason, Rite, and Art.* Cambridge, MA: Harvard University Press.

Laplanche, J., and J.-B. Pontalis. 1973. *The Language of Psycho-Analysis.* Trans. London: Hogarth Press.

Lapsley, Robert, and Michael Westlake. 1988. *Film Theory: An Introduction.* Manchester: Manchester University Press.

Law, Robin. 1991. *The Slave Coast of West Africa 1550–1750: The Impact of the Atlantic Slave Trade on an African Society.* Oxford: Clarendon Press.

———. 1989. "My Head Belongs to the King: On the Political and Ritual Significance of Decapitation in Pre-Colonial Dahomey." *Journal of African History* 30: 399–415.

Lawal, Babatunde. 1974. "Some Aspects of Yoruba Aesthetics." *British Journal of Aesthetics* 14, no. 3: 239–49.

Leach, E. R. 1954. "Aesthetics." In *The Institutions of Primitive Society,* by E. E. Evans-Pritchard et al. Oxford: Basil Blackwell, pp. 25–38.

Lebeuf, Jean-Paul. 1961. *L'habitation des Fali.* Paris: Librairie Hachette.

Le Herissé, A. 1911. *L'ancien royaume du Dahomey: Moeurs, religion, histoire.* Paris. Emile Larose.

Lestienne, Rémy. 1979. *Unite et ambivalence du concept de temps physique.* Paris: Centre National de la Recherche Scientifique.

Leuzinger, Elsy. 1971. *Afrikanische Kunstwerke: Kulturen am Niger.* Zurich: Villa Hügel Essen.

Lévi-Strauss, Claude. 1963. *Structural Anthropology.* New York: Basic Books.

Levine, Lawrence W. 1977. *Black Culture and Black Consciousness: Afro-American Folk Thought from Slavery to Freedom.* Oxford: Oxford University Press.

LeVine, Robert A. 1976. "Patterns of Personality in Africa." In *Responses to Change: Society, Culture, and Personality,* ed. George deVos. New York: Van Nostrand Co., pp. 112–36.

Levy, Robert. 1984. "Emotion, Knowing, and Culture." In *Culture Theory: Essays on Mind, Self, and Emotion,* ed. R. A. Schweder and A. LeVine. Cambridge: Cambridge University Press, pp. 214–37.

———. 1973. *Tahitians: Mind and Experience in the Society Islands.* Chicago: University of Chicago Press.

Lienhardt, G. 1985. "Self, Public and Private: Some African Representations." In *The Category of the Person,* ed. Michael Carrithers, Steven Collins, and Steven Lukes. Cambridge: Cambridge University Press, pp. 141–55.

Limón, José E. 1989. "*Carne, Carnales,* and the Carnivalesque: Bakhtin, *Batos,* Disorder, and Narrative Discourse." *American Ethnologist* 16, no. 3: 471–85.

Linker, Kate. 1984. "Representation and Sexuality." In *Art after Modernism: Rethinking Representation,* ed. Brian Wallis. New York: New Museum of Contemporary Art, pp. 391–416.

Lipsitz, George. 1990. "Mardi Gras Indians: Carnival and Counternarrative in Black New Orleans." In *Time Passages: Collective Memory and American Popular Culture,* ed. G. Lipsitz. Minneapolis: University of Minnesota Press, pp. 233–56.

Lovejoy, Paul E., ed. 1986. *Africans in Bondage: Studies in Slavery and the Slave Trade.* Madison: University of Wisconsin Press.

Lutz, Catherine. 1982. "The Domain of Emotion Words on Ifaluk." *American Ethnologist* 9, no. 1: 113–28.

Lutz, Catherine A., and Geoffrey M. White. 1986. "The Anthropology of Emotions." *Annual Review of Anthropology* 15: 405–36.

Lyman, Stanford M. 1970. *The Asian and the West.* Social Science and Humanities Publication no. 4. Reno Western Studies Center, Desert Research Institute. Reno: University of Nevada.

Lyotard, Jean François. 1984. *The Postmodern Condition: A Report on Knowledge.* Trans. Geoff Bennington and Brian Massumi. Minneapolis: University of Minnesota Press.

Macfarlane, A. D. J. 1970. "Witchcraft and Conflict." In *Witchcraft and Sorcery: Selected Readings,* ed. Max Marwick. Middlesex, England: Penguin Books, pp. 296–304.

MacGaffey, Wyatt. 1991. *Art and Healing of the Bakongo (Commented by Themselves).* Sweden: Folkens Museum—Etnografiska.

———. 1986. "Ethnography and the Closing of the Frontier in Lower Congo, 1885–1921." *Africa* 56: 263–79.

———. 1988. "Complexity, Astonishment, and Power: The Visual Vocabulary of Kongo Minkisi." *Journal of Southern African Studies* 14:188–203.

———. 1977. "Fetishism Revisited: Kongo *Nkisi* in Sociological Perspective." *Africa* 47, no. 2: 1977.

Macherey, Pierre. 1978. *A Theory of Literary Production.* Trans. Geoffrey Wall. New York: Routledge, Chapman Hall.

Mair, Lucy. 1969. *Witchcraft.* New York: McGraw-Hill.

Makang Ma Mbog, Mathias. 1972. "Les funérailles africaines comme psychothérapie des deuils pathologiques." *Psychopathologie africaine* 8, no. 2: 201–15.

Malinowski, Bronislaw. 1970. "Magic, Science, and Witchcraft." In *Witchcraft and Sorcery: Selected Readings,* ed. Max Marwick. Middlesex, England: Penguin Books, pp. 210–16.

———. 1954. *Magic, Science, and Religion and Other Essays.* Ed. Robert Redfield. New York: Doubleday.

Mandelbrot, Benoit B. 1983. *The Fractal Geometry of Nature.* New York: W. H. Freeman.

Manganyi, N. Chabani. 1985. "Making Strange: Race, Science, and Ethnopsychiatric Discourse." In *Europe and Its Others,* vol. 1 of *Proceedings of the Essex Conference on the Sociology of Literature.* Ed. Francis Barker et al., Colchester, England: University of Essex.

Manning, Patrick. 1982. *Slavery, Colonialism, and Economic Growth in Dahomey, 1640–1960.* New York: Cambridge University Press.

Marcuse, Herbert. 1978. *The Aesthetic Dimension: Toward a Critique of Marxist Aesthetics.* Boston: Beacon Press.

———. 1956. *Eros and Civilization: A Philosophical Inquiry into Freud.* London: Ark Paperbacks.

Marin, L. 1988. *Portrait of the King.* Dexter: University of Minnesota Press.

Marks, Morton. 1987. "Exploring El Monte: Ethnobotany and the Afro-Cuban Science of the Concrete." In *En Torno a Lydia Cabrera (Cincuentenario de 'Cuentos Negros*

de Cuba,' 1936–1986), ed. I. Castellanos and J. Inclan. Miami: Ediciones Universal, pp. 227–44.

Marshall, J. 1939. *Swords and Symbols: The Techniques of Sovereignty.* Oxford: Oxford University Press.

Marshall, Timothy. 1987. "Dialogic Structure." In *A Dictionary of Modern Critical Terms,* ed. Roger Fowler. London: Routledge and Kegan Paul, pp. 58–60.

Marwick, Max. 1970. Introduction and Postscript to *Witchcraft and Sorcery: Selected Readings,* ed. Max Marwick. Middlesex, England: Penguin Books.

Maupoil, Bernard. 1981. *La géomancie à l'ancienne Côte des Esclaves. Institut d'Ethnologie* 42. Paris: Musée de l'Homme.

Mauss, Marcel. 1979. *Sociology and Psychology: Essays.* London: Routledge and Kegan Paul.

———. 1968–69. *Oeuvres, 1–3.* Ed. V. Karady. Paris: Éditions de Minuit.

Mayer, Philip. 1970. "Witches." In *Witchcraft and Sorcery: Selected Readings,* ed. Max Marwick. Middlesex, England: Penguin Books, pp. 45–64.

McNaughten, Patrick R. 1979. *Secret Sculptures of Komo: Art and Power in Bamana (Bambara) Initiation Associations.* Working Papers in the Traditional Arts, no. 4. Philadelphia: Institute for the Study of Human Issues.

McRobbie, Angela. 1985. "Strategies of Vigilance: An Interview with Gayatri Chakravorty Spivak." *Block* 10: 7.

Meillassoux, Claude. 1986. *Anthropologie de l'esclavage: Le ventre de fer et d'argent.* Paris: Presses Universitaires de France.

———. 1975. *L'esclavage en Afrique precoloniale.* Paris: F. Maspero.

Memel-Fote, Harris. 1966. "The Function and Significance of Negro Art in the Life of the Peoples of Black Africa." In Colloquium, *Functions and Significance of African Negro Art in the Life of the People and for the People,* Dakar, First World Festival of Negro Arts, April 1–24, 1966.

Mercer, Peter. [1973] 1987. "Catharsis." In *A Dictionary of Modern Critical Terms,* ed. Roger Fowler. London: Routledge and Kegan Paul, pp. 26–27.

Mercier, Paul. 1954. "The Fon of Dahomey." In *African Worlds: Studies in the Cosmological Ideas and Surreal Values of African Peoples,* ed. Daryll Forde. London: Oxford University Press, pp. 210–34.

Merleau-Ponty, Maurice. 1964. *Sense and Non-Sense.* Trans. Hubert L. Dreyfus and Patricia Allen Dreyfus. Evanston, IL: Northwestern University Press.

Merlo, Christian. 1977. "Les 'Botchio' en civilisation béninoise." *Musée d'Ethnographie—Genève Bulletin Annuel* 20: 97–115.

———. 1966. *Un chef d'oeuvre d'art nègre: "Le buste de la prêtresse."* Auvers-sur-Oise: Archée.

Merton, Robert K. 1957. *Social Theory and Social Structure.* Rev. ed. New York: Free Press.

Messenger, John C. 1973. "The Carver in Anang Society." In *The Traditional Artist in African Societies,* ed. W. L. d'Azevedo. Bloomington: Indiana University Press.

Metraux, Alfred. [1959] 1972. *Voodoo in Haiti.* Trans. Hugo Charteris. New York: Schocker Books.

Meyerowitz, Eva L. R. 1944. "The Museum in the Royal Palace at Abomey, Dahomey." *Burlington Magazine* 84, no. 6: 147–51.

Middleton, John, and E. H. Winter, eds. 1963. Introduction to *Witchcraft and Sorcery in East Africa,* ed. John Middleton and E. H. Winter. New York: Praeger, pp. 1–26.

Miller, Jacques-Alain. 1977–78. "Suture (Elements of the Logic of the Signifier)." *Screen* 18, no. 4: 24–34.

Montilus, Guérin. 1979. "La naissance dans la pensée traditionelle Fon." Cotonou. Mimeograph.

———. 1972. "L'homme dans la pensée traditionelle Fon." Cotonou. Mimeograph.

Moore, Sally G. 1976. "The Secret of Men: A Fiction of Chagga Initiation and Its Relation to the Logic of Chagga Symbolism." *Africa* 46, no. 4: 357–70.

Moxey, Keith. 1989. *Peasants, Warriors, and Wives: Popular Imagery in the Reformation.* Chicago: University of Chicago Press.

Mudimbe, V. Y. 1982. *L'odeur du père: Essai sur des limites de la science et de la vie en Afrique noire.* Paris: Presence Africaine.

Murphy, William P., and Caroline H. Bledsoe. 1987. "The Importance of Being First: Kinship and Territory in the History of a Kpelle Chiefdom." In *The African Frontier: The Reproduction of Traditional African Societies,* ed. Igor Kopytoff. Bloomington: Indiana University Press, pp. 121–47.

Myers, Fred. 1986. *Pintupi Country, Pintupi Self: Sentiment, Place, and Politics among Western Desert Aborigines.* Washington, DC: Smithsonian Institution Press.

———. 1979. "Emotions and the Self: A Theory of Personhood and Political Order among Pintupi Aborigines." *Ethos* 7: 343–70.

Nadel, S. F. 1970. "Witchcraft in Four African Societies." In *Witchcraft and Sorcery: Selected Readings,* ed. Max Marwick. Middlesex, England: Penguin Books, pp. 264–79.

———. 1942. *A Black Byzantium: The Kingdom of Nupe in Nigeria.* London: Oxford University Press.

Neale, Stephen. 1980. *Genre.* British Film Institute. London: Paul Willemen.

Needham, Joseph. 1983. *Chemistry and Chemical Technology.* Vol. 5 of *Science and Civilisation in China.* Cambridge: Cambridge University Press.

Newman, Graeme. 1979. *Understanding Violence.* New York: J. B. Lippincott Co.

Nietzsche, Friedrich Wilhelm. 1978. *Thus Spake Zarathustra.* Trans. Walter Kaufmann. New York: Penguin Books.

———. 1967. *The Birth of Tragedy.* Trans. Walter Kauffmann. New York: Random House.

Ngubane, Harriet. 1977. *Body and Mind in Zulu Medicine: An Ethnography of Health and Disease in Nyuswa-Zulu Thought and Practice.* London: Academic Press.

Nooter, Mary H., ed. 1993. *Secrecy: African Art That Conceals and Reveals.* New York: Museum for African Art.

Norris, Robert. 1789. *Memoirs of the Reign of Bossa Ahádee, King of Dahomey.* London: Frank Cass and Co.

Notestein, Wallace. 1968. *A History of Witchcraft in England from 1558–1718.* New York: Thomas Y. Crowell.

Nunley, John W. 1987. *Moving with the Face of the Devil: Art and Politics in Urban West Africa.* Urbana: University of Illinois Press.

———. 1981. "The Fancy and the Fierce: Yoruba Masking Traditions in Sierra Leone." *African Arts* 14, no. 2: 52–58, 87–88.

Nyatepe-Coo, Georges. 1970. "*Le culture "Vodu" au Sud-Togo à Aneho.*" Ecole Pratiques des Hautes Études, VI Section, Paris.

Obeyesekere, Gananath. 1990. *The Work of Culture: Symbolic Transformation in Psychoanalysis and Anthropology.* Chicago: University of Chicago Press.

————. 1985. "Depression, Buddhism, and the Work of Culture in Sri Lanka." In *Culture and Depression,* ed. A. Kleinman and B. Good. Berkeley: University of California Press.

Ortigues, Marie-Cecile, and Edmond. 1984. *Oedipe africain.* Paris: L'Harmattan.

Ortner, S. 1978. *Sherpas through their Rituals.* Cambridge: Cambridge University Press.

Ottenberg, Simon. 1989. *Boyhood Rituals in an African Society: An Interpretation.* Seattle: University of Washington Press.

————. 1988. "Oedipus, Gender, and Social Solidarity: A Case Study of Male Childhood and Initiation." *Ethos* 16, no. 3: 326–52.

————. 1982. "Illusion, Communication, and Psychology in West African Masquerades." *Ethos* 10: 149–85.

————. 1972. "Humorous Masks and Serious Politics among Afikpo-Igbo." In *African Art and Leadership,* ed. D. Fraser and H. Cole. Madison: University of Wisconsin Press.

Packard, Randall M. 1981. *Chiefship and Cosmology.* Bloomington: Indiana University Press.

————. 1980. "Social Change and the History of Misfortune and the Bashu of Eastern Zaire." In *Explorations in African Systems of Thought,* ed. Ivan Karp and Charles S. Bird. Bloomington: Indiana University Press, pp. 237–67.

Palau-Marti, Montserrat. 1969. "Le sabre du dieu Gu." *Notes africaines* 121: 30–32.

Parrinder, Edward Geoffrey. 1969. *West African Religion: A Study of the Beliefs and Practices of the Akan, Ewe, Yoruba, Ibo, and Kindred Peoples.* London: Epworth Press.

Patterson, Orlando. 1982. *Slavery and Social Death.* Cambridge, MA: Harvard University Press.

Pazzi, Roberto. 1979. *Introduction à l'histoire de l'aire culturelle Ajatado.* Etudes et Documents des Sciences Humaines, Université du Bénin, ser. A, no. 1.

————. 1976. "L'Homme eve, aja, gen, fon et son univers: Dictionnaire." Lomé, Togo. Mimeograph.

Peek, Philip M., ed. 1991. *African Divination Systems: Ways of Knowing.* Bloomington: Indiana University Press.

Pelton, Robert D. 1980. *The Trickster in West Africa: A Study of Mythic Irony and Sacred Delight.* Los Angeles: University of California Press.

Pemberton, John. 1981. "Executioner and Victim." In *For Spirits and Kings: African Art from the Tishman Collection,* ed. Susan Vogel. New York: Metropolitan Museum of Art, pp. 84–85.

Philips, Ruth B. 1978. "Masking in Mende Sande Initiation Rituals." *Africa* 48, no. 3: 265–77.

Picton, John. 1986. "Art and Artifact in the Niger-Benue Confluence Region of Nigeria." In *Art in Africa,* ed. E. Bassani. Modena: Edizione Panini, pp. 52–57.

Pliya, Jean. 1971. *L'arbre fétiche.* Yaoundé, Cameroon: Éditions Cle.

————. 1970. *Histoire Dahomey, Afrique Occidentale.* France: Les Classiques Afri-
caines.

Polanyi, Karl, with Abraham Rotstein. 1966. *Dahomey and the Slave Trade: An Analysis
of an Archaic Economy.* Seattle: University of Washington Press.

Popplestone, John A., and Marion W. McPherson. 1988. *Dictionary of Concepts in Gen-
eral Psychology.* New York: Greenwood Press.

Price, S. R. F. 1984. *Rituals and Power: The Roman Imperial Cult in Asia Minor.* Lon-
don: Cambridge University Press.

Prigogine, Ilya, and Stengers, Isabelle. 1984. *Order out of Chaos: Man's New Dialogue
with Nature.* New York: Bantam Books.

Puckett, Newbell Niles. 1926. *Folk Beliefs of the Southern Negro.* Chapel Hill: University
of North Carolina Press.

Pulman, S. G. 1987. "Metaphor." In *A Dictionary of Modern Critical Terms*, ed. Roger
Fowler. London: Routledge and Kegan Paul, pp. 144–46.

Quénum, Maximilien J. 1938. *Au pays des Fons: Us et coutumes du Dahomey.* 2d ed.
Paris: Larose.

Radcliffe-Brown, A. R. 1950. "Introduction" to *African Systems of Kinship and Mar-
riage*, ed. A. R. Radcliffe-Brown and Daryll Forde. London: Oxford University Press.

Radin, Paul. 1971. *The World of Primitive Man.* New York: Dutton and Co.

Rahim, Habibeh. 1987. "Islamic Alchemy." In *The Encyclopedia of Religion*, vol. 1.
New York: Macmillan Publishing Co.: 196–99.

Rank, Otto. 1932. *Art and Artist: Creative Urge and Personality Development.* Trans.
Charles Francis Atkinson. New York: A. A. Knopf.

Ravenhill, Philip L. 1980. *Baule Statuary Art: Meaning and Modernization.* Working
Papers in the Traditional Arts, no. 5. Philadelphia: Institute for the Study of Human
Issues.

Read, John. 1947. *The Alchemist in Life, Literature, and Art.* London: Thomas Nelson
and Sons.

Répin, M. le Dr. [René]. 1863. "Voyage au Dahomey." *Le tour du monde:* 65–112.

Ricoeur, Paul. 1970. *Freud and Philosophy: An Essay on Interpretation.* Trans. Denis
Savage. New Haven: Yale University Press.

————. 1967. *The Symbolism of Evil.* Trans. Emerson Buchanan. Boston: Beacon Press.

Riesman, Paul. 1990. "The Formation of Personality in Fulani Ethnopsychology." In
Personhood and Agency: The Expression of Self and Other in African Cultures, ed. M.
Jackson and I. Karp. Uppsala Studies in Cultural Anthropology 14. Uppsala: Uppsala
University, pp. 169–90.

————. 1986. "The Person and the Life Cycle in African Social Life and Thought." *Afri-
can Studies Review* 29, no. 2: 71–138.

Rivière, Claude. 1981. *Anthropologie religieuse des Evé du Togo.* Paris: Lomé, Les Nou-
velles Éditions Africaines.

————. 1980. "Les représentations de l'homme chez les Evé du Togo." *Anthropos* 75:
7–24.

————. 1979a. "Dzo et la pratique magique chez les Evé du Togo," *Cultures et devel-
oppement* (Université Catholique de Louvain) 9, no. 2: 193–218.

————. 1979b. "Mythes et rites de la naissance chez les Ewe." *Annales de l'université du
Bénin.* Special issue. *Traditions togolaise:* 123–49.

Rosaldo, Michelle Z. 1984. "Toward an Anthropology of Self and Feeling." In *Culture Theory: Essays on Mind, Self, and Emotion*, ed. R. Shweder and R. LeVine. Cambridge: Cambridge University Press, pp. 137–57.

———. 1980. *Knowledge and Passion: Ilongot Notions of Self and Social Life*. Cambridge: Cambridge University Press.

Rosaldo, R. I. 1984. "Grief and the Headhunter's Rage: On the Cultural Force of Emotions." In *Text, Play, and Story: The Construction and Reconstruction of Self and Society*, ed. S. Plattner and E. Bruner. Washington, DC: American Ethnology Society, pp. 178–95.

Rousselle, Aline. 1988. *Porneia: On Desire and the Body in Antiquity*. Trans. Felicia Pheasant. Oxford: Basil Blackwell.

Rubin, Arnold. 1974. *African Accumulative Sculpture: Power and Display*. New York: Pace Gallery.

Russo, Mary. 1986. "Female Grotesques: Carnival and Theory." In *Feminist Studies/ Critical Studies*, ed. Teresa de Lauretis. Bloomington: Indiana University Press. (Also Vol. 8 of the series *Theories of Contemporary Culture*, University of Wisconsin–Milwaukee: 213–29.)

Ryder, A. F. C. 1965. *Materials for West African History in Portuguese Archives*. London: Athlone Press.

Sachs, Hanns. 1951. *The Creative Unconscious*. Cambridge: Sci-Art.

Sahlins, Marshall. 1958. *Social Stratification in Polynesia: A Study of Adaptive Variations in Culture*. New York: Pantheon.

Said, Edward. 1988. Forward to *Selected Subaltern Studies*, ed. R. Guha and G. C. Spivak. New York: Oxford University Press.

———. 1983. *The World, the Text, and the Critic*. Cambridge, MA: Harvard University Press.

Samuel, Raphael, ed. 1981. *People's History and Socialist Theory*. London: Routledge and Kegan Paul.

Saussure, F. de. [1983] 1986. *The Course in General Linguistics*. Ed. Charles Bally and Albert Sechehaye. Trans. Roy Harris. LaSalle, IL: Open Court.

Savary, Claude. 1978. *Sculptures africaines d'un collectionneur de Genève*. Geneva: Musée d'Ethnographie de Genève.

———. 1976. "La pensée symbolique de Fŏ du Dahomey." Geneva: Editions Médecine et Hygiène, Thèse de l'Université de Neuchâtel.

———. 1971. "Instruments de magie dahoméenne." *Musées de Genève* 120: 2–5.

———. 1970. "Poteries rituelles et autres objets culturels en usage au Dahomey." *Bulletin Annuel du Musée d'Ethnographie de Genève* 13: 33–57.

Schacht, Richard. 1989. "Nietzsche on Art in *The Birth of Tragedy*." In *Aesthetics: A Critical Anthology*, 2d ed., ed. George Dickie, Richard Sclafani, and Ronald Roblin. New York: St. Martin's Press, pp. 489–512.

Schapiro, Meyer. 1953. "Style." In *Aesthetics Today*, ed. M. Philipson and P. J. Gudel. Rev. ed. New York: New American Library.

Schieffelin, E. L. 1976. *The Sorrow of the Lonely and the Burning of the Dancers*. New York: St. Martins.

Schroyer, Trent. 1973. *The Critique of Domination: The Origins and Development of Critical Theory*. Boston: Beacon Press.

Schurtz, H. 1901. "Zaubermittel der Evheer (aus dem Städtischen Museum in Bremen)." *Internationalen Archiv für Ethnographie* 14: 1–15.

Schutz, Alfred. 1951. "Making Music Together: A Study in Social Relationships." *Social Research* 18, no. 1: 76–97.

Seeman, Melvin. 1959. "On the Meaning of Alienation." *American Sociological Review* 24: 783–91.

Segurola, R. Père B. 1963. *Dictionnaire Fon-Française.* Cotonou, Republic du Benin: Procure de L'Archidiocèse.

Shanin, Teodor. 1972. *The Rules of the Game: Cross-Disciplinary Essays on Models in Scholarly Thought.* London: Tavistock.

Shannon, Claude E., and Warren Weaver. 1949. *The Mathematical Theory of Communication.* Urbana: University of Illinois Press.

Shweder, Richard A., and Robert A. LeVine, eds. 1984. *Culture Theory: Essays on Mind, Self, and Emotion.* Cambridge: Cambridge University Press.

Sieber, Roy, and Rosalyn Walker. 1987. *African Art in the Cycle of Life.* Washington, DC: National Museum of African Art.

Siegmann, William. 1980. *African Sculpture from the Collection of the Society of African Missions.* Tenafly, NJ: S. M. A. Fathers.

Silberer, Herbert. 1917. *Problems of Mysticism and Its Symbolism.* Trans. Smith Ely Jelliffe. New York: Moffat, Yard and Co.

Silver, H. 1979. "Beauty and the 'I' of the Beholder: Identity, Aesthetics, and Social Change among the Ashanti." *Journal of Anthropological Research* 35, no. 2: 192–207.

Silverman, Kaja. 1983. *The Subject of Semiotics.* New York: Oxford University Press.

Simmel, Georg. 1950. *The Sociology of Georg Simmel.* Trans., ed. and intro. Kurt H. Wolff. Glencoe, IL: Free Press.

Siroto, Leon. 1972. "Gon: A Mask Used in Competition for Leadership among the Bakwele." In *African Art and Leadership,* ed. D. Fraser and H. M. Cole. Madison: University of Wisconsin Press, pp. 57–78.

Sivan, Nathan. 1987. "Chinese Alchemy." In *The Encyclopedia of Religion,* vol. 1. New York: Macmillan, pp. 186–90.

Skertchly, J. A. 1874. *Dahomey as It Is; Being a Narrative of Eight Months Residence in That Country with a Full Account of the Notorious Annual Customs, and the Social and Religious Institutions of the Ffons; Also an Appendix on Ashantee and a Glossary of Dahoman Words and Titles.* London: Chapman and Hall.

Smith, Pierre. 1985. "Aspects de l'esthétique au Rwanda." *L'Homme* 25, no. 4, 7–22.

Snelgrave, Captain William. [1734] 1971. *A New Account to Some Parts of Guinea and the Slave Trade.* London: Frank Cass and Co.

Sontag, Susan. 1977. *On Photography.* New York: Dell Publishing Co.

———. 1967. *Against Interpretation, and Other Essays.* New York: Dell Publishing Co.

Sotheby, Parke, Burnet, Incorporated. 1983. *The Ben Heller Collection Auction,* December 1, 1983. New York, NY.

Southall, Adam W. 1963. *Alur Society: A Study in Processes and Types of Domination.* Cambridge: Heffer and Sons.

Spector, Jack. 1988. "The State of Psychoanalytic Research in Art History." *Art Bulletin* 70(1): 49–76.

Sperber, Dan. 1985. "Anthropology and Psychology: Towards an Epidemiology of Representations." *Man,* n.s. 20: 73–79.

Spiess, C. 1902. "Zaubermittel der Evheer in Togo." *Globus* 81: 314–20.

Spieth, Jakob. 1911. *Die Religion der Eweer in Süd-Togo.* Liepzig: Dieterich'sche.

———. 1906. *Die Ewe—Stämme: Materiel zur kinde des Ewe-Volkes in Deutsch-Togo.* Berlin.

Spitz, Ellen Handler. 1985. *Art and Psyche: A Study in Psychoanalysis and Aesthetics.* New Haven: Yale University Press.

Spivak, Gayatri Chakravorty. 1988a. "Subaltern Studies: Deconstructing Historiography." In *Selected Subaltern Studies,* ed. R. Guha and G. C. Spivak. New York: Oxford University Press.

———. 1988b. "Can the Subaltern Speak?" In *Marxism and the Interpretation of Culture,* ed. Cary Nelson and Lawrence Grossberg. Urbana: University of Illinois Press, pp. 271–313.

———. 1987. *In Other Worlds: Essays in Cultural Politics.* New York: Methuen.

Stafford, Barbara Maria. 1991. *Body Criticism: Imaging the Unseen in Enlightenment Art and Medicine.* Cambridge, MA: MIT Press.

Steinberg, Leo. 1983. *The Sexuality of Christ in Renaissance Art and in Modern Oblivion.* New York: Pantheon Books.

Stéphanidès, Michel. 1922. "La naissance de la chimie." *Scientia* 21: 189–96.

Stewart, Susan. 1984. *On Longing.* Baltimore: Johns Hopkins University Press.

Suleiman, Susan. 1980. "Introduction: Varieties of Audience-Oriented Criticism." In *The Reader in the Text: Essays on Audience and Interpretation,* ed. Susan R. Suleiman and Inge Crosman. Princeton: Princeton University Press, pp. 3–45.

Surgy, Albert de. 1987a. "Examen critique de la notion de fétiche à partir du cas Evhé." In *Fétiches: Objets enchantés, mots réalisés; systèmes de pensée en Afrique Noire,* ed. Albert de Surgy. Cahier 8 (1985). Paris: École Pratique des Hautes Études, pp. 263–303.

———. 1987b. "Presentation." In *Fétiches: Objets enchantés, mots réalisés; systèmes de pensée en Afrique Noire.* ed. Albert de Surgy. Cahier 8 (1985). Paris: École Pratique des Hautes Études, pp. 7–11.

———. [1957] 1981a. *La Géomancie et le culte d'Afa chez les Evhé du littoral.* Paris: Publications Orientalistes de France.

———. 1981b. "Les Puissances du désordre au sein de la personne Evhé." *CNRS: La notion de personne en Afrique Noire. Colloques internationaux,* no. 544.

Szasz, Thomas S. 1970. *The Manufacture of Madness.* New York: Dell.

Tallant, Robert. 1971. *Voodoo in New Orleans.* New York: Collier Books.

Tambiah, S. J. 1976. *World Conqueror and World Renouncer: A Study of Buddhism and Polity in Thailand against a Historical Background.* London: Cambridge University Press.

Taussig, Michael. 1987. *Shamanism, A Study in Colonialism and Terror and the Wild Man.* Chicago: University of Chicago Press.

Tedlock, Barbara, ed. 1987. *Dreaming: Anthropological and Psychological Interpretations.* Cambridge: Cambridge University Press.

Thompson, D'Arcy Wentworth. 1966. *On Growth and Form.* Cambridge: Cambridge University Press.

Thompson, Robert Farris. 1983. *Flash of the Spirit: African and Afro-American Art and Philosophy.* New York: Random House.

———. 1978. "The Grand Detroit N'Kondi." *Bulletin of the Detroit Institute of Arts* 56, no. 4: 207–21.

———. 1973a. "The Sign of the Divine King." *African Arts/Arts d'Afrique* 3, no. 3: 8–17 and 74–79.

———. 1973b. "Yoruba Artistic Criticism." In *The Traditional Artist in African Societies,* ed. Warren d'Azevedo. Bloomington: Indiana University Press, pp. 56–68.

———. 1971. "Aesthetics in Traditional Africa." In *Art and Aesthetics in Primitive Societies,* ed. C. F. Jopling. New York: E. P. Dutton, pp. 374–81.

Tickner, Lisa. 1988. "Feminism, Art History, and Sexual Difference." *Gender* 3.

Todorov, Tzvetan. 1980. "Reading as Construction." In *The Reader in the Text: Essays on Audience and Interpretation,* ed. Susan R. Suleiman and Inge Crosman. Princeton: Princeton University Press, pp. 67–82.

Tolstoy, Leo. [1942] 1960. *What is Art?* Trans. Aylmer Maude. Indianapolis: Hackett Publishing Co. Reprinted in *Aesthetics: A Critical Anthology,* 2nd ed, ed. George Dickie, Richard Sclafani, and Ronald Roblin, pp. 57–63. New York. St. Martin's Press, 1989.

Turner, Victor. 1967. *The Forest of Symbols: Aspects of Ndembu Ritual.* Ithaca, NY: Cornell University Press.

Valeri, V. 1985. *Kingship and Sacrifice: Ritual and Society in Ancient Hawaii.* Chicago: University of Chicago Press.

Vansina, Jan. 1962. *L'évolution du royaume Rwanda des origines à 1900.* Brussels: Académie Royale des Sciences d'Outre-mer.

Varnedoe, Kirk, and Adam Gopnik. 1989. *High and Low: Modern Art, Popular Culture.* New York: Museum of Modern Art.

Veblen. Thorstien. [1899] 1979. *The Theory of the Leisure Class.* New York: Penguin Books.

Verger, Pierre Fatumbi. 1982. *Orisha: Les dieux Yoruba en Afrique et au nouveau monde.* Paris: A. M. Métailié.

———. 1957. *Notes sur le culte des Orisa et Vodun à Bahia, la Baie de tous les Saints, au Brésil et à l'ancienne Côte des Esclaves en Afrique.* Mémoires de l'Institut Français d'Afrique Noire, no. 51.

———. 1954. *Dieux d'Afrique: Culte des Orishas et Vodouns à l'ancienne Côte des Esclaves en Afrique et à Bahia, la Baie de tous les Saints au Brésil.* Paris: Paul Hartmann.

Vlach, John. 1978. *The Afro-American Tradition in Decorative Arts.* Exhibition Catalog. Cleveland, OH: Cleveland Museum of Art.

Vogel, Susan. 1980. "Beauty in the Eyes of the Baule: Aesthetics and Cultural Values." In *Baule Statuary Art: Meaning and Modernization,* ed. P. Ravenhill. Philadelphia: Institute for the Study of Human Issues.

———. 1976. "People of Wood: Bark Figure Sculpture." *Art Journal* (Fall): 23–26.

Vogel, Susan, and Francini N'Diaye. 1985. *African Masterpieces from the Musée de l'Homme.* New York: Center for African Art.

Vygotski, Lev S. [1965] 1974. "Kunst als Katharsis." In *Asthetische Erfahrung und literarisches Lernen,* ed. W. Dehn. Frankfort-am-Main: Athenaeum Fischer Taschenbuch Verlag, pp. 81–89.

Wahlman, Maude Southwell. 1993. *Signs and Symbols: African Images in African-American Quilts.* New York: Studio Books.

Warren, D. M., and J. K. Andrews. 1977. *An Ethnoscientific Approach to Akan Art and Aesthetics.* Working Papers in the Traditional Arts, no. 3. Philadelphia: Institute for the Study of Human Issues.

Waterlot, G. 1926. *Les Bas-Reliefs des Bâtiments royaux d'Abomey (Dahomey).* Paris: Institut d'Ethnologie.

Weber, Max. 1962. *Basic Concepts in Sociology.* Trans. H. P. Secher. Seacaucus, NJ: Citadel Press.

Weinsheimer, Joel C. 1985. *Gadamer's Hermeneutics: A Reading of Truth and Method.* New Haven: Yale University Press.

Weitz, Morris. 1962. "The Role of Theory in Aesthetics." In *Philosophy Looks at the Arts: Contemporary Readings in Aesthetics,* ed. Joseph Margolis. New York: Charles Scribner's Sons, pp. 48–60.

Wellek, René, and Austin Warren. [1942] 1956. *Theory of Literature.* New York: Harcourt, Brace, and World.

White, Geoffrey M., and John Kirkpatrick. 1985. *Person, Self, and Experience: Exploring Pacific Ethnopsychologies.* Berkeley: University of California Press.

White, Hayden. 1978. *Tropics of Discourse: Essays in Cultural Criticism.* Baltimore: Johns Hopkins University Press.

Wieschhoff, H. 1938. "Concepts of Right and Left in African Cultures." *Journal of the American Oriental Society* 58: 202–17.

Wikan, Unni. 1989. "Managing the Heart to Brighten Face and Soul: Emotions in Balinese Morals and Health Care." *American Ethnologist* 16: 294–312.

Wilden, Anthony. 1972. *System and Structure: Essays in Communication and Exchange.* London: Tavistock.

Wilentz, Sean, ed. 1985. *Rites of Power: Symbolism, Ritual, and Politics since the Middle Ages.* Philadelphia: University of Pennsylvania Press.

Willis, Roy. 1981. *A State in the Making.* Bloomington: Indiana University Press.

Wilson, M. Hunter. 1951. *Good Company: A Study of Nyakyusa Age-Villages.* Oxford: Oxford University Press.

Winter, E. H. 1963. "The Enemy Within: Amba Witchcraft and Sociological Theory." In *Witchcraft and Sorcery in East Africa.* ed. J. Middleton and E. H. Winter. New York: Praeger, pp. 277–99.

Winter, I. J. 1981. "Royal Rhetoric and the Development of Historical Narrative in Neo-Assyrian Reliefs." *Studies in Visual Communication* 7: 2–38.

———. 1989. "The Body of the Able Ruler: Towards an Understanding of the Statues of Gudea." In H. Behrens et al., *Dumu-E2-dub-ba-a: Studies in Honor of A. W. Sjöberg.* Philadelphia: University Museum, pp. 573–83.

Wittfogel, K. 1957. *Oriental Despotism: A Comparative Study of Total Power.* New Haven: Yale University Press.

Yamaguchi, M. 1972. "Kingship as a System of Myth: An Essay in Synthesis." *Diogène* 77: 43–70.

Yonker, Dolores M. 1985. "Invitations to the Spirits: the Vodun Flags of Haiti." *A Report from the San Francisco Crafts and Folk Art Museum.* Spring.

Zach, Natan. 1987. "Technique." In *A Dictionary of Modern Critical Terms,* ed. Roger Fowler. London: Routledge and Kegan Paul, p. 245.

Zempléni, Andras, and Jacqueline Rabain. 1965. "L'enfant *nitku bon:* Un tableau psychopathologique traditionnel chez les Iwolof et les Lébou de Sénégal." *Psychopathologie Africaine* 1, no. 3: 329–441.

Index

THE SOUTH PARK
EPISODE GUIDE

VOLUME 2 SEASONS 6 - 10

9 8 7 6 5 4 3 2 1
Digit on the right indicates the number of this printing

Library of Congress Control Number: 2009938625
ISBN 978-0-7624-3823-5

Creative Direction and Design by Christopher "Crispy" Brion
Art Direction by Brandon Levin
Licensing Artists: Erick Thorpe, Jeff Delgado
Layouts by Matthew Goodman
Edited by Greg Jones
Special Thanks to Anne Garefino
Typography: South Park and Arial

Running Press Book Publishers
2300 Chestnut Street
Philadelphia, PA 19103-4371

Visit us on the web!
www.runningpress.com
Visit South Park on the Web at
www.southparkstudios.com

THE SOUTH PARK
EPISODE GUIDE
Volume Two: Seasons 6-10

Text by Sam Stall & James Siciliano
Created by Matt Stone and Trey Parker

TOM'S RHINOPLASTY

Post Office

Running Press
PHILADELPHIA • LONDON

INTRODUCTION

Welcome to *The South Park Episode Guide: Volume 2*—the most anticipated sequel since Terrance and Phillip's *Asses of Fire 2*.

Packed within these pages is the most complete and comprehensive guide ever written to Seasons 6 through 10 of *South Park*. Every episode has been carefully cataloged and every word gloriously uncensored—starting with 2002's season premiere, "Jared Has Aides," all the way through to Season 10's gripping finale, "Stanley's Cup."

You'll not only enjoy learning about the inspiration behind your favorite shows, but this volume contains never-before-seen storyboards and exclusive show art. You'll get plot recaps, death counts and memorable quotes piled on top of pop culture nods and epic celebrity pwnage.

Want to know what was so special about Season 9's "Best Friends Forever," the episode that won *South Park* its first Emmy!? Or, better yet, learn what Matt and Trey think of the Crab People and how the creators decided who deserved to be called the Biggest Douche in the Universe.

And the fun doesn't stop there. Lemmiwinks, ManBearPig, Christmas Critters—there's enough behind-the-scenes secrets in here to give even the most novice *South Park* fan a raging clue. Kenny appears hoodless, Garrison debuts his new vagina and *South Park* wins a second Emmy for Season 10's "Make Love, Not Warcraft." It's not all just taco-flavored kisses, my friend.

I'm super, duper cereal.

—James Siciliano

SEASON

6

Kids skis and feet 603

E603: Asspen

Scene 100	Panel	BG

E603: Asspen

Scene 103	Panel	BG

Location/Time

Dialogue

Scene 108	Panel	BG

Location/Time

Dialogue

instructor enters from frame left.

Action/Efx

A Surfer type ski instru...
...ing a bright red ski...
...nd back.

BUTTERS
Do you guys smell that? It smells
...d out here too. I'm startin' to
...whole town smells like

Cartman Skis E603

E603 PAGE 75
102 Panel BG
BG Action →
No poles.

EXT. BUNNY HILL - DAY

...towards the bottom, near the lodge.
...ced by a small chair lift. Several
...d skiers are slowly trying to learn
...hill.

...tters and Ike are standing in a line
...hill wearing skis.

...they always do, but Cartman is
...super sweet ski gear. A whole new
...oves, a new hat - he has everything.

...with his arms sticking straight

...and ear muffs on (so we can still

...brown, His...mustache type smudge
...an earlier...e, Cartman gave
...er' in his...)

E603 PAGE 70
104 cont BG

Location/Time
Dialogue
Skier skis into
frame and ends
up back view.
Action/E...

...n his early twenties skis up,
...it with 'Ski Instructor' printed
...so has a whistle.

...Soray snow yet.

JARED HAS AIDES

Original Air Date: March 6, 2002
Episode 602

THE STORY: Subway restaurants spokesperson (and local celebrity) Jared Fogle stops by South Park to give a speech about weight loss. Soon after, the boys learn that his rapid slimming down was accomplished not just by eating Subway sandwiches, but also because he has "aides"—specifically, a dietitian and personal trainer.

The boys see potential in this "spokesperson" gig, and embark on making Butters the new spokesperson for City Wok. Butters binges on the Chinese food until he's nice and plump—however, when it comes time for him to drop the weight, Fat Butters can't seem to lose it. So Cartman, Stan, Kyle and Kenny "help" by performing amateur liposuction surgery on him.

Meanwhile, Jared decides to tell the world that "aides" are responsible for his weight loss. Except when he says "aides," everyone thinks he means AIDS. He goes on to tell the townspeople that they should all get aides, and announces that he's starting an "Aides for Everyone" foundation.

In short order, he's captured by an angry mob and brought to the town square to be lynched. This ruins the boys' City Wok deal, because now everyone hates Jared. Just before Jared's execution, Butters, Stan, and Kyle finally explain to the mob that it's all a big misunderstanding. The owner of City Wok renews his offer to use Butters as his spokesperson, but the boys refuse when they learn he can pay only "fifteen dowlar."

MEMORABLE LINES:

"How many times have we told you not to have self-performed liposuction surgery in our house?"
—Butters' mom

"I can't lose weight, Butters, 'cause I'm not fat. I'm big-boned. You can't slim down bones, stupid!"
—Cartman

"It's only in America that somebody can become famous just because they go from being a big fat ass to not being a big fat ass."
—Stan

"Dammit Butters! Keep eating or I'll kick you 'til you're deader than Kenny!"
—Cartman

"If you want him to get really fat as fast as possible, one of you will have to marry him."
—Chef

"You guys. . .I think I'm having a genius moment."
—Cartman

"You wouldn't be a penis butt, Butters. You'd be FAMOUS."
—Stan

"You guys have already gotten me in Dutch for getting fat, then I got in double Dutch for having liposuction, and now you're asking me to be in TRIPLE Dutch?! Huh-uh, I'll never be that Dutch."
—Butters

BODY COUNT

None, although Jared comes precariously close to being lynched by an angry mob in the South Park gallows.

WHERE DID THE IDEA COME FROM?

At the time, you couldn't watch TV for more than half an hour without catching one of Subway's "Jared" spots. Trey and Matt actually thought the idea was brilliant—lose weight eating a chain restaurant's food, then sell yourself to them as a spokesperson.

POINTLESS OBSERVATIONS

This episode features Cartman's infamous impersonation of Butters. He sounds so much like him it even fools Butters' parents, which winds up being really unfortunate for the real Butters.

We also get a glimpse into Butters' parents' work lives. We learn that Butters' mom works at a telemarketing office and his dad works at an insurance company.

The joke of "aides" being misunderstood as "AIDS" is used so repeatedly that Matt and Trey actually put in a scene where Jared is beating a dead horse.

CHARACTER DEBUTS

The owner of City Wok, Tuong Lu Kim, who thanks to his poor mastery of English refers to his establishment as "Shitty Wok." Years earlier, while Matt and Trey were putting together the movie *Orgazmo*, they amused themselves by calling a real City Wok, which the guy who answered the phone referred to as "Shitty Wok."

POP CULTURE REFERENCES

The scene in which Jared walks dejectedly down the street after being fired from his Subway gig is a parody of a similar scene in the movie *Philadelphia*—right down to the Bruce Springsteen-esque "Streets of Philadelphia" song playing in the background.

Cartman references the *Three's Company* star when he yells at Butters, "Who do you think I'm talking about Butters, Joyce Dewitt?!"

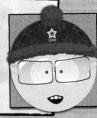

WHAT-THE-FUCK MOMENT

When Butters starts puking from eating too much, Cartman tells him to eat his own vomit because "Japanese girls do it." Butters, apparently satisfied with this answer, eats his own spew.

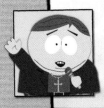

ORIGINAL SONGS

Jared gets his own little "Still Lookin' Good" theme song which plays throughout the episode. The townspeople also make their own personalized variations of this song.

CELEBRITIES IMPUGNED

Jared Fogle, the guy who lost a bunch of weight eating Subway sandwiches.

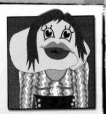

WHAT KYLE LEARNED

"It would have been wrong to exploit Butters' weight loss. Because then lots of fat people would have believed it and then gone and eaten a ton of Chinese food instead of dieting properly. They'd still be fat and we'd be responsible for their shattered dreams."

ASSPEN

Original Air Date: March 13, 2002
Episode 603

THE STORY: The boys visit Aspen with their families for a "free ski vacation." The only catch is that the parents have to sit through a 30-minute sales pitch for timeshares. Not a bad deal in theory. But the pitch goes on and on and on. Even when the parents try to forcefully leave, they keep finding themselves lured back into the pitch.

Meanwhile, the boys are on the slopes taking their first ski lesson. Stan is approached by an obnoxious professional skier named Tad, who challenges Stan to a ski race. Tad easily wins, but won't let the matter drop. In a nod to 80s movies where some average guy is challenged by some jerk who is great at something, Tad pressures Stan for a rematch—which Stan accepts, on one condition: if Stan wins, Tad's father won't close the local youth center.

Again, as in those 80s movies, where Average Guy trains like crazy and beats the jerk, Stan gets a ski coach, and with the help of a rock music montage, he manages to become a good skier in time for the race. Stan wins the race, but only because a teen girl who befriends him flashes her breasts at Tad, causing him to freeze in place helplessly.

Even after winning, the boys are sick of Aspen and skiing. Suddenly their parents turn up and tell them they've bought a timeshare, and that they'll have to visit the town for two weeks every year until the end of time.

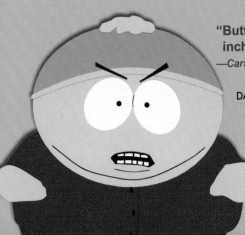

MEMORABLE LINES:

"Butters, I hate you with every inch of my body."
—*Cartman*

"Stan Marsh? Stan DARSH is more like it!"
—*Tad*

"I'm starting to think this whole town smells like doo-doo."
—*Butters*

"Oh Darsh, you're even dumber than I thought."
—*Tad*

"Well, our son is a perfect void filler."
—*Butters' dad*

"You ski out of your league, you're gonna have a bad time."
—*Thumper*

"This time, you're not just gonna lose, you're gonna die."
—*Tad*

WHERE DID THE IDEA COME FROM?

Matt was familiar with timesharing because his parents took advantage of "free" vacation weekends in exchange for listening to a sales pitch. Unlike the *South Park* folks, however, they never bought anything.

CHARACTER DEBUTS

Phil and Josh, the two Timeshare Salesmen who will not quit with their sales pitch. We also meet Thumper, the boys' ski instructor, and Tad, a rich, obnoxious skier who challenges Stan every chance he gets.

ORIGINAL SONGS

Tad performs his squeaky, electric guitar rendition of "Stan Darsh" at the Rec Center. Also, the 80s synth-powered anthem "Montage" plays over the montage of Stan getting better at skiing.

POINTLESS OBSERVATIONS

When Butters falls asleep, Cartman gives him a "Hitler" by sticking a finger up his own butt, then using the results to draw a Hitler moustache on Butters' upper lip. He also does the old "warm water trick," where he puts Butters' hand in warm water while he's sleeping, and then pees on him.

Butters is wearing a Chinpoko Mon t-shirt that says "Gotta Catch 'em." This is a reference to the Season 3 episode "Chinpoko Mon" which parodied the *Pokemon* craze. He can be seen wearing it again in "Fun with Veal" (page 18).

While discussing the treacherous K-13 Mountain, the Old Gas Station Worker (originally introduced in "Butters' Very Own Episode") makes another appearance. As usual, he's sharing the spooky, haunted folklore of the area.

WHAT-THE-FUCK MOMENT

Stan's skiing nemesis is defeated when the teen girl who befriends Stan flashes him, freezing him in his tracks. At the end of the episode, we see why this was so effective: instead of breasts, she has two hideous monsters on her chest—monsters based on the mutants from the film *Total Recall*.

POP CULTURE REFERENCES

Stan's battle with the obnoxious skier is an homage to the many campy movies of the 80s which pitted the "normal" guy against the "talented jerk." More specifically, however, this episode parodies the John Cusack movie *Better Off Dead*.

The "Montage" song (which helps Stan learn to ski quickly) was revamped and used in the movie *Team America: World Police*.

The chic shops that line the streets of Aspen—Prahda, Kucci, Tiffany's Aspen, Bernie's—are all parodies of famous upscale shops (Prada, Gucci, Tiffany & Co., and Barneys New York).

An instrumental version of the 80s classic "Take on Me" by A-Ha plays over the "South Park in Aspen" opening montage. It also plays over the closing credits, with a musical accompaniment by Mr. Slave (who is yet to be introduced).

WHAT STAN LEARNED

"Skiing sucks!"

15

FREAK STRIKE

Original Air Date: March 20, 2002
Episode 601

THE STORY: After seeing an episode of *The Maury Povich Show* that exploits disfigured freaks for prizes, the boys scheme to get on the show and win a prize. They choose Butters to be the "freak" and create the disease "Chinballitis" for him (a disease in which you have balls on your chin). With the help of the *Star Trek* geeks down the street, they manage to glue fake balls to his chin and get him on the show.

When Maury awards Butters a free trip to the world's largest miniature golf course, Cartman gets pissed. He decides to get a piece of the action by appearing (with his mom) on an episode about "out-of-control kids."

During the taping, the Freak Union, made up of people who make a living by exploiting their disabilities on TV, pickets outside the studio for better pay. They recruit Butters (whom they only know by his fake name, Napoleon Bonaparte) to join them. He does—but only because he's terrified that the freaks will realize he's faking and kill him.

The picketing interrupts the *Maury Povich* broadcast, which causes the audience watching Cartman to get up and leave. Povich, defeated, agrees to negotiate with the freaks. Furious that he won't get a prize for being an out-of-control kid, Cartman finds Butters and rips off his fake testicles in front of his newfound "friends." Still thinking the testicles were real, the freaks attack Cartman and chase him down the street.

MEMORABLE LINES:

"When I'm walking, they'll say 'Hey, there goes Chinballs!'"
—*Butters*

"What-ever! I do what I want!"
—*Cartman*

"When we look at you, we don't even see the testicles on your chin. We see the testicles in your heart."
—*Man with Terrible Skin Condition*

"Now, now, now—I'm not telling you people that your union doesn't matter, I'm just telling you that you're not really people."
—*Cop*

"Can you tell the audience how miserable your life is?"
—*Maury*

"But fellas, if I go on *Maury Povich* with balls on my chin, my parents are gonna be really mad!"
—*Butters*

"God, I wish Kenny was still alive. He'd put balls on his chin. He was such an awesome friend."
—*Cartman*

"Oh Jesus, see me through this."
—*Butters*

"I do crack and potpourri and gweezies."
—*Cartman*

BODY COUNT

Lobster Boy, a "fake" freak who turned out to be a real lobster. When the other "performers" on the talk show circuit found out, they killed him by dumping him in a vat of boiling water.

CHARACTER DEBUTS

We meet a whole bunch of freaks: Man With Foot on Head, Girl With Rapid Aging Disease, Disfigured Country Singer, and Man With No Face.

ORIGINAL SONGS

Butters and his union of freaks all get together to perform "Look for the True Freak Label."

WHERE DID THE IDEA COME FROM?

Matt and Trey invented the concept during a period when *The Maury Povich Show* ran an endless assortment of "inspirational" stories about hideously disfigured people. Of course it was really just an excuse to stare at them.

POINTLESS OBSERVATIONS

The geeks who fit Butters with chin-balls are the same guys who turned Timmy's wheelchair into a time machine in "Fourth Grade." Also, the ass-faced couple from "How to Eat with Your Butt" and Nurse Gollum from "Conjoined Fetus Lady" make brief cameos.

This is the first real episode where Butters takes over as the replacement friend for Kenny, who was killed off for good in "Kenny Dies." The boys even call Butters "Kenny" and make him wear Kenny's orange jacket.

CELEBRITIES IMPUGNED

Maury Povich, who's portrayed as a parasite living off the pain and suffering of others. Also, Liza Minnelli. She's portrayed as a member of the freak union, right alongside Woman with Crablike Body, Incredibly Obese Black Person, and Man with Brains Outside of Head.

POP CULTURE REFERENCES

A plea by the hideously deformed talk show guests for viewers to "look for the True Freak label" is a parody of the 1970s "look for the union label" TV commercials. Matt and Trey have seen the ad repeatedly because it's "immortalized" on their bootleg tape of the *Star Wars Christmas Special*.

As payment for putting fake balls on Butters' chin, Kyle gives the *Star Trek* nerds the original AVID cut of *Star Wars: Episode 1*. "AVID" is video editing software often used to cut feature films. Kyle goes on to say, "Why the hell would they want that anyway? *Episode One* sucked balls."

Also, one of the "out of control" things Cartman says he did was to "digitally put Jabba the Hutt back into the original *Star Wars* movie." This is not the first time Hutt has been mentioned in an episode.

In addition to *The Maury Povich Show*, the freaks mention a number of other daytime talk shows as part of their "circuit": *Jenny Jones, Oprah,* and *Sally Jesse*.

WHAT THE ELEPHANT MAN LEARNED

"A lot of decent hard-working freaks in America are losing their talk show jobs to freaks of a different nature. Sure, everyone in this great country of ours is a freak. But true physically deformed freaks must be recognized. For it's these real freaks that make you all feel better about yourselves for not being one. So next time you're watching television, make sure it's a show with "freak" freaks, and not just with people that are freaks because they're stupid trailer trash from the South. That's what we mean when we say, 'Look for the True Freak label.'"

17

FUN WITH VEAL

Original Air Date: March 27, 2002
Episode 605

THE STORY: During a field trip to a cattle ranch, Stan is horrified to learn that veal is made from baby cows. In an effort to stop this cruelty, the boys kidnap all the calves and lock themselves in Stan's bedroom with them. Soon they're accused of being terrorists and the house is surrounded by police.

To solidify his stance against killing baby animals, Stan becomes a vegetarian. Immediately, he gets sores all over his body. Cartman negotiates with the cops and manages to get, among many other things, a cattle truck driven by *Star Trek: The Next Generation's* Michael Dorn to take them to Denver International Airport, where a plane will fly them to Mexico.

They don't make it very far; the police apprehend them in front of the veal ranch. Stan, deathly ill, is rushed to the hospital where he's diagnosed with "vaginitis." When he stopped eating meat, his body broke out in small vaginas. The doctor states that if he refrained from eating meat much longer, he would have turned into "one great big giant pussy."

An IV of pure beef blood restores him. The calves are returned to the ranch, where they are allowed to grow up and live with the other cattle. It seems that Cartman, during his negotiations, got the FDA to change the world "veal" on restaurant menus to "little tortured baby cows," which put a pretty big damper on the veal market.

MEMORABLE LINES:

"We could kill Butters, and then float the calves on a river of blood."
—*Cartman*

"Butters, I'm going to kill you over and over again."
—*Cartman*

"This is going to be like Vietnam, huh fellas? Whoopie!"
—*Butters*

"If we don't do something soon there could be fifty, even sixty, people who have to go without veal for dinner. Are you prepared to let that happen?"
—*FBI Leader*

"Stan, you're behaving like a kid!"
—*Stan's dad*

"Oooh, Stan's in trouble. Let me kick his ass, mom."
—*Shelly*

"Oh Mike, you're breakin' my balls here, Mike."
—*Cartman*

"What did I tell you Stan? We save some baby cows from being eaten and now we're no-good dirty God damn hippies!"
—*Cartman*

"One for all and all for one, except Cartman!"
—*Stan*

"If you don't eat meat at all, you become a pussy."
—*Cartman*

WHERE DID THE IDEA COME FROM?

Trey and Matt are both confirmed carnivores, but veal is pretty much where they draw the line. "I don't eat babies," says Trey.

POINTLESS OBSERVATIONS

Live TV coverage of the cow hostage crisis proves so uninteresting that the network switches away to a show called *Puppies from Around the World*. The show will be seen again during "The New Terrance and Phillip Movie Trailer" (page 20).

The two Hippie Dudes from "Ike's Wee Wee" and "Roger Ebert Should Lay Off The Fatty Foods" can be seen protesting with the group of hippies outside of Stan's house.

Cartman uses his "You're breakin' my balls" technique to negotiate with the police in this episode. He mastered that negotiation technique while selling baby fetuses in "Kenny Dies."

CHARACTER DEBUTS

Rancher Bob, the farmer who owns the cattle farm. Also, the group of bearded, dirty Hippies make their debut. These hippies can be seen again in "Douche and Turd" (page 98) as well as "Die Hippie, Die" (page 118).

POP CULTURE REFERENCES

The kids break into the veal pen with the help of Cartman's "*Mission Impossible* Breaking and Entering Playset." Also, Butters attempts to make the calves stronger by using the "Suzanne Somers' Calf Exerciser."

Stan's dad says during a news interview, "We gave those kids everything and they've turned into little John Walkers." This is referencing John Walker Lindh, an American citizen who betrayed his country by becoming a Taliban leader. He was captured in the 2001 invasion of Afghanistan.

ORIGINAL SONGS

A snippet of the hippie, grassroots song "Help the Helpless" plays while the hippies are protesting outside of Stan's house.

CELEBRITIES IMPUGNED

Michael Dorn, a.k.a. Worf from *Star Trek: The Next Generation*, is recruited to drive the boys' getaway truck. He even wears a "Pasadena City College" shirt (where Dorn went to college) over his Klingon makeup. Cartman insists that Worf call him "Captain" for the rest of the episode.

WHAT STAN LEARNED

"It's wrong to eat veal because the animals are so horribly mistreated. But if you don't eat meat at all, you break out in vaginas."

19

THE NEW TERRANCE AND PHILLIP MOVIE TRAILER

Original Air Date: April 3, 2002
Episode 604

THE STORY: The boys are dying to see the premiere of the trailer for the new Terrance and Phillip movie, *Asses of Fire 2*, which is to be broadcast sometime during the commercial break of *Fightin' Round the World* with Russell Crowe. The boys will only endure watching the show—which features actor Russell Crowe visiting foreign lands and beating people up—to see the commercial.

The problem is, they can't seem to find a place to watch it. Shelly wants to watch *Buffy the Vampire Slayer* at Stan's house. At Kyle's house, they aren't allowed to interrupt Ike's viewing of *The MacNeil/Lehrer Report*. They try to watch it on Chef's new plasma TV, but the TV mistakenly gets switched to "human eradication mode," grows legs and rampages through town.

The boys then try (and fail) to watch it at a bar, a retirement home, and at Cartman's house (which is being fumigated). As a last resort, they sit down with a few crack addicts watching television outdoors, but the party is soon broken up when Chef's murderous plasma screen attacks.

Finally they go to Butters' house, which they learn has been empty and available all evening. They arrive just in time to see the T&P trailer, which shows practically nothing of the film. The kids love it.

MEMORABLE LINES:

"Chips, pop, cookies, Kleenex, toilet paper, flares—we won't have to leave the TV room for anything!"
—Stan

"God, I hate old people!"
—Cartman

"Oh God! Leave no doughnut behind!"
—Cartman

"Don't interrupt me, ya vagina!"
—Russell Crowe

"You ain't midgets, your lips are too full."
—Bartender

"I'm not a fat turd. I'm a stocky turd!"
—Cartman

"Dude, thank God for stupid people."
—Kyle

"Why don't you choke on some pig vomit, you stupid sops!"
—Russell Crowe

BODY COUNT

Russell Crowe fights, maims, and kills countless people in various countries around the world. Tugger, Russell Crowe's joyful boat companion, attempts to take his own life when Crowe starts performing an original song. Thankfully, Tugger survives the injury.

WHERE DID THE IDEA COME FROM?

At the time, Russell Crowe seemed to be constantly getting into fights.

CHARACTER DEBUTS

Tugger, Russell Crowe's anthropomorphic tugboat.

The Shady Acres Nursing Home Residents make their debut. These old, loose-boweled men and women can be seen again in "Grey Dawn" (page 68).

Also, Tom the Editor, who has the recognizable "Hey" on his shirt. He takes a beating from Crowe in this episode, and will make a very brief appearance at the end of "A Ladder to Heaven" (page 34).

POINTLESS OBSERVATIONS

While changing channels, the boys very briefly land on *Puppies From Around the World*, a program that is more fully explored in "Fun with Veal" (page 18). Also, this episode is offered in "real time." That is, everything that takes place in the show's 30-minute time frame does so within the mythical 30-minute limit of *Fightin' Round the World*. Even the program's commercial breaks coincide with the real *South Park* breaks.

In Chef's living room, there's a picture of him and Kathie Lee Gifford. The two got to know each other very well in "Weight Gain 4000."

The Toy Store has a Chinpoko Mon toy displayed in its front window.

POP CULTURE REFERENCES

Shelly's tampon incident is a parody of a scene from *The Shining*, in which blood pours out of an elevator. There is also a parody of *The MacNeil/Lehrer NewsHour*, a real TV news program of the same name, which Ike watches every night from 10-11 p.m.

Fightin' Round the World mimics documentary-style nature shows such as *The Crocodile Hunter* and *Man vs. Wild*. This type of show was also parodied in the Season 2 episode "Prehistoric Ice Man."

Chef's murderous TV-robot looks a lot like the ED-209 law enforcement robot from the movie *Robocop*. This was also parodied in "Korn's Groovy Pirate Ghost Mystery."

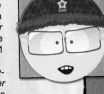

WHAT-THE-FUCK MOMENT

Early in the show, Butters is sent to buy tampons for Stan's sister Shelly. But he forgets to give them to her. When they turn up at Stan's house later and open the front door, they're swept away by a tidal wave of blood.

CELEBRITIES IMPUGNED

The entire episode is an extended rip on Crowe.

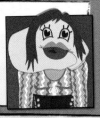

ORIGINAL SONGS

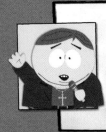

Russell Crowe's theme song "Fightin' Round the World" plays throughout this episode. Crowe also performs an original acoustic song "Gotta Get There Somehow," which doesn't go over so well with Tugger.

WHAT KYLE LEARNED

"TV shows are gay!"

PROFESSOR CHAOS

Original Air Date: April 10, 2002
Episode 606

THE STORY: When Stan, Kyle, and Cartman fire Butters as their friend, he snaps and decides to become the greatest super villain the world has ever seen—Professor Chaos. However his evil deeds—switching soup orders at Bennigan's, stealing Ms. Choksondik's chalkboard erasers—don't exactly inspire terror in the hearts of South Park's citizens. Nevertheless, he does acquire a sidekick—a first-grader named Dougie who becomes General Disarray.

At the same time, the boys hold auditions to find Butters' replacement. After putting the applicants through swimsuit and talent competitions, they take them to a ballpark to watch a game. Professor Chaos manages to seize control of the stadium's Jumbotron and promises to flood the entire town. Instead of panicking, the people in the stadium take off their clothes and party.

Chaos carries through with his "plan" to flood the town by turning on the hose in his backyard. It doesn't work, and after a water company crew turns off his water, he's forced to re-think his anarchy.

Professor Chaos decides instead to destroy the ozone layer by emptying one can of aerosol spray after another into the sky. This doesn't work either. The boys, unaware of the ongoing threat to the planet they have spawned, pick Tweek as their new friend.

MEMORABLE LINES:

"What if we don't want to be your friend?"
—Clyde

"If you receive a rose, please stay. If you don't, get the fudge out."
—Cartman

"I think I deserve to take Butters' place the most, because I've been hanging around these guys for like five years and I never get to say or do anything."
—Dog Poo

"Ah, the look on their faces when they got the wrong soup. I love bringing chaos!"
—Professor Chaos

"You don't drink tea at a baseball game you French piece of crap!"
—Cartman

"Wash your hands after you touch those hamsters, you'll get AIDS."
—Butters' mom

"You brought this upon yourselves! You made the outcasts of the world! Now watch! Watch as your precious planet drowns!"
—Professor Chaos

"Where I go, destruction will follow!"
—Professor Chaos

"I believe I said get the futch out which means kiss my futchin' ass, go futch yourself, futch ya, get the futch out, Clyde."
—Cartman

BODY COUNT

Ms. Choksondik. During the show's last moments, she is shown being taken away on a gurney. However, we don't see how she dies until the next episode, "The Simpsons Already Did It" (page 24).

BEHIND THE SCENES

Some thought was given to turning the episode into a cliffhanger by refusing to name Butters' replacement until the next batch of shows. Then they just decided to spill the beans and reveal that it was Tweek.

WHERE DID THE IDEA COME FROM?

Trey and Matt thought it would be funny if the boys fired Butters as their friend, then replaced him with an ever-changing assortment of characters. They also liked the idea of Butters turning to his dark side—which turned out to be not that dark.

POINTLESS OBSERVATIONS

The original group of candidates to replace Kenny includes: Wendy, Token, Craig, Clyde, Ike, Bebe, Jason, Dougie, Fosse and Bill, Quake, Filmore, the Home-Schooled Kid (Mark), Towelie, Jimmy, Timmy, Tweek, Pip, Loogie (from "The Tooth Fairy Tats 2000") and Damien, the son of Satan.

The newspaper that Butters flips through has the headline: "Afghanistan! Tajikastan! Pakistan! . . .damn those 'Stans'!"

Butters' "Minions of Chaos" (hamsters with glued-on tin foil suits) will make another appearance in "The Coon."

CHARACTER DEBUTS

Professor Chaos, Butters' evil alter ego, and his sidekick, General Disarray—formerly a first-grader named Dougie, first seen in "Two Guys Naked in a Hot Tub." Also, an unkempt background character finally speaks. He reveals that his name is Dog Poo.

POP CULTURE REFERENCES

During the talent competition segment of the contest to replace Kenny, Towelie tries (and fails miserably) to play Led Zeppelin's "Stairway to Heaven."

The boys' competition to find a new best friend—complete with direct-to-camera interviews and elimination challenges—mimics popular reality TV shows such as *The Bachelor*, *The Real World* and *Survivor*.

Butters has a poster for "GI Bill" on the door of his room. This is a parody of the popular kids toy GI Joe.

WHAT BUTTERS/ PROFESSOR CHAOS LEARNED

"I am an outcast. A shadow of a man who can find no companionship. No love from others. Fine! If I am to be an outcast, so be it! I'm through doing what others tell me to do, and I am sick of this world and the stinky people in it! From now on I will dedicate my life to bringing chaos to the world that has dejected me! I will become the greatest super villain the world has ever seen! Where I go, destruction will follow!"

THE SIMPSONS ALREADY DID IT

Original Air Date: June 26, 2002
Episode 607

THE STORY: Cartman sends away for "Sea People," tiny creatures that will supposedly form a mini-society in his fish tank. When he gets them, however, they're just brine shrimp. Disappointed, the boys make the best of a bad situation by putting some of them in Ms. Choksondik's coffee.

She immediately dies. A news report claims that semen (which the boys interpret as "Sea Men") was found in her stomach. Now the boys have to take action to cover their tracks. They visit the morgue, steal the semen sample from Choksondik's stomach, and then put it back in Cartman's Sea People aquarium. Overnight, the semen sample combines with the remaining Sea People to turn into. . .*real* Sea People. A miniature advanced civilization.

Meanwhile, Butters (in his Professor Chaos

persona) is slowly going mad. Every single idea for world destruction he invents has already been done on *The Simpsons*. Eventually he snaps and starts seeing *Simpsons*-esque characters everywhere. When he sees Cartman's Sea People society, he realizes that *The Simpsons* did the very same thing. However, the other kids say it doesn't matter, because *The Simpsons* have been on forever and done pretty much everything.

Seeing their reasoning and feeling better, Butters decides to go back to plotting the world's demise. At the same moment, the Sea People start a religious war—half worshipping Cartman as a god and the other half worshipping Tweek. They launch missile attacks against each other, shatter their aquarium, and die on Cartman's bedroom floor.

MEMORABLE LINES:

"Only three more hours, Sea People. Only three hours and you can take me away from this crappy God damn planet full of hippies."
—*Cartman*

"Be ye not jealous, Jew. I am creator of all things, yea."
—*Cartman*

"Ha ha! Time to wreak havoc on the world that shunned me!"
—*Butters*

"God dammit, how come every time I think of something clever, *The Simpsons* already did it?"
—*Butters/Professor Chaos*

EVIL PLOT #4-B

"I am god of the Sea People! You hear that? I am god of the Sea People! I am master of their great sunken empire! Mom, I'm god of the Sea People!"
—*Cartman*

"We killed our teacher, and they found our sea men in her stomach."
—*Stan*

BODY COUNT

Ms. Choksondik. She was revealed to be dead in the last episode. In this one we find out that she died with Mr. Mackey's semen in her stomach, though that's not what killed her. The two were last seen being intimate in Season 5's "Proper Condom Use."

CELEBRITIES IMPUGNED

Hillary Clinton. A brief TV news segment states that her "...ass just keeps getting bigger."

WHAT-THE-FUCK MOMENT

In order to avoid being discovered at the morgue, Cartman burrows inside Ms. Choksondik's corpse.

ORIGINAL SONGS

Cartman's joyful ode to his aquatic friends rings out in "Sea People and Me." Chef attempts to sing the boys a song about killing your teacher, but can't make it through.

WHERE DID THE IDEA COME FROM?

The episode references the fact that, too many times to count, the *South Park* crew has come up with ideas for episodes, only to realize *The Simpsons* already did it. *The Simpsons* would return the favor in "The Bart of War" (first aired May 18, 2003), in which Bart and Milhouse turn violent after watching *South Park*.

POINTLESS OBSERVATIONS

When Tweek seems terrified that a snowman the boys are building will come to life and attack him if he puts a carrot in it, Stan says, "Tweek, when has that ever happened, except for that one time?" It's a reference to "Jesus vs. Frosty," a pre-*South Park* short done by Parker and Stone in which a snowman is brought to life, Frosty-style. Except this particular snowman is a homicidal maniac.

This is the first time we see Dougie's house.

The Sea People go through three advanced civilizations: tiny Anasazi dwellings, ancient Egyptian pyramids, and an ancient Greek empire.

Cartman has a complex, mathematical epiphany with his "Final Theory of Composite Dynamics": Sea People + Sea Men = SeaCiety.

POP CULTURE REFERENCES

The idea of a miniature society that treats its human bene-factor as a god is pretty old. It served as the premise for a *Twilight Zone* episode, which served as the inspiration for *The Simpsons*, which served as the inspiration for *South Park*. Ironically, an episode of *Futurama* (created by the same people who do *The Simpsons*) also uses the con-cept—including an ending in which two different religious sects nuke each other.

When Butters starts hallucinating, he sees Dougie as Bart from *The Simpsons*. Bart can also be seen in "Cartoon Wars Part II" (page 154).

While watching Terrance and Phillip, we hear Terrance say that he "may have accidentally killed Celine Dion." We learned in "Not Without My Anus" that she is the mother of Terrance's love child.

The code word the boys use while breaking into the Coroner's Office is "Hammer Time." It comes from the rap hit "Can't Touch This" by MC Hammer, which Tweek has to hum to himself to remember the words.

WHAT KYLE LEARNED

"I guess this proves that war is the natural order of life."

RED HOT CATHOLIC LOVE

Original Air Date: July 3, 2002
Episode 608

THE STORY: South Park's parents, disgusted by charges that Catholic priests molest children, decide to become atheists. Cartman, who can't understand why a counselor asked him if Father Maxi ever put anything up his butt, theorizes that you can put food in your ass and crap out your mouth. Kyle bets Cartman $20 that he can't. To everyone's amazement, he does. Soon everyone starts doing it.

Horrified at what seems to be a widespread problem of priests molesting children, Father Maxi goes to the Vatican for help. There he discovers that pretty much every priest, everywhere, does it. When Maxi protests, he's told that nowhere in the Holy Document of Vatican Law is this considered wrong—and that the law can't be changed because no one can find the original document.

After a treacherous journey, Father Maxi retrieves the Holy Document of Vatican Law from the catacombs beneath St. Peter's Basilica and demands it

be altered to prohibit sex with young boys. The Pope then summons a "higher authority" to weigh in—a 20-foot-tall Queen Spider who says the law can't be changed. Disgusted, Father Maxi tears the old parchment in two, causing the basilica to crumble.

When the Cardinals accuse him of ruining the religion, Maxi says that people have forgotten what being a Catholic is all about. They are losing faith because they don't see how the religion applies to them. If people don't have a mythology to live by, they just start "spewing a bunch of crap out of their mouths."

Back in South Park, the adults (who thanks to Cartman have been literally spewing crap out of their mouths) hear Maxi on TV, decide to give up on atheism, forget all the outdated mumbo jumbo that has been made in Rome over the years, and live as Catholics in today's world.

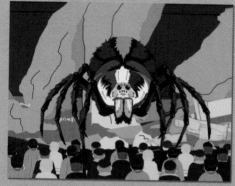

MEMORABLE LINES:

"Now, the key to shoving a turkey up your ass is first wrapping it in string, keeping the pointy wings neatly at the side."
—*Martha Stewart*

"Let's all be atheists!"
—*Butters' mom*

"Alright, now keep with me here, it gets a little complicated: If you eat food and crap out your butt, then maybe if you stuck food in your butt, you could crap out your MOUTH."
—*Cartman*

"So you crapped out of your mouth! Good for you! It's still stupid and immature!"
—*Kyle*

"YES! I DID IT!! I CRAPPED OUT MY MOUTH!!!"
—*Cartman*

"Chef! What would a priest want to stick up my butt?"
—*Stan*

"The Gelgamek vagina is three feet wide and filled with razor sharp teeth! Do you really expect us to have sex with them?!"
—*Gelgamek Cardinal*

"Cartman, that's the dumbest thing you've ever said! This week."
—*Kyle*

"Oh Randy, I don't want to put food up my butt anymore."
—*Stan's mom*

BEHIND THE SCENES

The idea of having Father Maxi descend into the bowels of the Vatican to retrieve a sacred text sounded like a nightmare to animate. They got around the problem by having it look like a scene from the old *Pitfall* video game.

CHARACTER DEBUTS

Clyde's parents, Mr. and Mrs. Donovan, have their debut in this episode. They join up with the rest of the parents and become members of the South Park Atheist Club.

Catholic priests, cardinals, and bishops from around the world debut, as well as The Queen Spider, who acts as the highest source of arbitration in the Catholic faith. Also the Gelgamek Catholics—an alien race that's adopted Catholicism.

CELEBRITIES IMPUGNED

Martha Stewart, who first demonstrates how to prepare a turkey for anal insertion, then actually does it. Stewart can also be seen demonstrating how to decorate your queefs in "Eat, Pray, Queef."

WHERE DID THE IDEA COME FROM?

The episode was developed in the midst of the seemingly endless scandals where Catholic priests were having sex with young boys. *South Park*'s other Executive Producer, Anne Garefino, is Catholic. Trey asked her how she felt about the sex scandals. What Priest Maxi says about the Catholic Church at the end of the episode is Trey's interpretation of what she said. Also, Matt and Trey had for years wanted to do a show in which people crapped out of their mouths. This was their chance.

POINTLESS OBSERVATIONS

Although the Pope was briefly seen in "Do The Handicapped Go to Hell?", this is his "big" debut. He will be featured in several more future episodes.

"Intero-Rectogestion" (eating food through the butt and crapping out the mouth) was deemed by the Surgeon General to be a much healthier way to eat. And he based this statement. . ."on absolutely nothing."

When looking for the notorious episode where "people crap out their mouths," many fans confuse this episode with Season 5's "How To Eat With Your Butt," which features no mouth-poopage.

POP CULTURE REFERENCES

"The Catholic Boat," the nightmarish cruise ship run by child-molesting priests, is a parody of the popular TV show *The Love Boat.*

Cartman is unsure what to buy with the $20 he won off Kyle—The Mega Man Racer or two packs of Denver Broncos Trading Cards.

WHAT STAN'S DAD LEARNED

"We don't have to believe every word of the Bible. They're just stories to help us live by. We shouldn't toss away the lessons of the Bible just because some assholes in Italy screwed it up."

FREE HAT

Original Air Date: July 10, 2002
Episode 609

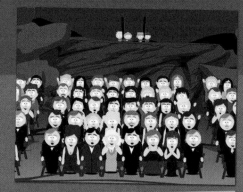

THE STORY: Stan, Kyle, Cartman, and Tweek organize a group to protest the "updating" of classic films such as *E.T.: The Extra-Terrestrial* and the original *Star Wars*. Cartman tries to pump up attendance at their first meeting by writing "Free Hat" at the bottom of their posters. Hundreds turn out, under the mistaken impression that the group wants to free imprisoned South Park resident Hat McCullogh, a baby murderer sent to prison in 1982. Not wanting to lose their supporters, the boys offer to free Hat AND save classic movies from their creators. The crowd rallies to their cause.

During an appearance on *Nightline*, Kyle inadvertently gives Steven Spielberg and George Lucas the idea of updating *Raiders of the Lost Ark*. To stop this travesty, the boys fly to California and raid Skywalker Ranch, hoping to steal the film's original negative. But they're caught, taken prisoner, and forced to attend the first viewing of the digitally enhanced *Raiders*. Tweek tries to disrupt the premiere by threatening to fire a rocket launcher at the movie print, but is instead taken prisoner as well.

Finally, the film debuts. It's so horrible that it kills the entire audience, Spielberg and Lucas included. The boys survive by closing their eyes, and return to South Park for a hero's welcome. Unfortunately, they soon discover they're being honored not for saving movies, but for helping to free Hat McCullogh.

MEMORABLE LINES:

"We're just gonna fly to California and break into George Lucas' house. What's stressful about that?" —*Kyle*

"We are simply passing through history. This. . . is IMPROVED history."
—*Steven Spielberg*

"Hat was attacked maliciously and unprovoked by a gang of babies in Westown Park. When that many babies get together, they can be like piranha."
—*Skeeter*

"What do you see as 'positive' about toddler murder?"
—*Ted Koppel*

"Yeah! Maybe we could melt the Governor's heart with a cool island song!"
—*Redneck*

"Give that man a baby!"
—*Skeeter*

"We believe that films have to be taken away from people like Steven Spielberg and George Lucas because they're insane."
—*Kyle*

"I told you guys. Never underestimate the power of a free hat."
—*Cartman*

BODY COUNT

Steven Spielberg and George Lucas, although both will be seen again in later episodes. Also Francis Ford Coppola and the entire audience viewing the "improved" *Raiders of the Lost Ark*.

CHARACTER DEBUTS

Spielberg and Lucas, who return in later seasons (most notably in "The China Probrem").

ORIGINAL SONGS

The townspeople of South Park try to melt the Governor's icy heart with the hot Caribbean song "In the Tropical Isles."

CELEBRITIES IMPUGNED

Spielberg and Lucas. Also Pat O'Brien, who hosts a show called *Excess Hollywood*, and Francis Ford Coppola, who serves as a minion of Spielberg. Ted Koppel also makes an appearance hosting his show *Nightline*.

WHERE DID THE IDEA COME FROM?

The concept voiced Trey and Matt's horror at how poorly the new *Star Wars* movies turned out—and their disgust that Lucas and Spielberg kept altering and updating their old films. Afterward Matt and Trey heard through the grapevine that Spielberg, who was actually considering messing with *Raiders of the Lost Ark*, had dropped the idea.

POINTLESS OBSERVATIONS

When the boys break into Skywalker Ranch to steal the *Raiders of the Lost Ark* print, they find a shelf of other "enhanced" films, including: *First Day of School Digitally Enhanced*, *Wedding Video Digitally Enhanced*, and *Kids' First Swimming Lesson w/ Digitally Enhanced Weather*. Lucas' Ranch is filled with *Star Wars* paraphernalia, including a picture of George Lucas and Jar Jar Binks (from *Star Wars: Episode 1*) hanging on the wall.

This is not the first time Cartman has used free prizes to lure in people to his cause. He has also offered "punch and pie" on several occasions, most notably in the movie *South Park: Bigger, Longer, and Uncut*.

This episode features a fake commercial for the digitally enhanced *Re-Release of South Park: Episode 1*, in which all of the crude animation is totally redone to feature absurd computer graphics. It also features live-action footage of Trey Parker and Matt Stone discussing the "necessary changes" they've made. This is the only time the two have physically appeared in the show.

POP CULTURE REFERENCES

Tweek's attempt to blow up the movie print is a recreation of the famous *Raiders of the Lost Ark* scene, as is the finale when all the film's viewers die. The ending to the episode, where the chest is wheeled into a massive, endless storage facility, is also a parody of *Raiders*—only this storage facility is for the "Red Cross 9/11 Relief Fund." Also, Lucas' statement that "It is too late for me boys," is taken from *Return of the Jedi*.

The new, redone versions of Spielberg/Lucas films are mocked: *E.T.: The Extra-Terrestrial*, *Saving Private Ryan: The Re-Re-Release*, and *The Re-Re-Re-Release of Star Wars: The Empire Strikes Back*. In fact, the joke of "guns being digitally changed to walkie talkies" (which actually happened in the re-release of *E.T.*) is used throughout the entire episode—all the "guns" are animated as walkie talkies.

WHAT STAN LEARNED

"Sometimes the things we do don't matter right now. Sometimes they matter later. We have to care more about later sometimes, you know? I think that's what separates us from the Steven Spielbergs and George Lucases of the world."

BEBE'S BOOBS DESTROY SOCIETY

Original Air Date: July 17, 2002
Episode 610

THE STORY: Two weeks after the death of Ms. Choksondik, her class is finally called back to school. In the interim, Bebe has begun to develop breasts. This makes her the center of attention for the boys—and an object of jealousy for the girls. She becomes so popular that Stan, Kyle, and Tweek boot Cartman from their group so they can spend more time with Bebe. They even rally to have her replace Wendy as class president. Bebe, oblivious about the true reason for her popularity, can't understand why the other girls suddenly despise her while the boys can't get enough of her.

The fourth-grade males regress into a primitive, caveman-like state and spend all their time loitering on Bebe's front lawn, waiting for her to venture out. Disgusted by her new magnetism, she comes to school wearing a cardboard box over her clothes.

Free of the tyranny of Bebe's breasts, the boys realize she's just as lame as ever, and that their judgment was clouded by boobs. Just then Wendy (who in a desperate bid for attention underwent breast augmentation surgery) shows up with a huge set of fake knockers. To her amazement, everyone laughs at her.

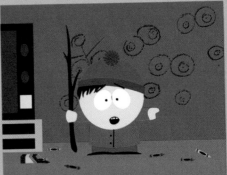

MEMORABLE LINES:

"Part of being a woman is having a friend one day and calling her a slut the next."
—*Bebe's mom*

"Yes darling, your breasts have a power that will unleash itself as you get older. They feed off the misery of boys and grow to bring woe wherever they can. You're blossoming into a woman."
—*Bebe's mom*

"Making breasts larger is a beautiful and wonderful thing. Making them smaller is. . .insane."
—*Dr. Hallis*

"God, you guys are SO stupid!!"
—*Wendy*

"I know you think this set of boobs is important now, but those boobs will be replaced by another set of boobs. Boobs will come and go. And then someday, you'll meet a pair of boobs that you want to marry. And those become the boobs that matter most."
—*Stan's dad*

"I heard that her asshole is like THIS big around."
—*Wendy*

"Eww. . .They're all hard and oogy!"
—*Butters*

BODY COUNT

Two space shuttle astronauts who crash land in South Park, only to find themselves face-to-face with the boys acting like apes. Unwilling to live in such a world, they shoot themselves.

WHERE DID THE IDEA COME FROM?

It's basically an observation about the ridiculous amount of time boys spend thinking about boobs. The South Park kids are obsessed with breasts without realizing they're obsessed with them.

POINTLESS OBSERVATIONS

Among the toys in Cartman's basement are a Chinpoko Mon, Mega Man, and his Big Wheel tricycle (notoriously seen in "Cartoon Wars Part I," page 152).

Tweek is shocked when he learns that "Cartman likes to play with dolls" (which he's seen doing in his basement this episode). However, the rest of the boys learned all about his doll-themed playtime in "Cartman's Mom's A Dirty Slut."

POP CULTURE REFERENCES

At the beginning of the episode, Cartman is reenacting a scene from *The Silence of the Lambs* in which he lowers a bottle of lotion to his doll, Polly Prissy Pants, at the bottom of a hole. He even gets Bebe to play "Lambs" with him.

When the astronauts' space shuttle crashes amid the group of ape-like boys, this is an homage to the epic film *Planet of the Apes*.

CHARACTER DEBUTS

This is the first time we meet Bebe's mother and Wendy's mother. Also, 4th-graders Smores and Bradley get their speaking debuts (Smores previously had one word of dialogue in Season 4's "The Wacky Molestation Adventure," but this is his big break). Dr. Hallis, the plastic surgeon responsible for Wendy's breast implants, is introduced as well.

WHAT-THE-FUCK MOMENT

Despite the fact that she's 8 years old, Wendy undergoes graphic and bloody breast augmentation surgery. It rivals anything you've seen on The Discovery Channel. We see the whole messy ordeal, complete with the doctor screaming, "Get in there, you bitch!!" while punching a silicon implant under her skin.

WHAT BEBE LEARNED
"Having boobs sucks."

CHILD ABDUCTION IS NOT FUNNY

Original Air Date: July 24, 2002
Episode 611

THE STORY: A child molester makes a failed attempt to abduct Tweek. This triggers a massive overreaction from the South Park parents. They decide to build a wall around the entire town. The owner of City Wok, Tuong Lu Kim, is commissioned to do it. (Basically because he's Chinese, and the Chinese have so much experience building big walls.)

To make things even more "secure," the parents outfit their kids with a device called Child Tracker—a helmet with a satellite dish that the boys have to wear at all times.

Things don't go as planned. Mongolian nomads show up and continually attack the new wall. Then, when a news report states that children are most often abducted by a parent, the adults decide that the children aren't safe around themselves, and banish all their kids outside the wall.

With no other choice, the children join forces with the Mongolians and manage to blow a hole in the barrier, reuniting them with their parents. The boys return home, secure with the knowledge that living in fear is never the answer—and that their parents are idiots.

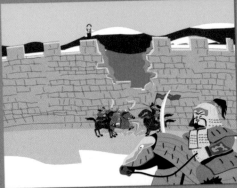

MEMORABLE LINES:

"God damn Mongorians!"
—*Tuong Lu Kim*

"Dude, sometimes I think our parents are really stupid."
—*Stan*

"My son has become a Mongolian? No! NOOOOO!"
—*Stan's mom*

"Rabble, rabble, rabble, rabble, rabble!"
—*Townsfolk*

"Just because I'm Chinese doesn't mean I go around building walls! I'm just a normal person like all of you, I eat rice and drive really slow—just like the rest of you! I'm not a stereotype!"
—*Tuong Lu Kim*

"You have to get out of here before we abduct you."
—*Stan's dad*

"Good. . .Then why don't you get into the back of my van and I'll drive you home."
—*Ghost of Human Kindness*

"Gee what a surprise. I guess Mongolians aren't such crappy, smelly people after all."
—*Tuong Lu Kim*

BODY COUNT

A crippled guy in a wheelchair who's run over by a train when Tweek, fearing the man's a child abductor, refuses to help him.

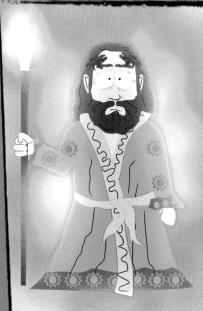

CHARACTER DEBUTS

The Ghost of Human Kindness, a.k.a. child abductor Frederick Johnson. He attempts to restore Tweek's faith in humanity by pointing out that the news only talks about bad things. Then tries to abduct him.

Mr. Mackey's parents, who also have abnormally large heads, make their over-protective debut in Mackey's classroom. They just want to make sure no one hurts "junior."

WHERE DID THE IDEA COME FROM?

The idea that Mongolians magically appear whenever someone puts up a wall came to Trey and Matt during a visit to China, while they were actually standing on the Great Wall. But it took years to finally work it into a *South Park* episode.

POINTLESS OBSERVATIONS

The boys can be seen playing Little League baseball (with no opponent) in this episode. Even though they hate it, they'll actually play real teams when they suit up in "The Losing Edge" (page 124).

Tuong Lu Kim's heat-seeking rocket launcher is named "The Mongolian Eradicator."

The Mongolian Trojan Horse is an homage to the ancient Greek legend of the Trojan Horse, which was used by the Greeks to secretly enter the city of Troy. However, the Mongolians reversed the attack by hiding outside the horse and putting sweet and sour pork inside.

POP CULTURE REFERENCES

When the boys watch *Men in Black II*, Stan says he hopes it won't "suck ass." Kyle responds with, "It will." Also, the boys' baseball team celebrates at Crust E. Krotch Pizza—a reference to Chuck E. Cheese.

The Ghost of Human Kindness is a parody of "The Ghost of Christmas Present" from *A Christmas Carol*.

As he's being taken away by the cops, the Ghost of Human Kindness says, "And I would have gotten away with it again, if it weren't for you meddling policemen!" This is a reference to the line frequently used by thwarted criminals in *Scooby Doo*. It was also used by Mr. Garrison in "Weight Gain 4000," after his unsuccessful attempt to kill Kathie Lee.

While shooting off his heat-seeking missile at the Mongolians, Lu Kim screams out "Say hello to my little friend!"—a famous line uttered by Al Pacino in the iconic film *Scarface*.

At the end of the episode, Mayor McDaniels declares, "Mr. Lu Kim—Tear down this wall!" This is a reference to the famous speech given by President Ronald Reagan at the foot of the Berlin Wall, where he called out to the Soviet leader, "Mr. Gorbachev, tear down this wall!"

CELEBRITIES IMPUGNED

A snippet from a news broadcast states that ". . .all the residents of Manhattan are prepared to evacuate if Mrs. Clinton's ass gets any bigger."

WHAT STAN'S DAD LEARNED

"You know who was right all along? The Mongolians. They knew that you just can't wall yourself off from the outside world. Putting walls up never helps anything. Tearing them down brings us together."

A LADDER TO HEAVEN

Original Air Date: November 6, 2002
Episode 612

THE STORY: The boys win a candy store shopping spree, but they can't collect their prize without their half of a special ticket—a ticket that was last in Kenny's possession. The problem is. . .their friend Kenny is dead. They steal the urn containing Kenny's remains, but when they open it, it just looks like chocolate milk mix—which Cartman promptly mixes with milk and drinks.

Desperate to get the other half of the ticket, they decide to build a ladder to heaven to ask Kenny where he put the ticket. Their effort (which adults think is merely an attempt to reach their friend) soon draws national media attention. Military recon teams on the scene soon find what they believe to be "weapons of mass destruction" in heaven. They are being constructed by Saddam Hussein (whom we learn was secretly killed by the

U.S. months earlier). A debate rages over whether we should bomb heaven to stop him.

Cartman starts having flashbacks from Kenny's perspective and realizes he somehow consumed Kenny's soul when he drank his ashes. During one flashback, he sees that the ticket stub is hidden in a box in Kenny's room. The boys recover it, have their shopping spree, and tell the adults they're done with the ladder. The grownups, realizing they were idiots for thinking Saddam Hussein was in heaven building WMDs, give up too.

The boys get on with their lives—until they realize that Kenny's soul now shares Cartman's body. Meanwhile, in heaven, we see Saddam Hussein really *is* building weapons of mass destruction.

MEMORABLE LINES:

"Now that Americans believe in heaven, should we bomb it?"
—*TV Reporter*

"Poor people don't have anything better to do than piss other people off! Don't you watch *Springer*?"
—*Cartman*

"If Saddam is building weapons, we have to stop him. With our weapons."
—*Stan's dad*

"You bet your fat clown ass it is!"
—*Cartman*

"You drank Kenny!"
—*Stan*

"Don't get cancer on the ladder, Cartman, you'll fall off and break it!"
—*Stan*

"Are you high or just incredibly stupid?"
—*UN Ambassador*

"Hold on, I'm checking for robot guards."
—*Cartman*

"Did I just call myself a blood belching vagina?"
—*Cartman*

"Aw, don't tell me we haven't even reached the cloud city yet!"
—*Cartman*

"A ladder to heaven? That's fucking stupid."
—*Mr. Garrison*

WHERE DID THE IDEA COME FROM?

Trey and Matt felt that kids building a ladder to heaven was well in keeping with the country's highly emotional and sentimental post-9/11 mood. It was also a good way to begin the long process of bringing Kenny back to life.

POINTLESS OBSERVATIONS

There's some confusion over how Saddam Hussein died. In Season 2's "Not Without My Anus," he was killed by farts; in the *South Park Movie*, he was reportedly killed by wild boars; and in this episode, George W. Bush says he was secretly killed by the United States.

Cartman yells at Kyle, "Your idea of heaven is getting five dollars off your Matzo Ball soup at Barney's Beanery by lying about a hair in it." Barney's Beanery is a well-known bar and eatery in Los Angeles.

In Kenny's flashback, Cartman is seen singing a rendition of Elvis Presley's "In The Ghetto." He also serenaded Kenny with this song in Season 2's "Chickenpox."

When asked about why he thinks Saddam Hussein would possibly be in *heaven*, President Bush goes off on an extended, far-fetched explanation about how Saddam was sent to hell, had a homosexual relationship with Satan, and was eventually banished to heaven to live with Mormons as a punishment. This is, in fact, the exact plot line from "Do the Handicapped Go to Hell?" and "Probably"—a two-parter from Season 4.

CHARACTER DEBUTS

Dead Kenny, trapped in Cartman's body. Also Lolly, the big, fat owner of Lolly's Candy Shop.

ORIGINAL SONGS

Alan Jackson's acoustic tearjerker "Where Were You When They Built The Ladder To Heaven?"

POP CULTURE REFERENCES

When the townspeople encircle the ladder to heaven and hold hands, it is an homage to a similar scene from *How the Grinch Stole Christmas*.

The Japanese try to build their own ladder to heaven so they can get there before the boys. This is a reference to the historical "Space Race" between the United States and the Soviet Union in the late 60s, which aimed to put their respective man on the moon first.

CELEBRITIES IMPUGNED

Country singer Alan Jackson (who wrote the 9/11 song "Where Were You When the World Stopped Turning?") comes to South Park to write a tearjerker about the boys' ladder to heaven. A TV reporter says he's in town "once again to capitalize on people's emotions." The lyrics include, "Where were you when they built the ladder to heaven? Did it make you feel like cryin' or did you think it was kind of gay?"

WHAT KYLE LEARNED

"Yeah, but now we think maybe heaven isn't a place you can get to. Maybe heaven is just an idea. A frame of mind, or something gay like that. Maybe heaven is this moment, right now."

THE RETURN OF THE FELLOWSHIP OF THE RING TO THE TWO TOWERS

Original Air Date: November 13, 2002
Episode 613

THE STORY: Stan's dad sends the boys, who are fully decked out in their *Lord of the Rings* costumes, on a playful "quest" to deliver a rented copy of the *Lord of the Rings* movie to Butters' house. However, Randy has also rented the porno *Back Door Sluts 9*, which he soon realizes he's mistakenly put in the *Lord of the Rings* video box.

The boys deliver the tape to Butters, who promptly watches it. Realizing their horrible mistake, Stan's parents eventually catch up with the boys and get them to perform another, even more important mission: retrieve the tape back from Butters. Butters loves the video he's seen and is distraught that the boys want it back. He begs them not to take his "precious." They take it anyway.

On the way home, the boys barely escape from three sixth graders intent on stealing the porno. Deciding that the movie possesses some horrible power, Stan, Kyle, and Cartman, accompanied by

Craig, Jimmy, and Filmore, decide to return it to the Two Towers Video Store in nearby Conifer. But a whole army of sixth graders, desperate to see the film, blocks their way.

Meanwhile, the parents fan out to look for the tape and their kids. The boys, hopelessly lost, suddenly encounter Butters, who's been following them and his "precious" tape. He guides them to the video store, but tries to grab the tape and run away with it. Just as the sixth graders turn up, Kyle grabs Butters and stuffs him (along with the tape) into the store's after-hours drop-off box.

The parents arrive at the video store and, thinking the boys have watched the porno, desperately try to put the movie (which the boys never saw) "into context" by talking pretty graphically about the various sex acts it portrays. The boys are shocked and appalled.

MEMORABLE LINES:

"Back Door Sluts 9 makes Crotch Capers 3 look like Naughty Nurses 2!"
—Butters' dad

"It's also important that you understand why some people choose to urinate on each other."
—Kyle's mom

"My movie! My awesome, cool movie! My . . . precious."
—Butters

"Quick! Cross the river! Sixth graders can't stand water!"
—Cartman

"You ready for some hot, steamy fun?"
—Stan's dad

"The guys at the office told me I had to rent this porno. They said this is, without a doubt, the hottest porno ever made."
—Stan's dad

"We're not lost, Jewgar of Jewlingrad! We just. . .don't know where we are!"
—Cartman

"Go ahead and play Harry Butthole Pussy Potter!"
—Cartman

"I don't know. I don't want to know. I'm out."
—Token, aka Talengharr the Black

"Five midgets spanking a man covered in thousand island dressi . . .is that making love?"
—Token, aka Talengharr the Blac

"And so, the party journeyed onward The great wizard, the skillful ranger, and the covetous Jew."
—Cartman

WHERE DID THE IDEA COME FROM?

Partially based on Matt seeing a porno when he was a kid, and not understanding what it was.

POINTLESS OBSERVATIONS

The boys' *Lord of the Rings* council is comprised of Timmy, Jimmy, Token, Craig, Pip, Dougie, Ike, Jason, Tweek, Stan, Kyle, Cartman, Clyde, Kevin, and Filmore (the kindergartener). Kevin, not getting the *Lord of the Rings* theme, wears a Stormtrooper mask from *Star Wars*.

CHARACTER RETURNS

The sixth graders make their triumphant return, this time on wheels. We last saw them bullying the boys in the Season 3 classic "Korn's Groovy Pirate Ghost Mystery." Back then, however, they were referred to as fifth graders. This change in title is due to Season 4's "Fourth Grade," where all the students in South Park moved up a grade.

CELEBRITIES IMPUGNED

The posters in the video store are for the films *Guys in Black Suits* and *Nutty, Nutty West*, both of them parodies of the Will Smith vehicles *Men in Black* and *Wild, Wild West*.

POP CULTURE REFERENCES

The episode is an extended parody of *The Lord of the Rings*, with Butters serving as Gollum, the boys as ring bearers, and the porno as the "precious" ring of power.

For a brief moment in Butters' basement, we catch a glimpse of the "hottest porno ever made"—on screen is porn star Evan Stone.

WHAT STAN'S DAD LEARNED

"Going number one or number two on your lover is something people might do, but you must make sure your partner is okay with it before you start doing it."

THE DEATH CAMP OF TOLERANCE

Original Air Date: November 20, 2002
Episode 614

THE STORY: Mr. Garrison tries to get himself fired from his new position as fourth-grade teacher so he can sue the school for sexual discrimination and make millions. He shows the kids a "science experiment" in which he inserts the class pet—a gerbil named Lemmiwinks—into the anus of his lover, Mr. Slave.

When his students refuse to attend class anymore, they're pronounced "intolerant" and sent off to Tolerance Camp, an Auschwitz-like prison where they're taught (via food deprivation, hard labor, and arts and crafts) to respect others. To top it off, Mr. Garrison wins a Courageous Teacher award.

Meanwhile, Lemmiwinks fights to survive in Mr. Slave's body. He's aided by the spirits of animals previously inserted in Slave's anus, including a frog, a sparrow, and a fish. Together they guide Lemmi-

winks on his quest to reach Mr. Slave's mouth . . . and freedom.

Furious that the school won't fire him, Mr. Garrison shows up at the Courageous Teacher ceremony wearing a pink headdress and strap-on dildo and riding Mr. Slave, who's dressed (barely) as a horse. The audience, far from horrified, applauds his courage. Defeated, Mr. Garrison admits he just wants to get fired so he can sue the school.

Realizing that their kids don't hate homosexuals, just Mr. Garrison, the parents retrieve the boys from Tolerance Camp. Mr. Garrison and Mr. Slave, who are judged to be intolerant of *themselves*, are sent in their place. But not before Mr. Slave coughs up Lemmiwinks. He has survived the trials of the gay man's ass, and is declared "the Gerbil King."

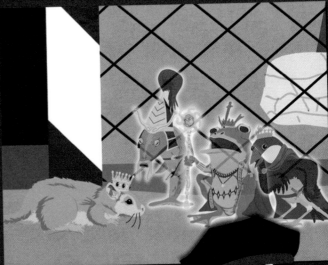

MEMORABLE LINES:

"I'm not fat, I have a different life choice."
—*Cartman*

"Dude, tolerance kicks ass!"
—*Cartman*

"Dude, I think that Mr. Slave guy might be a—Pakistani."
—*Cartman*

"I'm very happy to get this award. But you know what makes me even happier? Sucking balls."
—*Mr. Garrison*

"I will not put up with tom foolery in my classroom children! Mr. Slave, put this rubber ball in your mouth."
—*Mr. Garrison*

"What do you think is going to happen when I introduce the element of the gerbil to the endothermic heat of Mr. Slave's ass?"
—*Mr. Garrison*

"I stuck a gerbil up your ass and they want to give me a goddamn medal!"
—*Mr. Garrison*

"Holy Moly! I've got to find a way to get fired for being gay!!"
—*Mr. Garrison*

"The journey before you may be long and filled with woe / But you must escape the gay man's ass so your tale can be told."
—*Lemmiwinks' Theme Song*

"Oh, Jesus Christ!"
—*Mr. Slave*

"I should have never shoved all those poor animals up my ass!"
—*Mr. Slave*

"Children, there's a big difference between gay people and Mr. Garrison, do you understand that?"
—*Chef*

BODY COUNT

Although they aren't killed in this episode, the ghosts and remains of various other small animals are scattered throughout Mr. Slave's digestive tract. Among these are a frog, a sparrow, a fish, and a few other not-so-fortunate gerbils.

CHARACTER DEBUTS

Mr. Slave, Garrison's leather-wearing, sado-masochistic lover. He is brought in to serve as Garrison's teaching assistant, or for short, the "Teacher's Ass."

Lemmiwinks, the fourth grade's pet gerbil who winds up trapped in Mr. Slave's ass. Along with Lemmiwinks, we encounter the Frog Priest, Sparrow Prince, and Catatafish—all ghosts of animals that have been trapped within Mr. Slave's body.

ORIGINAL SONGS

Lemmiwinks gets "Gerbil King" treatment with his very own theme song, which plays repeatedly throughout the episode. Also, his trials and tribulations while journeying through Mr. Slave's body are narrated through musical riddles.

WHERE DID THE IDEA COME FROM?

This episode was part of the long process of trying to get everything back to the way it was before the boys got into fourth grade. This time, Mr. Garrison becomes their teacher once more.

POP CULTURE REFERENCES

The scenes in the Tolerance Camp are designed as an homage to films like *Schindler's List* that portray the brutality of Nazi concentration camps. They're also presented in black and white, just like the movie.

In the parents' Book Club meeting, they are seriously discussing the merits of *A Nancy Drew Mystery: The Curse of Spooky Island*. "Nancy Drew" is a book series that follows a fictional young amateur detective, popular among children and teen readers.

At Mr. Garrison's award ceremony, the white-haired audience member who says, "But the museum tells us to be tolerant," looks a lot like the *Star Trek* character Makora.

POINTLESS OBSERVATIONS

The Lemmiwinks story bears a strong resemblance (both in its animation style and in the choice of accompanying music) to the 1977 animated TV special *The Hobbit*. Matt and Trey say he's their Frodo—a passive character who survives by taking orders from others. Not surprisingly, Lemmiwinks has become one of *South Park's* most beloved characters.

A modified version of Lemmiwinks theme song will make an appearance at the end of "Stupid Spoiled Whore Video Playset" (page 106), after Paris Hilton gets stuck in Mr. Slave's ass.

There's a picture of Kathie Lee Gifford from "Weight Gain 4000" in Principal Victoria's office.

In the Tolerance Camp, the boys are forced to make macaroni pictures. This is not the first time— Moses also desired them in "Jewbilee."

CHARACTER DEPARTURES

Mr. Hat. After six seasons of being his right-hand man, Mr. Garrison finally decides that 4th grade students are "too old" for his trusty gay puppet. In his place, he introduces his gay partner, Mr. Slave.

WHAT MR. GARRISON LEARNED

"Look, just because you have to tolerate something doesn't mean you have to approve of it! If you had to like it, it'd be called the Museum of Acceptance! 'Tolerate' means you're just putting up with it!"

THE BIGGEST DOUCHE IN THE UNIVERSE

Original Air Date: November 27, 2002
Episode 615

THE STORY: The boys, Chef, and Cartman's mom fly to New York City to consult with "psychic" John Edward about how to get Kenny's soul out of Cartman's body. However, they quickly realize he's a fake and decide to visit Chef's parents in Scotland, who are well-versed in the art of exorcism.

Stan stays in New York City with Kyle, who was convinced by one of Edward's comments that his deceased grandmother wants him to enroll in a private Jewish school called Jewleeard. Stan tells Kyle that Edward, like all psychics, uses a technique called "cold reading" to trick people. To demonstrate how easily it can be done, Stan starts cold reading people on the street—unfortunately, he does it so well that people start believing *he's* psychic. Despite his protests, he gets his own TV show, *The Other Side*.

Meanwhile, in Scotland, Chef's parents draw Kenny's spirit out of Cartman's body. But without a "victim child" for a host, his soul just bounces around

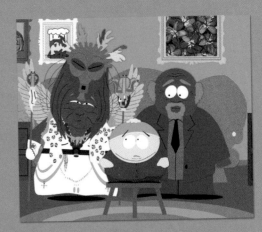

the house. . .until it eventually winds up in a pot roast.

Back in New York, John Edward challenges Stan to a "psychic showdown." But instead of reading minds, Stan tells the studio audience that the real mysteries of life and death are far greater than anything a douche like Edward could possibly imagine. Suddenly a UFO crashes through the roof. Aliens inform Edward that he's been nominated for the Biggest Douche in the Universe award. He's taken aboard their ship, which disappears into the sky.

Cured, Cartman returns home with the pot roast containing Kenny's soul. But through a luggage mix-up, it falls into the hands of comedian Rob Schneider, who eats it and becomes possessed.

Meanwhile, in the far off Valxen Galaxy, Edward does indeed win the Biggest Douche in the Universe Award.

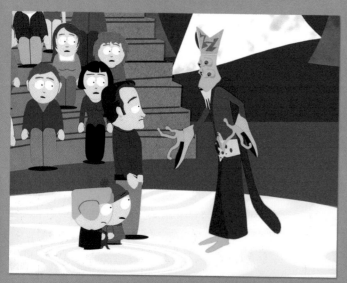

MEMORABLE LINES:

"Grandma's watching me. Always watching me."
—*Kyle*

"Oh Lord, they didn't bring a victim child."
—*Chef's mom*

"That's preposterous!! What this child needs is a time transplant!!"
—*Dr. Doctor*

"Rob Schneider is. . .A Carrot!"
—*Movie Trailer*

"From the creators of 'Der' and 'Tum Ta Tittaly Tum Ta Too,' Rob Schneider is 'Da Derp Dee Derp Da Teetley Derpee Derpee Dumb.' Rated PG-13."
—*Promo for Rob Schneider Movie*

"I'm saying this to you John Edward. You are a liar. You are a fake. And you are the biggest douche ever."
—*Stan*

"Oh well, I guess the child's a pot roast now."
—*Chef's dad*

"Here he is. The Biggest Douche of the Universe. In all of the galaxies, there's no bigger douche than you. . ."
—*Award Song*

"Cartman is your friend whether you like him or not."
—*Chef*

BODY COUNT

Rob Schneider, impaled on a flagpole just like Kenny in "Weight Gain 4000."

WHERE DID THE IDEA COME FROM?

The idea for this episode came from learning how "cold reading" takes advantage of people. Watching this asshole (John Edward) take advantage of people who thought they were really talking to their dead relatives seemed extra cruel.

POINTLESS OBSERVATIONS

While at Edward's house, Stan notices several books in his bookcase, including *How to Be a Psychic*, *Make Women Believe You're Psychic! Then Have Sex With Them!*, and *How To Sixty Nine With Yourself*.

When Kyle goes to Jewleeard, he wears the traditional garb of Hasidic Jews, complete with beard and long curls ("peyos"). Kyle also goes Orthodox in "Jewbilee."

We first met Chef's parents, Nelle and Thomas, in "Succubus," when they came to South Park for Chef's disastrous attempt at marriage. Throughout that initial episode, they tell stories of the Loch Ness Monster trying to take their "tree-fiddy" ($3.50). In this episode, Chef's mother offers Kenny's escaped soul "tree-fiddy."

The luggage tag on the pot roast in the airport reads "Chef McGillroy, South Park." However, we originally learned that Chef's name is *Jerome Chef McElroy* in "Chef Aid."

Among the aliens that land on earth to welcome John Edward, there is a "Visitor." These big-eyed, thin-bodied, grey aliens can be seen in tons of episodes, dating all the way back to the pilot, "Cartman Gets an Anal Probe."

POP CULTURE REFERENCES

Cartman's mom is unsure whether or not to drag her dying son to New York City, until she realizes she can take in the musical *Hairspray* while there. Also, when Chef's mom places her hands on Cartman and says, "This child is clean," she's parodying a similar line from the movie *Poltergeist*.

There's a picture of Martin Luther King, Jr. hanging on the wall in Chef's parents' living room. There's also a picture of Chef on the Great Wall of China in their bedroom.

CELEBRITIES IMPUGNED

John Edward, who is portrayed as literally the biggest douche in the universe. Perhaps the only challenger for that honor is comedian Rob Schneider, who also gets slammed. Throughout the episode, we see previews for Schneider's films: *The Stapler, A Carrot, Da Derp Dee Derp Da Teetley Derpee Derpee Dumb,* and *Kenny*. These absurd comedies in which he morphs into different inanimate objects are parodies of his actual movies, in which he's transformed into an animal and a woman.

WHAT STAN LEARNED

"At first I thought you were all stupid, listening to this douche's advice. But now I understand that you're all here because you're scared. You're scared of death and he offers you some kind of understanding. You all want to believe in it so much, I know you do. You find comfort in the thought that your loved ones are floating around trying to talk to you, but think about it: Is that really what you want? To just be floating around after you die, having to talk to this asshole? We need to recognize this stuff for what it is: magic tricks. Because whatever's really going on in life and in death is much more amazing than this douche."

MY FUTURE SELF N' ME

Original Air Date: December 4, 2002
Episode 616

THE STORY: The boys find a marijuana cigarette left in the woods by some high-schoolers. All the kids are afraid to touch it. They think coming in contact with marijuana could lead to doing harder drugs. Stan bravely steps forward, picks it up and throws it away.

Not too long after the incident in the woods, Stan's "Future Self" shows up on his doorstep. He is a drug addicted loser that's failed at life. Stan's parents kindly take him in. However when Stan learns that Butters has a "Future Self" as well (also a doping loser), he becomes suspicious. The boys soon discover that these "future selves" are really employees of Motivationcorp, a company hired by their parents to scare the kids into avoiding drugs and doing well in school.

Stan and Butters, furious at being tricked, visit a company called *The Parental Revenge Center of Western America* in order to seek retribution. It's run by Cartman, who for a small fee paints the interior of Butters' parents' home with poop. Meanwhile, Stan tries to get his parents to confess they're lying to him by pretending to chop off his hand, to see if his future self's hand will also disappear. But his parents won't give in and admit to the deception.

When Butters' parents see the poo-coated walls, they break down and admit that the whole Future Butters thing is a fraud. Stan finally calls his parents out and they also fess up, stating that they should have told him that drugs are a waste of time rather than exaggerating their dangers.

After he paints the walls of Motivationcorp with poop, Cartman admits he's been thinking about taking better care of himself and working harder. Suddenly Future Cartman appears to tell him that this is the moment he turns his life around for the better. Unimpressed and pissed off, Cartman spitefully informs his future self that he plans to overeat and do drugs. Instantly, his future self morphs into a fat plumber.

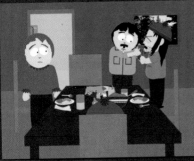

MEMORABLE LINES:

"I know how it feels to be really, really pissed off at your parents. And I will work hard—for you."
—*Cartman*

"Yeah Stan, why don't you go upstairs and play with yourself?"
—*Stan's dad*

"Well, three hundred gallons of poop isn't gonna smell like a garden, Butters."
—*Cartman*

"You know what us ultra-liberals say: When it comes to children and drugs, lies are okay."
—*Motivationcorp Manager*

"Look, you can make your wiener bigger in just three weeks."
—*Butters*

"Poop smearing is the hot ticket right now, Stan. Have you seen the poop swatches?"
—*Cartman*

"Just for that I'm gonna spend my whole childhood eating what I want and doing drugs when I want! Whateva, I do what I want!!"
—*Cartman*

WHERE DID THE IDEA COME FROM?

Trey and Matt were offended by over-the-top anti-drug commercials that implied that doing drugs just once could kill you, or that purchasing drugs funded terrorists. This episode tries to get across the idea that the real danger of drugs is that they screw up your life and turn you into a loser.

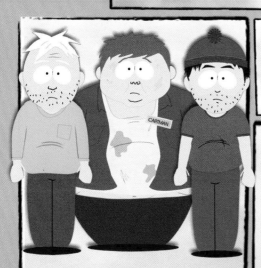

CHARACTER DEBUTS

Future Stan, Future Butters, and Future Cartman.

POP CULTURE REFERENCES

Future Butters is infatuated with the TV sitcom *Becker*, which Butters describes as "so stupid."

POINTLESS OBSERVATIONS

Cartman seems to speak fluent Spanish, which he uses to communicate with the Hispanic work crew he's hired to paint Butters' parents' house with poop.

Although it's unclear whether it's one of his comedy bits, Jimmy admits to doing ecstasy, saying, "me and my girlfriend took it, and we stayed up all night having s-s-sex."

While flipping channels after *The Osbournes*, we briefly see a glimpse of the Cheesy Poofs commercial from Season 2's "Roger Ebert Should Lay Off the Fatty Foods."

We learn from Future Stan that Sharon's maiden name is "Kimble" and Randy doesn't like chicken.

Butters reveals his "terrible secret"—his villainous alter ego as Professor Chaos—to Stan in this episode. Unfortunately, Stan confuses this terrible secret with Butters admitting he's gay.

With poop smearing being the "hot ticket," Cartman has these assorted poop swatch colors available: *Nut N' Corn Crunch, Classic Brown, Baby Green, Pepto Black, Basic Tan, Black and Tan Swirl, Cookies n' Cream,* and *Hangover Yellow.*

ORIGINAL SONGS

The campy, sitcom-style theme song "My Future Self N' Me" plays over the montage of Stan and his Future Self frolicking around.

CELEBRITIES IMPUGNED

The Osbournes. When Stan's mom catches him watching their MTV reality show, she warns that "It's going to make you retarded."

WHAT STAN LEARNED

"The best way to try to motivate somebody is by being direct with them, to be honest with them. I think the whole future self thing is a lie, and lies are never the right way to get your message across."

RED SLEIGH DOWN

Original Air Date: December 11, 2002
Episode 617

THE STORY: It's Christmastime in South Park and the townspeople have all gathered for the annual lighting of the South Park Christmas Tree. Before it's lit, however, Jimmy offers up his rendition of "The Twelve Days of Christmas". . .which takes all episode for him to sing.

Meanwhile, Cartman is nervous—he desperately wants the new Haibo robot doll for Christmas, but he's been so naughty he fears he won't get it. In order to "balance the books" fast, he attempts to perform an act of almost unbelievable niceness: bringing Christmas to Iraq.

With the help of Mr. Hankey and his Poo Choo Express, Cartman and the boys travel to the North Pole to recruit the help of Santa. Overcome with the spirit of the season, Santa signs on and loads his sled with presents for the Iraqi children. But while delivering presents over Baghdad, Santa's sleigh is shot down by a shoulder-fired missile. He is then taken prisoner and tortured.

Horrified, the boys and Mr. Hankey seek out Jesus, who joins them in their fight to recapture

Saint Nick. They return to Baghdad, guns blazing, and rescue Santa. Just before they can get away, however, Jesus is gunned down and dies. In keeping with Jesus' last wish to "not let them take away our Christmas spirit," Santa bombs Baghdad with special missiles that explode with festive items that decorate Iraq for Christmas.

Santa drops the boys off in South Park, where Jimmy has just finished singing his song. Santa lights the town tree and gives each of the boys Haibo robot dolls, which ultimately pisses Cartman off—seeing that the other boys have them too, he now thinks they are "worthless and gay."

Suddenly, in a memorable *South Park* Christmas moment, Kenny walks into the scene. He's been missing since Season 5's "Kenny Dies," where he died "for good" from a terminal illness. After saying he's just "been hanging out," the boys accept his presence as if nothing ever happened, and they walk off together feeling like things are finally back to normal.

MEMORABLE LINES:

"Sleigh is down. Reindeer . . . all dead. Both Santa's legs are broken. Santa's . . . very sad." —*Santa*

"Oh no, not Santa's balls!!" —*Santa*

"Howdy Ho, Jesus." —*Mr. Hankey*

"Come on, gang! It's up to us to save Christmas!" —*Cartman*

"I'm gonna fucking kill you!" —*Santa*

"It's not stupid! It's a toy that you can starve!" —*Cartman*

"If you cured cancer and AIDS next week, you would still owe two presents." —*Kyle's Cousin Kyle*

"This is Baghdad? God what a shit hole. I mean—Wow, these poor, unfortunate people!" —*Cartman*

"Oh my God, the Iraqis killed Jesus!" —*Stan*

"I'm having a precious Christmastime moment, Kyle, if you don't mind." —*Cartman*

"Hey, I'm just your naughty or nice accountant! Don't blame me for the numbers!" —*Kyle's Cousin Kyle*

"My children, you should know something. . .I'm packing." —*Jesus*

"What the hell are WE supposed to do?! We're like nine inches tall!" —*Gnome*

"Oh, this will be the happiest Christmas the Middle East has ever seen!" —*Cartman*

BODY COUNT

All of Santa's first-string reindeer (Donner, Blitzen, etc.) are blown to bits when his sleigh is shot down in Baghdad. Also, a large number of terrorists and Baghdad military personnel are killed in the bloody rescue of Santa. And finally, Jesus.

WHERE DID THE IDEA COME FROM?

This episode came together at the last possible moment. The big problem was figuring how to resurrect Kenny without disrupting the narrative flow. In the end, they decided to simply have him show up at the last possible moment.

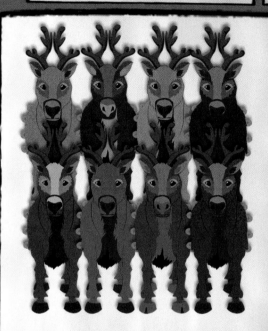

CHARACTER DEBUTS

The reindeer for Santa's backup sleigh, "Red Sleigh 2": Steven, Fluffy, Horris, Chantel, Skippy, Rainbow, Patches, and Montel.

POINTLESS OBSERVATIONS

Cartman has Kyle's Cousin Kyle add up how many times he's been bad over the previous year compared to how many times he's been good. According to Kyle's calculations, there were 4,312 instances of being naughty, and only three of being nice. Which means Cartman owes Santa 306 presents. This is, of course, a parody of how taxes are done.

When Santa's sleigh crashes into the Italian church, an old woman can be heard screaming "*La Morte Rossa*!"—which is Italian for "the Red Death." This is not to be confused with the screams of horror "*La Muerte Peludo*!" heard in Season 12's "Pandemic I" and "Pandemic II." That is Spanish for "the Furry Death."

There are real pictures of Saddam Hussein hanging on buildings in Iraq.

In the wide shot of the crowd at the end of the episode, there's a ton of *South Park* characters from many past episodes there to celebrate the holiday. To name a few: Chef's parents, Lolly (the candy store owner from "A Ladder to Heaven," page 34), the Thompsons (the ass-faced couple from "How to Eat With Your Butt"), the *Star Trek* Nerds, Kenny's full family, Mr. Adler (the boys' wood shop teacher) and Rancher Bob (from "Fun with Veal," page 18).

ORIGINAL SONGS

Mr. Hankey's joyful Christmas song "Poo Choo Train" rings out as his poop-train chugs its way to the North Pole. Cartman also breaks into his a cappella original, "Precious Christmastime Moment," while riding in Santa's sleigh.

POP CULTURE REFERENCES

Santa lives in his own Fortress of Solitude, a reference to Superman's Arctic command center. And when he's tortured by the Iraqis for information about the American invasion, he replies with a line from *Lethal Weapon*: "Then we're in for a long night, 'cause I don't know shit!"

The title and plotline of this episode, as well as many details throughout, parody Ridley Scott's war film *Black Hawk Down*.

The Haibo robot doll is a takeoff on other robot pet animals that were quite popular at the time, most notably Sony's AIBO robotic dog.

When Santa's delivering presents to the Iraqis, two children with big eyes and huge smiles come out to grab presents. This animation style is an homage to the stop-motion holiday specials done by Rankin/Bass in the 60s and 70s. While opening Santa's presents at the end of the episode, the boys' faces mimic this Rankin/Bass style as well.

WHAT SANTA LEARNED

"Christmas is a very special time of year, but . . . this year it almost didn't happen. There's a man named Jesus who gave his life to save me. And so I declare that every year on Christmas Day, we should remember Jesus for what he did and thank him for it. From now on, Christmas will be a day for remembering a brave man named Jesus."

CHARACTER RETURNS

A lot of characters make returns in this episode, including Mr. Hankey; Kyle's Cousin Kyle; Santa; Jesus; the Underpants Gnomes (whom, it is revealed, work at the North Pole for Santa Claus two months of the year); and of course, Kenny.

SEASON

7

Timmy Gay 708

KYLE CRAB Ep708

CANCELLED

Original Air Date: March 19, 2003
Episode 704

THE STORY: Cartman and the boys experience serious déjà vu—it seems like they're reliving the same events that took place in "Cartman Gets an Anal Probe." This familiar feeling is confirmed when the satellite dish in Cartman's ass reappears and goes on the fritz. The boys are soon abducted by aliens and taken into space.

Here, they are informed by a friendly alien (named Najix) that "Earth" is actually the set of the most-watched, longest-running reality TV show in the universe. Eons ago, intergalactic network heads put 17 different species—including Asians, Bears, Ducks, Jews, Deer, and Hispanics—together on the same planet and then televised the resulting chaos. And the satellite dish in Cartman's ass is one of thousands around the world that help broadcast the show.

When the boys' meddling causes earthlings to become aware that they're being watched, the network heads decide to "cancel" the show and destroy Earth. In desperation, the boys contact the Joozians, an alien race that controls all the media in the universe. They do lunch with two Joozian executives and then follow them to a strip club. The creatures get high on some sort of purple space powder (called "blancgh") and then retire to a hotel room to suck each other's jaggons—all while the boys watch and take a picture.

Afterward, a deal is struck. If the boys keep quiet about the jaggon-sucking incident, the Joozians won't destroy Earth. The kids' memories are erased and they're returned to South Park, none the worse for wear. Except for some reason, Kenny now possesses a photograph of what appears to be two aliens having sex.

MEMORABLE LINES:

"I'm sorry Earthlings, but you have to realize that the Universe is a business."
—*Joozian Network Exec.*

"We at Nerzod Productions started twenty billion years ago with one philosophy: the best universal television isn't scripted! It's REAL!"
—*Najix*

"What the funk and wagnalls are you talking about?"
—*Cartman*

"Where'd you learn to drive, aliens?! Chinese Auto School?!"
—*Chef*

"Kyle, I swear if I didn't have a guy's hand up my ass right now, I'd leap across the room and kick you in the nuts."
—*Cartman*

"Dude, I have no idea what we're seeing right now. But I have a feeling it's really, really wrong."
—*Stan*

"Oh yeah, suck my jaggon!"
—*Joozian Network Exec.*

"You know that feeling when the huge dump you just took shoots back up inside your ass? NO, I'M NOT ALRIGHT!"
—*Cartman*

SORT-OF-SIGNIFICANT OBSERVATIONS

In this episode, we learn that the alien "visitors" who make regular cameos in *South Park* episodes are really employees of an intergalactic TV production company, Nerzod Productions. The gigantic satellite dish placed in Cartman's ass is just one of some 50,000 that have been inserted in human rectums around the world to help broadcast the reality show.

CHARACTER DEBUTS

Jeff, the space expert. He's a satire of the nutball scientist played by Jeff Goldblum in *Independence Day*. The shape-shifting alien, Najix, who appears to the boys in various forms before finally settling on a giant ice-cream crapping taco, debuts in this episode. We also meet the large-nosed Joozian Network Executives, who control all the media in the universe.

CELEBRITIES IMPUGNED

Cartman wakes up inside an alien spaceship and screams, "I'm trapped inside Helen Hunt's ass!" When informed by Kyle that this isn't the case, he replies, "Oh, thank God! Oh thank—thank the Lord."

WHAT STAN LEARNED

"I'm sure you'll see that if you give our world time, it will become even more outrageous and violent."

WHERE DID THE IDEA COME FROM?

The idea of spoofing reality shows was originally suggested by none other than Norman Lear (creator of, among a great many other TV shows, *All in the Family*). He met Trey and Matt and wanted to work on something with them, and he actually is credited on several episodes. The plan was that this episode was supposed to be *South Park's* 100th episode, but it lost that honor thanks to a scheduling shuffle. Even though this wasn't officially the 100th episode, there are still a lot of self-reflexive nods to that staggering achievement. The Joozian Network Heads even mention, while dining in a ritzy alien restaurant, "A show should never go past a hundred episodes, or else it starts to get stale with ridiculously stupid plot lines and settings."

POP CULTURE REFERENCES

A car chase in which Chef and the boys outrun some aliens is done as an homage to *The Dukes of Hazzard*. Also, a brief section of live-action footage is similar to the Danish monster movie *Reptilicus*.

This is the second episode in which the science fiction movie *Contact* is singled out for ridicule. In "Tom's Rhinoplasty," Mr. Garrison vomits at the very mention of it. And in this episode Kyle calls it "gay" and Stan refers to it as "stupid." Furthermore, Jeff's desolate scientist station (surrounded by a field of satellite dishes) is modeled after a similar location from the film.

While trying to find a pleasing body form for the boys, Najix (the alien) transforms into a variety of pop culture icons: Santa, Michael Jordan, Don King, Mr. Roarke and Tattoo from *Fantasy Island*, comedian George Burns, JJ from *Good Times*, Saddam Hussein, rapper Missy Elliot, Frank Sinatra, and finally a taco that craps ice cream.

The reality TV shows made by Nerzod Productions are parodies of actual shows: *Who Wants to Marry A Gelgamek?*, *Antares 6 Millionaire*, and *Get Me Outta Here, I'm A Klingnanian!* are parodies of *Who Wants to Marry A Multi-Millionaire?*, *Who Wants to Be A Millionaire?*, and *I'm A Celebrity. . .Get Me Outta Here!*

In the process of decoding a message, Jeff mentions: "60—that's the number of episodes they made of *Punky Brewster* before it was cancelled." There were actually 88 episodes made of that TV show.

POINTLESS OBSERVATIONS

When the boys walk into the FOGNL Network office, snippets from past episodes play on the TVs in the background: The Marklars from "Starvin' Marvin in Space" can be seen, as well as aliens from "The Biggest Douche in the Universe" (page 40). The Marklars are mentioned again later, as are the Gelgamecks from "Red Hot Catholic Love" (page 26).

Although the boys briefly discuss it, the opening to this episode is almost exactly the same as the opening to the pilot episode, "Cartman Gets an Anal Probe." The animation, however, is just a little bit better.

This is the boys second time in space, the first time being in "Starvin' Marvin in Space." Cartman brags, "this is like my fifth time."

CHEESY POOFS

KRAZY KRIPPLES

Original Air Date: March 26, 2003
Episode 702

THE STORY: Jimmy performs stand-up comedy to a practically empty theater. It turns out everyone in town has gone to see paraplegic and stem cell research advocate Christopher Reeve, who is slowly regaining his strength by sucking the juices out of fetuses. Jimmy and Timmy, angered at the attention he receives, form their own "handicapped-from-birth" club—The Crips. After learning that an organization with that name already exists (and mistakenly believing that it's also composed of people crippled from birth), they join its Denver chapter.

In order to prove their street cred, they're sent out to kill some members of a rival gang, the Bloods. The boys unwittingly accomplish this when a gasoline tanker, swerving to avoid them, crashes into a gas station where Bloods gang members are hanging out, killing everyone. Soon Jimmy and Timmy are rolling around South Park in their new gang colors, terrifying the populace.

Meanwhile Reeve's fetus-sucking habit not only restores him to full mobility, but then gives him su-

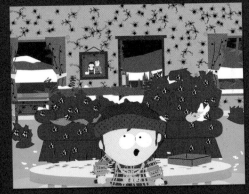

perpowers—and an insatiable desire for more and more fetuses. He founds his own Legion of Doom, which is committed to world domination and evil. But Reeve is thwarted by Oscar-winning actor Gene Hackman (whom he refers to as "Hack Man"). Hackman and his followers help secure a ban on stem cell research, then imprison Reeve in another dimension and shoot him into space.

Jimmy and Timmy have problems of their own. When Jimmy's house is sprayed with bullets by the rival Bloods gang, he finally realizes how much trouble he's gotten himself into. But instead of running for cover, he decides to bring the two enemy gangs together by doing an all night "lock in" at the Denver Recreation Center. After an impassioned speech in which Jimmy tells the rival gangs "I mean, come on," the two groups form a truce. The Crips and Bloods become fast friends, and even perform a musical number together.

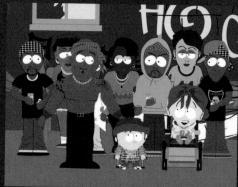

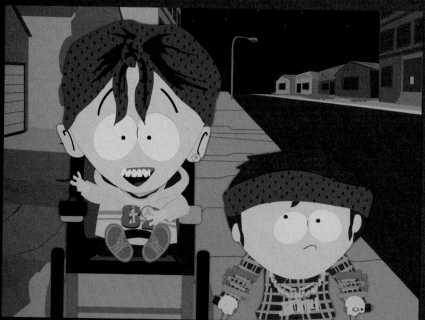

MEMORABLE LINES:

"That must be what the fellas meant by 'pop some punk-ass Bloods,' they want us to get them Soda Pop and treats!" —*Jimmy*

"The once immobile Mr. Reeve says his new organization will be committed to world domination and evil. What an inspirational story, Tom." —*Reporter*

"Tom, if irony were made of strawberries, we'd all be drinking a lot of smoothies right now." —*Reporter*

"Look, my gang, which I can't talk about because it's super secret, is the most important thing to me now. And if you don't like it, you can just pass the blunt to the nigga on your left." —*Jimmy*

"Tim and I would love to pop some punk-ass Bloods. We're terrific at it." —*Jimmy*

"You were sent here through the vengeful and angry hand of God to teach your mother and I a lesson. And that's a big responsibility, son." —*Jimmy's dad*

BODY COUNT

A group of 13 Bloods killed in a gasoline tanker crash caused (inadvertently) by Jimmy and Timmy.

CHARACTER DEBUTS

Jimmy's mother and father, Sarah and Ryan Swanson, who we learn used to make fun of crippled kids in high school. The gang of Crips and Bloods also get a starring role in this episode. "Also, Larry King debuts. He can be seen again in "A Million Little Fibers" (page 156) and Season 13's "Whale Whores."

ORIGINAL SONGS

The Crips and Bloods join forces for their funky and friendly tune "Na-Na-Na, Crips and Bloods."

WHERE DID THE IDEA COME FROM?

Trey and Matt considered going after Christopher Reeve for quite a while, but were always dissuaded by others who thought it deeply uncool. This time they decided to go for it. They blended it with another longstanding premise—having Jimmy and Timmy join the Crips.

POINTLESS OBSERVATIONS

Jimmy's last name is revealed to be Swanson (although he will be called Jimmy Valmer in later episodes). Also, Christopher Reeve's *Legion of Doom* includes Professor Chaos and General Disarray.

Timmy and Jimmy's Crip names are "Lil' Roller" and "Four Legs," respectively.

POP CULTURE REFERENCES

When the Bloods and Crips get together to sing at the end of the episode, they're parodying the numbers usually performed during *Fat Albert and the Cosby Kids*. They even play improvised, *Albert*-esque instruments.

Larry King is shown here, hosting *The Larry King Show*, an obvious parody of his actual show *Larry King Live*.

Many aspects of this episode parody the classic 1978 film *Superman*, although the roles of Christopher Reeve and Gene Hackman are totally reversed. Even the ending of this episode, where Reeve is encased in a 2-dimensional panel of glass and shot into space, is a nod to the beginning of the film.

Christopher Reeve's *Legion of Doom*—complete with the Hall of Doom headquarters—is an homage to the real *Legion of Doom*, a fictional gang of super villains (led by Lex Luthor) hellbent on bringing down the *Super Friends*. Some members of the original Legion are actually present: Black Manta, Cheetah, and Solomon Grundy, as well as parodies of Marvel villains Doctor Octopus and Doctor Doom.

CELEBRITIES IMPUGNED

Actor Christopher Reeve (best known for his role as *Superman*) gets the royal treatment for his support of stem cell research. Also, Christopher Reeve's *Legion of Doom* includes Osama bin Laden, Saddam Hussein, North Korean leader Kim Jong Il . . . and magician David Blaine, last seen in "Super Best Friends."

Gene Hackman, Christopher Reeve's "old nemesis from the movies," is once again portrayed as his archrival.

WHAT JIMMY LEARNED

"I guess we all learned that trying to get along is way better than p. . .player hatin'."

TOILET PAPER

Original Air Date: April 2, 2003
Episode 703

THE STORY: After serving a long detention for goofing off in art class, the boys exact revenge by toilet-papering their art teacher's house. However, Kyle is paralyzed with guilt for his part in the TP incident. Concerned that he will rat them out to the authorities, Cartman decides to bludgeon Kyle to death with a baseball bat. Unfortunately, he can only afford a wiffle ball bat, which proves ineffective.

Meanwhile, Officer Barbrady attempts to track down the perpetrators by consulting with a serial toilet-paperer named Josh Myers, who's incarcerated at Park County Juvenile Hall for TP-ing more than 600 houses in a year. He and Officer Barbrady strike up a Hannibal Lecter/Clarice Starling-like relationship. Eventually Barbrady arrests a suspect— Butters. Butters had nothing to do with the crime, but is convinced he's guilty anyway.

When the boys hear about this wrongful arrest, Stan and Kenny suddenly feel as bad as Kyle. They agree (to Cartman's horror) that they should confess to their art teacher the next day. Meanwhile, Butters' parents prove his innocence by providing a rock-solid alibi for the night of the incident. However, they vow to punish him severely for "fibbing" to the police.

In a brilliant example of damage control, Cartman confesses first and turns in the other three boys in the process. Stan, Kyle, and Kenny get two weeks of detention, while Cartman gets only one for "being brave." Shortly thereafter, Josh Myers escapes. He calls Barbrady just before he launches a TP attack on the greatest target of all—the White House.

MEMORABLE LINES:

"Tell me, the toilet paper. Was it quilted?"
—*Josh Myers*

"Just remember, he'd toilet paper you in a second if he had the chance."
—*Juvenile Hall Director*

"Remember to feel the clay. Be one with the clay."
—*Mrs. Streibel*

"Let Cartman do all the talking, okay? He's better at being in trouble than anybody."
—*Stan*

"Your toilet paperers are most likely males between the ages of eight and ten, and probably virgins."
—*Josh Myers*

"We have no choice. We have to kill Kyle."
—*Cartman*

"There's toilet paper on your hands too, Kyle."
—*Cartman*

"Officer, can I stay in jail please?"
—*Butters*

"Ta dao! Ta dao! How do you like me now?!"
—*Cartman*

"I'm killing you. But unfortunately I could only afford a wiffle bat, so it's going to take a while."
—*Cartman*

WHERE DID THE IDEA COME FROM?

This was one of those last-minute concepts that emerged shortly before the show was supposed to air. There weren't any deep political or cultural messages—just the boys being boys.

CHARACTER DEBUTS

Mrs. Streibel, the art teacher, and her family. Also Mr. Bell, the Grocery Store Cashier who makes a positive ID on the decomposing toilet paper. Josh Myers, the Hannibal Lecter-like serial TP-er, also makes his single episode cameo before escaping to freedom.

POINTLESS OBSERVATIONS

While locked up in jail, Butters worries about how his girlfriend Carrie will react, saying: "when she finds out about this, woo-smokies is she gonna be sore!" Although we never see her, she apparently lives in Michigan. Also, Butters' parents mention that he's in jail "again."

Through some skillful mind games, we learn that Officer Barbrady had a pretty twisted childhood: his Uncle Charles used to hit him with a belt, and his dad dressed him up like a girl on poker nights and made him sit on all his Uncles' laps.

POP CULTURE REFERENCES

Kyle hesitates before TP-ing the art teacher's house because there are kids inside, saying: "We didn't say nothin' about no kids, man!" It's a parody of a scene from *Scarface*. Also, the story Cartman invents to give the boys an alibi on the night of the TP-ing concerns them spotting Ally Sheedy, "the Goth chick from *The Breakfast Club*," in a bowling alley.

The infamous scene in which Cartman tries to kill Kyle on a boat in Stark's Pond is a nod to a similar incident in the film *The Godfather II*.

CELEBRITIES IMPUGNED

One of Kyle's guilt-fueled dreams includes live-action footage of ice skater Nancy Kerrigan crying after she was kneecapped in 1994. This is one of Matt's all-time favorite scenes.

WHAT CARTMAN LEARNED

Nothing. Cartman tries to give an emotional rendition of what he's learned, but Kyle cuts him off: "Oh stop it Cartman! You didn't learn anything! Not a God damn thing!"

I'M A LITTLE BIT COUNTRY

Original Air Date: April 9, 2003
Episode 701

THE STORY: The boys naively join an anti-war protest just to get out of school, but they are soon caught between the two clashing sides—pro-war and anti-war contingents. Angry at the kids' lack of knowledge and total indifference to the issues at hand, Mr. Garrison orders his students to create reports on what the Founding Fathers would think of the situation. Instead of just doing the work, Cartman develops a novel "research" technique. He loads his TV recording system with 50 hours of History Channel documentaries, then tosses it and himself into a tub of water, triggering his electrocution—and a flashback to 1776.

While his body lingers near death in the hospital (a mere side effect of his research technique), Cartman's mind embarks on a fantastical adventure in which he carries the first draft of the Declaration of Independence to the Continental Congress, and learns (from none other than Benjamin Franklin) that America gets its strength from its ability to "say one thing and do another." In other words, while a part of the U.S. population can instigate a war against an adversary, another part can bitch and complain about it. Thus, an American cause is advanced while the nation's appearance as a liberal, pluralistic society is preserved.

Cartman awakens from his coma and rushes to tell the townspeople, who've been engaged in a seemingly endless riot. His words cause them to come together and perform their own rendition of the Donny and Marie standard, "I'm a Little Bit Country, I'm a Little Bit Rock and Roll."

MEMORABLE LINES:

"Don't you see? All this dividin' up the town—it's just ridiculous. What we really should be doing. . .is just beating the hell out of each other."
—*Skeeter*

"The Founding Fathers want you all to know that we can disagree all we want, as long as we agree that America kicks ass." —*Cartman*

"Do you think kids in every town have to deal with this crap?"
—*Kyle*

"Cartman, you are hereby declared a full-fledged retard!" —*Kyle*

"P.S. Every Thursday should be free ice cream day."
—*John Adams reading the Declaration of Independence*

"Say guys, 1776 was so long ago, I wonder what life would have been like back then. . . back then. . .back then. . ."
—*Cartman*

"I'm not from here at all, I'm having a flashback!"
—*Cartman*

"If you don't like America, why don't you get out!"
—*Skeeter*

"Think of it, an entire nation founded on saying one thing and doing another!"
—*Stephen Hopkins*

"Wow. . .The Declaration of Independence Day."
—*Cartman*

BODY COUNT

The courier who was supposed to deliver the Declaration of Independence to the Continental Congress is bludgeoned to death by Cartman, who takes his place. Also, a number of townspeople are impaled, beaten, and killed during the brutal, violent fight that breaks out between the pro- and anti-war supporters.

WHERE DID THE IDEA COME FROM?

Matt and Trey noticed that while all the pro-Iraq War songs were by country artists, all the anti-war songs were by rockers. This made them think of the old Donny and Marie standard, "I'm a Little Bit Country, I'm a Little Bit Rock and Roll." Thus the entire episode hinged on getting rights to use the song—rights that weren't secured until the last possible moment.

POP CULTURE REFERENCES

Cartman sings the theme from *Dawson's Creek* while clubbing a courier to death during his 1776 flashback.

The Continental Congress as seen in this episode is laid out in similar fashion to the musical film *1776*. Also, the townspeople's brutal hand-to-hand combat and killing is an homage to battlefield scenes from movies like *Excalibur* and *Braveheart*.

The guitar player backing Randy on the anti-war/rock side is musical icon Slash, best known as the lead-guitarist in Guns n' Roses.

Cartman's DVR box is called "TV OH!," a joke on the popular recording device TiVo.

CHARACTER DEBUTS

Benjamin Franklin and Thomas Jefferson, both of whom Cartman meets during his flashback. Norman Lear provided the voice of Franklin. We also meet several other Founding Fathers: John Hancock, John Dickenson, Stephen Hopkins, and John Adams.

POINTLESS OBSERVATIONS

At the end of the episode there's a brief mention that this is *South Park's* 100th episode. Originally "Cancelled" (page 50) was supposed to get that honor. In the big finale on stage, tons of characters from the past 100 episodes are there singing along. To name a few: Towelie, Cheech and Chong (from "Cherokee Hair Tampons"), the Marklars (from "Starvin' Marvin in Space"), Jakovasaurs, The *Star Trek* Nerds, Nurse Gollum (from "Conjoined Fetus Lady"), Jared (from "Jared Has Aides," page 12), The Thompsons (the butt-faced couple from "How to Eat With Your Butt"), Joseph Smith (he's there twice; from the upcoming episode "All About Mormons," page 72), "Halfie" (from "Chickenlover"), Scott Tenorman, David Blaine, Kathie Lee Gifford, Terrance and Phillip, Ms. Crabtree, Sally Struthers, and Professor Chaos.

Hat McCullogh, the baby-killing convict from "Free Hat" (page 28) can be seen in the crowd of pro-war rednecks, as well as onstage with the big group at the end.

There's a picture of Cartman's little cousin Elvin in his hallway, and of his grandparents in the living room. We meet them all in "Merry Christmas Charlie Manson!"

ORIGINAL SONGS

Cartman sings a heartfelt flashback tune "1776" as he rides down the old cobblestone streets of Philadelphia. Also, Randy and Skeeter's dueling rock/country ballad "I'm A Little Bit Country, I'm A Little Bit Rock 'N Roll" gives a fresh, *South Park* take on the classic song by Donny and Marie.

WHAT CARTMAN LEARNED

"This country was founded by some of the smartest thinkers the world has ever seen. And they knew one thing: that a truly great country can go to war, and at the same time, act like it doesn't want to. You people who are for the war, you need the protesters. Because they make the country look like it's made of sane, caring individuals. And you people who are anti-war, you need these flag-wavers, because if our whole country was made up of nothing but soft pussy protesters, we'd get taken down in a second. That's why the Founding Fathers decided we should have both. It's called 'having your cake and eating it too.'"

FAT BUTT AND PANCAKE HEAD

Original Air Date: April 16, 2003
Episode 705

THE STORY: Cartman wins a Cultural Diversity Day contest for his report on "the important role of Latinos in the arts." He presents a ventriloquist act—a mouth and two eyes drawn on his left fist, which he refers to as "Ms. Lopez." Ms. Lopez speaks nonstop about her love for tacos and burritos, and Cartman's presentation easily beats Kyle's vastly more well-researched effort.

Soon Ms. Lopez takes on a life of her own. She records a music video that gets the attention of the real Jennifer Lopez's record company, which decides to fire J-Lo and hire the new "girl." Naturally J-Lo doesn't take this very well. She and her then-boyfriend, Ben Affleck, turn up in South Park. She gets into a fight with Cartman's hand, while Affleck falls in love with it.

The situation rapidly deteriorates. Ms. Lopez records a successful single, then keeps Cartman up at all hours, writing songs and practicing her "dancing." Even worse, she starts a torrid love affair with Affleck. One morning Cartman wakes up to find Affleck naked in his bed, with his "spooge" all over Ms. Lopez. And to top it off, Ms. Lopez and Affleck announce that they're getting married.

Desperate, Cartman turns to the other boys for help. Stan is at least willing to entertain the idea that Cartman has gone insane, but Kyle thinks it's just another con. They turn their backs on him, leaving Cartman to deal with the situation himself. He tries to simply walk away from the mess, only to be confronted by: Record Execs threatening a lawsuit if Ms. Lopez doesn't complete her album; a love-smitten Affleck; and a chainsaw-wielding, completely insane J-Lo.

They chase Cartman onto a bridge, where Ms. Lopez reveals that she's really Mitch Conner—a con artist who, out of shame for his actions, has taken a cyanide pill. He then "dies," leaving Cartman in full possession of his left hand.

J-Lo is taken away by the police and the rest of Ms. Lopez's pursuers leave. Although he's still skeptical, Kyle admits that maybe—just maybe—"something I don't understand" happened to Cartman. Only to have Cartman point and laugh, "I got you kinda! I got you kinda!"

The real Jennifer Lopez, broke and defeated, is last seen working at a La Taco.

MEMORABLE LINES:

"Don't think because I gotta lot of money, I won't give you taco flavored kisses honey. I'm gonna fulfill all your wishes with my taco flavored kisses."
—*Ms. Lopez's song "Taco-Flavored Kisses"*

"My kisses taste like tacos."
—*Ms. Lopez*

"My name is Hennifer Lopez. I eat tacos y burritos."
—*Ms. Lopez*

"Okay, what smart-mouthed little punk-ass bitch has been saying they're the new Jennifer Lopez, huh?"
—*Jennifer Lopez*

"Mmm, just like tacos."
—*Ben Affleck after kissing Ms. Lopez*

"Awww!! Ben Affleck's spooge!"
—*Cartman*

"Don't be fooled by all my money, I still like to eat tacos honey. . . So crispy on the outside, so super good and yummy."
—*Ms. Lopez*

"Your son appears to be...completely insane."
—*Dr. Doctor*

"Mostly, I'm sorry to you, Ben. I'm sorry I played tiddlywinks with your heart."
—*Mitch Conner*

"Ms. Lopez, would you like to give Kyle a kiss?"
—*Cartman*

"Hola, bitchola!" —*Ms. Lopez*

POINTLESS OBSERVATIONS

This is actually Ben Affleck's second *South Park* turn. He first appeared in "How to Eat with Your Butt" as the long-lost son of two people with butts for faces. In that episode, he was portrayed using a cutout of the real Affleck's face—unlike this episode, in which he's fully animated.

In the front window of the "UR Da Star" music video store, there's the black top-hat/hair worn by Slash in "I'm A Little Bit Country" (page 56); on the wall are pictures of Phil Collins (from "Timmy 2000") and Elton John (from "Chef Aid" and "An Elephant Makes Love to a Pig").

J-Lo's license plate reads "SPICY"; Ben Affleck's is "AWESOME."

POP CULTURE REFERENCES

Ms. Lopez bears a strong resemblance to a fist puppet named Johnny that was created by a Spanish puppeteer and *Ed Sullivan Show* regular named Señor Wences. There was a similar puppet in the film *The In-Laws.*

In Ms. Lopez's dream sequence, we see her on the cover of three magazines: *Peeps, Belle Beauty,* and *Vague*—parodies of real magazines *People, Belle,* and *Vogue.* Later, Ben and Ms. Lopez's forbidden romance appears on the cover of *The National Inquisition,* a joke on *The National Inquirer.* The cover of the *Inquisition* also has a picture of Yoko Ono, who was last seen in "World Wide Recorder Concert."

CELEBRITIES IMPUGNED

Jennifer Lopez and her boyfriend-at-the-time, Ben Affleck. J-Lo is portrayed as a bitchy hack. While writing songs for Ms. Lopez, Cartman notes, "Your style of music is so easy, it doesn't require any thought at all!" Ben Affleck comes across as equally useless. "I've been meaning to write a song or a poem, but I have no talent," he confesses to Ms. Lopez.

BODY COUNT

Mitch Conner, the small-time grifter allegedly possessing Cartman's hand. He takes a cyanide pill and disappears into the wind.

CHARACTER DEBUTS

Ms. Lopez and Mitch Connor (the con "man" supposedly responsible for the Ms. Lopez hoax). We also meet the real Jennifer Lopez and Ben Affleck, as well as the three BHI Record Executives.

ORIGINAL SONGS

Ms. Lopez (Cartman's hand puppet) gets signed to BHI Records and records several spicy hits: "Taco-Flavored Kisses," "Run for the Border," "I Love You Ben," and "Can I Have Your Tacos?"

WHAT-THE-FUCK MOMENT

In a scene that Matt and Trey still can't believe they got past the network, Ms. Lopez gives Affleck a hand job.

WHAT MITCH CONNER LEARNED

"I've been a cheater all my life. And now I've ruined a singer's career, lost a record company millions, and cost this little boy his precious time."

WHERE DID THE IDEA COME FROM?

At the time, everyone was fed up with the Affleck/Lopez romance. Also, Matt and Trey had for a long time wanted to give Cartman a hand puppet.

LIL' CRIME STOPPERS

Original Air Date: April 23, 2003
Episode 706

THE STORY: The boys form a detective club—the South Park Junior Detectives—and set about town asking if anyone needs a crime solved, for a dollar. An old woman commissions them to find a missing cherry pie, and they develop an elaborate, bone-chilling story about how her husband planned to kill her with a hammer and dismember her corpse so he could get the pie. Turns out, the family dog stole it.

Their next case concerns a little girl named Sarah who lost her doll. While checking her room for clues, another group of kids pretending to be FBI agents storm in. Acting on the theory that fake FBI agents outrank fake local cops, they kick the boys off the case.

Undeterred, the boys vow to find the doll before the FBI kids do. They interrogate Butters, then demand that he provide a semen sample. Butters has no idea how to do this, so they explain the process and leave him in Cartman's bathroom to work things out. Then, acting on a tip, they locate the stolen doll, which Fosse and Bill are using to play "Gynecologist." Sarah's mother is so impressed by their

work that she tells the Park County Police Department, which makes the boys Junior Detectives.

Their first assignment as Junior Detectives: take down a meth lab on the outskirts of town. As soon as they arrive, the lab's occupants open fire, inadvertently killing themselves along with numerous bystanders. The takedown angers some members of the force, most of whom are corrupt. The kids are given a chance to "redeem themselves" by visiting a strip bar run by a crime syndicate. Another massive gunfight breaks out, exterminating both the crooks and the crooked cops. The boys survive the showdown unscathed.

In honor of their service, they're promoted to full Detectives. But the boys are done with police work and go back to playing "Laundromat" in Cartman's basement. Butters (who has been in the upstairs bathroom this whole time) bursts in to tell them that after two days of relentless masturbation, he was finally able to produce a semen sample by thinking about Stan's mom's boobs.

Cartman asks if he'd like his pants cleaned for $4.95.

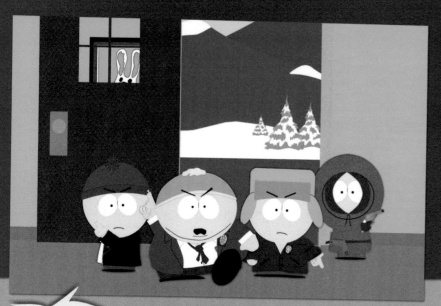

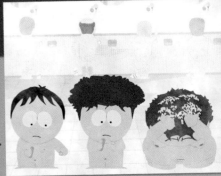

MEMORABLE LINES:

"Now go sit on the toilet and tug on your wiener until white stuff comes out, then put it in this cup."
—*Cartman*

"We're going to need semen samples from everything in this room."
—*Cartman*

"Cover me! I'm going slo-mo!" —*Cartman*

"I'm pullin' on my wiener, but nothing's happening."—*Butters*

"I don't know how they do things down at that dog and pony show they call the fourth grade but here we have rules!"
—*Lt. Dawson*

"Hey, Broflovski's a good cop!"
—*Cartman*

"Oh my God! What kind of television have you kids been watching?!" —*Old Lady*

"I was up there poundin' my wiener for two days straight and then I finally thought of Stan's mom's boobs and this little tiny splooch of white stuff came out!"—*Butters*

BODY COUNT

Numerous criminals, several cops, and boat-loads of innocent bystanders are killed in practically every way possible—guns, car crashes, plane crashes, explosions, and fire.

CHARACTER DEBUTS

The pretend FBI kids, who try to out-muscle the boys' detective agency, and Sarah Peterson, the five-year-old girl who lost her dolly.

Lieutenant Dawson, with the Park County Police, as well as a few other crooked cops on the force. We also meet the assorted strippers and staff of the nudey club "Peppermint Hippo." The Elderly Couple who proposition the boys with their pie mystery also make their debut. They will make several cameos in future episodes, including in "Grey Dawn" (page 68).

NUDITY ALERT

We actually get to see all the boys naked when they "hit the showers" in the police locker room. This also gives us a pretty good view of a hoodless Kenny (from behind).

WHERE DID THE IDEA COME FROM?

The episode was done just at the time the television series *CSI* was taking off. It also has its origins in Matt and Trey's youth, when both actually started their own pretend detective agencies.

POINTLESS OBSERVATIONS

Gino, the mob-boss owner of the strip club, states that he is going to "start having the McKormicks make our meth again"—possibly a reference to Kenny's family.

After Stan demands he's in charge of the investigation, he's told, "Not any more you're not!" by the fake FBI Agent kid. This same line will be used later in this episode, as well as repeatedly in "The Snuke," where FBI and other government agencies try to out-rank one another.

This is the first time we see Fosse's (the scraggily-haired kid) house; Fossie and Bill are, as usual, playing games and calling things "gay."

POP CULTURE REFERENCES

The boys' elaborate descriptions of how they think events unfolded mirrors the bloody flash-backs so common on *CSI*. Their relationship with Lieutenant Dawson and the "crooked cops" also gives a nod to many cop action movies, such as *Lethal Weapon* and *Beverly Hills Cop*. Cartman and Kenny play "good cop, bad cop" while interrogating Butters—another police tactic made popular by these films. We learned in "Toilet Paper" (page 54) that Butters is quite susceptible to admitting guilt, even when innocent.

"The Peppermint Hippo"—the skanky strip club where the boys are sent undercover—is a parody of the famous strip joint Spearmint Rhino. The boys will visit it again with Chef in "The Return of Chef" (page 148).

WHAT CARTMAN LEARNED

"Kenny, it doesn't go 'Pakew! Pakew!', it goes 'BANG BANG BANG!'"

61

RED MAN'S GREED

Original Air Date: April 30, 2003
Episode 707

THE STORY: The boys visit the Three Feathers Casino with Kyle and Stan's parents. While the boys are off watching a Native American comedian, the adults go to gamble away their money. Kyle's dad, we discover, has a terrible gambling problem, and proceeds to lose $26,000—most of which came from a line of credit he put up his house to obtain.

Meanwhile, the casino's Native American owners are buying up all of South Park so they can level it and use the land to build a superhighway to bring in more gamblers from Denver. In order to stop this travesty, the town needs to raise $300,000 to buy back the town and thwart the plan.

The boys come up with a desperate scheme: Take the paltry $10,000 the townspeople managed to raise, place it on a single roulette number and hope for a win, which would produce a $350,000 payout. The adults take the advice, bet everything on 31 black, and win. But seeing the potential for even more profit, Kyle's dad convinces the others to "let it ride." The townsfolk leave all their cash on

31 black, and lose everything on the next spin.

The next day, South Park's citizens line up to get checks for their homes. The boys, infuriated, decide to stand in front of the Indians' bulldozers. Soon the rest of the town joins their protest, effectively blocking the entrance to South Park. The Native Americans counter by giving the locals SARS-infected blankets, making everyone sick except Stan. He's sent to find a wise man so he can go on a "spirit journey" by inhaling paint thinner. During this journey, Stan learns that SARS can be stopped by the middle class elixir: Campbell's Chicken Noodle Soup, DayQuil, and Sprite.

Meanwhile, Chief Runswithpremise (the owner of Three Feathers Casino) learns that his own son, Premiserunningthin, has SARS. When he sees that the South Park residents are getting better, he asks if they'll provide the cure for his son. They do, and his son regains his health. Their kindness makes him have a change of heart, and the Chief spares the town.

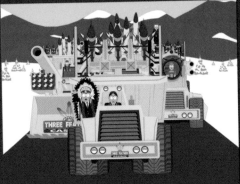

MEMORABLE LINES:

"Everyone grab a Chinese person and rub them on a blanket!"
—*Chief Runswithpremise*

"Oh, shove the song of the sparrow up your ass!"
—*Kyle's dad*

"I've got it you guys! We can get Kyle infected with AIDS! And then start a charity organization that we steal money from! Come on, let's go!"
—*Cartman*

"Their cash flows out of them like diarrhea from the buffalo." —*Blackbear*

"The spirit of middle-class white people is strong in you, Stan."
—*Stan's dad*

"I'm not a miner, dumbass. You see a shovel in my hand?"
—*Cartman*

"We grew up here. Our parents grew up here. We shop at that Wall Mart and eat at that Chili's. We take fish from the streams and bread them and freeze them to make fish sticks. This is not just a town, it is our way of life."
—*Stan*

"You shouldn't be such a dick, dude."
—*Cartman*

"Sorry Charlies! You can just keep your filthy bastard Indian money."
—*Mr. Garrison*

"When the Indians come to tear up our town, we kick 'em in the nuts!"
—*Cartman*

"Stanley, listen to me... I have SARS...There's only a 98 percent chance that I will live."
—*Stan's dad*

WHERE DID THE IDEA COME FROM?

A role reversal story in which Native Americans steal from white people presents lots of comedic opportunities.

CHARACTER DEBUTS

Chief Runswithpremise, leader of the Three Feathers Casino, and his son, Premiserunningthin—as well as Johnny Manymoons, the Native American stand-up comedian. And making his single-episode cameo is Alex Glick, the lucky kid who won the Season 7 Contest to be animated into the show.

POINTLESS OBSERVATIONS

While the boys are reminiscing, a video montage plays showing all the "great times" they've had in South Park: the zombie attack from "Pink Eye"; the Trapper Keeper monster destroying the town from "Trapper Keeper"; the mutant turkey battle from "Starvin' Marvin in Space"; Christopher Reeve throwing a car at Gene Hackman from "Krazy Kripples" (page 52); the giant fireworks snake that torched the town in "Summer Sucks"; the Knights of Standards and Practices fighting the evil dragon from "It Hits the Fan"; the town being destroyed by Pirate Ghosts from "Korn's Groovy Pirate Ghost Mystery"; the anti- and pro-war townspeople brawling from "I'm A Little Bit Country" (page 56); the townspeople killing one another in a Civil War reenactment from "The Red Badge of Gayness"; Mr. Hankey burying South Park with human feces from "Chef's Chocolate Salty Balls"; and the Mecha Streisand battle royale from "Mecha Streisand."

Kyle's dad admits he has a gambling problem. Unfortunately, a bit too late—he'd already gambled away their house, which is then totally demolished by the Native Americans.

At the town meeting discussing the Native American buyout of South Park, all the residents are gathered—including Towelie, who can be seen in the crowd.

POP CULTURE REFERENCES

When South Park's residents block the bulldozers sent to level the town, they do so while singing the Pat Benatar song "Love Is a Battlefield."

This episode came out during the height of the SARS "pandemic," which lasted from November 2002 to July 2003. SARS is a contagious respiratory disease that originated in China.

When Chief Runswithpremise offers blankets as a "sign of peace," Mr. Garrison says, "You had me at free blanket." This is a parody of a popular quote from the movie *Jerry Maguire*.

WHAT ALEX GLICK LEARNED

"Well, I guess we all learned that South Park is more than just a town. It's a community that nobody can split up."

SOUTH PARK IS GAY

Original Air Date: October 22, 2003
Episode 708

THE STORY: Kyle arrives at the bus stop to discover that Stan, Kenny, and Cartman are all dressing and acting like "metrosexuals" (highly-stylish, highly-effeminate straight men). They immediately take Kyle to the mall for a full makeover, so he can "fit in." However, Kyle's parents are less than excited about the new look. His dad heads over to Stan's house to talk about the issue, only to find all the South Park men are now dressing as metrosexuals and watching *Queer Eye for the Straight Guy*.

When the boys go to school, they're stunned to see that they aren't the only ones who are stylishly dressed. Every boy in the school has jumped on the metrosexual bandwagon. When Kyle tells Chef that he still isn't sold on metrosexuality, he's advised to be himself instead of what's cool. So Kyle abandons the trendy clothes and is promptly rejected by his friends.

Mr. Garrison is equally disturbed. All the straight men are acting gayer than him. He's no longer special. Enraged, he and Mr. Slave decide to fly to New York and murder the cast of *Queer Eye for the*

Straight Guy. Tortured on the playground and abandoned by his friends because he won't give in to peer pressure, Kyle has the same idea. The bloodthirsty trio run into each other on the subway and, after a brief argument over who will strike the first blow, decide to work together.

But their plan is thwarted when they learn that the *Queer Eye* guys aren't really gay . . . or even human. They're a race of subterranean Crab People who plan to turn all human males metrosexual, then take over the world. Kyle, Mr. Garrison, and Mr. Slave are taken prisoner and forced to watch as *Queer Eye for the Straight Guy* does a makeover of the President.

Suddenly, South Park's women (who are fed up with their newly effeminate husbands) burst into the studio and bludgeon the *Queer Eye* guys to death, inadvertently revealing their true Crab People identities. Stunned, the network's president vows to end the gay fad and, in its place, revive the Latin fad.

MEMORABLE LINES:

"Craig's trying to say that his dad can out dress you!"
—*Stan*

"Dude, I can't wait for Wendy to see how gay I look!"
—*Stan*

"Nice jacket, Kyle! Polyester is really the hot fabric this fall."
—*Cartman*

"My grandpa was Bi! So that makes me quarter Bi!"
—*Cartman*

"Chef, what did you do when white people stole your culture?"
—*Mr. Garrison*

"When the chicks at school see how gay we are, they're gonna be all over us!"
—*Cartman*

"We're here—We're not queer—But we're close—Get used to it!!"
—*Boys' chant during the Pride Parade*

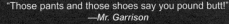

"Those pants and those shoes say you pound butt!"
—*Mr. Garrison*

"When all the world is metrosexual, the Crab People can finally reign supreme!"
—*Kyan, of the Crab People*

WHERE DID THE IDEA COME FROM?

The story sprang from a discussion among the writers about how far things had come since "Big Gay Al's Big Gay Boat Ride" was broadcast. At the time, Big Gay Al was shocking and groundbreaking. But by 2003, gay culture was entirely mainstream.

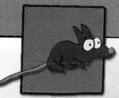

BODY COUNT

The five-member cast of *Queer Eye for the Straight Guy*.

CELEBRITIES IMPUGNED

The *Queer Eye* gentlemen, whom Mr. Garrison accuses of selling out their own culture.

CHARACTER DEBUTS

The Crab People, which Matt calls "probably the worst idea that we've ever had." They were inserted as a sort of "placeholder" in the script, until something a bit more refined could be developed. In the end, they decided to stick with the crustaceans.

ORIGINAL SONGS

Deep beneath the earth's crust, we are treated to the ominous, booming "Crab People" chant.

POP CULTURE REFERENCES

A few real TV shows are mentioned in this episode: *Boy Meets Boy* and *Will and Grace*. Also, at the end of the episode the Network Executive says, "I should have known they were Crab People. They tried this before with *The Jeffersons*."

The Metrosexual Pride Parade is an obvious nod to the Gay Pride Parade. The men and boys chant, "Out of the malls and into the streets!" and "We're here! We're not queer! But we're close! Get used to it!!"—both parodies of popular slogans used by Queer Nation in support of gay culture.

Cartman's shirt has a black-and-white image of pop icon Marilyn Monroe on it.

"All Things (Just Keep Getting Better)," the techno-pop song by Widelife (featuring Simone Denny), plays over both of Kyle's makeovers. This is also the real theme song to the *Queer Eye* TV show.

POINTLESS OBSERVATIONS

The stores at the mall shown during the makeover—"Forever 16" and "Marcy's"—are parodies of the all-too-real mall fixtures, Forever 21 and Macy's.

When Kyle refuses to go metro, Cartman pulls the boys aside, "We have no choice, you guys. We're just gonna have to kill Kyle." This is the same exact solution he proposes earlier in the season when he's scared Kyle will rat them out in "Toilet Paper" (page 54). He also proposes killing Kyle via explosives in the upcoming episode "Grey Dawn" (page 168).

WHAT STAN'S MOM LEARNED

"You see, at first we liked having our men be clean and neat. We thought that having them use product in their hair and wanting facials would make them sexier. But it doesn't."

CHRISTIAN ROCK HARD

Original Air Date: October 29, 2003
Episode 709

THE STORY: The boys' garage band Moop hits a creative wall—they can't seem to find their musical direction. Cartman suggests they form a Christian rock band (so they can get rich). The boys kick him out of the band. Pissed, he bets Kyle that his Christian band can make a platinum album first. Cartman then enlists Token to play bass (even though he's never touched one in his life) and Butters to play drums. They call their band "Faith +1."

Meanwhile, Stan, Kyle, and Kenny download songs off the internet to find a sound for their group. They're immediately arrested by the FBI for music piracy and given a crash course in the "evils" of free downloading. They become so violently opposed to the process that their band goes on strike until free downloading stops.

Cartman, on the other hand, busily writes songs for his Christian band. By simply replacing words like "baby" and "darling" with "Jesus," he masters the craft of Christian songwriting. Soon his group is signed by a major record label and becomes a huge success.

Meanwhile, Metallica hears about Moop's refusal to play and joins them—along with a host of other big-name acts. As the strike drags on, Kyle gets a letter from Cartman informing him that Faith +1's album has officially gone platinum. Kyle realizes he's been so busy trying to protect his music that he neglected to create any. He and Stan announce that their group is about art rather than cash and that they're abandoning the strike. The other big-name artists, who are just in it for the money, decline to follow suit.

Kyle has no choice but to admit Cartman won the bet and pay him $10. The next day, Cartman hosts a lavish award ceremony to honor Faith +1. In front of the entire town, however, Cartman learns that the Christian Recording Industry hands out "myrrh" albums to million-selling artists, not platinum. On this technicality, Kyle refuses to pay up. Cartman goes berserk, smashes his award, and shouts "F*** Jesus!"—ending his Christian rock career on the spot. Token beats him up and then Butters farts on his head and flips him off.

MEMORABLE LINES:

"Butters, remind me later to cut your balls off." —*Cartman*

"Token, how many times do we have to go through this? You're black. You can play bass." —*Cartman*

"This is the best day of my life." —*Cartman*

"I wanna get down on my knees and start pleasing Jesus! I wanna feel his salvation all over my face!" —*Cartman*

"Relax and enjoy, black asshole." —*Cartman*

"This is the worst day of my life." —*Kyle*

"Haven't you guys ever seen an album cover? You're supposed to be standing in random places, looking away like you don't care!" —*Cartman*

"I want to walk hand in hand with Jesus on a private beach for two. I want him to nibble on my ear and say 'I'm here for you'." —*Lyrics to Faith +1 song*

"First one to have a platinum album wins. GO!"—*Cartman*

"PS—Nya nya nya nya nyaaa nya, ha ha ha ha haaa ha." —*Cartman's letter to Kyle*

"I'm going to kill you one day, Token."—*Cartman*

"We're just about the money." —*Britney Spears*

WHERE DID THE IDEA COME FROM?

This episode sprang from Matt and Trey's longtime dream of cutting a Christian rock album that sounded legit, unless you listened to the lyrics very closely. If you did, you'd realize the songs weren't about loving Jesus, but about having a love affair with Jesus. They even planned to call it Faith +1.

CHARACTER DEBUTS

Sergeant Yates, a leading officer at the Park County Police Department. He will become a main fixture in the crime-solving department in future episodes, such as "The Jeffersons" (page 94) and "Miss Teacher Bangs A Boy" (page 166). We also meet pop star Britney Spears for the first time here. She will get her own special episode with "Britney's New Look."

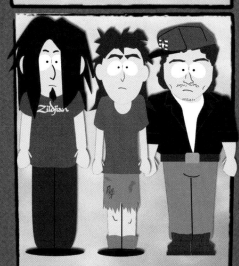

CHARACTER RETURNS

The Lords of the Underworld, Timmy's band from "Timmy 2000," can be seen striking along with other major artists at "Strikeapalooza."

ORIGINAL SONGS

Moop kicks off the episode with their screetchy, awful "Summer Time." We also get a healthy dose of Faith +1's catalogue: "Needing You," "Don't Ever Leave Me Jesus," "When You Are Gone," "I Wasn't Born Again Yesterday," "Start Pleasing Jesus," "The Body of Christ," "Three Times My Savior," "Up On That Cross," and their breakout hit "Jesus Baby."

POINTLESS OBSERVATIONS

When describing their musical influences, we learn: Kyle's a fusion guy, Kenny's background is more Latin jazz, and Stan is more Hip Hop and R&B oriented. Cartman, on the other hand, just likes money.

The Faith Records building is modeled after the iconic Capitol Records building in Los Angeles.

POP CULTURE REFERENCES

When the FBI agents lecture Stan and Kyle about the evils of free downloading, they state that rapper Master P's son won't get his own island in French Polynesia for his birthday. It's a parody of a scene in A Christmas Carol, which foreshadows the possible death of Tiny Tim.

Cartman describes Christian Rock music as "the easiest, crappiest music in the world to write," further backing it up with: "it worked for Creed." Also, the Christian rock band Sanctified is bedazzled with various religious symbols made to look "hardcore," including the ever-popular "Jesus Fish" with a pierced nose.

A number of famous musicians join Moop's "Strikeapalooza": Metallica; Alanis Morissette; Britney Spears; Blink 182; Master P and his family; Missy Elliot (seen briefly in "Cancelled," page 50); as well as Rancid, Meatloaf, Ozzy Osbourne, and Rick James (all previously featured in "Chef Aid"). Although they're not shown picketing, the boys also illegally download some Stevie Wonder and Judas Priest. And in their most trying moment, Kyle urges his band members to "fight through the hard times like Journey."

CELEBRITIES IMPUGNED

Performers who complain about free downloads don't get much love here. When FBI agents show Kyle and Stan examples of the "carnage" downloading causes, we see Britney Spears having to trade down from a Gulfstream IV jet to a Gulfstream III, and Lars Ulrich, the drummer from Metallica, forced to refrain from installing a gold-plated shark tank bar next to his pool.

WHAT KYLE LEARNED

"People are always gonna find a way to copy our music and swap it for free. If we're real musicians, then we should just play and be stoked that so many people are listening."

GREY DAWN

Original Air Date: November 5, 2003
Episode 710

THE STORY: During a memorial service at the South Park Farmer's Market for nine people who were killed when they were run over by an elderly woman driver, an old man loses control of his car and decimates the crowd of mourners. Shortly thereafter, an old couple searching for a Country Kitchen Buffet runs off a bridge and manages to kill a fisherman in the middle of a river. The rising body count causes the state DMV to consider suspending the licenses of people over 70.

The seniors don't take kindly to this attack on their rights, and hold a mass meeting at the Park County Community Center to plan their response. When the meeting lets out, the resulting wave of elderly drivers sends the town into a panic. The senior drivers kill another 14 pedestrians and rack up $3 million in property damage as they head home.

The DMV pulls the old people's licenses. However, Stan's grandpa doesn't get the memo. He's arrested for driving illegally and thrown in jail.

Furious, he contacts the American Association of Retired Persons (AARP) for help. But instead of sending lawyers or social workers, the organization sends a huge paratrooper army of old people to take South Park by force. The AARP announces that if the seniors don't get their licenses back (plus more Medicare and a ban on kids who skateboard on the sidewalk), they'll start killing hostages.

The boys escape into the forest to start a resistance movement. Cartman suggests they cut off the old people's food supply by shutting down their favorite restaurant, Country Kitchen Buffet. They infiltrate the eatery and lock the doors from the inside. Within hours, the elderly force collapses from hunger. The Army reclaims the town and frees its citizens.

The Marsh family realizes that, even though lots of people died, they all learned something. Namely that Stan's dad should stop treating his own father like a child, and that Grandpa Marsh needs to stop killing people with his car.

"Get off the streets! Get off the streets! Old people are driving!"
—*Stan's dad*

"Dude, I hate my family."—*Stan*

"Old people have gone mad!!"
—*Cartman*

"They've tried to stop them, son, but the seniors get up so early in the morning—they get everything done before anybody else is even awake."
—*Stan's dad*

"Kiss my sagging ass!"—*Grandpa Marsh*

"I am sick of having my mental condition come into question!"
—*Old Woman*

"I'm not fat, I just have a sweet hockey body."
—*Cartman*

"You just try taking me to jail, scrotum head! You just try!"
—*Grandpa Marsh*

"We'll start off by sneaking into town, cleverly disguised as black people."
—*Cartman*

MEMORABLE LINES:

"Now. . .can anybody remember what we're pissed off about?"
—*Grandpa Marsh*

"Mrs. Ryland, seniors are taking over the town. Would you like a gun?"
—*Old Woman in Nursing Home*

"Guys, I don't know if I ever told you this, but, well, I love you guys. Except for you, Kyle."
—*Cartman*

"Looks like Stan's dad's been hittin' the bottle again."
—*Cartman*

"Statistically speaking, we're safer inside the car with an old person driving, than outside."
—*Kyle*

BODY COUNT

Countless souls run over by careless elderly drivers and gunned down by the AARP. Also a number of elderly folks who died of starvation after the Country Kitchen Buffet was padlocked.

WHERE DID THE IDEA COME FROM?

The story was inspired by a horrific 2003 incident in which an elderly man drove his car through a farmer's market in Santa Monica, California, killing 10 people. Also, Trey said, "We kind of wanted to make a show that just kind of ripped on old people."

POP CULTURE REFERENCES

The AARP invasion and its aftermath are lifted from the 1984 Cold War–era film *Red Dawn*. Also, when an old guy says, "You can take our licenses but you'll never take our pride," it references a similar line in the 1995 film *Braveheart*.

The scene (and the accompanying music) in which the lone fisherman in Stark's Pond is killed by a pair of elderly drivers is a parody of the classic film *Jaws*. Also, there's a nod to the fright-flick *Friday the 13th*—when Randy and the boys are running through the spooky old house, they open a door only to find a dead, slashed-up body.

CELEBRITIES IMPUGNED

Mr. Garrison explains to his class that Genghis Khan was a "Mongol"—not a "mongoloid"—like the actor Nicolas Cage.

WHAT GRANDPA MARSH LEARNED

"I guess sometimes us seniors need to know when to stop driving so we don't put the responsibility on our families."

POINTLESS OBSERVATIONS

The plot pivots on a restaurant franchise called "Country Kitchen Buffet," which serves as the seniors' unofficial meeting place. This is a parody of the restaurant chain Old Country Buffet, which is popular among the elderly. Cartman states that when a restaurant was closed in a nearby town, the entire population of seniors quickly starved.

Cartman says, "Mostly hippies go to farmer's markets. Mostly." This is an homage to the line "They mostly come at night. Mostly." from the horror flick *Aliens*. Cartman also used this line in "Cat Orgy."

Lastly, Grandpa Marsh's first name is revealed to be Marvin.

CASA BONITA

Original Air Date: November 12, 2003
Episode 711

THE STORY: For his birthday, Kyle is allowed to invite three of his friends to go with him to Casa Bonita, a Disneyland-esque Mexican restaurant in Denver. To Cartman's dismay, Kyle decides to take Stan, Kenny, and . . . Butters.

Cartman tries to wrangle an invitation by being nice to Kyle, but Kyle bluntly points out that Cartman doesn't really know how to be nice. Finally, after Cartman makes a sincere-sounding apology for his previous acts, Kyle reluctantly tells him that if Butters can't go for some reason, he can take his place.

This is, of course, the opening Cartman needs. He convinces Butters that Earth is about to be struck by an asteroid and gets him to hunker down in Jimbo's old bomb shelter while he gets help.

With Butters out of the picture, Cartman heads to Kyle's house for their Casa Bonita adventure. But just as the boys are about to leave, Butters' parents show up worried, saying their son has gone missing. Kyle cancels the trip for one week in order to help with the search.

Cartman must now keep Butters under wraps for another seven days. He convinces Butters that the asteroid struck and destroyed the town. Butters agrees to stay in the bomb shelter until the radiation levels go down. Cartman tells him he can come out in a week.

When the volunteers expand their search area to include places like abandoned wells and bomb shelters, Cartman quickly moves Butters to a derelict gas station and seals him inside an old refrigerator—which is promptly hauled off to the dump. Butters manages to free himself and, mistakenly thinking the dump is the blasted remains of South Park, sets about "rebuilding society."

A full week passes, and Cartman finally accompanies Kyle, Stan, and Kenny to Casa Bonita. But just before they enter, the police call Kyle's mom to inform her that Butters has been found, and that they want to talk to Cartman. Cartman panics—he runs inside the restaurant to hurriedly take advantage of all the joys that Casa Bonita has to offer before he's arrested.

Finally the police catch up to him. Before he's hauled away, he's asked if all the grief he's caused—not to mention the week-long stint in juvenile hall he'll have to serve—was worth it. To which he replies, "Totally."

MEMORABLE LINES:

"Well ma'am, I guess we should get started repopulating the Earth, huh?"
—*Butters*

"Boy, that meteor sure did make everything stinky."
—*Butters*

"I'm sorry we had that fight just now. You know, I mean, I said some things, you said some things, but I think it was good and we've moved past it."
—*Cartman*

"Oh God, I hate cannibals!"
—*Butters*

"Kiss my balls asshole!"
—*Cartman*

"Eric, you're the best friend in the whole world. I. . .I love you."
—*Butters*

"You look so delicious! Must eat your brains!!"
—*Cartman*

"Maybe he caught a disease and died. That'd be so awesome."
—*Cartman*

"Oh God, he's eating my hand like a piece of chicken!"
—*Cartman*

"That's not being nice! That's just putting on a nice sweater!"
—*Kyle*

"Do you really think that beating up a handicapped kid is being nice?"
—*Kyle*

"Pray, Butters. Pray for all mankind."
—*Cartman*

ORIGINAL SONGS

Cartman performs a snippet of his Mexican ode to "Casa Bonita."

WHERE DID THE IDEA COME FROM?

The story revolves around an actual Lakewood, Colorado eatery called Casa Bonita, where Trey and Matt both dined as kids. It's still open today, and the ownership was gracious enough to allow *South Park* to use its real name. Pretty much everything mentioned in the episode, from indoor cliff diving on a fake waterfall to Black Bart's cave, is actually there.

POINTLESS OBSERVATIONS

In this episode, we learn that Butters' first name is "Leopold." We also learn that The Studcat Theater, the male-themed cinema frequented by Butters' father in "Butters' Very Own Episode," is located across the street from Casa Bonita.

When Cartman denies that he's ever ripped on Kyle for being Jewish, we are treated to a montage of previous shows in which he's done just that. A few notable clips are from: "Cartman Gets an Anal Probe," "Mr. Hankey's Christmas Classics," "Fun With Veal" (page 18), and "Lil' Crime Stoppers" (page 60).

Wellington Bear, that happy, smiling bear we see on a lot of the boys' toys and clothes, really makes an appearance in this episode. Cartman is seen with a Wellington Bear calculator, alarm clock, pajamas, and stickers. On the Casa Bonita calendar in Cartman's room, there are also stickers of Chinpoko Mon and Terrance and Phillip.

POP CULTURE REFERENCES

Twice during his ordeal, Butters sings the Chicago song "If You Leave Me Now." He will sing this again in future episodes. Also, before Cartman locks him in the refrigerator, he gives him a bag of Chips-A-Ho Cookies—an obvious reference to the Chips Ahoy brand.

Jimmy attempts to tell a knock-knock joke about Ingmar Bergman, the iconic Swedish director and writer, but before he gets to the punch line, Cartman punches him.

The outfit Butters wears while "rebuilding" in the dump is reminiscent of that seen in the post-apocalyptic movie *Mad Max 2: The Road Warrior*. During the rebuilding process, Butters makes sure to include his favorite chain restaurants, although he's not sure whether he wants it to be a P.F. Chang's or a Bennigan's.

WHAT KYLE LEARNED

"I should have known better! You never cared about my birthday at all!"

71

ALL ABOUT MORMONS

Original Air Date: November 19, 2003
Episode 712

THE STORY: A new student named Gary Harrison joins the boys' class. In addition to being a good student and mind-numbingly nice, Gary and his family are Mormons. Sick of Gary's do-good attitude, the boys nominate Stan to kick his ass. But instead of fighting, Stan winds up accepting an invitation to dinner at Gary's house.

Stan is stunned by the Harrison's "Family Home Evening," in which they tell stories, play music, sing, and most tellingly, share scriptures from the *Book of Mormon*. There's even a lengthy, dramatic retelling of the story of Joseph Smith, the church's founder.

Stan goes home and shares what he's seen with his own family. His dad, believing that some sort of cult is trying to indoctrinate his son, storms off to the Harrison home to kick ass. Instead, he too is disarmed by their kindness and hospitality. After hearing the highly improbable story of how Joseph Smith came to write the *Book of Mormon* (accompanied by flashbacks and a musical score that consists mostly of "dum dum dum dum dum"), Randy returns home to announce that he's invited the Harrisons over for dinner—and that, more importantly, the Marsh family is converting to the Mormon religion.

The other boys soon make fun of Stan's new buddy-buddy relationship with Gary. The Marshes proceed to have the Harrisons over for their first "Family Home Evening." Stan's dad says he's having a crisis of faith, which prompts Mr. Harrison to tell him the "best" part of the Joseph Smith story, which allegedly "proves he wasn't making everything up." It's the tale of how publisher Martin Harris and his skeptical wife Lucy (accompanied on the soundtrack by "smart, smart, smart") conveniently "lost" the first translation of the golden plates, to see if Smith could provide a word-for-word duplicate. . .which he could not.

Stan loses his temper over the absurdity of it all, stating that it's ridiculous to believe in something without proof. The Harrisons, unbothered, assert that their views are a matter of faith, and agree to disagree with the Marshes about it.

The only one who seems truly irritated is Gary. The next day at the bus stop, he tells Stan and the other boys that while his religion may not be strictly "true," it helps him and his family live good lives. Finally, he tells Stan to "suck my balls."

MEMORABLE LINES:

"You were supposed to kick his ass, not lick his butthole!"
—*Cartman*

"Hi! My name's Ura. Ura Fag."
—*Cartman*

"All you've got are a bunch of stories about some asswipe who read plates nobody ever saw out of a hat and then couldn't do it again when the translations were hidden!"
—*Stan*

"That does it! From now on, our family is Mormon!"
—*Stan's dad*

"Well, it looks like I don't have a class full of retards anymore, doesn't it children?"
—*Mr. Garrison*

"This Mr. Harrison is a—a white guy, right?"
—*Stan's dad*

"He's a pecker-face, that's what he is!"
—*Butters*

"Damn, that kid is cool, huh?"
—*Cartman*

"My brother is a stupid turd."
—*Shelly*

ORIGINAL SONGS

The Harrison kids all pick up instruments and jam out a brief bit of their original song "I Love My Family." Also, Joseph Smith's creationist tale of the *Book of Mormon* is told throughout the episode with the help of the song "Dum Dum Dum Dum Dum."

WHERE DID THE IDEA COME FROM?

Trey knows a lot about Mormonism, both through his work on the film *Orgazmo* (where he plays one) and the fact that his high school girlfriend was Mormon. "Every Mormon I know is a really good person," he says. However, just like any other religion, it gets harder to accept the closer you study it.

MORMON CULTURE REFERENCES

Many fans thought that the segments explaining the Mormon faith were outrageous fabrications cooked up by Matt and Trey. But every bit is a faithful representation of Mormon beliefs. Even "Family Home Evening" (a fun-and-games-and-religion evening for the whole family) is a real, weekly activity sanctioned by the Church of Mormon.

POINTLESS OBSERVATIONS

During Gary's family home evening, his brother Mark performs a bit of Shakespeare's *Hamlet.*

Gary gives Stan a homemade leather wallet, with a picture of Denver Broncos' quarterback John Elway carved into the front. Elway has been mentioned repeatedly throughout the series, dating all the way back to "Cartman's Mom's A Dirty Slut."

CHARACTER DEBUTS

Gary Harrison and his family: Mr. and Mrs. Harrison, his brother Mark, sister Jenny, little brother Dave, and baby sister Amanda—all perfect specimens of human kindness. We also meet a number of people essential in the foundation of the *Book of Mormon*. Most importantly, Joseph Smith.

POP CULTURE REFERENCES

Gary's family plays a board game called "Living," which is a parody of the classic board game Life. When Stan's family is sitting around watching TV, Shelly yells, "Shut up, Turd! We're watching *Friends*!" This is not the first time Shelly has displayed her affection for the sitcom; she forcefully puts it on in "Cat Orgy."

After returning from Gary's house, Sharon asks Randy, "So how'd it go, Clubber Lang?" Clubber Lang was the name of Rocky's rival (played by Mr. T) in the film *Rocky III.*

WHAT GARY LEARNED

"The truth is, I don't care if Joseph Smith made it all up, because what the church teaches now is loving your family, being nice, and helping people. And even though people in this town might think that's stupid, I still choose to believe in it."

BUTT OUT

Original Air Date: December 3, 2003
Episode 713

THE STORY: The boys watch an incredibly lame anti-smoking assembly put on by a group called "Butt Out," which ends with the group proclaiming, "If you don't smoke, you can grow up to be just like us!" Horrified at the prospect, Stan, Kyle, Kenny, and Cartman immediately head outdoors to light up. When Mr. Mackey surprises them, they toss their cigarettes into a dumpster, causing a fire that burns down the school. Instead of blaming the kids, the angry parents blame the tobacco companies—a view that the boys are happy to support.

Film director and smoking opponent Rob Reiner is called in to help stop the alleged spread of smoking among South Park's children. He preaches about the unhealthiness of the habit with the zealotry of an old-time prohibitionist—all while guzzling cheeseburgers and other junk food. In fact, he's so obese that he has to butter himself up just to squeeze out of his own limo.

Cartman develops a severe case of hero worship for Reiner, but the other boys are suspicious—especially when he tries to use them in his plan towards getting public smoking banned in Colorado.

To accomplish this, Reiner dresses as a woman (named "Rita Poon") and takes the boys on a tour of Big Tobacco Co., where he snaps a picture of the boys and then Photoshops cigarettes into their hands. But the smoking ban doesn't pass, and he is forced to take more severe measures.

Reiner asks if one of the boys would star in an anti-smoking commercial; Cartman immediately accepts. However, Cartman soon learns that his role in this commercial is lethal—he's playing a victim of secondhand smoke that's dying of cancer. And, in order for the commercial to really work, Reiner says he has to die. The anti-smoking group tries to achieve this by giving him a poison cupcake.

Cartman escapes and, along with the other boys, takes sanctuary in the tobacco factory. Soon it's surrounded by angry, torch-wielding citizens. Reiner inadvertently reveals his murderous intentions, turning the locals against him. When Cartman stabs him with a fork, massive amounts of "goo" pour out of the wound, killing Reiner. The boys admit they smoked of their own free will, and are finally grounded for burning down the school.

MEMORABLE LINES:

"I just know where this is heading. It's gonna end up with the whole town taking this too far, and us having to talk about what we learned to change everyone's minds, and I say we just stop it RIGHT NOW and go play cards or something."—*Kyle*

"BUTTER! BUTTER!"—*Rob Reiner*

"Wow, it's like, smoking brings a lot of people just a little bit of joy—and you get to take that away from them. You are so awesome."—*Cartman*

"For two billion dollars I'd handle my grandpa's balls, sir."—*Cartman*

"Oh my God! What kind of backward, hick state is this?!"—*Rob Reiner*

"Oh, I get it, Kyle. That's your Serbian Jew Double Bluff."—*Cartman*

"Dude, he just goes around imposing his will on people. He's my idol."—*Cartman*

"This seems like another one of those times when things are going to get way out of hand, you know? It's been happening a lot lately."—*Kyle*

"If you don't smoke, you can grow up to be just like us!"—*Butt Out*

"My goo! My precious goo!"—*Rob Reiner*

"That's nones the cool!"—*Butt Out*

"Smoking's bad, mkay."—*Mr. Mackey*

BODY COUNT

Rob Reiner, who we learn is made entirely of goo. Plus, a Big Tobacco worker who's thrown over the railing during Reiner's escape from the cigarette factory.

WHERE DID THE IDEA COME FROM?

Matt and Trey were severely irritated by Reiner's crusade for stricter public smoking laws in California. Ironically, Trey says that the Reiner classic *This Is Spinal Tap* had a huge influence on him.

POINTLESS OBSERVATIONS

Reiner's plan to sneak into a cigarette factory, photograph the boys there, then Photoshop cigarettes into their hands follows the elaborate hoaxing formula used in the MTV show *Punk'd*. In fact, just before he flees after taking the picture, he shouts, "You've just been Reiner'd!"

Throughout the episode, Kyle is very self-aware of the familiar story arc that's unfolding, saying "This is all following a formula!" Right from the beginning, he suggests that the boys just come clean and admit their guilt—instead of letting things get way out of hand and then having to fix the problem by convincing the town what they learned. At the end of the show, Stan even says to Kyle, "Well, I guess we learned our lesson." To which Kyle replies, "No we didn't, dude. No we didn't."

CHARACTER DEBUTS

Rob Reiner, and his team of anti-smoking henchmen (aka the Smoke Stoppers).

POP CULTURE REFERENCES

Cartman's commercial, in which he says he got terminal cancer from secondhand smoke, is a parody of an advertisement Yul Brynner did years ago. Also, the tobacco factory workers sing and dance like the Oompa Loompas from *Willy Wonka and the Chocolate Factory*.

ORIGINAL SONGS

The motivational group "Butt Out" sings their self-titled intro song, as well as the beatboxing rap breakdown. Also, the *Willy Wonka*-esque "Cigarette Song" is performed wonderfully by the entire staff of Big Tobacco Co.

CELEBRITIES IMPUGNED

Rob Reiner is portrayed as an overweight hypocrite, preaching about the dangers of secondhand smoke while stuffing himself with fatty, fried foods.

WHAT KYLE LEARNED

"You just hate smoking, so you use all your money and power to *force* others to think like you. And that's called fascism, you tubby asshole!"

RAISINS

Original Air Date: December 10, 2003
Episode 714

THE STORY: When Stan's longtime girlfriend Wendy breaks up with him, he goes into a state of severe depression. The other boys try to cheer him up by taking him to a restaurant called Raisins, whose wait staff is composed entirely of pre-teen girls dressed in skimpy, Hooters-esque outfits. The visit fails to lift Stan's spirits, but Butters falls in love with a Raisin girl named Lexus.

Meanwhile, Stan tries to patch up his relationship with Wendy. He first tries having his friends talk to her. When that doesn't work, he goes to Wendy's friends for help. Bebe suggests he stand outside her window and play a Peter Gabriel song, but he makes the ineffective choice of "Shock the Monkey." Even worse, when Wendy comes to the window, she's accompanied by Token.

Stan's mood worsens, and his dark, pain-filled outlook on life lands him in good standing with the school's clique of Goth kids. Stan joins their group, dressing in black and taking on the alias "Raven."

At the same time, Butters' constant visits to Raisins to see Lexus exhausts his cash supply. His parents are delighted about his new "girlfriend" because it means he isn't gay (his father actually won a bet with his mother over this). They take him to Raisins so they can meet his "girlfriend," only to discover the sad, ugly truth—she's just flirting with him to get his money.

Butters doesn't believe it. He stands by Lexus, who finally spells out the true nature of their relationship—or rather, their lack of one. Crushed, he withdraws from society just like Stan. The Goth kids invite him to join their group, but he declines, saying that even though he's sad, the very fact of his sadness makes him feel alive and vital. Stan agrees, ditches the Goths and returns to his life.

The next day he's back to normal—so back to normal that when Wendy and Token walk by, he calls her a bitch and gives Token the finger.

MEMORABLE LINES:

"I'm nine years old, dude! If I don't work things out with Wendy I could be alone my whole life."
—Stan

"Wendy breaks up."
—Bebe

"Our son hasn't learned yet that girls will pretend to like him for money."
—Butters' dad

"Oh yeah, well at least we HAVE assholes you dumb girl!"
—Butters

"If you want be one of the nonconformists, all you have to do is dress just like us and listen to the same music we do."
—Goth Kid

"You see, Butters, women know that they can make men do anything by flirting. And some girls, like these, turn that into a profession."
—Butters' dad

"You guys! I think our Raisins girl likes me!"
—Butters

"Life is pain. Life is only pain."
—Goth Kid

"There is darkness all around me. Deep, piercing black I cannot breathe. My heart has been raped."
—Goth Stan

"Why don't you go back to your Justin Timberlake and your homework you conformist asshole."
—Hairflip Goth Kid

"I'm not gonna live in a third world country with all the conformists."
—Goth Kid

WHERE DID THE IDEA COME FROM?

Matt and Trey liked the idea of a Hooters parody featuring younger girls, but couldn't figure out how to work the concept into the show. Then they remembered that guys who want to cheer up a friend who's broken up with his girlfriend always wind up at Hooters.

POP CULTURE REFERENCES

The episode offers a well known assortment of classic rock hits, including Cinderella's "Don't Know What You Got (Till It's Gone)"; Air Supply's "All Out of Love"; the Village People's "Y.M.C.A."; James Brown's "Living in America"; and Peter Gabriel's "Shock the Monkey."

Raisins is an obvious parody of Hooters, right down to the skimpy clothing and endless chicken wings. We even get a glimpse of the Raisins girls' "training": acknowledge any customer within 5 feet, giggle a lot and show off your raisins, sit down at the table while taking the order, and most importantly, provide the customers with physical contact. All of this ensures better tips.

The Goth Kids all drink coffee at Benny's, a parody of the chain restaurant Denny's.

Henrietta, the chubby Goth girl, complains that her parents, "Won't let her go to the Skinny Puppy show because her heroin addict aunt is coming over." She is apparently a big fan of this Canadian industrial rock band, as evidenced by the "Skippy Puppy" poster on her bedroom wall. She also has a "Blauhaus" poster, a reference to the gloomy English rock band Bauhaus.

In a display of his adorably innocent charm, Butters invites Lexus to come over so that the two can watch *The Exorcist* on DVD. Sadly, she declines.

POINTLESS OBSERVATIONS

Bebe's suggestion that Stan win Wendy back by playing a Peter Gabriel song beneath her window parodies the 1989 film *Say Anything*. Unfortunately for Stan, instead of selecting the Gabriel ballad "In Your Eyes" (as John Cusack did in the movie), he went with "Shock the Monkey."

Wendy becomes Token's girlfriend in this episode.

Stan's goth alter-ego "Raven" (complete with his "Nevermore" shirt) is an homage to American author and poet Edgar Allan Poe. His shirt even has a black and white portrait of him.

Butters' parents are elated at the prospect of their son dating a girl. In fact, his father wins a $10 bet off his wife, "You see, I told you he wouldn't turn out gay!" Mr. Stotch was caught in a gay bath house in "Butters' Very Own Episode" and will again discuss being bi-curious in "Cartman Sucks."

WHAT-THE-FUCK MOMENT

Stan, trying to win Wendy back, asks stuttering Jimmy to tell her she's "a continuing source of inspiration" to him. Jimmy walks up to Wendy and stammers, "Stan says you're a cont . . . you're a cont . . . Stan says you're a cont . . . cont. . . ." To this day, Trey and Matt can't believe the network let them get away with it.

CHARACTER DEBUTS

The conformist-hating Goth kids make their first appearance. Since this episode, they've reappeared a number of times, most notably in "You Got F'd in the A" (page 90) and "The Ungroundable."

The Raisins girls also make their debut.

WHAT BUTTERS LEARNED

"I'd rather be a cryin' little pussy than a faggy Goth kid."

IT'S CHRISTMAS IN CANADA

Original Air Date: December 17, 2003
Episode 715

THE STORY: The Broflovski's Chanukah celebrations are cut short when a Canadian couple named Harry and Elise Gintz appear at their front door, claiming to be Ike's birth parents. Even worse, they demand that Ike (whom they call "Peter") be returned to them. Horrified, Kyle's family takes the Gintzes to court. But the American court upholds the law created by Canada's new Prime Minister and the Gintzes take Ike back with them to Canada.

The loss devastates Kyle's parents. Kyle desperately tries to get the boys to go to Canada with him to retrieve Ike, but they're so engrossed in Christmas preparations that they refuse. However, when South Park's adults decide to give the money they were going to use for their family's Christmas gifts to the Broflovskis, the boys change their tune. Cartman is furious at Kyle, whom he threatens to beat up.

Kyle suggests that if they go to Canada and talk to the new Prime Minister, they can get Ike back in time to save Christmas. They book a flight on City Airlines (owned by City Wok owner Tuong Lu Kim) for "sixty-two dorra," which gets them four seats on a decrepit Cessna 432G, piloted by Lu Kim himself. The plane craps out over Canada and Lu Kim bails out, leaving the boys to crash land the plane.

The plane smashes into the ground, and the boys emerge into a colorful Canadian world, eerily similar to *The Wizard of Oz*. The Canadians speak in rhymes, dance, and act like Munchkins. They also meet Scott the Dick, who tells them they aren't welcome in Canada and will never get Ike back.

The boys start down Canada's one and only road in an effort to reach Ottawa, where the Prime Minister resides. En route, they pick up a Mountie riding a sheep (because the P.M.'s new laws took his horse away); a French-Canadian mime who wants to appeal a law banning the drinking of wine; and Steve, a Newfoundland resident who's angry that sodomy's been banned. They're also hounded by Scott the Dick, who follows their every move.

The rag-tag group finally reaches Ottawa and confronts the Prime Minister, who appears as a gigantic holographic head. As Kyle pleads his case, Scott the Dick shows up with Ike and his birthparents, intent on foiling the plan. The Prime Minister states that *all* his laws will remain in force forever, then incinerates Kenny with death beams from his eyes.

Stan pulls back a mysterious curtain to reveal none other than Saddam Hussein, crouched over the console that controls the holographic head. Saddam is quickly taken away and all his laws are declared null and void. The Gintzes have a change of heart and return Ike to Kyle.

But not everyone is happy. Cartman announces that it's officially Christmas Day and they're all still in Canada, without presents. Furious, he tries to kick Kyle's ass. Kyle halfheartedly punches him in the nose and Cartman immediately starts crying.

The Canadians hold a gigantic Christmas parade with the boys as honored guests, riding on Santa's sleigh. But Stan is still a bit sad, because having to spend all this time in Canada made him miss out on any chance of having a Christmas adventure.

MEMORABLE LINES:

"This is Canada! We only have one road!"—*Canadian*

"Excuse me. . .is this an invasion?"—*Canadian Doctor*

"It wasn't enough for you people to kill Jesus, now you have to kill Christmas too, huh?"
—*Cartman*

"It's Christmas day . . .and I'm in Canada."
—*Cartman*

"Mr. Garrison, every Christmas you suggest we get rid of all the Mexicans, and every Christmas we tell you no!"
—*Mayor McDaniels*

"This is it, Kyle. You and me. We're throwing down, right now!"
—*Cartman*

"Changing your mind is a Canadian custom we hold quite dear."
—*Harry Gintz*

"Canadian Christmas, it's the best! We drink and dance and show our breasts!"
—*Canadians*

"Well, I didn't want to say anything, Kyle, but maybe this is what your family gets for being Jewish at Christmas time."
—*Cartman*

"We know you have a choice of airlines, and it looks like you made the wrong one."
—*Tuong Lu Kim*

"Don't mind that guy hiding in the spider hole, that's just my friend."
—*Saddam Hussein*

"Please sit back, relax, and enjoy your shitty flight."—*Tuong Lu Kim*

BODY COUNT

Kenny. He gets killed for the first time since returning to life in "Red Sleigh Down" (page 44).

WHERE DID THE IDEA COME FROM?

Saddam Hussein was caught the Sunday before this episode aired, providing the perfect ending to the story. It was the seventh season's final reference to events in Iraq. "I think you could really call this the Iraq war season," Trey said.

POINTLESS OBSERVATIONS

This episode gives us a nice glimpse of the Broflovski's celebrating the first night of the Jewish holiday, Chanukah. We learn a good amount about Canada here: There is only one road in the entire country, their cars and bicycles have square wheels (as do most things), and that their country was devastated during the infamous Cola Wars.

Some popular Christmas toys in South Park this year: Sprinkle Time Make Your Own Marshmallow Factory, the John Elway Doll with Karate Chop Action, and the 2001 Okama Gamesphere (as seen in "Towelie").

CHARACTER DEBUTS

Harry and Elise Gintz, Ike's biological parents. We also meet Rick, the proud Canadian Mountie; the French Canadian Mime; and Steve, the "Newfie."

POP CULTURE REFERENCES

The boys' visit to Canada is an extended parody of *The Wizard of Oz*, with Saddam Hussein serving as The Great Oz, Scott the Dick as the Wicked Witch of the West, and the boys playing the role of the protagonists (Dorothy, Tin Man, Scarecrow, and the Lion). A few Canadian songs even parody music from the classic film.

ORIGINAL SONGS

After crash-landing in Canada, the boys are treated to the joyful "Canada Friends Loves You." As their journey continues, the boys are treated to more *Oz*-like tunes: "Follow the Only Road," "French Canada," and finally, "Canadian Christmas."

CELEBRITIES IMPUGNED

Saddam Hussein, who was both captured by Canadian forces and lampooned yet again on *South Park*. This was the second time during the series that he tried to take over Canada, the first being in "Not Without My Anus." For this episode, animators even used a new picture of Saddam post-capture (with full beard), instead of his old clean-shaven look.

WHAT KYLE LEARNED

"Family isn't about whose blood you have in you, family is about the people who cared about you and took care of you. We're not the same blood, but I love my little brother. We've taken care of him because he needed us to, and *that* makes us more family than anything."

CHARACTER RETURNS

Scott the Dick, last seen in Season 2's "Not Without My Anus," makes his mean-spirited Canadian return. Much like last time, he plays the American-hating villain.

SEASON 8

E801: Good Times With Weapons

105.16

105.18

Sc		BG

Sc	Pn	BG

walk up.

⑩

Match poses

Location/Time

Dialogue

STAN
Hello, Craig!

CARTMAN
LOOOOOK at what WEEEE got!

Ⓐ Cartman walks up to the foreground waving his weapon

REVERSE to show the boys, looking South Park style too. Still in the same positions.

Trans.

⑨⓪

Location/Time

Dialogue

CRAIG
Where'd you get those?

Action/Efx

③⑦

Trans.

Craig looks obviously en

Cartman sai hands

: Good Times With Weapons

105.12 cont. 801

105.

STAN
t tell you where we got 'em.
cret ninja stuff.

CARTMAN
that jealously I see in your
raig? MMMmmm yes... drown me
sweet wate your envy.

194

The boys
with thei

Trans

Stan Tonfa hands

GOOD TIMES WITH WEAPONS

Original Air Date: March 17, 2004
Episode 801

THE STORY: The boys find Japanese martial arts weapons at the local Park County Fair. They buy them and immediately fantasize that they are anime-style ninjas. The ninjas go out looking for trouble. They find it in the form of Butters, who transforms into an imposing anime of Professor Chaos and challenges them to a fight. An epic battle rages on, with the kids pretending to trade blows—until Kenny gets carried away and zings a definitely-not-pretend throwing star into Butters' left eye.

The kids panic. Butters desperately needs medical attention, and even worse, their parents might find out what they did. They don't want to risk discovery by taking Butters to the local hospital, so instead they disguise the bleeding, semi-conscious Butters as a dog and attempt to take him to a veterinarian. But on the way, they're confronted by Craig, Jimmy, Clyde, and Token, who've purchased their own martial arts weapons and are deep into their own anime fantasy. They challenge the boys to a fight.

The "Legendary Battle of Tokugata" ensues. During this mayhem, Butters stumbles off unnoticed. He eventually makes it to the hospital, wanders into the emergency room and collapses. Unfortunately, Dr. Doctor mistakes him for a dog and sends him to

the city pound, where he's scheduled to be euthanized. Butters manages to escape just in time.

Finally, the battling boys notice Butters' absence and search for him frantically. To cover their tracks, they go back to the fair to try to return their weapons. But on the way, Craig reports that Butters has been spotted wandering around near an auction that's being held on the fairgrounds.

In an effort to show off another of his ninja abilities (this time his "power of invisibility"), Cartman volunteers to sneak past the auction crowd and intercept Butters. He removes all of his clothes and slowly inches his way across the auction platform—totally naked—in full view of the stunned audience. Moments later, Butters himself stumbles onto the stage and collapses.

An angry town meeting follows, with the citizens all enraged at what they'd just seen. To their relief, Stan, Kyle, and Kenny realize that the adults don't care about what happened to Butters. All that matters to them is that Cartman "flashed his penis"—which is labeled by the parents as "the worst thing that's ever happened in this town." The boys happily throw Cartman to the wolves and get away unpunished—still in possession of their weapons.

WHERE DID THE IDEA COME FROM?

The concept of turning the boys into ninjas was developed during a writer's retreat in Jackson Hole, Wyoming. Drawing the boys as muscular assassins, but having them speak in their normal kids' voices, turned out to be comedy gold.

BEHIND THE SCENES

The animation team only had a week to create convincing anime versions of Stan, Kyle, Kenny, Butters, and Cartman. Even worse, as this episode was being prepared, Matt and Trey began serious production work on *Team America: World Police*, which was a comedy/action film that used marionettes instead of human actors. Pulling this off turned out to be even more difficult than it sounds.

CELEBRITIES IMPUGNED

Cartman, explaining his nudity at the auction, states that he had a "wardrobe malfunction," just like Janet Jackson during the Super Bowl XXXVIII halftime show.

POINTLESS OBSERVATIONS

This is the second time we've seen Cartman naked, the first being in "Lil' Crime Stoppers" (page 60). Even with all the crazy things that have happened in South Park, Kyle's dad says that Cartman flashing his penis was, "the worst thing that's ever happened in this town. The worst thing!"

The boys' ninja weapons and anime aliases are pretty deadly: With his Tonfa of Takanawa, Stan is the great and powerful Shadow Hachi. Kyle's powerful nunchucks make him into Bunraku. Harnessing the power of his Sai, Cartman becomes Bulrog, a tough, brute ninja that's dedicated his life to eradicating hippies. And with his Shuriken Star, Kenny becomes the deadly, not-so-creatively-titled Ninja Master Kenny. We also see that Craig is Ginza, with the powerful Blade of Kintama, and Token is Black Chaku, with the killer power of perfect spelling.

This episode features the infamous scene where Butters is forcefully dressed up like a dog (with a ninja star in his eye). The scene where he is repeatedly peed on and pooped on by other dogs is perhaps equally as notorious.

BODY COUNT

Nobody dies, but Butters gets pretty seriously injured and comes precariously close to being put down by animal control.

CHARACTER RETURNS

Sparky, Stan's gay dog. He was introduced in the 1st season classic "Big Gay Al's Big Gay Boat Ride" and was last seen briefly in Season 5's "Proper Condom Use." Here, he is shaved in order to obtain the hair for Butters' disguise.

POP CULTURE REFERENCES

When the guy at the fair says he can't sell to minors without their parents' permission, the boys burst into tears and tell him their parents are dead. The same plot device was used by the children in the 2004 film *Millions*. After they do this, Stan says, "God damn, that's like the twelfth time that's worked."

In glowing terms, Cartman references Mel Gibson and his feature film *The Passion of the Christ*, saying to Kyle: "Mel Gibson says you are snakes and you are liars. And if the Road Warrior says it, it must be true." Later in the episode (when challenging Kyle to throw away the nunchucks he paid money for), Cartman references Gibson again, saying: "Go ahead. Prove Mel Gibson wrong." This won't be the last time Cartman mentions *The Passion* (see the upcoming episode: "The Passion of the Jew," page 88).

ORIGINAL SONGS

The ninja-tastic "Let's Fighting Love" plays over the epic battle royale between the two warring factions of anime-boys. This tune is an homage to classic Japanese pop tunes, which often incorporate sections of nonsensical English.

WHAT STAN LEARNED

"I guess parents don't give a crap about violence if there's sex things to worry about."

UP THE DOWN STEROID

Original Air Date: March 24, 2004
Episode 803

THE STORY: Jimmy and Timmy are training to participate in the Special Olympics in Denver. When Cartman discovers that the event's top athlete gets $1,000, he decides to fake a disability and win the cash.

In order to pass as "disabled," Cartman trains in classic *South Park* fashion—with a montage. Backed by the song "Push It to the Limit," he practices making stupid faces, gives himself a horrendous haircut, starts wearing a bicycle helmet at all times, and carefully studies the behavior of kids riding the "short bus." He even convinces his mom to accompany him when he signs up to participate.

Meanwhile, Jimmy decides to improve his chances by juicing up on steroids. Soon he outperforms everyone—but at a terrible price. First, he's shamed when Timmy discovers what he's doing. Then, in a fit of 'roid rage, Jimmy beats up his girlfriend and his mother.

However, when game day comes, all that juicing helps Jimmy dominate the Special Olympics competition. Things don't go so well for Cartman, however. Though he possesses no mental or physical disabilities, he's so fat and out of shape that he's soundly beaten in every event.

Jimmy claims first place at the awards ceremony, while Cartman, who came in last, is given a "spirit award" and a gift certificate to Shakey's Pizza. But when he steps forward to claim his prize, Jimmy furiously accuses him of cheating—and then realizes the irony of one cheater accusing another. He confesses to using steroids, renounces his medal, and promises to return next year to compete "with honor."

Cartman, attempting to salvage the situation, tells his friends that he pretended to be disabled just to teach Jimmy about the evils of steroid abuse. Not surprisingly, no one buys it.

MEMORABLE LINES:

"You sure you weren't masturbating, Jim? It's okay if you were." —*Jimmy's father*

"Taking steroids is just like pretending to be handicapped at the Special Olympics." —*Jimmy*

"You guys' brains just can't compute complex plans like mine can." —*Cartman*

"I can't believe they exploit handicapped people like this. I mean, making them compete against each other just for our amusement." —*Cartman*

"What are you gonna do, Kyle, tell on me?! Then you'd be a great big no good double faced poopy pants tattle tale. Is that really how you deal with your problems? Grow up, Kyle." —*Cartman*

"You try to leave me and I'll kill you, bitch." —*Jimmy*

"I should kick your ass right here you lousy no good cheater!" —*Jimmy*

"Um, mommm. Would you mind coming with me to sign up for the Special Olympics so I can beat all the handicapped kids and win a thousand dollars?" —*Cartman*

"I just want a chance to change. Help me change?" —*Cartman*

"Cartman, if you do this, I really believe that you will go to Hell." —*Kyle*

CELEBRITIES IMPUGNED

At the end of the episode, as Jimmy rants about the immorality of athletes who take steroids, he's flanked by Major League Baseball players Mark McGwire, Barry Bonds, and Jason Giambi, all of whom have either been accused of, or admitted to, using performance-enhancing drugs. Also, when Cartman studies the behavior of the mentally disabled, he briefly watches a Kid Rock video.

WHERE DID THE IDEA COME FROM?

For years Matt and Trey toyed with the notion of Cartman sneaking into the Special Olympics, but the concept didn't seem strong enough to carry an entire show. Adding the steroid abuse angle gave them enough meat to make an episode.

POINTLESS OBSERVATIONS

We see the kids playing the "Investigative Reports with Bill Kurtis" board game—last seen in Season Four's "Cartman Joins NAMBLA."

Timmy adds a new word to his vocabulary in this episode: "Jimmy."

Although he was originally introduced as Jimmy Swanson in "Krazy Kripples" (page 52), Jimmy's last name from this point forward is "Valmer."

POP CULTURE REFERENCES

The episode's title is a satire of the novel/play/movie *Up the Down Staircase*. Also, when Jimmy goes into a 'roid-induced rage and beats up his girlfriend and mom, the scene is a reference to a similar moment in the 1992 movie *Lorenzo's Oil*, in which the protagonist (who takes steroids to battle a rare disease) punches his mother. Furthermore, Paul Engemann's song "Push It to the Limit," which plays while Cartman perfects his "retarded" act, is from the film *Scarface*.

On the wall in Cartman's bedroom, there's a poster of Mel Gibson from the film *Braveheart*. He also has Clyde Frog, MegaMan, and Rumper Tumpskin on his shelf. In Jimmy's bedroom, there's a poster for *The Six Billion Dollar Man*, a parody of the 70s SciFi television show *The Six Million Dollar Man*.

Cartman again mentions Mel Gibson's film *The Passion of the Christ*, saying that if Kyle had seen the film, he would know "that hell is reserved for the Jews and all those who don't accept Christ." He goes on to say that it is him who is worried about Kyle's soul.

CHARACTER DEBUTS

Nathan, the steroid pusher, and Nancy, Jimmy's girlfriend.

WHAT JIMMY LEARNED

"I know now that even if you do win on steroids, you're really not winners. You're just a pussy; you're just a big fat pussy. And if you take steroids, the only decent thing to do is come forward and say, 'Remove me from the record books, because I am a big, stinky, pussy, steroid-taking jackass.'"

THE PASSION OF THE JEW

Original Air Date: March 31, 2004
Episode 804

THE STORY: The boys are playing *Star Trek* outside of Cartman's house. While exploring the "foreign planet," Captain Cartman has Kyle immediately "eaten" by an imaginary space monster. Not wanting to be killed off, Kyle gets into a heated debate with Cartman. . .which quickly turns sour. Referencing the Mel Gibson-directed film *The Passion of the Christ* (which he's seen 34 times), Cartman claims that everyone hates Jews because they killed Jesus—and that if Kyle wants the real story, he should see *The Passion of the Christ*.

Kyle does indeed watch the film, and is appalled by the violent, bloody killing of Jesus. He tells Cartman—to his near-orgasmic delight—that he was right. Energized by this victory, Cartman prays before a poster of Mel Gibson and solemnly vows to spread the word about his film.

Stan and Kenny also see the film and are appalled for different reasons—they think it sucks and want their $18 back. However, they're told that if they want a refund, they'll have to take it up with Mel Gibson himself. Thoroughly pissed off, Stan and Kenny do just that. They take a bus to the actor's Malibu home and confront him in person . . .only to realize he's completely insane. He's also a sadomasochist, and tells the boys he won't return their cash even if they torture him—which he demands they do.

When the boys refuse, Gibson starts chasing them with a gun. They spot his wallet on a table, retrieve their $18 and flee to the bus station. But Gibson commandeers a tanker truck and pursues them.

Back in South Park, Cartman forms a Mel Gibson fan club that's filled with earnest adults interested in spreading *The Passion of the Christ's* message. They seem oblivious to the fact that Cartman (who's dressed in a Nazi-like uniform) is spreading a different message—extermination of the Jews. The clueless group holds a rally in front of the local theater, then marches through the streets while chanting anti-Semitic slogans in German. The crowd thinks they're speaking Aramaic.

Cartman's rally passes the local synagogue, where Kyle has astounded the congregation by suggesting that Jews should officially apologize for the crucifixion of Christ. The members of the local Jewish community (who want *The Passion of the Christ* removed from the theater) confront Cartman and his followers. Suddenly the bus carrying Stan and Kenny arrives, pursued by Gibson's tanker truck, which crashes into the theater and explodes.

Gibson emerges unscathed and launches into an insane rant that ends with him smearing his own feces on a building and imploring shocked onlookers to torture him. Seeing Gibson in his true form causes Cartman's followers to scatter, and Kyle's feelings of Jewish guilt quickly vanish.

MEMORABLE LINES:

"If I knew where Mel Gibson was, I'd be down on the floor licking his balls at this very moment, sir."
—*Cartman*

"No! Don't form an angry mob! The last time we did that we killed Jesus!"
—*Kyle*

"Leave it to a child to show us all the way, huh?"
—*Man at a Passion meeting*

"Stereotyping Jews is terrible!"
—*Jewish Woman*

"I feel so much better about being Jewish now that I see Mel Gibson is just a big whacko douche."
—*Kyle*

"Bitch don't call me a bitch, I'll pop your fucking head open."
—*Cartman*

"Well go ahead. I just sure hope you don't use those whips over there on the wall."
—*Mel Gibson*

"So you DO intend to torture me, huh? Go ahead!"
—*Mel Gibson*

"Ooh, Aramaic! Cool!"
—*Ticket Guy*

"Hail, Mel Gibson."
—*Cartman*

"This is America, and in America if something sucks, you're supposed to be able to get your money back!" —*Stan*

"That wasn't a movie, that was a snuff film!"
—*Stan*

"Have I been a good boy, Mr. Gibson?!"
—*Cartman*

"Oh, my nipples are so tender! Don't squeeze them anymore!"
—*Mel Gibson*

"Sweet, now I can just play with myself."
—*Cartman*

"Come on Kenny, we're going to Malibu!"
—*Stan*

WHERE DID THE IDEA COME FROM?

Matt and Trey knew that *The Passion of the Christ* was coming out, and went round and round trying to figure out how to handle it. They finally settled on the idea that Gibson, who includes graphic torture scenes in a disturbing number of his movies, was some sort of sadomasochist.

CHARACTER DEBUTS

Mel Gibson. Just like Saddam Hussein, he's portrayed using an actual photo of the actor's head. He'll return in "Imaginationland: Episode I," again complaining about his tender nipples.

CELEBRITIES IMPUGNED

Mel Gibson gets the royal treatment here—he's portrayed as an insane, unstable wacko with a weakness for torture and nipple-pinching. Also, Kyle has a horrific *Passion*-inspired dream filled with bloody images of Christ's death. . .and one quick picture of M*A*S*H star Alan Alda.

POP CULTURE REFERENCES

Stan tells Kenny they're going to get their money back because it's about "being able to hold bad filmmakers responsible." He goes on to add, "This is just like when we got our money back for *BASEketball*." This is a joke on the 1998 film starring Trey and Matt.

This episode begins with the boys playing *Star Trek* in Cartman's mom's minivan (aka "Shuttle Craft Spontaneity"). Their ranks are: Captain Cartman, 1st Officer Stan, engineer Kenny, and Vulcan Jew Kyle.

POINTLESS OBSERVATIONS

This is the second episode (after Season One's "Pinkeye") in which Cartman dresses as Hitler.

Mel Gibson's wild, cartoonish antics are similar to those employed by Daffy Duck in the classic animated show *Looney Tunes*.

Cartman gets a taste of his own medicine here, with Mel Gibson pooping all over his face. Butters met a similarly stinky fate in "Good Times With Weapons" (page 84), after the boys dressed him up as a dog and he wound up in an animal shelter.

MEL GIBSON MOVIE REFERENCES

Numerous allusions are made to Gibson's movie catalogue. His shout of "Give me back my money," references his 1996 movie *Ransom*. Later he shouts "Freedom!" and paints his face with blue streaks—an homage to 1995's *Braveheart*. Cartman also prays to a picture of Gibson in his full *Braveheart* garb. Finally, he chases the boys in a tanker truck similar to the one featured in 1981's *Mad Max 2: The Road Warrior*. Gibson even lifts a quote from that movie, "Two days ago I saw a rig that could haul that tanka. You wanna get outta here? You talk to me!"

Obviously, there are also tons of *The Passion of the Christ* references throughout, including recreations of Jesus' torture done *South Park*-style. Cartman even gets specific about the film's stats, "Three hundred million domestic box office, Kyle. The top grossing film of all time, Kyle. Those numbers don't lie."

WHAT STAN LEARNED

"If you wanna be Christian, that's cool, but you should follow what Jesus taught instead of how he got killed. Focusing on how he got killed is what people did in the Dark Ages and it ends up with really bad results."

YOU GOT F'D IN THE A

Original Air Date: April 7, 2004
Episode 805

THE STORY: The boys are playing outside with their remote controlled cars when a group of kids from Orange County show up and "serve" them with some hot dance moves. Not knowing what to do, the boys turn to Chef. It turns out the "serving" was more severe than the boys thought. Chef kindly encourages them to relax, then sadly informs the boys' parents about what's happened.

Stan's dad is pissed that his son didn't "dance back" when challenged, and teaches him a few moves of his own. The next day, the OC kids confront the boys with another "serving"—but this time, Stan "serves" them back (to the tune of "Achy Breaky Heart").

Temporarily defeated by Stan's superior dance moves, the OC kids tell them "it's on" and challenge them to a dance-off that Saturday: South Park's five best dancers vs. the OC kids. Feeling responsible for the heightened stakes, Stan's dad goes and tells the other team's dance coach that his son won't participate. But the coach "serves" Randy so severely that he is hospitalized.

Now Stan is also burdened with avenging his father's humiliation. He assembles a dance squad from the thin local pickings: a Goth kid (who participates in this horrifically "conformist" dance-off because doing so would be the height of non-conformity); a kid who dances really well in videogames (but not in real life); and a waitress from Raisins named Mercedes.

This leaves them one short of a five-person team. Mercedes suggests they talk to the state's champion tap dancer . . . a kid named Leopold Stotch. Realizing she's talking about Butters, Stan asks him to join. But at the very mention of tap dancing, Butters has a meltdown and runs away, leaving the fifth slot to be filled by a dancing duck named Jeffy. Chef tries to coach them, but it's soon obvious that, barring a miracle, they're screwed.

Desperate, Stan once again approaches Butters. It is here we learn that Butters has a terrible secret: during the National Tap Dance competition two years earlier, Butters' shoe flew off, triggering a series of events that killed eight people (actually 11, as Stan points out, because one of the victims was pregnant and two relatives of the victims committed suicide shortly thereafter). Stan tells Butters to put the tragedy behind him, but once again Butters won't listen.

The night of the dance-off, Jeffy the duck sprains his ankle, leaving South Park without a full squad. Just as the team contemplates forfeiting, Butters shows up and saves the day. Unfortunately, during his dance solo, his left shoe flies off his foot and into the rafters. It knocks a light loose, triggering a series of mishaps that kills the entire OC crew, plus their coach.

With their competition dead, the South Park team is declared victorious. The kids, screaming with joy, carry off Butters (who's screaming in horror) on their shoulders.

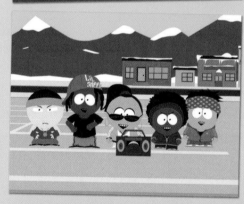

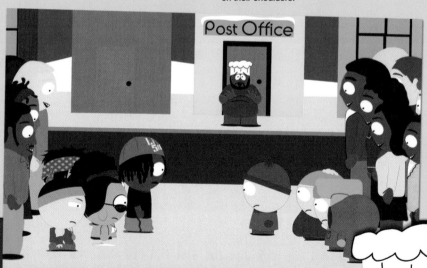

MEMORABLE LINES:

"You just got SERVED!"
—OC Kid

"If you get served and serve them back, then it's on! Don't you know anything?!"
—Chef

"Stanley, when somebody challenges you to dance, you have to dance back at them."
—Stan's dad

"I'm such a non-conformist that I'm not going to conform with the rest of you."
—Goth Kid

"I'm sorry, Stan. I'm not a dancer anymore...I gave that up."—Butters

"You have the heart and the soul. . .you just don't have the talent."—Chef

CHEF

WHERE DID THE IDEA COME FROM?

Matt and Trey decided to take on "dance movies" after seeing *You Got Served* at a theater in South Central L.A. The film sucked, but the audience was literally dancing in the aisles.

BODY COUNT

The eight . . . make that eleven . . . people killed during Butters' National Tap Dancing Championship accident. Also, the five OC dancers and their Coach, killed by yet another Butters' tap dancing atrocity.

CELEBRITIES IMPUGNED

The Goth kids say that they won't dance "like those Britney and Justin wannabes at school." Also, rapper Lil' Kim attends the OC/South Park dance off—she's about one foot tall and has breasts the size of her whole body.

POP CULTURE REFERENCES

After Stan gets "served," Randy tries to give his son some square-dancing pointers—which he does to the tune of "Achy Breaky Heart" by Billy Ray Cyrus.

The dance-videogame *Dancin' Dancin' Dancin' Machine* is a parody of the videogame *Dance Dance Revolution*, which was enormously popular around the time this episode was released.

In the dance studio where Stan and his crew are practicing, there are posters on the wall for *Felines* and *Le Cirque du Soleil*, parodies of the dance-filled shows *Cats* and *Cirque du Soleil*.

POINTLESS OBSERVATIONS

The episode parodies various dance-intensive movies, including 2000's *Bring It On* and 2001's *Save the Last Dance*. Its namesake, however, is 2004's *You Got Served*.

"The Goth Dance," as described by the Goth kids, is performed by "keeping your hands at your sides and your eyes on the ground. Then every three seconds, you take a drag on your cigarette." As these non-conformists show us, it's the only cool way to dance.

Two of the people Stan recruits to be on South Park's dance team—Mercedes and the Goth Kid—may look familiar; both were introduced in last season's episode "Raisins" (page 76).

Butters was the Colorado Tap Dancing State Champion in 2002. He also went to the National Championship in Nebraska that year, but things didn't quite work out.

Butters is playing with "Leggos!" in his room, building a mini-town. This playtime activity is an obvious nod to the iconic LEGO toys.

ORIGINAL SONGS

There's a lot of tasty tunes in this episode: The hip-hop, dance beat "Let's See You Dance" provides the soundtrack for many harsh "servings." There's also the hot rap joint "You Can't Step," which the kids attempt to "step" to. And Jeffy the duck gets country to the fiddle tune "You Do a Line."

Also, Butters sings his little ditty "Loo Loo Loo, I've Got Some Apples," which will reappear in several future episodes (including "Stupid Spoiled Whore Video Playset," page 106). Lastly, there's the instant-classic "I've Got Something In My Front Pocket For You," to which Butters tap-dances his heart out.

CHARACTER DEBUTS

The OC kids and their ultra-supportive "serving" Coach. We also meet Jeffy, the dancing duck, and Yao, the Asian kid who's an expert at videogame dancing.

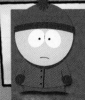

WHAT STAN LEARNED

"Someday you're gonna have to stop running from what happened and start dealing with it. Otherwise you might as well move to France with all the other pussies."

AWESOM-O

Original Air Date: April 14, 2004
Episode 802

THE STORY: Butters finds a box on his front porch containing the AWESOM-O 4000—an advanced automatron sent from Japan to serve as his personal robot. Even though everyone else clearly sees that AWESOM-O is just Cartman dressed in a crummy cardboard outfit, Butters suspects nothing of his new robot friend.

He proceeds to give his new "buddy" a bonanza of embarrassing personal information—including the fact that he has a "hesitated colon" which occasionally causes him to poop his pants. He also reveals that he possesses a videotape of Cartman dressed up like Britney Spears, dancing and making out with a Justin Timberlake cutout.

Stunned, Cartman has no choice but to stay in character until he finds that tape. Since he's supposed to be Butters' servant, he lugs around his laundry and even inserts medicinal suppositories in his anus. That night, as Butters sleeps, Cartman tosses his room in a desperate, fruitless search for the video. But he cannot find it, and he's forced to continue serving Butters.

Thinking Cartman and their son have become great friends, Butters' parents invite AWESOM-O to go on a trip with Butters to visit his relatives in Los Angeles. Once there, they go sightseeing all around town, eventually ending up at Catamount Pictures. Two movie executives see Butters with AWESOM-O

and mistakenly think they can program the robot to come up with movie ideas.

Over the next week, Cartman as AWESOM-O generates thousands of movie concepts—800 of them featuring Adam Sandler. Word of AWESOM-O's extraordinary abilities quickly reach the Pentagon, which captures the "robot" so it can be turned into a weapon.

AWESOM-O/Cartman is then taken to a secure location and chained to a table. When he protests that he's a real person, his captors misinterpret this to mean he's a self-aware robot. The military decides to "erase" his memories and consciousness using a very large drill. But at the last possible moment, a scientist stops the drill and releases Cartman. Just as Cartman goes to remove his helmet and end the ruse, Butters arrives, forcing him to continue on as AWESOM-O.

Butters begs for the life of his "best friend," a display so moving that it brings the Army brass to tears. But suddenly Cartman farts, breaking his cover. Butters, finally wise to the con, pulls off his helmet and reveals the truth.

The final scene shows Butters' video of Cartman dressed as Britney Spears—being shown to all of South Park's fourth graders, plus the Catamount Pictures execs and the military. Cartman (now without his AWESOM-O costume) is forced to watch it too.

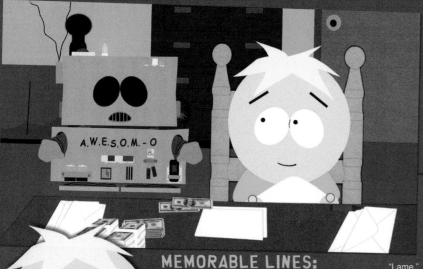

"Movie Idea No. 2305: Adam Sandler is trapped on an island and falls in love with a coconut."
—*AWESOM-O/Cartman*

MEMORABLE LINES:

"You can trust AWESOM-O. In fact, you should tell AWESOM-O all your most personal secrets. AWESOM-O will not make fun of you or tell your secrets to other people and stuff."
—*AWESOM-O/Cartman*

"Nobody knows it, but sometimes I poop my pants so I have to wear a diaper to school."—*Butters*

"Just slide it up in my anus there."—*Butters*

"Lame."
—*AWESOM-O/Cartman*

"Wait a minute. Did that robot just fart?"—*Army General*

"Wow kid, you're a little faggot!"
—*Army General*

"Hey there have you heard about my robot friend? He's metal and small and doesn't judge me at all!"—*Butters' song*

"Oh boy, I've never gotten a package this big! I've always wanted to have a huge package!"—*Butters*

"Actually, Eric is still supposed to be grounded for trying to exterminate the Jews two weeks ago."
—*Cartman's mom*

"Oh jeeze cheese Louise! My mom is gonna be awful sore when she sees this mess!"
—*Butters*

"Adam Sandler is like, in love with some girl, but then it turns out that the girl is actually a Golden Retriever. Or something."
—*AWESOM-O/Cartman*

"You are an incredible robot AWESOM-O. . .I was just wondering, are you by chance. . .a Pleasure Model?"
—*Catamount Movie Exec.*

"AWESOM-O must dispense oil waste. Where is the nearest toilet, please?"—*AWESOM-O/Cartman*

"I'm not a robot dumb ass! I'm alive!"
—*AWESOM-O/Cartman*

BODY COUNT

Mr. Scientist, the brave soul who tries to rescue AWESOM-O from the military. He makes an impassioned speech about what truly makes something human, in the process pulling out various internal organs until he dies.

WHERE DID THE IDEA COME FROM?

The concept sprang from a pre-season writer's retreat. The thing that sold it was the idea of Cartman saying "lame" in his robot voice.

POP CULTURE REFERENCES

The AWESOM-O name is a play on ASIMO, the groundbreaking humanoid robot developed by Honda. Also, when Butters and AWESOM-O cavort together during the "Robot Friend" montage, it's accompanied by music that sounds a lot like the theme from the old TV show *The Courtship of Eddie's Father*. During that montage, we also see them coming out of a theater showing the film *The Prince and Me*, a corny 2004 romantic comedy starring Julia Stiles.

The circular Pentagon meeting room bears a striking resemblance to that seen in the classic 1964 film *Dr. Strangelove*. Finally, when Cartman (still disguised as AWESOM-O) seems to activate himself, it's a parody of a similar scene in the 1995 anime classic *Ghost in the Shell*.

CHARACTER DEBUTS

The ultra-robot AWESOM-O 4000, five uncreative movie executives for Catamount Pictures, and a slew of Pentagon employees led by a U.S. Army General. We also meet Butters' Aunt Nelly and Uncle Bud, who live in Los Angeles. We will learn a bit more about Uncle Bud in "The Return of Chef" (page 148).

ORIGINAL SONGS

Butters sings the theme song "Robot Friend," a campy tune about his new best friend AWESOM-O. Two additional variations on this tune play later in the episode: one prominently featuring Hollywood, and the other, a sad ode to a lost friend.

POINTLESS OBSERVATIONS

Butters' birthday is revealed to be September 11. Also, for the second time Butters sings the Chicago song "If You Leave Me Now." The first was during "Casa Bonita" (page 70). Cartman's mom states that her son is grounded for trying to exterminate the Jews—a reference to "The Passion of the Jew" (page 88), which aired two weeks earlier.

Butters mentions a few of Cartman's cruel tricks: the time where Cartman made Butters think a meteor hit the Earth and convinced him to stay in a bomb shelter for three days ("Casa Bonita," page 70); and the time where Cartman pretended to be Butters on the phone, and called Butters' dad a pussy ("Jared Has Aides," page 12).

Butters drinks the tasty beverage Sunny Delight, and makes AWESOM-O serve it to the rest of the boys.

A number of Hollywood landmarks are parodied here: Universal Studios (complete with the *Jaws* ride), Disneyland, and Grauman's Chinese Theater (which just happens to be showing *The Passion*). Also, Catamount Pictures is a parody of Paramount Pictures, right down to the iconic water tower.

CELEBRITIES IMPUGNED

Adam Sandler, for whom AWESOM-O generates a never-ending supply of incredibly lame movie concepts. One is tentatively titled *Punch-Drunk Billionaire*—a play on the 2002 Sandler vehicle *Punch-Drunk Love*.

Also, Britney Spears and Justin Timberlake. Butters possesses a videotape with Cartman dressed up like Spears, dancing and making out with a Timberlake cutout. We actually see this tape at the end of the episode, and it is every bit as disturbing as it sounds.

WHAT THE ARMY GENERAL LEARNED

"Perhaps there is consciousness in this robot. Maybe we as a society need to realize that artificial intelligence is intelligence all the same, and we can learn from the robots."

THE JEFFERSONS

Original Air Date: April 21, 2004
Episode 807

THE STORY: A new kid named Blanket moves to South Park with his father, Mr. Michael Jefferson. The Jefferson's property is filled with arcade games, a Neverland-like zoo, and a collection of amusement park rides. Soon, word gets out and the Jefferson's backyard is flooded with all of South Park's kids.

Cartman quickly becomes enamored over how "awesome" Mr. Jefferson is; he latches onto him and calls him his new best friend. Kyle, on the other hand, becomes worried about Mr. Jefferson's careless attitude toward his own son. Especially when Blanket hurts himself and Mr. Jefferson is too busy playing "Choo Choo Train" to notice.

Stan's parents eventually invite Mr. Jefferson and Blanket over for a dinner with the other boys' families. Later that evening, Stan is awakened by the sound of Mr. Jefferson (dressed as Peter Pan) knocking on his window. He's followed shortly by Cartman, who's worried that Stan is trying to bogart his new friend. And then Kyle turns up with Blanket, whom he found wandering around in his backyard. The boys and Mr. Jefferson all spend the night together in the same bed, where they are discovered the next morning by Stan's parents, who are obviously horrified. The parents ban the boys from ever visiting Mr. Jefferson's house again.

Meanwhile, the Park County Police are hard at work figuring out a way to frame Mr. Jefferson for a crime—just as they do to all wealthy black men who fall within their jurisdiction. They take advantage of Mr. Jefferson's sleepover at the Marsh household to plant cocaine, pubic hairs, and blood spatter in Jefferson's home. But when he and Blanket finally return, the police abort their arrest because they think Jefferson is white.

Mr. Jefferson is convinced that the adults are out to get him, and confines a near-terrified Blanket to his home. Jefferson tries to cheer him up by playing a game of "got your nose," but when Blanket takes a turn, he actually does pull off his father's nose.

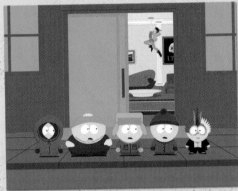

While Mr. Jefferson calls a plastic surgeon for help with his face, Kyle and Stan attempt to rescue Blanket by climbing up to his room and replacing him with a disguised (and parka-less) Kenny. But Jefferson—now a hideous, zombie-like creature—catches them mid-act and chases them into Blanket's room. Mistaking Kenny for his son, he tosses him into the air and smashes his brains out on the ceiling.

The boys escape just as the police arrive to arrest Jefferson (after a lot of dedicated field work, they now have proof that Jefferson is black and worthy of being framed).

Kyle scolds Mr. Jefferson, saying that since he has a kid, he can't act like a kid himself. He seems to absorb the lesson and vows to give up his money and live a normal life with his son. Since Jefferson's now just a regular, poor black man, the police lose interest and let him go. As Sergeant Yates notes, there's "no point in putting another poor black man in jail."

"No. . .They're ignorant... That's ignorant..."
—Mr. Jefferson

MEMORABLE LINES:

"Why is it that us policemen around the country have such a passion for framing wealthy African Americans with crimes they didn't commit?" —Sergeant Yates

"I hope they're not Austrian. That's the last thing this town needs." —Cartman

"Mr. Jefferson, I wish I could be around you all the time. You're awesome."—Cartman

"A guy moves into South Park with a Ferris wheel in his backyard, and Kyle has to see a problem with it!"—Cartman

"Well, excuse my French, Mrs. Marsh, but you can suck my fat hairy balls." —Cartman

"Would you like to ride on the train with me, and start a magical journey?"—Mr. Jefferson

"STAND DOWN! I REPEAT! STAND DOWN!! SUSPECT IS NOT BLACK!!!"—Sergeant Yates

"Have you been up my wishin' tree? It's where I come to think and dream. And now I'd like to show you my wishin' tree. . ." —Mr. Jefferson's song

BODY COUNT

Kenny. He gets his brain smashed into the ceiling by a playtime-crazed Mr. Jefferson. If you're keeping track, this is only the second time he's been killed since returning to life in Season 6's "Red Sleigh Down" (page 44).

WHERE DID THE IDEA COME FROM?

Trey and Matt resisted doing a Michael Jackson show because he was such an easy target. But the concept found its focus when they made the story about his son, Blanket.

POINTLESS OBSERVATIONS

This episode features the infamous scene in which Cartman and Mr. Jefferson kiss, although it seems to be just a nightmare in Stan's head.

We learn Sergeant Yates' first name is "Harrison."

The scene where Mr. Jefferson dangles Blanket precariously out of his second story window is a nod to the real life instance (caught on tape) in which Michael Jackson did the same thing to his young son.

CHARACTER DEBUTS

Kenny, sort of. For the first time since *South Park: Bigger, Longer & Uncut*, he's seen both without his hood and speaking with a non-muffled voice. In the movie his voice was provided by Mike Judge, but in this episode, Eric Stough did the honors.

In addition to Sergeant Yates (whom we met briefly in "Christian Rock Hard," page 66), we meet the rest of his team at the Park County Police Station: Detective Harris, Detective Murphy, Detective Johnson, and Detective Frakes. We also meet Maggie, Sergeant Yates' Scottish wife.

POP CULTURE REFERENCES

The episode's title is of course a reference to the old TV series *The Jeffersons*.

At the dinner table, the parents all briefly discuss basketball star Kobe Bryant, saying: "You think he was guilty or innocent?" They are referring to his sexual assault case, which at the time this aired, was all over the news. There's also a nod to the O.J. Simpson murder trial, with Sgt. Yates exclaiming: "Do you know how hard those cops worked to frame him?!"

Mr. Jefferson shows up at Stan's house dressed as the classic children's character Peter Pan, singing "Look at me, I'm Peter Pan! I'm a little boy forever!"

CELEBRITIES IMPUGNED

Michael Jackson, though he's never referred to as anything but "Mr. Jefferson" during the entire episode. At one point Blanket slips up and almost uses his real name, only to be corrected at the last moment by his father. Also, Blanket (aka Prince Michael Jackson II) is the actual name of Jackson's youngest child, born in 2002.

ORIGINAL SONGS

Mr. Jefferson croons boyishly with "Wishing Tree" and "Ride The Train." He also closes the episode with his big pop ballad "The Power to Change."

WHAT MR. JEFFERSON LEARNED

"I've been so obsessed with my childhood that I've forgotten about his. I thought having lots of rides and toys was enough, but Blanket doesn't need a playmate. He needs a father and a normal life."

95

GOOBACKS

Original Air Date: April 28, 2004
Episode 806

THE STORY: Humans from the year 3045 use a time portal to visit our century in search of employment. But the "Goobacks" (so named because they arrive covered in goo) work so hard and so cheaply that they take tons of jobs away from South Park residents. In a matter of days, the boys lose their snow-shoveling gigs to migrants who do the same work for only 25 cents, and Stan's parents hire a Gooback housekeeper for ten cents an hour.

The townspeople are growing uneasy with the exploding Gooback populace—many folks are now unemployed, and even more are just plain pissed off. Mr. Garrison is even forced to teach his class in both English and "Future Speak," the native language of the Goobacks.

Things come to a head at the local fast food joint Wendell's Burgers, when Stan can't get the immigrant workers to understand his order. After several attempts, he loses it and calls them "f***ing Goobacks." His parents overhear this and ground him for being an ignorant "timecist."

But when a Gooback replaces Stan's dad at

work, Randy becomes equally pissed off.

In an effort to stop the Goobacks, the local males form a well-thought-out plan: turn gay, so that future generations of job-takers will never be born. They go to Little Future (the Gooback part of town) and proceed to start having sex with each other in a big, sweaty, man pile.

Stan suggests that perhaps instead of everyone turning gay, they should try to work for a "better future." That way, the Goobacks won't need to come back in time. This strikes a chord with the man pile.

With the help of a montage, South Park residents start planting trees, recycling, giving food to the poor, and being all-around good people. It seems to work, as one-by-one the immigrants vanish into thin air.

There's just one problem. Stan and Kyle suddenly realize that all this save-the-world stuff is even gayer than the big orgy of man sex. The men agree, quickly take off their clothes, and return to the man pile.

MEMORABLE LINES:

"I want a God damn cheeseburger and some God damn fries you fucking Goobacks!"—*Stan*

"They took 'er jobs!"
—*South Park Residents*

"We're trying to turn everyone gay so that there will be no future humans! Present-day America number one!"—*Stan's dad*

"All you ever do is talk about your balls!"
—*Kyle*

"Which kind of verb is this? 'The sad girl puts balls in her mouth'—or in future speak, of course, 'Guack guack balls goack goack.'"—*Mr. Garrison*

"You're breakin' my balls, ma'am."—*Cartman*

"We can't understand you, asshole!"—*Cartman*

"If we can get everyone to turn queer, then there won't be no children to have no children, and the people from the future won't exist to take our jobs!"
—*Darryl Weathers*

"Stan Marsh, how dare you use that time-bashing slur!"
—*Stan's dad*

"Ouch, ma'am, please let go of that tight grip you have on my balls."—*Cartman*

"We're not raising our son to be an ignorant timecist!"
—*Stan's mom*

"This is even gayer than all the men getting in a big pile and having sex with each other."—*Cartman*

CELEBRITIES IMPUGNED

Conservative talk show host Bill O'Reilly. He holds a televised debate about the pros and cons of time migrants between a "pissed off, white-trash redneck conservative" and an "aging liberal hippie douche."

WHERE DID THE IDEA COME FROM?

The story is, of course, an allegory for the illegal immigrant issue.

POINTLESS OBSERVATIONS

For the second time this season, Cartman inexplicably says that newcomers from Austria are the last thing South Park needs. He made this remark once before in "The Jeffersons" (page 94).

In the beginning of the episode, while dodging vehicles on the highway, the Gooback narrowly avoids being hit by several vehicles, including a "Busy Beavers Moving Company" truck (last seen in Season 5's "Butters' Very Own Episode"), and an "Uncle Joe's Fresh Turkey" truck (the same company responsible for nearly killing Gobbles in Season 4's "Helen Keller! The Musical").

This is the second time Cartman has threatened to kick Kyle's ass, only to wind up with a bloody nose—the first being in "It's Christmas in Canada" (page 78). Also, the Goobacks can be seen cleaning a store display on South Park Avenue with the John Elway Doll with Karate Chop Action and Okama Gamesphere from that same episode.

CHARACTER DEBUTS

The Goobacks, all of whom are a hairless, uniform mix of all races. Their skin color is a "yellowy light brownish whitish color," and they all speak a gutturaL-sounding mash-up of all of Earth's languages.

Darryl Weathers (aka "pissed off, white-trash redneck conservative"), the now-unemployed redneck that leads the charge against the Goobacks. He can be seen again in Season 13's "W.T.F." and "Margaritaville."

We also meet Mrs. Gwakr, the Marsh's immigrant cleaning woman, as well as Aging Hippie Liberal Douche.

POP CULTURE REFERENCES

At one point, an unemployed man suggests encouraging global warming in hopes that it will cause a massive, sudden climate shift in the future. He's told that something so drastic could never happen overnight—a subtle dig at the 2004 disaster flick *The Day After Tomorrow*, which hinged on the premise that a new ice age could overwhelm the world in just a few days.

Fast food chain Wendy's bravely employs the first Gooback, and Wendell's Burgers (a McDonalds spoof) is seen later in the episode with a whole staff of Goobacks.

Broadcast journalist Aaron Brown, lead anchor for CNN (at the time), is used throughout this episode.

ORIGINAL SONGS

The happy-go-lucky tune "The Future Begins With You and Me" plays over a montage of present-day Americans making the world a better place. This turns out to be gayer than expected.

TIME TRAVEL REFERENCES

The portal that brings the Goobacks to the 21st century is said to operate by *Terminator* rules—that is, all trips are one-way. It's specifically stated that it doesn't work like the *Back to the Future* movies (which allow two-way travel) or the obscure film *Timerider*, which is "just plain silly."

WHAT STAN LEARNED

"I think it's wrong to call them Goobacks because they're no different from us. They're just humans trying to make their lives better. Look, it sucks that the immigrants' time is so crappy, but the cold hard truth is that if we let them all come back to our time, then it's just gonna make our time crappy too. Maybe the answer isn't trying to stop the future from happening, but making the future better."

DOUCHE AND TURD

Original Air Date: October 27, 2004
Episode 808

THE STORY: When PETA protests the use of a cow for South Park Elementary's mascot, the search begins for a less-controversial school symbol. The kids get to vote, but they really hate the lame choices offered by the school. Instead they plan to nominate and elect a "joke" candidate. But they can't decide between Kyle's favorite, a giant douche, and Cartman's choice, a turd sandwich.

Stan sees the entire exercise of picking between a douche and a turd as pointless and idiotic, and vows to sit out the election. His friends are stunned that Stan won't participate in the democratic process—particularly Kyle, who calls in Puff Daddy to help his friend see the light. Puff Daddy does this using his "Vote or Die" campaign—basically, if Stan doesn't vote, he'll kill him.

To avoid being shot, Stan casts a ballot for turd sandwich, which angers Kyle. Stan realizes his friend only wanted him to vote because he figured he would back his side. Once again, Stan withdraws from the balloting—an offense so great that he gets banished from South Park for eternity . . .or until he decides voting matters. He's tied up,

placed on the back of a horse, and run out of town in disgrace.

His horse wanders on and on, eventually ending up at a PETA commune. Here, we see that the PETA members have been living in "perfect harmony" with the animals—and by perfect harmony, they mean interbreeding and marrying their animal companions. Not surprisingly, Stan doesn't fit in here either. While he's there however, one of the camp's leaders helpfully explains the political process to him, stating that all such elections are between douches and turds, because those are the only types of people who can make it in politics.

Puff Daddy and his posse show up to kill Stan. But upon seeing Puffy's flamboyant fur coat, the PETA members throw red paint on him—so he kills them instead. Stan escapes in the confusion, returns to South Park, and is welcomed back as a voter.

With all eyes upon him, he casts his vote for turd sandwich—which is soundly beaten, 1,410 to 36. Even worse, Mr. Garrison announces that since the PETA people are all dead, the cow mascot can now remain in effect. Turns out, his vote really didn't matter.

MEMORABLE LINES:

"The outside world looks down on a man marrying a llama, but our love knows no boundaries."
—*PETA Member*

"God dammit you guys, Butters is our friend and he should be allowed to say his opinion!"
—*Cartman*

"A vote for Turd Sandwich is a vote for tomorrow."
—*Cartman*

"**I like it when you vote, bitch. Shake them titties when you vote, bitch.**"
—*Puffy's "Vote or Die" song*

"It's Mooey! Mooey wave to me!!"
—*Butters*

"Oh Jesus, not PETA again."
—*Mr. Garrison*

"**I thought I told you vote or die, bitch!**"
—*Puff Daddy*

"We have got to make Stan understand the importance of voting. . .because he'll definitely vote for our guy."—*Kyle*

"We've got spirit, yes we do! We are sandwiches filled with poo! YEAA!!"
—*Turd Sandwich*

"This is breaking your mother's heart, Stan. She couldn't even help tie you to the horse."—*Stan's dad*

"YOU'RE a turd sandwich!"
—*Turd Sandwich*

BODY COUNT

The entire South Park membership of PETA, gunned down by Puff Daddy and his entourage.

WHERE DID THE IDEA COME FROM?

This is the first episode of the second half of the season, and the final leg of what Matt and Trey call their year from hell. They did the first half of *South Park's* season eight, then immediately began working on the movie *Team America: World Police*. As soon as that was in the bag, they started in on the back half of this season—of which "Douche and Turd" was the first episode.

SOUTH PARK

SOUTH PARK

CHARACTER DEBUTS

A whole crew of hippie, animal-loving PETA members make their debut, including the PETA leader, his wife Janice (a llama), and their all-knowing chief Dr. Cornwallis (a mountain goat). On their compound, we also briefly meet a hideous, ostrich-human hybrid, the result of a sexual union between an ostrich and a PETA member.

Lastly, we are introduced to several potential mascots: Turd Sandwich, Giant Douche, and Mooey, the South Park Cow's original school mascot.

POINTLESS OBSERVATIONS

Mr. Garrison states that South Park Elementary has been attacked 47 times by eco-terrorists.

Butters dresses up like a Hula Girl to help promote his candidate Turd Sandwich; he will again put on a dress for his role in "Marjorine" (page 132).

When the town banishes Stan, Butters' dad is yet again shown blowing a large horn as the child exits the town. He first did this in "Child Abduction Is Not Funny" (page 32), when the parents sent off all of South Park's children to live outside their great wall.

CHEESY POOFS

POP CULTURE REFERENCES

The scene in which Stan is ridden out of town on a horse is yet another parody of a Mel Gibson movie. There was a similar scene in 1985's *Mad Max: Beyond Thunderdome*.

The Giant Douche mascot comes out and dances to 2 Unlimited's "Get Ready for This," while Turd Sandwich grooves out to "Who Let The Dogs Out" by Baha Men.

POLITICAL REFERENCES

The entire episode is a commentary on the 2004 presidential election, and elections in general. As Stan learns, "nearly every election is between some douche and some turd." In case you hadn't realized, Bush is the turd sandwich and John Kerry is the douche.

ORIGINAL SONGS

Puffy and his crew show us the importance of voting with their very persuasive rap "Vote or Die." There's also the gritty rock anthem "Let's Get Out and Vote."

CELEBRITIES IMPUGNED

Puff Daddy, who seems to take his "Vote or Die" slogan waaaay too seriously. He will again be referenced in the Season 13 classic "Fishsticks." Also, Jim Lehrer is called in to monitor a debate between Giant Douche and Turd Sandwich.

WHAT STAN LEARNED

"I learned that I'd better get used to having to pick between a douche and a turd sandwich because it's usually the choice I'll have."

SOMETHING WALL MART THIS WAY COMES

Original Air Date: November 3, 2004
Episode 809

THE STORY: The townspeople are delighted when a new Wall Mart opens in South Park. They're less delighted when the local retailers go out of business, leaving the stores on main street empty and deserted. They confront Wall Mart's manager and tell him they don't want the Wall Mart anymore. He explains that he's merely a prisoner of the store—right before he crashes through a window at the end of a rope, hanging himself.

The townspeople decide to boycott the store, but find they can't resist the bargains. So instead, they burn it down. Miraculously, the next day it's completely rebuilt. Even worse, now Stan's dad works there so he can get the 10 percent employee discount. Infuriated, Stan, Kyle, and Kenny take the bus to the company's Bentonville, Arkansas headquarters to speak to the management. Cartman tags along, but only because the Wall Mart has started "speaking" to him, and he wants to defend it against whatever the other boys are planning.

They meet with company president Harvey Brown, who tells them that ever since the first Super Center opened in 1987, the stores have multiplied across the nation, crushing all opposition. All their competitors eventually succumbed to the temptation of low, low prices and started shopping there

too. The only way to destroy a store, he asserts, is to strike at its "heart," which is usually located near the television department. As the boys leave, Brown shoots himself.

They return to South Park and mount a nighttime raid on the store. Cartman of course attempts to betray them, but Kenny distracts him with a sound beating. Stan and Kyle enter the store and run into Stan's dad, whom they enlist because they need his keys. The store tries to stop them by tempting them with ever-more-outrageous bargains on their way to the TV department. The boys are strong, but Stan's dad is not. . .he eventually succumbs to the allure of a $9.98 screwdriver set, but not before tossing the store keys to his son.

At the TV department, they find every screen occupied by a humanoid entity which claims it is Wall Mart. The being says the store's heart is located in a small room with a sign reading "Employees Only." Stan and Kyle look inside and find only a mirror. The heart of Wall Mart, they soon realize, is them—or rather, their desires.

They smash the mirror and flee the store as it implodes. The townspeople, humbled by their experience, decide to shop local.

MEMORABLE LINES:

"Where else was I going to get a napkin dispenser at nine thirty at night?!" —*Kyle's dad*

"It's simple economics, son. I don't understand it at all, but God I love it." —*Stan's dad*

"No matter what the Wall Mart does to try to stop us, we have to be strong!" —*Kyle*

"It's like we're a real town now." —*Mr. Garrison*

"Just look at the Marsh family, huh? Brand new television. New plastic dishware and cups. And enough bulk-buy ramen to last us a thousand winters." —*Stan's dad*

"Very well, Kenny! Let us battle!" —*Cartman*

"It's too late for me, son! I have to buy this stuff!" —*Stan's dad*

"Don't look! Don't look at its bargains!" —*Stan's dad*

"I'll bet you five bucks that when you die you crap your pants, asshole!" —*Cartman*

BODY COUNT

Harvey Brown (the Wall Mart executive), Mr. Grey (the manager of the South Park Wall Mart), and the store itself. In a running gag, all three crap themselves during their death throes, much to Cartman's delight.

Also, Stark's Pond and South Park Avenue bite the dust in this episode. Both locations, however, will return later this season.

WHERE DID THE IDEA COME FROM?

At the time, tons of people seemed angry about Wal-Marts coming to their towns. Yet none of these places, no matter how much they were vilified, ever lacked customers.

POINTLESS OBSERVATIONS

South Park's Wall Mart was built on what was formerly Stark's Pond.

Cartman plays violin here; it's the first time he's displayed this ability. Kyle, Kenny, and Stan all displayed their ability to play violin in Season 2's "Summer Sucks." Cartman has also shown his skills on guitar in Season 3's "Chinpoko Mon," although he will later decry the instrument because of hippies.

The townspeople all get together and sing "Kum Ba Yah" as the Wall Mart burns down. Ned also croons this tune around the campfire in "Volcano."

We learn at the end of this episode that all retail megastores—"Wal Mart, K-Mart, Target"—are all built on one single entity: Desire.

CHARACTER DEBUTS

Mr. Grey, manager of the South Park Wall Mart. Also, Mr. Jim Farkel, owner of Jim's Drugs.

POP CULTURE REFERENCES

After Wall Mart implodes, Chef says, "We know how to destroy it now. Spread the word to all the towns." This is done via Morse code, just as in the movie *Independence Day*. The same exact scene was also referenced in Season 3's "Chinpoko Mon." Also, the episode's title is a play on the Ray Bradbury novel *Something Wicked This Way Comes*—which was itself a line from *Macbeth*.

The scene in which the boys encounter the "Wall Mart being" in front of a wall of TV screens is an homage to "The Architect" from the film *The Matrix 2*.

HORROR MOVIE REFERENCES

The destruction of the heart of Wall Mart is very similar to the climax of 1979's *The Amityville Horror*. Likewise the death of the store manager is a parody of the nanny suicide in 1976's *The Omen*. Also, when Chef suggests that freezing the store might kill it, he's echoing the logic of the 1958 classic *The Blob*. Lastly, when Wall Mart is finally destroyed, it's sucked into the earth just like the house in 1982's *Poltergeist*. Except for the part where it poops itself. That didn't happen in *Poltergeist*.

CELEBRITIES IMPUGNED

Sam Walton, the real founder of Wal-Mart, is portrayed at the end of this episode as an ethereal, shape-shifting humanoid responsible for the evils of this superstore.

WHAT STAN'S DAD LEARNED

"I think I understand the symbolism of the mirror. The Wall Mart . . . is us."

PRE-SCHOOL

Original Air Date: November 10, 2004
Episode 810

THE STORY: Stan comes to the boys in a panic—Trent Boyett, a mean old classmate, has just been released from juvenile hall. This piece of news sends the rest of them (including Butters) into a state of pure shock. . .because they're the ones who put Trent in there.

During a flashback to pre-school, we learn that the boys got Trent to set a fire in their classroom so they could play "Fireman" and put it out by peeing on it. Unfortunately they failed to extinguish it. Their teacher, Ms. Claridge, tried to put out the growing fire and was promptly turned into a human torch. Hideously disfigured, she's now confined to a motorized wheelchair and can only communicate through electronic beeps—one for "yes," two for "no."

But that wasn't the worst of it. Rather than tell the truth and get in trouble, they blamed everything on Trent. Even Butters, the only other witness, refused to defend him. Trent got five long years in juvie hall and the boys promptly forgot about the whole thing . . . until now.

Butters is the first to feel Trent's vengeance. He gets a beating so severe (including two Indian sunburns and a second-degree titty twister) that he has to be hospitalized. Cartman says they should tell the authorities that Trent did it, but Kyle (who's more afraid of his mother finding out he's lied) won't let them tell.

Instead they hire the sixth graders as bodyguards—in exchange for their protection, they demand a picture of Stan's mom's breasts. The boys manage to fake this by drawing nipples on Cartman's butt and taking a photo. However the sixth graders prove no match for Trent, and all wind up seriously injured in the hospital. Stan is forced to turn to the one last person he can trust. . .his sister Shelly. She agrees to protect them, but only if they tell Ms. Claridge the truth about the fire.

The boys locate their old teacher, whose wheelchair has run out of juice in the middle of the street, and try to reconcile. But suddenly Trent appears, bent on revenge. Cartman (who has been carrying around his mom's taser) fires it at Trent Boyett, misses, and hits Ms. Claridge's wheelchair instead. The charge from the stun gun launches the wheelchair into a propane shop, setting Ms. Claridge on fire . . . again.

The police arrive and ask the now-even-more-unsightly Ms. Claridge if Trent tried to kill her. She beeps twice for "no," which the police interpret at "yes, yes." He's carted back to juvenile hall for another five years. Cartman, ecstatic, moons Trent with his nipple-bedecked butt as he's taken away. The boob-obsessed sixth graders happen to see this and kidnap Cartman for use as a masturbatory aid.

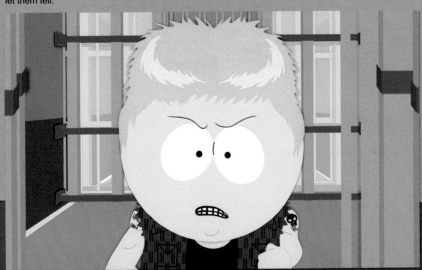

"Stupid little Fourthies!"
—*Head Sixth Grader*

"Jews can't be firemen."
—*Cartman*

MEMORABLE LINES:

"I am not going to have a titty twister! I hate titty twisters!"—*Cartman*

"Your mom has the sweetest boobs ever!"—*Sixth Grader*

"These are like the hottest tits I've ever seen!!!" —*Sixth Grader*

"You better pray I never get out of juvenile hall! You better all pray!!" —*Trent Boyett*

"Hey gaybots, what's goin' on?"—*Cartman*

"Our lives have not been enjoyable, Trent. I promise you!"—*Kyle*

"Stan's mom is old, so that means her nipples sag more to the bottom now."—*Cartman*

"There were no magical Christmas adventures or talking poo for me! I didn't get to fight a huge mechanized Barbra Streisand like you did! No accidental trips to Afghanistan for Trent Boyett!"—*Trent Boyett*

"I just can't stand to hear him scream like that. . .I'm gonna go upstairs."—*Butters' mom*

"Jesus Christ, I've never seen so many Indian sunburns and titty twisters in my life!"—*Dr. Doctor*

WHERE DID THE IDEA COME FROM?

For a while the idea of doing a *South Park Kids* series, with the boys as toddlers, was tossed around. Instead Matt and Trey decided to use the concept in a flashback show.

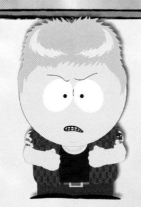

CHARACTER DEBUTS

Trent Boyett, the "meanest, dirtiest, toughest kid in the world," according to Cartman. Also poor Ms. Claridge and her motorized wheelchair.

We're introduced to the pre-school versions of a lot of the kids here. In addition to the boys and Trent, we meet pre-school Butters, and in the background, pre-school Wendy.

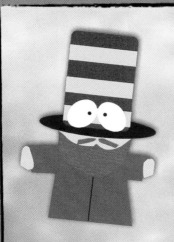

CHARACTER RETURNS

Mr. Hat, AWOL since the sixth season's "The Death Camp of Tolerance" (page 38), is briefly glimpsed on Mr. Garrison's hand during the pre-school flashback.

BEHIND THE SCENES

Actual kids were used to voice the toddlers. Though their dialogue is strewn with bleeps, they didn't actually use curse words. Instead the bleeps were dropped into their G-rated dialogue, allowing viewers' R-rated minds to fill in the blanks.

POINTLESS OBSERVATIONS

This is the second episode in which the pre-school boys are seen. The first time was during a flashback in Season Two's "Summer Sucks." That time, Kenny got blown up by a firecracker.

Trent Boyett has two tattoos: on his right arm, "Vengeance Is Mine Sayeth the Lord" (a quote from the Bible); on his left, "Never Forget" with the skull emblem for The Punisher (a Marvel comic antihero).

We learn that Stan's mom apparently has the "sweetest boobs ever." Also, if you put a necklace on it, Cartman's ass can pass for a pretty nice rack.

Trent Boyett's arsenal of weapons include: wet willies, snugees, Indian Sunburns, titty twisters, swirlees, Charlie Horses, and most horrifically, a Texas Chili bowl.

POP CULTURE REFERENCES

While making Cartman's ass into a pair of fake boobs, Kyle uses Madonna's 1992 photo book *Sex* as a reference. Also, the store called "Propane and Propane Accessories" is a reference to the cartoon series *King of the Hill*, created by Matt and Trey's friend Mike Judge. Furthermore, the episode's entire scenario is a play on the 1991 film *Cape Fear*.

For protection, the boys offer the sixth graders: a 12 pack of Dr. Pepper, a Chutes and Ladders board game, a DVD of *Harry Potter and the Chamber of Secrets*, and a coupon for the restaurant chain Red Robin. The sixth graders opt to see some killer boobage instead.

STAR TREK REFERENCES

Ms. Claridge's wheelchair, along with her "one beep, two beep" communications mode is taken from the *Star Trek* two-parter "The Menagerie," in which former Enterprise captain Christopher Pike is confined to an almost identical rig. Even his facial injuries are pretty much the same as Ms. Claridge's.

WHAT SHELLY LEARNED

"You can't run from your past, turds. Apologize and make amends."

103

QUEST FOR RATINGS

Original Air Date: November 17, 2004
Episode 811

THE STORY: The boys take an Audio/Visual class in school and create *Super School News*, a show that airs on South Park Elementary's closed circuit TV. Their team of anchors and reporters consists of Cartman ("Rick Cartman"), Jimmy, Kyle, Butters, Token, and Stan. But it doesn't go so well—only 4 kids tune in and they are told by their A/V teacher (Mr. Meryl) that their show will be cancelled due to low ratings. To make matters worse, they're getting crushed by Craig's show, *Close-Up Animals with a Wide-Angle Lens*. As the name implies, it consists of nothing but very tight shots of cute animals.

In an effort to keep their show on the air, the boys brainstorm bold new ways to juice up their show. They change the show's name to *Sexy Action School News*; make up stories instead of reporting real ones; show more scantily clad girls; and introduce a Panda Bear Madness Minute, during which the boys dance with people dressed as pandas. The show's ratings improve, allowing it to eek out a win over *Close-Up Animals with a Wide-Angle Lens*. But unfortunately, it gets pummeled by Craig's new show, *Close-Up Animals with a Wide-Angle Lens Wearing Hats*.

With cancellation looming, Cartman and company try to come up with an entirely new, even more sensationalist concept during yet another idea session. Jimmy urges the boys to reconsider their approach and focus more on journalistic integrity. No one listens, and even worse, no one can think of any new ideas.

After hours and hours of dead-end brainstorming, Kyle suggests they drink a bunch of cough medicine, in hopes that getting high will generate some good ideas. It doesn't, but they do trip balls. When the boys wake up after their all-night bender, they discover they've been watching *Close-Up Animals with a Wide-Angle Lens Wearing Hats* the entire night. And loving it.

Once Stan regains his faculties, it occurs to him that perhaps Craig's show is so popular because *all* of its student viewers are high on cough medicine. Which turns out to be precisely the case.

The kids blow the lid off the scandal with a hard-hitting report, and the cough syrup problem is eradicated. Ratings for Craig's show collapse, and *Sexy Action School News* is approved for 27 more episodes. However, the kids can't come up with any more fresh ideas and decide to bail.

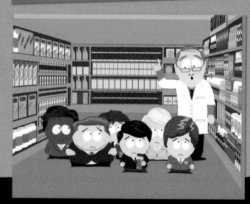

MEMORABLE LINES:

"Butters, only gay little dweebs read the funnies."
—*Cartman*

"Oh oh! Looks like it's Panda Bear Madness Minute!"
—*Token*

"Go play with yourself, Craig."—*Cartman*

"Whoa. . .I'm feeling kinda bowling ballish, fellas."—*Butters*

"Parent-teacher conferences will be held this Wednesday night, from seven to nine. So kids, get a lot of playing in before you get grounded."
—*Cartman*

"Kids don't care about the news, boys. It's boring. Kids want to see animals. Close up. With a wide angle lens."
—*Mr. Meryl*

"Fellas, this is our chance! Everyone get your hair looking as fantastic as possible. It's time for us to do the most incredible investigative news report of our journalistic lives!"—*Jimmy*

"You need to know how important ratings are, Craig. So I'm going to suspend you from school, and request that you have your testicles removed surgically."
—*Mr. Meryl*

"We need to make students think they have to watch our news show or they'll die."
—*Kyle*

"Then there's the Maximum Strength Dongatussin Cough n' Cold, but of course, that's only if you REALLY want to trip balls."
—*Mr. Anders*

BEHIND THE SCENES

Craig's show, *Close-Up Animals with a Wide-Angle Lens*, consists of live-action images of dogs and cats mugging for the camera. At one point *South Park's* writing staff was so depleted of concepts that Matt and Trey toyed with the notion of showing animal close-ups for 22 minutes and calling it a day.

PET DEBUTS

Trey's cat, Jake, and Matt's dog, Mr. Yes, can both be seen in *Close-Up Animals with a Wide-Angle Lens*.

CHARACTER DEBUTS

Mr. Meryl, the Audio/Visual Department teacher and closet cough syrup abuser. Also Whistlin' Willy, the annoying mascot of Whistlin' Willy's Pizza Gulch. Lastly, we meet Mr. Anders, the super-helpful drug store clerk. He is later arrested in the cough syrup bust.

CELEBRITIES IMPUGNED

During his "celebrity watch" segment, Butters says that he thought he saw Sigourney Weaver, but it turned out to be a dead horse.

WHERE DID THE IDEA COME FROM?

After returning, exhausted, from working on *Team America: World Police*, the creative team reached deep inside themselves and somehow produced three new episodes. This, their fourth, marks the moment when the wheels finally came off. After sitting for hours, staring at each other, the writing staff decided to have the kids be news reporters. This episode's long, fruitless idea meetings are painfully autobiographical. In fact, the "Idea Room" in this episode is modeled after *South Park's* writer's room.

POP CULTURE REFERENCES

The happy, romping music that plays over *Close-Up Animals with a Wide-Angle Lens* is a parody of the theme to *The Benny Hill Show*. While tripping balls, the only thing Kyle wrote down is the lyrics to the *Happy Days* theme song. Also, the sleek new studio used for the boys' investigative report on cough syrup is a nod to the classic news program *20/20*.

Jimmy excitedly reveals that he got an interview with the sitting Vice President, Dick Cheney, but no one cares. Cartman even says, "I don't know how we're going to fit that in between 'Cheerleader Pie Eating' and 'Who's Got Skid Marks Monday'."

When Butters is reading the "funnies," he cracks up at a line said by Dagwood—a character from the long-standing comic strip *Blondie*.

POINTLESS OBSERVATIONS

South Park Elementary's cough syrup abusers include Tweek, Bebe, Red, and the Goth kids.

We learn a ton about the *South Park* kids here: Sally Turner stuffs her bra (she was first seen in "Rainforest Shmainforest" and will be featured again in "Follow That Egg," page 134); the background character with the brown/red hat is named Pete Bellman and he pees sitting down like a girl; and Clyde Donovan has only one testicle. Also, Token's last name is revealed here to be "Black," even though his family name was originally introduced as "Williams" in Season 5's "Here Comes the Neighborhood." From here on out, his full name is Token Black.

This is the first time we see Whistlin' Willy's, the Chuck-E-Cheese-like pizza place that the boys eat at. It will become a commonly visited locale in the *South Park* world, featured in many future episodes. We learn here that you have to whistle to get your pizza, a rule that makes Cartman pissed: "God I wish we had Pizza Hut in South Park."

After brainstorming for days in their "Idea Room" and coming up empty-handed, Cartman desperately suggests doing something involving Crab People. This plot fix was actually employed in "South Park is Gay" (page 64).

There are three clocks in the Super School Newsroom: South Park, Denver, and La Casa Bonita—all are in the same time zone (and city).

NUDITY ALERT

While tripping balls, Butters takes off his clothes and runs naked through the streets.

WHAT CARTMAN LEARNED

"This sucks. I don't wanna keep having to come up with ideas for shows all the time. It hurts my head."

STUPID SPOILED WHORE VIDEO PLAYSET

Original Air Date: December 1, 2004
Episode 812

THE STORY: Paris Hilton visits South Park's mall to promote the opening of her new store, Stupid Spoiled Whore. True to its name, the shop offers everything needed to live the Hilton lifestyle, including "Skanque" perfume and the "Stupid Spoiled Whore Video Playset." The playset comes fully equipped with a "video camera, night vision filter, fake money, losable cell phone, and 16 hits of Ecstasy"—everything a girl needs to be a spoiled whore.

Wendy is disgusted by the store and what she perceives as the objectification of women. But apparently no one else is. Soon, all of her friends are playing the game and dressing like sluts.

Meanwhile, Paris grieves over the death of her pet Chihuahua, Tinkerbell, who committed suicide during an unbearable Hilton cell phone conversation. Tinkerbell shot herself rather than listen to her mistress' self-centered prattling. Paris spots Butters, is smitten, and immediately makes him her replacement pet, forcing him to wear a bear costume and calling him Mr. Biggles. Hilton offers Butters' parents $200 million for him. The Stotches make a counteroffer of $250 million, which she accepts.

Wendy becomes a social outcast because she won't act like a whore. Her friend Bebe even refuses to invite her to a party—a sex party—at her house. But the gathering is less than successful, since the boys who attend are frightened by the girls' advances and try to run away. Meanwhile, Wendy asks Mr.

Slave (the biggest whore she knows), to teach her how she can become a tramp just like the other girls. Mr. Slave explains that whores are born, not made, and goes to Bebe's house to break up the party.

Meanwhile, Butters (still in his bear costume) makes a terrifying discovery: all of Hilton's previous pets committed suicide. Unwilling to be next, he flees. Paris pursues him, and they both wind up at Bebe's party—just in time to hear Mr. Slave tell the crowd that Paris Hilton is, among a great many other things, "a thoughtless, talent-less lowlife."

The two argue and challenge each other to a "Whore Off"—a winner-takes-all contest to determine who is the bigger whore. Paris (among a great many other lewd acts) inserts a pineapple into her vagina. But Mr. Slave goes one better by forcing Hilton's entire body up his anus.

He then proceeds to tell the crowd that being a stupid, spoiled whore is nothing to be proud of. The girls see that Mr. Slave is right; they abandon their new lifestyle and apologize to Wendy.

Butters escapes the indentured servitude of being Mr. Biggles. But instead of being welcomed home, he's grounded. His parents were upset at the loss of their $250 million.

And as the credits roll, we see a struggling Paris Hilton. . .still trapped in Mr. Slave's ass.

"Butters, never get in a car with a stranger. Unless it's a limousine."
—Butter's dad

"Wow, I guess Paris isn't such hot shit after all."—Bebe

"Have fun, girls. And remember to party and be super-lame to everybody!"—Paris Hilton

"Ewww! This room's all middle class and small!"
—Paris Hilton

"Oh, I WENT there! I went there, took some pictures, and flew back already!"—Paris Hilton

"I'd like to gargle his marbles!"—Milly

MEMORABLE LINES:

"I need to get wasted. I haven't had a drink in like fourteen minutes. Why is everybody so stupid, anyway?"—Paris Hilton

"I'm a bad bear. I'm a very bad old bear."
—Butters

"The homosexual is right. From now on, Bebe, you're going to dress like a little girl."—Bebe's dad

"Sorry, Wendy. You're just not a whore. Get lost!"—Bebe

"You're dating Paris Hilton?! You are grounded, mister!!"
—Butters' mom

"Honey, I didn't work to become a whore. I was born a whore."—Mr. Slave

BODY COUNT

Paris' numerous former pets, all of whom killed themselves in highly creative ways. Cuddles the beagle committed seppuku; Patches the poodle hung himself; Scrambles the collie slit his wrists; and her Chihuahua Tinkerbell shot himself in the head with a pistol. Although it's unclear of her fate, Paris Hilton is condemned to the expansive bowels of Mr. Slave's colon.

WHERE DID THE IDEA COME FROM?

At the time, Paris Hilton was doing Guess Jeans ads. To Matt and Trey, it seemed as if she was being positioned as some sort of role model for young girls. Which looked, to them, like one of the worst ideas ever.

ORIGINAL SONGS

The catchy, Fisher-Price-esque theme to "Stupid Spoiled Whore Video Playset" plays over the commercial for the board game. While playing with apples, Butters sings a little snippet of "Loo Loo Loo, I've Got Some Apples." Also, when Paris is trapped tightly within the confines of Mr. Slave's anus, we here the fanciful song "Paris Hilton" (sung to the tune of the "Lemmiwinks" song from "The Death Camp of Tolerance," page 38).

CHARACTER DEBUTS

Although she's been a background character since the pilot episode, Annie Faulk (the 4th grader with blond hair and a brown coat) is officially introduced here. After 8 seasons, she gets her first big speaking role. We also meet Annie's mom, Mrs. Faulk.

Milly (the 4th grade girl with orange hair and an aqua jacket) also has her first speaking debut, as does Sally Turner (aka "Powder"), who we just learned stuffs her bra in "Quest For Ratings" (page 104).

A number of other 4th grade girls are also briefly introduced: Jessie and Kal, who try to get Wendy to play Stupid Spoiled Whore Video Playset; Beth, the girl that spends some time with Clyde in the closet; as well as Kelly Rutherfordminskin and Kelly Pinkertonsonfordter—two chicks that both deny knowing Cartman.

Both Wendy's father and Bebe's father also make their debut here. We met both of their mothers in "Bebe's Boobs Destroy Society" (page 30).

POINTLESS OBSERVATIONS

Paris can be seen guzzling s'mores-flavored schnapps, last seen in Season Three's "The Red Badge of Gayness."

We learn that Butters' grandfather was a coal miner for 50 years. Butters tries his hand at coal mining in an effort to raise $250 million so that his parents won't sell him to Paris Hilton. It doesn't work out.

A brief glimpse of Mr. Slave's life as a kid is shown through flashbacks. Turns out he's always been a whore, even as an infant.

POP CULTURE REFERENCES

The whored-out girls discuss using the all-too-real drug Ketamine, an animal tranquilizer that, when ground into a snortable powder, is known as Special K.

Wendy's parents are seen watching The Price is Right.

The fake commercial for Letcher-Price's "Stupid Spoiled Whore Video Playset" is a parody of various girl-themed, fashion playsets sold by toy giant Fisher-Price. Elements of the commercial also parody the infamous Paris Hilton sex tape.

CELEBRITIES IMPUGNED

Paris Hilton. She is shown as perhaps the biggest, most spoiled whore in the world. When pleading for his parents not to sell him, Butters cries: "She snores real bad! And she has a huge nose and this squishy thing that lives in her pants!" But it's not just Paris—we learn that "Britney Spears, Christina Aguilera, Tara Reid. . .They're all stupid spoiled whores!"

CHARACTER RETURNS

The Frog Prince, who resides in the magical neverland of Mr. Slave's lower GI tract, appears for the first time since "The Death Camp of Tolerance" (page 38). At the very end of the episode, he shows up to help guide Paris Hilton to freedom, just as he did for the gerbil Lemmiwinks.

WHAT MR. SLAVE LEARNED

"Being spoiled and stupid and whorish is supposed to be a bad thing, remember? Parents, if you don't teach your children that people like Paris Hilton are supposed to be despised, where are they gonna learn it?"

CARTMAN'S INCREDIBLE GIFT

Original Air Date: December 8, 2004
Episode 813

THE STORY: In an effort to be among the great pioneers of flight, Cartman puts on a pair of cardboard wings, stands on his rooftop, and jumps. Unfortunately. . .he does not fly. The resulting two-story fall causes massive cranial trauma and puts him in a coma. After two days, Cartman awakes from the coma, alive and coherent. During his two-day recovery period, he is given a new hospital roommate—the latest victim of the "Left Hand Killer" (a serial killer haunting South Park). The hospital room is swarming with police detectives.

The victim dies shortly after, and the cops—noticing the injured boy's ability to predict his crappy hospital food—now believe Cartman to be psychic. They take him to the latest crime scene and ask for his impressions. Cartman closes his eyes and sees "visions" of various snack foods—more specifically, "ice cream with sprinkles and Quadruple-Stuffs." Hearing this, the cops leap to the conclusion that Tom Johansen, owner of the local ice cream shop, is the killer. He's promptly arrested, beaten. . .then beaten some more.

When another murder occurs with Johansen in jail, the police believe there's now a copycat killer on the loose and seek help from the "Child Wunderkind with psychic abilities" once more. Cartman fingers another suspect, who's also immediately incarcerated. But the killings keep happening. And Cartman keeps naming suspects—including a group of "professional" psychics who recently challenged his credentials.

Meanwhile, Kyle notices an extremely creepy character at one of the crime scenes. Pissed that everyone is taking Cartman's bogus "readings" so seriously, Kyle takes matters into his own hands. He follows the creepy man home, does some fairly complex fingerprint and blood analysis work, and informs the cops that this guy is their man. They scoff at him, preferring to rely on Cartman's readings.

Feeling that there's no other way to make himself heard, Kyle straps on cardboard wings, jumps off the roof of his own house and sustains a head injury that lands him in the hospital...with a coma.

When Kyle wakes up, he tells the cops he's acquired psychic powers just like Cartman, and provides the police with the name and address of the Left Hand Killer. Meanwhile, the Killer kidnaps Cartman and plans to kill him—claiming that Cartman has denied him proper credit for his "work."

The police arrive just in time, and gun the killer down. Back at the hospital, they, along with the (now released) "professional" psychics, thank Kyle for helping them. Kyle tells everyone that psychic powers had nothing to do with it, and that no one can really read minds.

Not surprisingly, no one believes him. The professional psychics then square off with Cartman in a telekinetic battle. Suddenly the room's lights go out and the shelf above Kyle's bed collapses. Kyle, taken aback, insists there's a logical explanation for that too.

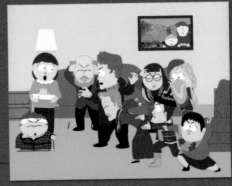

"I see you like cutting the eyes out of photos of women. My son is a big fan of that too."
—*Sergeant Yates*

"Don't make me do it, Kyle! I can make your head explode with a single thought!"—*Cartman*

"Kyle, don't fly too close to the sun or it'll burn your wings and you'll crash into the ocean!"—*Butters*

"I'm sure it will work! Go for it! Yea, Cartman! Fly fly fly!"
—*Kyle*

"I'm afraid that my powers are not for sale. And by that, I mean they absolutely ARE for sale."—*Cartman*

"Do not doubt my powers, Kyle."
—*Cartman*

MEMORABLE LINES:

"I'm afraid your son is . . . incredibly stupid. He thought he could fly with cardboard wings. The stupidity is so severe that it caused a fall which has put him into a deep coma."—*Dr. Doctor*

"What'dya got Wunderkind, are you seeing anything?"
—*Sergeant Yates*

"Look, kid, don't waste my time with your blood sampley, fingerprinty hocus pocus!"—*Sergeant Yates*

"Oh my god . . .it's a fried chicken sundae."
—*Cartman*

"Do you want to see my cotton panties?"
—*Left Hand Killer*

"I see . . . ice cream with sprinkles and Quadruple-Stuffs!"
—*Cartman*

"Stand back mother! We are having a telekinetic battle of minds!!"
—*Cartman*

BODY COUNT

The Left Hand Killer's numerous victims, as well as the serial killer himself. Also, one of the "real" Psychic Detectives is gunned down in a police raid, after he poorly attempts to defend himself with his mind.

WHERE DID THE IDEA COME FROM?

Matt and Trey, near catatonic from fatigue as they approached the end of the season, remember next to nothing about this episode.

CHARACTER DEPARTURES

Ms. Crabtree, the elementary school bus driver (and one-time stand-up comedian), is killed brutally by the Left Hand Killer. A cop mulling over her murder says, "She was considered an ancillary character, one the fans wouldn't miss much." A few moments later, he breaks down: "I know she hadn't been in any recent episodes but dammit she deserved better than this!"

CHARACTER DEBUTS

The Left Hand Killer, a.k.a. Michael Deets, who resides at 621 Costillo Street. Also, Tom Johansen, the ice cream shop owner, and the group of seven "real" Psychic Detectives, all of whom have paid the $25 comic-book-entry-fee to be called such.

POP CULTURE REFERENCES

The scene in which Cartman is kidnapped by the Left Hand Killer is a recreation of one of the more gruesome moments in the 1986 serial killer flick *Manhunter*.

Also, elements of the 1981 SciFi horror flick *Scanners* are parodied here, most notably when Cartman is trying to use his telekinetic "powers" to make other people's heads explode.

POINTLESS OBSERVATIONS

This is the boys' second run-in with fake psychics. The first was their battle with John Edward in "The Biggest Douche in the Universe" (page 40). Also Stark's Pond, which was paved over to make room for the Wall Mart (in "Something Wall Mart This Way Comes," page 100), is now back and better than ever.

While giving his inspirational pre-flight speech, Cartman mentions Copernicus (the 15th century astronomer who first named the sun as the center of the universe) as well as the Wright Brothers, "Orville and Redenbacher." While the Wright Brothers (Orville and Wilbur) are indeed credited with flying and creating the first successful airplane, "Orville Redenbacher" should be credited with making delicious popcorn.

Dr. Doctor, the lead medical expert at Hells Pass Hospital, has his real name revealed to be "Dr. Gauche" in this episode. Also, Sergeant Yates, head of Park County Police, is called "Lou" here. However, in "The Jeffersons" (page 94), his wife Maggie calls him "Harrison" Yates.

ORIGINAL SONGS

The soulful, gospel-like "Seasons Change" plays over the passage of time during Cartman's coma.

WHAT KYLE LEARNED

"The plain simple truth is that nobody is psychic. There's a logical explanation for every psychic story you've ever heard."

109

WOODLAND CRITTER CHRISTMAS

Original Air Date: December 15, 2004
Episode 814

THE STORY: Like many classic Christmas specials, a cheerful voice narrates this—and propels Stan through the twisted Christmas adventure, whether he likes it or not.

The story begins when Stan (aka "the boy in the red poof-ball hat") encounters a group of innocent-looking, talking forest animals called the Woodland Critters. After he makes a star for their Christmas tree, they convince him to build a manger for Porcupinie the Porcupine. . .who is pregnant with their Savior.

Stan is also asked to help them with another problem. Every year, one of the Critters conceives and carries their Savior, only to have a mountain lion kill the mother before she gives birth. Touched by their story, Stan hikes into the mountains and manages to slay the mountain lion by tricking it into leaping off a cliff.

But things aren't as they seem. The "bloodthirsty" lion has three small, talking cubs. Even worse, when Stan informs the Woodland Critters that he succeeded, they celebrate by holding a "blood orgy" in honor of their master—Satan.

It turns out that the Critters' Savior is really the Antichrist, whose birth the now-deceased mountain lion can no longer prevent. Stan, remembering the cubs, tries to enlist their help. When they inform him that they have no idea how to kill babies, Stan takes them to an abortion clinic for pointers.

Meanwhile, the Woodland Critters secure a human host for the Antichrist—Kyle, who as a non-baptized non-Christian, fits the bill perfectly. Stan and the cubs return to find that the Woodland Critters' Savior is already born, and that Kyle is being readied to receive him. Santa Claus shows up just in time and slaughters the Critters with a shotgun.

Suddenly overcome with the thirst for power, Kyle declares that he *wants* the Antichrist to possess him, so he can make the world a better place for the Jews. The Antichrist takes over Kyle's body and—

The action cuts to Mr. Garrison's fourth-grade class, where we learn the whole thing is a story Cartman made up for his "Write Your Own Christmas Story" assignment, which he's now reading aloud. Kyle objects, saying it's just another excuse to rag on him for being Jewish at Christmastime. Fearing another angry phone call from Kyle's mother, Mr. Garrison orders Cartman to stop.

But the other kids want to know the ending—they complain until Kyle gives in and lets the reading continue.

Back in the story, Kyle suddenly realizes the Antichrist is too much evil to take on and wants no more of it. So Stan has the three lion cubs, now well-versed in pregnancy termination, extract the squirming Prince of Darkness from his ass. Santa finishes off the Beast with a sledgehammer.

As a special Christmas present to Stan, Santa resurrects the lion cubs' mother. And everyone lives happily ever after. . .Except for Kyle, who dies of AIDS two weeks later.

BODY COUNT

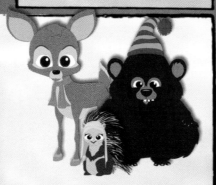

The saintly mountain lion mother, plus all of the Woodland Critters. One Critter was sacrificed to Satan via a cannibal-infused blood orgy, while the others were blown apart by a shotgun-wielding Santa Claus. Technically, however, the whole thing was just a story Cartman wrote, so no one really died.

WHERE DID THE IDEA COME FROM?

This is the episode that almost didn't happen. Normally the staff begins working on each new show on Thursday, working until it airs the following Wednesday. In this case, no one could come up with an idea. Finally, on Saturday morning, Trey decided they would do some sort of "Critter Christmas" parody loosely based on 1979's *John Denver and the Muppets: A Christmas Together* TV special. It seemed like pretty thin gruel, but that afternoon it started to click—especially when they had the Critters worship Satan and participate in a blood orgy.

POINTLESS OBSERVATIONS

This story obviously parodies the Biblical tale of the birth of Jesus—Porcupinie's immaculate conception; the hand-built manger; preparing for the birth of their Savior. There are also 12 Woodland Critters, as there are 12 Apostles. And when Stan is guiding the three mountain lion cubs toward the Antichrist Star glowing bright in the sky, this is a nod to the journey made by the Three Wise Men.

During Stan's joyous Christmas celebration at the end of the episode, his whole family is shown together—including Grandpa and his dog, Sparky. Even Shelly looks happy.

CHARACTER DEBUTS

The Woodland Critters. These adorable little forest creatures worship the Antichrist and aim to bring an end to the world as we know it. There's Squirrelie the Squirrel, Rabbitie the Rabbit, Beaverie the Beaver, Bearie the Bear, Racoonie the Racoon, Porcupinie the Porcupine, Skunkie the Skunk, Foxie the Fox, Deerie the Deer, Woodpeckerie the Woodpecker, Mousie the Mouse, and Chickadee-ee the Chickadee.

Also, we meet the mountain lion and her three lion cubs (who aren't named in the episode but are in the script: Tanner, Flick, and Jess).

POP CULTURE REFERENCES

The blood orgy action—and much of the episode's over-the-top violence—was inspired by similar gore-intensive scenes from the 1997 film *Event Horizon*. Also, the mountain lion's death scene is very similar to Mufasa's fall from a cliff in *The Lion King*. Lastly, Stan tries to ignore the Narrator's insistence that he find a way to stop the Woodland Critters by sitting on his couch and watching the classic TV show *The Jeffersons*.

ORIGINAL SONGS

The Critters sing their own cheery Christmas carol while decorating the tree, "Woodland Critter Christmas." There's also the signature John Denver-esque song "Christmas Time Is Once A Year," which is reprised by a full female choir for the end credits.

CHRISTMAS REFERENCES

The Narrator of our Woodland Critter Christmas story sounds quite similar to the voiceovers heard in many Dr. Seuss TV specials—most notably, *How the Grinch Stole Christmas*. Also, the craggily death mountain where the mountain lion lives is reminiscent of the Grinch's cave, as well as that of the Abominable Snowman from the classic 1964 TV special *Rudolph the Red-Nosed Reindeer*.

WHAT KYLE LEARNED

"This whole time your stupid story was just a way to rip on me for being Jewish at Christmas again!"

SEASON

9

314_00~

Location:

...es walking up holding an umbrella. He very casually ...and turns.

Cartman Ginger

Fancy Shirt 911

314_00 cont

0

Location:

Dialogue
CARTMAN (coughs)
How's everything with you guys?
KYLE
Wow, Cartman... you look... DIFFERENT.
CARTMAN
Yes, well, it's interesting you should point that out, Kyle. I went to the doctor yesterday, and apparently I suffer from a small skin pigment deficiency.
STAN
You mean... You're a GINGER?
CARTMAN
Actually, GINGERVITUS is the medical term.
KYLE
Is that an umbrella you're using?
CARTMAN
Yes, Kyle. The sun's rays are bad for my skin so I need to be protected when I'm outside. Well, I'm glad we've gotten all that out of the way, and we can just go on with our lives as normal now.
KYLE
Wow, that's a little ironic, isn't it?

Handwritten notes:

s. What's going on?

...TMAN'S FRONT VIEW.
...S PUPILS MOSTLY @ CAMERA

Efx
all stare at Cartman.

...otes #8 mouths.

...MAN SAYS FRONT HEAD
...LEANS TOWARD THEM
HE SPEAKS. Pupils @ CAMERA

↳ looking at
(to CARTMAN) CAMERA

MR. GARRISON'S FANCY NEW VAGINA

Original Air Date: March 9, 2005
Episode 901

THE STORY: After a lifetime of being "trapped in a man's body," Mr. Garrison visits Dr. Biber of the Trinidad Medical Center. There, he undergoes a cutting edge sex change operation (called a "vaginoplasty"), and with a few cuts and tucks, he is declared a full-bodied woman.

Meanwhile, Kyle fails to make the All-State basketball team and is told by his coach that "Jews can't play basketball." He leaves the court feeling depressed and cheated—even though he feels like a basketball player on the inside, he's limited by his outward appearance.

After the boys meet the radically reconstructed "Ms. Garrison" on the street, Kyle asks his parents to explain a sex change operation. His mother says it helps people whose self-image is at odds with their physical appearance. This strikes a chord with Kyle, who admits he's always thought he should be tall and black. He and Stan visit the Trinidad Medical Center where Doctor Biber tells Kyle that he could perform a "negroplasty" with relative ease, a process that would essentially make him tall and black.

Kyle's parents are furious when he asks permission to get the surgery. His father confronts Dr. Biber—who quickly learns of Gerald's affinity for dolphins. . .and offers to turn him into one. Kyle's dad opts for the "dolphinoplasty" operation and is soon hobbling around on a walker, with a dorsal fin and a blowhole on his neck.

Rejuvenated from the surgery, Kyle's dad has a change of heart. He can no longer deny his son the right to not be tall and black, so he lets Kyle get the negroplasty.

Things aren't going well for the newly minted "Ms. Garrison." Her boyfriend, Mr. Slave, leaves her. She then learns that even though she looks like a woman, she'll never have a period or be able to have children. Furious, she demands to be changed back—only to learn that her testicles were implanted in Kyle's new knees and that her scrotum was used to fabricate Kyle's father's dorsal fin.

The Negro-fied Kyle has now made the All-State basketball team and will play in a game that night. But Dr. Biber says Kyle only *looks* black, and that if he actually takes the court, the strain on his new knees will squash Garrison's former balls.

Garrison, Biber, Cartman, Stan, and Kenny rush to the basketball arena, but it's too late. After he makes a spectacular slam dunk, Kyle's testicle-enhanced knees explode when he lands on the court, blasting off his lower legs.

Dr. Biber apologizes for the inconvenience to Kyle and his father. He admits that, unlike Garrison's surgery, their changes were only cosmetic. He then agrees to turn them back into their former selves for a nominal fee. There's no going back for Garrison however—he decides to accept his new appearance and go on living as a woman.

MEMORABLE LINES:

"Wow! Just look at all these tampons!!"
—*Ms. Garrison*

"Well, I'm about to pee out my vagina for the first time! Give us a hug! GIRLS CLUB!!"
—*Ms. Garrison*

"It's Kyle! He's a Negro!!"
—*Butters*

"But I'm GAY. I don't LIKE vaginas."
—*Mr. Slave*

"You guys, Mr. Garrison has titties."
—*Cartman*

"He's a Jewish dolphin. . .A Jewphin."
—*Cartman*

"That dolphin has my scrotum, now let us in!"
—*Ms. Garrison*

"If you want, you can just scramble it and I'll queef it out myself."
—*Ms. Garrison*

"The first thing I'm going to do is slice your balls."
—*Dr. Biber*

"I hate being small and Jewish. I feel like a tall black man."
—*Kyle*

"I may be a dolphin but I'm also a lawyer."
—*Kyle's dad*

"Well, it's a good idea if you want to be tall and black. Otherwise, I wouldn't recommend it."
—*Dr. Biber*

"Those testicles in his knees are ticking time balls!"
—*Dr. Biber*

WHERE DID THE IDEA COME FROM?

The writing staff started the season with only a handful of half-developed ideas, including Mr. Garrison getting a sex change operation. The story about Kyle's frustration over not having the right body for sports is based on Trey's unrealized dream of playing for the Denver Broncos.

CHARACTER DEBUTS

Ms. Garrison. After vaginoplasty surgery and some fake titty implants, Mr. Garrison is no more.

Dr. Biber is the plastic surgeon who turns Garrison into a woman.

ORIGINAL SONGS

The breezy, ethereal "Swim With the Dolphins" plays over Gerald's visions of becoming one with the dolphins.

POINTLESS OBSERVATIONS

Scenes from a real-life sex change operation are used at the beginning of the episode. Originally there was almost a minute of bloody footage, but it got massively trimmed after an advance screening for Comedy Central.

In Kyle's family dining room, there's a picture of the Broflovski family fully decked-out in ski clothes. This picture is from the episode "Asspen" (page 14).

We learn a lot of medical terms here: When a woman wants to become a man, the procedure is called a "peenieplasty"; a man to a woman is a "vaginoplasty"; a white person to an African American is a "negroplasty"; an African American to a white person is a "caucasioplasty"; and lastly, a human to a dolphin is a "dolphinoplasty." All can be achieved with relative ease. . .if you have about three thousand dollars.

This episode marks the beginning of the end of the gaytastic relationship between Mr. Slave and Mr. Garrison. It will eventually come to a head later this season in "Follow That Egg" (page 134), when Mr. Slave and Big Gay Al get married.

POP CULTURE REFERENCES

After the sex change, Garrison flashes her breasts during what appears to be a *Girls Gone Wild*-like taping. But while the other women's boobs are obscured, Garrison's are displayed in all their tiny, pointy, disfigured glory.

Kyle admits to having always felt black: he listens to hip-hop, loves playing basketball, and watches UPN (a now-defunct cable network that catered largely to the African American demographic). He also admits that he's always wanted to play ball for the Denver Nuggets.

CELEBRITIES IMPUGNED

Michael Jackson, whom Dr. Biber offhandedly mentions as someone who'd had a "caucasioplasty"—a conversion from black to white.

WHAT MS. GARRISON LEARNED

"Even though I'm not truly a woman. . .I think I still like the new me. I'd rather be a woman who can't have periods than a fag."

DIE HIPPIE, DIE

Original Air Date: March 16, 2005
Episode 902

THE STORY: Cartman notices a disturbing increase in hippie activity around South Park. They have taken up residence in people's attics, in their walls . . .everywhere. At first he tackles the infestation himself, personally locking up 63 beatniks in his basement. But the problem soon becomes too much for him to handle solo. Desperate, he takes his fears to South Park's city council. He tells them that unless something is done, the exploding hippie population will cause a catastrophic hippie music festival the likes of which have never been seen.

The city council listens, then tells Cartman he's insane and throws him out. Shortly after, Officer Barbrady discovers the hippies "wrongfully" imprisoned in Cartman's basement and throws him in jail. Even worse, while he's locked up, the Mayor informs Cartman she's signed a permit *allowing* the hippies to stage the music festival.

Meanwhile, Stan, Kyle, and Kenny are out selling magazine subscriptions for their community youth program. They encounter a group of college hippies who inform them that selling magazines is turning the boys into a tool of "the corporations." Horrified at the sound of this, the boys start dressing like hippies and join the hippie clan so they can do something about "the corporations." They even turn up at the music festival—Hippie Jam Fest 2005— which quickly grows to disastrous proportions.

Almost too late, the town realizes its mistake, and seeks Cartman's aid. He agrees to help, on the condition that he be provided with a Tonka remote-controlled bulldozer and be allowed to play with it in the school parking lot while Kyle watches. He gets his terms and develops a daring plan—drill through the miles-thick festival crowd using a special vehicle called the Hippie Digger. Once at the stage, he will play a death metal song over the sound system. The hippies will disperse because, as everyone knows, hippies hate death metal.

At the same time Stan, Kyle, and Kenny grow bored with the music and pot smoking at the concert and ask the hippies when they actually plan on doing something. The hippies think getting high and listening to tunes *is* doing something. Disgusted, the boys try to leave, only to discover they're walled in on all sides by miles of hippies.

Just then, the Hippie Digger (manned by Cartman, Butters' mom, Stan's dad, and Chef) hacks its way through the dreadlocked, patchouli-scented throng to the stage. Cartman commandeers the sound system and blasts the Slayer song "Raining Blood," which instantly disperses the crowd. The boys, now free, reject the hippie lifestyle. And later, Cartman gets his Tonka bulldozer—which Kyle, as agreed, must watch him enjoy.

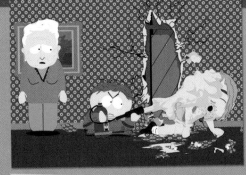

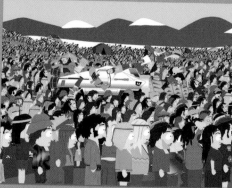

MEMORABLE LINES:

"Look, when hippies start to nest in a new area, it draws other hippies in. With the right weather conditions and topography, it can lead to a music festival."
—*Cartman*

"So it seems like we have enough people now. When do we start taking down the corporations?"—*Stan*

"Along with me, I'm going to need a scientist, an engineer. . .and of course, a black person who can sacrifice himself in case something goes wrong."
—*Cartman*

"You ate too much acid, man!"
—*Stan's mom*

"Problem is, if you see one hippie there's probably a whole lot more you're not seeing."—*Cartman*

"They're not people, they're hippies!"
—*Cartman*

"I can't wait to see the look on those little Eichmann's faces when they hear this crunchy groove!"—*Crunchy*

"I...don't want you to worry about me, Clyde Frog. You're the best stuffed animal I ever had."
—*Cartman*

BODY COUNT

Numerous hippies ground to bits by the blade of the Hippie Digger. Also, a number of band members mutilated and crushed when the drill crashes into the stage. While trying to stop Stan's dad from entering the hippie mob, Jimbo says that the hippies "just trampled Mrs. Farkle to death." We haven't been introduced to her, but she's dead now anyway.

CHARACTER DEBUTS

A whole buttload of stoners, nonconformists, and hippies—literally millions of them. Although they aren't specifically named in the episode, the hippies from the University of Colorado at Boulder have names in the script: Chachi (the leader), Crunchy (the dude with a guitar), Granola (the guy constantly eating granola), and the two girls, Rain (with the "Fish" shirt) and Navel (with the hippie coat).

WHAT-THE-FUCK MOMENT

When Mayor McDaniels realizes that signing a permit for the concert unleashed a hippie holocaust, she presses a large-caliber handgun to her head and fires, splattering a nearby wall with blood and brain matter. But a few scenes later she's back on her feet, sporting a head bandage covering her still-bleeding entrance and exit wounds.

WHAT STAN LEARNED

"Maybe instead of complaining about corporations being selfish, we should look at ourselves. I mean, is there anything more selfish than doing nothing but getting high and listening to music all day long?"

WHERE DID THE IDEA COME FROM?

Trey and Matt met while going to college in Boulder, Colorado, where they observed lots of hippies in their natural environment. They're particularly amused by the unshakable hippie belief that smoking weed and listening to music will somehow change the world. You may notice that a number of hippies in this episode are shown as specifically from University of Colorado at Boulder.

POINTLESS OBSERVATIONS

Butters' mother is apparently an engineer (although we have previously seen her working at a telemarketing office in "Jared Has Aides," page 12). There's also a flashback of Stan's parents circa 1969, attending the acid-soaked Woodstock Music Festival. This is the first episode where we see Stan playing guitar, although it looks as if he's still learning the chords. He will master the process in "Smug Alert!" (page 150).

A wealth of information is revealed about hippies. They usually live in colonies, have no money, and are deathly afraid of "the corporations." More specifically, they come in three types: "Giggling Stoners," a pretty common form usually found in attics; "Drum Circle Hippies," which usually form colonies if not treated; and worst of all, the "College Know It All Hippies." Cartman states that he's been keeping the town free of hippies since he was 5½ years old.

The bumper sticker on the hippie's car reads: "My Karma ran over your Dogma." There's also a modified Jesus Fish with two little legs sprouting from it, labeled "Darwin."

Finally, we learn that Chef (who speaks newly recorded dialogue for the last time in this episode) is a member of South Park's city council and is responsible for public safety.

POP CULTURE REFERENCES

Cartman's encounter with hippie-fied versions of Stan, Kyle, and Kenny is a parody of a scene from the zombie thriller *28 Days Later*. Also, Cartman's speech before the city council on the growing hippie problem recalls a similar moment in the 2004 disaster flick *The Day After Tomorrow*. Finally, the idea of using a giant drill to bore through the concert crowds is taken from the movie *The Core*, in which a similar vehicle carries humans to the center of the earth.

One of the college hippies is wearing a "Fish" shirt, a take-off on the popular stoner jam band Phish. The first band performing on stage looks an awful lot like them.

While warning the city council, Cartman claims that, "Reggae on the River, Woodstock, Burning Man—they would all pale in comparison." These are all immensely famous music festivals.

Hippie Kyle is wearing a t-shirt with the picture of revolutionary leader Che Guevara, who was largely responsible for the Cuban Socialist Revolution.

LIBERAL DOUCHE REFERENCES

The hippies regularly call Cartman "Little Eichmanns." It's a nod to University of Colorado-Boulder professor Ward Churchill, author of a paper asserting that the US provoked the 9/11 attacks. He called the victims Little Eichmanns, after Nazi holocaust architect Adolf Eichmann.

WING

Original Air Date: March 23, 2005
Episode 903

THE STORY: Token wins the Colorado Child Star Contest, netting him $200 and the chance to sing at the Miss Colorado Pageant in Denver. The boys decide they should be getting a cut of this money too and form the Super Awesome Talent Agency. After a bit of sweet-talking, Token signs with the boys and becomes their first client.

But the relationship is short lived. After Token performs to raves at the pageant, he's swept away by Don Hizeman, a slick agent from the Creative Arts Agency (CAA) in Los Angeles. Despite their protests, their client is gone.

Fortunately, word of their agency has spread. City Wok owner Tuong Lu Kim asks the boys to represent his wife, Wing, who's just been shipped over from China by the Chinese Mafia. She performs a unique rendition of ABBA's "Dancing Queen" for the boys, and they sign her because she's already secured an audition for *American Idol*.

The boys accompany her to Los Angeles for the competition, only to discover they'll have to wait weeks for an *Idol* shot. Instead they sign Wing up for another reality show that happens to have an open slot—*The Contender*. Wing's musical skills prove of little use in the boxing ring, however, as she sings "Fernando" while being beaten to a pulp

by a boxer nicknamed the Destructor. On the bright side, her performance impresses the show's host, Sylvester Stallone. After the match, he hires Wing to sing at his son's wedding for $4,000.

The boys are ecstatic at the big payday, until they see Wing forcefully taken away in a limousine by the Chinese Mafia—whom they mistakenly believe to be Creative Arts Agency minions. Determined to get her back, they track the Mafia guys to their lair, triggering a massive shootout that kills Kenny, along with a large number of Mafia thugs.

The Mafia leader says he "owns" Wing and threatens to kill her. The boys argue that they contractually owned her first, and demand he turn her over. Finally, they reach a mutual epiphany and realize that controlling other people is wrong. The boys decide to get out of the talent agent business, and conversely, the Chinese Mafia leader vows to stop enslaving people.

Wing performs at Stallone's son's wedding, to the delight of the assembled crowd—which includes the Chinese Mafia, the boys, and Wing's husband, Tuong Lu Kim. In the middle of her performance, Token appears—only now he's working as a waiter to try to earn enough cash to return to South Park. Apparently the folks at CAA didn't help him at all. Cartman tells him to fetch more bread and olive oil.

"**From now on, we are an entertainment team, Token. You just do all the singing, all the performing, and all the entertain-ing. . .And leave the rest to us.**"
—*Cartman*

"We're too smart to be talented."—*Stan*

"Hello? Oh yes, hi Colonel Sanders."—*Cartman*

MEMORABLE LINES:

"Just between us girls, nothing gets my vag wetter than a black man singing."
—*Ms. Garrison*

"You wouldn't kill her, 'cuz then she can't pay you money! We know because we're in the same business you are!"
—*Stan*

"Of course he sings, he's black."
—*Cartman*

"I will give 10% of my money to Stan, Kyle, Kenny, and Cartman because they are awesome and can find me lots of work as an artist."
—*Token's Super Awesome Talent Agency Contract*

"This just goes to show that hard work doesn't pay off. I'm going to be a homeless drug addict from now on!"—*Cartman*

BODY COUNT

A large number of Chinese Mafia henchmen bite the bullet. As does Kenny, who's gunned down in the shootout. This is the third time he's been killed since being resurrected in "Red Sleigh Down" (page 44).

CHARACTER DEBUTS

Wing. In addition to being Tuong Lu Kim's "wife," she is a real pop singer from New Zealand. The songs in this episode are actually her work. She even signed off on her image being used in the episode, with the only stipulation being the approval of her cartoon "self." Her website (www.wingmusic.co.nz) was plugged at the end of the show.

We also meet the Chinese Mafia. Even though many of them are killed off, they eventually become forces for good.

WHAT STAN LEARNED

"I think we all learned it's best to leave talent to the talented people."

POINTLESS OBSERVATIONS

In order to impress Token, Cartman pretends to have a chummy phone conversation with Abraham Lincoln—unaware that Lincoln has been dead for more than a century. Later he pretends to chat with Colonel Sanders, who died in 1980. Stan will actually have a conversation with the ghost of Abraham Lincoln in "The List."

The address of the Super Awesome Talent Agency is 23345 Avenida De Los Mexicanos.

"Creative Arts Agency" (CAA) is a parody of the very real Hollywood talent agency Creative Artists Agency, which is one of the top agencies in the biz. The boys' Super Awesome Talent Agency "office" (and their obsession with fountains) is an homage to the real thing. In addition to the movie posters for *I.T.* and *Terrance and Phillip's Asses of Fire*, there are two framed *Varieties!* clippings—a parody of the entertainment biz newspaper, *Variety*. The picture on one of the covers looks an awful lot like Paris Hilton. On the back wall, there's also a movie poster for *Ghost Dad*, a 1990 Bill Cosby flick.

POP CULTURE REFERENCES

Token belts out the Lou Rawls standard "You'll Never Find Another Love Like Mine" during his performance at the Miss Colorado Pageant. Matt and Trey used Rawls' original recording.

Wing performs a bit of ABBA's "Dancing Queen" in her audition for the boys, as well as "Fernando" (another ABBA song) while on *The Contender*. After Stallone hires her to sing at his son's wedding, the boys break out into an exciting rendition of Baha Men's "Who Let the Dogs Out?" At the wedding, Wing performs "Sing," a song popularized by The Carpenters.

The two shows that Wing participates in—*American Idol* and *The Contender*—are obviously based on the real, long-running reality TV shows of the same name.

The set-up for Stallone's son's wedding is an homage to the famous wedding scene from *The Godfather*. If you look closely, there are a number of famous people from previous episodes in attendance, most notably: George Lucas, Gene Hackman, and Ben Affleck. Also, the climactic shootout with the Chinese Mafia owes quite a bit to the finale of *Scarface*, including Cartman's use of the signature phrase, "You wanna play rough?"

CELEBRITIES IMPUGNED

Sylvester Stallone. His speech is so garbled and incomprehensible he needs an interpreter to make himself understood.

121

BEST FRIENDS FOREVER

Original Air Date: March 30, 2005
Episode 904

THE STORY: Kenny is the first to buy the much-coveted, brand-new Sony PSP videogame console. This, of course, pisses off Cartman. He wanted to be the first kid to have it, but now must sit idly by and watch as Kenny enjoys it. Kenny proceeds to spend every waking moment playing and mastering a game called *Heaven versus Hell*. In a glorious display of talent, he reaches Level 60—the highest level possible—and then is run over by an ice cream truck.

Kenny's spirit rises to Heaven, where he's informed that the PSP was invented by God himself. The device was designed to locate "the one" with the tactical skills to defend Heaven against the impending assault from the 10 billion-strong armies of Hell. Since Heaven has a measly population of less than ten thousand, this is no easy task, and it seems the fate of all the universe lies solely on Kenny.

But just as the final battle between Heaven and Hell is about to begin, Kenny is pulled back into his earthly body. An overzealous Dr. Doctor has revived him (despite the fact that he's been dead for an entire day), leaving him "alive," but in a vegetative state.

Cartman advocates pulling the plug—his not-

so-secret motive being Kenny's PSP. . .which he's inherited, but now can't have because Kenny isn't technically "dead." Cartman goes all the way to the Supreme Court, arguing that since he was Kenny's BFF (Best Friend Forever), he should decide his fate. The court sides with Cartman and Kenny's feeding tube is removed.

Stan and Kyle, however, realize that Cartman just wants Kenny's PSP and take their case for preserving their friend's life to the media. This whips up a firestorm of protest. Meanwhile, in Heaven, a much more literal firestorm brews as Satan's army prepares to attack the pearly gates.

Finally the stalemate on earth is resolved when the last page of Kenny's will is found and read. It turns out Kenny's sole request, if he ever ended up in a vegetative state and kept alive on life support, was that "please, for the love of God, don't ever show me in that condition on national television."

Chastened, both factions leave Kenny alone and let nature take its course. He passes away and ascends to Heaven, where he uses a golden PSP to guide God's forces to victory. In honor of his courageous efforts in saving all of humanity, Kenny is given the ultimate prize. . .a statue of Keanu Reeves.

MEMORABLE LINES:

"I can't wait to see the look on everyone's faces when I show up to school with a PSP. I wonder if Kyle will cry. Oh, PLEASE let Kyle cry!"
—*Cartman*

"Hail the holy PSP."—*Angels*

"That's not Kenny! Kenny sniffs paint and sets things on fire!"
—*Cartman*

"Oh my God. . .they killed Kenny!"
—*Archangel Michael*

"Japanese people don't have souls!"
—*Archangel Michael*

"Basically, Kenny, you are Keanu Reeves."
—*Archangel Michael*

"I DO have legal authority your honor. You see, I was Kenny's BFF."
—*Cartman*

"All you have to do is play the game, Kenny. Only this time. . .it's for reals."
—*Archangel Michael*

"Kenny is the same as he ever was. It's just that now he's more like. . .a tomato."
—*Dr. Doctor*

"What's the point? They have a Keanu Reeves now."
—*Satan*

"Let's go to the media! We'll make everyone in the country know that they're killing Kenny!!"
—*Stan*

"Amazing, doctor! You've revived somebody who's been legally dead for almost a day!"
—*Nurse*

BODY COUNT

Kenny. . .twice. He was hit by a truck, revived, then allowed to die again. In case you're counting, this is his fourth (and fifth) death since his resurrection in "Red Sleigh Down" (page 44).

Kevin, Satan's #1 man (and apparently his boyfriend) also gets toasted. Fed up with his persistent nagging, Satan kills/breaks-up-with him in a single blast of eye death rays. In the script, Kevin is referred to as "Brutis."

BEHIND THE SCENES

There was a big debate about whether the final battle between Heaven and Hell should be shown. In the end it was decided the story wasn't really about that. Plus, there just wasn't time to animate something so elaborate. So all we get is Archangel Michael's commentary about how incredibly cool it is.

CHARACTER DEBUTS

We are introduced to a number of heavenly angels, most prominently the marker-sniffing, Keanu Reeves-loving Archangel Michael.

WHAT KYLE LEARNED

"Maybe we should just let Kenny go in peace."

WHERE DID THE IDEA COME FROM?

The story is a commentary on the case of Terri Schiavo, a Florida woman in a persistent vegetative state. Attempts by her husband to have her feeding tube removed provoked international controversy—a controversy that reached its crescendo as this episode was prepared. Trey has said that the entire story came together in about 30 minutes—something that never, ever happens.

CELEBRITIES IMPUGNED

Keanu Reeves. Based on his roles in the *Matrix* movies and *Constantine*, he's portrayed as the gold standard for heroes who triumph over unbelievable odds. After Kenny leads Heaven's forces to victory, he's given a statue of Reeves.

NOT-SO-POINTLESS OBSERVATIONS

This episode won the Emmy for Outstanding Animated Program. After being previously nominated four times, this was *South Park's* first Emmy win. Incidentally, Terri Schiavo died the day after this episode originally aired.

POINTLESS OBSERVATIONS

Apparently God, who formerly only let Mormons past the pearly gates, has relaxed his entry requirements in order to increase Heaven's population.

During Kenny's PSP montage, we see the whole McCormick family in the amusement park once owned by Cartman in "Cartmanland." Kenny even plays the PSP while riding The Mine Shaft—the rollercoaster ride on which he was impaled in that episode (a death which wound up costing Cartman half a million dollars).

The driver of the ice cream truck that runs over Kenny is the same driver that picks up Butters in "Butters' Very Own Episode." He can be seen briefly in several other episodes, including "Goobacks" (page 96).

During the meeting of Heaven's angels, there is a stone statue of "God" in the background. We first met Him in Season 3's "Are You There, God? It's Me, Jesus."

According to the Supreme Court, a BFF (Best Friend Forever) is the most important, legally binding authority possible. To solidify such a relationship, a BFF Necklace is highly recommended.

POP CULTURE REFERENCES

Terri Schiavo's plight drove the story, but the stuff about Kenny playing a video game to save Heaven is a nod to the 1984 movie *The Last Starfighter*. This extremely obscure film is also referenced in Season Two's "Conjoined Fetus Lady."

VIDEO GAME REFERENCES

This is the second time a real video game system (in this case the Sony PSP) served as a plot device. The Sega Dreamcast, which played a pivotal role in Season Four's "The Tooth Fairy's Tats 2000," was the first.

THE LOSING EDGE

Original Air Date: April 6, 2005
Episode 905

THE STORY: The boys celebrate when their Little League team wins its final regular season game—not because they're excited, because it means they're done playing baseball for the rest of the summer. Unfortunately mid-celebration, they're told by their proud parents that the win qualifies them for a round of post-season contests.

Bummed out, they decide that they must do something to lose; they can't bear to spend any more time playing baseball. They all agree to take a dive during their next game. . .but this turns out to be far tougher than expected. Their opponents are equally sick of Little League and play even worse than they do, managing to squeeze out a loss. The same holds true for South Park's next few opponents, all of whom prove even more skilled at intentionally sucking.

Needless to say, the boys' parents have a different view of the situation. Oblivious to their kids' distaste for the game, they're super stoked at the prospect of ever-greater baseball "glory." Particularly Randy, who gets drunk at every game, picks a fight with a dad from the opposing team, and gets hauled off by the police. When told that the fathers of kids on playoff teams take drunk and obnoxious to a whole new level, he begins to train, *Rocky*-style, to meet the challenge.

Despite their valiant attempts to lose, the boys make it all the way to the Colorado Little League State Championship game in Denver. If they win,

they'll [unfortunately] spend the rest of the summer on the national circuit.

During the pre-game press conference, Randy gets a look at his probable opponent—an extremely fat, costume-clad parent called "Bat Dad." He is so huge and aggressive that Randy has a crisis of confidence. He even contemplates missing the game and ducking the fight.

While the parents hope their kids will win, the South Park kids go to extremes to ensure defeat. Kyle gets his cousin, Kyle, who has no athletic abilities and no knowledge of baseball, to join the team. But even that isn't enough. The Denver team has mastered the sport of sucking. They hit balls directly into the South Park kids' gloves and cause Kyle's cousin to score a home run by pitching the ball directly into his bat, then refusing to stop him as he slowly rounds the bases.

But just when all seems lost. . . or rather, won . . .Randy shows up for the game and takes on Bat Dad. Their bloody fight spills onto the field, where Randy takes an ass-whooping. The game's umpire yells that the next person who throws a punch will get his team disqualified—which sends the South Park kids into a frenzy. They rally behind Randy, giving him the strength he needs to get back up and knock out Bat Dad. This victorious punch also disqualifies South Park.

The boys' summer is saved. As his father is led away by the cops, Stan tells him he's the greatest.

"Sometimes I sweat from holding the bat for so long and then the heat steams up my glasses."
—*Kyle's Cousin Kyle*

"Don't throw the ball too fast, because I might get startled and I have asthma."
—*Kyle's Cousin Kyle*

"Bat Dad knows no fear! Bat Dad knows no pain! I want you, Marsh. I want you!"
—*Bat Dad*

"Son of a biscuit!!"
—*Butters*

MEMORABLE LINES:

"I worked hard. . .Believed in myself. . .And now I'm going to be fighting in the State Championship game. This is going to be the biggest fight of my life."
—*Stan's dad*

"You're about to be BAT DADDED!!"
—*Bat Dad*

"Let's face it. We're winners."
—*Jimmy*

"You wanna break me down?! You wanna hear me say it?! I'M SCARED!!"
—*Stan's dad*

BEHIND THE SCENES

The problem with putting the kids in uniforms was that, without their distinctive hats and clothes, they all look the same. A great deal of time was spent subtly tweaking their outfits so that viewers could tell them apart.

POP CULTURE REFERENCES

A number of scenes from the various *Rocky* movies are parodied throughout this episode as Stan's dad trains for the Little League fights.

Joe Esposito's hit song "You're the Best Around" plays over a long montage of South Park's Little League team unintentionally beating all their opponents. This song was popularized by the movie *The Karate Kid*, where it was used in similar montage fashion. It also plays again over the awesome, freeze-framed credits at the end of the episode.

When the boys are out of ideas about how to lose, Cartman turns to pop culture: "At this point in a sports movie, the team always goes out and finds a really sweet player to join their team." To which Clyde clarifies, "Like that motorcycle kid in *Bad News Bears*." It turns out their motorcycle kid is Kyle's Cousin Kyle.

CHARACTER DEBUTS

Tom Nelson, aka Bat Dad, the ultimate drunken asshole Little League parent. He even has his own costume, a skin tight cross between a WWE wrestler and Batman.

CHARACTER RETURNS

Kyle's Cousin Kyle. The boys fly him in from Connecticut because they needed "the very worst kid athlete in the whole world." He was last seen in briefly in Season 6's "Red Sleigh Down" (page 44).

HOODLESS KENNY

Kenny fans, rejoice! His blond mop and face can be seen quite clearly in several scenes—he's the unhappy kid with his hat sideways across his face. We also got a good peek at him hoodless in "The Jeffersons" (page 94), although here, you can see his face a bit more clearly.

WHERE DID THE IDEA COME FROM?

This episode sprang from a general consensus among the writing staff that the boys would look cute in baseball uniforms. The kids' aversion to baseball is shared by Trey and Matt, who never really got into "America's pastime."

WHAT STAN LEARNED

"I know we can lose if we try."

POINTLESS OBSERVATIONS

For the second time (the first being "Quest for Ratings," page 104), the boys dine at Whistlin' Willy's Pizza Gulch.

Butters' dad is the coach of the boys' Little League team. We also hear via Butters that his dad's motto is: "It's OK to lose, but if you don't try, you're grounded mister."

All the towns that the boys play against—Conifer, Fort Collins, Greeley, Pueblo—are all real Colorado towns that surround the Denver area.

The bat used by Kyle's Cousin Kyle is signed by baseball star Barry Bonds, who was last seen in "Up the Down Steroid" (page 86). Token was also shown playing with a similarly signed Bonds bat in Season 5's "Here Comes the Neighborhood."

THE DEATH OF ERIC CARTMAN

Original Air Date: April 13, 2005
Episode 906

THE STORY: Stan's mom comes home with a huge bucket of Kentucky Fried Chicken and the boys are really excited. While they quickly help unload the rest of the car, Cartman manages to eat the delicious, crunchy skin off of every single piece of chicken. The boys sit down to dig in only to find their chicken ravaged. Cartman then takes off, leaving the boys hopping mad.

The next morning, Stan, Kyle and Kenny decide to completely ignore Cartman all together. When he shows up and no one acknowledges or even looks at him, he leaps to the conclusion that he's dead and no one can see him. That belief is reinforced when he returns home to find his mother wailing uncontrollably upstairs and workers carrying out a kid-sized box. He doesn't realize that the box contains a toilet (which ruptured due to overwhelming amounts of chicken-skin-crap), or that his mom is "wailing" because one of the toilet repair guys is having sex with her.

Finally, he turns up at school, where everyone else has also decided to ignore him. Feeling he's a lost soul, he wanders the streets in despair—crying, moaning, and blubbering like a ghost.

Cartman then wanders by Butters, who says "hello" to him when they pass on the street. Cartman is ecstatic that Butters can "see" him. Butters, however, is terrified that he's seeing ghosts. They decide that Cartman can't "move on" until he finds closure with his loved ones. So Butters, acting as the mouthpiece for the plainly visible and audible Cartman, tells his "former" friends and family members what he really thinks of them, and apologizes for his wrongdoings.

When all of his hard work fails to propel him to Heaven, Cartman takes more drastic measures. He compiles a list of everyone he's ever wronged, then gives each one a gift basket. But this display of atonement doesn't allow him to pass into the next world either.

Meanwhile, Butters' parents worry that their son is losing his mind and have him institutionalized. In an effort to uncover his "past traumas," Butters undergoes a series of anal-intensive tests and experiments.

Cartman breaks Butters out of the institution and drags him to a psychic, who tells them that sometimes earthbound spirits must accomplish something important before they depart. Then she realizes Cartman is a spirit and runs away in a panic.

Just then a TV newscast reports that three escaped convicts are holding 12 people hostage at the local Red Cross. Cartman figures he's found his mission. He goes to the Red Cross building, walks straight in the front door and distracts the convicts (who can see him quite clearly) while Butters frees the hostages. The two kids sneak away as the police rush in and arrest the convicts.

Outside, Cartman thanks Butters for his help, and in a touching display, calls him his friend. He then tries one last time to get his eternal reward and transcend to Heaven. As he does this, the fourth grade boys appear and tell Cartman that, in light of his heroic actions, they won't ignore him anymore.

After taking a stunned moment to process this information, Cartman blames Butters for his humiliation and vows to get him back.

MEMORABLE LINES:

"Stupid butthole God!"
—*Cartman*

"I'm supposed to help him find out why his spirit is wandering the Earth, even though I know I'm most likely just completely insane."—*Butters*

"God forgave the Jews, you should be able to forgive me!"—*Cartman*

"I'm not going to heck Butters, I'm not black, alright?"
—*Cartman*

BEHIND THE SCENES

One of the biggest story problems (and the last bit to be written and animated) was the opening scene in which Cartman did something so heinous that it caused the other boys to freeze him out. This set the bar pretty high, considering all the things that Cartman had already done. The writing staff was eating Kentucky Fried Chicken together—and commenting on how the skin was the best part—when the solution hit them.

WHERE DID THE IDEA COME FROM?

The concept occurred to Trey during a production break, while he was hiking in Tasmania. It's the only time (so far) that he's come up with a usable idea while on vacation.

POP CULTURE REFERENCES

Butters is terrified after discovering his "ability" and screams out, "I'm like the kid in that movie! I'm seeing dead people!" He's referring, of course, to Haley Joel Osment's spooky character in the 1999 thriller *The Sixth Sense*.

CHARACTER RETURNS

When Cartman decides to give conciliatory gift baskets to all the people he's wronged, he visits a number of people from past episodes. Most notably: Scott Tenorman (still grieving at his parents' graves); Rabbi Schwartz (seen last in "The Passion of the Jew," page 88); the still-enormously-fat Sally Struthers (from "Starvin' Marvin"); and poor, wheelchair-bound Miss Claridge (from "Pre-School," page 102).

CHARACTER DEBUTS

We meet two medical "experts" in this episode— the Doctor that examines Butters and institutionalizes him, and Doctor Lindsay, the expert on the paranormal. Also, three escaped convicts.

POINTLESS OBSERVATIONS

The toys in Butters' room include a box of "Leggoze," a board game called "Sink My Ship" (a parody of Battleship), a Chinpoko Mon action figure, a Sea Man action figure (based off the superhero from "Super Best Friends"), and a doll modeled after Niblet, Korn's mascot from the Season 3 episode "Korn's Groovy Pirate Ghost Mystery."

We hear Butters sing his infamous "Loo Loo Loo, I've Got Some Apples" song again here. It can be heard again later this season in "Erection Day" (page 128).

Cartman compiles a massive list of things he must atone for. Many of these incidents we've seen: the time he convinced a woman to have an abortion so he could build a Shakey's Pizza (from Season 5's "Kenny Dies"); when he pretended to be retarded so he could join the Special Olympics ("Up the Down Steroid," page 86); when he tried to have all the Jews exterminated last spring ("The Passion of the Jew," page 88); and of course, the kid whose parents he had killed and made into chili which he then fed to the kid ("Scott Tenorman Must Die").

ORIGINAL SONGS

Cartman attempts to make up for all his wrongs with the catchy, upbeat "Make It Right." Unfortunately, the song isn't powerful enough to get him into heaven.

WHAT CARTMAN LEARNED

"What awaits each person in heaven is eternal bliss, divine rest, and $10,000 cash."

ERECTION DAY

Original Air Date: April 20, 2005
Episode 907

THE STORY: Jimmy starts getting sexually aroused at unpredictable and inconvenient moments. His timing couldn't be worse—South Park Elementary's big talent show is only days away and his stand-up routine is a yearly prizewinner. Terrified at the prospect of getting a hard-on in front of the entire school, he confides in Butters. Butters informs him that he needs to stick his erect penis into a girl's vagina, which will cause it to become soft and manageable again.

Armed with this knowledge, Jimmy explicitly propositions a little girl named Bertha in the school hallway. Needless to say, she doesn't go for it. Cartman, overhearing, offers a more time-honored strategy—take a girl to a nice Italian restaurant and pretend to be a good listener.

Jimmy manages to get a girl named Shauna to go out to dinner with him. Wearing headphones and a mic, Cartman coaches Jimmy on what to say during the date. Everything goes surprisingly well, until Jimmy gets ahead of himself and asks for sex. Outraged, Shauna tosses a glass of water on him, shorting out the headset and electrocuting him.

The night of the talent show, Jimmy sits on the curb outside, miserable and afraid to compete.

Officer Barbrady happens by, listens to his troubles, and informs Jimmy that little girls don't *want* to have sex. However, the streetwalkers who work Colfax Point are more than willing.

Jimmy immediately takes off for Colfax Point, where he finds a plump prostitute named Nut Gobbler. Misunderstanding the nature of the hooker/client relationship, he then takes her out to dinner. But before he can seal the deal, they're surprised by Nut Gobbler's pimp, Q-Money, who thinks Jimmy is trying to steal his ho.

The pimp takes off with Nut Gobbler in his car. Jimmy pursues her in a taxi. After a long chase, the pimp drags Nut Gobbler to a rooftop, where Jimmy battles him using the only weapon at his disposal—the weapon of comedy. He distracts the pimp with jokes while Nut Gobber sneaks up and clocks him with a pipe. The hooker and the fourth-grader then retire to a cheap hotel for sex.

Meanwhile, back at school, the dreary, never-ending talent show is grinding toward an end. But just as Ms. Garrison is about to call it an evening, Jimmy shows up and asks for the microphone. Spent and confident, he launches into his set...and then suddenly gets another erection.

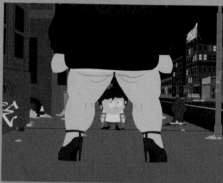

"Sir! I paid for that lady and by taking her, you are no better than a common thief!"
—Jimmy

"Hey, who's droppin' bombs in there?! How about a courtesy flush?"*—Butters*

"Nut Gobbler! Grab onto my crutch!"
—Jimmy

"Now we will tally up the judges' scores and find out which act they hated the least."*—Ms. Garrison*

"Follow that pimp and ho!"*—Jimmy*

"Colfax Point. Pimps and hos and tricks in rows. Women walk the streets with corns on their feets. Broken dreams, and no ice creams. . ."*—Narrator*

MEMORABLE LINES:

"I have a raging hard-on that just won't quit, and the talent show has already started!"*—Jimmy*

"Alright, Jimmy, when she finally shuts her trap again, I want you to repeat whatever she said and then follow it with 'Wow, how insightful.'"*—Cartman*

"I've been laid like 5,000 times."
—Cartman

"I need to put my penis in a woman's vagina. Any takers?"*—Jimmy*

"Jimmy, as you get older your body goes through a lot of changes. Certain hormones start to release as your whole reproductive system begins to awaken. And so if you like, we can take off our shirts and kiss."
—Dr. Pal

BODY COUNT

An unfortunate motorcyclist gets his head lodged between Nut Gobbler's legs during the high-speed chase. Although he's not killed, he'll probably never be the same.

WHERE DID THE IDEA COME FROM?

Matt and Trey wanted to do an episode in which one of the boys started getting erections, but couldn't decide which boy should have the honors. They went with Jimmy because, as a self-styled stand-up comic, he'd have the greatest potential for embarrassment.

POINTLESS OBSERVATIONS

During a bathroom scene, Butters shows off his signature urinal technique: pulling down his pants and hiking up his shirt before peeing. He's done this several times in other episodes.

Rebecca (aka "Red")—the girl with the signature red hair and navy blue shirt—is referred to as "Bertha" here.

The old, saggy stripper that's crying her eyes out as Jimmy carries Nut Gobbler away certainly gets around—she can be seen slinging dances at the Peppermint Hippo strip club in "Lil' Crime Stoppers" (page 60) and "The Return Of Chef" (page 148), and also at the police station in "Bloody Mary" (page 142).

Jimmy is the first one of the boys to go "all the way" with a girl.

CHARACTER DEBUTS

Dr. Pal, the "hip," "cool" physician who helps kids learn about their growing bodies . . .and then asks them if they want to take their shirts off and kiss. Nut Gobber, the hooker with a heart of gold (and a nasty urinary tract infection), as well as her pimp, Q-Money.

We also meet Shauna Krawly, a fourth grade girl with brown hair and a purple shirt. Jimmy takes her out on a pretty successful date. . .until he asks to stick his penis in her vagina.

POP CULTURE REFERENCES

During the talent show, Cartman performs a profanity-laden reading from the movie *Scarface*. Also, when Jimmy finally gets to have sex with Nut Gobbler, he carries her off in a parody of the closing scene of *An Officer and a Gentleman*. The song "Up Where We Belong" by Joe Cocker and Jennifer Warner plays over this—also from that film.

After Cartman's stellar advice on how to get laid, Jimmy asks for Cartman's help on his date, saying, "You're like a white Hitch." This is a reference to the 2005 romantic comedy *Hitch*, which starred Will Smith as a "dating expert."

Colfax Point—the seedy part of Denver shown here—is modeled after "The Point" from the HBO documentary *Hookers At The Point*, complete with Narrator and corn-footed hookers.

ORIGINAL SONGS

Butters' favorite tune "Loo Loo Loo, I've Got Some Apples" gets official treatment here—he practices and performs it for the school's talent show. The performance doesn't go so well, but at least it's more successful than his tap dancing display in "You Got F'd in the A" (page 90). Also, the Goth kids perform a snippet of their Cure-esque tune "Talent Shows Are For Fags."

CELEBRITIES IMPUGNED

During his stand-up routine, Jimmy tells a joke about home décor giant Martha Stewart: "Apparently Martha Stewart is out of jail. Have you heard about this? Have you seen this? She's very excited to get started on her new show: *Martha Stewart Living—With an Electronic Ankle Bracelet*." He also tells another Stewart joke towards the end of the episode, saying, "She's apparently gotten real good at baking cakes with keys in them."

Jimmy's routine also contains jokes about Pope John Paul II and Michael Jackson, but these don't go over quite as well.

WHAT JIMMY LEARNED FROM BUTTERS

"You see, Jimmy, when a man's penis becomes hard, the man puts it into a lady. Into her 'vagina.' Then, the hard penis sneezes milk inside the lady's tummy, and after it's all done sneezin' milk, the penis stops bein' hard, and the man loses interest in the lady."

TWO DAYS BEFORE THE DAY AFTER TOMORROW

Original Air Date: October 19, 2005
Episode 908

THE STORY: Cartman and Stan are playing in a docked speedboat on Jefferson Lake—a vehicle which Cartman says belongs to his Uncle Roy. Cartman dares Stan to drive, saying that he'll take full responsibility if anything happens. Stan punches the gas, launching the boat uncontrollably around the lake and into the world's largest beaver dam. The dam explodes, flooding the nearby town of Beaverton.

As the two swim breathlessly to safety, Cartman announces that the boat doesn't belong to his uncle—or to anyone he knows.

As word of the disaster gets out, the boys decide to keep their involvement to themselves. Meanwhile, Beaverton's residents are forced onto their roofs by the high water. The media makes things even worse by launching into a rumor-fueled frenzy, falsely "reporting" that the survivors have descended into violence, rape, and even cannibalism.

Everyone is so busy trying to figure out who to blame that no attempt is made to offer aid or rescue those in need. Stan's dad attends a statewide meeting of scientists to discuss the cause of the flood, and they conclude that global warming is the culprit. In fact, it's determined that global warming is going to unleash an attack "two days before the day after tomorrow". . .which turns out to be that day.

The townspeople panic at the news and barricade themselves in the community center, where they watch endless global warming news reports on TV. Stan's dad informs the huddled masses that

the heating of the atmosphere has triggered a new ice age, and that the outside temperature will soon fall to "over 70 million degrees below zero."

Well aware that global warming had nothing to do with the Beaverton flood, Stan confesses his involvement to Kyle. They, along with Cartman, leave the community center and head to Beaverton to try to help. But instead of helping, they mistakenly ram their boat into the local oil refinery—which quickly sets fire to the entire town.

Stan calls his dad, still unable to confess, and pleads for rescue. With the help of Mr. Stotch and Mr. Broflovski, the dads bundle up against the cold and journey outside to attempt a rescue. They make it about halfway through town before they overheat in the balmy weather and collapse.

Meanwhile, the army finally arrives in Beaverton and airlifts the survivors—and the boys—to safety. But not before Cartman pulls a gun on Kyle and demands he hand over his bag of "Jew Gold" that all Jews carry around their necks. After denying the existence of "Jew Gold," Kyle actually does produce a bag filled with gold from around his neck, but throws it into the fire rather than let Cartman have it.

Back in town, the populace is informed by the Army that global warming didn't cause the flood—*Crab People did.* Stan can't take it anymore and confesses that he was responsible for breaking the dam. But they think he means to imply that everyone is responsible for what happened. One by one, the citizens step forward and say (despite Stan's repeated admissions of guilt), "I broke the dam."

To **Beaverton**
Home of the World's Largest **Beaver Dam !**

"We weren't here. This didn't happen. Okay? We were both at my house all afternoon playing Tea Party."—*Cartman*

"If we survive this, I don't intend to live in poverty. Give me your Jew Gold now!" —*Cartman*

"**I'm afraid us adults let you children down. We didn't take care of our Earth and now you've inherited our problems!**"—*Stan's dad*

MEMORABLE LINES:

"Within the hour the temperature outside will fall to over seventy million degrees below zero."—*Stan's dad*

"All Jews carry gold in a little bag around their necks. Hand it over!" —*Cartman*

"What's important is figuring out whose fault this is."—*Stan's dad*

"Global warming is going to strike two days before the day after tomorrow." —*Scientist*

BODY COUNT

The death toll in Beaverton was reported as being in the hundreds of millions, which is particularly devastating since Beaverton only has a population of about eight thousand. Even worse, Fox News reported that over 600 billion people were killed by global warming in Chicago alone. Also, Ms. Garrison suffered from a broken leg and a leaky boob.

CHARACTER RETURNS

This episode marks the third mention of the infamous Crab People, who were first deployed in Season 7's "South Park is Gay" (page 64). They were also briefly discussed (but not seen) in Season 8's "Quest for Ratings" (page 104).

Also, in the ensuing chaos after global warming is unveiled, we see Nurse Gollum (from "Conjoined Fetus Lady") and Mr. Derp (from "The Succubus") all fleeing the school in horror.

PHALLIC REFERENCES

The penis Stan's dad unwittingly draws on a map of America refers to a widely publicized National Weather Service wind distribution map for Hurricane Rita, which looked like a wiener. It also references a map scene from *The Day After Tomorrow*.

WHERE DID THE IDEA COME FROM?

The episode was inspired by the Hurricane Katrina relief effort—or more accurately, the lack thereof. It also fulfilled Trey and Matt's long-standing desire to do a global warming episode that skewered the 2004 disaster movie *The Day After Tomorrow*, which they consider one of the worst films ever made.

POINTLESS OBSERVATIONS

During Stan's dad's global warming speech, the audience repeatedly says "peas and carrots." This is something that movie and TV extras sometimes mutter to make it look like they're carrying on a meaningful conversation. Also, in one crowd scene a bystander wears a hat that reads "John Denver Experience." This references a carnival ride seen in Season Four's "Cartman Joins NAMBLA."

A number of entities are accused of causing the Beaverton flood here: Global Warming, George Bush, Communists, Chinese Radicals, Terrorists, and Al-Qaeda (who apparently bombed the dam with WMDs).

According to Cartman, all Jews carry "Jew Gold" in a little bag around their necks. In fact, they also carry fake bags of gold around their necks to keep the real bags of gold safe. Turns out, he was right.

POP CULTURE REFERENCES

The moment in which the townspeople declare "I broke the dam" is a parody of a scene from 1960's *Spartacus*, in which the title character's followers all proclaim "I'm Spartacus."

Obviously, a number of scenes from *The Day After Tomorrow* are directly parodied here, including the scene where Randy addresses a cliché assembly of scientists and politicians. When Randy is challenged, he even says, "With all due respect, Cliché Dissenting Republican, the economy isn't going to matter The Day After Tomorrow."

While locked away in the community center, the townspeople all work themselves into a frenzy by watching endless reports by Fox News.

CELEBRITIES IMPUGNED

The line "George Bush doesn't care about beavers" references rapper Kanye West's accusation: "George Bush doesn't care about black people." He made this statement on live TV during the concert for Hurricane Katrina on NBC. West will get a lot more attention in Season 13's "Fishsticks."

WHAT SOME BACKGROUND CHARACTER IN THE LAST SCENE THOUGHT HE LEARNED

"Don't you see what this child is saying? We can't spend all our energy placing blame when something bad happens. He's saying . . . we all broke the dam."

131

MARJORINE

Original Air Date: October 26, 2005
Episode 909

THE STORY: During an emergency meeting of the fourth-grade boys, Cartman makes an earth-shattering revelation: the girls have acquired some sort of high-tech, mystical time relic that allows them to see the future. After showing surveillance footage of the girls operating this "Future Telling Device" (really just a paper fortune teller that all girls make in the 4th grade), the boys immediately put a complex plan in motion to steal the device for themselves.

It's decided that Butters must fake his own death, then pose as a new female student so that he can infiltrate an upcoming slumber party and steal The Device. His "death" is faked by dropping a dead pig dressed in his clothes from the Bowery Building. The fall, witnessed by a crowd of bystanders, is thoroughly convincing. Especially to his parents, who dissolve into hysterical grief.

The next day at school, Ms. Garrison introduces a new female student—a girl from Dallas named Marjorine. Her "mother" (actually Cartman) then phones Heidi's mother and secures an invitation to the slumber party. However Butters/Marjorine doesn't fit in here either, and is soon reduced to tears by the other girls' cruel remarks.

When he/she locks herself in the bathroom, Wendy and Bebe decide they've been too hard on Marjorine, and lure her out to give her a makeover. Soon she's having a ball, dancing to Justin Timberlake tunes with the rest of the girls. This infuriates Cartman, who (along with the rest of the boys) is watching everything from outside.

Meanwhile, Butters' parents are heartbroken over the loss of their son—so heartbroken that his father digs up his body (really the pig carcass) and in a paganistic ritual, reburies it at an old Indian cemetery. Even though he's been warned anything resurrected there will return to life as an undead abomination, Mr. Stotch is willing to risk it.

Back at the party, Heidi's father spots the boys outside and raises the alarm. Figuring the jig is up, Butters grabs The Device and escapes. However, he refuses to accompany the boys back to Cartman's house, where they've set up a high-tech "containment field" to house the artifact. Saying the device is nothing but trouble, he instead goes home to tell his parents he isn't dead.

The boys take the device to their hideout, but decide that Butters is right. Its power is too great and will bring disaster to whoever possesses it. They move The Device to the woods and have Kenny blow it up, creating a fireball large enough to be seen from space.

Butters' homecoming doesn't go as planned either. His parents are thoroughly convinced that their son, now risen from the dead, is some sort of evil monstrosity—a walking abomination—and are terrified when he shows up. Instead of welcoming him back, they chain him up and lock him in the basement. When he says he's hungry, his parents kill a saleswoman and offer up her body for Butters "to feed on."

Butters says he'd prefer some Spaghetti-Os instead.

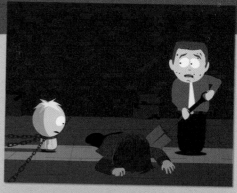

"**Well, I'm just a typical little girl. I like dancin' an' and ponies and getting my snootch pounded on Friday nights.**"
—*Butters/Marjorine*

"You aren't there to have fun you black asshole!!"
—*Cartman*

"Sometimes, dead is better."
—*Old Gas Station Worker*

"Oh Butters. . .you smell like. . .bacon."—*Butters' dad*

"You, sir, mocked Cartman before, yet you too sit here demanding answers! Now, damn you, let him speak!"—*Clyde*

"Now Butters, we don't know exactly what it is that girls do at their slumber parties. But if they all start . . . you know . . . lezzing out, just roll with it."
—*Cartman*

"Just come down now son, and we promise we won't ground you for more than a couple weeks."
—*Butters' dad*

"I'm sorry son, but you're a demon spawn now."—*Butters' dad*

MEMORABLE LINES:

"Just keep stalling, Butters. We don't have the dead pig quite ready yet." —*Cartman*

"You're going to live alone because you're a nerdy, dorky, geek!"
—*Red*

"God only knows the horrors that go on at girls' slumber parties."
—*Cartman*

"Oh god, it's terrible!! WHAT HAVE I DONE?!!"—*Butters' dad*

CHARACTER DEBUTS

Marjorine—the poorly disguised, equally vulnerable female version of Butters. In case you hadn't realized, she's called Marjorine because she's a fake Butters.

Also, Heidi Turner, the 4th grade girl with brown hair and a lime green shirt. She's been in several episodes before (such as "Probably" and "Stupid Spoiled Whore Video Playset," page 106), but she gets her first big role here. Her mother and father, Mr. and Mrs. Turner, make their debuts as well.

Although they aren't formally introduced, two other 4th grade girls have their quasi-debut: Isla (the brown-haired girl with a red shirt, shown operating The Device with Bebe and the girls in the beginning), and Esther (the black-haired girl with an aqua jacket, as shown on Cartman's "Surveillance Targets" board).

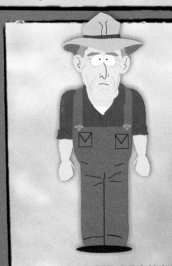

CHARACTER RETURNS

The old man who tells Butters' dad about the old Indian cemetery is based on the character of Jud Crandall from the 1989 film *Pet Sematary*. He's been seen twice before, in Season 5's "Butters' Very Own Episode" and "Asspen" (page 14).

BODY COUNT

The saleswoman who is killed by Butters' dad so that his "undead" son could "feed." There's also the dead pig that the boys dress up as Butters and toss off a building.

WHERE DID THE IDEA COME FROM?

Trey and Matt think there's too much going on in this episode. About 50 percent too much, to be exact. Either of the stories—Butters rising from the grave, or dressing up as Marjorine to steal the girls' fortune-telling device—could easily have stood alone.

POINTLESS OBSERVATIONS

Butters' grave marker bears the following Biblical quote: "Jesus said 'Come unto me all ye who labor and are heavy laden and I will give you rest.' Matt. 11:28."

Cartman uses his Wellington Bear Video Camera to capture the surveillance footage of the girls—a new device in the growing Wellington Bear catalogue. He similarly uses his Speak and Record Bear to catch Shelly and Skyler in "Cat Orgy."

At Heidi's slumber party, there's a Barbie-esque Paris Hilton doll on the floor. This comes from "Stupid Spoiled Whore Video Playset" (page 106). There's also a board game called Blister, a parody of Twister.

Clyde and Cartman seem to get along strangely well in this episode—despite the fact that Clyde has admitted to hating Cartman on multiple occasions.

POP CULTURE REFERENCES

Heidi, the slumber party hostess, has a poster for a line of toy dolls called "Twerpz" tacked to a wall. It's a spoof of the Bratz dolls.

Cartman's plot to infiltrate the girls' slumber party (by dressing up one of the boys as a chick) bears a striking resemblance to the 2002 film *Juwanna Mann*, which Kevin directly points out. Cartman gets pissed, "No, not like *Juwanna Mann*, Kevin, okay? It's WAY cooler than that!"

Red brings the new Justin Timberlake CD (*Justified*) to the slumber party. Later, they all dance to Timberlake's dance hall hit "Rock Your Body." The girls also play "Light as a Feather, Stiff as a Board," which is a popular levitation game played at slumber parties.

The containment facility the boys build to house the "Future Telling Device" looks a lot like the containment center set up outside of Elliot's house in the classic film *E.T.: The Extra-Terrestrial*. This was also parodied in Season 2's "Chef's Chocolate Salty Balls."

WHAT BUTTERS LEARNED

"That time device is nothing but trouble!!"

FOLLOW THAT EGG!

Original Air Date: November 2, 2005
Episode 910

THE STORY: For the 4th grade's lesson on "Parenting," Garrison pairs the kids into boy/girl couples and assigns them each an egg, which they must take care of for one full week as if it were a baby. Stan gets angry when his ex-girlfriend Wendy is paired with Kyle. So angry, in fact, that he neglects his own egg (which he's caring for with Bebe) and tells Kyle that his hat is stupid.

All this pales in comparison to Garrison's problems. When she visits her former lover (Mr. Slave) to patch things up, she discovers he now lives with Big Gay Al—and that the two plan to marry as soon as same-sex unions are legalized in Colorado. Furious, Garrison vows to do whatever it takes to stop gay marriage.

Soon Garrison and an army of like-minded protestors meet with the governor, who's terrified of the controversial issue and won't consider vetoing the measure unless he can find some sort of political cover for himself. Garrison says he can provide a "study" proving that gay marriages are unstable. To do this he mixes up the lineup for his egg experiment, putting Stan and Kyle together as a "gay" couple. He figures the boys will destroy the egg, proving his point and nudging the governor into vetoing the same-sex marriage bill.

But things don't go as planned. In spite of the fact that Stan and Kyle aren't getting along, nothing happens to their egg. So Garrison hires a professional Israeli assassin named Jikartha, who literally shoots the egg out of Stan's hand. But just when all seems lost, Kyle reveals that he gave Stan a decoy egg, and that he's carrying the real one safe and sound. The boys reconcile, and Stan tells Kyle he really doesn't think his hat is stupid.

They jump in a taxi and race to Denver, where the final "egg check" is taking place on the steps of the Colorado statehouse. As the boys rush through the crowd of gay supporters/protesters, Jikartha opens fire and detonates land mines, killing bushels of bystanders—but failing to stop Stan and Kyle. They make it to the podium, reveal their undamaged egg to Garrison, and collapse.

Same-sex marriage is made legal in Colorado, and Kyle and Stan are hailed as heroes (utterly confusing them, since they weren't aware of their pivotal role in the debate). Big Gay Al and Mr. Slave get married, both adorned in tasteful white gowns. Afterward, Wendy tells Stan that she's sorry she doubted his parental abilities. Stan tells her to get lost.

MEMORABLE LINES:

"I just wanted a big house and lots of respect. I didn't want this kind of responsibility."—*Governor of Colorado*

"Stan, do you really think my hat is stupid?"
—*Kyle*

"Look at the freak egg! It has two daddies!"
—*Ms. Garrison*

"If you break your egg, it means you have a dead baby. And if you kill your baby, you get an F."
—*Ms. Garrison*

"Fags are getting married over my dead body!"
—*Ms. Garrison*

"Well maybe I didn't want to have an egg with you, okay Bebe?!"
—*Stan*

"You're taking that egg and if you break it again, so help me God I will break both your legs and burn down your house!!"—*Ms. Garrison*

"With the help of some adorable fourth grade students, we have completed our scientific, non-biased study of fags having kids."—*Ms. Garrison*

"This egg is fine! Gays can get married!!"
—*Governor of Colorado*

WHERE DID THE IDEA COME FROM?

Trey and Matt thought it would be funny if Garrison, who transformed himself from an openly gay man into a homosexual-hating woman, led the charge against same-sex marriage.

BODY COUNT

The numerous demonstrators gunned down and blown up by the egg assassin as Stan and Kyle make their way to the Colorado statehouse.

POP CULTURE REFERENCES

This episode draws its plot from the raging battles that were (and still are) going on in the United States between the pro- and anti-gay marriage sects. This episode aired shortly after Connecticut legalized civil unions between same-sex couples in October 2005. Massachusetts was the first state to legalize the bond, which happened in November 2003.

CHARACTER DEBUTS

Jikartha, the Israeli assassin hired by Garrison to kill Stan and Kyle's egg. This self-proclaimed "world's greatest killer" is based out of a seedy establishment known as The Akbar. We also meet the Governor of Colorado.

CHARACTER RETURNS

Big Gay Al appears for the first time since Season 5's "Cripple Fight." He's now Mr. Slave's lover and soon-to-be husband.

POINTLESS OBSERVATIONS

All the kids receive white eggs except for Token, whose egg is brown.

Wendy broke up with Stan two seasons ago in "Raisins" (page 76), a breakup which briefly left Stan heartbroken and Goth-ed out. Their relationship hasn't been discussed much since then.

Stan and Kyle's Daily Egg Evaluation reads: "MORNING: Woke up at 7a.m., washed Egg in sink. Dried. Dusted with baby powder. Dressed Egg in overalls and combed hair. Egg is very happy!! AFTERNOON: After lunch, Egg watched basketball game on the playground. After, took a nap. Stan is a protective father. EVENING: Took a shower with Egg. Egg went to bed at 8:30 p.m."

The cab driver that's recklessly hauling ass to get the boys to the Governor's gay marriage rally is the same driver that recklessly drove Jimmy in his effort to retrieve his whore, Nut Gobber, in "Erection Day" (page 128). He's hit his mark both times.

ORIGINAL SONGS

Ms. Garrison sings a heart-felt ode to Mr. Slave with "Love Lost Long Ago."

WHAT STAN LEARNED

"Like I give a crap about what you think, Wendy."

GINGER KIDS

Original Air Date: November 9, 2005
Episode 911

THE STORY: During oral report day at school, Cartman gives a presentation entitled: "Ginger Kids: Children with Red Hair, Light Skin, and Freckles." In it, he discusses the grossness of kids suffering from the "Gingervitus" disease—the symptoms of which include their inability to go in the sun, and their total lack of soul.

Needless to say, his report pisses off Kyle. Having red hair himself (but not freckles or pale skin), Kyle calls this presentation a bunch of crap. Cartman goes on to correct Kyle, saying that hybrids like himself are called "Daywalkers," and they too are part of the problem.

His denunciation of Gingers is so convincing that soon they're excluded from eating in the school cafeteria. Angered by the discrimination Cartman is causing among the students, Stan, Kyle, and Kenny decide to give him a taste of his own medicine. The three boys sneak into his house in the middle of the night, knock him out, then dye his hair red, bleach his skin and tattoo his face with freckles.

To their delight, the new "Ginger" Cartman now endures the same ridicule he helped foster. Unfortunately, this ironic turn of events fails to teach him the lesson he deserved. Cartman founds the Ginger Separatist Movement, which puts forth freckled red-

heads as some sort of master race. He rallies other Gingers to his cause, and soon has a loyal army of disgruntled Ginger minions.

Fearing things are spinning out of control, Kyle, Stan, and Kenny decide to sneak back into Cartman's room and change him back into his old self. But before they can do this, they're kidnapped by a pack of Ginger kids who, on Cartman's orders, have fanned out across South Park to round up every "normal" kid they can find. The captives are taken to the "Exterminate All Non-Gingers Conference" in the Sunset Room at the Airport Hilton.

The Separatists' plan is to throw all non-Gingers into a pit of lava—with Cartman's nemesis Kyle (the Daywalker) first in line. But just before he's sacrificed, Kyle begs for a final word with Cartman—whispering into his ear the truth about Cartman's "condition." Horrified, Cartman instantly undergoes a radical change of heart, telling his followers that violence isn't the answer and that hand-in-hand, we can live together.

After a bit of convincing (through song), all the "normals" are released from their cages. Kyle calls Cartman a manipulative asshole, which Cartman admits is probably true.

MEMORABLE LINES:

"I'M GINGER!! HELP ME!! HELP ME!!!" —*Cartman*

"RED POWER!"—*Cartman*

"If you really don't want to have Ginger kids, marry an Asian woman. Asians don't carry the recessive gene. I know a guy who's marrying a Japanese woman very soon for just that reason."—*Mr. Foley*

"In the meantime, shut your God damn Daywalker mouth!"—*Cartman*

"Make no mistake! Ginger kids ARE evil. Do you know who was Ginger? Judas." —*Cartman*

"We need to let everyone in this school know that we are not inferior! That we are, in fact, beautiful, totally awesome, and super smart!!" —*Cartman*

"Your son will be Ginger his whole life. You might want to just . . . put him down."—*Dr. Doctor*

"Ginger kids eat in the hallway!"—*Token*

"We've all seen them. On the playground, at the store, walking on the streets. They creep us out and make us feel sick to our stomachs."—*Cartman*

"Um, oh but anyway, ohh—oh wow! I can't believe how great it feels to finally love my fellow man!"—*Cartman*

"But you just said they should all die fifteen seconds ago." —*Ginger Kid*

WHERE DID THE IDEA COME FROM?

Trey is a little bit freaked out by Ginger kids. He'd wanted to do something about them for a long time.

ORIGINAL SONGS

After his quick change of heart, Cartman unites all Gingers and non-Gingers with his happy sing-along number "Hand in Hand."

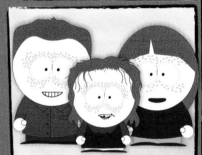

CHARACTER DEBUTS

The Foley family, complete with their three creepy, always-smiling Ginger kids. There's also Jody, Cartman's right-hand Ginger (with the red and white shirt).

LOCATION DEBUTS

The Sunset Room at the Airport Hilton. Cartman uses this as the meeting ground for his Ginger Separatist Movement gatherings. It will used again for Cartman's AIDS Benefit Concert in "Tonsil Trouble," as well as for Coonicon '09 in "The Coon." Gary Nelson, the over-helpful Hilton Guest Relations worker, will also make a return.

THEATRICAL REFERENCES

When the Ginger kids protest the casting of a non-Ginger in the title role of *Annie*, it's a satire of a similar controversy that kicked up when a non-Asian was cast to play a leading Asian character in *Miss Saigon*.

CELEBRITIES IMPUGNED

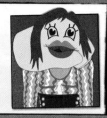

When Cartman tries to name famous Gingers throughout history, the only one he can think of is Ron Howard. As his final argument against Gingers, Cartman says, "If you think that the Ginger problem is not a serious one. . .think again." As he says this, a slide of Carrot Top flashes on the screen.

POP CULTURE REFERENCES

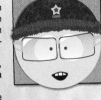

Cartman calls redheaded kids who lack pale skin and freckles "Daywalkers." The term comes from the *Blade* movies, in which the half-vampire/half-human protagonist is sometimes called a Daywalker by full-blooded vampires.

Right before he discovers he's turned Ginger, Cartman hums the Kenny Rogers hit "You Picked a Fine Time to Leave Me, Lucille."

In the library, several posters and books can be seen in the background: *The Bear, The Horse, and the Closet* (a parody of *The Lion, the Witch and the Wardrobe*), The Backward Beaver, and a book that has Najix (the ice-cream crapping taco from "Cancelled," page 50) on the cover. There's also a "READ" poster with Yoda from *Star Wars* on it.

During the non-Ginger raid, the shot where the boy and girl walk hand-in-hand down the street—only to be surrounded by Gingers—is loosely modeled after a similar scene from Michael Jackson's "Thriller."

POINTLESS OBSERVATIONS

According to Cartman, "Gingervitus" is a disease which causes very light skin, red hair and freckles, and "it occurs because Ginger kids have no souls." Kids who have Gingervitus cannot be cured. People who have this disease but don't have to avoid the sun are called "Daywalkers." This is not to be confused with "Gingivitis," which is a disease causing inflammation of the gums.

We get our first glance at the boys' new Hispanic-looking bus driver in this episode. The job has been vacant since Ms. Crabtree was murdered in last season's "Cartman's Incredible Gift" (page 108). The driver looks an awful lot like the "Stereotypical Sleepy Mexican" we met in "The Death Camp of Tolerance" (page 38).

POINTLESS OBSERVATIONS ABOUT GINGERS

During production of this episode the staff turned up some interesting information about Gingers. Redheads apparently require more anesthetic than "regulars" during surgery, because they have a higher tolerance to drugs. Redheads in England are seeking minority status. And there are actually a few redheaded Japanese—the product of long-ago unions between Dutch sailors and the locals.

WHAT CARTMAN LEARNED

"If there's one thing I've learned, it's that the only way to fight hate is with more hate."

TRAPPED IN THE CLOSET

Original Air Date: November 16, 2005
Episode 912

THE STORY: Stan takes a free "personality test" from some Scientologists and is informed, to his surprise, that he's deeply depressed. They promise to help him, for the low price of $240. Stan forks over the cash and has his "thetan levels" monitored using an "E-meter." He produces such a high reading that the results are immediately dispatched to Scientology's Los Angeles headquarters. The President of Scientology says there can be only one explanation—Stan is the reincarnation of the church's founder, L. Ron Hubbard.

Shortly thereafter, a mob of Scientologists (including church leaders and John Travolta) show up on the Marsh family's front lawn. They want Stan to lead them, but his father sends him to his room instead. There he finds Tom Cruise, who asks Stan (who he believes is the reincarnated Hubbard) what he thinks of his acting. When Stan tells him he's "OK" but not as good as, say, the guy in *Napoleon Dynamite*, Cruise has a meltdown and locks himself in Stan's closet, refusing to come out.

Over the course of the episode, a number of people try to get Cruise to come out of the closet including Randy and Nicole Kidman, but their efforts are fruitless. In fact, Cruise won't even admit that he's in the closet. Unable to sway him, R. Kelly and Travolta join him—both locking themselves in the closet as well.

Downstairs, the President of Scientology reveals the church's deepest, most bizarre secrets to Stan. Afterward he says he wants Stan to continue in Hubbard's footsteps by writing more about the events he just described. Stan obliges, even though he protests he doesn't know what he's doing. At first his ideas meet with the church's approval—until he asserts that Scientology, like most religions, should stop charging people for help.

Appalled, the President reveals another of the church's deepest secrets—it's just a scam to make money. And if Stan knows what's good for him, he'll play along. He then escorts Stan outside so that he can read some samples of his new writings (soon to be available in book form for a nominal fee) to the assembled crowd. But Stan can't go through with it. He admits that he's not the reincarnation of L. Ron Hubbard and that Scientology is a racket.

However, Stan's honesty doesn't go over so well. Instead of turning on the Scientology leadership, the followers scream at Stan for defaming their religion and threaten to sue him. Relieved that the boy isn't actually Hubbard, Tom Cruise (as well as R. Kelly and Travolta) finally comes out of the closet. Just like everyone else, Cruise threatens to bring a lawsuit. But Stan holds his ground and dares them to do their worst.

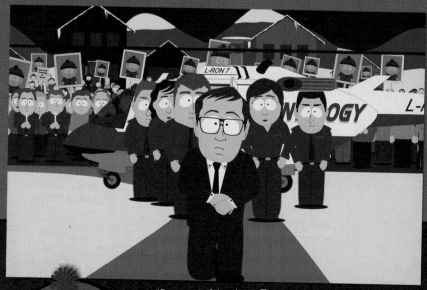

MEMORABLE LINES:

"Stan, I just want you to know that I still hate Kyle more than you."—*Cartman*

"We're not coming out the closet. So you can just go away."
—*Tom Cruise and John Travolta*

"Come out of the closet, Tom. You're not fooling anyone."
—*Nicole Kidman*

"Stan, don't you know the first law of physics? Anything that's fun costs at least eight dollars."
—*Cartman*

"I'm not in the closet."
—*Tom Cruise*

"You don't actually believe this crap, do you?"
—*President of Scientology*

"I'm not scared of you! Sue me!"
—*Stan*

"What's better than telling people a stupid story and having them believe you? Having them PAY you for it, stupid!"
—*President of Scientology*

"Do you ever whistle. . .just for the fun of it?"
—*Brian, the Scientology tester*

"Tell me why Tom Cruse in the closet or else I'm gonna shoot someone."—*R. Kelly*

"Dad! Tom Cruise won't come out of the closet!"—*Stan*

"There is a reason for people feeling sad and depressed. . .an ALIEN reason."
—*President of Scientology*

BODY COUNT

An all-time South Park record, if one counts the millions of aliens allegedly exterminated by Lord Xenu.

CHARACTER DEBUTS

The evil Lord Xenu, the lead bad guy in Scientology's creation story. The account of how he sent millions of beings into exile on prehistoric Earth fits in quite nicely with *South Park's* other science fiction-themed episodes.

A whole hierarchy of Scientologists also make their debut—from Brian the "thetan level" tester all the way up to the President of Scientology.

CELEBRITIES IMPUGNED

A number of celebrities get the royal treatment in this episode. Most notably Tom Cruise, a famous advocate of Scientology. He is portrayed here as a highly-emotional, somewhat delusional person. John Travolta (also a famous Scientologist) doesn't fare much better—he runs around screaming "oh my God!" repeatedly and eventually refuses to come out of the closet as well.

R. Kelly and Nicole Kidman (Cruise's one-time wife) also get a nod here. So does "author" and "prophet" L. Ron Hubbard.

WHERE DID THE IDEA COME FROM?

Matt and Trey tackled Scientology obliquely in Season Five's "Super Best Friends." This time they went for the whole enchilada, creating arguably the most controversial *South Park* of all time—both for its attack on the famously litigious Scientologists, and for the "closet" subplot featuring the only-slightly-less-litigious Tom Cruise.

POINTLESS OBSERVATIONS

Mr. Mackey is one of the many townspeople considering joining Scientology in the beginning of the episode.

During the description of what Scientologists believe, there's a scene where an assembly line of aliens are being frozen. In it, there is a Marklar (from "Starvin' Marvin in Space") and an already-frozen, partially-visible Joozian (from "Cancelled," page 50). When the souls of these dead aliens were later "forced to watch brain washing material" (with 3D glasses, no less), they were treated to visions of Jesus, Buddha, and ancient Egyptian hieroglyphics.

In the closing credits, the names of everyone who worked on the show are replaced with the names "John Smith" or "Jane Smith."

POP CULTURE REFERENCES

The episode's title is taken from the 22-part music video/soap opera "Trapped in the Closet," created by rapper R. Kelly. Just as he does in the series, he sing-narrates everything he does here. The scene in Stan's bedroom with R. Kelly, Travolta and Cruise is a particularly awesome parody of Episodes I & II of the music videos.

In the opening scene, the boys are talking about the trading cards they just bought—Kyle's pumped that he got a "Jake Plummer" and Cartman's bummed that he got a "crappy A.J. Feeley." Both are professional players in the NFL. Stan's bedroom also has a ton of Denver Broncos paraphernalia in this episode, including a poster of John Elway.

When Tom Cruise pleadingly asks "L. Ron" (Stan) how his acting is, Stan says "He's OK"—he's not as good as Leonardo DiCaprio, Gene Hackman, or that guy who played *Napoleon Dynamite* (Jon Heder), but he's OK.

SCIENTOLOGY REFERENCES

During a retelling of the Scientology origin story, the words "This is what Scientologists actually believe" appear under the action. This is to avoid the sorts of misunderstandings generated during "All About Mormons" (page 72), when a completely accurate retelling of the story of Mormonism seemed so absurd that some viewers thought Matt and Trey made it up. All of what's shown here—the Dianetics book, personality tests, "auditing," "thetan levels," etc.—stays true to the Scientology religion.

Furthermore, the Scientology Celebrity Center seen here is modeled after the very real, equally massive mansion of the same name in Los Angeles. It's also true that L. Ron Hubbard was a science fiction writer.

WHAT STAN LEARNED

"Look everybody. . .we're all looking for answers. You know? We all want to understand who we are and where we come from, but. . .sometimes we want to know the answers so badly that we believe just about anything."

FREE WILLZYX

Original Air Date: November 30, 2005
Episode 913

THE STORY: The boys visit the Denver Sea Park and watch a splash-tacular performance by Jambu the killer whale. After the show's over and the crowd leaves, Kyle stays behind to hang out with Jambu. He taps on the glass and starts talking to the whale. To his surprise, the whale talks right back.

Kyle excitedly runs off and returns with the rest of the boys. After a minute, Jambu speaks to them all—telling them his real name is Willzyx and that he comes from the moon, where his family still lives. What's worse, if he doesn't return to the moon very soon, he'll die.

What the boys don't realize is that the whale's "voice" is a prank provided by Brian and Mike, the park's two show announcers talking over the P.A. system. The boys return home, rally the other kids and hatch a daring plan to kidnap Willzyx and return him to the moon.

In the middle of the night, the boys sneak into the park and launch a bold rescue attempt. The next morning, the park is swarming with cops and confused employees—no one has any idea who stole the whale. Except, of course, for Brian and Mike, who nervously hatch a plan of their own to re-capture the giant mammal.

The boys stash Willzyx in a swimming pool in Clyde's backyard and begin work on Stage Two: finding a rocket to transport the seven-ton whale to the surface of the moon. Russia wants $20 million. China seeks $10 million—and tells the boys to go fuck themselves when they try to haggle. They try a few other countries too, but their prices are well beyond the boys' means.

Meanwhile, Brian and Mike have started searching around South Park, desperately hoping to locate the whale before it's discovered that their prank caused the theft. They find the pool behind Clyde's house. It's now empty, but the whale feces floating in it gives them a clue they're on the right track.

Willzyx is now in Kyle's room, being regularly hosed down with water to keep it comfortable. Just in time, Stan and Craig strike a deal with the Mexican Space Program for the reasonable price of $200.

They hustle the whale onto a truck and head for Tijuana. . .only to be intercepted by Brian and Mike and, shortly thereafter, by the police. Finally the Animal Liberation Front, which applauded the theft of the whale from the beginning, comes onto the scene with guns blazing. After killing most of the opposition, A.L.F.'s leader (who believes the boys plan to release the whale into the sea) drives them the rest of the way to Tijuana.

With the help of A.L.F., the boys successfully get Willzyx to the water, and after a tearful goodbye, release him off into the ocean. But just as the A.L.F. leader declares victory, the Mexican rocket launches skyward with Willzyx in tow.

A mariachi band plays in celebration. The boys congratulate themselves for helping their friend return home. And in the last shot of the show, the whale is seen successfully laying on the surface of the moon. . .dead.

MEMORABLE LINES:

"Mexico has a space program?"
—Clyde

"Okay Kyle, we're gonna go get splashed some more. But if you wanna go make love to the whale, that's fine."*—Cartman*

"Si. . .Fly. . ."
—Manuel, the Head of MASA

"You kids told me you won that whale at Pizza Hut!"
—Truck Driver

"Have you noticed any whales in your pool at all?"
—Mike

"Save the whales, motherfucker."
—A.L.F. Member

"I'm totally wet!! This is awesome!!"
—Cartman

"Jambu, you wanna talk about rocket ships?"*—Kyle*

"I thought I was crazy. He said my dad was gonna sneak in my room naked one night and beat me up."
—Craig

"I wish I could return and dance in the moon castle with my wife and three children again."
—Willzyx

"Alright, in order to make our plan work, we're going to need the pool from Clyde's backyard, Timmy's wheelchair, the Russian Government, and all of our skateboards."*—Stan*

BODY COUNT

A cop, Mike (one of the announcers for Denver Sea Park), and a few A.L.F. members all get shot up during the final gunfight to save Willzyx. And of course, Willzyx.

WHERE DID THE IDEA COME FROM?

The show began with a single concept—a dead whale on the moon. All the writers had to do was figure out how it got there. "This is a great example of a simple idea done well," Trey said.

POINTLESS OBSERVATIONS

While kidnapping Willzyx, all of the boys dress in black and wear blackface. . .except for Token, who wears whiteface.

The Animal Liberation Front (A.L.F.) is not to be confused with the American Liberation Front (A.L.F.)—an organization formed by Cartman and Butters in "The China Probrem."

The Mexican space program is called MASA (Mexicano Aeronautico Y Spacio Administracion), a pretty obvious parody on America's space agency, NASA. Also "Jambu" the killer whale is an homage to Sea World's "Shamu," the stage name of their iconic killer whale.

This is the only time that there is absolutely no audio during the closing credits—just a dead whale on the moon.

CHARACTER DEBUTS

Willzyx (aka Jambu), the "talking" whale from the moon. Unfortunately, he only makes it through one episode. We also meet Brian and Mike, the two Sea Park announcers.

POP CULTURE REFERENCES

The two PA announcers talk about watching the Fox reality show *Trading Spouses*. Also, Kyle's parents take Ike to watch the new *Harry Potter* movie. Kyle opts not to go because he's on the phone with the Japanese Space Program.

WHAT-THE-FUCK MOMENT

The two guys from Denver Sea Park produce a composite sketch of the boys, which they show around South Park in an attempt to track them down. Originally Trey considered making it four crude stick figures before taking the opposite approach—producing lifelike pencil sketches of Kyle, Stan, Cartman, and Kenny. The final effect is both fascinating and a little bit unsettling.

CELEBRITIES IMPUGNED

When Clyde's mom is shown drawings of the four boys and asked if she knows them, she says, "The fat one in the middle [Cartman] looks like Dakota Fanning."

Russian President Vladimir Putin is first excited with the prospect of saving his failing country with the "whale to the moon" mission, but when he thinks it's a prank call, he screams, "Kiss my ass George Bush! This is not funny!!"

WHAT THE LEADER OF A.L.F. LEARNED

"It is children, with their innocence and their spirit, who know what is truly best for all the world."

141

BLOODY MARY

Original Air Date: December 7, 2005
Episode 914

THE STORY: The boys all attend karate lessons—where they're taught about the art of "disaprin" from their Japanese instructor—while Stan's dad proceeds to get totally hammered at the bar next door. He then picks the boys up, double-fisting beers, and winds up getting pulled over for drunk driving.

After a night in jail, he's forced to talk to school kids (including Stan's class) about the dangers of drunk driving. More importantly, he's forced to attend Alcoholics Anonymous meetings, where he learns that alcoholism is a "disease."

Burdened with the notion that he cannot be healed from this deadly disease without the help of a higher power, he wallows in his drunken sadness, drinking more than ever and even shaving his head. Stan begs his father to get a grip, but Randy, now wheelchair-bound, sees no way out. He needs a miracle.

Meanwhile, a statue of the Virgin Mary in the courtyard of a nearby church has started to bleed . . .out its ass. Soon, the faithful flock to see the "miracle," hoping that the sacred discharge can cure their various illnesses. Stan's dad, now well into a multi-day drinking bender, sees a news report about the statue and is sure the statue is the answer to all his problems. Since he no longer has a license (and is also very drunk), he has Stan drive him.

Once there, he cuts to the front of the massive line of the infirm, reasoning that his alcoholism is worse than anything from which they suffer. He's rewarded with a face full of healing blood from the statue. After which he wipes his eyes and mouth and announces that he's "cured." For five days he stays clean and sober.

He's celebrating his God-given sobriety with the other AA members at Whistlin' Willy's Pizza Gulch when a news report announces that the Pope has personally examined the statue and determined that, in fact, it *isn't* a miracle. The blood, the Pope announces, is from the statue's vagina—not it's anus. And since "chicks bleed from their vaginas all the time," it's no big deal.

Stan's dad—along with every other recovering alcoholic in the restaurant—realizes that a Higher Power *didn't* intervene to help him, and immediately starts pounding booze again. But Stan points out to his father that, if God didn't make him swear off the sauce, he must have found the strength to do it himself.

Stan says that he should learn to drink in moderation—with "disaprin"—as this is better than either total abstinence or total inebriation. His father finally gets it, and decides to listen to his son. The two walk off together to watch a football game at a friend's house. . .and pound a couple (but only a couple) of brews.

"Boy this lemonade is great! Who knew how fun being sober could be?!"
—Stan's dad

"They say her divine ass blood has miraculous healing powers."
—Stan's dad

MEMORABLE LINES:

"There's a reason God made our penises like little hoses, boys."—Stan's dad

"If you don't make the right choices in life, you could end up being a big loser, just like Stan's dad."
—Ms. Garrison

"No more blowing guys on Colfax Avenue for a pint of vodka for this cowboy!"
—Bill at AA

"Disaprin . . .come from within."
—Stan

"You need to know something . . .you have a DISEASE."
—Michael, the AA Leader

"A chick bleeding out her vagina is no miracle. Chicks bleed out their vaginas all the time."—Pope Benedict XVI

"The statue of the Virgin Mary has started to bleed . . . out its ass."
—TV Reporter

"You're a butter! You're a dirty line cutter!"
—Guy in line to see the statue

WHERE DID THE IDEA COME FROM?

The idea of the statue of the Virgin Mary bleeding out of her butt came from the many examples of people thinking they see the image of the Virgin Mary in burnt toast or a paint splotch.

POINTLESS OBSERVATIONS

This episode features a couple rare *South Park* moments: Stan's dad shaving his head bald (it's the only time he's ever seen without a full head of hair); and the boys all gi'd out in their karate uniforms.

While trying to intervene at the AA meeting, Stan mentions, "I also know a thing or two about cults. I was the leader of one for a while." He's referring to his role in "Trapped in the Closet" (page 138), where he briefly took the reigns as the leader of Scientology.

POP CULTURE REFERENCES

After their karate class, the boys are trying to hurry home to catch the final episode of the ABC series *Lost*.

Stan's dad is hooked on S'Moors Beer. The bottle (complete with a silver, mountain-filled label) looks an awful lot like Coors Light beer. This S'Moors beverage company is responsible for a lot of the booze in South Park, as we learned with the S'Mores-flavored Schnapps in "The Red Badge of Gayness."

CHARACTER DEBUTS

We meet the boys' karate Sensei, who masterfully teaches them the art of "dis-aprin." There's also Michael, the Alcoholic's Anonymous leader, as well as a ton of other lemonade-loving alcoholics.

CELEBRITIES IMPUGNED

Pope Benedict XVI, who in spite of the fact that numerous people, including a Cardinal and Stan's dad, have already been sprayed in the face by the Virgin Mary's ass blood, still insists on standing waaay too close to the statue's backside. He will return again in Season 11's "Fantastic Easter Special."

WHAT STAN LEARNED

"If you devote your whole life to completely avoiding something you like, then that thing still controls your life and you've never learned any discipline at all."

SEASON

10

Episode E_1008

25

54

0

626_40

626_45

Location:

Dialogue

Action/Efx He looks like he's in pain from sweaty diarrhea.

aft manual.

imagine Jun afte Korean BBQ.

Boys Fat Reclining Poses 1008

LAB RULES

SCHOOL - COMPUTER LAB -- DAY

626_35 0

Episode E_1008

626_35 *cont.* 0 62

Location: INT. KYLE'S ROOM -- NIGHT

Dialogue

Use the leaning back Kyle for this shot.

Action/Efx

Fat Kyle at his desk, playing.

Location:

Dialogue

closed eyes & #8 mouth Rub wrist.

Action/Efx

He makes a grimace, then holds up his mouse hand

Location:

Dialogue

Action/Efx
and moves it

Cartman Fat Zitty Turnaround Poses 1008

Action/Efx
the computer la ots of
look inside

THE RETURN OF CHEF

Original Air Date: March 22, 2006
Episode 1001

THE STORY: Chef wants more excitement in his life, so he leaves town to join an organization called the Super Adventure Club. But when he returns to South Park after a three-month absence, something about him seems . . . different.

To be more specific, he keeps propositioning all the kids for sex.

Stan, Kyle, Cartman, and Kenny visit the headquarters of the Super Adventure Club to see if its members can account for Chef's strange behavior. After an enthusiastic presentation by the group's leader, William P. Connelly, they learn that the club travels the world, having adventures and molesting children. Its leader even tries to hypnotize the boys, leading them to believe they did the same thing successfully to Chef.

The boys take their friend to a psychiatrist, who officially declares Chef "brainwashed." In an effort to get Chef back to normal, he and the boys visit a strip club. But just as the strip club "therapy" begins to work on Chef, he's knocked out and kidnapped by the Super Adventure Club.

The boys follow them back to their headquarters, where they are held at gunpoint and told the history of the organization and the reason for its beliefs. The group thinks that children have particles called "marlocs" in their bodies, and that when adults have sex with them, these "marlocs" release energy that

grant the child molesters immortality.

The boys manage to evade the Super Adventure Club members, rescue Chef, and make a break for it. But as they cross the rope bridge to freedom, the Super Adventure Club's leader convinces Chef to turn back. Just then, lightning strikes—cutting the bridge in half and sending Chef plummeting into a ravine where he's impaled on a tree stump. He's then attacked by a mountain lion and a grizzly bear.

A Super Adventure Club member tries to kill the mountain lion with a high-powered rifle, but hits Chef instead. By the time the carnage ends, Chef is disemboweled and skinned. Cartman, uncharacteristically optimistic, says that perhaps he isn't dead, because people always crap themselves when they die. But no sooner does Cartman finish speaking than the corpse does, indeed, soil himself.

Chef is honored during an extremely well-attended memorial service in South Park. Most agree with Kyle's assertion that they should remember the man he once was, not what that "fruity little club" turned him into.

But the Super Adventure Club isn't quite done. Back at their headquarters, the reanimated remains of Chef have been turned into an armor-clad cybernetic monster: Darth Chef. And he definitely, positively, still wants to molest children.

"You bastards! You BASTARDS!"
—*Kyle*

"What's a Pedal File?"
—*Butters*

MEMORABLE LINES:

"Bitch, I'll twist your nuts off."
—*Cartman*

"I think he wants to have sex with me!"
—*Clyde*

"Come on children, let's all go home and make love."—*Chef*

"Oh my God, they killed Chef!"—*Stan*

"Sorry dude, but this fruity little club isn't taking our friend."
—*Kyle*

"I'm gonna make love to your asshole, children."
—*Chef*

"Chef, we love you."
—*Stan*

"I must say you're starting to become quite a thorn in my balls."
—*Leader of the Super Adventure Club*

"Then it's off to the mighty Himalayas, where we will climb the K2 and molest several Tibetan children on the east summit!"
—*Leader of the Super Adventure Club*

"Hey guys, you know what they call a Jewish woman's boobs? Joobs."—*Cartman*

CHARACTER DEBUTS

The Super Adventure Club makes its child-molesting debut. At its head is William P. Connelly, Esquire—the Head Adventurer. We also meet Detective Jarvis and Robert J. Neeland, the psychiatrist.

More importantly, the cybernetic monstrosity Darth Chef is revealed, complete with a glowing light-saber-esque spatula and a thirst for naked children. He hasn't been seen since.

SCIENTOLOGY REFERENCES

When the leader of the Super Adventure Club launches into a preposterous explanation of why molesting children causes immortality, the words "This is what the Super Adventure Club actually believes" appear on the bottom of the screen. It references the Scientology creation story laid out in "Trapped in the Closet" (page 138), which was so preposterous Trey and Matt felt they needed to run the sentence "This is what Scientologists actually believe" beneath it.

POP CULTURE REFERENCES

Darth Chef's voice was provided by Peter Serafinowicz, who voiced Darth Maul in *Star Wars Episode I: The Phantom Menace*. His black, armor-clad costume is an obvious nod to Darth Vader.

WHERE DID THE IDEA COME FROM?

After the broadcast of "Trapped in the Closet," Isaac Hayes, who was a Scientologist, gave notice and quit the show. Shortly before work on Season 10 began, word broke that Hayes (perhaps with outside prompting) accused Matt and Trey of being bigots. This served to inspire the plot of this episode, where we say goodbye to Chef (whom Hayes had voiced since *South Park's* beginning) and blast Scientologists once again. Chef's dialogue was created by patching together lines from previous episodes.

CHARACTER DEPARTURES

Chef. He's burned, dropped down a cliff, impaled, shot, and then torn limb-from-limb by a grizzly bear AND a mountain lion.

POINTLESS OBSERVATIONS

Chef's funeral is attended by, among a great many others, Terrance and Phillip, Elton John (whom Chef helped to stardom in Season 2's "Chef Aid") and Kathie Lee Gifford, with whom he had sex in Season 1's "Weight Gain 4000."

This episode starts with "Previously on South Park," but there was no actual previous episode. This was a device used to give the audience a good amount of backstory before the episode started. What we're seeing is supposedly Part Two of "Life Without Chef."

When Detective Jarvis asks the boys if Chef ever touched them in their no-no places, Butters excitedly says, "My Uncle Bud did that to me once!" We met his Uncle Bud briefly in "AWESOM-O" (page 92).

It should be clarified that the "Adventure Club" goes around the world exploring, hunting and kayaking, while the "Super Adventure Club" goes around the world having sex with children.

The boys take Chef to The Peppermint Hippo, a seedy strip club last seen in "Lil' Crime Stoppers" (page 60). Many of the strippers are the same as before—except for Spantaneus Bootay, the large, *large* black woman so bootylicious that she's able to momentarily break Chef's brainwashing.

Kenny displays a special ninja ability with his "Spin Blossom Nut Squash!" which he uses to crush a S.A.C. guy's balls.

CHEESY POOFS

WHAT KYLE LEARNED

"We're all here today because Chef has been such an important part of our lives. A lot of us don't agree with the choices Chef has made in the past few days. Some of us feel hurt and confused that he seemed to turn his back on us. But we can't let the events of the last week take away the memories of how much Chef made us smile. I'm gonna remember Chef as the jolly old guy who always broke into song. I'm gonna remember Chef as the guy who gave us advice to live by. So you see, we shouldn't be mad at Chef for leaving us. We should be mad at that little fruity club for scrambling his brains."

SMUG ALERT!

Original Air Date: March 29, 2006
Episode 1002

THE STORY: Kyle's dad buys a hybrid car, which instantly transforms him into a smug, environmentally sensitive douche. He attempts to spread the eco-friendly message by giving his gas-guzzling neighbors fake tickets for "failing to care about the environment," but this only pisses people off. Convinced he can't keep his progressive family in an ignorant, SUV-driving place such as South Park, he decides to move everyone to San Francisco.

Stan is unbelievably bummed out by his best friend's departure and, in a long-shot bid to get Kyle's family to move back, writes a song advocating the use of hybrids. It becomes a local hit and does, indeed, turn hybrids into a sensation. Soon everyone drives them—and feels really, really good about it.

But Stan is far from a hero. The town's environmental protector, Ranger McFriendly, informs him that while smog rates are down, the hybrid drivers are generating a huge, toxic cloud of "smug." South Park now has the second-highest smug concentration in the nation—second only to San Francisco.

Meanwhile, in San Fran, Kyle's parents fit in perfectly with their equally self-satisfied neighbors. They hold wine and cheese parties, talk politics, and regularly pause to bend over and sniff their own farts. Kyle and his brother Ike are less than thrilled with their new home and new friends, and start using the same coping method all San Francisco kids use to tolerate their douchebag parents: drugs. They drop acid and proceed to trip balls.

Unbeknownst to them, the smug cloud over San Francisco is converging with all the smug being generated by South Park, along with a smaller smug disturbance single-handedly generated by George Clooney's 78th Academy Awards acceptance speech. The resulting "perfect storm of self-satisfaction" will ravage South Park and wipe San Francisco off the map.

Cartman decides to take drastic action to save Kyle and his family. Not because he likes them, but because life without his greatest enemy is way too boring. With the help of Butters and a Hazmat suit to avoid contact with hippies, Cartman journeys into San Francisco and locates the Broflovskis—who lay semiconscious from overdoses of acid and smugness—then extracts them just before disaster strikes.

South Park is bruised by the storm but not broken. San Francisco, however, disappears "completely up its own asshole." To Stan's relief, the Broflovskis turn up with no memory of how they escaped. Embarrassed that anyone might find out that he saved Kyle, Cartman says nothing.

The townspeople vow never to purchase hybrids again. However Stan points out that hybrids are perfectly fine, as long as you don't turn into a self-righteous asshole when you get one. The adults, feeling this is too much to ask, revert to driving gas guzzlers. Cartman calls Kyle a "sneaky Jew rat" and Kyle calls him a "fucking fat ass." Thus the natural order is restored.

MEMORABLE LINES:

"Stop talking with your eyes closed! That's what smug people do!"
—Stan's dad

"You guys, this is OUR party. That no good back-stabbing Jew rat is finally leaving!"
—Cartman

"You know Butters, you make a lousy Jew."
—Cartman

"I swore I would never set foot in San Francisco."
—Cartman

"Maybe I'll take just half a hit of acid." *—Kyle*

"Yeah! I'm a dumb Jew!"
—Butters

"I'm totally tripping balls." *—Ike*

"San Francisco, I'm afraid, has disappeared completely up its own asshole." *—TV Reporter*

"You mean—we should drive in hybrids . . . but not act like we're better than everyone else because of it?"
—Stan's dad

"I'm sorry Stan. I'm sorry your gay little song killed your friend."
—Stan's dad

"Kid, thanks to your gay little song, there's not gonna be a San Francisco!" *—Weatherman*

"GOOD FOR YOU!"
—Hybrid Drivers

"Being smug is a good thing." *—Kyle's dad*



BODY COUNT

The entire population of San Francisco is wiped out by the smug catastrophe, except for Kyle and his family. South Park and Denver also take a hit, but manage to survive the ordeal.

WHERE DID THE IDEA COME FROM?

The idea that hybrids cause "smug" evolved from numerous true-life experiences. Trey bought a hybrid for his mom, who reported that people in other hybrids regularly flashed her a self-satisfied thumbs up or shouted "Good for you." Matt and Trey also attended a high-powered Hollywood function where all the bigwigs owned hybrids (along with gas-guzzling private jets). Someone said in all seriousness that they "needed to set an example." Trey thinks it's okay to feel good about doing good, "As long as you're not a fucking dick about it."

POP CULTURE REFERENCES

The three storms combining into a single, massive tempest is a reference to the 2000 movie *The Perfect Storm*, which ironically starred George Clooney, the creator of one of the smug clouds.

Cartman sings a bit of the 1969 hit "Na Na Hey Hey Kiss Him Goodbye" by Steam.

CHARACTER DEBUTS

Ranger McFriendly, the guy who watches over South Park's delicate ecosystem—and who informs Stan, in no uncertain terms, that his song about hybrids may doom them all. There's also Keenen Williams, the meteorologist for South Park's News Station. He teams with McFriendly to fight the perfect storm of smugness.

Finally, there's a whole slew of really smug, fart-loving San Franciscans with long, hyphenated last names. Fortunately, they're wiped off the map before this whole thing is through.

POINTLESS OBSERVATIONS

Stan has a *Road Warrior* poster in his bedroom, which is kind of strange, given that its star, Mel Gibson, tried to kill him in "The Passion of the Jew" (page 88). It will remain tacked up on his wall for the next few seasons.

This is the second time Cartman has saved Kyle's life—the first being in "Cherokee Hair Tampons," where he (unwittingly) gave Kyle a last-minute kidney transplant. Ironically, he has tried to kill him a number of times since then (and will continue to do so).

A lot can be learned about smugness from this episode. Smug people talk with their eyes closed; hybrid cars are better for emission levels, but people who drive them are the leading cause of smug; and too much smug in the atmosphere leads to "Global Laming."

CELEBRITIES IMPUGNED

George Clooney, whose super-smug Oscar acceptance speech single-handedly forms one of the three smug storms that converge to ravage the Western United States and annihilate San Francisco. Snippets of his speech can be heard as the smug cloud passes overhead.

ORIGINAL SONGS

Stan's eco-friendly guitar hit "Hey People, You Got To Drive Hybrids Already" inspires everyone in South Park to buy hybrids. Unfortunately, this gay little song also causes a smug storm, the likes of which have never been seen. There's also a brief snippet of the jazzy "Smuggy Day in San Francisco Town."

WHAT KYLE LEARNED

"Hybrid cars don't cause smugness. People do. Look, hybrid cars are important. They may even save our planet one day. What you all need to do is just learn to drive hybrids and not be smug about it."

CARTOON WARS PART I

Original Air Date: April 5, 2006
Episode 1003

THE STORY: Hysterical panic sets in when news that the animated TV show, *Family Guy*, will air an image of the Muslim prophet Mohammed in an upcoming episode. Fearing it will incite extremist violence, everyone barricades themselves in the community center and waits for the worst. To their relief, the image is censored by Fox at the last minute. But the townspeople's hysteria returns when they learn the episode is only the first half of a two-parter, and that during the next installment, Mohammed will definitely appear.

The boys are on opposite sides of this issue—Stan and Kyle like the show and feel like censoring it would be a strike against free speech. Cartman, however, is unusually sympathetic to the Muslim religion. He calls *Family Guy's* actions an insult to Islam and an invitation to holy war. More importantly, he vows to do something to stop it.

After Kyle has a gruesome nuclear nightmare where he experiences the loss of his family due to terrorist attacks, he is swayed to Cartman's way of thinking. Kyle agrees to accompany Cartman on his Big Wheel mission to Los Angeles to try to get the episode pulled.

It doesn't take long, however, for Cartman's true motives to surface. He could care less about the Muslims or the threat of violence. He just hates *Family Guy*. Cartman reasons that if he can get just one episode pulled, other pressure groups will be able to get the ones they hate pulled as well. The show will thus lose all credibility and be cancelled.

Angry at being betrayed, Kyle vows to impede his plan, and the two embark on a high-speed Big Wheel chase down the highway. Kyle eventually loses control of his tricycle and bails out just as it careens over a cliff and crashes into the valley below, exploding on impact. Bruised and battered, he watches helplessly as Cartman, laughing, pedals off into the distance.

Meanwhile, South Park's residents cope with the fear of impending doom. They call in an expert University Professor, who lays out the most practical plan: In order to show Islamist radicals that they had no part in *Family Guy's* actions, they must literally bury their heads in the sand. The townspeople soon agree, and begin the massive undertaking of burying everyone's head beneath a mound of sand.

In Hollywood, President Bush arrives to personally appeal to the President of Fox, stressing the episode must be censored as a matter of national security. However, the President of Fox is accountable to the writers of *Family Guy*. They insist the image of Mohammed not be censored. He then tells Bush the bizarre truth about *Family Guy's* writing staff—a truth that won't be revealed until . . . Part Two.

"It's Friday night, but you can't have sex, and you can't jack off, there's sand in your eyes and probably in the crack of your ass, and then some cartoon comes along, from a country where people ARE getting laid, and mocks your prophet!"
—*Ms. Garrison's 'Muslim Sensitivity Training' Lecture*

MEMORABLE LINES:

"Compare me to *Family Guy* again and so help me I will kill you where you stand."—*Cartman*

"*FAMILY GUY*!! I damn you to hell!!"
—*Stan's dad*

"Muslims are mad because of *Family Guy*, not because they can't jerk off."
—*Cartman*

"If we're still alive in the morning, then we'll know we're not dead!"—*Stan's dad*

"Try my Mr. T Tea."
—*Mr. T*

"How would you feel, Kyle, if there was a cartoon on television that made fun of Jews all the time?"
—*Cartman*

"You think THAT'S bad. . . . Remember when I auditioned to be David Hasselhoff's car?"
—*Peter Griffin*

CELEBRITIES IMPUGNED

Although they're only fictional characters, the cast of *Family Guy* gets it pretty hard here. This episode features several minutes of mock *Family Guy* footage—complete with throw-away gags and random jokes. The result is surprisingly on point.

WHERE DID THE IDEA COME FROM?

The episode was inspired by the uproar over a Danish newspaper's publication of cartoons depicting the prophet, Mohammed, and the knee-jerk self-censorship it inspired in the West. Matt and Trey's stance, portrayed quite elegantly in this two-parter, is that while Muslims are certainly entitled to believe whatever they want, trying to intimidate the rest of the world into doing the same infringes on free expression. Even worse, bowing to such threats is the lowest form of moral cowardice.

POP CULTURE REFERENCES

The dream sequence in which Ike and Kyle get blown up by an atomic bomb is a reference to a similar scene in *Terminator II: Judgment Day*. Also, the opening scene with everyone fleeing their houses in terror is an homage to the 2005 flick *War of the Worlds*.

In the fake *Family Guy* clips, we see a bunch of celebrity one-offs: David Hasselhoff a la *Knight Rider*, Mr. T serving up some tea, and Captain Kirk (from *Star Trek*) singing Captain and Tennille's "Love Will Keep Us Together."

In Cartman's speech about "television economics," he explains that all it takes to kill a show forever is to get one episode pulled—saying, "it's exactly what happened to *Laverne & Shirley*."

In the middle of their heated argument, Cartman distracts Kyle with, "Oh my God . . . is that Tim McGraw?!" The mere mention of this country-singing superstar is enough to distract Kyle and give Cartman a head start.

POINTLESS OBSERVATIONS

Music from *Team America: World Police* plays during this episode's closing credits.

Stan's mom reads the bedtime story *The Bubble Gum Prince in 'The Land of Chocolate'* to her son.

The entire show focuses on the chaos that would ensue if the image of Mohammed was shown on television. Ironically, *South Park* already did just that—in Season 5's "Super Best Friends." Mohammed was a crucial, totally-uncensored member of the Super Best Friends.

Cartman packs a bag full of man-supplies for his trip to Los Angeles: Cheesy Poofs, Snacky Cakes, doughnuts, Dr. Pepper, and Sprite. He eventually will use these items to run Kyle off the road in a fantastic *James Bond*-type car chase.

CHARACTER DEBUTS

South Park-ified versions of the *Family Guy* characters: Peter, Lois, Stewie, Meg, Chris, and Brian, the family dog (who resembles a black-eared Snoopy). They look like bizzaro versions of the Fox originals.

There's also Professor Thomas from the University. He's the brilliant mind behind the "bury your head in sand" technique.

MATT AND TREY REFERENCES

Cartman's ferocious assertion that he is "nothing like *Family Guy*" reflects the *South Park* creators' annoyance at constantly being compared to the show. Cartman's passionate speech to Kyle in the middle of the highway is particularly introspective—laying out all the reasons why he is "nothing like *Family Guy*."

WHAT BUTTERS' DAD LEARNED (BUT NOBODY ELSE DID)

"Freedom of speech is at stake here, don't you all see? If anything, we should all make cartoons of Mohammed, and show the terrorists and the extremists that we are all united in the belief that every person has a right to say what they want! Look, people, it's been real easy for us to stand up for free speech lately. For the past few decades we haven't had to risk anything to defend it. But those times are going to come! And one of those times is right now. And if we aren't willing to risk what we have, then we just believe in free speech, but we don't defend it!"

CARTOON WARS PART II

Original Air Date: April 12, 2006
Episode 1004

THE STORY: The episode opens with an announcement that Part Two of "Cartoon Wars" has been replaced by a Terrance and Phillip special called *The Mystery at the Lazy "J" Ranch*. The T&P special contains an image of Mohammed riding a horse, which the Canadian Broadcasting Company censors. Pissed, Terrance and Phillip march into the CBC Network Head's office and demand their episode be aired without censorship. They go on to argue that *Family Guy* is about do the very same thing, uncensored, in the United States. But the Network Head is unswayed, saying there's probably someone on the way to Fox right now to stop it.

The action then jumps to Cartman, who's just arrived at Fox Studios. There, he runs into none other than Bart Simpson, who says he hates *Family Guy* too. After a brief conversation, they agree that Cartman is by far the more evil and manipulative of the two, and is thus best-qualified to sway the network brass. When he's finally allowed to see the Fox executives, Cartman pretends to be a crippled Danish child whose father was killed by terrorist violence. His plea to stop the *Family Guy* episode proves so compelling that he's allowed to speak to the show's "writers."

Meanwhile, Kyle—who was left tricycle-less and stranded at the end of the last episode—hitches a ride into Hollywood. But the moment he steps foot on the Fox lot, he's intercepted, knocked out, and locked in a supply shed by Bart.

Cartman is taken to see *Family Guy's* writers, which turn out to be a group of manatees in a large tank. The placid aquatic mammals "write" the show

by selecting from a vast supply of "idea balls," each with a noun, verb, or pop-culture reference on it. A set of five is used to create each one of the show's set-piece gags.

The animals ignore Cartman's touching story, mostly because they're the only mammals in the world that are immune to terrorist threats. Stranger still, it's revealed that if even one idea ball is removed from the tank, they will refuse to work. Cartman turns this information to his advantage by secretly pilfering an idea ball, causing the manatees to stop working. The President of Fox doesn't know what to do to appease the writers. Cartman tells the President of Fox that the manatees are screwing with him and that he needs to take a stand. Convinced, the President pulls the *Family Guy* episode shortly before air time.

But all is not lost. Kyle convinces Bart to release him, finds Cartman, and then battles him in a lengthy slap fight that eventually lands them in the President of Fox's office. Cartman pulls a gun and demands the episode not run, while Kyle makes an impassioned plea against censorship. Just before airtime, the President decides to stand up to the threat of terrorist violence (and the much-more-immediate threat of getting capped by Cartman) and run the show.

The episode, which features Mohammed in a lame, throwaway gag, airs as planned. The terrorists immediately launch their "devastating" response—a crude cartoon of their own, featuring George W. Bush, Carson Kressley (from *Queer Eye for the Straight Guy*), and Jesus . . . pooping on each other.

MEMORABLE LINES:

"If you look closely at the writing in *Family Guy*, you will see that the jokes never derive from the plot. And I think that's totally gay."
—*Osama bin Laden*

"It's time I stop letting these prima donna manatees tell me what to do!"
—*President of Fox*

"You think THAT'S bad?! Remember the time I got a salmon helmet from Mohammed while wearing a toga?"
—*Peter Griffin*

"Forgive me Mr. President, but this 'First Amendment' sounds like a lot of bureaucratic jibbery-joo."
—*Reporter*

"No hitting in the balls."—*Cartman*

"Laundry—date—winning—Mexico—Gary Coleman. A perfect *Family Guy* joke!"
—*Writer's Assistant*

"Oh God damnit, you gave him one of your gay little speeches, didn't you?!"
—*Cartman*

"I . . . am . . . GOD!"
—*Cartman*

"Don't you know anything about manatees? They're the only mammals that are completely unmoved by terrorist threats."
—*Family Guy Staffer*

"Manatees are very ethical writers. Either everything's okay to write about, or nothing is."
—*Family Guy Staffer*

"Cowabunga, motherfucker."
—*Bart Simpson*

"Let this be our final battle."—*Cartman*

WHERE DID THE IDEA COME FROM?

This is the second part of the previous episode. It spanned two shows in part because Matt and Trey wanted another week to try to talk Comedy Central (without success, as it turned out) into letting them show Mohammed. During Kyle's impassioned speech about censorship to the President of Fox, he even says, "Yes. People can get hurt. That's how terrorism works. But if you give in to that, *Doug*, you're allowing terrorism to work. Do the right thing here." This is a direct shout out to Doug Herzog, President of Comedy Central.

Ironically, this episode became almost as notorious for ripping on *Family Guy*—which, for the record, both Trey and Matt strongly, strongly dislike. Or, to be more specific, they strongly dislike its anything-for-a-gag writing style.

CHARACTER DEBUTS

Bart Simpson. He joins forces with Cartman (at least at first) in his plot to get *Family Guy* cancelled. Also, when Cartman and Kyle fight, they roll through the offices of another Fox animated show, *King of the Hill*. Staffers from both *King of the Hill* and *The Simpsons* contacted Matt and Trey after the first part of "Cartoon Wars" aired and expressed similar feelings about *Family Guy*.

We also meet the Network President of the Canadian Broadcasting Company (CBC). He denies Terrance and Phillip's request to air the Mohammed episode uncensored, and he will give them even worse news in Season 13's "Eat, Pray, Queef." There's also the *Family Guy* "Writing Staff"—aka a bunch of manatees. The head writers we're introduced to are Gretchen, Flubber, Tigger, Pete, and Lucy.

CELEBRITIES IMPUGNED

Gary Coleman makes a guest spot in a *Family Guy* joke—on a date with Peter in Mexico—saying his popular catchphrase, "What you talkin' bout Willis?"

BEHIND THE SCENES

In the scene supposedly containing Mohammed, there is instead a black slate reading, "In this shot, Mohammed hands a football helmet to *Family Guy*. Comedy Central has refused to broadcast an image of Mohammed on their network." This is not an embellishment. This scene was fully animated in the show—Matt and Trey refused to cut it and Comedy Central refused to air it—so, once the show was delivered, Comedy Central inserted this slate on their end. In the actual scene, Mohammed looked totally normal and hands a football helmet with a dead salmon on it to Peter.

POINTLESS OBSERVATIONS

The episode starts with what has become a classic *South Park* April Fools joke: "And now, the thrilling conclusion of Cartoon Wars . . . Will not be seen tonight! So that we can bring you this Terrance and Phillip Special!" This same gag was played on the fans in Season 2's "Not Without My Anus" (much to the displeasure of those same fans waiting to find out who Cartman's father was). The gag is referred to again in "Eat, Pray, Queef."

In *The Mystery at the Lazy "J" Ranch*, Terrance is still shown as significantly overweight—a continuation of the events that unfolded in Season 5's "Behind the Blow."

When trying to decide who should go and talk with the network heads, Cartman or Bart Simpson, Bart says he once stole the head off a statue (a reference to a *Simpsons* episode called "The Telltale Head"). Cartman responds, "Wow, that's pretty hardcore. Geez. That's like this one time, when I didn't like a kid, so I ground his parents up into chili and fed it to him." He's talking of course about "Scott Tenorman Must Die." Later in the episode, Bart is seen writing in chalk: "I Hate *Family Guy*." It's a nod to *The Simpsons'* opening credits where he writes something different on the chalkboard every episode.

The Al-Qaeda film at the end of this episode features cutouts of a number of *South Park* staff members . . . all taking a crap on one another.

POP CULTURE REFERENCES

The President of Fox gives the code for dropping the *Family Guy* episode as "zero zero destruct." It's a reference to the "zero zero destruct zero" code used to (almost) destroy the Enterprise in the *Star Trek* episode "Let That Be Your Last Battlefield," and to actually destroy her in the 1984 film *Star Trek: The Search for Spock*.

The title card for Terrance and Phillip's *Mystery at the Lazy "J" Ranch* is done in a style very similar to that of fictional amateur detectives *The Hardy Boys*. See "Mystery of the Urinal Deuce" (page 164) for more on that.

When Cartman tries to convince the Fox executives to pull the episode, he takes on the persona of "Little Danny Pocket," complete with a tiny crutch. This is an homage to Tiny Tim from *A Christmas Carol*.

There's a billboard for a show called *The IE (The Inland Empire)*. This is a joke on the hit Fox show *The OC*, replacing it with a very hot, landlocked area outside of Los Angeles. There's also a billboard for *Cold Age: The Smackdown*—a parody of the animated film *Ice Age: The Meltdown*.

WHAT KYLE LEARNED

"People can get hurt. That's how terrorism works. But if you give in to that, you're allowing terrorism to work."

155

A MILLION LITTLE FIBERS

Original Air Date: April 19, 2006
Episode 1005

THE STORY: Towelie is fired from his wait staff job at P.F. Chang's because he's waaaay too stoned. Now unemployed and broke, he gets high and comes up with an idea to make money. He writes his memoirs and takes them to a book publisher. Unfortunately, his novel is rejected for publication because "people aren't interested in the autobiographies of towels." So Towelie gets high and has another idea. He pretends to be human, changes his name to Steven McTowelie and markets his book once more. This time it finds a publisher and wins a spot on *The Oprah Winfrey Show*, guaranteeing that his life story, *A Million Little Fibers*, will become a bestseller.

The book flies off the shelves and makes Towelie rich. But the seeds of his destruction are already being sewn by none other than Oprah's vagina and anus—Minge and Gary—both of which feel neglected by their workaholic host. The two orifices contact Geraldo Rivera with a startling revelation: Steven McTowelie is not a person—he's a towel.

Rivera breaks the news, creating a firestorm of controversy. Oprah's vagina and anus are thrilled, because they think the embarrassment will cause the cancellation of Oprah's show, forcing her to spend more time with them. And everything seems

to be going as planned. Oprah invites Towelie back, allegedly to give his side of the story. But when he returns to the show (no longer in "human" disguise), she instead incites her audience to burn and lynch him.

Towelie is chased down the street by the mob and cornered in front of the First National Bank of Chicago. But before the crowd can tear him apart, Oprah's Minge pulls a revolver out the front of her pants, guns down a cop and takes the audience (and Towelie) hostage. He sees that Oprah will never have time for either her Minge or her Gary. Minge demands a plane to take him and Gary to France.

Resisting the ever-present temptation to get high, Towelie instead comes up with a daring rescue plan. He slides under the bank's locked doors, opens them from the inside and quietly ushers the hostages indoors, allowing them to escape unnoticed. A police sniper then shoots Oprah in the crotch, killing Gary. Oprah's Minge, distraught and emotional over the death of his mate, takes his own life.

Oprah is then carted off to the hospital, while Towelie is hailed as a hero. He vows to no longer get high for ideas. Instead he'll get high *after* he comes up with ideas, as a reward.

"I have come up with a shocking discovery that is going to rock the balls and ass of the literary world."
—*Geraldo Rivera*

"I can't take it any more. All she does is work, work, work. Never pays any attention to the ol' minge."
—*Minge*

MEMORABLE LINES:

"I want a chopper and a jet waiting at the airport to take us to France. Plus, we need some fresh knickers right away."
—*Minge*

"If I was a towel, why would I be wearing this hat? And this fake mustache"—*Towelie*

"YOU'RE a towel!!!"
—*Towelie*

"Every time I get high I come up with ideas that get me in more trouble."—*Towelie*

"Well you know what I think, Towelie? I think you're a lying sack of shit."
—*Oprah*

"Oprah's going to be okay. I wish I could say the same for her vagina and asshole."—*Negotiator*

"This is the most unstable vagina I've ever talked to."—*Negotiator*

"Oh man . . . I have no idea what's going on."
—*Towelie*

"This is the most unstable vagina I've ever talked to."—*Negotiator*

"Is this audience ready for a good old-fashioned lynching?"—*Oprah*



BEHIND THE SCENES

This was supposed to be a "banked show." One that was partially done in advance so that, at some point during the production run, the team could take a couple days off. They took their days off, and then realized that the material they'd already written and animated (concerning Towelie undergoing an "intervention" to curtail his drug use) had to be scrapped. Instead, they married the *A Million Little Pieces* controversy and Oprah's talking privates with the Towelie story. The final result, Matt says, was "weirdness on top of weirdness."

WHERE DID THE IDEA COME FROM?

This episode mocks the controversy over the James Frey memoir *A Million Little Pieces*—a book that Oprah Winfrey endorsed on her show. In retrospect, Trey thinks the episode's major plot devices—Towelie getting his weed habit under control and Oprah's talking vagina—could have made two separate shows.

POINTLESS OBSERVATIONS

None of the boys make an appearance in this show—only the second time this has happened since Season 4's "Pip."

We get a view of Towelie's apartment for the first time here. In his room are several bongs, junk food, and two posters: *High Moments* (a parody of stoner magazine *High Times*) and "Thankful Dead" (a play on hippie jam band Grateful Dead).

Towelie apparently spells his name "Toweleeeie." On the front cover of his book, *A Million Little Fibers*, there's a review from the *Chicago Globe* reading: "The most fascinating tale of drug addiction since William S. Burroughs' *Junkyard*." This is a joke on Burroughs' semi-autobiographical tale of heroin addiction, *Junkie*.

Towelie's hotel room has a framed picture Wrigley Field, home of the Chicago Cubs.

CHARACTER DEBUTS

Oprah's talking private parts, Minge and Gary. We also meet Towelie's "human" alter-ego, Steven McTowelie.

POP CULTURE REFERENCES

Towelie's book is published by Arbitrary House, a reference to Random House.

Chapters four through eight in Towelie's book are exclusively about Doritos brand corn chips. He also has a bag of Chiporitos in his room.

BODY COUNT

A Chicago cop gunned down by Oprah's Minge. After the hostages are freed, Gary (Oprah's anus) takes a bullet from a sniper. Minge—unable to live a life without his asshole mate Gary—then takes his own life.

CELEBRITIES IMPUGNED

Oprah Winfrey. She's shown as a fat workaholic that never, ever takes time to play with her minge or asshole. Also, Geraldo Rivera, making his first appearance since Season 1's "Weight Gain 4000." In this episode, however, he's a lot more flamboyant.

Lastly, the elder Larry King makes another cameo interviewing Towelie on his show *Larry King Live*. He was last seen in "Krazy Kripples" (page 52).

WHAT TOWELIE LEARNED

"I learned that I shouldn't get high to come up with ideas. I should come up with ideas and then get high, to reward myself."

MANBEARPIG

Original Air Date: April 26, 2006
Episode 1006

THE STORY: During a special school assembly, former Vice President Al Gore stops in to educate the students about the single biggest threat to our planet: ManBearPig. According to Gore, this "half man, half bear, half pig" roams the Earth alone, trying to get you.

Later, while the boys are playing basketball, Gore pays a surprise visit dressed in a shitty ManBearPig costume—warning that next time, this could actually be the real monster. He's super cereal. He then continues to "spread awareness" by calling Stan frantically in the middle of the night, demanding that he and the rest of the boys attend a vital morning meeting concerning the MBP threat.

Feeling sorry for Gore (who has no friends and cries frequently), Stan agrees to attend. He drags along Kyle, Cartman, and Kenny to the meeting at Gore's hotel room, which is set up as a high-tech MBP Command Center. Just then, an alert goes off signaling that ManBearPig is holed up in a famous Colorado tourist spot called Cave of the Winds. The boys don't want to go, but when they learn Gore can get them out of school, they give in.

At the Cave of the Winds, the boys and Gore join a tour group to explore the caverns. During the tour, however, Gore thinks he hears ManBearPig lurking in the darkness and starts blasting off his shotgun, causing a massive cave-in that traps the kids.

Stranded, the boys all search for ways out. No one finds anything—except for Cartman, who secretly discovers a mound of gold and treasure. In order to keep it safe from the others, he painfully swallows every piece over the next few days. Consuming all this treasure makes him horrifically bloated and immobile. Unaware of the true cause, the boys believe him to be severely ill, and struggle to carry Cartman to safety.

Meanwhile, rescue teams frantically dig through the rubble to try and rescue the missing boys. Gore, however, urges the workers to stop digging, and instead fill the cave with molten lead, as this is the only way to make sure ManBearPig is dead. The workers ignore his plea and continue to search.

Taking matters into his own hands, Gore diverts a nearby river, effectively flooding the cave with water in an attempt to drown MBP. Instead, he almost succeeds in drowning the boys, who barely escape with their lives. They emerge from the rubble in the middle of a memorial service being held in their honor.

Kyle berates Gore for his ManBearPig obsession, while Cartman learns that his "treasure" was just worthless junk positioned in the cave as a tourist photo spot. He then begins to slowly, painfully shit out great masses of coins and jewelry. He's still at it when the credits roll.

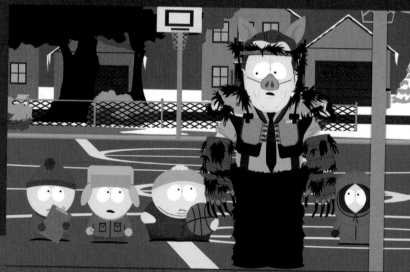

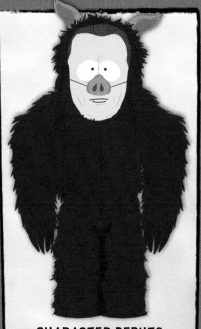

CHARACTER DEBUTS

ManBearPig—a deadly crossbred monster that is half man, half bear, and half pig. Although only sketches of this mythical beast are shown here, the danger is super cereal. The creature finally reveals itself in bloody fashion during next season's "Imaginationland: Episode II."

WHERE DID THE IDEA COME FROM?

Trey and Matt toyed with the ManBearPig concept for a long time, but couldn't find a spot for it until Al Gore's documentary *An Inconvenient Truth* came along. In this episode, the ephemeral creature serves as a stand-in for global warming. Gore even says at the end of the episode, "Maybe I'll make a movie. A movie starring me. Then people will take me super cereal!"

Trey also loves the part where they get lost in the cave, because it's a chance to let the boys act like boys.

POINTLESS OBSERVATIONS

During the Cave of the Winds tour, the guide points out various stalagmite and stalactite formations with names such as "The Hanging Mushroom," "Man With Helmet and Two Bowling Balls," and "The Two Sisters"—all of which look like gigantic stone penises.

Cave of the Winds is a real tourist attraction outside of Denver, Colorado. What you see here is modeled after the real place (well, minus all the stone penises).

CELEBRITIES IMPUGNED

Al Gore comes across as a twitchy goofball with no friends, struggling to get someone, anyone, to take him "cereal." This is his first appearance since his brief cameo in Season 3's "The Red Badge of Gayness." He will return again in "Imaginationland: Episode III," still spreading MBP awareness.

WHAT STAN LEARNED

"I was nice to you because I felt sorry for you. Because you don't have any friends. But now I see why you don't have any friends! You just use Man-BearPig as a way to get attention for yourself, because you're a loser!"

TSST

Original Air Date: May 3, 2006
Episode 1007

THE STORY: Cartman's mother is called into Mr. Mackey's office after her son's reckless actions land another student in the hospital. It seems that Cartman's behavior is completely off the charts and, not knowing what else to do, his mother turns to reality TV shows. She first calls upon the expert help of Nanny Stella from *Nanny 911*, but after only a few hours with Cartman, she's driven to near-homicidal rage.

Nanny Jo from *Supernanny* arrives on the scene and guarantees a "new Eric Cartman" in 3 days time. In that time, however, Cartman does something so unspeakable that she goes completely insane and has to be locked up in a mental institution.

As a last resort, Cesar Millan from *The Dog Whisperer* is called in. Though he's not exactly an expert on children, his dog training techniques work extremely well on Cartman, whom he describes as dominant, aggressive, and obese. The trick, he says, is for Cartman's mother to become the "pack leader."

To Cartman's fury, Millan demonstrates this by "nipping" at his neck with two fingers and resolutely ignoring him until he becomes calm and submissive. Cartman is taken for a walk on a leash, then forced to submit to the adults' authority before being given a piece of chicken from a bucket of KFC.

Not surprisingly, he doesn't take well to the new regimen. He tries to run away, but when none of his friends will take him in, he soon returns home. Deciding that murdering his mother is his only way back to a "normal" life, he sneaks into her bedroom with a knife while she sleeps.

But suddenly, at the last possible moment, it dawns on him—perhaps for the first time—that his mom is a human being, not his property. And perhaps, just perhaps, the world doesn't revolve around him. This leads to a violent, surrealistic battle between his good and bad sides, before the good finally, amazingly, triumphs. Beaten, Cartman vomits black ink in the hallway and passes out.

The next day his mom finds him in the kitchen, eating a sensible breakfast and studying for school. Delighted with the change, she thanks Cesar Millan and asks him to see *Madame Butterfly* with her that Friday. But Millan, to whom she's only a client, politely declines and leaves town.

Dejected, she asks Cartman if he'll go with her to the show instead—and then bribes him with a visit to KFC and the promise of a new toy. Cartman asks for two new toys. His old self, it seems, has triumphed after all.

MEMORABLE LINES:

"Stop trying to bogart my Xbox, you fat bitch!"
—*Cartman*

"What the hell is this? Skinless chicken? Boiled vegetables and salad? This is just like Auschwitz!"
—*Cartman*

"Okay, I'm sorry I handcuffed Billy Turner's ankle to a flagpole and then gave him a hacksaw. And then told him I had poisoned his lunch milk and that the only way he could get to the antidote in time would be to saw through his leg."—*Cartman*

"Well nice going asshole, you made my mom cry."
—*Cartman*

"TSST!"—*Cesar Millan*

"Yes, let the anger come! Strike me down while you can. But it won't make your dried-up ovaries any more fertile!"
—*Cartman*

"I've thought about it a lot, and I've decided . . . I have to kill my mom."
—*Cartman*

"Alright, seriously, you're starting to piss me off now."—*Cartman*

"HE SPIT IN MY MOUTH!"
—*Nanny Stella*

"God dammit! I am not a dog!"—*Cartman*

CHARACTER DEBUTS

Cesar Millan, host of *The Dog Whisperer*. He is perhaps the only person ever to successfully correct Cartman's behavioral problems—at least, temporarily. There's also Nanny Stella from *Nanny 911* and Nanny Jo from *Supernanny*.

ORIGINAL SONGS

Cartman and his mother share a brief a cappella duet in Mr. Mackey's office with "My Mom's the Best Mom."

WHERE DID THE IDEA COME FROM?

Trey is a big fan of the TV show *The Dog Whisperer*. He guessed that Millan's techniques would also work on children, and was proven right. Parents who watch the episode tell him they now use *Dog Whisperer* tactics on their kids, with great success.

POINTLESS OBSERVATIONS

In the *Nanny 911* intro to Cartman's behavioral problems, there is a clip spliced in from "The Passion of the Jew" (page 88), where he's dressed in the Hitler uniform. Ironically, Cartman will repeatedly refer to his mother as "Hitler" once she asserts herself as the dominant person in their relationship.

According to the "Plan to Kill Mom" diagram presented by Cartman, the final stage in his murder plan is to "Frame Token!"

The Cartman family's television says "Fony" rather than Sony.

CHILD DISCIPLINE OBSERVATIONS

Matt says that any girl he's ever dated who described her mother as "her best friend" turned out to be a head case like Cartman. Well, not exactly like Cartman, but pretty bad.

POP CULTURE REFERENCES

Cartman briefly sings the Journey song "Don't Stop Believin'." Also, a jokey parody of the Men at Work tune "Be Good Johnny" plays over the intro to *Supernanny*.

When Cartman struggles with the concept of actually becoming an obedient child, he undergoes a physical transformation like the one in the climax of 1980's *Altered States*. Furthermore, the closing scene in which Cartman looks knowingly at the camera while embracing his mother is reminiscent of the finale of *The Omen*.

The main conflict between Nanny Stella and Cartman arises over his Xbox 360. The videogame console is pretty accurately recreated here.

WHAT CARTMAN LEARNED (AND THEN FORGOT)

"The world doesn't revolve around me!"

MAKE LOVE, NOT WARCRAFT

Original Air Date: October 4, 2006
Episode 1008

THE STORY: The boys start playing the online computer game *World of Warcraft*, but their fun is soon ruined by an ultra-powerful player, NWBZPWNR, who keeps killing them—or rather their heavily-muscled, exotic-looking on-screen avatars. They complain to the game's creator, Blizzard Entertainment, but the company brass is already well aware of the problem.

It seems the ultra-gamer has spent the last year and a half doing nothing but playing *Warcraft*, allowing him to reach an almost godlike level—and to kill other players (even Blizzard's admins) at will. The Blizzard execs fear that if something isn't done soon, users will get frustrated and find something else to do with their lives.

After once again being mercilessly killed by NWBZPWNR, Cartman gathers all the boys for an emergency *Warcraft* meeting. Here, they plan a massive, coordinated attack on the villain. But even when all the kids attack at once, they're no match for their uber-powerful rival.

After the defeat, the boys decide to ditch the game and play outside. All except for Cartman, who comes up with a daring plan: Re-enter the game, hide in the woods, and boost their power levels by killing millions of boars. 65,340,285 boars, to be exact. Once they all become powerful enough, they can challenge their nemesis again.

Over the next two months they play the game obsessively, growing progressively more powerful onscreen, and progressively fatter, and pimplier, in the real world. *Warcraft* company execs follow their progress with interest, believing they might have a chance of defeating the renegade. To stack the odds in their favor, they decide to give them the mythical Sword of a Thousand Truths—a special weapon stored on a 1 GB USB flash drive, originally removed from the game because it was too powerful.

Unfortunately for the boys, they've already initiated their attack on NWBZPWNR from Cartman's basement. They are seventeen hours into the epic duel when the Blizzard execs try to deliver the sword to Stan's house, only to find him gone. His father, himself a novice *Warcraft* player, volunteers to log on and deliver the sword to his son. He commandeers a computer at a Best Buy and hands over the weapon just before being mortally wounded by the rogue gamer.

Stan immediately uses the sword to drain his nemesis' defensive shields. Kenny then shoots him with an arrow, Kyle blasts him with a fire spell, and Cartman delivers the coup de gras by smashing his head with a war hammer. Other players come out from hiding to celebrate the great victory. Stan, Kyle, Cartman, and Kenny, now horrendously out of shape from weeks of subsisting on Hot Pockets and energy drinks, have saved the world . . . of *Warcraft*.

MEMORABLE LINES:

"Butters, go buy *World of Warcraft*, install it on your computer and join the online sensation before we all murder you."—*Cartman*

"When Hitler rose to power there were a lot of people who just 'stopped playing.' You know who those people were? The French. Are you French, Clyde?" —*Cartman*

"Don't you have better things to do than going online killing people?!"—*Cartman*

"I'm not an R-tard..." —*Stan's dad*

"I think Kyle has sweet titties."—*Kenny*

"Looks like you're about to get pwned." —*Cartman*

"My mouse-clicking finger hurts."—*Kyle*

"How do you kill that which has no life?" —*Blizzard Executive*

"Gentlemen, this could very well lead to the end of the world . . . of *Warcraft*." —*Blizzard Executive*

"Mom, more Hot Pockets!" —*Cartman*

BEHIND THE SCENES

The staff, never dreaming that *Warcraft's* maker, Blizzard Entertainment, would help them, experimented with how to produce video game-like images themselves. Finally they just asked the company if they could use their characters, and were pleasantly surprised to find them highly stoked about being on *South Park*. The action scenes are directly from actual game play. Blizzard staff members camped out in the *South Park* offices and played the game under Trey's direction.

BODY COUNT

Countless newbs in the *World of Warcraft* get pwnd by the evil one. And during the final battle, NWBZPWNR gets his head smashed in with a war hammer by Cartman's dwarf character. However, it was established early on that this guy had no life, so it hardly counts as a death.

VIDEO GAME REFERENCES

The episode's fictional Sword of a Thousand Truths showed up in a later version of *World of Warcraft*. The Blizzard programmer wearing a T-shirt reading "Dwarf Needs FOOD!" references a video game called *Gauntlet*. Lastly, the scene where Stan's dad flags down a driver—only to beat him up and steal his car—was done a la *Grand Theft Auto*.

CHARACTER DEBUTS

The all-powerful renegade player, NWBZPWNR, makes his debut. In reality, he's just some morbidly obese geek that's spent the past year and a half parked in front of his PC playing *World of Warcraft*. Although the ultra-player is never actually named in the show, he's referred to as "NWBZPWNR" throughout the script.

Kenny, Stan, Kyle, and Cartman all take on their uber-fat, pimply gamer personas here. The result is classic. Finally, we briefly are introduced to Nelson, Randy's co-worker at the Geology Station.

WHERE DID THE IDEA COME FROM?

Both Matt and Trey are video game nuts with a more-than-passing knowledge of *World of Warcraft*. And since most of the staff are players too, it seemed like a natural fit for the show.

POP CULTURE REFERENCES

When Cartman rips on Clyde for wanting to quit playing, asking if he's French, he says "*Voulez vous coucher avec moi*, Clyde?" This French phrase gained worldwide popularity for its use in the hit disco jam "Lady Marmalade." It means: "Do you want to sleep with me (tonight)?"

"Live to Win" by Paul Stanley (of KISS fame) plays over the boys' boar-killing montage.

Junk food is all over the place in this episode. Among other things, NWBZPWNR munches on some "Chips-A-Ho! Cookies" (a parody of Chips Ahoy!), and the boys live off Snacky Cakes, Cup Ramen, and Chinese takeout from City Wok. Rockstar energy drinks appear on almost every gamer's desk. There are also a few scattered cans of "Red Balls" (a parody of Red Bull).

In one of the scenes with the rogue gamer, he has a Big-Gulp-type soda tub with a *Pirates of the Caribbean*-esque lid. The cup reads "Buccaneers of the Bahamas."

POINTLESS OBSERVATIONS

When the boys play together in Cartman's basement, the Antonio Banderas blow-up doll first seen in Season 3's "Korn's Groovy Pirate Ghost Mystery" (and many times thereafter) can be seen in the corner. There's also Clyde Frog, Peter Panda, and Rumper Tumpskin.

In NWBZPWNR's apartment, there is a mini-model of Zazul (the demon from "Hell on Earth 2006," page 168) on top of his computer, and an Okama Gamesphere (from "Towelie") next to his TV.

Butters admits that he doesn't play *World of Warcraft*—instead, he plays *Hello Kitty Island Adventure*. That's not actually a real game.

We get a good look at a lot of the boys' rooms here—some for the first time. Token has a bass guitar and some jazz posters; Tweek has coffee and a scary clown; and Clyde has a poster for Monster Machines and more importantly, a *Playboy*.

In order to gain enough experience points, the boys kill 65,340,285 boars. It takes them seven weeks, five days, thirteen hours, and twenty minutes (with three hours a night to sleep).

In Kenny's house, we briefly see his parents arguing in the background. Kenny's mom actually punches his dad in the face—a healthy dose of domestic abuse we haven't seen since Season 2's "Chickenlover."

Stan's character's name in *World of Warcraft* is LUVS2SPWGE.

NOT-SO-POINTLESS OBSERVATIONS

This episode won the 2007 Emmy for Outstanding Animated Program. It was the show's second Emmy, the first being Season 9's "Best Friends Forever" (page 122).

WHAT CARTMAN LEARNED

"You can just hang outside in the sun all day tossing a ball around, or you can sit at your computer and do something that matters."

MYSTERY OF THE URINAL DEUCE

Original Air Date: October 11, 2006
Episode 1009

THE STORY: Someone takes a crap in the boys' urinal at South Park Elementary, launching Mr. Mackey on a relentless investigation to find the perpetrator. When no one fesses up, Mr. Mackey calls in the authorities, who are equally baffled. Feeling it's too big a mystery for them to handle alone, the police soon call in the Hardly Boys to help.

Cartman, however, has his own theories. He believes it's a conspiracy just like 9/11—an idea that, despite its absurdity, slowly gains traction with the townspeople. Cartman further muddies the waters when he unveils a complicated Powerpoint presentation during "Show and Tell." Through a series of complex mathematics, the presentation names Kyle as the perpetrator of the 9/11 attacks.

It's a far-fetched notion, but the other kids nevertheless start looking at Kyle strangely, and even worse, the CIA stakes out his house. Pissed, he tells his mother, who calls a town meeting to complain that their children still don't have a clear understanding of the terrorist attacks. But it soon becomes apparent that the townspeople, many of whom are nursing their own conspiracy theories, don't either.

While trying to locate someone who can prove Kyle's innocence, Kyle and Stan stumble upon the 9/11 conspiracy organization 911Truth.org. But too late—just as they arrive, the FBI raids the building, arresting the boys along with the organization's founder. They're then taken to the White House, where President Bush announces—to Kyle's dis-

believing cries of "Really?"—that the government had indeed planned the whole thing.

The President then shoots the 9/11 conspiracy guy in the head, and in the ensuing chaos, the boys manage to escape. Later, on the street, they see the conspiracy guy alive and well. After a long chase, the boys corner him. He admits that he's just a pawn in the government's system . . . and then is shot dead by the Hardly Boys' father.

The old man takes them to his home and explains that all the conspiracy organizations are secretly run by the government. Bush and his entire Cabinet suddenly appear at the house and take up the explanation. Since about a quarter of the U.S. population is "retarded," the government wants to keep them appeased with conspiracy stories. The other 75 percent will be satisfied with the straightforward truth—that 9/11 was caused by pissed-off Muslim militants.

Suddenly, Stan puts a gun to Kyle's head and admits that it was *he* who dropped the deuce in the boys' room urinal. The only reason he went along on this foolish mission was to secure bogus "proof" that the government was involved both in 9/11 and the urinal deuce incident. The government was more than happy to play along, because it made them look all-powerful.

Stan comes clean to Mr. Mackey about the urinal incident, and as punishment must clean out the offending dookie-filled urinal personally.

"One of you thought it would be a good idea to pull down your pants, mkay, hover your butt cheeks over the urinal, and squeeze out a chocolate hot dog, mkay."
—*Mr. Mackey*

MEMORABLE LINES:

"For Show and Tell today I have brought my shocking Powerpoint report on the truth behind the 9/11 attacks."—*Cartman*

"I've got such a raging clue right now."
—*Joe Hardly*

"The turd could have been put there to cover up 9/11!"
—*Jimbo*

"And take two minus one plus nine eleven and you get twelve—which leads us all to the mastermind of the 9/11 attacks . . . Kyle."
—*Cartman*

"What's a urinal?"—*Butters*

"My clue's kinda pointing this way..."
—*Frank Hardly*

"Let's see what your mom and dad have to say about your little poopscapade."
—*Mr. Mackey*

BODY COUNT

The 911Truth.org conspiracy theorist (named Brian in the script) gets a double dose of death. He's pretend-shot by President Bush, then killed for real by the Hardly Boys' father.

WHERE DID THE IDEA COME FROM?

This episode is, according to Matt and Trey, a little about insane 9/11 conspiracy theories and a lot about someone taking a dump in a urinal—something that happened at Matt's elementary school when he was a kid.

POINTLESS OBSERVATIONS

Mr. Mackey states that South Park Elementary has more than 300 male students.

Dick Cheney is dressed like a crazed hunter and armed with a crossbow. When he goes to kill the boys, he misses by a long shot, yelling, "Dangit I missed again!" This is a subtle reference to the hunting accident that occurred earlier in 2006, in which Cheney "missed" a quail and shot a fellow campaign contributor in the face.

A man on the street is reading the magazine Mother Trucker. The same magazine is read by the PA Announcers in "Free Willzyx" (page 140).

This is the only time Stan has ever pulled a gun on Kyle, or threatened his life in general. That job is normally left for Cartman.

CHARACTER DEBUTS

Frank and Joe Hardly (aka the Hardly Boys)—two young whippersnappers whose raging clues give them a keen ability to solve mysteries. They're based, of course, on the fictional mystery-solving duo The Hardy Boys. We meet their father, Fenton Hardly, as well.

There's also Leeroy, a 4th grade student with freckles and glasses who shows off his "dumb little frog" during Show and Tell. Lastly, we meet Jose Venezuela, the school's janitor. He was previously employed at the Museum of Tolerance ("The Death Camp of Tolerance," page 38), where he was wrongfully thought to be the wax statue of a "Stereotypical Sleepy Mexican."

POP CULTURE REFERENCES

Before being interrupted by Mr. Mackey, Ms. Garrison is lecturing her class on the intricacies of celebrity love life: "And so class, that is when Jolie countered back to Aniston and said things like . . ." This is of course referencing the Jennifer Aniston/Angelina Jolie/Brad Pitt saga.

During Cartman's heartfelt song about 9/11, he croons: "Almost all the evidence points one way. But I'm like Charlie Sheen and Gloria Estefan . . . I need to know what really happened on 9/11."

FECAL OBSERVATIONS

Over the course of the episode, the piece of urinal feces is variously referred to as "mud monkey," "dook," "fudge dragon," "brown rag doll," "chocolate hot dog," "chud," and "dookey." Also, in Season 3's "Starvin' Marvin in Space," Cartman accuses Kyle of pooping in a urinal. Kyle counters by saying that it was Cartman, and that he saw him do it. Finally, we learn that Clyde had a colostomy at age 5.

ORIGINAL SONGS

Cartman shows off his softer side with his soul-searching piano ballad "What Really Happened on 9/11?"

WHAT KYLE LEARNED

"Anybody who thinks 9/11 was a conspiracy is a retard."

CHARACTER RETURNS

Shop teacher Mr. Adler briefly resurfaces.

MISS TEACHER BANGS A BOY

Original Air Date: October 18, 2006
Episode 1010

THE STORY: Cartman is honored with the chance to be South Park Elementary's Hall Monitor—an opportunity which he embraces by morphing himself into a clone of Dog the Bounty Hunter, complete with beard and an ever-present can of bear mace. Minutes later, he's roaming the hallways, ferociously looking for any acts of "hallway infractions."

He finds one soon enough, in the form of a crayon-scribbled love note from Ike to his hot kindergarten teacher, Ms. Stephenson. But it seems that Ike's love is not just one-sided. During a montage sequence, we see Ike and Ms. Stephenson having dinner, watching a sunset, and then lying in bed together, disheveled after a round of "incredible sex."

To provide cover for their affair, Ms. Stephenson decides to "tutor" Ike privately at her home. However, Kyle quickly discovers what's really going on when he goes to pick up his brother and catches the two lovers taking a bath together. He's shocked not only by the relationship, but by the fact that Ike is a more-than-willing participant. Not knowing where to turn, he reports the crime to the police . . . but finds that they're more titillated than concerned.

When Kyle mentions to Cartman that his brother and the teacher often sneak into the hallways to make out (a clear violation of the rules), Cartman jolts to action. He surprises the couple, maces Ms. Stephenson and drags them to the principal's office. Outraged, Principal Victoria alerts the police and the media.

But things don't work out as planned. Most of the town sees Ike not as a victim, but as an extraordinarily lucky little boy. Ike tells Kyle he's "dead to him." And Ms. Stephenson (who blames her behavior on alcoholism) gets an absurdly short stint in rehab before being released.

Once freed she goes immediately to the Broflovski home, takes Ike, and flees with him to the Airport Hilton, where they await a flight to Milan. But Cartman, furious that Ms. Stephenson got away with violating hall pass rules, assembles a crack team of bounty hunters and tracks them down. Kyle joins him and they raid the hotel, spraying mace on pretty much everyone in sight.

Ike and Ms. Stephenson hear this commotion and flee, and after a bear-mace-filled chase, everyone winds up on the roof. Realizing that their love will never be fully realized in this world, Ms. Stephenson plans to jump to her death with Ike. But Kyle pleads with his brother to live his life, have fun, and then "ruin it by having a serious relationship."

Ms. Stephenson and Ike run hand-in-hand towards the edge and jump—but Ike, at the last moment, changes his mind and runs to Kyle. Ms. Stephenson falls to her death. Cartman wraps things up by saying, "I hope you've learned, kids, that if you don't go with Christ, you could end up just like that splattered bitch down on the pavement."

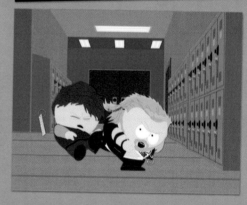

MEMORABLE LINES:

"Alright, cool bra. Go with Christ."
—*Cartman*

"You just dealt with the Dog, bitch."
—*Cartman*

"I don't tell you how to run your class. Don't tell me how to run my hallway."
—*Cartman*

"HALL PASS! SHOW ME YOUR HALL PASS!!"
—*Cartman*

"Ike made a no no!"
—*Ike*

"You're dead to me, Kyle."—*Ike*

"Nice..."
—*Numerous People and Cops*

"Hey there Mr. Wiener, whaddya know? Do you need to tinkle tinkle? Yes I do think so."
—*Butters*

"The case is shocking due mostly to the fact that the teacher . . . is pretty hot."
—*News Reporter*

"Dammit, where were all these sexed-up teachers when I was a kid?"
—*Sergeant Yates*

"We need to track this student down and give him his Luckiest Boy in America Medal right away!"
—*Sergeant Yates*

"When we make love, he can give it to me hard, or soft and gentle."
—*Ms. Stephenson*

BODY COUNT

Ms. Stephenson. She jumps off the roof of a hotel after making a suicide pact with Ike—a pact Ike opts out of at the last minute. Cartman also takes great liberties with his Hallway Monitor status by beating up, arresting, and bear-macing countless students and civilians.

CHARACTER DEBUTS

Ms. Stephenson, Ike's first love, makes her debut and grisly departure in this episode.

CELEBRITIES IMPUGNED

When the teacher tries to escape punishment by claiming she's an alcoholic, Cartman says she's using "the Mel Gibson defense." This refers to his infamous DUI stop, after which he blamed alcohol for the anti-Semitic remarks he made to the arresting officers.

Duane "Dog" Chapman (from *Dog the Bounty Hunter*) and his wife/business partner Beth get a nice helping of parody in this episode. Leeroy and Earl, two members of Dog's redneck Hall Monitor crew, are modeled after actual cast members from the show as well.

WHERE DID THE IDEA COME FROM?

Trey was a big fan of the TV show *Dog the Bounty Hunter*. Cartman had been slated to play Dog in "Die Hippie, Die" (page 118) and "Mystery of the Urinal Deuce" (page 164), but it didn't quite work out.

The Ike/Ms. Stephenson affair drew from the media hype surrounding several scandals involving female teachers having sexual relationships with their young male students.

POINTLESS OBSERVATIONS

Even though Cartman founded the Ginger Separatist Movement in "Ginger Kids" (page 136), he seems to have lost all respect for "red power." He rips into the old ginger Hallway Monitor pretty severely.

While many of the boys don't quite have a grasp on the whole sex thing, Cartman breaks it down real simple: "What's to understand? You get a boner, slap her titties around some, and then stick it inside her and pee." That is unless you don't want to get her pregnant, in which case you just "pull it out and pee on her leg." Butters shared similar sex advice with Jimmy in "Erection Day" (page 128).

Apparently Kyle and Ike have been back to Jewbilee camp after their adventure with Kenny and Moses in Season 3's "Jewbilee." On his bedroom desk is a framed picture of him, Ike, the Squirts, and two Elders with "Jewbilee 2002" imprinted on it.

POP CULTURE REFERENCES

During a montage that shows the development of the relationship between Ike and Ms. Stephenson, the REO Speedwagon song "Can't Fight This Feeling Anymore" plays in the background. Later, the sexual classic "Afternoon Delight" by Starland Vocal Band plays in Ms. Stephenson's home.

When Kyle is about to spill the beans to his mother about his little brother's affair, Ike interrupts, screaming "SPIDERMAN! SPACE MAN!!"

Cartman gets super bad-ass with his guitar-charged Hallway Monitor theme song, "I Am the Dog." The song is a parody of the opening to *Dog The Bounty Hunter*. It also gets reprised towards the end of the episode, featuring new lyrics for Dog's crew.

WHAT KYLE LEARNED

"I know your first love seems like the only love, but trust me it's not. You have so much life ahead of you."

HELL ON EARTH 2006

Original Air Date: October 25, 2006
Episode 1011

THE STORY: It's Halloween, and Satan unveils his grand plan to open up the gates of hell . . . to throw a super-awesome Sweet 16-style party in Los Angeles. Soon, he proclaims to his quivering minions that anyone who wants to come must have a blue wristband and wear a costume. And no one can dress like *The Crow*.

Just like a real *Super Sweet 16* party, the affair soon becomes a bloated, overpriced mess, and Satan turns into a spoiled, demanding bitch. He decides the party needs a super cool dessert to ensure that all the guests remember his greatness, and commissions a massive cake shaped like a Ferrari Enzo. Three serial killers—Ted Bundy, John Wayne Gacy, and Jeffrey Dahmer—are returned to earth and given the critical task of picking up the Ferrari cake and delivering it to the party.

Meanwhile, back in South Park, the boys are experimenting with a Bloody Mary-like ritual. With candles lit, they stand in front of a mirror and chant the name of rapper Biggie Smalls three times. Butters actually succeeds in summoning him, only to discover the rapper is furious, that now that he's been released from Hell, he's going to miss Satan's party. Biggie tells Butters (at gun point) that if he doesn't get him back to Los Angeles in time for the party, he's gonna pop a cap in his ass.

Butters and Biggie hop on the next plane to LA. Midflight, however, Smalls suddenly disappears. To his immense rage, the other boys have chanted his name, summoning him right back to South Park.

Back in Los Angeles, Bundy, Gacy, and Dahmer brutally butcher their assignment to pick up Satan's Ferrari cake. They first murder all the bakers who prepared the cake, and then proceed to drop the cake itself while attempting to load it onto the truck. In a last ditch effort, they try to bake one themselves . . . only to wind up stabbing and murdering one another.

Satan's assistant, Demonius, is forced to make a last-minute substitution and tracks down a cake shaped like an Acura TL. Even though no one notices the switch, Satan flies into a petulant rage over not getting exactly what he wanted.

After a loud and very public rant, he suddenly realizes that, in trying to stage a Halloween party just like spoiled rich girls, he's become a spoiled rich girl. He decides to let everyone into his party whether they have a wristband or not. Butters, who's milling around outside, asks to borrow a makeup mirror and uses it to summon Biggie Smalls. With his help, Biggie finally arrives at Satan's bash, and asks Butters to party with him. Figuring he's going to get grounded anyway, Butters agrees.

MEMORABLE LINES:

"When everyone sees the Ferrari cake, they will shudder and know my greatness."
—*Satan*

"Nobody can look hotter than me, it's my *Super Sweet 16* Halloween party!"
—*Satan*

"Dammit, what didn't Diddy do?"—*Satan*

"Oh my God, I crapped my pants... YOU GUYS, I CRAPPED MY PANTS!"
—*Cartman*

"Please don't ice me, homey."—*Butters*

"Come on Helen, let's just go back to hell. I'm suddenly not so hungry for Acura cake."
—*Man at Satan's party*

"I HAVE to invite celebrities or else my party won't be cool!"
—*Satan*

"HERE ME DEMONS! LORD SATAN HATH DEMANDED A FERRARI CAKE!"
—*Zazul*

"Biggie Smalls, Biggie Smalls, Biggie Smalls..."
—*Butters*

"Get out of the way, Hitler! You're ruining my entrance!"
—*Satan*

"Dahmer! Stop having sex with those intestines!"
—*Ted Bundy*

"He is bringing hell here to Los Angeles and from what we understand, the gathering is going to be . . . completely of the hook."
—*Bishop*

BODY COUNT

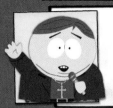

Ted Bundy, Jeffery Dahmer, and John Wayne Gacy brutally murder the bakers who created Satan's cake, along with some random passersby. Shortly after, they turn the violence in on themselves and wind up pretty bloody.

WHERE DID THE IDEA COME FROM?

The episode parodies the MTV reality show *My Super Sweet 16*, in which spoiled rich girls get catered to and act like jerks. Matt particularly loved the Ferrari cake, but was worried it might not go over well. Comparisons to the Crab People were made.

ORIGINAL SONGS

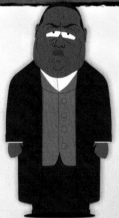

Butters sings a brief snippet of a tune while brushing his teeth, "Oral Hygiene Can't Be Beat."

POINTLESS OBSERVATIONS

The alcohol at Satan's party is sponsored by Bacardi and Ketel One.

To give Stan's dad a fresh taste of Biggie, Cartman breaks down into a rap: "Escargot, my car go, one eighteen, sipping on booze at the House of Blues." It's a mash-up of two of Biggie's hit songs "Hypnotize" and "Going Back to Cali." Butters later sings a bit of "Going Back to Cali" on the plane.

At Satan's Halloween party, there is a demon dressed in a carrot costume a la Rob Schneider's film *A Carrot* from "The Biggest Douche in the Universe" (page 40).

The Catholic priests all have Knott's Berry Farm bracelets instead of the real ones. This is an old-school amusement park in southern California; it's been referenced several times in other episodes.

CHARACTER DEBUTS

Deceased rapper Biggie Smalls. He's condemned to materialize before whoever says his name three times into a mirror. Kyle, Randy, and Butters (twice) all successfully summon him.

We also are introduced to Satan's Council. The two lead helpers are Demonius, the darkly cloaked man with the scar on his face, and Zazul, the lead demon. Zazul can be seen briefly in "Best Friends Forever" (page 122).

POP CULTURE REFERENCES

Satan forbids Hell's minions from dressing up as *The Crow* . . . because "it's lame." Yet he himself tries out a *Crow* costume before instead taking Zazul's slutty schoolgirl outfit for himself. Satan's party takes place at The W Hotel in Los Angeles, an uber-exclusive worldwide hotel chain. Also, while planning his party at The W, Satan toys with a number of luxurious desert items . . . only to learn that P. Diddy has already done all of them.

"Oh Yeah" by Yellow plays while the bakery chefs are making the Ferrari cake. This is an homage to the classic 1986 movie *Ferris Bueller's Day Off*, which used this tune in similar Ferrari-loving fashion.

There are tons of pop culture-infused costumes visible at Satan's bash. Most notably: Tickle Me Elmo, Captain America, *Coneheads*, Neo from *The Matrix*, and Hitler, who's dressed as the "Can You Hear Me Now?" guy from the long-running Verizon Wireless commercials.

Lastly, Bundy, Dahmer, and Gacy participate in murderous "hijinks" that parody *The Three Stooges*. There's even an old-school movie title card for *The Three Murderers*, complete with the old Columbia Pictures logo.

WHAT-THE-FUCK MOMENT

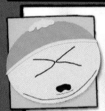

A group of Catholic priests intent on crashing the party all walk around with naked boys on leashes.

CELEBRITIES IMPUGNED

George Burns, Gandhi, and Princess Diana are all portrayed as damned souls. Diana shows up at Satan's party dressed as Lara Croft from *Tomb Raider*. Mel Torme and Frank Sinatra are also present at Satan's party.

Perhaps the most controversial celebrity depicted at Satan's party, however, was the recently deceased Steve Irwin, who shows up with a stingray's tail still impaled in his chest. Not recognizing him, Satan tells him that it's "too soon" to make fun of Irwin's death and asks him to leave. When Irwin says he's the real Crocodile Hunter, Satan then kicks him out for not wearing a costume.

WHAT SATAN LEARNED

"This party is for you. It's for all of you who make my life so special. If I don't realize that, then I'm no better than a rich American teenage girl."

GO GOD GO

Original Air Date: November 1, 2006
Episode 1012

THE STORY: Cartman is literally dying to get his hands on the new Nintendo Wii game console. But with three weeks to go until its release, he simply can't hold out any longer. He tries sleeping, pacing, and watching TV, but nothing makes the days pass any quicker. In order to bypass the wait, Cartman comes up with a genius plan: freeze himself until the Wii is released.

After the boys all refuse to help with Cartman's suspended animation scheme, he turns to Butters, who is happy to oblige. The two then trudge out to an isolated spot in the mountains and proceed to bury Cartman, without a coat, in the vast sea of snow. As he is instructed, Butters will then retrieve him on the day of the Wii's release.

Meanwhile, Ms. Garrison violently opposes teaching evolution in her class. Her resistance prompts the school to hire biologist and evolution expert Richard Dawkins to handle the subject in his place. At first Garrison despises Dawkins, but this changes when the two go out to dinner together. Over the meal, Dawkins converts Garrison to atheism and the two retire to Garrison's home for hardcore sex. They become a couple, and Garrison turns into a rabid advocate of atheism. The two decide that together they must cleanse the world of all religious beliefs, putting an end to human conflict forever.

Back in the mountains, Cartman's plan goes awry. A freak avalanche buries his body under tons of snow and sweeps away the landmarks Butters relied on to find him. He stays frozen until the year 2546, when representatives of the Unified Atheist League find and thaw him out.

It seems that in the future, the entire world is ruled by atheism and science. Yet conflicts still exist. The atheists have splintered into three constantly warring factions: the Unified Atheist League, the United Atheist Alliance, and Allied Atheist Alliance, composed of sentient sea otters.

During a deadly gun fight, Cartman (aka the "Time Child") is kidnapped by UAA soldiers and taken away—but not before the AAA's leader vows to smash Cartman's skull "like a clam on my tummy." But to Cartman, all these problems pale in comparison to the biggest tragedy: in the future, there is no Wii.

Now a prisoner of war, it seems the Time Child's journey is just beginning. . .

MEMORABLE LINES:

"Do you mind telling me why my daughter now thinks she's a retarded fish-frog?"—*Mr. Triscotti*

"So there you go. You're the retarded offspring of five monkeys having butt sex with a fish-squirrel. Congratulations."
—*Ms. Garrison*

"With your intellect and my balls, we can change the future of the world."
—*Ms. Garrison*

"I hate you, but I'm not gonna help kill you!" —*Kyle*

"SCIENCE HELP US!"
—*Shpeck*

"Know this Time Child! I shall smash your skull like a clam on my tummy!"
—*Sea Otter King*

"Very well. But there is to be no more throwing of feces. Understood?"
—*Principal Victoria*

"No, it's not a good idea, it's an AWESOME idea."
—*Cartman*

"I know I'm special. This isn't news to me."—*Cartman*

"I'm just a little boy from the past who wants to play Nintendo Wii."
—*Cartman*

"After everything we've been through together, you guys won't even help me freeze myself!"
—*Cartman*

"I've just never seen a woman with such...BALLS."
—*Richard Dawkins*

"I'm not a monkey, I'm a woman!"
—*Ms. Garrison*

"Yeah! Pound my monkey hole, Richard!!"
—*Ms. Garrison*

"It's like waiting for Christmas... times a thousand."
—*Cartman*

BODY COUNT

Several members of the Unified Atheist League and the United Atheist Alliance are killed in an explosive, high-tech shootout over possession of the Time Child (aka Cartman).

WHERE DID THE IDEA COME FROM?

Trey and Matt's views on God, religion, and atheism are pretty complex. But their love of video games is pretty straightforward. At the time this episode was created, Trey (like Cartman) was much more concerned about the imminent release of the Wii. Hence the show itself is sort of about atheism, but mostly about the super sweet Wii.

VIDEO GAME REFERENCES

This is the fourth time Cartman has taken extreme measures to secure a gaming system. In Season 4's "The Tooth Fairy's Tats 2000," he got into organized crime to raise the cash to buy a Sega Dreamcast. And during "Best Friends Forever" (page 122), he sought to have Kenny's feeding tube removed so he could inherit his PSP. Finally, in Season 5's "Towelie," he and the other boys faced death together to recover their Okama Gamesphere.

POINTLESS OBSERVATIONS

The restaurant Buca de Faggoncini, last seen in "Erection Day" (page 128), returns. The show's title is a satire of the popular children's book *Go Dog Go!*, which also happens to be the first book that Officer Barbrady read (in Season 2's "Chickenlover"). Professor Chaos and General Disarray also make a return appearance playing "Kill the Super Heroes" in Butters' back yard. Chaos was last seen two seasons ago in "Good Times With Weapons" (page 84).

There are three warring factions of Atheists in the future: The Unified Atheist League (which Garrison and Dawson are credited with starting), the United Atheist Alliance, and the Allied Atheist Alliance (composed of sea otters). They all want possession of the Time Child, and they all think the other sects have a stupid name. Much like the Marklars from "Starvin' Marvin in Space," these future atheists have modified their vocabularies. Any time the word "God" would have been used, it's replaced with the word "Science"—as in, "Science damn you!" or "Oh My Science!"

CHARACTER DEBUTS

Richard Dawkins, the world-renowned evolutionary scientist. This character is based on the real British biologist and scientist of the same name.

We also meet the three atheist sects from 2546, as well as some of their leaders. Most notably is Shpeck, the leader of the Unified Atheist League, and Tlandus, the blond-haired leader of the United Atheist Alliance.

Lastly, we meet Heidi Triscotti and her parents—all devout Catholics who want no part of Ms. Garrison's evolution lecture. With the exception of her hairclip, Heidi Triscotti looks extremely similar to Heidi Turner, whose family we met in "Marjorine" (page 132).

POP CULTURE REFERENCES

When Cartman travels forward in time, he's accompanied by the theme music and visuals from the opening of the TV series *Buck Rogers in the 25th Century*. Also, Cartman freezes with the top half of his head sticking out of the snow, looking just like Jack Nicholson in *The Shining*.

A lot of the futuristic design from 2546 is modeled after what's seen in *Star Trek*. Especially the interior of the UAA's ship, which looks a lot like the bridge from the Enterprise.

Cartman paces outside of the videogame shop EV Games—a parody of popular chain EB Games. In the store, there's the videogame *Twerpz* (a parody of Bratz) and the mega-popular *StarCraft*.

WHAT-THE-FUCK MOMENT

To demonstrate her feelings about the theory of evolution, Ms. Garrison poops in her hand and hurls feces at evolutionary expert Richard Dawkins. Instead of being upset about the poo bath, however, Dawkins admires Garrison's "balls" and asks her out to dinner.

WHAT GARRISON LEARNED

"No, I totally get it now! Evolution explains everything! There is no great mystery to life, just evolution and God's a spaghetti monster! Thank you, Richard!"

ATHEISTIC REFERENCES

Richard Dawkins makes passing mention of the Flying Spaghetti Monster, a satirical "supreme being" invented to highlight the unprovability of pretty much any deity, doctrine, or religion.

GO GOD GO XII

Original Air Date: November 8, 2006
Episode 1013

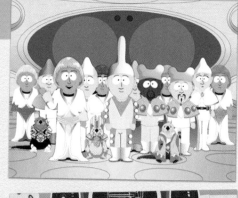

THE STORY: We return to the Time Child's atheistic adventures with this next installment of "Go God Go." Our story resumes as Cartman—riding with a clan of sea otters on the backs of ostriches—visits the ancient Museum of Technology in New New Hampshire to acquire the world's last remaining Wii console.

He finally finds the precious Wii—and immediately beams away from the sea otters. This double-cross against the otters has provided the United Atheist Alliance with crucial wartime information. But more importantly for Cartman, he's finally got the Nintendo Wii (which he's now waited 500 years to play).

But Cartman soon discovers that the gaming system is completely incompatible with 26th century viewing screens. Disgusted, he uses a special device called the "Crank Prank Time Phone" (designed to let children make crank calls to people in the past) to call his own time and get someone, anyone, to prevent him from freezing himself. Unfortunately, no one—least of all his past self, whom he refers to as an "asshole"—believes him.

For the moment he remains stuck in the atheistic future—a future, he learns, that was shaped primarily by Richard Dawkins and his wife, Garrison. Yet the pacifistic, God-free future they imagined never came

to be. God is certainly gone, but the various atheistic factions keep right on fighting. Their current cause du jour is over something they call "the great question."

Things come to a head when the United Atheist Alliance decides to attack the clam fields of the Allied Atheist Alliance (the sea otters). However the otters are on to them. They plan to lure the forces of the United Atheist League into attacking, then wipe out both the UAL and the UAA in a surprise attack.

As the three warring factions all commence their attacks on one another, Cartman desperately makes one more call to the past. He reaches Dawkins and Garrison, who are in the middle of having sex. Almost by accident, he mentions to Dawkins that his "girlfriend" used to be a man. This key piece of information instantly ends their relationship, which changes the future radically. Suddenly the three formerly warring factions are now at peace.

Cartman is beamed back to the 21st century, where he vows to patiently wait the three weeks until the Wii console debuts. Until he discovers that the time machine overshot, returning him a full two months before the Wii comes out. Suddenly he receives a phone call from his future self, telling him to definitely not do the thing he's thinking of doing. Cartman hangs up.

MEMORABLE LINES:

"I will suck your balls Kyle. Stop me from freezing myself, and I will get on my knees and I will suck your balls."
—*Cartman*

"HAIL SCIENCE!!"
—*Otters*

"Suck my balls, K-10. I'm not in the mood."
—*Cartman*

"SCIENCE DAMN YOU, TIME CHILD!!"—*Blavius*

"I will personally kill the Time Child and eat his entrails on my tummy!"
—*Blavius*

"How reasonable is it to eat off of wood instead of your tummy?!"
—*Hartsol*

"I've been waiting for 500 years to play Nintendo Wii, and if I don't play soon, I'm going to bust a nut!"
—*Cartman*

"Crank Prank Time Phone is not intended for use by otters."—*Narrator*

"Oh yeah! I'm a monkey!! Give this monkey what she wants!!"
—*Ms. Garrison*

"Kill the table eaters! In the name of almighty science!"
—*Hartsol*

BODY COUNT

Innumerable humans and otters slaughtered in the wars between the Unified Atheist League, the United Atheist Alliance, and the Allied Atheist Alliance. Also, The Wise One—the oldest, most intelligent sea otter. His insightful speech to the AAA on God and peace gets him mauled to death by his own army.

WHERE DID THE IDEA COME FROM?

Trey and Matt wanted it to look like Cartman had been in the future for quite a while—hence the episode being titled "Go God Go XII" instead of "Go God Go II." At first they hadn't a clue about the story, other than that they wanted to have otters riding ostriches. Ultimately, they elected to nail two points: That the idea of a peaceful atheistic society is absurd, because people will always fight; and that the super-smart people who advocate atheism often lack basic common sense—just like Richard Dawkins, who somehow misses the fact that Garrison used to be a dude.

POINTLESS OBSERVATIONS

Cartman's "Crank Prank Time Phone" is made by Zazbro, a play on Hasbro.

We see a commercial for "Glade Monvert Cleaner," a product that apparently makes your Mingey sparkle like never before. Also, you can briefly see a picture of Garrison's parents hanging in his living room. We met these non-child-molesting folks in "World Wide Recorder Concert."

CHARACTER DEBUTS

Blavius, the leader of the sea otters with the pendant on his head, and Hartsol, his right-hand-otter with the glass screen over his eye. Lastly, we meet Young Shpeck—son of Unified Atheist League's leader Shpeck, who was killed in the last episode.

There's also the Time Child's various robotic "pets," including a robot dog named K-10, a robot cat named KIT-9, and a robot bird called KOK-A-3.

POP CULTURE REFERENCES

The theme and opening credits montage from *Buck Rogers in the 25th Century*, which was used in Episode 1, is reprised for the opening of Part XII. Many other elements from *Buck Rogers* are parodied throughout as well, such as calling the ruined city "New New Hampshire" (almost all cities in the show had the prefix "New").

The opening shot with the overgown ruins of a city is an homage to classic films *Planet of the Apes* and *Logan's Run*. Also, the United Atheist Alliance's control room is loosely modeled after the battle room from the new *Battlestar Galactica* TV series.

In the "Games of Our Ancestors" section of the Museum of Technology, there are a number of real gaming systems on display. Most notably: a first generation Nintendo, Nintendo Game Cube, Nintendo Wii, and a Dancin' Dancin' Dancin' Machine (last seen in "You Got F'd in the A," page 90).

ORIGINAL SONGS

During the commercial for the high-tech toy, we hear the up-beat, Mattel-esque theme for "Crank Prank Time Phone."

WHAT TLANDUS, THE UNITED ATHEIST ALLIANCE LEADER, LEARNED

"Tell everyone in the past for us, that no one single answer . . . is ever the answer."

STANLEY'S CUP

Original Air Date: November 15, 2006
Episode 1014

THE STORY: Stan's bike is impounded for unpaid parking tickets, and the only way he can get it back is by performing community service. He's enlisted to coach the Park County Pee Wee hockey team, which turns out to be quite a bummer for him. The kids can barely skate, let alone play. And even worse, one of the little players (Nelson) has terminal cancer.

At home, Randy is equally horrified to find out about his son's coaching gig. Apparently, when Stan was four years old, he missed a crucial shot during a Pee Wee hockey game that forced his team to settle for a tie. The painful memory is still fresh for his father—even though Stan can't seem to remember the traumatic event (although he does recall going to Shakey's Pizza afterwards).

Meanwhile, Nelson's condition worsens. He's now bedridden and far too sick to play. As a dying wish, he asks Stan to win their next game against Adams County. Try as they might, however, their next match results in a 0-0 tie. And Nelson is left in what Dr. Doctor refers to as "cancer limbo."

The South Park team is then slated to face a much better team from Denver County in the Pepsi Center. Hoping that a win will give Nelson the strength to carry on, Stan adds a "ringer" to the ros-ter—Kyle's brother Ike, recruited solely because he's Canadian. Stan's father confronts his son about his return to the Pepsi Center, the sight of his failure years earlier. The incident (which Stan still can't remember) is so vivid to his father that he almost doesn't attend the game.

Thus the stage is set for a classic "sports movie" finish, in which the underdog defeats the better team. Only it doesn't work out that way. They arrive for the match-up (to be played during the intermission of an NHL Colorado Avalanche/Detroit Red Wings game) only to discover that the opposing team didn't show.

Not wanting the kids—who have been through way too much "emotional crap"—to leave the arena empty-handed, the Avalanche let Stan's team take on the Red Wings during the third period. Twenty minutes of savage body checking later, the Pee Wees lose 32-2. The Red Wings hoist a huge trophy while "We Are the Champions" plays.

Stan is humiliated. His father is furious with him for failing. A player tells Stan that he hates him. And shortly thereafter, as a sort of traumatic cherry on top of a sadness sundae, the bedridden Nelson succumbs to cancer.

MEMORABLE LINES:

"The game tonight, I'm gonna be watching, so could you . . . make it so I don't have cancer?"
—*Nelson*

"Coach, please don't let us lose to Adams County. My daddy will beat me again."
—*Park County Player*

"Stan, your mother's been worried sick, and I've been watching TV!"
—*Stan's dad*

"Oh and it appears the goalie has pooped his pants."—*Announcer*

"I'm just his father. But you're his coach! You're like a father to him!"—*Nelson's dad*

"Just remember, Stan, WIN OR LOSE. Those are your two options. WIN . . . OR LOSE."—*Stan's dad*

"Stan Marsh is a bright young man. He's got a great family. A promising paper route. Only problem is. . . his bike's been impounded!"—*County Official*

"He isn't worse, but he isn't getting better. It's almost as if . . . his cancer were TIED."
—*Dr. Doctor*

BEHIND THE SCENES

This episode was partially written and animated before the run began, so that the crew could take off a couple days at some point. But instead of being used in the middle of the run as planned, it kept getting held because no one knew what to do with it. Finally, with only one episode left and no other ideas in sight, it was time to knuckle down and make it work.

CHARACTER DEBUTS

Nelson (the kid with cancer) and his parents, Mr. and Mrs. Brown. There's also the rest of Stan's Pee Wee hockey team: Morgan, Sammy, Billy, Nelson, Tad, and Chris.

Lastly, we meet the County Official, who seems to have an endless assortment of movie plots at his disposal, as well as Gavin Throttle, coach of the Adams County hockey squad.

CELEBRITIES IMPUGNED

The Crocodile Hunter, lampooned a few episodes earlier in "Hell on Earth 2006" (page 168), gets it again—twice. When Stan tries to reassure a player that the opposing team isn't going to literally "kill" them, the boy says, "That's what Steve Irwin said about the stingrays." Before that, Dr. Doctor states that if Stan loses the big game, Nelson "is gonna die faster than Steve Irwin in a tank full of stingrays."

BODY COUNT

Little Nelson loses his battle to cancer. The rest of South Park's Pee Wee team also recieves a solid ass whooping courtesy of the Detroit Red Wings.

WHERE DID THE IDEA COME FROM?

The story turns clichéd sports movies, from *The Bad News Bears* to *The Mighty Ducks*, upside down. Stan even says to his players, "Haven't you guys ever seen these movies?! We're just supposed to rally together, believe in ourselves, and we win in the end!"

Matt's favorite part is the last bit, where there's a huge, cliché happy ending—only it's for the opposing team. It's *their* happy ending that we witness.

POINTLESS OBSERVATIONS

The *South Park Gazette*, according to its sign, was established in 1997—the same year *South Park* debuted. In the office for the *Gazette*, there are three framed articles behind Mr. Jarvis—all referencing past episodes: "What Is Scuzzlebutt??" with a picture of the notorious monster from Season 1's "Volcano"; "Local Inventor Hits Big!!" with a snapshot of Garrison and his breakthrough IT from Season 5's "The Entity"; and "Smug Alert!!!" from this season's disaster epic "Smug Alert!" (page 150).

In the hockey flashback, we get a nice view of Stan's parents with longer, 70s-style hair. The only other time we've seem them rock this fashion was during a brief Woodstock flashback in "Die Hippie, Die" (page 118).

POP CULTURE REFERENCES

The hockey arena carries an ad for Lizard Ade, an obvious reference to Gatorade. There's also an ad for an arching "W" with the phrase "Gotta Love It!" (a joke on McDonald's slogan "I'm Loving It").

During the action-packed game montage between South Park and Adams County, "Song 2" by Blur blasts.

This whole episode is an extended parody of the classic Disney flick *The Mighty Ducks*—a movie about an attorney who is forced to coach a hockey team after a drunk driving arrest. The flashback of Stan missing the goal is set up exactly like the opening to the film, except instead of Stan being emotionally scarred, Randy takes the burden. And as the icing on the *Ducks*-parody cake, "We Are the Champions" by Queen blasts over the Red Wings celebration.

WHAT NELSON LEARNED JUST BEFORE HE FLATLINED

"No hope, no hope. . ."

THE SOUTH PARK

EPISODE GUIDE

VOLUME 2 SEASONS 6 - 10